LONDON GOLDSMITHS

VIRTUTUM

JUSTITIA

H.STABLER

REGINA

1935

To
The Worshipful Company of
Goldsmiths of London
this Record is
Most Gratefully
Dedicated

THE LONDON GOLDSMITHS
1200–1800

A RECORD OF THE NAMES AND ADDRESSES OF
THE CRAFTSMEN
THEIR SHOP-SIGNS AND TRADE-CARDS

COMPILED BY

SIR AMBROSE HEAL, F.S.A.

FROM THE RECORDS OF THE GOLDSMITHS COMPANY
AND OTHER CONTEMPORARY SOURCES

DAVID & CHARLES REPRINTS

ISBN 0 7153 5515 5

First published in 1935 by Cambridge University Press
This reprint published in 1972 by David & Charles (Publishers) Limited

Publishers Note
The following changes have been made in this reprint.
The format has been reduced to 9″ × 6″, and the plates have
been printed on both sides of the paper which accounts for a
reduction in the total number of pages

Reproduced and printed by Lewis Reprints Limited
The Brown Knight & Truscott Group, London and Tonbridge for
David & Charles (Publishers) Limited, South Devon House
Newton Abbot, Devon

CONTENTS

LIST OF PLATES

TRADE-CARDS

(vii)

LIST OF PLATES

The dates given on the Plates indicate the period during which the goldsmith was working at the address from which the card was issued. In cases where one year only is given, this is the actual date of a bill which has been made out on the back of the card.

PREFACE

THE ORIGINAL INTENTION WITH WHICH THIS BOOK WAS
planned was merely to provide some record of the trade-cards issued by London
goldsmiths during the seventeenth and eighteenth centuries and to supplement it
with the details available concerning the dates and addresses of their issuers.

The standard works on English goldsmiths were turned to in the hope that this
complementary information would be forthcoming, but it was soon discovered
that while these books were admirably arranged for the purpose of enabling the
collector readily to assign the correct date to a piece of plate, and to say who made
it, it was no easy matter to abstract information from them about the maker him-
self. As these personal details were essential to the main purpose of the book, it
became necessary to extend the original plan and to compile a list of the London
goldsmiths which should afford as much of this detailed information about the
individual craftsmen as could be collected.

Sir Charles Jackson's fine book, *English Goldsmiths and Their Marks* (Mac-
millan & Co. 1921), is of the greatest value in establishing the date and the maker's
name in connection with the particular maker's mark. The tables of date-letters and
makers' marks which it contains go far beyond any other work dealing with the
goldsmith's craft. These tables alone are sufficient to ensure that, for many years to
come, Jackson will be the standing authority to be consulted by collectors whenever
it is a question of deciding the date or the authorship of a piece of goldsmith's work.

To those, however, who are not so closely concerned with the date of an actual
piece, but rather with the goldsmith himself, Jackson is not so helpful. If we seek
to know the location of a man's place of business, what shop-sign he used, the date
when he moved from one address to another, whom he succeeded or who followed
him, we shall get very little assistance from *English Goldsmiths* other than the name of
the town in which the man worked. Even to ascertain the dates when any particular
goldsmith was working is not easy. The first great obstacle is that there is no index
of names—an index of the initials occurring on the makers' marks is the only guide
vouchsafed—consequently it becomes necessary to turn up every reference under the
appropriate initials. Needless to say that the same initials will apply to many names.
Accordingly, in order to make sure of the full range of dates which cover a maker's
period, every single entry under that man's name has to be checked in the body of
the text. With a common name like James Smith there is no alternative but to turn
up each one of the ninety-three possible initial references in the index. Having done
so one finds that five of these relate to James Smiths and that there is no means of

distinguishing between any two, or more, bearers of this name. Even with an uncommon name like Paul de Lamerie no less than twenty-eight possible references have to be tested, but of these only five are found to bear on de Lamerie. If it would interest us to know what sign hung over a man's shop we shall only be able to discover this in a dozen cases out of the, approximately, 2800 entries which appear in Jackson's list of the "Names of London Goldsmiths" covering the period from the twelfth to the end of the eighteenth century.

In order to describe the scope of the present volume it is necessary to point out the ways in which it differs from Jackson's standard work and in what direction attempts have been made to supplement it. Jackson was concerned to describe the maker's mark, to provide the name of the maker who used that mark, and to say when he used it. His list is arranged chronologically. The present undertaking does not concern itself with the maker's mark, that ground having been well covered by Jackson and also by Chaffers. The aim here is to provide an *alphabetical* list of goldsmiths who were working in London from the earliest times of which we have record down to the end of the eighteenth century; adding their dates *and addresses* wherever ascertainable. It is hoped that this alphabetical list may be found to facilitate reference to the chronological arrangement adopted by Jackson and that the additional information here given will add to its interest and usefulness.

In his list of London goldsmiths, up to the end of the eighteenth century, Jackson gives, approximately, 2800 names. In the following pages all those names will be found and to them have been added records of more than 3600 goldsmiths and jewellers gathered from various other sources. The names of about 350 pawn-brokers have also been included, making a list of nearly 7000 names all told.

It will be seen, therefore, that the limits of the original intention of this book have been exceeded. From the basic plan of merely compiling a record of those London goldsmiths who were known to have issued trade-cards during the seventeenth and eighteenth centuries it has grown into a directory of London goldsmiths from the twelfth to the eighteenth century.

A good nucleus for such a directory existed in Chaffers' *Gilda Aurifabrorum* (Reeves and Turner, 1899) where there is a list of nearly 2000 names and addresses taken from the records of the Goldsmiths' Company. With Chaffers as a basis on which to build, it seemed feasible to attempt to compile a list of London goldsmiths, jewellers, etc., who were working before the year 1800, which would in most cases give their addresses and the dates at which they flourished. Unfortunately the material that Chaffers had at his command seems to have provided him with somewhat limited information as to the shop-signs of the goldsmiths. In the table of "Goldsmiths' and Plateworkers' House Signs" which he compiled, ranging from 1551 to 1773, he was only able to give us about 200 instances of signs that were

known to him. This list we have now been able to extend to close upon 1500 recorded signs.

Systematic records of goldsmiths previous to the last years of the seventeenth century no longer exist, though it is known from a reference in *The Touchstone for Gold and Silver Wares* (1677) that a list of the makers' names, identifying their marks, was being kept during the reign of Charles II. These old records, unfortunately, were destroyed in a fire which broke out at the Goldsmiths' Hall in 1681. From the year 1697 onwards the books containing the "workmen's marks and places of abode", together with their names and the dates against each entry, are still preserved at the Goldsmiths' Hall. Much valuable information has been found in the advertisement columns of contemporary newspapers, London Directories and certain Parish Registers. All the known collections of trade-cards and bill-heads have been examined and extracts have been made from various wills, leases, inventories, memoirs and polling lists, etc. The work of that indefatigable searcher after shop-signs—the late F. G. Hilton-Price—has been largely drawn upon. His series of articles on "Signs of Old London", some of which appeared in *London Topographical Records* and others in *Archaeological Journal,* have provided much useful material, and his *Handbook of London Bankers* has been the authority for many details relating to the goldsmith-bankers. Other by-ways of London topography have been searched for stray records, as well as the more obvious works of reference.

It has not been considered necessary to include in this volume historical notes on the development of the craft, nor to give records of the Goldsmiths' Company, as these subjects have been fully dealt with in the works of Prideaux, Jackson, Chaffers, Alfred Jones, W. J. Cripps and others where they are readily accessible. Nor, for similar reasons, has it seemed desirable to deal in any categorical way with the work of individual craftsmen. A few notes have been put together on those London goldsmiths whose names have become famous or notorious for one reason or another. In this section the more notable Lord Mayors, the eminent goldsmith-bankers and some of the outstanding craftsmen have been indicated and particulars of their careers have been given in those cases which seemed to have uncommon interest. A separate list has been made of all the goldsmiths who are referred to by Samuel Pepys in his diary and a few characteristic particulars of his dealings with them have been cited.

It has also been thought worth while to put on record a register of the shop-signs of the London goldsmiths and, in order to carry out the original intention of this volume, an attempt has been made to form as complete a catalogue of their trade-cards as has been possible. A selection of about eighty cards has been reproduced in this volume.

PREFACE

In compiling this catalogue of London goldsmiths' trade-cards I have drawn upon all those collections which are known to me—both public and private. To fellow-collectors and to curators alike I owe my thanks for their unfailing courtesy in assisting my researches and in allowing me to reproduce their specimens. The list of collections laid under contribution will be found in the chapter on trade-cards on p. 25. I owe debts of gratitude to many whose special knowledge of the history of the goldsmith's craft has been of invaluable assistance to me: particularly I have to thank Mr Francis Buckley for allowing me to make full use of his *Old London Goldsmiths 1666–1706* and for his indefatigable kindness, extended over many years, in sending me transcripts of goldsmiths' advertisements which he has culled from early newspapers. The late Mr P. A. S. Phillips, whose posthumous volume (*Paul de Lamerie*) has recently been published, most generously gave me permission to take advantage of the list he compiled of those foreign goldsmiths who took out letters of denization in London. To him and to Dr Joan Evans I owe much information relating to the Huguenot refugees. I am likewise indebted to Mr Alfred E. Jones for much useful data concerning the seventeenth-century goldsmiths and to Mr H. Wilson Parker for permission to use his design of the leopard's head, the mark of the London Assay Office, which is reproduced on the binding.

Above all I have to express my most grateful thanks to the Wardens and the Court of Assistants of the Worshipful Company of Goldsmiths, without whose generous help the publication of this volume would not have been possible. From the Officers of the Company I have received much kindly advice and all possible assistance when consulting the archives in their charge.

AMBROSE HEAL

Beaconsfield
June 1935

I
GOLDSMITHS, BANKERS AND PAWNBROKERS

II
EMINENT LONDON GOLDSMITHS

(i) Lord Mayors
(ii) Other Notabilities
(iii) Famous Craftsmen

GOLDSMITHS, BANKERS AND PAWNBROKERS

The range of trades covered by this book is a somewhat wider one than that dealt with by other writers on the subject who have mostly confined themselves to the craft of the goldsmith proper. For the purposes of this more general record it was necessary to recognise the overlapping of various branches of the trade: goldsmiths with bankers and jewellers; bankers with goldsmiths and pawnbrokers; jewellers with goldsmiths and toymen. A man may fall into one or all of these categories according to the occasion of the reference. For example—on his own bill-head it often occurs that a man will describe himself as "goldsmith, jeweller and toyman", whereas by the exigency of the more succinct entry in a directory, or in an obituary notice, he will be referred to under one heading only.

The term "goldsmith" is generally used to denote workers in gold and silver and also those who dealt in gold and silver wares. In the seventeenth century it covered those members of the craft who acted in the capacity of bankers to their customers. This accommodation began to be practised by the English goldsmiths about the year 1645. They also lent money on pawns and issued notes. The London Directory issued in 1677 under the title of *A Collection of the Names of the Merchants living in and about the City of London* contains a list of no fewer than fifty-eight "Goldsmiths that keep Running Cashes", of these thirty-five were resident in Lombard Street. In the early ledgers of Edward Backwell, and of Blanchard and Child, accounts may be seen headed "Pawnes" to which all interest and profits arising from money lent on pledges, or marketable securities, were placed.[1] Fortunes were made rapidly in those days; some of the methods employed are to be studied in a pamphlet published in 1676 entitled *The Mystery of the New Fashioned Goldsmiths or Bankers Discovered.*

It seems unlikely that the term "banker" came into use much before the end of the seventeenth century. The earliest use of the term that has been noted is in the registers of the parish of St Mary Woolnoth where there is an entry of the baptism of a daughter of George Reed "bancker" on 17 February 1700.

By the time that George II had come to the throne the goldsmiths had relinquished the money-lending side of their business, and the profession of banking was firmly established on its own basis. Advances upon pledges, or pawns, had become the affair of the pawnbroker, and announcements indicating this change were inserted in the newspapers—"All persons that have any Jewels, Plate or other goods Pawned to Mr. Tho^s Sturt, goldsmith in Castle Yard Holborn are desired to redeem them

[1] Hilton-Price's *Handbook of London Bankers* (1891).

(3)

by 24 June next or they'll be dispos'd of—he having left off taking in Pawns" (*London Gazette*, 3 April 1701).

Pawnbroking, though a very ancient institution, does not appear to have been carried on as a separate business before the end of the seventeenth century. It is found to exist in conjunction with various trades such as upholsterers, leather sellers and even bricklayers. Until the middle of the eighteenth century it was legal for publicans to take pledges, but this was prohibited by law in 1751. Pawnbroking having been a recognised function of the goldsmith for so long, members of the fraternity have been included in this survey when records of them have been found previous to 1775. Most of these names have been taken from the list compiled by F. G. Hilton-Price and published in the *Archaeological Journal*, Vol. LIX, June 1902.

EMINENT LONDON GOLDSMITHS

LORD MAYORS

During the period with which we are dealing, namely from the twelfth to the end of the eighteenth century, many well-known names occur among the London goldsmiths. From their craft alone fifty-five members were elected to the office of Mayor, or Lord Mayor, of London. Some few of these, however, were not practising goldsmiths although members of the Goldsmiths' Company. Among the earliest of these, the "Mayors" of London (the title of "Lord Mayor" did not come into general use much before the middle of the sixteenth century), we find Leofstane and Fitz Alwyn in the twelfth century, and Gregory de Rokesley who was elected to the office no fewer than eight times between 1274 and 1284.

In the following century we have Nicholas de Farndone, who was four times Mayor between 1309 and 1323; Sir Richard Betoyne, a strong supporter of Queen· Isabella and Mortimer; Sir Nicholas Twyford who was knighted for his services in the Wat Tyler insurrection; Sir Adam Bamme, the immediate predecessor of the celebrated Richard Whittington; and Sir Drugo Barentyn. Each of these last two filled the office of Mayor twice. Sir John Shaw, who had been knighted on Bosworth Field, served in 1501–2. The sixteenth century saw the rise of that line of great goldsmith-bankers, all of whom became Lord Mayors: Richard Gresham, Martin Bowes, Richard Martin, Thomas and Robert Vyner, Francis Child, Charles Duncome and Richard Hoare. Sir Richard Gresham, who served

the office of "Mayor of London" 1537–8, was probably the last to bear that title; by the middle of the century the designation of the Chief Magistrate as "Lord Mayor" had become generally adopted. Of the fifty-five goldsmiths who became Lord Mayor previous to the year 1800, eighteen were of sufficient importance to find places in the pages of the *Dictionary of National Biography*.

OTHER NOTABILITIES

Brief mention may be made of other goldsmiths, whose names are famous or notorious for one reason or another. Arranging these in some kind of chronological order we come first to Michael Thovy, who had brought himself into disfavour by supporting the cause of the Barons and who was hanged on a charge of murder in 1275. In the middle of the fifteenth century John Sutton met his death on London Bridge defending the City against Jack Cade (1450), and shortly afterwards Sir Matthew Philip distinguished himself in the Fauconberg rising (1471). The name of William Shore comes down to us as the husband of the fair and witty Jane, famed as the mistress of Edward IV. He has often been confused with his brother Matthew Shore, who also was a goldsmith; both were in Lombard Street. Thomas Wood and Sir Thomas Gresham are connected in our minds with the development of the City, the former more particularly with the building of Goldsmiths' Row and the street that bears his name, the latter as founder of the Royal Exchange. Gresham carried on his business at the Sign of the Grasshopper in Lombard Street upon the site of the present Martin's Bank where the sign still persists. During the reign of Elizabeth two goldsmiths, Thomas Greene and Richard Robinson, were drawn, hanged and quartered at Tyburn for the capital offence of "clipping gold coins". Robert Herrick the poet was born in Wood Street and came of a goldsmith's family, his father Nicholas and his uncle Sir William both being in this trade. To Sir Hugh Myddelton, who carried on a successful business as goldsmith and jeweller in Basinghall Street, we owe the New River undertaking which was opened on Michaelmas Day 1613, the same day on which his elder brother, Sir Thomas, was elected Lord Mayor.

The name of George Heriot, goldsmith to James I, is known to us as that of the founder of Heriot's Hospital in Edinburgh, an institution on the lines of Christ's Hospital, which has been a powerful factor in the educational work of that city to this day. Thomas Violet was arraigned before the Star Chamber for exporting gold

and silver with the result that he was imprisoned, and several other goldsmiths, his accomplices, were heavily fined. These sentences may have accounted for the saying that "he failed to please his friends while he certainly displeased his enemies".

In 1658, according to Smith's *Obituary*, Hugh Lewis, goldsmith in Little Britain, was hanged at Tyburn for receiving stolen plate. Sir John Barkstead, one of the regicides, who in his early days had been a goldsmith in the Strand but under the Commonwealth had occupied many high positions, was executed in 1662. Alderman Backwell, who figures frequently in Pepys' *Diary*, is credited with being the chief originator of the system of "goldsmiths' notes" which were the earliest kind of banknotes issued in this country. After having amassed a huge fortune he was ruined through the closing of the Exchequer by Charles II in 1672 at which time the Crown's indebtedness to him amounted to nearly £300,000. Sir Robert Vyner was another of the great goldsmith-bankers whose downfall came about through the same cause. Miles Prance, jeweller to Charles II, achieved notoriety as an arch-perjuror by his "confessions" and recantations concerning Titus Oates' alleged popish plot. One of the victims of Prance's perjuries was William Stayley, goldsmith in Covent Garden, who was falsely charged with high treason and hanged at Tyburn in 1678.

Previous reference has been made to the rise of the great goldsmith-bankers at the end of the seventeenth and the beginning of the eighteenth centuries. In addition to those who were chosen to serve as Lord Mayor, and who have been previously mentioned in that connection, other names are outstanding. Robert Blanchard, who laid the foundations of Child's bank, started in business at the *Marygold*, Temple Bar, in 1661. Two years later he became head of the firm and by 1670 had taken his step-son, Francis Child, into partnership. Samuel Hankey founded his firm at the *Ring & Ball* in Fenchurch Street about the year 1685. In the first decade of the following century the sign was changed to the *Golden Ball* and subsequently to the *Three Golden Balls*[1]. The famous firm of Coutts was originally established by George Middleton at the *Three Crowns* in the Strand, near St Martin's Church. In 1692 he had taken John Campbell into partnership and later the firm became Campbell & Coutts, James Coutts having married a niece of George Campbell. Another famous firm was founded by Andrew Drummond. He was at the *Golden Eagle*, Charing Cross, in 1712. The firm of Snow (later Strahan) survived vicissitudes to which other houses succumbed. Sir Jeremiah Snow escaped the general catastrophe

[1] For the origin of this sign see p. 43.

when Charles II closed the Exchequer in 1672, and in the fatal "Bubble" year of 1720 Snow's avoided disaster again. Their good fortune was celebrated by John Gay in his "Epistle to Thomas Snow, goldsmith, near Temple Bar":

> Oh thou whose penetrative wisdom found
> The South Sea rocks and shelves where thousands drowned
> When credit sunk and commerce gasping lay
> Thou stood'st nor sent'st one bill unpaid away
> When not a guinea chinked on Martin's boards
> And Atwell's self was drained of all his hoards.

This Martin was the successor of Sir Thomas Gresham at the *Grasshopper* in Lombard Street and Atwell traded at the *Griffin* in Exchange Alley. In the middle of the eighteenth century two goldsmiths, Nicholas Sprimont and George Moser, made names for themselves outside their own craft. The former, who was known for his curious rendering of shell-fish and rock-work, employed his facility in modelling to such purpose that in 1749 he succeeded Charles Gouyn, the founder of the Chelsea porcelain factory. Moser, the most famous gold-chaser of his day, carried on an art school afterwards known as the St Martin's Lane Academy. In 1768 he was one of the foundation members of the Royal Academy and was elected their first Keeper.

Peter Wirgman was a noted character of St James's Street in his day. It was to his shop that Dr Johnson repaired when he wished "to choose a pair of silver buckles, as those he had were too small" (Boswell). James Neild, the prison reformer, made a fortune as a jeweller in St James's Street. He was the father of that eccentric character, John Camden Neild, who left his fortune, valued at £500,000, to Queen Victoria. According to Dr Abraham's recently published *Life of Lettsom*, the Quaker physician, this sum built Balmoral.

FAMOUS CRAFTSMEN

Among the names of the many famous goldsmiths mentioned in these pages special reference may be made to some of those whose work is particularly renowned, or whose businesses had some especial character.

A large proportion of the names of the most celebrated craftsmen, it will be noticed, are those of French Protestant refugees who sought shelter in this country after the revocation of the Edict of Nantes in 1685. They, and their descendants, had a great influence on the design of English goldsmiths' work at the end of the seventeenth and the first half of the eighteenth century. A most valuable paper on

the Huguenot goldsmiths was recently contributed to the Huguenot Society by Dr Joan Evans and will be found in the Society's *Proceedings*, Vol. XIV, No. 4. This publication contains a very full list of the Huguenot goldsmiths in England and Ireland with biographical notes. I am indebted to this list for some of the particulars here given.

Taking the names of the London craftsmen in some kind of alphabetical order, we come first to the Peter Archambos (Archambaud) father and son. Peter Archambo senior entered his mark in 1720 and apprenticed his son to Paul de Lamerie in 1738, but he was immediately "turned over" to his father. John Bodington and Laurence Coles were both established in Foster Lane in 1697.

The famous shop near Charing Cross, carried on by various members of the Chenevix family, was the resort of the fashionable world in the seventeen-thirties and forties. It will be recalled that Mrs Chenevix (*née* Mary Roussel), "the toy-woman of Suffolk Street", had parted with her house at Strawberry Hill to Horace Walpole in 1748. John Cooqūs (or Cogues) in Pall Mall was, according to Cunningham,[1] the maker of Nell Gwyn's silver bedstead. Although his name is very variously spelt, there seems to be no good reason for identifying him with his better known contemporary John Coggs of the Strand, nor, as has been suggested, with Mr Cooke the silversmith mentioned by Samuel Pepys (*Diary*, 2 Nov. 1660).

Augustine Courtauld in 1708 was the first of this famous family of goldsmiths to be entered at Goldsmiths' Hall. He was succeeded in the Chandos Street business by his son Samuel who afterwards moved to Cornhill. The eminent medallist, John Croker, started life as a jeweller in 1691. He was responsible for engraving all the dies of the gold and silver coinage during the reigns of Anne and George I and the early part of the reign of George II. He also struck a large number of commemorative medals which were remarkable for accuracy of minute detail. Louis Cugny (or Cuny) flourished during the reigns of Queen Anne and George I at the *Three Crowns* in Panton Street. It seems very possible that Peter de la Fontaine whose trade-card was engraved by Hogarth (see Plate XXI) may have been identical with the Peter Fountain with whom David Garrick carried on the voluminous correspondence which is preserved in the Forster Collection now at the Victoria and Albert Museum. The likelihood of his being connected with Peter Fountain the forger who was hanged in 1746 seems quite remote.

[1] In *The Story of Nell Gwyn*, by Peter Cunningham, Cooqūs's bill is given in detail on pp. 135–7. Articles on John Cooqūs, silversmith, appeared in the *Antiquaries Journal*, July and October 1934.

The name of Paul de Lamerie is probably better known to the general public than that of any other goldsmith of his time and is the most familiar one to amateurs of eighteenth-century plate. His mark has frequently been confused with that of his master, Pierre Platel, to which it bore certain resemblances. The monograph on de Lamerie's life by the late Mr P. A. S. Phillips, recently produced by the Goldsmiths' Company, gives full details of this master's career.[1]

William Gamble of Foster Lane was a noted plate-worker during the reign of William III. His son Ellis Gamble is remembered chiefly for the fact that William Hogarth was bound apprentice to him in 1712. Hogarth engraved the rather un-distinguished trade-card of his master "Ellis Gamble, goldsmith at the Golden Angel in Cranbourn-Street, Leicester-Fields" (see Plate XXIX). Daniel Garnier, one of the prominent Huguenot craftsmen, was working in Pall Mall 1690–7.

William Garrard of Staining Lane entered his name at Goldsmiths' Hall in 1735, but no claim seems to have been made to connect him with the famous firm of Crown jewellers that still flourishes in Albemarle Street to-day. This business was founded by George Wickes who was trading in Leadenhall Street, and in Thread-needle Street, during the reign of George I. He appears to have moved to Norris Street in the Haymarket about 1730 and is found at the *King's Arms* in Panton Street in 1735. Robert Garrard was taken into partnership by John Wakelin who had succeeded to the business in 1792. Robert Garrard was followed by his son Robert Garrard junior, in 1802, who, later on, was joined by his brothers James and Sebastian.

Richard Gatesfield was a silver cock-spur maker in Exeter Street, Strand, in the middle of the eighteenth century. He is mentioned in Hallam's poem *The Cocker*.

The Harraches were a large Huguenot family of goldsmiths of whom we have records from 1675 to 1773. The most famous of these was Peter Harrache who was working in Suffolk Street in 1675 when he entered his mark. He died in 1700 and was succeeded by his son Peter of Compton Street, Soho. Other important Huguenot goldsmiths were Paul Crespin, Pierre Le Cheaube, the Le Sage family, Isaac Liger, Louis Mettayer, Mark Paillet, Simon Pantin, father and son, Pierre Platel, Philip Rainaud and David Willaume. Most of them were working in the neighbourhood of Charing Cross and Pall Mall during the last decade of the seven-teenth century and during the reign of Queen Anne.

The Pilleau family who traded at the *Golden Cup* in St Martin's Lane, and later in Chandos Street (1697–1755), were remarkable for the fact that they combined

[1] *Paul de Lamerie* (Batsford, 1935).

"ye art of making and setting Artificial Teeth, no ways discernable from Natural ones" with their ordinary business of goldsmithing (see Plate LVII). Alexis Pilleau, in his advertisements, claimed that "he fixes artificial teeth so that one may chew with them". In this connection it has been interesting to discover that one of the most famous, if not the most famous, firms making "dentures" to-day was founded at the beginning of the last century by a goldsmith—Claudius Ash.

To revert to the English craftsmen, mention must be made of Ralph Leake and to the celebrated Anthony Nelme who entered his mark in 1697 and flourished at the *Golden Bottle* in Ave Maria Lane until 1722 when he was succeeded by Francis Nelme. Contemporary with them were Humphrey and John Payne who, before they removed to Cheapside in 1720, had been established for many years in Gutter Lane; also Benjamin Pyne who at that time was working in St Martin-le-Grand.

In the middle of the eighteenth century Abraham Portal set up as a goldsmith in Soho and later moved to Ludgate Hill where he founded the firm of Portal and Gearing. From 1768 onwards he wrote a number of plays and poems which brought him some measure of literary fame. One of his operas was given at Drury Lane.

Coming down to more recent times we have, at the end of the eighteenth century, the firm of Rundell and Bridge of Ludgate Hill "incorporating" that finished craftsman Paul Storr. Their business, at the sign of the *Golden Salmon*, is to be traced through the partnerships of Pickett and Rundell, and before them Thead and Pickett, back to Henry Hunt who founded it in 1745. The present day firm in Bond Street is linked with the old Ludgate Hill business by the successive stages of Storr and Mortimer, Mortimer and Hunt, now Hunt and Roskell: a record of craftsmanship running back nearly two centuries.

III
SAMUEL PEPYS AND
HIS GOLDSMITHS

SAMUEL PEPYS AND HIS GOLDSMITHS

The *Diary of Samuel Pepys* supplies us with many vivid sketches of the goldsmiths of his day. We get his impressions of the character of the men themselves, his appreciation, or otherwise, of their wives, descriptions of their homes and, what is particularly interesting, an insight into their methods of conducting business.

In his position as Clerk of the Acts of the Navy Pepys was responsible for the provision, equipment and victualling of the ships. His continual preoccupation in those days of financial stringency was to secure the means by which the Fleet could be maintained. Consequently it devolved largely on Pepys to stave off creditors and to raise further loans; with the Dutch in the Medway and a bankrupt Treasury the position was desperate. His despondent remark that "so long as we and the world must be subjected to these bankers I do despair of compassing it" has been echoed in more recent times.

During the period covered by the diary, 1660–9, Pepys was in close touch with the powerful goldsmiths in the city, constantly visiting their shops in Lombard Street and Cheapside, negotiating loans for his contracts, checking his tallies, now and again buying a piece of plate or adding a dozen silver spoons to his household store.

The two goldsmiths whose names are the most familiar ones to readers of the diary are Alderman Edward Backwell and Sir Robert Vyner. The dealings of Pepys with these two financiers were on a very large scale and he has occasion to mention both of them more than fifty times. His business with John Colvill "my little new goldsmith" must have been a very considerable one also, for we hear of him nearly thirty times during the course of the diary. The names of twelve other goldsmiths occur in various connections. A brief summary of the more characteristic references may be of interest.

BACKWELL. In the quite early days of Mr Pepys' appointment to the clerkship of the Acts he came into close touch with Alderman Backwell, and during 1660 several visits to the *Unicorn* in Lombard Street are recorded. In June Pepys changes his "Dutch money" there and chooses £100 worth of plate on behalf of the Earl of Sandwich. On Christmas Eve of that year—"after dinner I went and chose a payre of candlesticks to be made ready for me at Alderman Backwell's". A few days later he changed his mind about these and "took a brave state-plate and cupp in lieu of the candlesticks that I had the other day". For some time after this we hear no more of his visits to the *Unicorn* until one day in November 1662 he goes to see Backwell

and "saluted his lady a very pretty woman". A few months later he is discussing with the goldsmith plans for "making another ally from his shop through over against the Exchange door which will be very noble and quite put down the other two". This reference is rather cryptic, but Wheatley, in an explanatory note, quotes Mr J. Biddulph Martin ("The Grasshopper in Lombard Street") who supposes that by "the other two" are meant Pope's Head Alley on the west of the premises and the alley opposite Abchurch Lane on the east. In July 1665 Backwell goes on a mission to Flanders to raise a large loan. At this time Pepys realised that Backwell was getting into deep water, "But he says he hath a good master, the King, who will not suffer him to be undone, as otherwise he must have been, and I believe him". Unfortunately, the confidence that the Alderman placed in his "good master" was not justified, for the closing of the Exchequer by Charles II brought about the ruin of Backwell and several other bankers. Previous to his downfall the diarist tells us of the ambitious plans that Backwell had made for rebuilding his premises destroyed by the Great Fire. "He showed me the model of his houses that he is going to build in Cornhill and Lumbard Street; but he hath purchased so much there that it looks like a little town and must have cost him a great deal of money" (12 April 1669). Mr Pepys continued to keep his own private banking account at Backwell's until the crisis in 1672.

BEAUCHAMP. We hear of James Beauchamp in two connections. In November 1660 Mr Pepys says "I went into Cheapside to Mr Beauchamp's the goldsmith to look out for a piece of plate to give Mr Fox from my Lord,[1] for his favour about the £4000, and did chose a gilt tankard". A few days later—"there came Mr Beauchamp to me with the gilt tankard and I did pay him for it £20". The only other occasion that we hear of Beauchamp is in 1663 when an action was brought against Sir William Batten by "Field the rogue". Pepys had an old score to wipe out; "and so to Mr Beacham (sic) the goldsmith...he being one of the jury tomorrow... I have been telling him our case and I believe he will do us good service there". Despite their friend in court the verdict was not entirely favourable; "the jury did give us but £10 damages and the charges of the suit which troubles me; but it is well it went not against us, which would have been much worse" (2nd and 3rd June, 1663).

COLVILL. At the earliest visit to John Colvill recorded in the diary (24 May 1665) Mr Pepys did not receive a very favourable impression of his "little new goldsmith"

[1] Earl of Sandwich.

—"after dinner Creed and I to Colvill's thinking to shew him all the respect we could by obliging him in carrying him 5 tallys of £5000 to secure him for so much credit he has given Povy to Tangier, but he like an impertinent fool, cavills at it, but most ignorantly that ever I heard man in my life". Later on, however, he says "But, Lord! how Colvill talks of the business of publique revenue, like a madman, and yet I doubt all true". On 19 June 1665 he tells us how having "dined alone (my wife having gone to her mother's)" he makes occasion to call at Lombard Street for the ostensible reason of settling his bill £6. 14s. 6d. for a dozen silver salt-cellars that he had bought. Mrs Colvill had evidently caught his appreciative eye on some previous occasion and here he affirms that "my little new goldsmith's wife indeed is one of the prettiest, modest black women that ever I saw". Colvill's house was doubtless burnt down in the Great Fire, for in October 1666 Pepys tells us that he "lives now in Lime Street" and a couple of years later says that he is "building a fine house where he formerly lived in Lombard Street". Colvill was another of those who suffered from the action of Charles II in closing the Exchequer in 1672. It is recorded that he made a total loss of his deposits there amounting to £85;832. 17s. 2d.[1]

COOKE. It has not been possible to identify this silversmith; half a dozen of his name were working in London at this period. He is alluded to on one occasion only in the diary—2 November 1660—"In the afternoon I went forth and saw some silver bosses put upon my new Bible, which cost me 6s. 6d. the making, and 7s. 6d. the silver, which, with 9s. 6d. the book, comes in all to £1. 3s. 6d. From thence with M[r] Cooke that made them, and M[r] Stephens the silversmith to the tavern, and did give them a pint of wine".

HINTON. On 18 December 1665 Mr Pepys mentions that he dined at the *Pope's Head* "and there with M[r] Hinton, the goldsmith, and others very merry". Wheatley, in a note to this entry, says that this was Edmund Hinton of Lombard Street, but one should not forget that in the list of "Goldsmiths that keep Running Cashes" given in the London Directory for 1677,[2] there was also a Benjamin Hinton at the *Flower de Luce* in Lombard Street. Pepys adds that a Dr Hinton was present on the same festive occasion and of him Wheatley, quoting Ellis's *Original Letters*, says that he was knighted as "a reward for having procured a private advance of money from his kinsman, the goldsmith, to enable the Duke of Albemarle to pay the army".

HOARE. Mr Pepys' own private account was kept at Hoare's bank from 1680

[1] Hilton-Price's *Handbook of London Bankers*.
[2] *A Collection of the Names of the Merchants living in and about the City of London* [1677].

until 1701. No mention of Sir Richard Hoare's name will be found in the diary (which was brought to a close in 1669) but it occurs in the list of persons who were presented with mourning rings at Pepys' funeral in 1703. Before the year 1690 Hoare was trading at the *Golden Bottle* in Cheapside; he then moved to Fleet Street.

MEYNELL. The earliest entry relating to Francis Meynell is on 18 September 1662: "Mr Coventry and I by invitation to Sheriff Maynell's, the great money-man" where amongst "much noble and brave company" Mr Pepys enjoyed "the privilege of their rare discourse, which is great content to me above all other things in the world". Shortly afterwards, however, he is incensed at the sheriff's methods which, in common with those of other bankers, he considers extortionate. Borrowers, he complains, "are forced to pay fifteen or sometimes twenty per cent for their money which is a horrid shame and that which must not be suffered. Nor is it likely that the Treasurer…will suffer Maynell the goldsmith to go away with £10,000 per annum as he do now get by making people pay after this manner for their money". After this we find the laconic entry on 8 October 1666: "Alderman Maynell, I hear, is dead". It will be noticed that Meynell's death occurred within a month of the outbreak of the Great Fire. It appears not unlikely therefore that his end may have been brought about, or hastened, by that catastrophe.

PARGITER. Of John Pargiter Mr Pepys held no very high opinion. On 21 October 1661 the diarist went "early with Mr Moore by coach to Chelsy…and having taken up Mr Pargiter, the goldsmith (who is the man of the world that I do most know and believe to be a cheating rogue), we drank our morning draft there together of cake and ale, and did make good sport of his losing so much by the King's coming in, he having bought so much of Crown lands, of which, God forgive me, I am very glad". Other than this we hear very little of Pargiter except that on one occasion he was present at a gathering of Mr Pepys' friends where they all "were very merry and had a good venison pasty", and at another time Mr Pepys encountered him in Moorfields where "he would needs have me drink a cup of horse-radish ale which he and a friend of his troubled with the stone have been drinking of".

PINCKNEY. On 1 December 1660 Mr Pepys speaks of "calling upon Mr Pinckney, the goldsmith, he took us to the tavern and there gave us a pint of wine". Hilton-Price, in his *Handbook of London Bankers,* identifies him as Major Henry Pinckney of the *Three Squirrels* in Fleet Street, the founder of the banking house

of Gosling. Wheatley, in his foot-note to the above passage in the *Diary*, follows
Hilton-Price. Both writers, however, seem to have overlooked the fact that there
was another goldsmith, William Pinckney, who also was in business at this time.
Henry Pinckney was one of the three goldsmiths who are known to have issued
tokens (see p. 44). According to Noble's *Memorials of Temple Bar* his house was
destroyed in the Great Fire. The Pinckneys suffered heavily in the closing of the
Exchequer in 1672.

STEPHENS. This goldsmith is variously referred to in the diary as " Stephens"
or "Stevens". He may possibly be identical with Roger Stephens who was
working at that time. On 23 January 1661 Mr Pepys had occasion to visit "Stevens
the silversmith... to make clean some plate against tomorrow". This was in prepara-
tion for the first dinner party given in his new quarters at Seething Lane. "This (the
dinner) cost me above £5, and merry we were—only my chimney smokes!"

An entry on 19 October 1664 tells how he took his two silver flagons to be valued
at Stevens'. "They weigh 212 oz: 27 dwt: which is about £50, at 5s. per oz: and
they judge the fashion (workmanship) to be worth 5s. per oz: more...but yet am
sorry to see that the fashion is worth so much and the silver come to no more."
From which we may infer that Pepys' appreciation of craftsmanship was not very
high. Another allusion to "Mr Stephens the silversmith" will be found in con-
junction with Cooke, *q.v.*

STOKES. It seems unlikely that we should have heard much of Humphrey Stokes
(or Stocks) had it not been for the fact that he had a pretty wife. On his way home
from the Exchange (10 January 1666) Mr Pepys records that he had "the oppor-
tunity I longed for of seeing and saluting Mrs Stokes, my little goldsmith's wife in
Paternoster Row, and there bespoke a silver chafing-dish for warming plates". On
9 November of the same year he goes again "to my little goldsmith's whose wife is
very pretty and modest that ever I saw any". It will be remembered that Pepys
spoke of Mrs Colvill as his "little new goldsmith's wife" in June 1665, but Wheatley
has no hesitation in concluding that this visit in November 1666 was paid to Mrs
Stokes. On 2 September 1666, the day on which the Great Fire broke out ("Jane
called us up about three in the morning to tell us of a great fire they saw in the
City"), Mr Pepys describes how he saw "the streets full of nothing but people and
horses and carts loaden with goods, ready to run over one another, and removing
goods from one burned house to another...among others I now saw my little gold-

smith Stokes receiving some friend's goods, whose house itself was burned the day after".

TEMPLE. An entry in the diary on 30 September 1665 relates how Mr Pepys and three or four companions "took ship in the Bezan" (Basin) to Woolwich. Of this company was "Mr Temple, the fat blade, Sir Robert Viner's chief man". In November of the following year, at the house of his colleague Captain Cocke, he encounters Mrs Temple who "after dinner fell to play on the harpsicon till she tired everybody, that I left the house without taking leave, and no creature left standing by her to hear her". Not in this particular respect alone did Mrs Temple fail in her efforts to please, for in the following year Pepys mentions another meeting with "Mr Temple, whose wife was just now brought to bed of a boy, but he seems not to be at all taken with it". The "fat blade" appears to have left Sir Robert Vyner's employ about this time, for in 1670 we find him set up at the *Three Tuns* in Lombard Street where he was in partnership with John Seale until 1684.

VYNER, SIR ROBERT. Sir Robert Vyner has to his name more mentions in the diary than any other goldsmith—it occurs no fewer than fifty-eight times. One of the earliest of the entries is on 24 May 1665. "At last Mr Viner by chance comes, who I find a very moderate man, but could not persuade the fool to reason but brought away the tallies again, and so vexed to my office, where late, and then home to my supper and to bed." The following September Mr Pepys spends a pleasant day visiting Sir Robert and Lady Vyner at their fine house, Swakeleys, near Ickenham. He is vastly impressed with the grand state in which his host lives, "no man in England in greater plenty and commands both King and Council with his credit he gives them". Pepys at this time was at his wits' end to raise money in order to keep his beloved Fleet at sea and was very often compelled to borrow large sums from Vyner and others at exorbitant rates. On various occasions during the tragic year of 1666 we hear of his visits to Sir Robert's shop in Lombard Street, bespeaking orders for plate; and it is with some pride he records on 18 December that he "carried home another dozen of plates which makes my stock of plates up to $2\frac{1}{2}$ dozen". It was in that same year that Sir Robert Vyner was appointed Sheriff and in 1674/5 he served the office of Lord Mayor.

VYNER, SIR THOMAS. Sir Thomas Vyner hardly comes into the diary at all. His funeral only is recorded. For this ceremony (1 June 1665) Mr Pepys says "I put on my new silke camelott sute; the best that ever I wore in my life, the sute costing

me above £24". To view the procession he went to Goldsmiths' Hall, which, however, was "so full of people, that we were fain for ease and coolness to go forth to Paternoster Row to choose a silke to make me a plain ordinary suit. That done we walked to Cornehill and there at Mr Cade's [the *Three Golden Lyons* tavern] stood in the balcon and saw all the funeral". Sir Thomas Vyner's business was carried on at the *Vine* in Lombard Street. He was elected Sheriff in 1648 and made Lord Mayor in 1653/4.

WALLINGTON. He was brought to a musical party at Pepys' house at Seething Lane on 15 September 1667. Although "being a very little fellow did sing a most excellent bass, and yet a poor fellow, a working goldsmith, that goes without gloves to his hands". Mr Pepys was so pleased with "the little man that sings so good a base" that the visit was repeated in the December following. Wheatley adds a note concerning some of Wallington's compositions which appeared in a collection called *New Ayres and Dialogues composed for Voices and Vyols*, published in 1678.

GOLDSMITH'S TRADE-CARD IN THE PEPYS' COLLECTION

Taking into account Mr Pepys' many transactions with members of the craft, it is remarkable that we should find only one specimen of a goldsmith's trade-card in the collection which he formed and which is housed in Magdalene College, Cambridge. It may appear to be even more curious that the name of the goldsmith who issued this card—John Orchard at the *Rose & Crown* in Lombard Street—should never be mentioned in the pages of the diary. This, however, is easily explained on the grounds that the diary ran only from 1660 to 1669 and no record of Orchard has been found prior to the year 1695. His trade-card will be found illustrated on Plate LII.

IV
LONDON GOLDSMITHS'
TRADE-CARDS

Except for a few museum specimens, and their lineal descendants which decorate the stately banking houses in Lombard Street, the sign-boards of the old goldsmiths are practically extinct. The miniature representation of those signs which are known to us through the records of the goldsmiths' marks convey but little impression of the signs themselves. The trade-card is the only contemporary source which affords us any adequate idea of the goldsmiths' signs as they were displayed in Cheapside and Lombard Street and other quarters where the craft congregated. The engravings on these cards give precise, and often extremely decorative, renderings of the shop-signs, and, in addition, they frequently afford us authentic records of articles which have now become obsolete.

One of the main purposes of this volume is to draw attention to the historical value of these engravings as records of the individual craftsmen, their wares and the actual shops where they carried on their trade. No other documents present, in one *coup d'œil*, so vivid a picture of the goldsmith's business as it was carried on during the seventeenth and eighteenth centuries.

The use of the trade-card was primarily that of a hand-bill, or advertisement, calling attention to the name and the whereabouts of the shopkeeper and to the kind of trade he was engaged in. Sometimes they would be used as memoranda for small accounts, and these bearing their appropriate dates are of particular interest to us. In addition to the direct evidence which they afford of the date when such and such a shop was in existence, they give first-hand information as to the kinds of wares then in demand and the prices they fetched.

These trade-cards have also their topographical interest in supplying the names and location of old streets long since swept away; occasionally they illustrate street scenes and shop interiors, and so record the architecture and fashions of their day. The lettering employed is generally well drawn and well spaced; the design of the advertisement is dignified, and the engraving highly accomplished.

Goldsmiths' cards are usually rather more elaborate and of better execution than those in most other trades, owing, partly no doubt, to the fact that the goldsmiths were a well-to-do body and also that engraving was part of their own craft. Hogarth, as has already been mentioned, engraved the trade-card of his master, Ellis Gamble. Other well-known engravers employed in producing cards for this trade were Sturt, Kirk and Benjamin Cole.

In the earliest cards the shop-sign dominates the design and the actual sign-board itself is frequently shown; it is quite simply drawn and more or less heraldically treated. Gradually a more elaborate form was evolved with the sign enclosed in an ornamental frame. From this type developed the rococo border, in the prevailing Chinese manner, on the scrolls of which various pieces of goldsmith's work were displayed, but the shopkeeper's sign still occupied a prominent place in the design. From 1762 onwards, when the houses began to be numbered, the sign-board lost its significance and consequently the shop-sign became a less important feature on the trade-card. Finally, towards the end of the century, the sign disappeared altogether and more attention was given to the illustration of the wares advertised, or alternatively, some allegorical subject was introduced.

Three outstanding collections, which contain the earliest specimens of trade-cards, are those in the Pepys' Library at Magdalene College, Cambridge; the Douce Collection in the Bodleian Library, Oxford; and the Bagford Bills in the British Museum. It is noteworthy that these three great collectors should have had the perspicacity to consider that such everyday objects were worth preserving, and that they would acquire an interest in time to come. Among other important collections should be mentioned the Banks Collection and the Franks Collection, both in the British Museum, the collections at Guildhall, the Victoria and Albert Museum, and the London Museum. A particularly fine private collection was lost to this country when the effects of the late Lord Leverhulme were sold. This has now gone to the Metropolitan Museum of New York.

To supplement the plates which illustrate the trade-cards reproduced in this volume an endeavour has been made to compile a list of all the seventeenth and eighteenth-century London goldsmiths' cards of which specimens have been noted in various collections, both public and private, and to give their provenances. So far as is known, this is the first time that such a register has been attempted in any trade and it is unlikely that it is more than approximately complete. Examination of all the collections known to the writer has only produced records of about 350 goldsmiths' cards issued before the end of the eighteenth century. As this scrutiny has been conducted for over twenty years it will be appreciated that specimens are not plentiful. It is hoped, by the publication of this list, that hitherto unreported examples of goldsmiths' trade-cards will be brought to light.

A LIST OF
THE TRADE-CARDS OF LONDON GOLDSMITHS
ISSUED IN THE SEVENTEENTH AND
EIGHTEENTH CENTURIES

An attempt has been made to compile a list of the trade-cards issued by London goldsmiths and jewellers, etc., so far as this could be achieved by reference to the public and private collections known to the author.

The collections from which records have been taken are indicated by the following symbols placed after each entry.

KEY TO PROVENANCES

A.	= Author's Collection.
B.	= Banks Collection in British Museum.
B. A.	= Birmingham Assay Office.
B. B.	= Bagford Bills in British Museum.
C.	= Crichton Collection.
D.	= Douce Collection in the Bodleian Library.
F.	= Franks Collection in British Museum.
F. M.	= Freemasons' Library.
G.	= Guildhall Library.
H.	= Mr Arthur Hill's Collection.
J. E. H.	= Mr John Eliot Hodgkin's Collection.
L.	= London Museum Library.
L. C.	= Library of Congress, Washington.
L. C. C.	= London County Hall Library.
M.	= Metropolitan Museum, New York.
P.	= Hon. Gerald Ponsonby's Collection.
V. & A.	= Victoria and Albert Museum.
W.	= Westminster Library.

PROVENANCES

C. & J. ADAMS, *goldsmiths, jewellers & hardwaremen*; No. 10 King Street, Cheapside. A.

JOHN ALDERHEAD, *working goldsmith & jeweller*; At yᵉ Ring & Pearl in Bishopsgate. A.

JOHN ALDERHEAD, *working goldsmith & jeweller*; At the Ring & Pearl in Bishopsgate, near the South Sea house. A.

EDWARD ALDRIDGE, *working goldsmith*; At the Golden Ewer, in Lilly Pot Lane in Noble Street, near Goldsmiths' Hall. A.

ALEXANDER AND SHRIMPTON, *goldsmiths*; Anchor & Key, Wood Street, Cheapside.
(*Billhead* 1768) A.

WILLM. ALLDRIDGE, *working goldsmith*; At the Black-moor's Head in Red Lion Passage, Holborn. A.

JOHN ALLEN, *jeweller, goldsmith & toyman*; The Corner of the Old Jewry in the Poultry (No. 42). A.

WILLIAM ALLEN, *silver buckle maker to His Majesty*; No. 92 Strand, near Beaufort Buildings.
(*Trade-card & billhead* dated 1781) A.

THOMAS ANDREWS, *goldsmith, jeweller & cutler*; No. 85 Cornhill, three doors from the Royal Exchange. (From Calcutta in Bengal.) A.

GEORGE ANTT, *goldsmith & jeweller*; At the Case of Knives, No. 158, South side of the Strand, six doors from Somerset House, opposite the New Church. F.

STEPHEN ARDESOIF, *goldsmith & jeweller*; At the Golden Cup, on the New Pavement, Charing Cross. H.

JOHN BAILY, *goldsmith*; At the Scepter & Crown at yᵉ upper end of Lombard Street. B.B.

WILLM. & JOHN BALLISTON, *silver & brass casters*; The Golden Eagle, Rupert Street, St James's. M.

SAMUEL BARBER, *jeweller & hardware man*; No. 5 Angel-Street, St Martin's-Le-Grand. A.

JOHN BARKER, *goldsmith*; Morocco Ambassador's Head, Lombard Street.
(*Engraved by Hogarth*) F.

WM. BARRETT, *working silversmith*; No. 50 Aldersgate Street. A.

J. BAXTER, *silver clasp maker*; No. 2, In the Hope-passage, Ivy lane, Paternoster Row. A.

EDWARD BENNETT, *goldsmith*; At yᵉ blue Lion & Crown, yᵉ corner of Tooley Street, London Bridge. (*Bill* dated 1747) G.

CHARLES BERG AND SAMUEL GRANT, *jewellers*; Ring & Pearl, against Cecil Street in the Strand. W.

BINGANT, *gold chaser*; Star of Mystery in Salisbury Street in the Strand.
(*Engraved date* 1751 (?)) H.

ANTHONY BLACKFORD; At yᵉ Golden Cup & Crown, Lombard Street, maketh & selleth all sorts of Plate Rings and Jewells. B.B.

PAUL BOUILLARD, *jeweller*; In Great Suffolk Street, near the Haymarket. (Dated 1751) P.

RICHD. BOULT, *goldsmith & jeweller*; At the Blue Anchor & Star, opposite Woodstreet, Cheapside. (2 variants) A.

BOURNE (successor to Mr Boursot), *jeweller & goldsmith*; At the Crown & Pearl in New Street, St Martin's Lane. A.

BOX, *jeweller, goldsmith & toyman*; No. 13 Ludgate Street. A.

JOHN BOX, *jeweller, goldsmith & toyman*; No. 17 Ludgate Street. P.

JOSEPH BRAMLEY, *wholesale goldsmith & jeweller*; No. 175 Aldersgate Street, Corner Little Britain. A.

BRANSTON AND BIRD, *jewellers, goldsmiths & toymen*; No. 39 Cornhill. A.

PROVENANCES

JOHN BRIGHT AND SHEFFIELD-PLATE COMPANY'S WARE-ROOMS; Bruton-Street, Berkeley Square. *(Billhead 1797)* A.

JOHN BRISCOE, *jeweller & goldsmith*; At his Old Shop, the Three Kings & Golden Ball, Opposite Foster Lane in Cheapside. (3 variants, *bills* dated 1752 & 1756) A.

STAFFORD BRISCOE, *jeweller & goldsmith*; At the Oldest Shop, the Golden Ball only, the corner of Friday Street, Cheapside. (3 variants, *bills* dated 1749–67) A.

STAFFORD & JOHN BRISCOE, *jewellers & goldsmiths*; At the Golden Ball, Cheapside. A.

BRISCOE & MORRISON, *jewellers & goldsmiths*; At the Old Shop, the Three Kings & Golden Ball, opposite Foster Lane in Cheapside. (2 variants, *bills* dated 1762 & 1764) A.

RICHARD BROOK, *goldsmith & jeweller*; No. 1 Poultry. A.

J. BROWN, *jeweller & watch-maker*; No. 149 Fleet Street. A.

WILLIAM BROWN, *jeweller & goldsmith*; At the Old Shop, No. 14, the Golden Ball, opposite Foster Lane in Cheapside. *(Bill dated 1769)* A.

JOHN BROWNE, *working jeweller & silversmith*; No. 9, Fish street-hill, near yᵉ Monument. A.

JAMES BUFFAR, *goldsmith & jeweller*; At the King's Arms in Cheapside, opposite Foster Lane. A.

JOHN BUHL; At the sign of yᵉ Two Gold Candlesticks & Blue Coffee Pot in St Martin's Lane, facing Chandois Street, near Charing Cross. H.

BULL, *goldsmith &c.*; No. 15 Leicester Square. A.

BURCHELL, *cutler, goldsmith & jeweller*; At the Anodyne Necklace, No. 78 in Long Acre, next Drury Lane. A.

GEORGE BURROWS, *working goldsmith, buckle, spoon-maker, &c.*; Clerkenwell Close. A.

THOMAS CALDECOTT, *working goldsmith*; At the Cabinet, the South side of St Paul's Church Yard. A.

THOMAS CALDECOTT, *working goldsmith*; Remov'd to the late Mr Southam's, opposite Bartholomew Close in Little Britain. A.

CHARLES CALLAGHAN, *working silversmith & jeweller*; At the Silver Lion, 463 Strand. A.

JOSEPH CAMPBELL, *jeweller*; At the Crown & Pearl, in King Street, St Ann's, Soho. F.

JOHN CARMAN, *working goldsmith & sword cutler*; At the Ewer & Swords, near Bartletts Buildings, Holbourn. A.

BENJAMIN CARTWRIGHT, *working goldsmith*; At the Crown & Pearl, near yᵉ George Inn, West Smithfield. A.

GEORGE CATON; At the Golden Lion & Crown, the corner of May's Buildings, St Martin's Lane. Selleth all sorts of gold, silver...buttons. A.

RICHARD CHADD AND JOHN RAGSDALE, *jewellers & goldsmiths*; New Bond Street. B.

RICHARD CHADD AND JOHN RAGSDALE, *jewellers & goldsmiths*; Almost opposite Conduit Street, New Bond Street. M.

CHALMERS & ROBINSON, *jewellers & goldsmiths*; At the Ring & Cup in Walkers Court, Berwick Street, Soho. A.

CHALMERS & ROBINSON, *jewellers & goldsmiths*; At the Golden Spectacles in Sidneys Alley, Leicester fields. (2 variants) A.

CHARMAN, *jeweller*; No. 26 St James's Street. P.

PAUL DANIEL CHENEVIX; A l'Enseigne de la Porte d'Or, vis à vis, de la rue de Suffolk au quartier de Charing Cross. Vend toute sorte de Bijouterie en Or et en Argent de l'ouvrage des meilleurs ouvriers.... B.

PAUL DANIEL CHENEVIX; At the Golden Door over against Suffolk Street, Charing Cross. *(Billheads 1731 & 1735)* L.C.

THOMAS CHESSON, *jeweller*; near Queen Street, Cheapside. (Engraved date 1736) F.

(27)

LONDON GOLDSMITHS' TRADE-CARDS

EBR. CLARK, *hardwareman & silversmith*; At the end of St Dunstan's Ch., Fleet Street. (From Fenchurch Street.) A.

THOMAS CLARK; At the Golden Head, near Arundel Street in the Strand. Selleth all sorts of Plate, Jewels & Jewellers Work done by the Best Workmen.... H.

CLARKE [? M.], *jeweller, goldsmith, hardwareman & toyman*; At the Eagle & Pearl opposite Brook Street, Holbourn (No. 9). A.

LETTICIA CLARKE, *jeweller & goldsmith*; At the Eagle & Pearl, opposite Brook-Street, Holborn. A.

RICHARD CLARKE, *jeweller & toyman*; At No. 102, the Eagle & Crown, opposite Bow Lane, in Cheapside. M.

JONAS CLIFTON, *goldsmith*; At the Crown in Henrietta Street, Covent Garden....Removed from a little beyond Hungerford in y^e Strand. H.

HENRY COLES, *jeweller*; At the Eagle & Pearl in Tavistock Street, Covent Garden. F.

J. B. COLES, *goldsmith & jeweller*; No. 54 Barbican. P.

EDWARD COOKE, *goldsmith & jeweller*; In the Haymarket, Southwark. A.

HENRY COPPER, *makes assays in gold & silver*; Carey Lane. B.A.

THOMAS COTTON, *goldsmith*; London. *(Book-plate)* A.

LA. PA. COURTAULD, *jeweller, goldsmith &c.*; At the Crown in Cornhill, opposite the Royal Exchange, No. 21. *(Billhead 1768)* A.

SAMUEL COURTAULD, *goldsmith & jeweller*; At the Crown in Cornhill, Facing the Royal Exchange. A.

SAMUEL COURTAULD, *goldsmith & jeweller*; At the Rising Sun in Shandois Street, St Martin's Lane. H.

COURTAULD & COWLES, *goldsmiths, jewellers & toymen*; At the Crown in Cornhill, opposite the Royal Exchange. *(Bill dated 1778)* M.

COWARD & Co., *goldsmiths & jewellers*; No. 27 Royal Exchange. A.

COWELL, *watch-maker, jeweller, goldsmith & toyman*; At the Dial, opposite Pope's Head Alley, Cornhill. A.

G. COWLES, *jeweller & working goldsmith*; No. 26 Cornhill, late partner with Mrs Courtauld. A.

G. COWLES, *jeweller & working goldsmith*; No. 30 Cornhill, late partner with Mrs Courtauld. M.

JAMES COX, *goldsmith*; At the Golden Urn in Racquet court, Fleet Street. A.

JOHN CURGHEY, [*goldsmith*]; At the Ship near St Dunstan's-Church, Fleet Street. *(2 bills dated 1744 & 1749)* L.C.

[DANIELL'S] LONDON SILVER PLATE MANUFACTORY; At the Silver Lion, opposite Goldsmiths'-Hall, Foster Lane, Cheapside. Carried on by Thomas Daniell and his late Father upwards of 50 years. *(2 variations)* A.

THOMAS DANIELL & JOHN WALL, *silversmiths & jewellers*; No. 20 Foster Lane, Opposite Goldsmiths' Hall. A.

EDWD. DARVILL, *working goldsmith, silversmith & jeweller*; At y^e Golden Ball in Watling Street, near Bow Lane. A.

DAVIES, *goldsmith, jeweller & toyman*; No. 153 Leadenhall Street, near Cornhill. A.

TIMOTHY DAVIES, *jeweller, goldsmith, cutler & toyman*; The corner of Clifford Street, New Bond Street. *(Billhead dated 1783)* A.

WILLM. DEARDS SENR., *toyman*; At the corner of Dover Street, Piccadilly. M.

WILLIAM & MARY DEARDS; At the Star, the end of Pall-Mall near St James's, Hay-market. Buy and sell all sorts of Jewels, Watches, Plate and all other curious work in Gold, Silver and Gilt.... A.

JOHN DE CREZ, *jeweller & toyman*; At the Harlequin in Princes Street, near Coventry Street, Leicester Fields. *(Billhead 1775)* A.

(28)

LONDON GOLDSMITHS' TRADE-CARDS

JOHN DELAFONS, *jeweller & goldsmith*; At the Crown & Pearl, near the Four Swans within Bishopsgate.　　A.

PETER DE LA FONTAINE, *goldsmith*; At the Golden Cup in Litchfield Street, Soho.
(Engraved by W. Hogarth) A.

DELIGNY, *working jeweller*; No. 24 Aylesbury Street, Clerkenwell.　　A.

BASIL DENN JUNR., *goldsmith & jeweller*; At yᵉ Gold Ring on London Bridge, near Southwark. A.

WILLIAM DEVIS, *watch-maker & goldsmith*; At the Dial opposite St Dunstan's Church, Fleet Street.　　A.

CHARLES DICK, *jeweller & goldsmith*; In Coventry Street, Opposite yᵉ Haymarket.　　A.

SIGISMUND GODHELP DINGLINGER, *jeweller*; At yᵉ Diamond Cross in St Martin's-le-Grand.　　A.

EDWARD DOBSON, *jeweller & working goldsmith*; At the Crown, Ring & Pearl, Near Shoe Lane, Fleet Street.　　A.

SANDYLANDS DRINKWATER, *small-worker in gold and silver*; At the Hand & Coral, in Gutter Lane, Cheapside.　　F.

DRU. DRURY, *goldsmith to Her Majesty*; In the Strand, successor to Nath. Jeffreys.　　P.

DUBOIS, *small worker*; At the Golden Star in Eagle Court in the Strand....Bijoutier à l'Étoile d'Or dans Eagle court dans le Strand.　　H.

PETER DUTENS, *jeweller*; At the Golden Cup, Chandois Street, St Martin's Lane.　　V.&A.

JAMS (*sic*) EDWARDS, *clock & watch-maker, goldsmith & jeweller*; No. 149 Holborn-Barr's.　A.

WILLIAM EDWARDS, from Fetter lane, *goldsmith, watch-maker & hardwareman*; At Staples Inn Gate, near Holborn Bars.　　A.

ANTHONY ELLINES; At the Crown, Sun & Seven Stars, under St Dunstan's Church, facing Corbett's State Lottery Office. Sells all sorts of Rings, Earrings, Necklaces....　　A.

THOS. ELSWORTH, *jeweller*; At the Crown & Pearl in the New Rents, St Martin's Le-Grand. A.

THOS. ELSWORTH, *jeweller*; near the Lion in the Wood, Salisbury-court, Fleet Street.　　A.

JNO. F. ESTIENNE, *jeweller & toyman*; At yᵉ Star & Pearl in Dukes Court, St Martin's Lane. F.

EVANS, *goldsmith, jeweller & toyman*; The next door to Saville house, Leicester Square.　　A.

WILLIAM EVANS, *goldsmith, jeweller & hardwareman*; No. 23 Aldgate High Street.
(Billhead dated 1774) A.

BANKS FARRAND, *goldsmith*; 48 Cheapside.　　A.

THOMAS FAZAKERLEY, *watch-maker & goldsmith*; At the Dial & Crown in St John's Street, near Hicks Hall.　　A.

ALEXR. FIELD, *working silversmith*; No. 2 Bowling Green Walk, Haberdashers row, Hoxton. A.

CHARLES FINCH, *button-maker & gilder*; At yᵉ Queen's Head in Great Russel Street, Covent Garden.　　H.

F. FISHER, *working jeweller in general*; 44 Duke Street, West Smithfield.　　A.

JOSEPH FISHER, *goldsmith*; No. 2 North Side of Leicester Square.　　P.

WM. PARK FISHER, *goldsmith & jeweller*; At the Eagle & Pearl in Tavistock Street, Covent Garden.　　A.

JOHN FLUDE, *pawnbroker & silversmith*; No. 2 Grace Church Street.　　B.A.

ANN FOOTE, *goldsmith*; At the Ring, near the Maypole, Eastsmithfield.　　H.

FORSTER & JOHNSON, *jewellers & goldsmiths*; At the Pearl in Wood Street, Cheapside.　　A.

JOHN FOSSEY, *goldsmith & jeweller*; At the Blackmoor's Head & Sun, yᵉ corner of Ball Alley, Lombard Street.　　A.

I. FOSTER; No. 1 Bartlets Buildings Passage, Fetter Lane. Makes the following Articles, Men & Women's Gold, Silver & Gilt Chains... (Watch Keys, Seals, Trinkets, etc.).　　A.

JOHN FRASER, *goldsmith*; At the Ship & Pineapple, opposite Castle Court in the Strand.　　W.

(29)

PROVENANCES

FRASER, *working goldsmith & jeweller*; No. 5 Little St Martin's Lane. M.

FRENCH, *goldsmith*; At the Ring & Pearl in Old Round Court, near Chandois Street. W.

JOHN FROST, *goldsmith & jeweller*; At the Golden Cup, opposite St Peter's Church, Cornhill. A.

ELLIS GAMBLE, *goldsmith*; At the Golden Angel in Cranbourn-Street, Leicester-Fields. A.

PHILLIPS GARDEN, *working goldsmith & assayer in gold & silver*; Tryes all Manner of Oars &
Makes Gold & Silver touch Needles...; At ye Golden Lion, ye North side of St Paul's Church
Yard. (*Bill* dated 1749) A.

PHILLIPS GARDEN, *working goldsmith & jeweller*; At the Golden Lion, in St Paul's Church
Yard. A.

ABRAHAM GARDNER; At the Eagle & Crown, opposite Bow Lane, Cheapside.
 (*Billhead* dated 1762) A.

THOMAS GARDNER, *goldsmith & watch-maker*; At the Dial in the Minories, near Aldgate. G.

R. GARRARD & BROTHERS (late WAKELIN & GARRARD), *goldsmiths & jewellers to His
Majesty*; Panton Street, Haymarket. A.

CHARLES GEDDES; At the Crown & Pearl in the Strand, near Durham Yard. Makes & sells
all sorts of Jewellers Work.... H.

SAML. GODBEHERE (late Mr Stamp's); No. 86 Cheapside. P.

E. GODFREY, *goldsmith, silversmith & jeweller*; At the Hand, Ring & Crown in Norris Street,
St James's, Hay-Market. (2 variants) A.

GOLDNEYS (late Neild); No. 4 St James's Street. (*Billhead*) A.

GOODBEHERE, WIGAN & Co. (late Mr Stamp's), *manufacturers of gold & silver plate &
dealers in...Coin, Bullion & Jewells*; No. 86 Cheapside, next Mercers Chapel.
 (*Billheads* dated 1787 & 1796) A.

RICHD. & JOSPH. GOSLING, *goldsmiths & jewellers*; At the Fox & Crown in Cornhill. M.

GRAY, *goldsmith & jeweller*; No. 13 New Bond Street. (*Billhead* dated 1792) A.

THOMAS GRAY, *ouvrier en Acier, Or, Argent, etc.*; No. 42 Sackville Street.
 (*Billhead* dated 1787) A.

RICHD. GREEN, *goldsmith & jeweller*; In the Strand, opposite the New Exchange. A.

JOSEPH GREENSILL, *goldsmith & jeweller, silversmith & cutler*; No. 35 Strand, between
Buckingham and Villiers Streets (N.B. No connection with the shop next door of the same
name). A.

GRIFFIN & ADAMS, *goldsmiths, jewellers & cutlers to his Royal Highness the Duke of Clarence*;
No. 17 Ludgate Street. A.

THOMAS HAMLET, *silversmith & jeweller, &c. to their Royal Highnesses the Princesses Augusta,
Elizabeth, Mary & Sophia*; No. 1 Princes Street, Leicester Square. A.

JOHN HANNAM; At the Goulden Cup, the North Side of St Paul's Church Yard beyond the
Narr[o]w passage towards Cheapside.... D.

THOMAS HARDING, *working goldsmith & jeweller*; At the Crown & Spur in ye Minories.
 (2 variants) A.

WILLM. HARDY, *goldsmith & jeweller*; In Ratcliff highway, near Sun Tavern Fields.
 (*Engraved by W. Hogarth*) A.

THOMAS HARPER, *working goldsmith & jeweller*; No. 207 Fleet Street. P.

THOS. HARRACHE, *jeweller, goldsmith & toyman*; At the Golden Ball & Pearl, in Pall Mall. A.

JACOB HARRIS, *goldsmith & jeweller*; In Clements Inn, leading to Clare Market. A.

AARON HART, (?) *goldsmith or jeweller*; At the Crown & Pearl in Bennet street, near Great
Queen street, Westminster. J.E.H.

JOSEPH HEGER, *working jeweller*; Holles Street, Clare Market. F.

GEORGE HEMING, *goldsmith & jeweller*; At ye Hand & Hammer, opposite ye Black Bear Inn
in Piccadilly. A.

LONDON GOLDSMITHS' TRADE-CARDS

THOMAS HEMING, *goldsmith to His Majesty*; At the King's Arms in Bond Street, facing Clifford Street. A.

GEORGE HEMING & WILLIAM CHAWNER, *goldsmiths*; At the King's Arms in New Bond Street, facing Clifford Street.[1] (*Billhead* dated 1778/9)

DAVID HENNELL, *working goldsmith*; At the Flower-de-Lis & Star in Gutter Lane, y^e corner of Cary Lane, near Cheapside. A.

W. HICKMAN, *silversmith, cutler & hardwareman*; No. 91 Borough, Southwark. A.

HILL, *fancyworker, etc....lockets, rings, bracelets, etc., etc.*; At the Arms of France, Ball Alley, Lombard Street. M.

CHRN. HILLAN, *Gold Smith*; At the Crown & Golden Ball in Compton Street, St Anns. A.

GEORGE HINDMARSH, *jeweller & goldsmith*; At the Crown, opposite Durham Yard in the Strand. F.

HENRY HOARE, *Goldsmith*; In London, 1704. (*Bookplate*) A.

HODGES, *jeweller, goldsmith & engraver*; At the Golden Eagle in Maiden Lane, Cov^t. Garden. A.

JOHN HOLLIER, *jeweller*; In Arundell Street in the Strand. A.

JOHN HOLLIER, *jeweller*; In Rolles Buildings, Fetter Lane. A.

GEORGE HOUSTON, *goldsmith*; At y^e Golden Cup, near St Dunstans-Church, Fleet Street. P.

JAMES HOWARD, *necklace-maker*; At y^e Hand & Beads, on London Bridge, 1735. H.

JOHN HOWARD, *necklace-maker*; From London Bridge, at y^e Hand & Beads, next the Monument Yard, Fish Street Hill. A.

JOHN HOWARD, *necklace-maker & importer*; No. 40, the Hand & Beads, opposite Crooked Lane, Fish Street Hill. (*Billhead* dated 1780) A.

HUGHES'S, *button & toyshop*; At the Blue Anchor, near the Talbot Inn, in the Strand. A.

WILLIAM HUNT & SON, *gold-workers*; At the Golden Lyon in King Street, Cheapside. A.

CATHERINE HUNTER; At the White Bear in King Street, Cheapside, near Guild-Hall. (Sells toys & jewellery.) M.

WM. HUNTER, *jeweller & goldsmith*; At the Anchor & Ring in Lombard Street, No. 51. A.

WILLIAM HUNTERS, *goldsmiths & jewellers*; At the Anchor & Ring in Lombard Street. A.

HENRY HURT [*goldsmith & toyman*; At the Golden Salmon on Ludgate Hill]. (*MS. bill* dated 1750) A.

HYDE & LEEDS; dans la rue de Cornhill proche la bourse Royale à Londres. Vend toutes sortes de Quincaillerie de la Fabrique de Londres, Birmingham & Sheffield avec toutes sortes de Tabatières d'or, d'argent, Email & Pinchbeck etc. toutes sortes de Chaines de Montres & autre Bijoutaries en Or, Argent & Pinchbeck.... A.

JNO. JACKSON, *jeweller*; At y^e Crown & Pearl in George Street by Goldsmiths Hall, Foster Lane. A.

JOHN JACOB, *goldsmith*; At the Acorn in Panton Street, Near Leicester-Fields. (*Bill on back* dated 1768) A.

THOMAS JARVIS, *watch-maker & goldsmith*; At the Dial, Wapping Old Stairs. B.A.

NATHL. JEFFERYS, *goldsmith to Her Majesty*; In the Strand. A.

NATHL. JEFFERYS, *jeweller to His Royal Highness the Duke of York*; Corner of Dover Street, Piccadilly. A.

JEFFERYS & Co., *goldsmiths, jewellers, cutlers, &c.*; At the Great Knife Case, No. 91 Fleet Street. A.

JEFFERYS & JONES, *goldsmiths & jewellers*; In Cockspur Street, near Charing Cross. (*Billhead* dated 1782) A.

CHRISTR. JOHNSON, *jeweller*; At the Crown & Pearl in Salisbury Court, Fleet Street. A.

[1] In the possession of Messrs Heming, Conduit Street.

(31)

LONDON GOLDSMITHS' TRADE-CARDS

LAWRENCE JOHNSON, *working goldsmith*; At the corner of Exeter Street, in Katherine Street, near the Strand. A.

JOHNSTON & GEDDES; At the Golden Ball in Panton Street, near Leicester Square. Make and sell all sorts of Jewellers' work. A.

FREDERICK KANDLER, *goldsmith*; Against St James's-Church, Jermain Street.
(*Billhead* 1767) A.

JOHN KENTISH, *goldsmith, jeweller & toyman*; At the Star, the corner of Pope's Head Alley, opposite the Royal Exchange, Cornhill (No. 18). (2 variants & *billhead* dated 1760 & 1762) A.

KIRK AND SAVAGE; No. 52 St Paul's Church Yard. Choice of Silver and other Buckles. A.

FRANCIS LAMBERT, *goldsmith & jeweller*; No. 12 Coventry Street, corner of Panton Square. A.

LAMBERT & RAWLINGS, *goldsmiths, jewellers & silversmiths*; N⁰. 12 Coventry Street. A.

JOHN LEGRIX, *French-Plate worker*; At yᵉ sign Chandelleir, next door to the Golden Leg, opposite Langley Street in Long Acre. A.

SIMON LESAGE, *goldsmith & jeweller*; At the Golden Cup, the Corner of Suffolk Street, near the Haymarket. A.

EDWARD LEWIS, *goldsmith & watch-maker*; At the Naked Boy & Coral, St Margaret's Hill, Southwark. F.M.

THOMAS LIDDIARD, *goldsmith & watch-maker*; No. 54 St Paul's Churchyard. P.

JAMES LOVE, *goldsmith*; No. 23 Aldgate High Street. P.

JOSEPH LOWE, *jeweller*; At the King's Head, near Bartlett's Building, Holborn. A.

CHARLES LOWNDES & THOS. BATHURST, *silver button makers & gilders*; At the Crown in Russell Street, the Corner of Bow Street, Covent Garden. F.

WILLIAM LUTWYCHE, *working goldsmith & jeweller*; At the Anchor & Dove, No. 15 in Fenchurch Street, near Gracechurch Street. (*Billhead* dated 1771) A.

LYNAM & BULL, *goldsmiths & jewellers*; At the Golden Salmon, No. 36 New Bond Street. B.

ROBERT & THOS. MAKEPEACE, *goldsmiths & jewellers*; Serle Street, Lincoln's Inn Fields. A.

MANLY, *goldsmith & jeweller*; No. 119 Cheapside, opposite Bread Street; and No. 1 Suffolk Street, Charing Cross, opposite Pall Mall. A.

WILLIAM MANNING, *goldsmith & jeweller*; At yᵉ Golden Key & Crown, opposite the Post Office, Lombard Street. M.

LEWS. MASQUERIER, *goldsmith & refiner*; At the Ring & Pearl in Coventry Street, near the Hay-Market. H.

MASQUERIER & PERIGAL, *goldsmiths, jewellers & toymen*; At the Ring & Pearl, No. 11 in Coventry Street, St James's. B.

JAMES MITCHELL, *goldsmith*; No. 84 Little Tower Hill. P.

JAMES MITCHELSON, *jeweller*; At the Crown & Pearl in Throgmorton Street, near the Royal Exchange. M.

A. MONDET, *jeweller*; At the Old Feathers, near Argyle Buildings in Oxford Road. M.

JNO. MONTGOMERY, *goldsmith*; At the Angel, corner of Cambridge Street in Golden Square.[1]

JOHN MOORE, *Original spring spur maker*; At the Hand & Spur, near Exeter Exchange in the Strand. Makes and sells spring spurs in Silver and Steel.... H.

WILLIAM MOORE, *goldsmith & watch-maker*; No. 5 Ludgate Street. P.

MORRIS, *goldsmith, jeweller & toyman*; At the King's Arms, the corner of Norris Street in St James's, Hay-Market. A.

[1] This card is in the Hogarth Collection, Print Room, British Museum. It is the same design as that of Ellis Gamble's card.

LONDON GOLDSMITHS' TRADE-CARDS

HENRY MORRIS, *jeweller, goldsmith & toyman*; At the Golden Key, the corner of Salisbury Court, Fleet Street. (2 variants) A.

RICHARD MORRISON, *jeweller & goldsmith*; At his Old Shop, No. 15 the Three Kings & Golden Ball, opposite Foster Lane in Cheapside. Successor to Mr Stafford Briscoe. (*Bill dated 1769*) A.

H. MOUNTFORT, [*jeweller & toyman*]; next yᵉ Temple Gate, Fleet Street. A.

JAMES NEILD, *jeweller, goldsmith & sword-cutler*; In St James's Street, near the Royal Palace. (3 *billheads dated 1778–91*) A.

ANTHONY NELME, *goldsmith*. (2 *billheads dated 1706–07*) C.

ANTHONY & FRANCIS NELME, *goldsmiths*; At yᵉ Gold Bottle in Ave Mary Lane. (*Billhead dated 1721*) C.

GEORGE NELTHORPE, *jeweller & goldsmith*; At the Signe of the Rose & Crown over against the Blew-Coate Hospital-gate in Newgate-street. B.B.

NEWMAN, *goldsmith & jeweller*; No. 49 Lombard Street. P.

JOHN NEWMAN, *goldsmith & jeweller*; 17 Piccadilly. A.

ROBERT NEWMAN, *gold-chain-maker*; In Cock Lane near Snow-hill Conduit. A.

JONATN. NEWTON & THOS. COLE, *goldsmiths & jewellers*; At the Crown & Acorn in Lombard-Street. A.

WILLM. NODES, *goldsmith, jeweller & sword-cutler*; In New Bond Street, near Grosvenor Street. Successor to Mr Robinson. (2 *billheads* dated 1769 & 1776) A.

Cˢ· NORRIS, *working jeweller*; At the Anchor & Crown in Lombard Street. A.

NORRIS Junior, *jeweller & goldsmith*; No. 22 Cheapside. P.

NORRIS Junior, *jeweller & goldsmith*; No. 26 Cheapside. M.

JOHN ORCHARD, *goldsmith*; In Lumbard Street. A.

MARY OWEN, *jeweller & goldsmith*; At yᵉ Wheatsheaf in Cheapside. A.

FRANCIS PAGES, *goldsmith*; At the Golden Cup in Orange-street, near Red-Lyon-Square. (*Bill on back dated 1731*) A.

PANTIN, *goldsmith, jeweller & toyman*; At the Crown & Sceptres, the corner of Mitre Court, Fleet Street. (2 variants) A.

JOHN PARKER & EDWD. WAKELIN, *goldsmiths & jewellers, successors to Messrs Wickes & Netherton* (*silversmiths to the Prince and Princess of Wales*); In Panton street near St James's, Hay Market. (2 variants) A.

PETER PARQUOT, *jeweller & goldsmith*; At the Eagle & Pearl in King Street, St Ann's facing Nassau Street. A.

R. PARR, *jeweller & goldsmith*; At the Diamond Cross, near Salisbury Court, Fleet Street. A.

R. PARR, *jeweller & goldsmith*; At the Diamond Cross, facing yᵉ Pump, in St Paul's Church Yard. F.

SUSANNA PASSAVANT; At the Plume of Feathers on Ludgate Hill opposite the Old Baily (from the late Mr Willdey, the corner of St Paul's Church-Yard). Sells all sorts of Toys, Plate, Jewels & Jewellers Work.... A.

PATERSON AND CRICHTON, *jewellers*; At the Crown & Pearl in Green Street, Leicester Square. A.

D. PAYAN, *jeweller*; No. 44 St Martin's Lane, Charing Cross. A.

HUMPHREY & JOHN PAYNE, *goldsmiths & jewellers*; At the sign of the Hen & Chickens, in Cheapside. A.

THOMAS & RICHARD PAYNE, *Magazin de Bijoux*; No. 42 Cheapside and No. 10 Cockspur Street, Pall Mall. Manufacturers of Plate in the newest Taste & Fashion. (*Billhead dated 1783*) A.

PERCHARD & BROOKS, *goldsmiths & jewellers*; No. 14 Clerkenwell Green. A.

PETIT, *jeweller* (successor to Mr Is. Ladvocat); No. 5 Macclesfield Street, Soho. B.A.

JNO. C. PETTIT, *working goldsmith*; No. 2 Dogwell Court, Lombard Street, White Friars. A.

PICKETT & RUNDELL, *jewellers*; The Golden Salmon, No. 32 Ludgate Hill.
(*Billhead* dated 1785) A.

P. PILLEAU, *goldsmith*; At the Golden Cup, in Shandois-Street. Makes & sells Gold & Silver Plate. He Likewise Succeeds his Father Lately Deceas'd. Who, liv'd at yᵉ corner of Newport-Street, & St Martin's-Lane, in yᵉ Art of Making and Setting Artificial Teeth. No ways discernable from Natural ones. A.

PINARD, *goldsmith & laceman*; At the Crown in New Street, Covent Garden. A.

GEOᴱ· PINNOCK, *working jeweller & goldsmith*; At the Star & Perl Adjoining to the George & Blue Boar Inn, Opposite Red Lion Street, High Holborn. A.

PITTS, *goldsmith & jeweller*; Piccadilly, near Half Moon Street. B.A.

THOMAS PITTS, *working silversmith & chaser*; At the Golden Cup in Air Street, Piccadilly. H.

C. & J. PLUMLEY, *watch-makers, goldsmiths, jewellers & dealers in second-hand plate*; No. 43 Ludgate Hill. A.

WILLM. PLUMLEY, *watch-maker, goldsmith & jeweller* (Nephew to Mr [J.] Briscoe, late of Cheapside); At No. 43 Ludgate Hill. M.

CHAS. CHAPMAN POND, *jeweller & goldsmith*; From London, having recently taken a House in yᵉ Butter Market in St Edmund's Bury. M.

PORTAL & GEARING, *goldsmiths, jewellers & toy-men*; At the Salmon & Pearl, No. 34 on Ludgate Hill. A.

THOS. POWELL, *jeweller*; At the Peacock in Gutter Lane, Cheapside. A.

PRATT, SMITH & HARDY, *goldsmiths & jewellers*; No. 82 Cheapside. A.

C. PRESBURY, *silversmith & jeweller*; At the Queen's Head, No. 9 New Street, Covent Garden. A.

H. PUGH, In Racquett-Court, Fleet Street. Makes and sells all sorts of Curiosities in Gold, Silver, Amber and Tortoise-shell.... D.

GEORGE RAGSDALE, *jeweller, goldsmith & toyman*; At the Golden Vause in New Bond Street, near Conduit Street. Successor to Mess. Chadd & Ragsdale. (*Billhead* dated 1781) A.

JOHN RAYMOND, *goldsmith*; At the Boy & Corall in Gutter Lane. A.

JOHN RAYNES, *gold-chain-maker*; At the sign of Pallas in Foster Lane. A.

REYNOLDS, *goldsmith & jeweller*; No. 92 Minories. M.

RIVIERE & SON, *jewellers*; No. 68 New Bond Street; No. 29 Milsom Street, Bath; No. 331 Cheltenham. A.

GEORGE ROBERTSON; At the Crown & Pearl, near yᵉ corner of the Hay-Market, faceing Piccadilly. Makes & sells all sorts of Jewellers' Work. A.

JOHN ROBINSON, *goldsmith & jeweller*; At the Star & Ring in New Bond Street, St George's, Hanover Square. (2 *billheads* dated 1759 & 1769) A.

WALTER ROBOTHAM; At the red M & Dagger in Pope's-Head-Alley, agaⁿˢᵗ the Royal Exchange in Cornhill. Makes & sells all sorts of Curiosities in Gold, Silver, etc.... P.

JAS. ROBY, *goldsmith, jeweller & cutler*; In Prince's Street, facing Coventry Street, Leicester Square. A.

JOHN ROKER, *working goldsmith*; At the Golden Cup, opposite yᵉ London Workhouse, without Bishopsgate. M.

PHILIP ROKER, *working goldsmith*; At the Golden Cup in Bishopsgate Street, opposite Skinners Street. M.

FRANCIS RUFFIN, *gold chain maker & small worker in gold*; At the Crown & Chains in Cary Lane near Goldsmiths Hall. From the Late Mr Kemp. A.

PROVENANCES

RUNDELL & BRIDGE, *jewellers*; The Golden Salmon, No. 32 Ludgate Hill. (Late Pickett & Rundell.) (*Billhead* dated 1791) A.

RUNDELL & BRIDGE, *jewellers*; The Golden Salmon, No. 32 Ludgate Hill. (Late Pickett & Rundell.) (*Trade-card* dated 1791) M.

RUNDELL, BRIDGE & RUNDELL, *goldsmiths, jewellers & watch-makers to their Majesties*; [32 Ludgate Hill]. A.

FEND. [FENDALL] RUSHFORTH, [*Assayer to the Goldsmiths' Company*]; Goldsmiths' Hall, 1771. A.

PETER RUSSEL; At Chenevix's Toy Shop, Facing Suffolk Street, Charing Cross.
(*Billhead* dated 1759) A.

JOSEPH SAVORY, *working goldsmith, jeweller & cutler*; No. 48 Cheapside.
(*Billhead* dated 1783) A.

GEORGE SEATON, *jeweller*; No. 29 Gutter Lane. P.

RICHD. SEVERN, *jeweller & toyman*; The corner of Pauls-Grave-Head-Court, near Temple Barr. A.

SHAW AND PREIST, *working goldsmiths*; At the Unicorn in Wood Street, near Maiden Lane. G.

THOS. SHEPHERD, *working silversmith*; Glasshouse Yard, Aldersgate Street. A.

JAMES SHRUDER, *goldsmith*; At yᵉ Golden Ewer in Greek-street, Sohoe. G.

JOSEPH SILVER, *jeweller*; No. 28 Hatton Garden. (*Billhead*) A.

JOHN SIMMONS, *goldsmith & jeweller*; At the Golden Ball, corner of Racquet Court in Fleet Street. F.

JAMES SMITH, *working goldsmith*; At yᵉ Angel, in yᵉ Great Old Bailey, near Newgate. B. A.

WALTER SMITH, *goldsmith & jeweller*; No. 98 Bishopsgate Street Without. P.

WILLIAM SMITH, *jeweller & working goldsmith*; At the Black Moors Head, opposite Gutter Lane, Cheapside. (2 variants) A.

JOHN SOTRO, *goldsmith & toyman*; At the Acorn in St Pauls Church Yd. A.

THOMAS STACKHOUSE; In Blue Ball Court, Salisbury Court, Fleet Street. Sells necklaces, ear-rings, etc. M.

JOHN STAMPER, *goldsmith & jeweller*; At the Star, the Corner of Hind Court, opposite Water Lane in Fleet Street. A.

JOHN STEERES; At the Blue Lion in Old Round Court, Chandos Street.
(*Billhead* dated 1771) A.

JOHN STEERES, *goldsmith, jeweller & cutler*; No. 9 Pall Mall. (*Billhead* dated 1786) A.

JOHN STEVENSON (successor to Mr Wm. Careless); at the Golden Lion, opposite St Clement's Church in the Strand. (*Bill* on back dated 1766) A.

WILLIAM STEWART, *jeweller*; At the Crown & Pearl in the Strand, facing Hungerford Market. W.

CHR. STIBBS, *goldsmith, jeweller & cutler*; No. 17 Poultry. A.

JAMES STONES, *working goldsmith*; At the Golden Ball in Maiden-Lane, near Goldsmiths-Hall. A.

CHARLES STOREY, *jeweller & toyman*; At the Sun in Sidneys Alley, Leicester Fields. A.

SUTHERLAND, *ring-maker, enameller & jeweller*; No. 6 Orange Street, Leicester Square. A.

JAMES SUTTON, *working goldsmith & jeweller*; No. 86 Cheapside, next door to Mercers Chapel. (*Billhead* dated 1780) A.

JOSEPH SUTTON, *working goldsmith*; At the Acorn in New Street, near Covent Garden. A.

WILLM. SUTTON & COMPY., *working goldsmiths & jewellers* (successors to Mr Stamp); No. 85 Cheapside. A.

GEORGE TAYLER, *silversmith & bucklesmith*; No. 32 Blue Anchor Alley, Bunhill Row. P.

(35)

D

JOHN TAYLOR, *goldsmith*; At the Golden Cup, against Southampton Street, in yᵉ Strand. A.

PETER TAYLOR, *goldsmith*; At the Golden Cup, against Southampton Street, in yᵉ Strand. M.

SAMUEL TAYLOR, *jeweller*; The corner of Lad Lane in Wood-Street. (2 variants) A.

WILLIAM TAYLOR, *silver buckle maker*; In Huggin Alley, Gutter Lane, Cheapside. A.

GARNET TERRY, *engraver & jeweller*; No. 54 Paternoster Row, Cheapside.
(*Billhead* dated 1780) A.

JAMES THOMASSON, *goldsmith & jeweller*; At yᵉ Golden Cup & Key in Fen Church Street, near Cullum Street. A.

EDWARD TOULMAN, *small worker in gold & silver*; Great Dean's Court, St Martin's-le-Grand, near St Paul's. F.

CHRISTOPHER TOWES, *engraver & jeweller*; No. 119 Cheapside.
(*Bill on back* dated 1795) A.

JOHN TOWNSEND, *working goldsmith & jeweller*; At the Golden Lion in St Paul's Church Yard, No. 61. A.

JOHN TOWNSEND, *working goldsmith & jeweller*; At the Golden Lion, the North side of St Paul's Ch. Yard. (Another variant with "No. 61" added) A.

JONᴺ· TRENHOLME; At the Case of Knives & Forks, & Goldsmiths-Arms in Wood Street. A.

[TROUGHTON.] To be sold great variety of Jewellery Goods at Troughton's Wholesale Warehouse, Fenchurch Street. F.

Jᴮ· TRIPP, *goldsmith & jeweller*; At the Golden Ball in St Martin's Lane facing May's Buildings. W.

WILLM. TURTON, *small worker in silver*; No. 43 Grub-Street, Cripplegate. A.

STEPHEN TWYCROSS, *working jeweller*; No. 9 Newcastle Street, Strand. A.

MARIE ANNE VIET & THOS. MITCHELL, *jewellers*; At yᵉ sign of yᵉ Dial & Kings Arms, on Cornhill, near yᵉ Royal Exchange. (Dated 1742) A.

JOHN WAKELIN AND WILLM. TAYLER, *goldsmiths & jewellers*, successors to Parker & Wakelin; In Panton Street, near St James's, Hay-Market.¹

WAKELIN & GARRARD, *goldsmiths & jewellers to their Majesties*; Panton Street, Hay Market.
(*Billhead*) A.

SAML. WALKER, *working jeweller & gold seal maker*; No. 23 Finch Lane, Cornhill. A.

THOMAS WALLIS, *working goldsmith*; No. 54 Red Lion Street, Clerkenwell. (*Billhead*) A.

WARRE, *jeweller & goldsmith*; At the Golden Lion, the fifth door from Devereux Court, Nearer Temple Barr. A.

WILLM. WARWICK, *gold seal maker & jeweller*; 88 London Wall.
(A variant with address 2 Charter House Square) A.

WETHERELL & JANAWAY, *jewellers & goldsmiths & toymen to the Royal Family*; No. 114 Cheapside. A.

THOMAS WHIPHAM, *working silver-smith*; Remov'd from Ave-mary Lane to the Grasshopper near White Friers on the South side in Fleet Street. A.

WHIPHAM & NORTH, *goldsmiths & jewellers*; Fleet Street. (*Billhead*) A.

JOHN WHITE, *goldsmith*; At yᵉ sign of yᵉ Golden Cup in Arundell-Street in yᵉ Strand. A.

JOHN WIBURD, *working goldsmith*; In Babbmays-Mews, Jermyn Street, St James's. A.

GEORGE WICKES, *goldsmith & jeweller, silversmith to his Royal Highness yᵉ Prince of Wales*; In Panton Street, two doors from the Hay Market.¹

GEORGE WICKES & SAMUEL NETHERTON, *goldsmiths & jewellers, silversmiths to his Royal Highness the Prince of Wales*; In Panton Street, near St James's, Hay-Market.
(2 variants) A.

WILLM. WIGHT, *jeweller*; At the Crown in King Street, Cheapside. A.

¹ In possession of Messrs Garrard.

LONDON GOLDSMITHS' TRADE-CARDS

SAMUEL WILDMAN, *goldsmith & jeweller*; At the Sun, opposite Lawrance Lane, Cheapside.
(*Billhead* dated 1792) A.

WILLERTON & ROBERTS, *jewellers & toymen*; In New Bond Street.
(*Billhead* dated 1773) A.

ROBERT WILLIAMS, *goldsmith, jeweller, watch-maker & hardwareman*; At No. 6, near Northumberland Street, Strand. (*Billhead* dated 1784) A.

WM. WILLIAMS, *working goldsmith*; At the Spread Eagle in Foster Lane. A.

JAMES WILLMOT, *goldsmith & jeweller*; At yᵉ Flying Horse between the Savoy & yᵉ Fountain Tavern in the Strand. A.

JOHN WILLMOT, *gold ring maker*; the corner of the 3 Tun Tavern, St Margaret's Hill, Southwark. G.

THOMAS WINTLE; No. 9, the Ring & Pearl in the Poultry. Makes & Sells all sorts of Goldsmiths & Jewellers-Work. A.

JOHN WORSLEY; At the Ring & Pearl & Case of Knives, opposite Mincing Lane, Fenchurch Street. A.

CHARLES WRIGHT, *jeweller*; At the Crown & Pearl in Wood Street, near Cheapside. H.

JOSEPH WRIGHT (successor to Mr Tisdale), *working-goldsmith & water-gilder*; At the Ring & Chain in Cross Street, Hatton Garden. A.

PAUL WRIGHT, *jeweller & goldsmith* (successor to Mr Edward Smith); No. 12 Foster Lane, Cheapside [at the Parrot & Pearl]. H.

YOUNG [HENRY], *goldsmith, jeweller, hardwareman & toyman*; At the Star & Garter, near St Paul's, Ludgate Street. (3 variants of *trade-card* and *billhead* dated 1781) A.

V

GOLDSMITHS' SHOP-SIGNS & TOKENS

THE GOLDSMITHS' MARKS AND THEIR SHOP-SIGNS

The registered marks, which from 1363 onwards all goldsmiths were required to set upon their works, are outside the scope of this volume as their history and records have been fully dealt with by Jackson, Chaffers and other writers. It is only the connection that these marks had with the shop-signs that concerns us here. When the goldsmith was required to affix a personal mark to his wares some emblem or device had to be adopted. The most obvious and appropriate mark for him to select was the one that he had made his own by displaying it on the sign-board over his door. Towards the end of the sixteenth century the custom of using a symbol only for the maker's mark gradually fell into disuse and the initials of the maker, in conjunction with his symbol, were coming to be largely used. By the time of Charles II this device (except in conjunction with initials) had almost entirely disappeared. In 1697 it was ordained that the maker's mark should consist of the first two letters of his surname, but this ambiguous practice was disallowed in 1739 and the more personal mark, bearing the initials of the maker's Christian and surnames, came into use and has so persisted until this day.

Although the symbol had lost its prominence on the maker's mark, it still continued to provide the distinctive sign over his shop and the sign-board remained in general use until the latter half of the eighteenth century when it was superseded by the general numbering of the streets. In addition to the bearing which the shop-sign had upon the goldsmiths' marks these signs are of considerable interest from many other points of view. Very little attention, however, has been drawn to them. Chaffers, as has been mentioned, records only a couple of hundred and Jackson might be said to have ignored the subject altogether had he not, for some reason which is not evident, thought fit to indicate thirteen!

Of those trades dealt with in this book, namely, goldsmiths, jewellers, toymen, bankers and pawnbrokers, more than 1500 individual records of shop-signs have been collected. In every instance it has been possible to give the name of the tradesman using the sign, the street in which it was found, and the date—or a closely approximate date—when it was in use. These particulars will be found in the List of London Goldsmiths' Shop-Signs (see p. 51).

Shop-signs, as distinct from inn-signs, have not received the consideration they deserve. That their origin is of great antiquity there can be no doubt. The early Egyptians employed them; Aristotle and other Greek writers allude to their use. Roman signs are to be seen at Pompeii in the form of panels in relief beside the shop fronts. In their earliest form they displayed some simple object typical of a man's trade—a hand for the glover, a knife for the cutler, a bunch of grapes for the vintner, and so on. Almost the only shop-signs left to us to-day are symbols of this kind. We still occasionally see a large red hat set up over the hatter's, a dangling trout at the fishing-tackle shop, a kettle above the ironmonger's, a jar at the oilman's, a tea canister at the grocer's and a roll of tobacco outside the tobacconist's.

The history and origins of the shop sign-board are so inseparably bound up with economic development, and are so interwoven with the heraldic achievements of the monarchy and the nobility, with the vicissitudes of the Church and the rise of the City Guilds, that it is remarkable that more study has not been given to this fascinating subject.

For a period after the Great Fire the sign-board fell into disfavour; in the rebuilt streets the sign was carved on a stone panel let into the face of the building. Gradually, however, the more prominent hanging sign-board came into use. These boards with their ornamental iron brackets became larger and more elaborate until they constituted a nuisance in the narrow London streets. A commission of enquiry was set up and in 1762 the removal of sign-boards was proclaimed. By this time most people could read sufficiently to decipher a name or a figure, so when the numbering of the houses was instituted the new methods soon came to be generally adopted.

It frequently happens that curious combinations of emblems occur on sign-boards such as the *Lamb & Dolphin*, the *Naked Boy & Perriwig*, the *Angel & Gloves*, the *Bull & Bed-post*, the *Cow & Snuffers*, and so forth. The apparent incongruity of association usually arose from a tradesman succeeding to a shop where a well-known sign had been in use by his predecessor and to this he added his own sign or one which was appropriate to his calling. This resulted in a casual combination of the two signs. In other cases an apprentice setting up for himself would use the sign of his late master in conjunction with a device of his own. Occasionally three, or even four, emblems were combined on one board.

Among the signs favoured by goldsmiths it is natural that we should find a number displaying the *Golden Cup*, that being one of the charges on the arms of the Goldsmiths' Company. Variations of this emblem occur such as the *Cup & Cover*, the *Golden Ewer* and the *Gold Vase*. Signs particularly appropriate to jewellers are combinations such as the *Ring & Pearl* or the *Hand & Ring*. The *Eagle & Pearl* is a very usual jeweller's sign but the reason for this is not apparent. The *Blackamoor*, or the *Black Boy*, the *Peacock*, and the *Unicorn* were emblems generally adopted in conjunction with luxury trades as denoting elegance or rarity. The *Crown* or the *King's Arms* were commonly used by those enjoying royal patronage. Such favourite signs as the *Acorn*, the *Angel*, the *Sun*, and the *Three Flower-de-Luces* were in general use by all trades.

PAWNBROKERS' SHOP-SIGNS

The *Three Balls* of the pawnbrokers' is the sign most consistently connected with any one trade. The earliest version of this device was the *Three Bowls* and this was the common form from the Great Fire up to the middle of the eighteenth century. The later developments of it were the *Three Blue Bowls*, the *Three Blue Balls*, or the *Three Balls*. The familiar *Three Golden Balls* did not come into vogue much before 1760 though I have found two examples of it used by pawnbrokers in the year 1731.[1]

The origin of this famous sign has been much discussed. Hilton-Price[2] follows Larwood and Hotten[3] in the statement that it was "taken from the lower part of the coat-of-arms of the Dukes of Medici from whose states and from Lombardy nearly all the early bankers came". It is likely that the sign did derive directly from these arms but there are certain discrepancies between the two. The Medici coat bore roundels, which are discs and not spheres; furthermore, these varied in number from eleven to six, variously arranged, but were never three in number; neither was the metal *or*. A theory has been advanced that the Lombards assumed the emblem of St Nicholas which was the three purses full of gold, sometimes represented as balls of gold, with which the good saint came to the timely aid of a certain distressed nobleman, who, seeing his family on the verge of starvation, was about to sacrifice his three daughters to an infamous life when the charitable St Nicholas appeared and presented each daughter with a purse of gold. The bag-shaped purses came to take the form of three golden balls which are recognised as the saint's especial emblem.

[1] See page 85. [2] "Signs of Pawnbrokers" (*Archaeological Journal*, Vol. LIX, p. 168).
[3] *History of Signboards*, p. 128.

LONDON GOLDSMITHS' TOKENS

Of the tokenage issued by London tradesmen in the seventeenth century only three specimens are recorded which can be definitely attributed to goldsmiths. Three other issues are known which bear the insignia of the Goldsmiths' Arms, but it is doubtful whether these were tokens of goldsmiths or whether, as seems more likely, they were the currency of taverns frequented by members of the trade. The reference numbers given are those used in Williamson's edition of Boyne's *Trade Tokens issued in the seventeenth century* (1889).

No. 1089. Fleet Street:

H · P · AT · 3 · SQUIRRELLS = Three Squirrels.
IN · FLEET · STREETE = H. P. $\frac{1}{4}$.

Henry Pinckney founded the banking house of Gosling c. 1650. An example of this token is in the British Museum.

No. 1347. The Hermitage, Wapping:

IOHN · MAYHEW · GOVLDSMITH = His Half Peny.
NEARE · THE · ARMITAGE · BRIDG = I. M. 1666. $\frac{1}{2}$.

An example of this token is in the Guildhall collection.

No. 2862. Smithfield West:

EVODIAS · INMAN · HIS · HALFE · PENY. (In four lines.)
IN · SMITHFEILD · ROVNDS · GOVLDSMITH. (In four lines.) $\frac{1}{2}$.

NOTES ON EMBLEMS IN GOLDSMITHS' SHOP-SIGNS

The following brief notes on the origins and uses of the shop-signs employed by goldsmiths, bankers and pawnbrokers may serve to indicate the directions in which fuller information may be sought. They are mere hints to the study of the subject. The signs are in alphabetical order of the emblem or of the qualification usually given to it—e.g. *Golden Cup, Three Balls*. If a device has been listed under its name, or with one qualification, it has not usually been repeated when met in conjunction with another qualification. Thus *Blue Anchor* is not given when *Anchor* has previously been noted, nor *Three Flower-de-Luces* if *Flower-de-Luce* has already appeared. In the cases of coupled signs (such as *Crown & Pearl*) these have not been repeated in their inverted form (*Pearl & Crown*). The information given has for the most part been taken from Larwood and Hotten's *History of Signboards* (1867) or J. H. MacMichael's articles on London Signs which appeared in *The Antiquary*, Vols. XL–L (1904–14), but other sources have also been laid under contribution.

NOTES ON SHOP-SIGN EMBLEMS

Acorn or *Acron*. The spelling "Acron" is found as late as 1742.

Anchor & Crown or *Crown & Anchor*. The badge of the Navy.

Angel or *Golden Angel*. Usually represented with a scroll in his hand signifying the Angel Gabriel and the Salutation of Our Lady. Forty-five instances of these signs have been listed.

Anodyne Necklace. A noted "quack" cure in the seventeenth century.

Arms of France. Three Flower-de-Luces.

Artichoke. Was ranked as a delicacy when introduced into this country in the reign of Henry VIII. Evelyn says that they were "so rare in England that they were sold for a crown a-piece".

Ball & Crown. See *Golden Ball & Crown*.

Ball & Ring. Probably derived from the game of pall-mall where the ball was struck through an iron ring.

Baptist's Head. St John, patron saint of the Knights of Jerusalem.

Beehive. A wax chandler's sign but generally used to symbolise industry. The beehive used to be one of the few living signs. Another one was the caged squirrel.

Bird in Hand. Signified No Credit. A bird in the hand worth two in the bush.

Black Boy, or *Blackamoor*. The vogue amongst ladies of fashion to have negro attendants.

Black Bull. A badge used by Edward IV indicating his descent from the house of Clare.

Black Peruke. The long wig of thick black hair was made the fashion by Charles II. The style did not go out until the days of William III though the colour was changed to suit various complexions. See also *Blue Perriwig*.

Black Raven. As the chosen agent of ministration to Elisha the bird became an emblem of Providence. It was a Jacobite symbol, having served as a badge of the ancient Scottish kings.

Black Spread Eagle. Was a charge on the arms of the Scriveners' Company.

Black Swan. At one time considered a *rara avis*.

Blackamoor's Head. Cf. John Blackmoor (page 55) who employs this sign as a *rebus*.

Blackmoor. See *Black Boy*.

Blue Ball. A mercer's sign representing a ball of silk.

Blue Boar. See *Boar's Head*.

Blue Perriwig. The peruke began to fall into disuse in 1764 when natural hair came to be worn. See also *Black Peruke*.

Boar's Head. A cognisance of Richard III. Sometimes debased to the *Blue Pig*, see also *Blue Boar*.

Bolt & Tun. A tun (large cask) pierced by a bolt (arrow). Used as a *rebus* by Thomas Bolton.

Bull. From the constellation Taurus.

Cannon. The cannon, or gun, was the cognisance of King Edward IV, of Queen Mary, and of Queen Elizabeth.

Catherine Wheel. Adopted from the badge of the Knights of St Catherine of Mount Sinai. This Order was created for the protection of pilgrims to and from the Holy Sepulchre and thus became an emblem of protection to travellers.

Cornish Daw, or *Chough*. Jewellery was supposed to appeal to the acquisitive habits of this bird. Vide "*Jackdaw of Rheims*." Cf. *Crow & Bracelet*.

Crooked Billet. An untrimmed staff or log. Possibly a vestige of the ancient cult of tree-worship.

Cross Keys. Arms of the Papal See. The emblem of St Peter and his successors.

Crow & Bracelet. See *Cornish Daw*.

Crown. Eighty-three instances of goldsmiths using this sign with its combinations have been listed.

Crown & Anchor. See *Anchor & Crown*.

Crown & Cushion. The crown carried before the king at coronation.

Crown & Dolphin. Armorial bearing of the Dauphin.

Crown & Pearl. Usually a jeweller's sign; twenty-eight instances of it have been listed.

Cup or *Golden Cup.* The arms of the Goldsmiths' Company are quarterly *gules* and *azure*, first and fourth a leopard's head *or*, in second and third a cup covered between two buckles of the last.

Curtain. Usually an upholsterer's sign.

Dagger. A charge on the Arms of the City of London—popularly supposed to represent the dagger of Sir William Walworth with which he slew Wat Tyler. Stow contradicts this idea and attributes the device to the sword of St Paul.

Dagger Ordinary. The *Dagger Tavern* in Foster Lane, near Goldsmiths' Hall, was noted for its pies, hence the fame of its "ordinary".

Dial. Usually a watchmaker's sign.

Diamond Cross. A jeweller's sign.

Dog & Bear. Derived from the sport of bear baiting popular in the seventeenth century.

Dog & Pottage Pot or *Dog's Head in Pot.* Usually a hardwareman's sign.

Dolphin. See *Crown & Dolphin.*

Duke of Montagu's Head. This probably celebrates Ralph the first Duke of Montagu.

Eagle. It is noteworthy that this sign and its combinations are common with jewellers but never used by goldsmiths.

Eagle & Pearl. See above.

Falcon. A charge on the Arms of the Stationers' Company.

Five Bells. This numeral is not unusual in pawnbrokers' signs but no instance has been found of it in use by a goldsmith. I have seen no explanation of this figure Five but the magic symbol of the pentagram, or five-pointed star, may be its origin.

Fleece or *Golden Fleece.* Jason's golden fleece was used as an emblem of the wool trade.

Flower-de-Luces. A charge on the Arms of France.

Flying Horse. Pegasus or the swinging horse of public games.

George. Usually indicates an abbreviation of St George.

Golden Angel & Crown. Arose from the decorative representation of the Crown supported by cupids in the Renaissance manner.

Golden Ball. See p. 43.

Golden Ball & Crown. The Orb, insignia of Royalty.

Golden Bottle. A leather bottle gilt.

Golden Cock. From earliest times this bird has been given a mystical significance.

Golden Cup. See *Cup.* Fifty-nine instances of goldsmiths using this sign have been listed.

Golden Fleece. See *Fleece.*

Golden Head. Usually met with as an artist's sign. William Hogarth lived at the *Golden Head* in Leicester Fields.

Golden Heart. The Bleeding Heart was an emblem of the Virgin.

Golden Key. See *Cross Keys.*

Golden Star. The emblem of the Holy Virgin.

Golden Urn, Vase or *Ewer.* See *Cup.*

Grasshopper. The originator of this sign was Sir Thomas Gresham.

Hampshire Hog. This may possibly share a derivation in common with Winchester's *Trusty Servant* (?).

Hand & Spur. Used by silversmith cock-spur makers.

Hole in the Wall. Believed to have originated with the hole made in debtors' prisons through which food or money was passed.

Jack. The only instance of this sign that I have met with was in Wood Street. It may be no more than a coincidence that "Jack" and "Wood" are both terms which occur in the game of bowls.

Kings & Keys. Probably an abbreviation of the *Three Kings & Cross Keys.*

Lamb & Leopard. The leopard of this incongruous association arose from the English plate-mark.

Maidenhead. The crest of the Mercers' Company.

Man in the Moon. The legendary origin of this sign is traced to the man who gathered sticks upon the Sabbath-day. Cf. *Numbers* xv. 32 *et seq.*

Marygold. It is said that this sign came from a popular reading of the sign of the Sun.

Naked Boy. A satirical sign reflecting upon the constant changes of fashion.

Palm Tree. One of the oldest symbols known, it was used by Assyrians, Greeks and Romans.

Palsgrave's Head. The Palsgrave Frederick, husband of the Princess Elizabeth, daughter of James I.

Peacock. In ancient times this bird was possessed of a mystic character. The fabled incorruptibility of its flesh led to its typifying the Resurrection. On sign-boards it stood for fine and fashionable things.

Plume of Feathers. A plume of ostrich feathers was the cognisance of the Black Prince.

Ram. The crest of the Clothworkers was a mount *vert*, thereon a ram *statant.*

Raven. See *Black Raven.*

Red M & Dagger. The cutlers used the punch-mark of their initial on their signs. The instance quoted is the sign of Walter Robotham, successor to Jonathan Milner, whose mark it originally was.

Ring & Ball. See *Ball & Ring.*

Rising Sun. A badge of Edward III.

Royal Exchange & Grasshopper. Commemorates Sir Thomas Gresham's sign and the Exchange which he built.

Seven Stars. The Pleiads, a group of stars in the constellation of Taurus. Commonly known as the "Seven Sisters".

Snail. A most unusual sign typifying, no doubt, Perseverance. No other instances of it have been met with in any other trade. It is notable that all the three instances recorded occur in Tower Street.

Spotted Dog. Talbot—a sporting dog with black and white markings.

Star & Garter. The insignia of the Order.

Sugar Loaf. Usually found as a grocer's sign.

Sun & Marygold. See *Marygold.*

Three Balls, Three Blue Balls, Three Bowls or *Three Golden Balls* (see p. 43). One hundred and ninety-seven instances of these signs have been listed.

Three Crowns. The city of Cologne adopted Three Royal Crowns as its arms when the precious relics of the Three Kings (the Magi) found a final resting-place there in the twelfth century.

Three Cups. See *Cup.*

Three Kings. The three Magi—see also *Three Crowns.*

Three Neats' Tongues. Ox tongues—usually an inn sign.

Three Tuns. Derived from the Vintners' Arms.

Unicorn. The high value put upon unicorns' horns caused the goldsmiths to adopt this animal as a sign of rarity. Thirty-one instances of goldsmiths using this sign have been listed.

Vine. Used as a *rebus* by Sir Thomas Vyner.

Vizard Mask. A vizard was a kind of mask.

White Hart. Badge of Richard II.

White Lion. Badge of Edward IV.

VI
A LIST OF LONDON GOLDSMITHS'
SHOP-SIGNS

A LIST OF
SHOP-SIGNS OF LONDON GOLDSMITHS, JEWELLERS, BANKERS AND PAWNBROKERS

ACORN (see also ACRON and GOLDEN ACORN)

Aldersgate street; THOMAS RUSH, goldsmith.	1739–1773
Drury lane; ISAAC CORNASSEAU, silversmith.	1722
Fetter lane; THOMAS RUSH, goldsmith.	1724
Fleet street, over against the Temple, next door to the Queen's Head tavern;	
RICHARD PIERSON, goldsmith.	1672–1712
EDWARD PIERSON, goldsmith.	1718–1731
Foster lane; WILLIAM DARKERATT, goldsmith.	1718–1724
WILLIAM DARKERATT, junior, goldsmith.	1724
Lombard street; GEORGE SNELL, goldsmith & banker.	1666
WILLIAM SNELL, goldsmith & banker.	1666
JOHN BRASSEY, goldsmith.	1691–1710
BRASSEY & CASWALL, goldsmiths.	1707
JOHN & NATHANIEL BRASSEY, goldsmiths.	1716–1720
NATHANIEL BRASSEY, goldsmith.	1720–1724
NATHANIEL BRASSEY & LEE, goldsmiths & bankers.	1730–1740
Monument, near the; — BAKER, silversmith.	1732
New street, Covent Garden [*No. 12*]: JOSEPH SUTTON, goldsmith.	1754–1784
Pall Mall; LEWIS METTAYER, goldsmith.	1700–1725
Panton street, near Leicester fields; JOHN JACOB, goldsmith.	1768
St Paul's churchyard, North side of; JOHN SOTRO, goldsmith & toyman.	1720
Strand; THOMAS GILPIN, goldsmith.	1730

ACORN & CROWN (see also CROWN & ACORN)

Lombard street; — NEWTON, goldsmith & jeweller.	1738

ACORN & RING

Duke street, York buildings [*Strand*]; JACOB DUHAMEL, jeweller.	1720

ACORN & STAR

Bishopsgate street [*No. 98*]; WALTER SMITH, goldsmith & jeweller.	1760–1762

ACRON (see also ACORN)

Drury lane, upper end of; — POUNTIN, goldsmith.	1715
Fetter lane; THOMAS RUSH, goldsmith.	1724

ANCHOR

Cheapside; — BUTLER, silversmith.	1673
Huggin alley, Wood street; SAMUEL MERITON, goldsmith.	1746
Russell street, Covent Garden; EDWARD WALDEGRAVE, goldsmith.	1690–1721
St Paul's churchyard; — WARD, silversmith.	1717

ANCHOR & CASE OF KNIVES

Cornhill, near Royal Exchange; HYDE & LEEDS, jewellers & hardwaremen.	1763–1768

ANCHOR & CROWN

Lombard street; JOHN EMES & Co., goldsmiths.	1702–1721
JONATHAN NEWTON, goldsmith.	1718–1740
JOHN GARBETT, goldsmith.	1747
THOMAS LEACH, goldsmith & jeweller.	1747–1762
[*No. 48*] JOHN HENRY VERE, goldsmith & jeweller.	1766–1773
C. NORRIS, jeweller.	c. 1770
Russell street, Covent Garden; EDWARD WALDEGRAVE, goldsmith.	1690–1721

ANCHOR & DOVE
Fenchurch street; WILLIAM LUTWYCHE, goldsmith & jeweller. 1771
Lombard street; JOHN HENRY VERE & WILLIAM LUTWYCHE, goldsmiths. (Before) 1766
 WILLIAM LUTWYCHE, goldsmith. 1766–1772

ANCHOR & GLOBE
Lombard street; — BRADFIELD, goldsmith. 1716

ANCHOR & KEY
Wood street; WILLIAM ALEXANDER, goldsmith. 1742
 ALEXANDER & SHRIMPTON, goldsmiths. 1768

ANCHOR & RING
Lombard street [No. 51]; WILLIAM HUNTER, goldsmith & jeweller. 1732–1762
 WILLIAM HUNTER, junior, goldsmith & jeweller. 1762–1796

ANCHOR & THREE CROWNS
Lombard street; RICHARD MORSON, goldsmith & banker. 1700–1736

ANGEL (see also GOLDEN ANGEL)
Brydge's street, Covent Garden; RICHARD ROYCROFT, goldsmith. 1714
Cambridge street, corner of, Cambridge square; JOHN MONTGOMERY, goldsmith. 1729–1749
Catherine street, Strand; RALPH LEEKE, goldsmith. 1692
Charing Cross; — FALKNER, goldsmith. 1681
Cheapside; — CLARKE, goldsmith. 1553
 — HICKFORD, goldsmith. 1653
 SIR JAMES HALLETT, goldsmith (?). 1690–1734
 JAMES HALLETT, junior, goldsmith. 1706–1723
Cranbourn street, Leicester fields; THOMAS RAYNER, goldsmith. 1722
Fleet street; JOHN JACKSON, goldsmith. 1684–1714
 [Near Temple Bar] WILLIAM PARKER, goldsmith. 1692–1697
Fleet street; MRS JACKSON, goldsmith. 1719
 [No. 115, corner of Racquet court] JAMES SMITH, silversmith. 1751–1780
Foster lane; JOHN DUCK, goldsmith. 1678–1745
Lombard street; JOHN LINDSAY, goldsmith & banker. 1663–1679
 JOHN WALLIS, goldsmith & banker. 1677
 JOHN LINDSAY & PEIRCE REEVE, goldsmiths & bankers. 1679
 PEIRCE REEVE, goldsmith & banker. 1679
 FRANCIS KENTON, goldsmith & banker. 1682–1687
 WILLIAM SHEPPARD, goldsmith. 1690–1702
 JOHN SHEPPARD, goldsmith. 1690–1702
 WILLIAM SHEPPARD & JOSEPH BRAGG, goldsmiths. 1696–1702
 JOSEPH BRAGG & WILLIAM SHEPPARD, goldsmiths. 1695–1702
 STEPHEN RAM, goldsmith. 1700–1719
Old Bailey, near Newgate; JAMES SMITH, goldsmith. c. 1760
Silver street, Golden square; JOHN MONTGOMERY, goldsmith. 1729–1749
Strand; GEORGE LEWIS, goldsmith. 1697–1714
 ARTHUR DICKEN, silversmith. 1720–1724

ANGEL & CROWN
Cecil court, St Martin's lane; JANVIER, silversmith. 1710
Fleet street; JOHN JACKSON, goldsmith. 1684–1714
Lombard street; JOHN EWING & BENJAMIN NORRINGTON, bankers &
 goldsmiths. 1677
Newport street, near Leicester fields; PETER DOVE, goldsmith. 1696–1712
Strand [over against New Exchange, near Durham yard];
 GEORGE LEWIS, goldsmith. 1697–1714
 GEORGE HORNE, goldsmith. 1716–1728
 GEORGE HORNE & DAVID KILMAINE, goldsmiths. 1716
 DAVID KILMAINE, goldsmith. 1716–1728
 HORNE & TEMPLE, goldsmiths. 1730–1740

ANODYNE NECKLACE
Long Acre, [No. 78] next Drury lane;
 JAMES MATTHEW BURCHELL, goldsmith & jeweller. 1774–1779

ARMS OF FRANCE
Ball alley, Lombard street; JAMES HILL, jeweller, etc. 1788–1793

ARTICHOKE [see GOLDEN ARTICHOKE]
Exchange alley; JEREMIAH THOMAS, goldsmith. 1668–1684
 ROBERT MOORE & JEREMIAH THOMAS, goldsmiths. 1684–1692

BALL & RING
Fenchurch street; SIR HENRY HANKEY, goldsmith. 1690–1704

BAPTIST'S HEAD
Great Old Bailey, facing the; — CLEMENS, pawnbroker. 1752, 1753

BEAR
Foster lane, right against Goldsmiths' Hall; RICHARD CROFT, goldsmith. 1675–1701

BEEHIVE
Watling street; JAMES CAEPELL, goldsmith. 1677

BELL
Charterhouse lane; JOHN BUSH, pawnbroker. 1693
 RICHARD NEWNHAM, pawnbroker. 1702
Deadman's place, Southwark; BENJAMIN HALL, pawnbroker. 1715
Grub street; — DORRELL, silversmith. 1735
Maiden lane, Covent Garden; — HAMMOND, pawnbroker. 1706
Strand, at the backside of St Clement's; THOMAS JOHNSON, pawnbroker. 1708

BELL & MAGPIE
Bishopsgate Without; — ALBERT, silversmith. 1733

BIBLE
Lombard street; GEORGE BRAITHWAITE, goldsmith & clock-maker. 1728
Serle street, over against Lincoln's Inn Back Gate;
 HALDANBY LANGLEY, goldsmith 1690–1718

BIRD IN HAND
Fleet street; AMBROSE MEAD, goldsmith. 1665
Nightingale lane, lower part of; JEAN BOSALL, pawnbroker. 1719
 JANE EDSALL, pawnbroker. 1720

BISHOP'S HEAD
Little Old Bailey; — ACHURCH, silversmith. 1733

BLACK BOY
Cheapside; — GYLBARD, goldsmith. 1562
Fleet street, over against St Dunstan's Church; — GRIGGE, goldsmith. 1660
 JOSEPH WILSON, goldsmith. 1688–1704
Lombard street; PETER PERCIVAL (or PERCEFULL) & STEPHEN EVANS, goldsmiths & bankers. 1677–1688
 PETER PERCIVAL, goldsmith. 1688–1690
London bridge, near the Gate; JOHN AMY, goldsmith. 1698–1714
 JOHN BUCK, goldsmith. 1712–1714
Russell street, Covent Garden; THOMAS CATTERALL, goldsmith. 1697–1718

BLACK BULL
Mint street; WILLIAM HARDING, goldsmith. 1712

BLACK DOG
Lombard street; JOHN RAND, goldsmith. 1703–1713

BLACK HART
Bishopsgate street;	ANN COLLIER, pawnbroker.	1702–1707
Bishopsgate street;	JOHN POWELL, pawnbroker.	1714, 1715
Bishopsgate Without, Skinner's street end;	ANN LILL, pawnbroker.	1720

BLACK HORSE
Cheapside;	JAMES ST JOHN, goldsmith.	1677
Lombard street;	HUMPHREY STOKES, goldsmith & banker.	1677
	ROBERT STOKES, goldsmith.	1700–1705 (?)
	JOHN BLAND, goldsmith.	1728–1740
	JOHN & STAMPER BLAND (BLAND & SON), goldsmiths.	1740–1747
Strand, near Charing Cross;	— KETCH, goldsmith & banker.	1677
near Northumberland House;	RICHARD ADAMS, goldsmith.	1682–1715

BLACK LION
Birchin lane;	EDWARD MOMPESSON, goldsmith.	1693–1701
Cheapside, over against Mercers' Chapel;	WILLIAM SCARBOROUGH, goldsmith.	1642–1663
Fleet street, within Temple Bar;	SIR THOMAS FOWLES, goldsmith & banker.	1666–1692
	ROBERT FOWLES, goldsmith, banker & jeweller.	1693–1705
	FOWLES & WOOTTON, goldsmiths.	1693, 1694
near Temple Bar;	THOMAS WOOTTON, goldsmith.	1700–1703
Temple Bar;	JOHN MEAD, goldsmith & banker.	1705–1727
	MEAD & BRIGHTALL, goldsmiths & bankers.	1715
	WILLIAM MEAD, goldsmith & banker.	1722–1724
Lombard street; EDWARD PINFOLD, goldsmith.		1686–1712
IRONSIDE & BELCHIER, goldsmiths, bankers & clock-makers.		1729–1744
St Martin's lane, near Charing Cross;	WILLIAM FRANCIS, goldsmith.	1692–1712
St Martin's lane;	MRS FRANCIS, goldsmith.	1720
Strand, corner of Salisbury court, near Savoy;	GEORGE HILL, goldsmith.	1679–1694
near the Maypole;	— WEEKS, goldsmith.	1681
near Durham yard;	WILLIAM WALKER, goldsmith.	1683–1689
Strand;	— GILLINGHAM, silversmith.	1703

BLACK PERUKE
Panton street, Leicester fields;	PHILIP NORRIS, pawnbroker.	c. 1710
	ELIZABETH NORRIS, pawnbroker.	1716

BLACK RAVEN
Newgate street;	JOHN BURNINGHAM, goldsmith.	1694

BLACK SPREAD EAGLE
Cheapside;	SIR CHARLES DOE, goldsmith.	1641–1671
Fenchurch street;	WILLIAM HALSTED, goldsmith.	1694
Foster lane;	FRANCIS SPILSBURY, goldsmith.	1729–1739
Holborn, near the Watch House;	THOMAS RUMBOLD, pawnbroker.	1705
Lombard street;	JOHN BEVAN, goldsmith.	1672
	JAMES TAYLER, goldsmith.	1676
	JOSEPH FREAME & THOMAS GOULD, goldsmiths & bankers.	1728–1736
	JAMES BARCLAY, goldsmith & banker.	1736
	JOSEPH FREAME & JAMES BARCLAY, goldsmiths & bankers.	1736–1759
Phoenix street, near Bloomsbury;	JOHN HOW, pawnbroker.	1704
	DAVID STEPHENS, pawnbroker.	1716

BLACK SWAN
Charterhouse lane;	HESTER PEDLEY, pawnbroker.	1707
East Smithfield;	MRS PARNUM, goldsmith.	1689
Holborn;	RICHARD WOOD, goldsmith.	1675
Newgate street;	— HALL, goldsmith.	1690

(54)

BLACKAMOOR'S HEAD

Within Aldgate;	JOHN NEWTON, goldsmith.	1748–1753
Barbican;	— BARLOW, silversmith.	1743
Broad street, St Giles';	— BARBOT, silversmith.	1726
Castle street, Long Acre;	MRS SMITHSON, pawnbroker.	1718
Charing Cross;	EDWARD WHARTON, goldsmith.	1694–1699
Cheapside;	ROBERT CUTHBERT, goldsmith.	1675–1703
	THOMAS WILDMAN, goldsmith.	1742–1762
Church street, Soho;	JOHN BLACKMOOR, pawnbroker.	1711
Gutter lane;	JOHN GOREHAM, goldsmith.	1728–1761
Lombard street;	LONG & BLAND, goldsmiths.	1718–1720
	JOHN LONG, goldsmith & banker.	1719–1725
	JOSEPH CLARE, goldsmith.	1721
Princes street, Leicester fields;	— VAUGHAN, goldsmith.	1731
Strand, corner of York buildings;	J. NORCOTT, goldsmith.	1703–1710
	WILLIAM LUKIN, silversmith.	1712–1734
corner of Buckingham street;	DANIEL & JOSEPH NORCOTT, goldsmiths.	1713–1721
Strand;	GEORGE HINDMARSH, goldsmith.	1743
	(See also CROWN, *Strand, and in Tooley street*.)	

BLACKMOOR'S HEAD

Within Aldgate;	JEREMIAH MARLOW, junior, goldsmith.	1718–1734
	— LAMB, goldsmith.	1743
Cheapside;	THOMAS SMITH, goldsmith.	1656–1659
	THOMAS SMITH & WILLIAM GIBBONS, goldsmiths.	1659
[*No. 32, opposite Gutter lane*]	WILLIAM SMITH, jeweller & goldsmith.	1760–1779
Fetter lane;	WILLIAM ALLDERIDGE, goldsmith.	1751
Foster lane;	JAMES WEST, goldsmith.	1734–1739
Great St Andrew street, St Giles';	FRANCIS HARRACHE, silversmith & toyman.	1732–1758
Gutter lane;	ISAAC DAVENPORT, goldsmith.	1695–1703
Lombard street;	SIR JOHN SWEETAPLE, goldsmith & banker.	1677–1701
Minories;	WILLIAM REEVE, goldsmith.	1731
Red Lyon passage, Holborn;	WILLIAM ALLDERIDGE, goldsmith.	1770–1773
Saffron hill;	THOMAS JEFFERYS, pawnbroker.	1716
Strand, corner of York buildings;	PHILIP PLATEL, goldsmith.	1737

BLACKMOOR'S HEAD & SUN

Lombard street, corner of Ball alley;	JOHN FOSSEY, goldsmith & jeweller.	1748

BLUE ANCHOR

Little Tower hill;	— GREEN, goldsmith.	1699
Lombard street;	THOMAS WHITE, goldsmith.	1677–1695
Strand, near the Talbot Inn;	— HUGHES, button & toyshop.	c. 1760

BLUE ANCHOR & STAR

Cheapside, over against Wood street;	MICHAEL BOULT, goldsmith.	1713–1745
	RICHARD BOULT, goldsmith & jeweller.	1744–1753

BLUE BALL

Foster lane;	— JONES, goldsmith.	1743
Holborn, near Little Queen street;	— PARKE, goldsmith.	1744
Hoxton market;	WILLIAM POWELL, pawnbroker.	1731, 1732
Little New street, near Shoe lane;	MRS RYLANDS, pawnbroker.	1726
London wall;	— DAVIDSON, pawnbroker.	1757
New Gravel lane, Shadwell;	JOHN RANCOCK, pawnbroker.	1723
Orange street, Leicester fields;	WALTER VINCENT, pawnbroker.	1724
Queen street, Seven Dials;	MRS WILLIAMS, pawnbroker.	1718
Tower street, Seven Dials;	— AVELINE, goldsmith.	1726

BLUE BOAT
Ratcliff Highway; SAMUEL BARNES, pawnbroker. 1710

BLUE FLOWER POT
Clare court, Drury lane; JOHN HOBART, goldsmith (?). 1702
Queen street, near Seven Dials; MRS COX, pawnbroker. 1702

BLUE LION
Old Round court, Chandos street; JOHN STEERES, goldsmith. 1771

BLUE LION & CROWN
Tooley street, corner of, London bridge; EDWARD BENNETT, goldsmith. 1739–1747

BLUE PERRIWIG
Russell street, Covent Garden, next door to the Rose tavern; — FARRAN, goldsmith. 1710–1712

BLUE PLOUGH
Lombard street; JOSEPH WILSON, goldsmith. 1695–1720

BLUE SPIKES
Lime street; GEORGE BARKER, jeweller. 1724

BLUE & WHITE BALL
Drury lane, near Brownlow street; J. PULLEN, pawnbroker. 1726

BOAR'S HEAD
West Chepe, near Honey lane; JOHN ECCLESTON, goldsmith. 1552

BOLT & TUN
Cornhill; THOMAS BOLTON, goldsmith (?). 1666
Lombard street; JOHN BOLTON, goldsmith. 1677–1686

BOY & CORAL
Gutter lane; JOHN RAYMOND, goldsmith. c. 1755

BROWN BEAR
Bow street, Covent Garden; THOMAS DALEMAN, pawnbroker. 1753

BUCK & COCK
Lombard street; — WHITE, goldsmith. (Before) 1666–1670

BULL
Birdcage alley, near St George's Church, Southwark; — CHEARY, goldsmith. 1745
Charterhouse lane; JOSEPH ARTHUR, goldsmith. 1653
 GEORGE PICKERING, goldsmith. 1653

BUNCH OF GRAPES
Cheapside; NATHANIEL POTTER, goldsmith. 1659
 THOMAS HOSKINS, goldsmith. 1687–1703
 JOHN LAVINTON, goldsmith. 1707
 STAFFORD BRISCOE, goldsmith. 1711, 1712
Lombard street; JOHN TASSELL, goldsmith. 1670–1695
Strand, near New Exchange; JOSEPH FELLS, goldsmith. 1679–1702
 near York buildings; — HANNE, goldsmith. 1705

CABINET
St Paul's churchyard, South side of; THOMAS CALDECOTT, goldsmith. c. 1760

CANDLESTICK
Foster lane; WILLIAM GOULD, silversmith. 1733–1748
Gutter lane; JAMES GOULD, goldsmith. 1739–1743

CANDLESTICK & SNUFFERS
Gutter lane; THOMAS STACKHOUSE, silversmith. 1724

LONDON GOLDSMITHS' SHOP-SIGNS

CANNON
Barbican; CHARLES FRY, pawnbroker. 1717
St John street; — DRAKE, silversmith. 1731

CARDINAL'S CAP [or RED HAT]
Strand, near Charing Cross; JOHN DIGGLE, goldsmith. 1694–1701

CARPENTERS' ARMS
Clerkenwell; — GRIFFIN, silversmith. 1730

CASE OF KNIVES
Strand, South side of, [No. 158] six doors from Somerset House, opposite the New Church;
 GEORGE ANTT, goldsmith & jeweller. 1772–1784

CASE OF KNIVES & FORKS & GOLDSMITHS' ARMS
Wood street; JONATHAN TRENHOLME, haft-maker & silver small-worker. c. 1760

CASTLE
Fleet street; MATTHEW COCKETT, goldsmith. 1700

CAT
Strand, near Cecil street; EDMOND PAYNE, goldsmith. 1700–1715
Without Bishopsgate; ANDREW DU CANE, goldsmith. 1685–1697

CATHERINE WHEEL
Blackman street, Southwark; THOMAS MANN, pawnbroker. 1708–1710
Houndsditch; CHARLES MILLS, pawnbroker. 1725

CHANDELIER
Long Acre, next door to the Golden Leg, opposite Langley street;
 JOHN LEGRIX, goldsmith. c. 1760

CHESHIRE CHEESE
Vinegar yard, Drury lane; DAVID ARNOLD, pawnbroker. 1712

CLOTHWORKERS' SHEARS
Houndsditch; JOHN WILLMOTT, pawnbroker. 1731

COCK
Lombard street; JOHN SNELL, goldsmith & banker. 1680
Old Bailey; RICHARD VINCENT, goldsmith. (Before) 1737

COCK & PEARL
King street, Covent Garden; WILLIAM WATKINS, jeweller. 1706
Newport street; — JONES, jeweller. 1718–1722

CORNISH DAW
Essex street; THOMAS JENKINS, goldsmith. 1688–1708

CROOKED BILLET & THREE HORSESHOES
Houndsditch; MRS SARAH BIKER, pawnbroker. 1700

CROSS KEYS
Cheapside; SIR JOHN WILLIAMS, goldsmith. c. 1620
Fleet street, below Fleet conduit; FRANCIS SEDGWICK, goldsmith. 1685–1690
 (See also at CROSS KEYS & CUSHION.)
Little Britain; MATTHEW CUTHBART, goldsmith. 1701–1724
Threadneedle street; — LAUNDRY, silversmith. 1727

CROSS KEYS & CUSHION
Fleet street, next Nando's Coffee-house, between the Temple gates;
 FRANCIS SEDGWICK, goldsmith. 1685

CROW & BRACELET
Old Change [Cheapside]; EDMOND COOPER, goldsmith. 1704

HGS (57)

CROWN

Cecil court, St Martin's lane;	— MATTHEWS, pawnbroker.	1745
Cornhill, opposite Royal Exchange [No. 21];		
	SAMUEL COURTAULD, goldsmith.	1751–1762
	LOUISA PERINA COURTAULD, goldsmith & jeweller.	1765–1768
	COURTAULD & COWLES, goldsmiths, jewellers & toymen.	1769–1778
	SAMUEL COURTAULD, junior, goldsmith.	1777–1780
Exeter street [Strand];	RICHARD GATESFIELD, silver cock-spur maker.	1751
Fetter lane;	THOMAS IMMINES, pawnbroker.	1727–1731
	THOMAS JENNINGS, pawnbroker.	1719–1725
Fleet street, near Serjeant's Inn;	SAMUEL CRANMER, goldsmith.	1722–1752
Henrietta street, Covent Garden;	JONAS CLIFTON, goldsmith.	c. 1730
Holborn;	MARGARET HIGNETT, pawnbroker.	1725
over against Brownlow street;	JOHN CHABBERT, goldsmith & jeweller.	1731–1744
Holborn hill;	— CLEMENS, pawnbroker.	1753
King street, Cheapside;	WILLIAM WIGHT, jeweller.	c. 1760
Lombard street;	THOMAS WILLIAMS, goldsmith & banker.	1669–1697
	JAMES BLAGRAVE, goldsmith.	1690–1697
	BENJAMIN TUDMAN, goldsmith & banker.	1697–1712
	BENJAMIN TUDMAN, junior, goldsmith & banker.	1701
	STEPHEN CHILD & BENJAMIN TUDMAN, goldsmiths.	c. 1700–1712
	GREEN & EADES, goldsmiths.	1719
New street, Covent Garden [No. 2];	PAUL PINARD, goldsmith & laceman.	c. 1760–1784
Noble street;	SAMUEL HUTTON, goldsmith.	1724
	— CAMPAR, silversmith.	1752
Peter street, the Mint, Southwark;	WILLIAM MATTHEWS, pawnbroker.	1744
Piccadilly, next door to Fleece tavern;	ANNE STANGER, pawnbroker.	1704
Strand, against York house;	THOMAS WILCOX, goldsmith.	1681
over against Exeter Exchange;	JOHN PHELPS, goldsmith & pawnbroker.	1699
a little beyond Hungerford;	JONAS CLIFTON, goldsmith.	1718
opposite Durham yard;	GEORGE HINDMARSH, goldsmith (?).	c. 1750
Tooley street, Southwark;	GEORGE HINDMARSH, goldsmith.	1751
	(See also BLACKAMOOR'S HEAD, Strand.)	
Tottenham Court road;	ISAAC CALLARD, goldsmith.	1739
Wych street;	— WARREN, silversmith.	1748

CROWN & ACORN (see also ACORN & CROWN)

Lombard street; — NEWTON, goldsmith & jeweller.		1711
JONATHAN NEWTON & THOMAS COLE, goldsmiths & jewellers.		1744, 1745

CROWN & ANCHOR

Fenchurch street, near opposite to Rood lane;	RICHARD LANGTON, goldsmith.	1746–1753
Lombard street;	RICHARD LANGTON, goldsmith.	1741–1746

CROWN & CHAINS

Carey lane; FRANCIS RUFFIN, gold chain-maker.	c. 1760

CROWN & CUSHION

Bridgewater square; ROBERT SHORTER, pawnbroker.	1744

CROWN & DIAL

Fleet street, between Water lane and Salisbury court; ROBERT HALSTED, goldsmith.	1662–1703

CROWN & DOLPHIN

Moor street; HUMPHRY DELL, goldsmith & jeweller.	1722

CROWN & GOLDEN BALL
Compton street, Soho; CHRISTIAN HILLAN, silversmith. 1741
 WILLIAM CRIPPS, silversmith. 1743–1753

CROWN & PEARL
Bennet street, near Great Queen street, by Storey's gate, Westminster;
 AARON HART, goldsmith or jeweller (?). c. 1760
Within Bishopsgate, near the Four Swans; JOHN DELAFONS, goldsmith & jeweller. 1749–1768
Cannon street; JOHN ATTLEBOROUGH, jeweller. 1747
Cheapside; — WELLS, goldsmith. 1731
Cornhill; SAMUEL WEST, goldsmith. 1725
Fleet street, corner of Palsgrave court, near Temple Bar;
 RICHARD SEVERN, jeweller & toyman. c. 1760
Frith street, Soho; THOMAS FOUBERT, goldsmith & jeweller. 1735–1738
George street, by Goldsmiths' Hall, Foster lane; JOHN JACKSON, jeweller. 1734
 PETER LA COSTE, jeweller. 1744, 1745
Gerrard street, Soho; WILLIAM STEWART, jeweller. 1762
Green street, Leicester square; PATERSON & CRICHTON, jewellers. c. 1765
Haymarket, near corner of, facing Piccadilly; GEORGE ROBERTSON, jeweller. c. 1760
King street, Soho; JOSEPH CAMPBELL, jeweller. c. 1770
Leicester fields; PETER GOUILLET, jeweller. 1744
Little Old Bailey; — BURDETT, silversmith. 1732
Lombard street; JOHN DYER, goldsmith. 1744
 (See also PEARL & CROWN.)
Ludgate hill [No. 43]; WILLIAM PLUMLEY, goldsmith, jeweller &
 watch-maker. 1768
 C. & J. PLUMLEY, goldsmiths, jewellers &
 watch-makers. c. 1770
Ludgate street, near St Paul's; JOHN BROWN, jeweller. 1748
New rents, St Martin's-le-Grand; THOMAS ELSWORTH, jeweller. c. 1750
New street, Covent Garden; JOHN BOURSOT, goldsmith. 1753
 by St Martin's lane; T. FAULKNER, goldsmith. 1731
 — BOURNE, goldsmith & jeweller. c. 1760
 JOHN BOURSOT, goldsmith. 1753
Pope's Head alley, Cornhill; SHEPHERD & NORRIS, goldsmiths. 1761
Salisbury court, Fleet street; CHRISTOPHER JOHNSON, jeweller. c. 1760
Strand, over against Exeter Change; JOHN PHELPS, goldsmith & pawnbroker. 1684–1697
Strand; MRS CHIVEN, goldsmith. 1709
 facing Hungerford market; WILLIAM STEWART, jeweller. c. 1760
 near Durham yard; CHARLES GEDDES, jeweller. c. 1765
Throgmorton street, near the Royal Exchange; JAMES MITCHELSON, jeweller. [N.D.]
West Smithfield, (i) near the George inn [No. 18]. (ii) Bartholomew close;
 BENJAMIN CARTWRIGHT, goldsmith &
 toyman. 1739–1774
Wood street; HUMPHRY DELL, goldsmith & jeweller. 1709–1714
 CHARLES WRIGHT, jeweller. c. 1760

CROWN & RING
Brydge's street, Covent Garden; HENRY SAUL, goldsmith. 1755
Duke street, York buildings [Strand]; JACOB DUHAMEL, jeweller. 1715–1720
Henrietta street, Covent Garden; JACOB DUHAMEL, jeweller. 1730–1737

CROWN, RING & PEARL
Fleet street, near Shoe lane; EDWARD DOBSON, jeweller & goldsmith. 1755–1773

CROWN & SCEPTRE
Fleet street; JOHN PEPYS, watchmaker & jeweller. 1715–1749
Holborn, Fetter lane end; — METCALFE, goldsmith. 1707
 MARY METCALFE, goldsmith. 1714–1718

(59)

CROWN & SCEPTRE (*continued*)
 Lombard street; ROBERT CHESTER, goldsmith. 1704, 1705
 JOHN BAYLEY, goldsmith. 1707–1715
 (See also SCEPTRE & CROWN.)

CROWN & SCEPTRES
 Fleet street, [No. 45] corner of Mitre court;
 LEWIS PANTIN, junior, goldsmith, jeweller & toyman. 1770–1781

CROWN & SEAL
 Noble street; DAVID MOWDEN, goldsmith. 1738

CROWN & SPUR
 Minories [No. 43]; THOMAS HARDING, goldsmith & jeweller. 1751–1781

CROWN, SUN & SEVEN STARS
 Fleet street, under St Dunstan's Church, facing Corbett's State Lottery Office;
 ANTHONY ELLINES, jeweller. c. 1750

CROWN & THISTLE
 Lombard street; GEORGE BRAITHWAITE, goldsmith & clock-maker. 1732
 JOHN BARRY, goldsmith. 1747

CUP
 East Smithfield; — CATES, goldsmith. 1712
 Leadenhall street; MAKEPEACE HOLLOWAY, goldsmith. 1694
 Sydney street, by Leicester fields; JOHN HULBART, goldsmith. 1714

CUP & CROWN
 Lombard street [No. 46]; HENRY SHEER, goldsmith. 1751–1755
 W. SHEER, goldsmith. 1753
 HENRY SHERE & HENRY ARNOLD, goldsmiths. 1760–1768

CUP & RING
 Minories; — GREENOUGH, goldsmith. 1721
 Without Cripplegate, over against Cripplegate conduit; — JOHNSON, goldsmith. 1721–1723
 Wood street; — JOHNSON, goldsmith. (Before) 1721

CUP & STAR
 Fleet street, near Bride lane; — REYNOLDS, goldsmith. 1718

CURTAIN
 Hollywell mount; COOPER & GILES, silversmiths. 1773

DAGGER
 Lombard street; NICHOLAS CLOBURY, goldsmith. 1665

DAGGER ORDINARY
 Foster lane; WILLIAM WADE, goldsmith. 1661–1665

DIAL
 Aldersgate street; JAMES BROGDEN, goldsmith & watch-maker. 1765–1794
 Cornhill, opposite Pope's Head alley; JOHN COWELL, watch-maker & goldsmith. 1763–1800
 East Smithfield; THOMAS BUSHNELL, goldsmith. 1692
 Fleet street, opposite St Dunstan's Church; WILLIAM DEVIS, watch-maker & goldsmith. 1750–1765
 London bridge, on; WILLIAM POST, watch-maker & goldsmith. 1738
 Minories; — WILCOCK, goldsmith. 1695–1699
 near Aldgate; THOMAS GARDNER, goldsmith & watch-maker. 1740–1752
 Strand, near Savoy gate; JOSEPH GAYWOOD, goldsmith. 1712, 1713
 Wapping Old Stairs; THOMAS JARVIS, watch-maker & goldsmith. c. 1750

DIAL & CROWN
 St John's street, near Hick's Hall; THOMAS FAZAKERLEY, watch-maker & goldsmith. 1765–c. 1780

DIAL & KING'S ARMS
Cornhill, near Royal Exchange;
 THOMAS MITCHELL, jeweller. 1742–1751
 MARIE ANNE VIET & THOMAS MITCHELL, jewellers & toymen. 1742

DIAL & THREE CROWNS
Borough, Southwark; WRIGHT & SELLON, goldsmiths & watch-makers. 1749–1769

DIAMOND CROSS
Charing Cross, next door to Mr Drummond's; JOHN SAGNIER & CO., goldsmiths & jewellers. 1760
Fleet street, near Salisbury court; ROBERT PARR, jeweller & goldsmith. c. 1760
St Martin's-le-Grand; SIGISMUND GODHELP DINGLINGER, jeweller. 1749
St Paul's churchyard, facing y^e pump; ROBERT PARR, jeweller & goldsmith. 1767

DOG & BEAR
Southwark; — COOK, jeweller. 1731

DOG & POTTAGE POT
Lisle street, corner of, in Prince's street, St Ann's [Soho]; WILLIAM TORBET, plate-worker. 1737

DOLPHIN
Ludgate hill; SAMUEL BRACKLEY, goldsmith. 1716

DOUBLE CANE CHAIR
Postern gate, Great Moorgate; RICHARD BOWLES, pawnbroker. 1707

DOVE & TWO BALLS
Baldwin's gardens [Gray's Inn lane]; — RAMSEY, pawnbroker. 1755

DUKE OF MONTAGU'S HEAD
[No. 35] Strand, near York buildings; JAMES TRIQUET, jeweller & goldsmith. 1762–1774

EAGLE & CROWN
Cheapside, opposite Bow lane [No. 102]; ABRAHAM GARDNER, jeweller. 1762
 RICHARD CLARKE, jeweller & toyman. [N.D.]

EAGLE & PEARL
Church street, Soho; JAMES BROWN, jeweller. 1752
Craven street; CHARLES FLEURIAN, jeweller. 1755
Duke street, York buildings [Strand]; FRANCIS FLEURIAN, jeweller. 1730
Great Suffolk street, near the Haymarket; PAUL BOUILLARD, jeweller. 1751
Fetter lane [No. 113]; JOSEPH SILVER, jeweller & goldsmith. 1780–1784
Holborn Bars [No. 9], opposite Brook street; LETITIA CLARKE, jeweller & goldsmith. 1790–1802
 M. CLARKE, jeweller & goldsmith. 1790–1793
King street, St Ann's, facing Nassau street; PETER PARQUOT, jeweller & goldsmith. 1744
Tavistock street, Covent Garden; HENRY COLES, jeweller. 1753–1755
 WILLIAM PARK FISHER, goldsmith & jeweller. c. 1760

ELEPHANT
Poultry; MOSES WILLATS, goldsmith. 1762

EWER & SWORDS
Holborn, near Bartlett's buildings; JOHN CARMAN, goldsmith & sword cutler. c. 1760

EXCHANGE
Lombard street; RICHARD SNAGG, goldsmith. 1683

FALCON (see also GOLDEN FALCON)
Fleet street; THOMAS MINSHULL, goldsmith. 1679–1699

FIVE BELLS & CANDLESTICK
(No address); MRS LAUGHTON, pawnbroker. 1717

FIVE BLUE BALLS
Chandos street, Covent Garden; — GATES, pawnbroker. 1753

FIVE BLUE BOWLS
Chandos street; — CARMALT, pawnbroker. 1742

FIVE ROSES
Saffron hill; ROBERT GRIMES, pawnbroker. 1687
 near Holborn; RICHARD NEALSON, pawnbroker. 1704–1708

FLEECE (see also GOLDEN FLEECE)
Lombard street; EDWARD LAMBERT, goldsmith. 1692–1699

FLOWER-DE-LUCE
Cheapside; JOHN ANTHONY CLAYTON, goldsmith. 1704–1706
Fleet street, corner of Mitre court; JAMES SEYMOUR, goldsmith. 1693–1734
 near Serjeant's Inn; JAMES SEAMER, goldsmith. 1695–1709
Great Russell street; CHARLES KNIGHT, goldsmith & clock-maker. 1685–1697
 JOSEPH KNIGHT, goldsmith. 1696–1712
Lombard street; BENJAMIN HINTON, goldsmith & banker. 1663–1702
Newgate street, near the gate; JOHN PEIRCE, goldsmith. 1710
Strand, near Round court; JOHN BOWMAN, goldsmith. 1693–1714

FLOWER-DE-LUCE & STAR
Gutter lane, corner of Cary lane, near Cheapside; DAVID HENNELL, goldsmith. 1736–1758

FLYING HORSE
Fore street, near Cripplegate; JOSEPH GOODALE, pawnbroker. 1702
King street, Westminster; RICHARD HUTTON, goldsmith. 1677
 — EALES, goldsmith. 1714–1721
Lombard street; THOMAS SHARPE, goldsmith. 1676
 RICHARD SNAGG, goldsmith. 1691
Strand, between the Savoy and the Fountain tavern;
 JAMES WILMOT, goldsmith & jeweller. 1741

FOX
Lombard street; GEORGE SNELL, goldsmith & banker. 1640–1677
 JOHN SNELL, goldsmith & banker. 1668–1685
 SAMUEL BOULTON, goldsmith. 1689–1694
 RALPH GERRARD, goldsmith. c. 1703–1709
 GEORGE NEWELL, goldsmith. c. 1703–1728

FOX & CROWN
Aldersgate street; — FOWLER, silversmith. 1720
Philip lane, Addle street; — GOSLING, goldsmith. 1732
 RICHARD & JOSEPH GOSLING, spoon-makers. 1773

GEORGE
Fleet street, near Salisbury court; GEORGE BOWER, goldsmith. 1678–1689
Lombard street; — WARK, goldsmith. 1551–1560
 THOMAS ROWE, goldsmith & banker. 1670–1690
 THOMAS ROWE & THOMAS GREEN, goldsmiths & bankers. 1672–1677
Minories; — COLEMAN, pawnbroker. 1759
Newgate street; RUPERT CLEMENTS, goldsmith. 1695–1706

GILDED HEART [see also GOLDEN HEART]
Without Bishopsgate; JOHN EXTON, pawnbroker. 1699

GILT FOX
Cheapside; JOHN FOX, goldsmith. 1569–1597

GLOBE
Lombard street; BENJAMIN ROBINSON & WILLIAM ARCH, goldsmiths & bankers. 1703–1708
 WILLIAM ARCH, goldsmith. 1707
Shoe lane; THOMAS COATES, pawnbroker. 1693

GLOBE & ANCHOR
Lombard street; JOHN BRANFIELD, goldsmith. 1710–1714

GOAT
Fleet street, near the Temple gate;	THOMAS THORPE, goldsmith.	1684
Lombard street;	THOMAS PRICE, goldsmith & banker.	1675–1686
Strand, next door to the Fountain tavern;	JOHN MEAD, goldsmith & banker.	1683–1702
	WILLIAM MEAD, goldsmith & banker.	[N.D.]
Strand;	EDMOND PAYNE, goldsmith.	1705, 1706

GOLD BOTTLE [see also GOLDEN BOTTLE]
Ave Maria lane; ANTHONY & FRANCIS NELME, goldsmiths.		1706–1721
FRANCIS NELME, goldsmith.		1706–1721

GOLD CHAIN
Old Change; EDWARD COOPER, gold chain-maker. c. 1700

GOLD LION [see also GOLDEN LION]
Lombard street; JOHN BOLITHO & JOHN WILSON, goldsmiths.		1673–1683
Strand; ROBERT PEACOCK, goldsmith (?).		(Before) 1765

GOLD RING
Charing Cross;	ESAYE BERTHET, goldsmith.	1728
Cheapside;	— SMITH, goldsmith.	1719
Fleet street;	— ELLIS, goldsmith.	1702–1721
	(See also RING.)	
near Salisbury court;	EDWARD AMSON, goldsmith & plate-worker.	1705–1720
Lombard street, corner of Ball alley;	JOHN FOSSEY, goldsmith.	1747, 1748
London bridge, on, near Southwark;	BASIL DENN, junior, goldsmith & jeweller.	1743–1754
St Margaret's hill, Southwark;	RICHARD PETERS, goldsmith.	1726–1747
	JOHN TOWNSEND, goldsmith.	1751

GOLDEN ACORN
Lombard street;	JOHN BRASSEY, goldsmith.	1691–1710
	BRASSEY & CASWALL, goldsmiths.	1707
	JOHN & NATHANIEL BRASSEY, goldsmiths.	1716–1720
St Paul's churchyard, North side of;	JOHN SOTRO, goldsmith & toyman.	1750
Strand, over against the New Church;	JECONIAH ASHLEY, goldsmith.	1744

GOLDEN ANCHOR
Cheapside;	JOHN GILPIN, goldsmith.	1692–1700
Fleet street, over against St Dunstan's Church;	ROBERT COLE, goldsmith.	1694, 1695
Holborn, near Fetter lane;	CHRISTOPHER BIRKHEAD, goldsmith.	1680
Lombard street;	THOMAS PARDO, goldsmith & banker.	1677
St Martin's lane, over against Slaughter's Coffee-house;		
	PEZÉ PILLEAU, senior, goldsmith & artificial teeth maker.	1709
Strand, without Temple Bar;	SIR JEREMIAH SNOW, goldsmith & banker.	c. 1660
	SNOW & WALTON, goldsmiths & bankers.	1660
	THOMAS SNOW, goldsmith & banker.	1700–1720
	JOHN WARNER, goldsmith.	1682–1722
Whitecross street;	ISAAC MILLER, junior, pawnbroker.	1708
	JOHN BREACH, pawnbroker.	1719

GOLDEN ANGEL
Cheapside;	SIR JAMES HALLETT, goldsmith.	1690–1734
	JAMES HALLETT, junior, goldsmith.	1706–1723
Cranbourn street, Leicester fields;	ELLIS GAMBLE, goldsmith.	1712–1733
Fleet street;	GEORGE SQUIRE, goldsmith.	1720
Long Acre;	DENIS BOURSIN, goldsmith.	1723
Pall Mall;	NATHANIEL BOSTOCK, goldsmith & broker.	1719–1723
Strand;	GEORGE LEWIS, goldsmith.	1697–1714

GOLDEN ANGEL & CROWN
Strand, over against New Exchange; GEORGE LEWIS, goldsmith. 1697–1714

GOLDEN ARTICHOKE
New Exchange [Strand]; MRS JANE WALDO, jeweller (?). 1719
Strand, facing Cecil street; — EDGE, jeweller. 1744

GOLDEN BALL

Corner of Bearbinder lane;	THOMAS FAULKERINGHAM, goldsmith.	1701
Bishopsgate street;	JOHN DELAFORCE, pawnbroker.	1756
Brownlow street, Drury lane;	JOHN ASHMAN, pawnbroker.	1700
Burleigh street, near Exeter street, Strand;	JONATHAN GODDARD, pawnbroker.	1744
Chandos street;	— MARTIN, goldsmith.	1725
	JAMES MARTEL, jeweller.	1728
Charing Cross;	ABRAHAM ARDESOIF, jeweller.	1762
Charles street, near St James's square;	MRS HODGES, pawnbroker.	1704
Cheapside, near Bow Church;	— MAGGOT, silversmith.	1718
corner of Friday street;	STAFFORD BRISCOE, jeweller & goldsmith.	1732–1767
	STAFFORD & JOHN BRISCOE, jewellers & goldsmiths.	1742–1760
[No. 14], opposite Foster lane;	WILLIAM BROWN, jeweller & goldsmith.	1768–1784
Compton street, Soho;	PAUL CRESPIN, silversmith.	1720–1757
Cornhill, corner of St Michael's alley;	CAVE JONES, goldsmith.	1732
Crown court, Long walk, near Christ Church hospital;	WILLIAM MEARS, pawnbroker.	1717
Cursitor alley, Chancery lane;	THOMAS GATES, pawnbroker.	1703
Cursitor street;	THOMAS MARSH, pawnbroker.	1764
Duke's court, St Martin's lane;	THOMAS WRIGHT, goldsmith.	1765–1775
Fenchurch street;	JOHN HIND, goldsmith.	1663–1690
	ABRAHAM HIND, goldsmith.	1675–1690
	JOHN TOPLADY, goldsmith.	1686
	SIR HENRY HANKEY, goldsmith.	1701–1723
	MESSRS HANKEY, goldsmiths.	1721
Fleet street, corner of Salisbury court;	PHILIP ROBINSON, goldsmith.	1713–1728
corner of Racquet court;	JOHN SIMMONS, goldsmith.	1753–1756
Foster lane;	EDMUND MEDLYCOTT, goldsmith.	1748–1755
	— BAILEY, goldsmith.	1721
Gerrard street, Soho;	WILLIAM SHAW, goldsmith.	1743–1745
Goodacre's court, St Martin's lane;	GEORGE HALEY, silversmith.	1699
Gravel street, near Brook's market, Holborn;	MRS COMBYS, pawnbroker.	1718
Great Hart street, Covent Garden;	ROBERT LAWSON, pawnbroker.	1744
Grub street;	WILLIAM CROSS, pawnbroker.	1715
	FRANCIS UNDERWOOD, pawnbroker.	1716
Heming's row [St Martin's lane];	CHARLES PRICE, pawnbroker.	1711
High Holborn;	THOMAS UNDERWOOD, pawnbroker	1707
Holborn, near Turn-stile;	SAMUEL HIGGINS, goldsmith.	1682–1699
Holborn bridge, corner of Plum-tree court;	JOHN FARNELL, goldsmith.	1729
King street, Soho;	PETER BROWN, jeweller.	1747
Litchfield street, (?) corner of Newport alley;	JOHN TRIBLE, jeweller.	1729
Little Queen street, Oxford road;	GEORGE MURE, pawnbroker.	1756
Lombard street;	JOHN THURSBY, goldsmith.	1677–1700
Long Acre, against Rose street;	EDWARD EVANS, pawnbroker.	1719, 1720
Maiden lane, Covent Garden;	JOHN WAYT, pawnbroker.	1726
	MARY WAIGHT, pawnbroker.	1731
Maiden lane, near Goldsmiths' Hall;	JAMES STONES, goldsmith.	c. 1760–1790
Marylebone street, near Golden square;	— BROWN, pawnbroker.	1759–1764
Middle row, St Giles'-in-the-fields;	CHRISTOPHER WHITMORE, pawnbroker.	1707
Mutton lane;	THOMAS COLE, pawnbroker.	1717
Newgate street;	HUGH (?) ROBERTS, goldsmith.	1691–1701

GOLDEN BALL (*continued*)

Norton Folgate;	WESCOMBE DRAKE, silversmith.	1724
Oxford chapel [*Chapel court, Henrietta street, Marylebone*];		
	BENNETT BRADSHAW & ROBERT TYRILL, silversmiths.	1737–1739
Oxford road;	JOHN HORBBIN, pawnbroker.	1747
Pall Mall;	DAVID WILLAUME, senior, goldsmith & banker.	1697–1706
	— BOUCHER, jeweller (?).	1707, 1708
Panton street, near Leicester square;	ALEXANDER JOHNSTONE & CHARLES GEDDES, jewellers.	c. 1760
	CHARLES GEDDES, jeweller.	c. 1765
Plumtree street, Bloomsbury;	JOHN WHOMAN, pawnbroker.	1731
Saffron hill;	— BURCHMORE, pawnbroker.	1753
St Andrew's street, St Giles'-in-the-fields;	MRS RAYNHAM, pawnbroker.	1705
	MRS REMO, pawnbroker.	1712
St Ann's lane;	JOSHUA READSHAW, goldsmith.	1697
St James's street, on the terrace in;	DAVID WILLAUME, junior, goldsmith & banker.	1716–1744
St James's street;	WILLIAM CRIPPS, silversmith.	1752
	— CRIPPS, silversmith.	1762
	MARK CRIPPS, silversmith.	1767–1773
St Martin's lane;	THÉODORE BRISSAC, goldsmith.	1700, 1701
	CHARLES HATFIELD, goldsmith.	1727–1739
	SUSANNAH HATFIELD, goldsmith.	1740
facing May's buildings;	JOB TRIPP, goldsmith.	1754
St Martin's-le-Grand;	— PEARSON, goldsmith.	1753
St Swithin's lane;	WILLIAM DENNEY, silversmith.	1697
near Stocks market, or, over against the Sun tavern, behind the Royal Exchange;		
	THOMAS FOLKINGHAM, silversmith.	1706–1724
Staining lane, near Haberdashers' Hall;	WILLIAM JUSTIS, goldsmith.	1731–1755
Strand;	JOHN COOPER, goldsmith.	1712
	JOHN COWPER, goldsmith.	1719, 1720
Upper Moorfields;	JOHN BALL, pawnbroker.	1725
Watling street, [*No. 64*] *near Bow lane;*	EDWARD DARVILL, goldsmith.	1757–1793
Whitecross street, Southwark;	— HARRISON, pawnbroker.	1744
Windmill street, near the Haymarket;	PAUL DE LAMERIE, goldsmith.	1712–1737
Wood street, near Cheapside;	JAMES WILKS, goldsmith.	1735

GOLDEN BALL & BUNCH OF GRAPES

(*No address*); MARY JONES, pawnbroker.	1722

GOLDEN BALL & CANISTER

Cloth fair; J. MACKFARLEN, goldsmith.	1739

GOLDEN BALL & CROSS KEYS

Horton street, Clare market; SIMON PETER, pawnbroker.	1724–1744

GOLDEN BALL & CROWN

Cheapside; JOHN COOKE, goldsmith.	1751–1753

GOLDEN BALL & PEARL

Cheapside; — POWNALL, goldsmith.	1712–1721
SAMUEL WHITEWAY, goldsmith.	1725–1731
Noble street; FULLER WHITE, goldsmith.	1742–1773
FULLER WHITE & JOHN FRAY, goldsmiths.	1750
Pall Mall; THOMAS HARRACHE, jeweller, toyman & goldsmith.	1751–1773

GOLDEN BELL

Strand, near Northumberland House; GEORGE SAUNDERSON, goldsmith.	1693–1696

GOLDEN BELLOWS

Newgate street; JOHN PEARCE, goldsmith.	1742–1760

GOLDEN BOTTLE (see also GOLD BOTTLE)

Amen corner, Ave Maria lane;	ANTHONY NELME, goldsmith.	1691–1722
	FRANCIS NELME, goldsmith.	1721
Ave Maria lane;	JAMES GOULD, goldsmith.	1741–1744
Cheapside;	— PERRYN, goldsmith.	1653
	RICHARD TEMPEST, goldsmith.	1664–1673
	JAMES HOARE, goldsmith & banker.	1664–1690
	SIR RICHARD HOARE, goldsmith & banker.	(Before) 1674–1690
	JAMES & RICHARD HOARE, goldsmiths & bankers.	c. 1674–1690
near the conduit;	NATHANIEL RAGDALE, goldsmith.	1695–1706
upper end of;	— MADDING, or MADDEN, goldsmith.	1716–1730
Fleet street;	JAMES HOARE, goldsmith & banker.	c. 1690
	SIR RICHARD HOARE, goldsmith & banker.	c. 1690–1719
	JAMES & RICHARD HOARE, goldsmiths & bankers.	c. 1690
	CHARLES HOARE, goldsmith & banker.	1697
	HENRY HOARE, goldsmith & banker.	1718–1724
	BENJAMIN HOARE, goldsmith & banker.	1724–1728
Strand, near Charing Cross;	HENRY THORNYCROFT, goldsmith.	1697–1707

GOLDEN BUCK (GOLDEN HIND, or GOLDEN HART)

Fleet street, next door but one to Serjeant's Inn gate;		
	JOHN PARGITER, goldsmith.	1636–1668
over against St Dunstan's Church;		
	JOHN MAWSON & Co., goldsmiths & bankers.	1675–c. 1683
near St Dunstan's; FRANCIS CLARK, goldsmith.		1693–1699

GOLDEN BUCK

Fleet street;	— SOMMERS, goldsmith.	1686
	PARKER & CRADOCK, goldsmiths.	1712
Lombard street; WILLIAM FORDHAM, goldsmith & jeweller.		1701–1729 (?)

GOLDEN COCK

Strand;	ROBERT MORY, goldsmith.	1693
near Norfolk street; JOHN SMITH, goldsmith.		1694–1697

GOLDEN CROSS

Strand, near Exeter Change (or near the Savoy);	JOHN & JOSEPH GAYWOOD, goldsmiths.	1693–1697
	JOSEPH GAYWOOD, goldsmith.	1693–1706

GOLDEN CROWN

Fleet street, between Water lane and Salisbury court;	ROBERT HALSTED, goldsmith.	1662–1703
New street, Covent Garden;	LOUIS OUVRY, goldsmith.	1740–1742
Orange street;	JONATHAN ROBINSON, goldsmith.	1723

GOLDEN CUP

Air street [No. 20], *Piccadilly*;	THOMAS PITTS, silversmith.	1767–1793
Albemarle street, near St John's square [*Clerkenwell*];	ABRAHAM COCKE, goldsmith.	1747
Arundel street, Strand;	JOHN WHITE, goldsmith.	1719–1724
Bishopsgate Without;	JOHN ROKER, goldsmith.	1740–1745
	JOHN & PHILIP ROKER, goldsmiths.	1743–1773
Cannon street, near Abchurch lane;	MATTHEW PERCHARD, goldsmith.	1744–1768
Carey lane;	— ELLIS, silversmith.	1735
Chandos street, upon the paved stones in;		
	P. PILLEAU, junior, goldsmith & maker of artificial teeth.	1719–1755
Chandos street;	LEWIS DESSEBUES, goldsmith.	1720
	— BOURSIN, silversmith.	1726
	PETER DUTENS, jeweller.	1730, 1731
Charing Cross, on the New Pavement;	STEPHEN ARDESOIF, goldsmith.	1762–1765
Cheapside;	EGRIJCK HYSSCKENS VAN EMDEN, goldsmith.	1550
	ROBERT KER, goldsmith.	1712–1732

GOLDEN CUP (*continued*)

Cornhill;	BRISCOE & SMITH, goldsmiths.	1721
opposite St Peter's Church;	JOHN FROST, goldsmith & jeweller.	1757
[*No. 62*] *North side of, second house from Bishopsgate*;		
	THOMAS MALLESON, goldsmith & jeweller.	1765–1793
Coventry street, Piccadilly;	PETER ARCHAMBO, goldsmith.	1739–1747
	PETER ARCHAMBO, junior & PETER MEURE, goldsmiths.	1749–1755
East Smithfield;	WILLIAM KEATE, goldsmith.	1697–1714
Fleet bridge;	THOMAS CORY, goldsmith.	1687–1689
Fleet street;	JOHN CORY, goldsmith.	1697–1722
corner of Mitre tavern, or, near St Dunstan's Church;		
	GEORGE HOUSTON, goldsmith.	1742–1773
Foster lane;	T. & R. GURNEY, silversmiths.	1721
	THOMAS COOKE & RICHARD GURNEY, goldsmiths.	1721–1773
	RICHARD GURNEY & THOMAS COOKE, goldsmiths.	1721–1773
Gerrard street, end of, near Newport market;	EDWARD HOLADAY, goldsmith.	1712–1719
Golden lane, St Luke's;	WIDOW STEVENSON, pawnbroker.	1745
Grafton street, near Newport market;	EDWARD HOLADAY, goldsmith.	1709, 1710
Great Russell street, Covent Garden;	RICHARD WRIGHT, goldsmith & banker.	1697–1718
	WILLIAM WRIGHT, goldsmith & banker.	1699–1724
	ANTHONY WRIGHT, goldsmith & banker.	1729–1754
Green street, Leicester square;	PETER ARCHAMBO, goldsmith.	1720–1722
Gutter lane;	WILLIAM LUKIN, silversmith.	1699
	HUMPHREY PAYNE, goldsmith.	1701–1720
Henrietta street [*No. 5*];	ANTHONY WRIGHT, goldsmith & banker.	1759–1768
Henrietta street;	ANTHONY WRIGHT & SON, bankers.	1774
Holborn bridge;	WILLIAM YOUNG, goldsmith.	1752–1755
Leicester square;	PETER DUTENS, jeweller.	1744–1765
Litchfield street, Soho;	PETER DE LA FONTAINE, goldsmith.	c. 1740
Little Newport street;	RICHARD WEBB, goldsmith.	1747
Lombard street;	JOHN BUTLER, goldsmith.	1680–1689
	JONATHAN KIRK, goldsmith.	1703–1705
Ludgate hill [*No. 5*]; RICHARD MORSON & BENJAMIN STEPHENSON, goldsmiths.		1760–1774
New Fish Street hill;	WILLIAM ATKINSON, silversmith.	1725
Noble street, Foster lane;	MARGARET YORK (*alias* DOUGHTY), pawnbroker.	1725
Orange street, near Red Lion square; FRANCIS PAGES, goldsmith.		1729–1739
Panton street;	— STRUDER, goldsmith.	1751
Pemberton row, near Gough square, Fleet street; WILLIAM GRUNDY, goldsmith.		1751
Russell street, Covent Garden;	— LUCY, goldsmith.	1687
St Anne's, Soho;	ETIENNE RONGENT, goldsmith.	1731
St Martin's lane, upper end of, over against Slaughter's Coffee-house;		
	P. PILLEAU, junior, goldsmith & maker of artificial teeth.	1719
St Paul's churchyard, North side of, beyond the narrow passage towards Cheapside;		
	JOHN HANNAM, goldsmith.	1698
St Swithin's lane;	JOHN RUSLEN, goldsmith.	1690–1715
	CHARLES JACKSON, goldsmith.	1739
Shire lane;	WILLIAM WARHAM, goldsmith.	1698–1722
Shoreditch;	RALPH FRITH, silversmith.	1728
Strand, near Hungerford market;	WILLIAM SPRING, goldsmith.	1701–1727
Strand;	WILLIAM LUKIN, goldsmith.	1718
corner of Cecil street, against Southampton street; JOHN TAYLOR, goldsmith.		1728–1734
	PETER TAYLOR, goldsmith.	1740–1753
	PETER & JOHN TAYLOR, goldsmiths.	1740
Suffolk street, corner of, near the Haymarket; SIMON LESAGE, goldsmith.		1739–1761

GOLDEN CUP & COVER

Fleet street, near Fleet bridge;	JOHN HOPKINS, goldsmith.	1736–1763

GOLDEN CUP & CROWN
Lombard street; ANTHONY BLACKFORD, goldsmith. 1702–1716

GOLDEN CUP & KEY
Fenchurch street, near Cullum street; JAMES THOMASSON, goldsmith & jeweller. 1745

GOLDEN CUP & RISING SUN
Clerkenwell close; EBENEZER COKER, goldsmith. 1738–1781

GOLDEN DOOR
Charing Cross, near, over against Suffolk street;
 PAUL DANIEL CHENEVIX, goldsmith & toyman. 1731–1742
GOLDEN DOVE
Old Artillery ground, near Spitalfields; MRS ELIZABETH JONES, pawnbroker. 1716

GOLDEN (or GREEN) DRAGON
[Fleet street], near Inner Temple gate, next door to the Three Squirrels;
 HENRY PINCKNEY, goldsmith. 1660–1666
 WILLIAM PINCKNEY, goldsmith. 1660–1675
Fleet street; PHILIP PINCKNEY, goldsmith. 1680

GOLDEN EAGLE
Charing Cross; ANDREW DRUMMOND, goldsmith & banker. 1712–1754
Maiden lane, Covent Garden; — HODGES, jeweller, goldsmith & engraver. [N.D.]
Rupert street, St James's; WM. & JOHN BALLISTON, silver & brass casters. [N.D.]

GOLDEN EAGLE (or GOLDEN FALCON)
Fleet street, over against St Dunstan's Church;
 ABRAHAM CHAMBERS, goldsmith. 1683–1693
 ABRAHAM CHAMBERS, junior, goldsmith & banker. 1733–1756

GOLDEN EWER
Foster lane; EDWARD ALDRIDGE, goldsmith. 1743–1765
 EDWARD ALDRIDGE, senior & junior, goldsmiths. 1762
Greek street, Soho; JAMES SHRUDER, goldsmith. 1739
Hedge lane, corner of, Leicester square; JAMES SHRUDER, goldsmith. 1744–1749
Lily-pot lane; EDWARD ALDRIDGE, goldsmith. 1739–1743

GOLDEN FALCON
Fleet street; THOMAS MINSHULL, goldsmith. 1679–1699
Holborn, at the Fetter lane end, near Furnival's Inn; JOHN FODEN, goldsmith. 1691–1694
Old Fish street; — ESTWICK, goldsmith or jeweller (?). 1713
Strand, Essex buildings; ROGER JACKSON, goldsmith. 1691
 against Hungerford market; — MINSHULL, goldsmith. 1711, 1712
West Smithfield; JOHN PEPYS, goldsmith. 1688

GOLDEN FALCON (or GOLDEN EAGLE)
Fleet street, over against St Dunstan's Church;
 ABRAHAM CHAMBERS, goldsmith. 1683–1693
 ABRAHAM CHAMBERS, junior, goldsmith & banker. 1733–1756

GOLDEN FAN
Andrew's street, St Giles's; — FERRON, silversmith. 1733

GOLDEN FLEECE
Cheapside, near Bow Church [No. 48];
 JOSEPH SAVORY, goldsmith, cutler & jeweller. 1782–1788
Lombard street; BERNARD TURNER & SAMUEL TOOKIE, goldsmiths & bankers. (Before) 1666–1677
 BERNARD TURNER, silversmith. 1668–1677
 NATHANIEL WOOLFREY, goldsmith. 1696–1705
 NATHANIEL WOOLFREY & SIR MATTHEW KIRKWOOD, goldsmiths. 1705
 SIR MATTHEW KIRKWOOD, goldsmith & banker. 1700–1718

GOLDEN FLEECE (or FLEECE)
Lombard street; EDWARD LAMBERT, goldsmith. 1692–1699

GOLDEN HART (or GOLDEN BUCK)
Fleet street, near St Dunstan's; FRANCIS CLARK, goldsmith. 1693–1702

GOLDEN HEAD
[No address];	JAMES PALTRO, goldsmith.	1739
Fountain court, Strand;	ISAAC FAVRE, jeweller.	1731
Gray's Inn lane, on the Paved Stones;	THOMAS PINGO, jeweller.	c. 1750 (?)
Pall Mall [No. 40];	PETER CASTELFRANC, jeweller.	1753–1793
Strand, near Arundel street;	THOMAS CLARK, jeweller.	c. 1750
Tavistock street, Covent Garden;	ANDREW MAYASTRE, jeweller.	1722–1745
Villiers street, York buildings;	DENIS CHIRAC, jeweller.	1721–1731
	PHILIP HARDEL, jeweller.	1755

GOLDEN HEART
Bishopsgate street; — NELME, goldsmith. 1693
Dean street, Soho; HENRY HEBERT, silversmith. 1747
St James's street; G. K. MURRAY, goldsmith. 1755

GOLDEN HIND
Fleet street; — SOMMERS, goldsmith. 1686

GOLDEN HIND (or GOLDEN BUCK, or GOLDEN HART)
Fleet street, next door but one to Serjeant's Inn gate; JOHN PARGITER, goldsmith. 1636–1668
Fleet street; JOHN MAWSON & Co., goldsmiths & bankers. 1668–1680

GOLDEN INN
Cheapside; SIR HUGH MYDDELTON, goldsmith. 1609–1615

GOLDEN KEY
Chamber's street, Goodman's fields;	— RYLE, pawnbroker.	1744
Eagle court, Strand, against Somerset House;	THOMAS BYFIELD, pawnbroker.	1709
[Fleet street], next the Inner Temple gate;	BENJAMIN FLEMING, goldsmith.	1709, 1710
Fleet street [No. 82], corner of Salisbury court;		
	HENRY MORRIS, jeweller, goldsmith & toyman.	1733–1777
	HENRY MORRIS & SON, goldsmiths.	1751, 1752
Grafton street;	ALLAIN TURMEAU, goldsmith.	1748–1755
Litchfield street, Soho;	ALLAIN TURMEAU, goldsmith.	1762
	JANE TURMEAU, goldsmith.	1762
Lombard street;	THOMAS MASON, goldsmith.	1706
	JAMES THOMPSON, goldsmith.	1709–1725
Strand, against Exeter Change;	HENRY JENNINGS, goldsmith.	1686–1688
Strand;	JOHN CHETWIND, goldsmith.	1687–1692
without Temple Bar;	RICHARD NICHOLLS, goldsmith.	1705–1720
	RICHARD NICHOLLS & ABRAHAM FOWLER, goldsmiths & bankers.	1720
Widegate street, Bishopsgate;	MRS GOODMAN, pawnbroker.	1745

GOLDEN KEY & CROWN
Lombard street, opposite the Post Office; WILLIAM MANNING, goldsmith & jeweller. 1747–1755

GOLDEN LION
Drury lane, near the Playhouse;	THOMAS BARRETT, pawnbroker.	1701
over against Short's gardens;	— SIMSON, goldsmith.	1710
Fleet street;	MICHAEL SCHRIMPSHAW, goldsmith & banker.	1675–1699
over against Fetter lane end;	— GRUNSTON, goldsmith.	1679

GOLDEN LION (*continued*)

Fleet street;	ROGER JACKSON, goldsmith.	1692
	JAMES MARMION, goldsmith.	1694, 1695
	SAMUEL WRAGG, goldsmith.	1700
	THOMAS TAYLOR, goldsmith.	1711
Great St Andrew's street, Seven Dials;	JOHN BARBOT, goldsmith.	1751
Gutter lane;	JAMES GOULD, goldsmith.	1722–1737
Holborn bridge;	RICHARD WARTER, silversmith.	1708–1747
	SAMUEL DAVIES, goldsmith.	1747–1749
King street, Cheapside;	WILLIAM HUNT & SON, goldsmiths.	1755–1763
Lombard street;	PETER LUPART, goldsmith.	1693–1696
Newgate street;	RICHARD WHIP, goldsmith.	1723–1727
St Paul's churchyard, North side [No. 61];		
	PHILLIPS GARDEN, goldsmith & jeweller.	1739–1762
	JOHN TOWNSEND, goldsmith & jeweller.	1762–1765
	JOHN & ELIZABETH TOWNSEND, goldsmiths & jewellers.	1768–1772
Strand, without Temple Bar;	HENEAGE PRICE, goldsmith.	1681–1709
corner of Arundel street;	ROBERT COOPER, goldsmith.	1694–1714
fifth door from Devereux court, nearer Temple Bar;	— WARRE, jeweller & goldsmith.	c. 1760
opposite St Clement's Church;	JOHN STEVENSON, gold & silver button maker	1766–1774

GOLDEN LION & CROWN

St Martin's lane, the corner of May's buildings;		
	GEORGE CATON, gold & silver button maker.	c. 1760

GOLDEN PARROT

Cheapside; PHILIP ROBINSON, goldsmith.		1714, 1715

GOLDEN RING

Fenchurch street; JEFFERY UTBERD, goldsmith.		1719–1721
Lombard street; FRANCIS YATES, goldsmith.		1678–1704

GOLDEN ROSE

Frith street, Soho; R. RANIOLDE, pawnbroker.		1745
Lombard street; THOMAS BRAND, goldsmith.		1702–1714

GOLDEN SALMON

Ludgate hill, North side of [No. 32];		
	HENRY HURT, goldsmith & toyman.	1745–1755
	THEAD & PICKETT, goldsmiths.	1758–1768
	WILLIAM PICKETT, goldsmith & jeweller.	1758–1796
	PICKETT & RUNDELL, goldsmiths & jewellers.	1777–c. 1780
	PHILIP RUNDELL & JOHN BRIDGE, goldsmiths & jewellers.	c. 1780–c. 1840
New Bond street [No. 36]; LYNAM & BULL, goldsmiths.		1793

GOLDEN SALMON & PEARL

Ludgate hill [No. 32]; THOMAS CHESSON, jeweller.		1753–1760

GOLDEN SNAIL

Carey lane; CHARLES JONES, jeweller.		1747
Fleet street; BENJAMIN WATTS, goldsmith.		1720, 1721
	JAMES BROOKER, goldsmith.	1734

GOLDEN SPECTACLES

Sidney's alley, Leicester fields; CHALMERS & ROBINSON, jewellers & goldsmiths.		1773

GOLDEN STAR

Eagle court, Strand; — DUBOIS, goldsmith.		c. 1750

GOLDEN TUN

[Strand], near Ivy bridge; CHARLES WHEELER, goldsmith.		1681

GOLDEN UNICORN
Butcher Hall lane, Newgate street; DAVID CLAYTON, jeweller. 1714
Cheapside; DAVID CLAYTON, jeweller. 1703–1711
King street, Westminster; ROBERT WILLIAMS, goldsmith. 1726–1762

GOLDEN URN
Racquet court, Fleet street; JAMES COX, goldsmith. 1751

GOLDEN VAUSE
New Bond street [No. 25], near Conduit street;
RICHARD CHADD & JOHN RAGSDALE, jewellers & goldsmiths. 1749–1768
GEORGE RAGSDALE, jeweller, goldsmith & toyman. 1769–1783

GOLDEN WHEATSHEAF
Houndsditch; JOHN SMALLMAN, pawnbroker. 1736

GOLDSMITHS' ARMS & RING
Bride lane; JOHN HOPKINS, goldsmith. 1730
Fleet street; JOHN HOPKINS, goldsmith. 1732–1736

GRAPES
Lombard street; HENRY LAMB, goldsmith & banker. 1677–1703

GRASSHOPPER
Fleet street; WILLIAM HART, goldsmith & banker. 1738–1747
[No. 61]; THOMAS WHIPHAM, silversmith. 1760–1784
WHIPHAM & NORTH, silversmith. 1790–1802
Foster lane; THOMAS MAUNDAY, goldsmith. 1641–1665
Lombard street; MATTHEW SHORE, goldsmith. c. 1461–1480
SIR THOMAS GRESHAM, goldsmith. 1549–1579
RICHARD MARTIN, junior, goldsmith & banker. 1584–1618
CLEMENT PUNGE, goldsmith. 1638–1665
SIR CHARLES DUNCOMBE, goldsmith & banker. 1672–1695
CHARLES DUNCOMBE & RICHARD KENT, goldsmiths & bankers. 1672–1684
CHARLES DUNCOMBE & VALENTINE DUNCOMBE, goldsmiths & bankers. 1682–1688
— SPENCER, goldsmith. 1693
— SPINK, goldsmith. 1696
ANDREW STONE, goldsmith. 1699–1711
STONE & MARTIN, goldsmiths & bankers. 1701–1711
THOMAS MARTIN, goldsmith & banker. 1702–1718
JAMES & THOMAS MARTIN, goldsmiths & bankers. 1714–1725
JAMES MARTIN, goldsmith & banker. 1717–1728
ROBERT SURMAN, goldsmith & banker. 1731–1748
Pall Mall; CROFT & BACKWELL, bankers. 1774
Suffolk street, corner of; JAMES MAITLAND, silversmith. 1728–1730

GREAT KNIFE CASE
Fleet street [No. 91]; HENRY JEFFERYS & Co., goldsmiths, jewellers & cutlers. 1796

GREEN DOOR
Litchfield street, near Newport market; JOHN TUITE, goldsmith. 1721–1739

GREEN DRAGON
Addle hill; MRS CODLICOTT, pawnbroker. 1754
Cheapside; EDWARD HANSON, goldsmith. 1665
Lombard street; THOMAS NEVETT, goldsmith. 1637–1655
Strand; — ROBERTS, goldsmith. 1695–1700

GREEN [or GOLDEN] DRAGON
[Fleet street], near Inner Temple gate, next door to the Three Squirrels;
WILLIAM PINCKNEY, goldsmith. 1660–1675

GREEN RAILS
Tokenhouse yard, upper end of; LEWIS BARIL, jeweller. 1721–1760

GREYHOUND & HARE
Houndsditch; MARY SHAW, pawnbroker. 1717

GRIFFIN
Exchange alley, Lombard street;
 SIR THOMAS COOK & NICHOLAS CAREW, goldsmiths & bankers. 1675–1684
 WILLIAM ATTWELL & ADRIAN COURTNEY, silversmiths. 1687–1705
 ATTWELL & HAMMOND, goldsmiths & bankers. 1714–1722

HALF MOON
Cheapside, over against Foster lane; THOMAS HOW, goldsmith. 1698, 1699
Porter street, Soho; — ALLIX, silversmith. 1731
Spital gate, Bishopsgate street; EDWARD ROWLEY, goldsmith. 1708

HALF MOON & CROSS PISTOLS
Minories; JOHN BLANKLEY, pawnbroker. 1687

HALF MOON & STAR
Foster lane; GARBETT & PELL, silversmiths. 1726

HAMPSHIRE HOG
St Giles's; HENRY FLANNAGAN, pawnbroker. 1764

HAND & BEADS
Fish Street hill [No. 40], *next Monument yard*;
 JOHN HOWARD, necklace-maker & jeweller. 1763–1781
London bridge; JAMES HOWARD, necklace-maker & jeweller. 1735–1760
 JOHN HOWARD, necklace-maker & jeweller. 1760

HAND & BUCKLE
Fore street; — LEE, goldsmith. 1752
St Martin's court; — BILLE, silversmith. 1736

HAND & CORAL
Gutter lane; SANDYLANDS DRINKWATER, silversmith. 1731–1772

HAND & EAR
Old Bailey, next St Sepulchre's Church; JOHN FOX, pawnbroker. 1707

HAND & HAMMER
Piccadilly, opposite the Black Bear inn; GEORGE HEMING, goldsmith & jeweller. c. 1760–1773

HAND & PEARL
Leadenhall street, against St Mary Ax Church; FRANCIS TRATT, jeweller. 1718

HAND & PEN
King street, Seven Dials; THEOPHILUS DAVIS, goldsmith. 1758

HAND & RING
Norris street, Haymarket; JOHN NEVILLE, goldsmith. 1743–1752
 NEVILLE & DEBAUFRE, goldsmiths. 1747
Poultry; ELIAS WILLIS, goldsmith. 1712

HAND, RING & CROWN
Norris street, St James's, Haymarket; BENJAMIN GODFREY, goldsmith. 1732–1739
 ELIZABETH GODFREY, goldsmith. 1741–1758

HAND, RING & PEARL
Bow street, upper end of Earl's court; SAMUEL DAILLEY, jeweller. 1730

HAND & SEAL
Gutter lane; JOHN FOSSEY, goldsmith. 1724–1733

HAND & SPUR
Clerkenwell close;	— HARE, silversmith.	1738
Denmark court, Strand;	JOHN ORME, silversmith.	1743
Exeter street, Strand;	JOHN ORME, silversmith.	1744
Strand, near Exeter Exchange;	JOHN MOORE, silver spur-maker.	c. 1750
Wood street;	— ECCLES, silver spur-maker.	1735

HARE
Lombard street;	ROBERT WELSTEAD, goldsmith.	1657–1672
	THOMAS SMITH, goldsmith.	1755

HARLEQUIN
Princes street, near Coventry street, Leicester fields; JOHN DE CREZ, jeweller & toyman. 1775

HARP
Goldsmiths' row, Cheapside; SIR RICHARD MARTIN, goldsmith & banker. 1558–1617

HART
Lombard street; FRANCIS NEAVE, goldsmith. 1649

HAT & BIBLE
Cheapside; — WILDMAN, goldsmith. 1725

HAT & FEATHERS
Goswell street;	SAMUEL HUTTON, goldsmith.	1734–1740
	SARAH HUTTON, goldsmith.	1740

HEART & CROWN & WHITE HORSE
Lombard street; JOHN HARLING, goldsmith. 1660–1691

HELMET
Cornhill; ROBERT TRAPPIS, goldsmith. 1534–1549

HEN & CHICKENS
Cheapside, opposite Bow Church;	EDWARD HARRISON, goldsmith.	1686–1716
Cheapside;	HUMPHREY PAYNE, goldsmith.	1720–1740
	HUMPHREY & JOHN PAYNE, goldsmiths & jewellers.	1753–1755
Fleet street;	— SARGANT, silversmith.	1762
Tooley street, near London bridge;	EDWARD BURNET, goldsmith.	1718
	JAMES SMITH, goldsmith.	1731

HIND (? or GOLDEN HART, *q.v.*)
Fleet street; [FRANCIS (?)] CLARK, goldsmith. 1694

HOLE IN THE WALL
Great Kirby street; WILLIAM WALL, pawnbroker. 1726

JACK
Wood street, Cheapside; — BUSCOMBE, goldsmith & silversmith. 1734

JEWEL & CROWN
Strand, near Durham yard; — LOWDERS, goldsmith. 1693, 1694

KEY
Golden lane, near Cripplegate; JOHN CRANWELL, pawnbroker. 1704

KING & KEY
Fleet street, next door but one to the White Horse inn; — CLARK, pawnbroker. 1749–1752

KING'S ARMS
Bond street, facing Clifford street;	THOMAS HEMING, goldsmith.	1765–1773
	GEORGE HEMING & WILLIAM CHAWNER, goldsmiths.	1773–1781
Cheapside;	JOHN PASSEL, goldsmith.	1689–1697
opposite Foster lane;	JAMES BUFFAR, goldsmith & jeweller.	1748

KING'S ARMS (*continued*)

Fleet street;	FRANCIS KENTON, goldsmith & banker.	1668–1677
	M. KENTON, goldsmith.	1677
between the Temple gates; JAMES BUFFAR & THOMAS DOXEY, goldsmiths.		1752
	JAMES BUFFAR, goldsmith & jeweller.	1755
Hatton wall, near Hatton Garden;	JOHN HOWARD, pawnbroker.	1707
Lombard street; — PAYN, goldsmith.		1687
	MOOR & PAYN, goldsmiths.	1687–1704
Norris street, corner of, St James's, Haymarket; — MORRIS, jeweller, goldsmith & toyman.		c. 1760
Panton street, near St James's, Haymarket;	GEORGE WICKES, goldsmith.	1735–1761
	GEORGE WICKES & SAMUEL NETHERTON, goldsmiths & jewellers.	1751–1759
	JOHN PARKER & EDWARD WAKELIN, goldsmiths & jewellers.	1759–1777
St Martin's lane; — PILLEAU, French goldsmith.		1697
Vere street;	WALTER COMPTON, goldsmith.	1680–1692

KING'S ARMS & BIRDCAGE

Strand, opposite Durham yard; GEORGE HINDMARSH, goldsmith.		[N.D.]

KING'S ARMS & SNUFFERS

Strand; BENJAMIN CARTWRIGHT, goldsmith & toymaker.		1749–1756

KING'S HEAD

Cheapside, over against Mercers' Chapel; FULK BOOKEY, goldsmith.		1687
Cheapside;	— RAGDALE, goldsmith.	1694
Cornhill, by Royal Exchange;	SAMUEL LAYFIELD, goldsmith.	1685
Gerrard street, Soho;	MATTHEW DUROUSSEAU, goldsmith.	1710
Holborn, over against the Bull inn;	MRS URSULA PITMAN, goldsmith.	1684–1690
near Bartlett's buildings;	JOSEPH LOWE, jeweller.	1748
Lombard street; THOMAS KILBORNE & JAMES CAPILL, goldsmiths & bankers.		1677–1682
	JOHN JENKINS & WILLIAM KING, goldsmiths.	1699–1715
St John's street; EDWARD MADDUX, goldsmith.		1658–1687
Strand, over against St Clement's Church; JOHN COGGS, goldsmith & banker.		1664–1710
	JOHN COGGS & JOHN DAWN, goldsmiths & bankers.	1696–1709
by Temple Bar; CHARLES HOLLOWAY, goldsmith.		1692–1699

LAMB

Cheapside conduit;	SAMUEL LEEK, goldsmith.	1680
Cheapside, over against Half Moon tavern; — FISH, goldsmith.		1709, 1710
Cheapside;	JOHN HUTCHINS, goldsmith.	1725

LAMB & LEOPARD (see also LEOPARD & LAMB)

Fleet street, over against St Dunstan's Church; J. CANE, goldsmith.		1702–1707

LAMB & WOOLPACK

Cow Cross; — COLE, silversmith.		1731

LAMP

Lombard street; THOMAS BRASSEY, goldsmith.		1692–1696

LEG & DIAL

Grub street; THOMAS BELL, pawnbroker.		1725

LEOPARD

Strand, over against St Clement's Church; JOHN MILLS, goldsmith.		1687

LEOPARD & LAMB (see also LAMB & LEOPARD)

Fleet street; J. CANE, goldsmith.		1702–1707

LION

Lombard street; RICHARD WARTOPS, goldsmith.		1673
	ROWLAND WORTOPP, goldsmith.	1674

LOCK & KEY

Holborn, over against Hatton garden; MRS SNELLING, goldsmith.		1716
Petticoat lane;	JOHN SMART, pawnbroker.	1744

MAIDENHEAD
Great Wood street; THOMAS WOODS, goldsmith. 1694
Maiden lane; THOMAS MERRY, silversmith. 1699
 JOHN FLAVIL, goldsmith. 1726
MAN IN THE MOON
King's road, Chelsea; DANIEL CHRISTIAN FUETER, silversmith. 1753– c. 1760
MARYGOLD
Fleet street; WILLIAM WHEELER, goldsmith & banker. 1627–1663
 WILLIAM WHEELER, junior, goldsmith & banker. 1666– c. 1675
Fleet street, within Temple Bar; THOMAS EAST, goldsmith. 1660
 ROBERT BLANCHARD, goldsmith & banker. 1661–1681
 SIR FRANCIS CHILD, goldsmith & banker. 1664–1713
 ROBERT BLANCHARD & FRANCIS CHILD, goldsmiths &
 bankers. 1670–1681
 FRANCIS CHILD & JOHN ROGERS, goldsmiths & bankers. 1681
 JOHN ROGERS, goldsmith & banker. 1681
 SIR ROBERT CHILD, goldsmith & banker. 1713–1721
 SIR FRANCIS CHILD, junior, goldsmith & banker. 1721–1740
MERMAID
Lombard street; EDWARD DELVES, goldsmith. 1570–1638
 — HACKER, goldsmith. 1664
 PETER WADE, goldsmith. 1667–1687
MITRE
Eagle street, Red Lion square; CHARLES BELLASSYSE, goldsmith. 1740
Foster lane; JOHN BODINGTON, goldsmith. 1697–1727
 EDMUND BODINGTON, goldsmith. 1727–1729
Leadenhall lane; SAMUEL WASTELL, goldsmith. 1705–1708
Monkwell street; WILLIAM BELLASSYSE, goldsmith. 1716
Strand, near York buildings; JOHN MARTIN STOCKER, goldsmith. 1705–1712
Strand, York buildings; — DRUMMOND, goldsmith. 1716
Strand; JOHN GUERRE, goldsmith. 1717
MOROCCO AMBASSADOR'S HEAD
Lombard street; JOHN BARKER, goldsmith. 1725–1755
MOROCCO'S HEAD
Lombard street; JOSEPH BRANDON, goldsmith. 1690–1693
MOVING HEAD
Borough, Southwark; — BURGESS, pawnbroker. 1754

NAKED BOY
Fleet street, near Fleet bridge; JAMES HERIOT, goldsmith. 1664–1717
 HARBOARD HERIOT, goldsmith. 1711–1717
NAKED BOY & BUNCH OF GRAPES
Strand, near Hungerford market; ROBERT MORY, goldsmith. 1693–1699
NAKED BOY & CORAL
St Margaret's hill, Southwark; EDWARD LEWIS, goldsmith & watch-maker. 1766

OLD BELL
Deadman's place, Southwark; EDMOND CHANTRELL, pawnbroker. 1711–1720
OLD FEATHERS
Oxford road, near Argyle buildings; A. MONDET, jeweller. [N.D.]
OLD GOLDEN BALL
Charles street, St James's market; MRS HANNAH SMITH, pawnbroker. 1723–1725
OXFORD CITY
Gutter lane; SAMUEL WELDER, goldsmith. 1714–1720

PALLAS
Foster lane; JOHN RAYNES, goldsmith. 1743

PALM TREE
Northumberland court, Strand, near Charing Cross; PETER BRUNET, jeweller. 1729

PALSGRAVE'S HEAD
Fleet street, near Temple Bar; — CRUTCH, goldsmith. 1679
 — GRIMSTONE, goldsmith. 1679
Exchange alley [*Lombard street*]; CHARLES EVERARD, junior, goldsmith. 1658–1700

PARROT
Cheapside [*No.* 112], *corner of Honey lane*; HENRY NETTLESHIP, goldsmith. 1770
Minories; — HARDEY, goldsmith. 1727
 MRS HARDEY, goldsmith. 1743–1747
Shoe lane, near Fleet street; MRS DOROTHY HARVEY, pawnbroker. 1705
 THOMAS HARVEY, pawnbroker. 1707
Strand, without Temple Bar; GEORGE BOOTHBY, goldsmith & banker. 1720–1741

PARROT & PEARL
Foster lane [*No.* 12]; PAUL WRIGHT, goldsmith. 1771–1773

PEACOCK
Castle street, Leicester fields; SIMON PANTIN, goldsmith. 1717–1728
 SIMON PANTIN, junior, goldsmith. 1729–1733
 LEWIS PANTIN, goldsmith. 1733–1744
Cornhill, near Royal Exchange; JOHN MERTTINS, jeweller. 1685–1703
 SIR GEORGE MERTTINS, goldsmith & watch-maker. 1688–1727
 MARTIN (? MERTTINS) & HOWELL, goldsmiths. 1703
 BENJAMIN HOWELL, goldsmith. 1704–1715
 SIR GEORGE MERTTINS & JOHN MITFORD, goldsmiths. 1712, 1716
 JOHN MITFORD & MICHAEL MERTTINS, goldsmiths. 1720
Gutter lane, Cheapside; THOMAS POWELL, jeweller. c. 1760
New Round court, Strand; — JONES, jeweller. 1762
St Martin's lane; SIMON PANTIN, goldsmith. 1699–1701

PEACOCK, or PEACOCK'S FEATHERS, or PEACOCK & FEATHERS
Cornhill, near Royal Exchange; BENJAMIN HOWELL, goldsmith. 1704–1715

PEACOCK & FEATHERS
Cornhill; JOHN COX & EDWARD CLEAVE, goldsmiths & bankers. 1715–1721

PEARL
Bow street, Covent Garden; PETER DARDENNE, jeweller. 1702–1721
Buckingham street; ISAAC LACAM, jeweller. 1733
Heming's row [*St Martin's lane*]; JOHN LIGER, goldsmith. 1730–1732
St Martin's lane; — TIFFARD, jeweller. 1721
Wood street, Cheapside; FORSTER & JOHNSON, jewellers & goldsmiths. c. 1760

PEARL & CROWN
Grafton street, Soho; PIERRE MICHON, goldsmith. 1705–1710
Lombard street; JOSEPH DYER, goldsmith. (See also CROWN & PEARL.) 1756–1762
Southwark; JACOB FOSTER, silversmith. 1726–1728

PEARL & THREE STARS
Green street, Leicester fields; ISAAC BOURDO, jeweller. (Before) 1738

PHOENIX
Lombard street, corner of Sherborne lane; NICHOLAS SMITH, goldsmith. 1680–1684
 NICHOLAS SMITH & W. POTTER, goldsmiths. 1681–1683
 [*No.* 10]; LADBROOK & CO., goldsmiths & bankers. 1736–1842
Fetter lane, against Bond's stores; JOHN BRANSTON; pawnbroker. 1704

PLOUGH
Cheapside;	— DALBY, silversmith.	1708
Lombard street;	PETER WHITE, goldsmith & banker.	1673–1695
	PETER WHITE & THOMAS CHURCHILL, goldsmiths & bankers.	1677–1690
	THOMAS COURCHY (? CHURCHILL), jeweller.	1679
	LAUD DOYLE, goldsmith.	1694–1696
	JOSEPH WILSON, goldsmith.	1695–1720

PLUME OF FEATHERS
Ludgate hill, opposite Old Bailey; SUSANNA PASSAVANT, jeweller & toyman. 1755

PORTER
Gracechurch street, near; JOHN COOKE, goldsmith. 1690–1706

PRINCE OF WALES'S HEAD
Poultry, over against the Bank; THOMAS PORT, goldsmith. 1717–1730

PRINCE'S HEAD
Poultry; THOMAS PARTRIDGE, goldsmith. 1727

PURSE
Cheapside; THOMAS CALTON, goldsmith. 1526–1530

QUEEN'S ARMS
Cheapside;	ANTHONY DERRICK, goldsmith.	1550–1580
Fleet street;	— ELLIS, goldsmith.	1702
Lombard street;	PAYNE & CO., goldsmiths.	1710–1721

QUEEN'S HEAD
Fleet bridge;	ROBERT FOWLES, goldsmith & jeweller.	1675
Foster lane;	JOHN HOLLAND, goldsmith.	1711, 1712
Grafton street, Soho;	GOWAN (or GODWIN) BIRKENHEAD, goldsmith.	1702–1732
	PETER BIRKENHEAD, goldsmith.	1743
Great Russell street, Covent Garden;	CHARLES FINCH, silver button-maker.	c. 1760
Gutter lane;	SAMUEL BOURNE, goldsmith.	1696–1704
	JOHN HARVEY, goldsmith.	1739–1750
New street, Covent Garden [No. 9];	CHARLES PRESBURY, silversmith & jeweller.	1790–1793
Southwark, over against St Margaret's Church;	THOMAS DAY, goldsmith.	1687
[Strand], near Bedford House;	JOHN GASTON, goldsmith.	1668
Strand, over against St Clement's Church;	WILLIAM FINALL, goldsmith.	1708–1712
	ISAAC DAVENPORT, goldsmith.	1731

RAM
Lombard street;	THOMAS TOWNLEY, goldsmith.	1677
	ROBERT WARD & JOHN TOWNLEY, goldsmiths & bankers.	1677

RAVEN
[Strand], over against Exeter Change; EDMOND PAYNE, goldsmith. 1702

RED BALCONY
Suffolk street; DAVID MESGRET, jeweller. 1695, 1696

RED CROSS
Lombard street; RICHARD SHELDON, goldsmith. 1680

RED HAT [see CARDINAL'S CAP]

RED LAMP
King street, St James's; WIDOW HUMPHREYS, pawnbroker. 1745

RED LION
Hop garden, Bedfordbury; — DRYSDALE, pawnbroker. [N.D.]

RED M & DAGGER
Pope's Head alley, Cornhill; WALTER ROBOTHAM, toyman & jeweller. 1731

RING
East Smithfield, near the Maypole; ANN FOOTE, goldsmith. 1752
Fenchurch street; HENRY WILKIN, goldsmith. 1705–1710
Fleet street; — HEMPSTEAD, goldsmith. 1710
Villiers street; KENDAL FYNES, jeweller. 1728
Wine Office court, Fleet street; — ELLIS, goldsmith. (See also GOLD RING.) 1702–1721

RING & ACORN
Shug lane, Golden square; PETER L'HEMMEDIEU, goldsmith. 1752

RING & BALL
Fenchurch street, under St Dionis Backchurch; SAMUEL HANKEY, goldsmith. 1685–1690
SIR HENRY HANKEY, goldsmith & banker. 1690–1704
Little Tower hill; JOSEPH GREEN, goldsmith & pawnbroker. 1723–1734
Minories; WILLIAM THRELKELD, goldsmith. 1743
MRS MARY THRELKELD, goldsmith. 1752–1755

RING & CHAIN
Cross street, Hatton Garden; JOSEPH WRIGHT, goldsmith & water-gilder. c. 1750

RING & CROWN
West street, near Seven Dials; JOHN DELAFONS, jeweller. 1738

RING & CUP
Aldersgate, near, next door to the Bull & Mouth inn; JOHN JOHNSON, silversmith. 1714
Walker's court, Berwick street, Soho; CHALMERS & ROBINSON, jewellers & goldsmiths. c. 1760

RING & PEARL
Abchurch lane, opposite Pontac's; JOHN WILLMOT, goldsmith. 1748–1755
Bishopsgate street, near South Sea House; JOHN ALDERHEAD, goldsmith. 1750–1766
[No. 114]; JOHN ALDERHEAD, goldsmith. 1768–1794
Bread street, Cheapside; ANTHONY PLANCK, jeweller. 1727
Broad street; JAMES BERCHERE, jeweller. 1711–1714
Buckingham street, York buildings; J. HOLBROOK, jeweller. 1762
Coventry street [No. 11], St James's;
MASQUERIER & PERIGAL, goldsmiths, jewellers & toymen. 1774–1777
Heming's row [St Martin's lane]; DENIS PERE, jeweller & silversmith. 1742
King street, St Giles's; WILLIAM BAYLEY, silversmith. 1733
Ludgate street [No. 18], South side of St Paul's churchyard;
RALPH AYSCOUGH, ring-maker & goldsmith. 1753–1777
Old Round court, near Chandos street; — FRENCH, goldsmith. c. 1760
Pearl street [near Newport market]; — MIGAULT, jeweller. 1724
Poultry [No. 9]; THOMAS WINTLE, goldsmith & jeweller. 1760–1790
Queen street [Seven Dials]; — DUCEMETIERE, jeweller. 1751
Strand, over against the Five Bells tavern; — HUGES (or HUGHES), jeweller. 1722
near Beaufort buildings; — GILCHRIST, jeweller. 1755
over against Cecil street; CHARLES BERG & SAMUEL GRANT, jewellers. c. 1760 (?)
Tavistock street, Covent Garden; LOUIS FURY, jeweller. 1715

RING & PEARL & CASE OF KNIVES
Fenchurch street, opposite Mincing lane; JOHN WORSLEY, jeweller. c. 1780

RING & RUBY
Lombard street; THOMAS MUSCHAMPE, goldsmith. 1560–1578

RISING SUN
Chandos street, St Martin's lane; SAMUEL COURTAULD, goldsmith. 1746–1751
Norton Folgate, near Hog lane; MRS GALLWITH, pawnbroker. 1730
Tavistock street, Covent Garden; — YEO, goldsmith. 1746

ROD [? ROSE] & CROWN
 St Bride's lane, Fleet street; ANDREW ARCHER, goldsmith. 1710–1725

ROE BUCK
 [Strand], against Salisbury House; — JENNINGS, goldsmith. 1688

ROSE
 Belton street, near Long Acre; ANTHONY BELL, pawnbroker. 1731
 Cheapside; HENRY GILBERT, goldsmith. 1569–1580
 Exchange alley, Lombard street; BENJAMIN LANE, goldsmith. 1694–1717
 Fleet street; EDWARD AMSON, goldsmith. 1695–1706
 near St Bride's Church; ARTHUR SADLER, pawnbroker. 1739
 Lombard street; HENRY NELTHORPE, goldsmith & banker. 1675–1677
 THOMAS BRAND, goldsmith. 1702–1714
 Salisbury court, Fleet street; THOMAS GRAINGER, pawnbroker. 1711–1720
 Stanhope street [? Clare market]; WILLIAM COOLING, pawnbroker. 1719
 Strand, over against St Martin's lane; WILLIAM DARKERATT, goldsmith. 1725–1732
 WILLIAM DARKERATT, junior, goldsmith. 1731–1733
 Strand; JAMES MANNERS, goldsmith. 1734–1739
 Tower street; WILLIAM CHAPMAN, goldsmith. 1681

ROSE & CROWN
 Cheapside; — CORDELL, goldsmith. 1687
 (? VALENTINE) BARRINGTON, goldsmith. 1695–1697
 Cornhill; JOSEPH WARD, goldsmith. 1706–1708
 Field lane [Holborn]; CHARLES MARTIN, goldsmith. 1729
 Foster lane; SYMON KNIGHT, goldsmith. 1699, 1700
 Lombard street; JOHN ORCHARD, goldsmith. 1695–1697
 SANKEY & TRIST, bankers. Early 18th century
 corner of Nag's court; RICHARD GINES, goldsmith. 1698–1742
 GEORGE & WILLIAM GINES, goldsmiths & bankers. 1751–1758
 GINES & ATKINSON, bankers. c. 1760–1765
 Newgate street, over against the Blue-Coat Hospital gate; GEORGE NELTHORPE, jeweller. c. 1710
 St Bride's lane; JOHN HOPKINS, goldsmith. 1720–1726
 St Martin's-le-Grand; JOHN JONES, silversmith. 1733–1737
 Strand, corner of Fountain court; JOHN LACAM, jeweller & goldsmith. 1744–1747

ROSE [ROD (?)] & CROWN
 St Bride's lane, Fleet street; ANDREW ARCHER, goldsmith. 1710–1725

ROSE & THREE BALLS
 East Smithfield; — PEARCY, pawnbroker. 1758
 Prince's street, Clare market; THOMAS STONE, pawnbroker. 1758

ROYAL EXCHANGE & GRASSHOPPER
 Lombard street; SIR ROGER HUDSON, goldsmith. 1682–1705
 JOHN HUDSON, goldsmith. 1702–1705

ST PETER & THE KEYS
 St Paul's churchyard; ALLEN BANKES, goldsmith. 1672

SALMON & PEARL
 Ludgate hill [No. 34]; ABRAHAM PORTAL, goldsmith & jeweller. 1763–1778
 PORTAL & GEARING, goldsmiths, jewellers & toymen. 1774–1778
SASH
 Earl street, St Giles's; RICHARD SMITH, pawnbroker. 1707

SCEPTRE & CROWN [see also CROWN & SCEPTRE]
 Upper end of Lombard street; JOHN BAILY, goldsmith. 1707–1715

SEVEN STARS
Clare street, Clare market; MATTHEW WEST, goldsmith. 1697–1731
Fleet street, at Fleet Ditch, near Globe tavern; — ELLIS, goldsmith. 1710–1712
Friday street; WILLIAM SWAN & CO., goldsmiths. 1702–1744
Lamb's Conduit passage, near Red Lion square; DANIEL PARKER, pawnbroker. 1709
Lombard street; THOMAS SEYMOUR, goldsmith. 1660–1698
 WILLIAM SNELL, goldsmith & banker. 1665
Old Bailey, over against Sun tavern; MATTHEW WEST, goldsmith. 1731–1735
Petticoat lane; CHARLES MILLER, pawnbroker. 1726
Stonecutter street, Shoe lane; ESTHER ROBARTS, pawnbroker. 1721
[Strand], Shipyard, near Temple Bar; MRS SARAH WHITMORE, pawnbroker. 1707

SEVEN STARS & BALL
Houndsditch; RICHARD HEWETT, pawnbroker. 1730

SHIP
Cannon street; ALEXANDER ROODE, goldsmith. 1694–1706
Cheapside; EDWARD GILBERT, goldsmith. 1562–1569
Fleet street, corner of Crane court, near Fetter lane; JOHN CURGHEY, goldsmith. 1734–1749
Gracechurch street; THOMAS TYSOE, goldsmith. 1699–1706

SHIP & CROWN
Gracechurch street; GEORGE GINES, goldsmith. 1721–1744
 corner of Nag's Head court;
 THOMAS PEWTRESS, goldsmith & banker. 1748–1754
 THOMAS PEWTRESS & JOSIAH ROBERTS, goldsmiths & bankers. 1753

SHIP & PINEAPPLE
Strand, opposite Castle court; JOHN FRASER, goldsmith. [N.D.]

SHIP & SHEARS
High Holborn; ADAM STOWERS, pawnbroker. 1754

SHIP ON THE HOOP
Westchepe; NICHOLAS DE FARNDON, goldsmith. 1339–1361

SILVER BALL
Pall Mall; RICHARD BEAUVOIR, jeweller. 1690–1703

SILVER CUP
Maiden lane; — JENNINGS, goldsmith 1718

SILVER LION
Foster lane [No. 20]; THOMAS DANIELL, goldsmith. 1782–1793
Foster lane; CHARLES CALLAGHAN, silversmith & jeweller. 1782–1792
Strand [No. 463]; CHARLES CALLAGHAN, silversmith & jeweller. 1792

SIR ISAAC NEWTON'S HEAD
Cornhill; B. DICKENSON, silversmith. 1728

SIX BELLS
Long Acre; — COMPIEGNE, goldsmith. 1738

SNAIL
Tower street; FULLER BRIGHT, goldsmith. 1702–1707

SNAIL & RING
Tower street; FULLER BRIGHT, goldsmith. 1708
 SIMON BRYAN, goldsmith. 1743

SPOTTED DOG
Cheapside, over against Foster lane; WILLIAM TANNER, goldsmith. 1707–1713
Lombard street; JOHN MARLOW, goldsmith. 1686–1697
 THOMAS MORSE, goldsmith. 1718–1724
 THOMAS GLADWIN, silversmith. 1719
 [? JOSEPH] BARRETT, goldsmith. 1728

SPREAD EAGLE
Foster lane; THOMAS WHIPHAM & WILLIAM WILLIAMS, goldsmiths. 1740–1746
 WILLIAM WILLIAMS, goldsmith. 1742–1748
Lombard street; JEREMIAH MARLOW, goldsmith & engraver. c. 1677–1709
Strand; JOHN SPACKMAN, goldsmith. 1694–1696

STAR
Bedford street, Covent Garden; PHILIP BRUGIER, junior, goldsmith. 1752–1773
Chancery lane, by the pump, or, over against the Black Spread Eagle;
 WILLIAM WARHAM, junior, goldsmith. 1712–1715
Charing Cross; — SHIELDS, jeweller. 1751–1762
Cornhill [No. 18], corner of Pope's Head alley;
 JOHN KENTISH, jeweller, goldsmith & toyman. 1758–1793
Fleet street, corner of Hind court, opposite Water lane;
 JOHN STAMPER, goldsmith & jeweller. 1762–1766
Lombard street, near Exchange alley;
 JOHN WASSON, goldsmith. 1660–1662
 CHARLES EVERARD, goldsmith & banker. 1662–1665
 JOSEPH HORNBY, goldsmith & banker. 1666–1677
 JOSEPH & NATHANIEL HORNBY, goldsmiths & bankers. 1670–1700
 — HORNBY, goldsmith & banker. 1677–1688
 NATHANIEL HORNBY, goldsmith & banker. 1677–1696
Pall Mall, end of, near St James's, Haymarket;
 WILLIAM & MARY DEARD, goldsmiths & toymen. c. 1770
St Margaret's hill, Southwark; MOSES SICKLEMORE, goldsmith. 1692–1694

STAR & GARTER
Ludgate street [No. 18], near St Paul's; HENRY YOUNG, goldsmith, jeweller & toyman. 1779–1793
Strand, near Norfolk street; SHELLEY & KING, goldsmiths and jewellers. 1770–1772

STAR & PEARL
Duke court, St Martin's lane; JOHN FRANCIS ESTIENNE, jeweller. 1752–1755
High Holborn, opposite Red Lion street, adjoining to the George & Blue Boar inn;
 GEORGE PINNOCK, jeweller & goldsmith. c. 1760

STAR & RING
New Bond street; JOHN ROBINSON, goldsmith & jeweller. 1759–1769

STAR & WHEATSHEAF
Cheapside; — MAULTON, goldsmith. 1716

STAR OF MYSTERY
Salisbury street, Strand; — BINGANT, gold chaser. 1751

STRIPED BALL
Long Acre, next door to the King's Bagnio; — WHITCHURCH, pawnbroker. 1716

SUGAR LOAF
Bucklersbury; GEORGE WILKINSON, jeweller. 1709
Fore street, by Moor lane; THOMAS SETH, pawnbroker. 1709
St Martin's lane, on the Paved Stones; SAMUEL MORGASS, silversmith. 1715

SUN
Charterhouse lane, West Smithfield; THOMAS WATERS, pawnbroker. 1729
 JONATHAN WATERS, pawnbroker. 1731
Cheapside [No. 63], opposite Laurence lane;
 WATKINSON WILDMAN, goldsmith. 1730–1765
 SAMUEL WILDMAN, goldsmith & jeweller. 1768–1796
Cheapside; W. ATKINSON, goldsmith. 1744
Great Russell street, Covent Garden; HENRY JERNEGAN, goldsmith. 1720
Holborn bridge; — BESLEY, silversmith. 1720
Jermyn street; WILLIAM MORGAN, goldsmith. 1706
Little Lombard street; MICHAEL WILSON, goldsmith. 1695–1709

SUN (*continued*)
Lombard street; JOHN ADDIS & CO., goldsmiths. 1677–1685
 JOHN ADDIS & SON, goldsmiths. 1683
 SAMUEL COOKE & STEPHEN VENABLES, goldsmiths. 1718–1721
 — FIELD, goldsmith. 1728
St Swithin's lane; FRANCIS GARTHORNE, goldsmith. 1677 (?)–1726
 JOS. ALLEN & MORDECAI FOX, goldsmiths. 1729–1743
Sidney's alley, Leicester fields; CHARLES STOREY, jeweller & toyman. 1751–1773
Silver street, near Cripplegate; CORNELIUS DREW, pawnbroker. 1707–1718
[Strand], without Temple Bar; JOHN EAST, goldsmith & banker. 1663–1688
 WILLIAM EAST, goldsmith. 1687
 PHILIP PINCKNEY, goldsmith. 1697–1708
Strand, against Southampton street; — KEIGWIN, goldsmith. 1710–1712
[Strand] (i) *Without Temple Bar.* (ii) *Corner of Dutchy lane.* (iii) *Opposite Catherine street.*
[All three addresses relate to the same house.]
 WILLIAM HODSOLL, goldsmith & banker. 1714–1763

SUN DIAL
Corbet court, Spitalfields; ELIZABETH WARNER, pawnbroker. 1716

SUN & MARYGOLD
Strand, near Somerset House, opposite Catherine street, by the Savoy;
 RICHARD HAMMERSLEY, goldsmith. 1694–1696
 WILLIAM HODSOLL, goldsmith & banker. 1712

SURGEONS ARMS
Broad street; WILLIAM DEPESTOR, goldsmith. 1677

SWAN
Foster lane; [JEREMIAH (?)] KING, goldsmith. 1736
[Strand], over against St Clement's Church; — SUDBURY, goldsmith. 1664

TABARD
Southwark; JOHN MABBE, junior, goldsmith. 1578

TEA KETTLE
Fair street, Horsley down; MARY CORNE, pawnbroker. 1757

TEA TABLE
Chiswell street, Moorfields; — ERWIN, pawnbroker. 1752

THISTLE & CROWN
Cheapside; JOSEPH TERRITT, goldsmith. 1752

THREE ANCHORS
Lombard street; JOHN FREAME, goldsmith & banker. 1694–1702
 JOHN FREAME & THOMAS GOULD, goldsmiths & bankers. 1694–1708

THREE ANGELS
Lombard street, against George yard; MARY BROWNE & MARGARET MAURICE, (?) goldsmiths. 1723
 RICHARD BROWNE, goldsmith. 1731

THREE BALLS
Barbican; JOHN BERRY, pawnbroker. 1760
Beale street, corner of, Golden square; — SCRIVEN, pawnbroker. 1753
Blackman street, Southwark; JOHN PEARSE, pawnbroker. 1745
Chandos street, Covent Garden; — GATES, pawnbroker. 1765
Coventry street, Haymarket; — WATSON, pawnbroker. 1745–1760
Cow Cross; — MASTER, pawnbroker. 1760
Denmark street, St Giles's Church; — HARRISON, pawnbroker. 1753
 over against St Giles's Church; — FELLS, pawnbroker. 1754
Drury lane, corner of Bennett's court; FRANCIS PATRICK, pawnbroker. 1756
Fleet street, corner of Bride lane; RICHARD BRISTOW, goldsmith. 1716–1736

THREE BALLS (*continued*)

Grub street, corner of Hanover court;	CLEM HART, pawnbroker.	1760
Holles street, Clare market;	ROBERT BARRETT, pawnbroker.	1752
	WILLIAM CARTER, pawnbroker.	1752
King street, Tower hill;	THOMAS WARNER, pawnbroker.	1774
Lumber court, corner of, Seven Dials;	— CHILD, pawnbroker.	1765
New Belton street [St Giles's];	THOMAS PRETTY, pawnbroker.	1755
	ROBERT HALL; pawnbroker.	1764
Petticoat lane, Whitechapel;	EDWARD HARRISON, pawnbroker.	1747
Russell court, Brydge's street, Covent Garden;	— ROCHFORT, pawnbroker.	1754
Russell street, corner of, Brydge's street, Covent Garden;	WILLIAM JOHNSON, pawnbroker.	1753
Covent Garden;	— BOWERS, pawnbroker.	1754
	— MONKS, pawnbroker.	1764
St John's, Clerkenwell, near the pound;	— WARNER, pawnbroker.	1765
Shoe lane;	ARCHIBALD CAMPBELL & JAMES CROCKETT, pawnbrokers.	1742
West street, near Seven Dials;	— PARDOE, pawnbroker.	1754
Wheeler street, Spitalfields;	MRS BROWN, pawnbroker.	1753
Winford street, corner of Bell lane, Spitalfields;	MOSES CORONEL, pawnbroker.	1763

THREE BALLS & ACORN

Golden lane;	— PAYNE, pawnbroker.	1763

THREE BALLS & GOLD BALL

Bow street;	— MORGAN, pawnbroker.	1764

THREE BELLS

Fleet street, near Fleet bridge (or near Bride lane);	CHARLES HOUSTON, (?) goldsmith.	1731
	RICHARD BRISTOW, goldsmith.	1727–1732

THREE BLACK LIONS

Near Charing Cross;	JOHN PEARSON (or PARSONS), goldsmith.	1689–1694
Russell street;	PAUL CAREW, goldsmith.	1699–1706
[Strand], without Temple Bar, near Palsgrave Head court;	JAMES WILLITT, goldsmith.	1697
	WILLIAM ROBERTS, goldsmith (?).	1707
Strand, corner of Old Round court;	STEPHEN & FRANCIS EWENS, pawnbrokers.	1721

THREE BLUE BALLS

Barbican, corner of Beach street;	— SCRIVEN, pawnbroker.	1755
Bedford row, corner of Featherstone buildings;	— BIBBY, pawnbroker.	1756
Bennett's court, Drury lane;	WILLIAM STRINGER, pawnbroker.	1752
Boswell court, St Clement's, Strand;	MOSES COROUCH, pawnbroker.	1754
Brownlow street, Drury lane;	THOMAS ATKINS, pawnbroker.	1745
Castle street, Leicester fields;	— STILES, pawnbroker.	1758
Charles court, Strand, near Hungerford market;	JOHN BUCHAN, pawnbroker.	1720
Charles street, Long Acre;	JACOB PULLEN, pawnbroker.	1729
Denmark street, over against St Giles's Church;	— FELLS, pawnbroker.	1754
Fair street, Horsleydown;	THOMAS HARRISON, pawnbroker.	1742
Golden lane;	— PAYNE, pawnbroker.	1753–1763
Grub street, corner of Hanover court;	CLEMENT HART, pawnbroker.	1758
Holles street, Clare market;	— PRICE, pawnbroker.	1760
Holliwell street, Strand;	SAMUEL GRAYGOOSE, pawnbroker.	1758
James street, Grosvenor square;	RICHARD RICKABY, pawnbroker.	1757
King street, Golden square;	— WALTON, pawnbroker.	1758
Little Russell street, Covent Garden;	— MONK, pawnbroker.	1765
Petticoat lane;	— ALLEN, pawnbroker.	1745
Rose street, Covent Garden;	— MERRITT, pawnbroker.	1764
St Martin's lane, Strand;	— SCRIVEN, pawnbroker.	1760
Silver street, Oxford road;	JOHN BLAND, pawnbroker.	1758

G

THREE BLUE BALLS (*continued*)

Snowhill;	— BROWNE, pawnbroker.	1753
Strand, corner of Half Moon street;	— FELLS, pawnbroker.	1754
facing Hungerford market;	— JORDANS, pawnbroker.	1760

THREE BLUE BALLS & ANCHOR
St Clement's lane, Clare market; JOHN MIDDLETON, pawnbroker. 1745

THREE BLUE BOWLS
Charles street, near Long Acre; JACOB PULLEN, pawnbroker. 1729

THREE BLUE BOWLS & GOLDEN BALL
Stanhope street, Clare market; JAMES FLETCHER, pawnbroker. 1729

THREE BOWLS

Adam and Eve court, Oxford road;	JOHN PHITHIAN, pawnbroker.	1747
Aldersgate;	JOSEPH WALKER, pawnbroker.	1722
Bride lane, Fleet street;	RICHARD STOCKWELL, pawnbroker.	1715–1719
Cecil court, near St Martin's lane;	AMOS HAYTON, pawnbroker.	1710
Covent Garden, corner of Russell court;	— CARMALT, pawnbroker.	1745
Crown court, corner of, facing Compton street;	— IRTON, pawnbroker.	1742
Drury lane;	WILLIAM CHAMBERS, pawnbroker.	1709–1712
corner of Bennett's court;	GEORGE STRINGER, pawnbroker.	1745
Eagle street, near Red Lion square, Holborn;	HENRY HARWOOD, pawnbroker.	1705
Fetter lane;	WILLIAM BARNES, pawnbroker.	1717
Great Wild street;	— SHEARER, pawnbroker.	1744
Heming's row, near St Martin's lane;	AMOS HAYTON, pawnbroker.	1715
Holborn;	RICHARD HEWETT, pawnbroker.	1698
Holborn bridge;	JOHN DUNN, pawnbroker.	1716
Holles street, Clare market;	LAZARUS COMBE, pawnbroker.	1703–1708
Little Newport street;	RICHARD PRETTY, pawnbroker.	c. 1715
Little Russell street, Bloomsbury;	MRS MARY HEWLETT, pawnbroker.	1728
Long Acre;	BARBARA BRAXTON, pawnbroker.	1714
	MRS ELIZABETH PENNE, pawnbroker.	1724
Market lane, St James's;	ISAAC DAVIS, pawnbroker.	1720
near St James's market;	JOHN PASHLEY, pawnbroker.	1707–1710
	CHARLES SMITH, pawnbroker.	1731
Plumtree street, St Giles's;	JOHN CROUCH, pawnbroker.	1702–1710
Robin Hood court, Shoe lane;	THOMAS CROSFIELD, pawnbroker.	1720
Rose street, Covent Garden;	— MORRILL, pawnbroker.	1759
Russell street, Covent Garden;	— BOWER, pawnbroker.	1754
Salisbury court;	AARON MOORE, pawnbroker.	1725
Shoe lane; ARCHIBALD CAMPBELL & JAMES CROCKETT, pawnbrokers.		1742
Skinner street, Snow hill;	— BEIGHTON, pawnbroker.	1745
Snow hill, corner of Hosier lane;	— PRICE, pawnbroker.	1742–1753
	— PIKE, pawnbroker.	1744
Stanhope street, Clare market;	— BIBBY, pawnbroker.	1745–1753
Vere street, by Clare market;	RICHARD PRETTY, pawnbroker.	1719
West street, near Seven Dials;	— HUMPHREYS, pawnbroker.	1758
Wych street, near St Clement Danes, Strand; ABRAHAM BIBBY, pawnbroker.		1721–1732
corner of Maypole alley;	JOSEPH JOHNSON, pawnbroker.	1742

THREE BOWLS & ANCHOR
St Clement's lane, Clare market; JOHN MIDDLETON, pawnbroker. 1745

THREE BOWLS & GOLDEN BALL
Stanhope street, Clare market; — BIBBY, pawnbroker. 1745–1753

THREE BOWLS & ROSE
St Martin's lane, lower end of; — CADDY, pawnbroker. 1744

THREE CANDLESTICKS
Foster lane; CHARLES ALCHORNE, goldsmith. 1734

THREE COCKS
Cheapside, upper end of; JAMES LAPLEY, goldsmith & banker. 1659–1694
 — KNOTT, goldsmith. 1695
 CAPT. PEARCE, goldsmith. 1700–1703
St John's lane, near Hick's Hall; THOMAS BASTIN, pawnbroker. 1708–1724

THREE CROWNS
Cheapside, lower end of; THOMAS MOULDEN, goldsmith. 1733–1739
Drury lane, over against the Castle; CHARLES TEMPEST, goldsmith. 1702–1712
 ROBERT TEMPEST, goldsmith. 1723
High Holborn, near the Watch House; — HOLLOWAY, pawnbroker. 1721
Lombard street; WILLIAM SHORE, goldsmith. 1466–1480
Panton street, corner of, and Hedge lane, near Leicester fields; — CUGNY, goldsmith. 1703–1727
 by Leicester fields; HENRY HEBERT, silversmith. 1734–1739
Strand, near Hungerford market; JOHN CAMPBELL, goldsmith. 1691–1712
 near St Martin's lane;
 GEORGE MIDDLETON & JOHN CAMPBELL, goldsmiths & bankers. 1692– c. 1712
 CAMPBELL & PARTNERS, goldsmiths & bankers. 1709
 GEORGE CAMPBELL & GEORGE MIDDLETON, goldsmiths & bankers. 1714–1748
 GEORGE CAMPBELL & JAMES COUTTS, goldsmiths & bankers. c. 1755–1761
 JAMES & THOMAS COUTTS, goldsmiths & bankers. 1761–1778

THREE CROWNS & ANCHOR
Lombard street; RICHARD MORSON, goldsmith & banker. 1700–1736

THREE CUPS
Strand, near Somerset House; HUGH HAMMERSLEY, goldsmith. 1677–1690

THREE FLOWER-DE-LUCES
Cheapside; SIR JOHN JOHNSON, goldsmith. 1672–1698
 JAMES JOHNSON, goldsmith & banker. 1677–1689
 HENRY JOHNSON, goldsmith. 1703
Fleet street; JAMES SEAMER, goldsmith. 1701–1739
Henrietta street; JOHN GREEN, goldsmith. 1687–1695
Holborn; — UNDERWOOD, goldsmith. 1701, 1702
Lombard street; SIR STEPHEN EVANS, goldsmith. c. 1680
 RICHARD NORWOOD, goldsmith. 1701–1704
Strand; — HARRISON, goldsmith. 1692–1698

THREE FLOWER-DE-LUCES & CROWN
Henrietta street, Covent Garden; WILLIAM MAN, goldsmith. 1701

THREE GOLDEN ANCHORS
Near Whitechapel Bars, next door to the Crown & Magpie;
 HENRY BARLOW, goldsmith & jeweller. 1747

THREE GOLDEN BALLS
Aldersgate street; EDMUND HEWETT, pawnbroker. 1753
Bird street, Grosvenor square; — JASON, pawnbroker. 1758
Carnaby street, Golden square; — DOBREE (?), pawnbroker. 1757
Clare street, Clare market; — SPIRES, pawnbroker. 1760
Fenchurch street; SIR JOSEPH & SIR THOMAS HANKEY, bankers. 1765–1768
Fleet market; — ALEXANDER, pawnbroker. 1759
Great Pulteney street, Golden square; — STOCKDALE, pawnbroker. 1754
Houndsditch; THOMAS RUDGE, pawnbroker. 1731
Little St Andrew's, Seven Dials; RICHARD ADNEY, pawnbroker. 1731
Little Turnstile; — GIBSON, junior, pawnbroker. 1756

THREE GOLDEN BALLS (*continued*)
Oxford street; — POWELL, pawnbroker. 1765
St John street, Clerkenwell, near the pound; — WARNER, pawnbroker. 1760–1765

THREE GOLDEN COCKS
Cheapside, upper end of; CAPT. PEARCE, goldsmith. 1700–1703
St John's lane; R— M—, pawnbroker. 1704

THREE GOLDEN LIONS
Gutter lane; ANTHONY CARTER, goldsmith. 1706
JAMES GOULD, goldsmith. 1722–1727
Near Temple Bar; JOHN LUND, goldsmith. 1695–1712

THREE GOLDEN LIONS, ANCHOR & RING
Lombard street; WILLIAM HUNTER, goldsmith & jeweller. 1752

THREE GREEN BALLS
Berwick street; — HATTON, pawnbroker. 1745

THREE HALF MOONS
Lombard street; SAMUEL GREEN, goldsmith. 1726

THREE HATS
Horsley Down, Southwark; ELIZABETH HATTER, pawnbroker. 1710

THREE HORSESHOES
Cow Cross; — CARTWRIGHT, silversmith. 1732

THREE KINGS
Cheapside; WILLIAM LADDE, goldsmith. 1695–1699
JOSEPH BEACHCROFT, goldsmith. 1705–1713
JOSEPH BARRETT, goldsmith. 1724–1744
JOHN BRISCOE, jeweller & goldsmith. 1753–1762
near St Paul's; BRISCOE & MORRISON, jewellers & goldsmiths. 1762–1769
Lombard street; THOMAS PEWTRESS & JOSIAH ROBERTS, goldsmiths & bankers. 1768
Newgate street; EDWARD ELMES, goldsmith. 1699–1717

THREE KINGS & GOLDEN BALL
Cheapside, opposite Foster lane; STAFFORD BRISCOE, jeweller & goldsmith. 1738–1759
[No. 15], opposite Foster lane; JOHN BRISCOE, jeweller & goldsmith. 1744–1756
BRISCOE & MORRISON, jewellers & goldsmiths. 1762–1772
RICHARD MORRISON, goldsmith. 1769–1783

THREE KINGS & SPOTTED DOG
Cheapside, near Old Change; JOSEPH BARRETT, goldsmith. 1744

THREE LIONS
Lombard street; RALPH GERRARD, goldsmith. 1699– c. 1703
RALPH GERRARD & GEORGE NEWELL, goldsmiths. 1701– c. 1703
RALPH GERRARD & CHARLES HERLE, goldsmiths. 1709

THREE NEATS' TONGUES
Near St Margaret's Church, Westminster; BENDISH RASH, pawnbroker. 1719

THREE PIGEONS & CROWN
Drury lane; SAMUEL ROWLINGS, pawnbroker. 1709

THREE SQUIRRELS
Fleet street, over against St Dunstan's Church;
HENRY PINCKNEY, goldsmith. 1650–1660
JAMES CHAMBERS, goldsmith. c. 1680–1714
ABRAHAM CHAMBERS, goldsmith. 1683–1695
JOHN CHAMBERS, gold & silver buckle-maker. 1693
ABRAHAM FOWLER, goldsmith. 1696–1723

THREE SQUIRRELS (*continued*)
Fleet street, over against St Dunstan's Church;

GEORGE WANLEY, goldsmith & banker.	1713–1727
GEORGE WANLEY & GEORGE CRADOCK, goldsmiths & bankers.	1713–1720
— NICHOLLS, goldsmith.	1721
ABRAHAM FOWLER & JAMES ROCHE, goldsmiths.	1723–1729
ABRAHAM CHAMBERS & THOMAS USBORNE, goldsmiths.	1733–1749
SIR FRANCIS GOSLING, goldsmith & banker.	1742–1768
WARD & GOSLING, bankers.	1742
GOSLING & BENNET, bankers.	1743–1752
GOSLING & CO., goldsmiths & bankers.	1747

THREE TOBACCO ROLLS
Blackamoor street; WIDOW ROOKE, pawnbroker. — 1703

THREE TUNS
Lombard street; JOHN TEMPLE, goldsmith. — 1670–1683
ROBERT WELSTEAD & THOMAS TEMPLE, goldsmiths & bankers. — 1672
JOHN TEMPLE & JOHN SEALE, goldsmiths & bankers. — 1677–1684
JOHN & THOMAS TEMPLE, goldsmiths. — 1678–1684

TURK'S HEAD
Bennet street, St James's; — GOUYNIN, jeweller. — 1752
Lombard street; — BARBER, goldsmith. — 1744

TWO BLUE POSTS
Grafton street, Soho; ISAAC L'ADVOCAT, jeweller. — 1733–1744

TWO CANDLESTICKS & KEY
Great St Helen's, within Bishopsgate; THOMAS DOXSEY, goldsmith (?). — 1756–1773

TWO GOLD CANDLESTICKS & BLUE COFFEE POT
St Martin's lane, facing Chandos street, near Charing Cross;
JOHN BUHL, silversmith & buckle-maker. — 1768–1774

TWO GOLDEN BALLS
Chick lane, West Smithfield; — KAY, pawnbroker. — 1753–1756
Fetter lane, Holborn; — KAY, pawnbroker. — 1762
Grub street; — FRANCIS, pawnbroker. — 1744

TWO GOLDEN BALLS & CROWN
St Martin's lane, bottom of; FORSHALL & BLONDELL, pawnbrokers. — 1758

TWO GREEN POSTS
George street, York buildings, Strand; — JONES, jeweller. — 1721–1729

TWO KINGS & KEY [see also KING & KEY]
Fleet street, next door but one to the White Horse inn; — CLARK, pawnbroker. — 1752

TWO VIZARDS MASKS & GOLDEN BALL
Hewit's court, near St Martin's Church, Strand; JOHN CHURCH, pawnbroker. — 1710–1715

TWO WHITE FRIARS
Fleet street; — BURKITT, silversmith. — 1716

UNICORN
Cheapside; — GODDERDYKE, goldsmith. — 1561
JOHN JENKINS, goldsmith. — 1695, 1696
corner of Wood street; JOHN JACKSON, jeweller & toyman. — 1699
Exchange alley, South end of, Lombard street, between the Grasshopper and the White Horse;
EDWARD BACKWELL, goldsmith & banker. — 1650–1683
Fenchurch street; JOSEPH BRANDON, goldsmith. — 1685
JAMES DODD, goldsmith. — 1705–1710

UNICORN (continued)
Fleet street, near Serjeant's Inn; JOHN SHALES, goldsmith.		1674–1699
	MRS SHALES, goldsmith.	1692
	SHALES & SMITHIN, goldsmiths.	c. 1695–1702
Henrietta street, Covent Garden;	RICHARD BEALE, goldsmith.	1731–1773
Holborn, over against Gray's Inn gate; THOMAS HICKENS, goldsmith.		1694–1701
Lombard street;	JOHN PORTMAN, goldsmith & banker.	1644–1663
	CHARLES EVERARD, goldsmith & banker.	1652–1662
	JOSEPH HORNBY, goldsmith & banker.	1666
	RICHARD SNAGG, goldsmith.	1682
	HENRY LAMBE, goldsmith.	1683–1709
	KNIGHT & JACKSON, goldsmiths & bankers.	1727–1729
Russell street, Covent Garden;	EDWARD SANDFORD, goldsmith.	1689–1705
	EDWARD CARTER, goldsmith.	1743, 1744
Strand;	RICHARD LASSELS, goldsmith.	1680–1694
near Hungerford market;	JOHN PEARSON, goldsmith.	1694–1698
	JOHN PEARSON & LANCELOT KEETE, goldsmiths.	1698
	LANCELOT KEATE, goldsmith.	1698–1716
	LANCELOT KEATE & THOMAS PEARSON, goldsmiths.	1699–1728
Suffolk street;	JOSEPH CRESWELL, toyman.	c. 1760
Swithin's lane, near the Post Office;	THOMAS FARREN, goldsmith.	1703–1741
Tothill street;	— HENRY, goldsmith.	1745–1751
Wood street, near Maiden lane;	WILLIAM SHAW & WILLIAM PREIST, goldsmiths.	1749–1758

UNICORN & BIBLE
Cheapside; JAMES SPITTIMBER, goldsmith. 1745

UNICORN & CROWN
Lombard street; — WINSTANLEY, goldsmith. 1751–1755

UNICORN & PEARL
Cheapside, near Queen street; THOMAS CHASSON, jeweller. 1732

UNICORN & RING [or GOLD RING]
Lombard street; ANDREW DOLTON, goldsmith. 1717, 1718
ARCHIBALD GILCHRIST, goldsmith & jeweller. 1731–1742

VINE
Lombard street;	SIR THOMAS VYNER, goldsmith & banker.	1623–1665
	CHARLES SHALES, goldsmith.	1693–1734
	SAMUEL SMITHIN, goldsmith.	1702
	SHALES & BOWDLER, goldsmiths.	1715
	THOMAS MINORS, goldsmith & banker.	1738
	MINORS & BOLDERO, goldsmiths & bankers.	1742–1760

VIZARD MASK [see also TWO VIZARDS MASKS & GOLDEN BALL]
Hewet's court, near St Martin's Church, Strand; THOMAS HENLEY, pawnbroker. 1704, 1705

WHEATSHEAF
Cheapside, upper end of; JOHN PARTRIDGE, goldsmith.	1691–1706
WILLIAM OWEN, goldsmith.	1720–1740
MRS MARY OWEN, goldsmith.	1745
Gutter lane; WILLIAM GOULD, silversmith.	1732
Tavistock street; — BOUCHER, goldsmith.	1736

WHEATSHEAF & ANCHOR
Gracechurch street [No. 37]; JOHN GILL, goldsmith. 1755–1768

WHEATSHEAF & CROWN
Lombard street; DENNIS LANGTON, goldsmith. 1709–1712

WHEATSHEAF & STAR
Cheapside; JOHN MALTON, goldsmith. 1716–1724
 THOMAS ALDWORTH, goldsmith. 1722

WHEEL BARROW
Crooked lane; BENJAMIN COOPER, goldsmith. 1725

WHITE BEAR
King street, Cheapside, near Guild-Hall; CATHERINE HUNTER, toyman & jeweller. [N.D.]
Little Newport street; — MEELE, pawnbroker. 1720

WHITE HART
Foster lane; SIMON JOUET, goldsmith. 1739–1747
King street, Westminster; JAMES EALES, goldsmith. 1690–1710
 — EALES, goldsmith. 1714–1721
Knightsbridge; NICHOLAS BIRKHEAD, goldsmith & clock-maker. 1693
Ludgate street; EDWARD COLLINS, pawnbroker. 1715

WHITE HORSE
Fleet street, near Fleet bridge; THOMAS ISSOD, goldsmith. 1690–1697
 SETH LOFTHOUSE, goldsmith. 1712–1722
 THOMAS BURGESS & SETH LOFTHOUSE, goldsmiths. 1719
Little Tower hill; — GARDNER, pawnbroker. 1754
Lombard street; JAMES ST JOHN, goldsmith. 1687–1695
 SAMUEL LAYFIELD, goldsmith. 1694–1697
 facing Lloyd's Coffee-house;
 THOMAS GLEGG & SAMUEL VERE, goldsmiths & bankers. c. 1730–1734
London bridge; JOHN BODY, silversmith. 1722

WHITE LION
Lombard street; SIR MARTIN BOWES, goldsmith. 1524–1566
Strand, against Bull Inn court; HUGH NORTH, goldsmith. 1698–1703

WHITE SWAN
Foster lane; GEORGE MORRIS, goldsmith & enameller. 1751–1752

WINDSOR CASTLE
Charing Cross; DAVID WILLAUME, goldsmith & banker. 1686–1690

VII

A LIST OF
THE LONDON GOLDSMITHS, JEWELLERS,
BANKERS AND PAWNBROKERS
UP TO THE YEAR 1800,

SETTING OUT THEIR NAMES,
ADDRESSES AND DATES

A LIST OF
THE LONDON GOLDSMITHS, JEWELLERS, BANKERS
AND PAWNBROKERS

ABBAT JOHN, *goldsmith*; Castle Baynard ward. 1583
ABBISS (or ABBIAS) ROBERT, *goldsmith*; parish of St Mary Woolnoth. 1686–1700
ABBOT PETER, *jeweller*; London. (Died) 1725
ABBOTT JOHN, *goldsmith*; Birchin lane. 1706–1720
ABBOTT JOHN, *silversmith*; 28 St James's street. 1790–1793
ABDY — (see NICHOLL & ABDY).
ABDY STEPHEN & JURY WILLIAM, *goldsmiths*; Lily Pot lane. 1759
ABDY WILLIAM, *haft and hilt-maker, goldsmith*; Noble street. 1763
 (No. 5) Oat lane, Noble street near Cheapside. 1765–1817
ABEL EDMUND, *goldsmith*; parish of St Botolph, Bishopsgate. 1641
ABEL EDWARD, *goldsmith*; parish of St Peter's, Cornhill. 1650–1660
ABEL RICHARD, *goldsmith, engraver to the Mint*. 1243
ABERCROMBIE ROBERT, *plate-worker*; St Martin's-le-Grand. 1731–1743
ABERCROMBIE ROBERT & HINDMARSH GEORGE, *plate-workers*; Christopher's Court,
 St Martin's-le-Grand. 1731
ACHESON JAMES, *goldsmith*; parish of St Helen's, Bishopsgate. 1605
ACHURCH —, *silversmith*; Bishop's Head, Little Old Bailey. 1733
ACTON — (see STEVENSON & ACTON).
ACTON JOHN, *goldsmith*; parish of St Mary Woolnoth. 1601–(Deceased) 1638
ACTON JOHN, *goldsmith*; Cheapside. 1642
 Parish of St Faith [under St Paul's]. (Will proved) 1648
ACTON WALTER, *goldsmith*; London. 1717
ACUTT JOHAN, *goldsmith*; Fleet street. 1680
ADAM (or ADAMS) CHARLES, *plate-worker*; Foster lane. 1702–1710
ADAM (or ADAMS) RICHARD, *goldsmith*; parish of St Mary Woolnoth. 1616–1648
ADAMS — (see GRIFFIN & ADAMS).
ADAMS C. & J., *goldsmiths, jewellers & hardwaremen*; No. 10 King street, Cheapside. 1784–1793
ADAMS Jos. (cf. C. & J. ADAMS), *goldsmith*; London. 1772–1779
ADAMS NICHOLAS, *goldsmith*; parish of St Peter, Westcheap. (Buried) 1542
ADAMS RICHARD, *goldsmith*; Black Horse, near Northumberland House, Strand. 1682–(Bankrupt) 1712
ADAMS STEPHEN, *plate-worker*; Lily Pot lane. 1760
ADAMS STEPHEN, *silversmith*; St Ann's lane. 1784
ADAMS STEPHEN (the younger), *goldsmith*; St Ann's lane. 1791–1799
ADAMS STEPHEN & SON, *goldsmiths*; St Ann's lane, Foster lane. 1790–1796
ADDIS GEORGE, *goldsmith & watchmaker*; 79 Cornhill. 1790–1793
ADDIS GEORGE, *goldsmith & watchmaker*; 3 Birchin lane, Cornhill. 1790–1796
ADDIS JOHN & CO., *goldsmiths*; Sun, Lombard street. 1677–1685
ADDIS JOHN & SON, *goldsmiths*; Sun, Lombard street. (Bankrupt) 1683
ADDIS WILLIAM, *goldsmith & watchmaker*; 3 Birchin lane. 1755–1784
ADE —, *the King's goldsmith*; London. 1300

LONDON GOLDSMITHS

ADIS JOHN, *goldsmith*; parish of St John Zachary. 1400–(Died) 1461

ADNEY RICHARD, *pawnbroker*; Three Golden Balls, Little St Andrew's, near Seven Dials. 1731

ADTHERTON JOHN, *goldsmith*; parish of St Mary Woolnoth. (Buried) 1664

ADYS JOHN, *goldsmith*; parish of St John Zachary. 1450–(Buried) 1461

ADYS MILES (successor to JOHN ADYS); London. 1478–1492

AGARD THOMAS, *goldsmith*; parish of All Hallows, Bread street. (Will proved) 1638

AHEARNS S., *goldsmith*; Laurence Pountney hill. 1677

AIME PETER, *jeweller*; parish of St Martin's-in-the-fields. 1709

AINELL JOHN, *silversmith*; Little Britain. 1766

AKED WILLIAM, *goldsmith*; Paternoster row. 1772

ALANSON JOSEPH, *watchcase maker*; Oxford Arms passage, [Warwick lane]. 1778

ALBERT —, *silversmith*; Bell & Magpie, Bishopsgate Without. 1733

ALCHORNE CHARLES, *goldsmith*; Three Candlesticks, Foster lane. 1729–1734

ALCOCK JOHN, *goldsmith*; Cripplegate. 1734–1743

ALDERHEAD JOHN, *working goldsmith*; Ring & Pearl, Bishopsgate street, near South Sea House. 1750–1766

ALDERHEAD JOHN, *goldsmith, jeweller & watchmaker*; Ring & Pearl, No. 114 Bishopsgate street. 1768–1794

ALDERHEAD JOHN, *goldsmith*; Bethnal Green. 1792

ALDEWYN NICHOLAS, *goldsmith*; London. 1540–1553

ALDRIDGE CHARLES, *plate-worker*; Aldersgate street. 1772–1786

ALDRIDGE CHARLES, *goldsmith*; Falcon street, Aldersgate street. 1790–1793

ALDRIDGE CHARLES & ANDREWS ELIZABETH, *goldsmiths*; Cornhill. (Dissolved partnership) 1793

ALDRIDGE CHARLES & GREEN HENRY, *goldsmiths*; London, 1737. Aldersgate street. 1773–1777

ALDRIDGE CHARLES & GREEN HENRY, *plate-workers & silversmiths*; No. 62 St Martin's-le-Grand. 1775–1784

ALDRIDGE EDWARD, *working goldsmith*; Golden Ewer, Lilly-pot lane, in Noble street, near Goldsmiths' Hall. [Removed to Foster lane 1743.] 1739–1743

ALDRIDGE EDWARD, *working goldsmith*; Golden Ewer, Foster lane, Cheapside. 1743–(after 1762) London. 1763–1765

ALDRIDGE EDWARD [JUNIOR], *goldsmith*; Golden Ewer, Foster lane. 1762
Removed to George street, St Martin's-le-Grand. 1762–1766

ALDRIDGE EDWARD [SENIOR] & EDWARD [JUNIOR], *goldsmiths*; Golden Ewer, Foster lane. (Partnership dissolved)[1] 1762

ALDRIDGE EDWARD, *goldsmith*; Bishopsgate. 1781

ALDRIDGE EDWARD & STAMPER JOHN (cf. JOHN STAMPER), *plate-workers*; London. 1753–1757

ALDWORTH THOMAS, *goldsmith*; Wheatsheaf & Star, Cheapside. 1721, 1722

ALESTRE (or ALESTRY) PAUL, *goldsmith*; St Martin's lane. 1677

ALEXANDER —, *pawnbroker*; Three Golden Balls, Fleet Market. 1759

ALEXANDER JOHN, *goldsmith & pawnbroker*; 20 Haymarket. 1790–1796

ALEXANDER WILLIAM, *plate-worker*; Anchor & Key, Wood street. 1742

ALEXANDER & SHRIMPTON, *goldsmiths*; Anchor & Key, Wood street. 1768

ALEY GEORGE, *goldsmith*; parish of St Vedast, Foster lane. (Buried) 1587

ALEYN GILES, *goldsmith*; Fleet bridge. 1634–(Will proved) 1652

[1] E. Aldridge senior remained at Foster lane and his son removed to George street, St Martin's-le-Grand.

(94)

Plate I

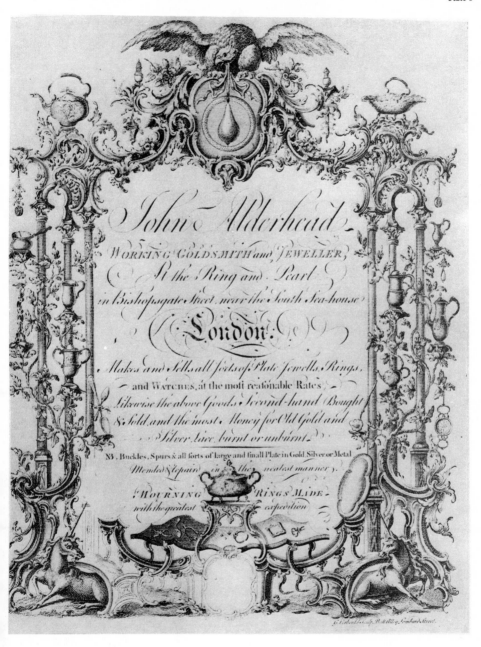

John Alderhead

WORKING GOLDSMITH and JEWELLER,
At the Ring and Pearl
in Bishopsgate Street, near the South Sea-house

London

Makes and Sells all sorts of Plate, Jewells, Rings,
and Watches, at the most reasonable Rates.
Likewise the above Goods Second-hand Bought
& Sold, and the most Money for Old Gold and
Silver lace, burnt or unburnt.

N.B. Buckles, Spurs & all sorts of large and small Plate in Gold, Silver or Metal
Mended & Repaired in the neatest manner.

MOURNING RINGS MADE
with the greatest expedition

JOHN ALDERHEAD 1750–1766

Plate II

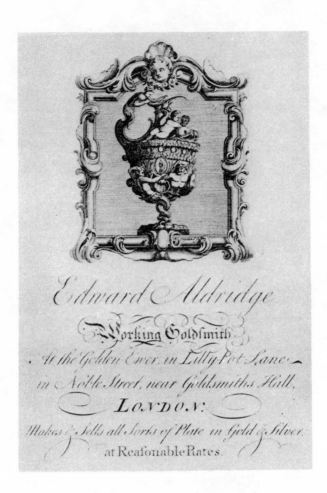

EDWARD ALDRIDGE 1739–1765

ALLARD Augustus, *goldsmith*; Kings street. 1677
ALLASON Robert, *goldsmith*; between Mitre Tavern and Aldgate. 1707–(Bankrupt) 1709
ALLDERIDGE William, *goldsmith*; Blackmoor's Head, Fetter lane. 1751
ALLDRIDGE (or ALLDERIDGE) William, *goldsmith*; Blackmoor's Head, Red Lyon Passage,
 Holborn. 1770–1773
ALLEINE Jonathan, *plate-worker*; Fenchurch street. 1772–1778
ALLEN —, *pawnbroker*; Three Blue Balls, Petticoat lane. (Leaving off trade) 1745
ALLEN Henry, *goldsmith*; parish of St Vedast, Foster lane. (Will proved) 1622
ALLEN (or ALLYN) James, *goldsmith*; parish of St Mary Woolnoth. 1572–1589
ALLEN James, *plate-worker*; Chancery lane. 1766–1771
ALLEN John, *goldsmith*; London. 1516
ALLEN John, *goldsmith*; Bull Head court, Wood street. (Bankrupt) 1743
ALLEN John, *watchcase maker & plate-worker*; Carthusian street. 1761–1772
ALLEN John, *plate-worker*; Chancery lane. 1766
ALLEN John, *working goldsmith*; (No. 42) Poultry, corner of Old Jewry. 1769–1779
ALLEN Jos. & FOX Mordecai, *plate-workers*; Sun, St Swithin's lane. 1729–1743
ALLEN Thomas, *goldsmith*; parish of St Vedast. 1679
ALLEN Thomas, *goldsmith*; London. 1697–1716
ALLEN Thomas, *goldsmith*; Gutter lane. 1697
ALLEN William, *silversmith*; Gutter lane. 1780
ALLEN William, *silver buckle-maker & jeweller*; No. 92 Strand, near Beaufort buildings. 1781–1793
ALLEN William, *goldsmith*; Strand. (Bankrupt) 1785
ALLEN William, *goldsmith*; Noble street. 1800
ALLEYN Richard, *goldsmith*; London. 1531–1553
ALLEYN Robert, *goldsmith*; London. 1528–1553
ALLEYNE J., *goldsmith*; London. 1569–1570
ALLIN Samuel, *jeweller*; Red Lion court, Silver street, near Wood street. 1726
ALLISON Robert (cf. Robert ALLASON), *goldsmith*; Minories near Aldgate.
 (Bankrupt) 1714–1734
ALLIX —, *silversmith*; Half Moon, Porter street, Soho. 1731
ALLONEAU Isaac, *goldsmith*; West street. 1729–1730
ALSOP Robert, Sir, *goldsmith*; London. 1750–1752
ALSOP Thomas, *goldsmith*; London. 1653
ALSOPP John, *goldsmith*; parish of St Vedast, Foster lane. 1560–(Buried) 1563
ALLSOPPE W., *goldsmith*; London. 1569
ALLYN James (see ALLEN).
ALSTON Thomas, *goldsmith*; Clare market. (Bankrupt) 1721
ALWYN FitzHenry,[1] *goldsmith*; London. 1189–1213
ALYN (or ALLEYNE) John, *goldsmith*; London. 1465–1486
AMADAS Robert, *goldsmith to Cardinal Wolsey*; parish of St Mary Woolnoth. 1494–(Buried) 1532
AMBER Norton (see GREEN & AMBER), *goldsmith & banker*; London. 1733
 Near Durham yard, Strand. 1745–1755
AMSON Edward, *goldsmith*; Rose, Fleet street. 1695–1706
AMSON Edward, *goldsmith & pawnbroker*; Gold Ring (or Ring), near Salisbury court in
 Fleet street. 1705–(Deceased) 1720

[1] The first Mayor of London and Provost of the City, 1189–1213.

AMY John, *goldsmith*; Black Boy, near the Gate, on London bridge. 1698–1714
ANDERTON Francis, *jeweller*; London. 1685
ANDEWERPE John, *goldsmith*; London. 1545
ANDREWS —, *goldsmith*; New Bond street. 1796
ANDREWS Abraham, *jeweller*; Bank Coffee House, Threadneedle street. 1760
ANDREWS Eliza (or Elizabeth) (cf. Thomas ANDREWS), *goldsmith & watchmaker*;
 85 Cornhill. 1790–1808
ANDREWS George, *plate-worker*; Red Lion street, Clerkenwell. 1763–1773
ANDREWS George, *goldsmith*; (formerly of Moorfields), Whitecross street. (Bankrupt) 1769
ANDREWS Gervase, *goldsmith*; parish of St Peter's, Cheapside. 1641
 London. (Will proved) 1654
ANDREWS Richard, *jeweller*; Little Britain. 1744
ANDREWS Richard, *goldsmith*; Leadenhall street. 1773
ANDREWS Robert, *goldsmith*; London. 1580
ANDREWS Robert, *plate-worker*; Gutter lane. 1745
ANDREWS Robert, *gold-worker*; 13 Little Wild street. 1793
ANDREWS Thomas (cf. Eliza ANDREWS), *goldsmith & jeweller*; No. 85 Cornhill, three
 doors from the Royal Exchange. c. 1780
ANDREWS William, *plate-worker*; Mugwell street. 1697–1707
ANGIER Bernard, *silversmith*; parish of St Margaret's Westminster. (Married) 1675
ANNESLEY Arthur, *plate-worker*; Heathcock street (? = Heathcock court, Strand). 1758–1762
ANSELL (or ANSILL) James, *goldsmith*; Panton street. 1768–1772
ANTHONY Charles, *goldsmith*; parish of St John Zachary. (Married) 1593
ANTHONY Derick, *goldsmith*; parish of St Mary Woolnoth. 1550
ANTHONY Thomas, *goldsmith*; parish of St John Zachary. (Will proved) 1618
ANTT George, *goldsmith & jeweller*; Case of Knives, No. 158, South side of the Strand, six
 doors from Somerset House, opposite the New Church. 1770–1784
APPLETON Nathaniel, *silversmith*; Aldersgate street. 1773–1786
APULTON Richard, *goldsmith*; London. 1509–1516
AQUANUS Cornelius, *goldsmith*; parish of St Michael's, Cornhill. (Married) 1583
ARCH William, *goldsmith*; Globe, Lombard street. 1707
ARCH William & ROBINSON Benjamin, *goldsmiths & bankers*; Globe, Lombard street. 1703–1708
ARCHAMBO Peter, *plate-worker*; Golden Cup, Green street, Leicester square. 1720–1722
 Removed to Heming's row [St Martin's lane]. 1722
 Golden Cup, Coventry street. 1739–(Died) 1767
ARCHAMBO Peter [Junr.], *plate-worker*; Golden Cup, Coventry street.
 (Apprenticed) 1738–(Died) 1768
ARCHAMBO Peter [Junr.] & MEURE Peter, *plate-workers*; Golden Cup, Coventry street.
 1749–1755
ARCHBOLD Francis, *plate-worker*; Foster lane. 1697–1702
 London. 1724
ARCHER — (see HOW, MASTERMAN & ARCHER also MASTERMAN & ARCHER),
 goldsmith. 1768
ARCHER Andrew, *plate-worker*; Fleet street. 1703
ARCHER Andrew, *plate-worker*; Rod & Crown, St Bride's lane, Fleet street. 1710–(Deceased) 1725
ARCHER Josias, *goldsmith*; parish of St Saviour's, Southwark. 1662–(Died) 1668
ARDESOIF Abraham, *jeweller*; Golden Ball, Charing cross. 1762

ARDESOIF ISAAC, *jeweller*; near Bride lane, Fleet street. 1747

ARDESOIF STEPHEN, *goldsmith & jeweller*; Fountain court, Strand. 1756–1773

ARDESOIF STEPHEN, *goldsmith & jeweller*; Golden Cup, on the New Pavement, Charing cross.
1762–1765

AREY —, *goldsmith*; Panton street, near Panton square. 1748

ARMES JAMES, *goldsmith*; Christchurch, within Aldgate. 1578

ARMSTRONG JOSEPH, *jeweller*; 18 and 19 Paternoster row. 1790–1793

ARNELL HUGH, *plate-worker*; King street, Soho. 1734

ARNELL JOHN, *goldsmith*; Little Britain. 1773–1780

ARNETT HUGH (cf. — ARNOLD), *plate-worker*; Foster lane. 1719

ARNETT HUGH & POCOCK EDWARD, *goldsmiths*; London. 1719–1724

ARNOLD — (cf. HUGH ARNETT), *goldsmith*; Foster lane. 1714

ARNOLD —, *goldsmith*; near Gray's Inn Gate, Holborn. 1755

ARNOLD DAVID, *pawnbroker*; Cheshire Cheese, Vinegar yard, Drury lane. 1712

ARNOLD HENRY, *goldsmith* (see SHERE & ARNOLD); No. 46 Lombard street. 1760–1793

ARNOLD RICHARD, *goldsmith*; parish of St Bartholomew. 1642–(Will proved) 1644

ARNOLD THOMAS, *plate-worker*; London Wall. 1770–1772

ARNOLDE GODFREY, *jeweller*; Aldersgate ward. 1618

ARNOLE JOHN, *goldsmith*; Little Britain. 1770

ARTHUR JOHN, *jeweller*; 31 Surrey street, Strand. 1790–1793
9 Howard street, Strand. 1796

ARTHUR JOSEPH, *goldsmith*; Bull, Charterhouse lane. 1653

ASH FRANCIS, *goldsmith*; London. 1634–(Died) 1660

ASH THOMAS, *goldsmith*; London. 1652–1697
Steyning lane. 1697–1712

ASHFORTH WILLIAM, *silversmith*; Bartholomew close. 1784

ASHLEY —, *goldsmith*; London. 1509–1516

ASHLEY JECONIAH, *goldsmith*; Golden Acorn, over against the New Church in the Strand.
(Died) 1744

ASHLEY JEREMIAH, *plate-worker*; Green street. 1740

ASHMAN JOHN, *pawnbroker*; Golden Ball, Brownlow street, Drury lane. (Giving up trade) 1700

ASHTON WILLIAM, *goldsmith*; Lombard street. (Insolvent) 1743

ASKE ROBERT, *goldsmith*; London. 1561–1583

ASKEW —, *goldsmith*; Barbican. 1730

ASKEW RICHARD, *goldsmith*; White Horse yard, Aldersgate ward. 1692

ASPINSHAW JOHN, *plate-worker*; Whitechapel. 1763

ASPLIN RICHARD, *goldsmith*; London. 1529

ATKINS —, *pawnbroker*; (late of) Broad street, Carnaby market. 1747

ATKINS JAMES, *silver buckle maker*; 12 Well street, Cripplegate. 1796

ATKINS THOMAS, *pawnbroker*; Three Blue Balls, Brownlow street, Drury lane. 1745

ATKINSON CHRISTOPHER, *plate-worker*; Foster lane. 1707–(Died) 1753

ATKINSON MATTHEW, *goldsmith*; Strand. 1693

ATKINSON POWELL, *goldsmith*; High Holborn. (Died) 1747

ATKINSON THOMAS, *goldsmith*; parish of St Mary Woolnoth. (Married) 1610–1617

ATKINSON W., *goldsmith*; Sun, Cheapside. 1744

H

ATKINSON WILLIAM, *silversmith*; Golden Cup, New Fish street hill.	1725
London.	1736
ATTHOW CHRISTOPHER, *goldsmith*; St Mary, Savoy.	1674
ATTLEBOROUGH JOHN, *jeweller*; Crown and Pearl, Cannon street.	1747
ATTWELL WILLIAM & CO-PARTNERS, *goldsmiths*; Exchange alley, Lombard street.	1687–1711
ATTWELL WILLIAM & COURTNEY ADRIAN, *silversmiths*; Griffin, Exchange alley.	1687–1705
ATTWELL (or ATTWILL) & HAMMOND, *goldsmiths & bankers*; Griffin, Exchange alley.[1]	
	1714–(Failed) 1722
AUBIN HENRY, *plate-worker*; Prince's court, Lothbury.	1700
AUGIER THOMAS, *goldsmith*; Brownlow street.	1773
AUMONIER PETER, *goldsmith*; St Anne's, Westminster.	1727
AUSTEN DANIEL, *goldsmith*; Foster lane.	(Will proved) 1656
AUSTIN JAMES, *goldsmith*; Fenchurch street.	1661
AUSTIN JOHN, *goldsmith*; Star, Fenchurch street.	1664–1670
AUSTIN WILLIAM, *goldsmith*; London.	1439
AUTEN (or AUTIN) WILLIAM, *jeweller*; Aldersgate ward.	1618
AVELINE —, *goldsmith*; Blue Ball, Tower street, Seven Dials.	1726
AVELINE SAMUEL, *goldsmith*; St Martin's-in-the-fields.	1709–1711
AVENON WILLIAM, *goldsmith*; parish of St Catherine Cree.	(Will proved) 1631
AVERELL HENRY, *goldsmith*; London.	1523–(Died) 1540
AYRES THOMAS, *goldsmith & jeweller*; 160 Fenchurch street.	1790–1796
AYRES WILLIAM, *goldsmith*; Bishopsgate street.	1779
AYSCOUGH JAMES, *jeweller & goldsmith*; Ludgate street.	1775
AYSCOUGH RALPH, *ring-maker & goldsmith*; removed from Old Change, Cheapside.	1753
Ring & Pearl, Ludgate, south side of St Paul's Churchyard.	1753–1765
No. 18 Ludgate street (same house as above).	1766–1777

BABINGTON, H., *goldsmith*; London.	1613–1664
BACH (or BACK) JOHN (cf. JOHN BACKE), *working goldsmith*; parish of St Mary Woolnoth.	
	1688–1701
BACKE (or BACHE) JOHN (cf. JOHN BACH also DENNY & BACKE), *plate-worker*; Dove	
court, Lombard street.	1700–1729
BACKHOFFNER ANDREW, *jeweller*; 111 Strand.	1777
105 Strand.	1779
BACKWELL EDWARD,[2] *goldsmith & banker*; Unicorn, south end of Exchange alley, between	
the Grasshopper and the White Horse, Lombard street. 1650–(Bankrupt) 1672. (Died) 1683	
BACKWELL, DAREL, HART & CROFT (cf. CROFT & BACKWELL), *goldsmiths*;	
Pall Mall.	1756
BADCOCK W.[3], *goldsmith*; London.	1677
BAGDALE — (see RAGDALE).	
BAGFORD JOHN, *goldsmith*; Shoe lane, near the Angel.	(Married) 1699
BAGGS HENRY, *goldsmith*; parish of St Martin, Vintry.	1651–1658

[1] ATTWELL & CO. failed after the collapse of the South Sea Bubble. In 1720 Gay in his letter to Snow the goldsmith wrote: "And Atwell's self was drained of all his hoards".

[2] In Pepys's *Diary* there are twenty-six references to him.

[3] Author of *A Touch-stone for Gold and Silver Wares*, by W. B. of London, goldsmith. First edition published 1677.

BAGNALL William, *plate-worker*; West Smithfield. 1744
BAILEY —, *goldsmith*; Golden Ball, Foster lane. 1721
BAILEY Henry, *plate-worker*; Foster lane. 1750–1760
BAILY —, *goldsmith*; Gutter lane. (Married) 1730
BAILY (or BAYLEY), John, *goldsmith*; Sceptre & Crown [or Crown & Sceptre], at yᵉ upper end
of Lombard street. 1707–1715
BAINBRIDGE Mary, *plate-worker*; Oat lane. 1707
BAINBRIDGE William, *goldsmith*; London. 1690 (?)
BAIRD John, *jeweller & watch-maker*; 190 Strand. 1779
BAKER —, *silversmith*; Acorn, near the Monument. 1732
BAKER Francis, *goldsmith & jeweller*; Threadneedle street. 1731
Behind the Royal Exchange. 1732
Poultry. (Died) 1740
BAKER George, *goldsmith*; parish of St Martin's-in-the-fields. (Will proved) 1621
BAKER George, *plate-worker*; Bell court, Foster lane. 1724–1750
BAKER James, *goldsmith*; London. 1758
New court, Bunhill row. 1773
BAKER James, *buckle-maker*; Northampton court. 1789
BAKER James, THE YOUNGER, *buckle-maker*; Northampton court. 1791
BAKER John, *plate-worker*; Old Bailey. 1770
BAKER Lancelot, *goldsmith*; Aldersgate ward. 1692
Parish of St Katherine Creechurch. 1695
BAKER Pointer, *plate-worker*; Compton street, Soho. 1773
BAKER Richard, *silversmith*; formerly of St Alban's, Wood street; late of Cork, Ireland.
(Insolvent) 1769
BALCOMB — (see WOLDING & BALCOMB).
BALDREY Robert, *goldsmith*; Wapping. (Will proved) 1655
BALDRYE William, *goldsmith*; parish of St Mary Staining. (Married) 1595
BALL Anthony, *pawnbroker*; Rose, Belton street, near Long Acre. 1731
BALL John, *pawnbroker*; Golden Ball, Upper Moorfields. (Left off trade) 1725
BALL Robert, *goldsmith*; parish of St Mildred, Bread street. (Will proved) 1631
BALLANTINE William, *working goldsmith*; 16 St Martin's-le-Grand. 1790–1796
BALLARD —, *jeweller*; Pall Mall. 1752
BALLARD John, *goldsmith & banker*; Lombard street. 1677–(Bankrupt) 1694
BALLETT John, *goldsmith*; parish of St Vedast, Foster lane. (Buried) 1595
BALLETT Richard, *goldsmith*; parish of St Vedast, Foster lane. (Buried) 1587
BALLETT Thomas, *goldsmith*; parish of St Margaret, Westminster. (Will proved) 1627
BALLIN Isaac, *jeweller*; 20 Swan street, Minories. 1790–1793
BALLISTON William & John, *silver & brass casters*; Golden Eagle, Rupert street, St James's. [N.D.]
BALLY Peter, *goldsmith*; Queenhithe ward. 1583
BAMBRIDGE William, *plate-worker*; Whitechapel. 1697–1703
BAME Harre (cf. Henry BAMME), *goldsmith*; Warden of Goldsmiths' Company. 1380
BAMFORD Thomas, *plate-worker*; Gutter lane. 1719–1720
Foster lane. 1739
BAMFORD Thomas, *plate-worker*; St Clement's lane, Strand. 1773
BAMME Adam, Sir¹, *goldsmith*; parish of St George, Botolph lane. 1382–(Died) 1397

¹ Twice Mayor of London, 1390–1 and 1396–7.

(99)

BAMME HENRY (cf. HARRE BAME), *goldsmith*; Compter alley. 1383–(Will enrolled) 1416

BAMPTON THOMAS, *goldsmith*; London. 1567–1569

BANCKES HUMPHREY, *goldsmith*; London. 1630

BANCKS THOMAS, *goldsmith*; parish of St Vedast, Foster lane. (Buried) 1594

BANGOR JOSEPH, *jeweller*; York buildings [Strand]. 1764

BANKES ALLEN, *goldsmith*; St Peter & the Keys, St Paul's churchyard. 1672

BANKS THOMAS, *goldsmith*; parish of St Vedast, Foster lane. (Buried) 1626

BANISTER HENRY, *goldsmith*; parish of St Pancras, Soper lane. 1609–(Died) 1628

BANISTER THOMAS, *goldsmith*; London. 1519

BANNISTER R., *goldsmith, silversmith & jeweller*; 17 Bridges street, Covent garden. 1796

BANY JOHN, *goldsmith*; parish of St Clement Danes. c. 1641

BANYARD JOHN, *goldsmith*; London. 1509

BARANTYN DRUE, *goldsmith*; Chantry of St John Zachary. 1461

BARBE JOHN, *plate-worker*; West street, Seven Dials. 1735–1773
 St Andrew's street. 1742

BARBER —, *goldsmith*; Turk's Head, Lombard street. 1744

BARBER GABRIEL, *goldsmith*; parish of St Mary Woolnoth. 1607, 1608

BARBER GABRIEL, *goldsmith*; London. 1717–1739

BARBER, JAMES, *plate-worker*; Bond street. 1773

BARBER SAMUEL, *jeweller*; No. 5 Angel street, St Martin's-le-Grand. c. 1780

BARBER WILLIAM, *jeweller & goldsmith*; 39 Cornhill. 1784–1793

BARBITT J., *goldsmith*; London. 1739

BARBITT JAMES, *plate-worker*; New street, Covent Garden. 1703–1720

BARBITT JOSEPH, *plate-worker*; New street, Covent Garden. 1703–1717

BARBOT —, *silversmith*; Blackamoor's Head, Broad street, St Giles. 1726

BARBOT JOHN, *goldsmith*; Golden Lion, Great St Andrew's street, Seven Dials. 1751

BARBOT JOHN & SON, *goldsmiths*; Great St Andrew's street, Seven Dials. 1765

BARBOT PAUL, *goldsmith*; Great St Andrew's street, Seven Dials. 1768–1779

BARBOT PAUL, *goldsmith*; Tottenham court, New road. 1790–1793

BARBUT —, *silversmith*; New street, near St Martin's lane. 1720

BARBUT JOSEPH, *goldsmith*; St Martin's-in-the-fields. (Married) 1690

BARCLAY, JAMES (see FREAME & BARCLAY), *goldsmith & banker*; Black Spread Eagle, Lombard street. 1736

BARDOLPH JOHN, *goldsmith*; London. 1553

BARENTYNE DRUGO, Sir,[1] *goldsmith*; against Goldsmiths' Hall, Foster lane. 1393–(Buried) 1415

BARIL BERCHER, *jeweller*; Tokenhouse yard. 1753–1755
 At Mrs Parkerson's in New court, Throgmorton street. 1760
 [No. 29] Prince's street, near the Mansion House. 1763–1770

BARIL LEWIS, *jeweller*; at the Green Rails, upper end of Tokenhouse yard. 1721–1760

BARKER —, *jeweller*; next door to the arch in St Paul's churchyard. 1728

BARKER GEORGE, *goldsmith*; parish of St John's, Walbrook. (Married) 1581

BARKER GEORGE, *jeweller*; Blue Spikes, Lime street. 1724

BARKER GEORGE, *jeweller*; next to Dean's court, St Paul's churchyard. 1730
 Gutter lane. 1736

BARKER GEORGE, *jeweller*; Southampton street, Covent Garden. 1744

[1] Twice Mayor of London, 1398–9 and 1408–9. He re-built the Goldsmiths' Hall in 1407.

BARKER George, *goldsmith*; Bow street, Covent Garden. 1755

BARKER John, *goldsmith*; London. 1469–1481

BARKER John, *goldsmith*; Broad street. 1642
 London. 1650–(Died) 1659

BARKER John, *goldsmith*; Morocco Ambassador's Head, Lombard street. 1725–(Bankrupt) 1755

BARKER John (see STAMP & BARKER).

BARKER John & SON, *goldsmiths*; Lombard street. 1747

BARKER Joseph, *plate-worker*; Strand. 1746
 Great Russell street, Bloomsbury. 1748

BARKER Robert, *goldsmith*; Gutter lane. 1789

BARKER Samuel, *silversmith*; Whitecross street. 1767
 Coversly's fields [? Coverlead's fields, Spitalfields]. 1778

BARKER Susannah, *working goldsmith*; No. 29 Gutter lane. 1790–1793

BARKSHEAD (or BARKSTEAD) Michael, *goldsmith*; parish of St Clement Danes. 1620–1641

BARKSTEAD John, Sir,[1] *goldsmith*; Strand. ? before 1645
 London. 1645–(Executed) 1662

BARLOW —, *silversmith*; Blackamoor's Head, Barbican. 1743

BARLOW Henry, *goldsmith & jeweller*; Three Golden Anchors, next door to the Crown &
 Magpie, near Whitechapel Bars. 1747

BARLOW Henry & CO., *goldsmiths*; No. 23 Aldgate Without. 1770–1772

BARLOW Theophilus, *silversmith*; Windmill court, Pye corner. (Insolvent) 1720

BARNABE Gregory, *goldsmith*; London. 1602

BARNARD Edward, *goldsmith*; Amen corner. 1791–1795

BARNARD John, *goldsmith*; London. c. 1450

BARNARD John, *plate-worker*; Gutter lane. 1720

BARNARD Thomas, *goldsmith & jeweller*; 77 Strand, near Adelphi. 1784
 72 Strand. 1790–1796

BARNARD Thomas & SAVORY Joseph (see Joseph SAVORY), *goldsmiths*; Adam street,
 Adelphi. (Partnership dissolved 1781.
 T. Barnard continues business.) 1779–1781

BARNES —, *jeweller*; Upper Moorfields. 1731

BARNES Christopher, *silversmith*; Wine Office court. 1792

BARNES Joel, *silversmith*; Duke street, West Smithfield. 1790–1793
 Wine Office court. 1794

BARNES John, *goldsmith*; parish of St Mary Woolnoth. (Buried) 1540

BARNES John, *goldsmith*; parish of St Clement Danes. c. 1641

BARNES John, *jeweller*; Crane court. 1770

BARNES Samuel, *pawnbroker*; Blue Boat, Ratcliffe highway. 1710

BARNES William, *goldsmith*; by Ludgate, on Ludgate hill. 1702–1731

BARNES William, *pawnbroker*; Three Bowls, Fetter lane. 1717

BARNESTEY William, *goldsmith*; Foster lane. 1768

BARNET Alexander, *plate-worker*; [? St Bride's Church, near Fleet ditch]. 1759
 London. 1777

BARNET Edward, *plate-worker*; Tooley street. 1715–1718

BARNS A., *silversmith*; 3 Duke street, Smithfield. 1796

BARNS William, *silversmith*; Old Swan yard, Clerkenwell. 1723

[1] Regicide, see p. 6.

(101)

BARNSLEY WILLIAM, *silversmith*; Bond street. 1776

BARONS JOHN, *goldsmith*; London. 1540–1553

BARRAS JOSHUA, *goldsmith*; London. 1720

BARRE GILES, *brooch-maker*; in the Fleet. 1564

BARRETT EDWARD, *goldsmith*; London. 1720

BARRETT JOHN, *goldsmith*; London. (Bequest) 1511

BARRETT JOHN, *plate-worker*; Castle street. 1737

BARRETT JOHN, *plate-worker*; Feathers court, Holborn. 1739

BARRETT — (? JOSEPH), *goldsmith*; Spotted Dog, Cheapside. 1728

BARRETT JOSEPH, *goldsmith*; Three Kings, Cheapside. 1724–1731
 Three Kings & Spotted Dog, near Old Change, Cheapside. (Died) 1744

BARRETT PHINEAS, *goldsmith*; St Bartholomew's. 1789

BARRETT ROBERT, *pawnbroker*; Three Balls, Holles street, Clare market.
 (Succeeded Wm. Carter) 1752

BARRETT THOMAS, *pawnbroker*; Golden Lion, near the Playhouse, in Drury lane.
 (Left off trade) 1701

BARRETT WILLIAM, *goldsmith*; Addle street. 1771

BARRETT WILLIAM, *working silversmith & clock-maker*; 50 Aldersgate street. 1777–1793

BARRETT WILLIAM, *jeweller*; 15 Charterhouse street. 1790–1796

BARRIER ABRAHAM, *plate-worker*; Rathbone place. 1775
 London. 1785

BARRIER ABRAHAM & DUCOMMIEU (or DUCOMMON) LOUIS, *spoon-makers*; Rathbone
 place. 1773–1778

BARRINGTON — (? VALENTINE), *goldsmith*; Rose & Crown, Cheapside. 1695–1697

BARROW JOHN, *goldsmith*; Tottenham Court road. 1773

BARRY JOHN, *plate-worker*; Crown & Thistle, Lombard street. 1747
 Paternoster row. 1758

BARRY ST JOHN, *goldsmith & jeweller*; No. 3 Minories. 1777–1784
 No. 135 Leadenhall street. 1789–1793

BARTHELMY JAMES, *French jeweller & goldsmith*; Charing Cross. 1735

BARTHOLOMEW NICHOLAS, *goldsmith*; London. 1545–1569

BARTHOLOMEW THOMAS, *goldsmith*; Fleet street. 1696

BARTON ANDREW, *goldsmith*; parish of St Agnes and St Anne, Aldersgate. 1617

BARTON THOMAS, *goldsmith*; Cheapside. 1755–1760

BARWELL EDWARD, *goldsmith*; London. 1668

BASENIRE (or BISMERE) WILLIAM, *goldsmith*; London. 1443–1455

BASKERVILLE GEORGE, *plate-worker*; Shandoy [Chandos] street. 1738
 Cock street. 1745

BASKERVILLE GEORGE, *plate-worker*; Albion buildings [Bartholomew close]. 1773
 London. 1789–1792

BASKERVILLE GEORGE & MORLEY T., *plate-workers*; Albion buildings [Bartholomew
 close]. 1755–1775

BASKERVILLE GEORGE & SEMPEL WILLIAM, *plate-workers*; Clare market. 1755

BASSETT ARTHUR, *goldsmith*; parish of St Mary Woolnoth. 1609

BASSILL ANTHONY, *goldsmith*; Blackfriars. 1576

BASSINGWHITE J., *plate-worker*; Russell street. 1770

BASSY JONATHAN, *goldsmith*; London. 1697

Plate III

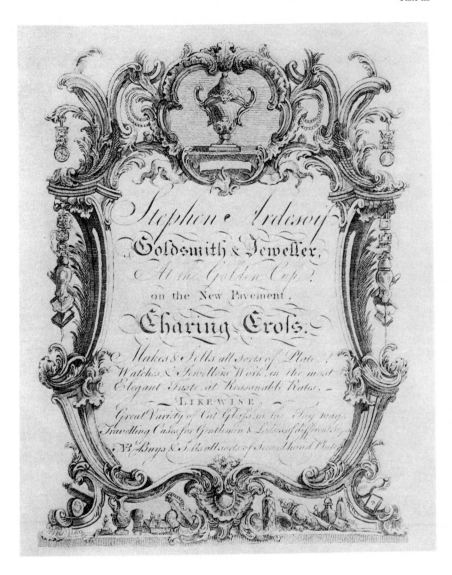

STEPHEN ARDESOIF 1762–1765

Edward Bennett
Goldsmith.
at ý blue-Lion & Crown ý corner
of Tooley Street,
London Bridge.
Makes & Sells all sorts of Plate,
Rings, & Jewels, at Reasonable
Prices.

EDWARD BENNETT 1747

BASSY & CASWALL (see BRASSEY & CASWALL).

BASTIN Thomas, *pawnbroker*; Three Cocks, St John's lane near Hicks's Hall. 1708–1724

BATAILLE Jaques, *goldsmith*; London. 1707

BATCH Humfrey, *goldsmith & silversmith*; parish of St Mary Woolnoth. 1644–1651

BATCH John, *goldsmith*; parish of St Mary Woolnoth. 1681–1696

BATE Robert, *goldsmith*; St Bartholomew's Exchange. (Will proved) 1621

BATEMAN Hester, *goldsmith*; Bunhill row. 1773–1789
 107 Bunhill row. 1784

BATEMAN Hester & CO., *silversmiths*; No. 107 Bunhill row. 1790–1793

BATEMAN Jonathan, *goldsmith*; Bunhill row. 1784

BATEMAN Peter & Anne, *plate-workers*; No. 106 Bunhill row. 1791–1796

BATEMAN Peter, Anne & William, *plate-workers*; Bunhill row. 1800

BATEMAN Peter & Jonathan, *plate-workers*; Bunhill row. 1790

BATEMAN Peter & William, *plate-workers*; Bunhill row. 1805

BATEMAN William, *goldsmith*; Bunhill row. 1800

BATES Aaron, *plate-worker*; Field lane. 1730
 Gutter lane. 1751

BATES Anthony, *goldsmith*; London. 1562
 Parish of St Vedast, Foster lane. (Died) 1607

BATES Henry, *plate-worker*; Widegate street. 1738–1739

BATES Humfrey, *goldsmith*; parish of St Mary Woolnoth. 1642–1648

BATES John, *goldsmith*; Bull and Mouth street, Aldersgate. (Insolvent) 1748

BATES Samuel, *plate-worker*; Gutter lane. 1728
 Foster lane. 1744–1755

BATES Samuel, *goldsmith*; Islington. 1773

BATES & DOGGETT, *silversmiths*; No. 174 Oxford street. 1796

BATH Humphrey, *goldsmith*; parish of St Mary Woolnoth. (Married) 1641–1651

BATHE John, *goldsmith*; London. 1700–1714

BATHIE David, *jeweller*; No. 68 Dorset street, Salisbury square. 1790–1793

BATHURST Benjamin, *goldsmith*; St Mary Axe. 1677–1694 (?)

BATHURST Thomas (see LOWNDES & BATHURST).

BAUDIT Peter, *jeweller*; No. 4 St Martin's lane. 1790–1793

BAUDRY Philip, *goldsmith*; parish of St Olave, Silver street. (Will proved) 1651

BAVEN Thomas, *goldsmith*; London. 1553

BAWDYN Andrew, *goldsmith*; parish of St Michael's, Cornhill. (Died) 1588

BAXTER George, *silversmith*; No. 151 Strand. 1796

BAXTER J., *silver clasp-maker*; No. 2 Hope passage, Ivy lane, Paternoster row. c. 1780

BAXTER William, *goldsmith*; Shoe lane. 1774
 Arundel street. 1782
 Gray's Inn lane. 1793

BAYE William, *goldsmith*; parish of St John Zachary. 1641–(Will proved) 1648

BAYLER Richard (cf. Richard BAYLEY), *goldsmith*; London. 1739

BAYLEY (or BAILY) John, *goldsmith*; Crown & Sceptre (or Sceptre & Crown), Lombard street. 1707–(Bankrupt) 1715

BAYLEY John, *plate-worker*; [No. 106] Wood street. 1751–1781

BAYLEY Richard, *plate-worker*; Foster lane. 1708–1748

BAYLEY WILLIAM, *goldsmith*; Silver street. 1727
BAYLEY WILLIAM, *silversmith*; Ring & Pearl, King street, St Giles's. (Deceased) 1733
BAYLEY WILLIAM, *plate-worker*; Aldersgate. c. 1770 (?)
BAYLEY WILLIAM, *goldsmith*; London. 1770–1783
BAYNAM RICHARD, *goldsmith*; Cheapside. (Will proved) 1626
BAZING WILLIAM, *jeweller*; No. 8 Crane court, Fleet street. 1790–1793
BEACH (or BEECH) THOMAS, *goldsmith*; Blackamoor's Head, Cheapside. 1706–1732
BEACH THOMAS, *goldsmith*; Maiden lane, Covent Garden. 1768–1770
BEACHAM JAMES[1] (cf. BEAUCHAMP), *goldsmith*; parish of St Vedast, Foster lane. 1650–(Buried) 1688
BEACHCROFT JOSEPH, *goldsmith*; Three Kings, Cheapside. 1705–1721
BEADLE JOHN, *plate-worker*; Old Bailey. 1773
BEADNALL JOHN (see FOUNTAIN & BEADNALL).
BEALE GEORGE, *plate-worker*; Distaff lane. 1713–1719
BEALE RICHARD, *plate-worker*; Unicorn, Henrietta street, Covent Garden. 1731–1773
BEALE WILLIAM, *goldsmith*; parish of All Hallows, Honey lane. (Married) 1579–1625
BEAMONT (or BEAUMONT) JAMES, *goldsmith*; parish of St Mary Woolnoth. 1635–1641
BEAMONT JOHN, *goldsmith*; parish of St Vedast, Foster lane. (Buried) 1647
BEANE BARTHOLOMEW, *goldsmith*; parish of St Mary Woolnoth. 1572, 1573
BEARE (or BEERE) THOMAS, *plate-worker*; Drury lane. 1751
BEATY JAMES, *goldsmith*; Greek street, Soho. 1773
BEATTY JAMES, *goldsmith*; late of Greek street. (Deceased) 1762
BEAUCHAMP EDWARD, *silversmith*; Castle street, Holborn. 1790–1793
 No. 14 Lower Holborn. 1790–1796
BEAUCHAMP JAMES[1] (cf. JAMES BEACHAM), *goldsmith*; Cheapside. 1660–1663
BEAUMONT JAMES, *goldsmith*; parish of St Mary Woolnoth. 1635–1641
BEAUVAIS JOSEPH, *goldsmith*; Plumtree street, Bloomsbury. 1790–1793
BEAUVOIR (or BEAVER) RICHARD, *jeweller*; Silver Ball, Pall Mall. 1690–1703
BEAVAN THEOPHILUS, *goldsmith*; No. 86 New Bond street. 1790–1793
BEAVER RICHARD (see BEAUVOIR).
BECK GODFREY, *goldsmith*; parish of St Mary Woolnoth. 1669–(Buried) 1689
BECK WILLIAM, *goldsmith*; London. 1516
BECKETT JOHN, *goldsmith*; London. 1724
BEDDALL BENJAMIN, *silversmith*; Clerkenwell. (Insolvent) 1769
BEDELL (or BEDLE) MICHAEL, *silversmith*; near the New Exchange (Strand). 1777
 No. 429 Strand. 1779
BEDINGFIELD HUMPHREY, *goldsmith*; London. (Married) 1633–(Died) 1677
BEDWELL MARTIN, *goldsmith*; London. 1724
BEDWIN I., *goldsmith & jeweller*; No. 86 New Bond street. 1796
BEECH THOMAS (see BEACH)
BEERE THOMAS (see THOMAS BEARE).
BEEREBLOCKE WILLIAM (cf. WILLIAM BERBLOCKE or BEREBLOCKE), *goldsmith*; London. 1550–1569
BEESLEY HENRY, *plate-worker*; Nicholas lane. 1714

[1] Pepys in his *Diary* refers on 14th and 19th Nov. 1660 to "Mr Beauchamp the goldsmith" and on 2nd June 1663 to "Mr Beacham the goldsmith".

BEEZLEY Thomas, *plate-worker*; London Wall. 1755
BEIGHTON —, *pawnbroker*; Three Bowls, Skinner street, Snow hill. (Giving up business) 1745
BEKKYSWE Thomas, *goldsmith*; London. c. 1450
BELANGER Pierre, *goldsmith*; Newport alley. 1706
BELCHIER — (see IRONSIDE & BELCHIER also IRONSIDE, BELCHIER & HOW).
BELDON John, *plate-worker*; Paternoster row. 1784–1789
BELDON & WHITE, *jeweller*; No. 40 Hatton Garden. 1796
BELEY Derick, *goldsmith*; parish of St Margaret, New Fish street. (Married) 1612
BELGERS (or BILGERS) M., *jeweller*; New street, Covent Garden. 1796
BELL —, *pawnbroker*; Chandos street. 1698
BELL David, *plate-worker*; Ironmonger row. 1756
London. 1772
BELL Joseph, *plate-worker*; Cannon street. 1716
London. 1724
BELL Joseph, *goldsmith*; Shoe lane. 1760
BELL Joshua, *plate-worker*; Carey street. 1756
BELL Thomas, *pawnbroker*; Leg & Dial, Grub street. 1725
BELL Thomas, *jeweller*; White Friars. (Insolvent) 1725
BELL Tiball, *gold chain-maker*; Castle street, Southwark. 1782
BELL William, *goldsmith*; Cheapside. (Buried) 1663
BELL William, *plate-worker*; Monkwell street. 1759
BELL William, *watch-case maker*; Silver street. 1767
Pierpoint row, Islington. 1771
BELL William, *goldsmith*; Rolls buildings. 1773
BELLAMY Edward, *pawnbroker*; St Anne's, Limehouse. 1748
BELLAMY Edward, Junior, *spoon-maker*; Tooley street. 1756–1773
BELLAMY William, *plate-worker*; Foster lane. 1717
BELLANGER Pierre, *goldsmith*; Newport alley. 1706–1709
Crispin street, Spitalfields. 1710–1717
BELLASSYSE Charles [son of Wm. Bellassyse], *goldsmith*; Mitre, Eagle street, Red Lion square. 1740
BELLASSYSE William, *goldsmith*; Mitre, Monkwell street. 1716
Removed to Holborn. 1723
BELLIARD Charles, *jeweller*; Pall Mall. 1762–1793
BELLINGHAM Robert, *goldsmith*; Joyner's court, Houndsditch. 1698
BELLIS James, *goldsmith*; King street, Covent Garden. 1762
No. 9 Pall Mall. 1768–1788
BELSHAWE Joseph & Peter, *goldsmiths*; Farringdon Without. 1583
BENBOWE Francis, *goldsmith*; Coleman street. (Will proved) 1621
BENBRIDGE William, *goldsmith*; near Half Moon alley, Bishopsgate Within. 1691/2
BENDIX Lyon, *silversmith*; St Catherine's. 1790–1793
BENN William, Sir,[1] *goldsmith*; Bishopsgate Without. 1740–1755
BENNET John, *jeweller*; No. 33 Featherstone street. 1790–1793
BENNET Sampson, *goldsmith*; Katherine court, Seething lane. 1747
BENNET & ROLPH, *silver chaser, goldsmith & jeweller*; No. 67 Threadneedle street. 1779
BENNETT —, *jeweller*; Founders' court, Lothbury. 1751

[1] Lord Mayor of London, 1747.

BENNETT Edward, *plate-worker*; Little Britain. 172

BENNETT Edward, *goldsmith*; Blue Lion & Crown, corner of Tooley street, London Bridge.
1739–174

BENNETT, Edward, Junr., *goldsmith*; London. 175

BENNETT Edward, *spoon-maker*; Lombard street. 1771–177

BENNETT John, *haft-maker*; Threadneedle street. 177

BENNETT Peter, *plate-worker*; Little Britain. 173
Goswell street. 173

BENNETT Richard, *goldsmith*; parish of St Saviour's, Southwark. 161

BENNETT William, *goldsmith*; Bartholomew's close. 179
Aldersgate street. 1796–180

BENOIMENT Louis, *goldsmith*; Fenchurch street. 177

BENSLEY John, *jeweller*; No. 18 Castle street, Holborn. 179

BENSON Thomas, *goldsmith*; parish of St Mary Woolnoth. (Married) 1544–156

BENTLEY —, *goldsmith*; on London Bridge. 173

BENTLEY Benjamin, *plate-worker*; London. 1698–173
(Cf. TIMBRELL & BENTLEY.) 1714, 171

BENTLEY Benjamin, *plate-worker*; Tooley street. 172

BENTLEY John & JONES Richard, *goldsmiths*; No. 18 Castle street, Holborn.
(Partnership dissolved) 180

BENTLEY Nathaniel,[1] *hardwareman & jeweller*, No. 46 Leadenhall street. c. 1755–180
Jewry street, Aldgate. 1804–180
Leonard street, Shoreditch. 1807–(Died) 180

BENTON —, *silversmith*; Half Moon, Gutter lane. 172

BERBLOCKE William (cf. William BEEREBLOCKE or BEREBLOCKE), *goldsmith*;
parish of St Vedast, Foster lane. 1588–(Buried) 162

BERCHER —, *jeweller*; Bond street. 171

BERCHERE James, *jeweller*; Ring & Pearl, Broad street. 1711–1714

BERCHERE James Lewis, *jeweller*; Broad street. 1701–1704

BERCHERE Louis, *goldsmith*; London. 1682

BEREBLOCKE William (cf. William BEEREBLOCKE or BERBLOCKE), *goldsmith*;
London. 165

BERG Charles & GRANT Samuel, *jewellers*; Ring & Pearl, against Cecil street, in the Strand.
c. 1760 (?)

BERKENHEAD James, *jeweller*; Dean's court, St Martin's-le-Grand. 175
No. 31 Gutter lane. 1777–178

BERKENHEAD John, *jeweller*; No. 31 Gutter lane. 1790–179

BERNAN James, *silversmith*; No. 30 Ludgate hill. 1796

BERNARD John, *goldsmith*; Gutter lane. 1703

BERNES John, *the King's goldsmith*; London. 1422

BERNY David, *jeweller*; London. 1682

BERRIE J. & A., *working goldsmiths*; No. 30 Ludgate hill. 1796

BERRIE James William, *goldsmith*; Ludgate hill. 1796

BERRIE John, *silversmith*; No. 92 St Martin's lane. 1790–1793

BERRINGER John, *silver buckle-maker*; Great New street. 1786

[1] In his youth was known as "the beau of Leadenhall street," but in later years became notorious as "Dirty Dick." (*D.N.B.*)

BERRY John, *pawnbroker*; Three Balls, Barbican. 1760
BERT James, *jeweller*; Silver street, Wood street. 1790–1793
BERTHELOT John, *plate-worker*; Peter street, Holborn. 1739
 Long lane, Holborn. 1741
 Cow Cross, Holborn. 1750–1752
BERTHET Esaye, *plate-worker*; Gold Ring, Charing Cross. 1728
BERTHON Honorat, *goldsmith*; Hare court. 1697–1710
 Compton street. 1714–1717
BERTIE Isaiah, *goldsmith*; Little Bridge street, Westminster. 1762
BERTIE James, *goldsmith*; King street, Westminster. 1747–1751
BERTRAND Paul, *goldsmith*; St Martin's-in-the-fields. 1709–1711
BESCHEFER James, *plate-worker*; Leicester fields. 1704
BESLEY —, *silversmith*; Sun, Holborn bridge. 1720
BESLEY Nicholas, *goldsmith*; St Martin's-in-the-fields. (Insolvent) 1723
BEST George, *goldsmith*; Lombard street. 1657
BETANE Richard, Sir (see Sir Richard BRITANE).
BETHAM James, *plate-worker*; Staining lane. 1743
BETTESWORTH & CO., *silversmiths & pawnbrokers*; No. 26 Cranborne alley. 1790–1793
BETTS John, *plate-worker*; Holborn. 1720
BETTS William, *goldsmith*; Brydges street, Covent Garden. 1737
BEVAN Hugh, *silversmith*; No. 32 Marylebone street. 1790–1793
BEVAN John, *goldsmith*; Black Spread Eagle, Lombard street. 1672
BEVAULT Thomas, *plate-worker*; Foster lane. 1712
BÉZIERS Henry, *goldsmith*; Hungerford market. 1690
BIBBY —, *pawnbroker*; Three Bowls (or Three Bowls & Golden Ball), Stanhope street, Clare market. 1745–1753
BIBBY —, *pawnbroker*; Three Blue Balls, corner of Featherstone buildings, Bedford row. 1756
BIBBY Abraham, *pawnbroker*; Three Bowls, Wych street, near St Clement's Danes (Strand). 1721–(Died) 1732
BICKERTON — (see POOLE & BICKERTON).
BICKERTON Benjamin, *silversmith*; No. 14 Jewin street, Aldersgate. 1765–1796
BICKERTON Thomas Worsley, *goldsmith*; No. 14 Jewin street, Aldersgate. 1792
BIETRY Leonard, *goldsmith & jeweller*; Cockspur street, Pall Mall. (Leaving off business) 1762
BIGGE Richard, *plate-worker*; St Swithin's lane. 1700–1725 (?)
BIGGLESTONE James, *goldsmith*; Princes street. (Insolvent) 1729
BIGGS Nicholas, *goldsmith*; Redcross square. 1776
BIGGS Roger, *goldsmith*; No. 64 Barbican. 1796
BIGNELL John, *plate-worker & silver caster*; Staining lane. 1718–1729
BIKER Sarah, Mrs, *pawnbroker*; Crooked Billet & Three Horseshoes, Houndsditch. 1700
BILGERS — (see BELGERS).
BILLE —, *silversmith*; Hand & Buckle, St Martin's court. 1736
BILLINGSBY John, *goldsmith*; London. 1661
BILLINGSLEY Francis, *plate-worker*; Covent Garden. 1697
BILLS Edward, *silversmith*; St Martin's lane. 1735
BINCKES Thomas, *goldsmith*; parish of St Mary Staining. (Dead. Widow married Wm. Baldrye, *q.v.*) 1595
BINDON George, *plate-worker*; Theobald's court. 1749

BINGANT —, *gold-chaser*; Star of Mystery, Salisbury street, Strand. 1751 (?)

BINGE GEORGE, *goldsmith*; Lombard street. 1618

BINGER CHRISTOPHER, *goldsmith*; Windmill street, Tottenham Court road. 1773

BINGHAM TH., *watch-chain maker*; Holborn. 1770

BINGLEY JOHN, *watch-case maker*; Little Britain. 1766–1768

BINLEY MARGARET, *goldsmith*; Gutter lane. 1771

BINNELL DANIEL, *goldsmith*; parish of St Mary Woolnoth. 1599

BIRCH EDMOND, *goldsmith*; parish of St Catherine Cree. (Will proved) 1650

BIRD —, *goldsmith*; New street, Covent Garden. 1771

BIRD — (see BRANSTON & BIRD).

BIRD JOHN, *goldsmith*; London. 1568–1578

BIRD JOHN, *goldsmith*; London. 1770–(Died) 1772

BIRD JOHN, *jeweller*; No. 14 Bartlett's buildings, Holborn. 1790–1793

BIRD JOSEPH, *silversmith*; Foster lane. 1697–(Died) 1735

BIRKENHEAD JAMES, *goldsmith*; Gutter lane. 1773

BIRKHEAD CHRISTOPHER, *goldsmith*; Golden Anchor, near Fetter lane in Holborn. (Died) 1680

BIRKHEAD GOWAN (or GODWIN), *goldsmith*; Queen's Head, Grafton street, Soho. 1702–1732

BIRKHEAD JAMES, *goldsmith*; Knightsbridge. 1603–1620

BIRKHEAD NICHOLAS, *goldsmith & clock-maker*; removed from King's Head, Holborn to White Hart, Knightsbridge. 1693

BIRKHEAD PETER, *goldsmith*; Queen's Head, Grafton street, St Ann's (Soho). 1743

BIRON CHRISTOPHER, *plate-worker*; Aldersgate street. 1773

BIRT JAMES, *goldsmith & jeweller*; No. 5 Silver street, Wood street. 1773–1795

BISHOPP FRANCIS, *goldsmith*; parish of St Mary Woolnoth. 1628–(Died) 1675

BISLEY JOHN, *goldsmith*; parish of St Bride's, Fleet street. (Married) 1602

BISMERE WILLIAM (see WILLIAM BASENIRE).

BLACHFORD JOHN,[1] *goldsmith*; London. 1724–(Died) 1755

BLACK LOUIS, *plate-worker*; Haymarket. 1761

BLACKBORROW SAMUEL, *plate-worker*; Mugwell street. 1720
London. 1738

BLACKELES BALDWIN, *diamond cutter*; Cripplegate Within. 1618

BLACKFORD ANTHONY, *goldsmith*; Golden Cup & Crown, Lombard street. 1702–(Deceased) 1716

BLACKFORD DOROTHY (widow of ANTHONY BLACKFORD), *goldsmith*; Lombard street. 1716

BLACKFORD J., *goldsmith*; London. 1749–1750

BLACKMOOR JOHN, *pawnbroker*; Blackamoor's Head, Church street, near St Ann's Church, Soho. 1711

BLACKMORE HENRY, *silversmith*; parish of St Mary Woolnoth. 1615–(Died) 1651

BLACKMORE JOHN, *goldsmith*; parish of St Mary Woolnoth. 1587–(Died) 1651

BLACKWELL ADAM, *goldsmith*; No. 9 Staining lane. 1786–1793

BLAGRAVE EDWARD, *goldsmith*; parish of St John Zachary. 1692, 1693

BLAGRAVE (or BLAYGRAVE), JAMES, *goldsmith*; Crown, Lombard street. 1690–(Died) 1697

BLAKE EDWARD, *goldsmith*; Tower street. 1677
Aldersgate ward. 1692

BLAKE JOHN, *goldsmith*; St Swithin's lane. 1677

[1] Lord Mayor, 1750–1.

Plate V

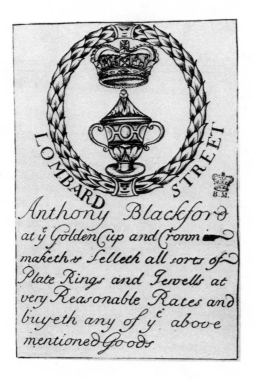

ANTHONY BLACKFORD 1702–1716

Plate VI

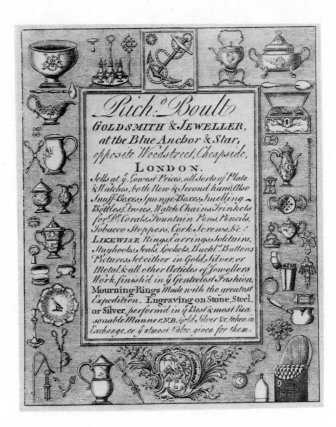

RICHARD BOULT 1744-1753

BLAKE John, *goldsmith*; No. 5 Long's court, Leicester square. 1790–1804

BLAKE Thomas, *jeweller*; Old Bailey. 1784

BLAKE William, *watch-case maker*; Staining lane. 1778

BLAKELEY Benjamin, *plate-worker*; Strand. 1715–1720
 Russell street, Covent Garden. 1738, 1739
 London. 1768, 1769

BLANCHARD Robert, *goldsmith and banker*; Marygold, within Temple Bar. 1661–(Died) 1681

BLANCHARD Robert & CHILD Francis, *goldsmiths and bankers*; Marygold, within Temple Bar. 1670–1681

BLANCHET Josias, *goldsmith*; West street. 1717

BLAND — (see LONG & BLAND).

BLAND Cornelius, *silversmith*; Aldersgate street. 1769–1788
 Jewin street. 1782
 No. 116 Aldersgate street. 1790–1793
 No. 126 Bunhill row. 1796

BLAND Hugh, *goldsmith*; London. 1243

BLAND James & Elizabeth, *goldsmiths*; Bunhill row. 1791–1794

BLAND James Howett, *goldsmith*; Bunhill row. 1797

BLAND John, *goldsmith*; Black Horse, Lombard street. 1728–1740

BLAND John & BLAND Stamper (BLAND & SON), *goldsmiths*; Black Horse, Lombard street. 1740–1747

BLAND John & SON (Stamper BLAND), *goldsmiths*; Black Horse, Lombard street. 1740–1747

BLAND John, *pawnbroker*; Three Blue Balls, Silver street, Oxford road. 1758

BLAND John & DARE (or DOVE) Matthew, *goldsmiths*; London. (Bankrupt) 1720

BLAND Nathaniel, *plate-worker*; Noble street. 1714

BLANKLEY John, *pawnbroker*; Half Moon & Cross Pistols, Minories. 1687

BLOMER Henry, *goldsmith*; London. 1668

BLONDELL — (see FORSHALL & BLONDELL).

BLUNDELL Peter, *goldsmith*; London. 1599

BLUNT John, *goldsmith*; Gold street, Cheapside. (Insolvent) 1743

BOBY James, *goldsmith & jeweller*; Princes street, Leicester square. 1790

BOCHTON Thomas (see BOUGHTON).

BOCK Mark, *goldsmith*; Shoe lane. 1773
 London. 1799

BOCQUET Paul & Rob., *gold-workers*; No. 12 Gloucester street, Bloomsbury. 1772–1774

BODINGTON Edmund, *goldsmith*; Mitre, Foster láne.
 (Succeeded John Bodington.) 1727–(Insolvent) 1729

BODINGTON John, *goldsmith*; Mitre, Foster lane. 1697–1727
 Goldsmiths' Hall. 1727

BODLE —, *silversmith*; Charles court, Strand. 1712

BODY John, *silversmith*; White Horse, London bridge. 1722, 1723

BOHEME Maurice, *goldsmith*; Lad lane, near Wood street. 1709
 Goldsmith street. 1724–1727

BOIT Charles, *jeweller & enameller*; London. 1705–(Died) 1726

BOKYS Thomas, *goldsmith*; London. 1516

BOLD Michael, *goldsmith*; parish of St Vedast, Foster lane. 1613–(Buried) 1617

BOLDERO Henry (cf. MINORS & BOLDERO), *goldsmith*; London. 1772

(109)

I

BOLER John, *goldsmith*; parish of St Michael-le-Quern.　　　　　　　　(Will proved) 1623
BOLITHO John & WILSON John, *goldsmiths*; Gold Lion, Lombard street.　　　　1673–1683
BOLT Michael, *goldsmith*; London.　　　　　　　　　　　　　　　　　1724
　　　　　　Cheapside.　　　　　　　　　　　　　　　　1730–(Died) 1758
BOLTER John, *goldsmith*; London.　　　　　　　　　　　　　　　　　1553
BOLTON Job, *goldsmith*; Bolt & Tun, Lombard street.　　　　　　　　　1677–1686
　　　　　　Lombard street.　　　　　　　　　　　　　　　　1692, 1693
BOLTON John, *goldsmith*; London.　　　　　　　　　　　　　　　　1662
BOLTON Peter, *goldsmith*; London.　　　　　　　　　　　　　　　　1561
BOLTON Samuel, *goldsmith*; parish of St Mary Woolnoth.　　　　　　　1693–1695
BOLTON Thomas, *goldsmith* (?); Bolt & Ton, Cornhill.　　　　　　(Buried) 1666
BOND William, *plate-worker*; Foster lane.　　　　　　　　　　　　1753–1756
BOND William & PHIPPS John, *plate-workers*, Foster lane.　　　　　　1754–1765
BONE Ishmael, *plate-worker*, Abchurch lane.　　　　　　　　　　　1699
BONET Samuel, *jeweller*; Great St Andrew street, Seven Dials.　　　　　1751
BONHOM (or BONOM) John, *jeweller*; next door to the Duchess of Newcastle's, St James's
　　　　　　street, St James's square.　　　　　　　　　　1707–1718
BONNER John, *jeweller*; Petty France.　　　　　　　　　　　　　1679
BONNER Joseph, *gold & silver buckle-maker*; Heming's row, St Martin's lane.　1793
BONNY Francis, *goldsmith*; London.　　　　　　　　　　　　　　1689
BONNY Thomas, *goldsmith*; London.　　　　　　　　　　　　　1647–1659
BONOIMONT Louis, *jeweller*; Carey lane.　　　　　　　　　　　　1766
BONSALL Henry, *goldsmith*; London.　　　　　　　　　　　　　1538–1553
BOOKER Philip, *goldsmith*; parish of St Mary Woolnoth.　　　　　　1691–1694
BOOKEY Fulk, *goldsmith*; King's Head, over against Mercers' Chapel.　　1686, 1687
BOOTBY Roger (cf. Roger BOOTHBY), *goldsmith*; London.　　　　　　1600
BOOTH Edward, *goldsmith*; Fleet street.　　　　　　　　1721–(Insolvent) 1729
BOOTH William, *goldsmith*; parish of St Botolph, Aldgate.　　　　　c. 1589
BOOTHBY George, *goldsmith & banker*; London.　　　　　　　　　1701
　　　　　　Parrot, without Temple Bar, in the Strand.　　　　　1720–1741
BOOTHBY John, *goldsmith*; parish of St Mary Woolnoth.　　　　　　1613
BOOTHBY Roger (cf. Roger BOOTBY), *goldsmith*; parish of St Sepulchre.
　　　　　　　　　　　　(Dead—widow re-married) 1620
BORCHERS Albrecht, *goldsmith*; Spaw fields (? Spa fields, Clerkenwell).　　1773
BOREMAN Louis, *goldsmith*; London.　　　　　　　　　　　　　1500
BORRETT Phineas, *goldsmith & ring-maker*; Staining lane.　　　　　　1782
　　　　　　Queen's square, Aldersgate street.　　　　　　1790–1793
　　　　　　No. 93 Aldersgate street.　　　　　　　　　1796
BORRIS John, *goldsmith*; Cheapside.　　　　　　　　　　　　　1721
BOSALL Jean, *pawnbroker*; Bird in Hand, the lower part of Nightingale lane.　1719
BOSSALL Henry (see Henry BOSWELL).
BOSTOCK Nathaniel,[1] *goldsmith & broker*; Golden Angel, Pall Mall.　　1719–1723
　　　　　　Exchange alley.　　　　　　　　　　　　(Murdered) 1728
BOSTON William, *goldsmith*; London.　　　　　　　　　　　　　1451
BOSWELL Henry, *goldsmith*; parish of St Mary Woolnoth.　　　1539–(Buried) 1557

　　[1] "Robbed and barbarously murthered upon the Causeway at Lambeth", July 1728.

LONDON GOLDSMITHS

BOSWELL James, *goldsmith*; Bishopsgate street. (Bankrupt) 1696
BOTELIER Robert, *goldsmith*; London. 1451–1488
BOTELIER William, *goldsmith*; parish of All Hallows, Bread street. 1668–(Married) 1679
BOTHE William, *goldsmith*; parish of St Botolph, Aldgate. (Married) 1589
BOTTOMLEY John, *pawnbroker*; St Paul's churchyard. 1767
BOUCHER —, *jeweller*(?); Golden Ball, Pall Mall. 1707, 1708
BOUCHER —, *silversmith*; Wheatsheaf, Tavistock street. 1736
BOUCHETT René, *jeweller*; St Anne's, Westminster. 1709
BOUCHIER Gabriel, *goldsmith*; Bread street. (Born) 1611–(Married) 1633
BOUGHTON (or BOCHTON) Thomas, *goldsmith*; Lombard street. 1539–1550
BOUILLARD Isaac, *goldsmith*; Compton street. 1717–1720
BOUILLARD Paul, *jeweller*; Eagle & Pearl, Great Suffolk street, near the Haymarket. 1751
BOUJONNIER Guillaume, *diamond cutter*; High Moorfields. 1702
BOULT Michael, *goldsmith*; Blue Anchor & Star, Cheapside, over against Wood street.
 1713–(Retired) 1745
BOULT Richard, *goldsmith & jeweller*; Blue Anchor & Star, Cheapside, over against Wood
 street. 1744–1753
BOULTBY John, *goldsmith*; London. 1613
BOULTON John, *goldsmith*; (?) Lombard street. 1651
BOULTON Samuel, *goldsmith*; Fox, Lombard street. 1689–1694
BOULTON T. P. & HUMPHREYS Arthur, *plate-workers*; Poultry. 1780
BOURCHAR Thomas, *brooch-maker*; Blackfriars. 1564
BOURDO Isaac, *jeweller*; Pearl & Three Stars, Green street, Leicester fields—afterwards
 Ryder's court, St Ann's. (Deceased) 1738
BOURELIER John Francis, *jeweller & clock-maker*; No. 9 Arundel street, Strand. 1768–1790
BOURNE — (successor to John Boursot), *jeweller & goldsmith*; Crown & Pearl, New street,
 St Martin's lane. c. 1760
BOURNE Aaron, *goldsmith*; Maiden lane, Covent Garden. 1770
 No. 5 New street, Covent Garden. 1773–1781
BOURNE George (see NORTHCOTE & BOURNE).
BOURNE John, *goldsmith*; New street, Covent Garden. 1773
BOURNE Samuel, *goldsmith*; Queen's Head, Gutter lane. 1696–1704
BOURNE & HAWKINS, *jewellers & hardwaremen*; No. 12 Cheapside. 1793
BOURRELIER (or BOURELIER) —, *jeweller*; Arundel street, Strand. 1755
BOURSIN —, *silversmith*; Golden Cup, Chandois street. 1726
BOURSIN Denis, *goldsmith*; Gold (or Golden) Angel, Long Acre. 1723
BOURSIN Edme, *goldsmith*; London. 1716
BOURSOT Jacob, *goldsmith*; New street, Covent Garden. 1749
BOURSOT John (succeeded by John Bourne), *goldsmith*; Crown & Pearl, New street, Covent
 Garden. 1753
BOURTET Pierre, *goldsmith*; St Giles's. 1708
BOUTEILLER Pierre, *plate-worker*; St Martin's court. 1727
 London. 1730–1735
BOVILLARD Isaac, *jeweller*; Great St Andrew street, near the Seven Dials, in Soho. 1727
BOWDEN (or BOWDON) William, *goldsmith*; London. 1460
BOWDON Edward, *goldsmith*; London. Temp. Henry VI
BOWDLER Thomas (see SHALES & BOWDLER), *goldsmith*; Lombard street. 1736

(111)

LONDON GOLDSMITHS

BOWE Thomas, *goldsmith*; Mugwell street. (Insolvent) 1729
BOWEN Owen, *jeweller*; No. 6 Castle yard, Holborn. 1777–1779
BOWEN Thomas, *goldsmith*; parish of St Mary, Lothbury. 1622
BOWER (or BOWERS) George, *goldsmith*; George, near Salisbury court, Fleet street. 1678–1689
BOWER —, *pawnbroker*; Three Balls, Russell street, Covent Garden. 1754
BOWERS George, *pawnbroker*; No. 13 Marsham street, Westminster. 1752
BOWES Martin, Sir,[1] *goldsmith*; White Lion, Lombard street. 1524–(Died) 1566
BOWES Martin, Junior, *goldsmith*; parish of St Mary Woolnoth. 1544–1566
BOWES Thomas, *goldsmith*; parish of St Mary Woolnoth. 1542–(Died) 1591
BOWES Thomas, *goldsmith*; parish of St Michael Bassishaw. (Married) 1594
BOWLES Richard, *pawnbroker*; Double Cane Chair, Postern street, Great Moorgate. 1707
BOWMAN — (see LAMB & BOWMAN).
BOWMAN Edward, *goldsmith*; London. 1724
BOWMAN John, *goldsmith*; London. 1613
BOWMAN John, *goldsmith*; Flower-de-luce, Strand, near Round court. 1693–1714
BOWYER William, *goldsmith*; parish of St Vedast, Foster lane. (Buried) 1576
BOX —, *goldsmith & toyman*; No. 13 Ludgate street. 1781
BOX John (see LYNAM & BOX).
BOX John, *jeweller & goldsmith*; No. 17 Ludgate street. 1784–1796
BOX Robert, *goldsmith*; London. 1323
BOYCE Thomas, *goldsmith*; Lombard street. 1611
BOYLSTON Thomas, *goldsmith*; parish of St Botolph, Aldgate. (Married) 1666
BRABANT —, *goldsmith*; St Swithin's lane. 1677
BRABOURNE Samuel, *goldsmith*; Poultry. 1677
BRACE John, *goldsmith*; parish of St Vedast, Foster lane. (Buried) 1712
BRACKLEY Samuel, *goldsmith*; Dolphin, Ludgate hill. 1716
BRADFIELD —, *goldsmith*; Anchor & Globe, Lombard street. 1716
BRADLEY James, *jeweller*; Wood street. 1755–1765
BRADLEY Jonathan, *plate-worker*; Carey lane. 1697
BRADSHAW Anthony, *goldsmith*; London. 1636–1667
BRADSHAW Joshua, *goldsmith*; over against Goldsmiths' Hall, Foster lane. 1695–1709
BRADSHAW Stephen, *pawnbroker*; next door to Golden Hart, Queen street, Cheapside. 1711
BRADSHAW Bennett & TYRILL Robert (see also Robert TYRILL), *silversmiths*; Golden Ball, Oxford Chapel [Chapel court, Henrietta street, Marylebone]. 1737–1739
BRAFORD Benjamin, *plate-worker*; Laurence Pountney lane. 1697
BRAGG Joseph [partner with William Sheppard], *goldsmith*; Angel, Lombard street. 1695–(Bankrupt) 1702
BRAGGE Richard, *goldsmith*; parish of St Peter, Paul's Wharf. 1613–(Will proved) 1647
BRAITHWAITE George, *goldsmith & clock-maker*; Bible, Lombard street. 1728
 Crown & Thistle, Lombard street. 1732
 Lombard street. 1738–1740
BRAMLEY Joseph, *wholesale goldsmith & jeweller*; No. 10 Maiden lane, Wood street. 1784
 No. 175 Aldersgate street, corner of Little Britain. 1790–1796
BRAMPTON George, *goldsmith*; parish of St Peter's Westcheap. 1630
BRAND —, *goldsmith*; in Portsoken Ward. 1568

[1] Lord Mayor, 1545–6. Six times M.P. for London. (*D.N.B.*)

(112)

Plate VII

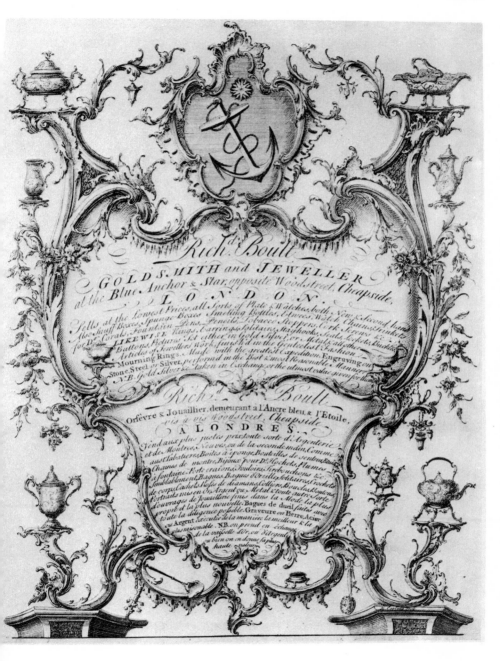

ICHARD BOULT

1744-1753

Plate VIII

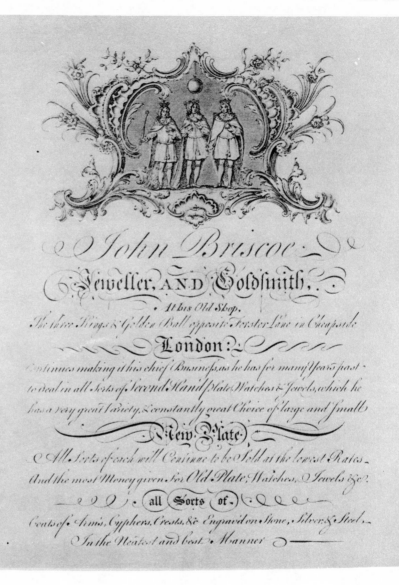

John Briscoe

Jeweller, AND Goldsmith,

At his Old Shop,

The three Kings & Golden Ball opposite Forster Lane in Cheapside

London:

Continues making it his chief Business, as he has for many Years past
to deal in all Sorts of Second Hand Plate Watches & Jewels, which he
has a very great Variety, & constantly great Choice of large and small

New Plate

All Sorts of each will Continue to be Sold at the lowest Rates,
And the most Money given for Old Plate Watches, & Jewels &c.

all Sorts of

Coats of Arms, Cyphers, Crests, &c Engrav'd on Stone, Silver & Steel,

In the Neatest and best Manner

JOHN BRISCOE 1752

BRAND —, *goldsmith*; Lombard street. 1718
 London. 1721

BRAND Thomas, *goldsmith*; Golden Rose (or Rose), Lombard street. 1702–1714

BRAND William, *silversmith*; parish of St Dunstan's-in-the-West. 1674

BRANDON Joseph, *goldsmith*; Unicorn, Fenchurch street. 1685
 Removed to Morocco's Head, Lombard street. 1690
 Parish of All Hallow's, Lombard street. 1692–1693

BRANDON Robert, *Queen Elizabeth's principal goldsmith*; parish of St Mary Woolnoth.
 Married (1548)–(Buried) 1591

BRANFIELD John, *goldsmith*; Globe & Anchor, Lombard street. 1710–1715

BRANSTON John, *pawnbroker*; Phoenix, against Bond's stables in Fetter lane. 1704

BRANSTON Thomas & BIRD, *jewellers, goldsmiths, toymen & clock-makers*; No. 39 Cornhill. 1775

BRASBRIDGE Joseph,[1] *silversmith & cutler*, No. 98 Fleet street. 1790–(Died) 1832

BRASHAM Edward, *goldsmith*; "late of London". 1696

BRASSEY John, *goldsmith*; Acorn, Lombard street. 1691–1710
 Without Aldgate. 1725–1731

BRASSEY John & Nathaniel, *goldsmiths*; Acorn, Lombard street. 1716–1720

BRASSEY Nathaniel, *goldsmith*; Acorn, Lombard street. 1720–1724

BRASSEY Thomas, *goldsmith*; Lamp, Lombard street. 1692–1696

BRASSEY & CASWELL, *goldsmiths*; Acorn, Lombard street. 1700–1707

BRASSEY Nathaniel & LEE, *goldsmiths & bankers*; Acorn, Lombard street. 1730–1740

BRASSIER George, *goldsmith*; No. 28 Giltspur street. 1790–1793

BRATTLE —, *Deputy Assayer at Goldsmiths' Hall*; London. 1666

BRATTLE Charles, *King's Assayer at the Mint*; London. 1690–1716

BRATTLE Daniel, *Assayer at the Mint*; London. c. 1700

BRATTLE John, Sir, *King's Assay Master at the Mint*; London. 1670–1690

BRAXTON Barbara, *pawnbroker*; Three Bowls, Long Acre. 1714

BRAY Richard, *goldsmith*; London. 1509–1516

BRAY Thomas, *silversmith*; King street, Westminster. 1790–1793

BRAZIER George, *working goldsmith*; Giltspur street. 1784
 No. 114 Bishopsgate Within. 1790–1796

BREACH John, *pawnbroker*; Golden Anchor, Whitecross street. 1719

BREACLIFFE —, *goldsmith*; Barbican. 1767

BREAKSPEARE William, *goldsmith*; parish of St John Zachary. 1450–(Buried) 1461

BREERES William, *goldsmith*; St Leonard's, Shoreditch. (Buried) 1638

BRENT Moses, *haft-maker*; Bell yard, Little Britain. 1783–1789

BRETT William, *plate-worker*; Norris street, St James's. 1695–1697

BRETTON Richard, *goldsmith*; London. (Married) 1588–1603

BREWOOD Benjamin, *goldsmith*; Gough square. 1755
 Pemberton row [Gough square]. 1767

BRICE Hugh, Sir (see BRYCE).

BRICKBECK Christopher, *goldsmith*; parish of St Vedast, Foster lane. (Buried) 1570

BRIDGE John (see RUNDELL & BRIDGE).

BRIDGES Joseph, *plate-worker*; Foster lane. 1765, 1766

[1] Published his autobiography *Fruits of Experience* (1822). (*D.N.B.*)

BRIDGES Samuel, *goldsmith*; parish of St Saviour's, Southwark. 1628

BRIDGMAN Thomas, *silversmith*; No. 7 Red Cross square. 1790–1793

BRIGGS W., *goldsmith & silver chaser*; No. 4 Racquet court, Fleet street. 1796

BRIGHT — (see SNOW, BRIGHT & KIRKE).

BRIGHT Fuller, *goldsmith*; Snail, Tower street. 1702–1707
 Snail & Ring, Tower street. 1708

BRIGHT John & SHEFFIELD-PLATE COMPANY'S WAREROOMS; No. 37 Bruton
 street, Berkeley square. 1797–1817

BRIGHT Samuel, *jeweller*; St Martin's court, St Martin's lane. 1790–1793

BRIGNALL Edward, *jeweller & goldsmith*; No. 148 Oxford street. 1790–1793

BRIGHTHALL — (see MEAD & BRIGHTHALL).

BRIND Henry, *plate-worker*; Foster lane. 1742–1749

BRIND John, *goldsmith*; Long lane, West Smithfield. (Insolvent) 1724

BRIND Thomas, *silver turner*; Lillypot lane. 1783

BRIND Walter, *goldsmith & silversmith*; No. 34 Foster lane. 1749–1796

BRISCOE Messrs, *goldsmiths*; Golden Ball, Cheapside. 1743

BRISCOE John, *jeweller & goldsmith*; Three Kings & Golden Ball, [No. 15] Cheapside, opposite
 Foster lane. 1744–1756
 Three Kings, Cheapside. 1753–1762

BRISCOE Stafford, *goldsmith*; Bunch of Grapes, Cheapside. 1711, 1712

BRISCOE Stafford, *jeweller & goldsmith*; Golden Ball [or Golden Ball Only], Cheapside,
 corner of Friday street. 1732–1767
 Three Kings & Golden Ball, Cheapside, opposite Foster lane. 1738–1759

BRISCOE Stafford & John, *jewellers & goldsmiths*; Golden Ball, the corner of Friday street,
 Cheapside. 1742–1760

BRISCOE & MORRISON (see also Richard MORRISON), *jewellers & goldsmiths*; Three
 Kings & Golden Ball, [No. 15] Cheapside, opposite Foster lane. 1762–1772
 Three Kings, Cheapside, near St Paul's. 1762–1769
 (Mentioned, no address.) 1781

BRISCOE & SMITH, *goldsmiths*; Golden Cup, Cornhill. 1721

BRISSAC Theodore, *goldsmith*; Golden Ball, St Martin's lane. 1700, 1701

BRISTOW Richard, *goldsmith*; Ludgate street. 1708
 Three Balls, or Three Bells, Fleet street, corner of Bride lane. 1716–1736

BRITANE (BRITAINE or DE BETOYNE) Richard, Sir,[1] *goldsmith*; Bread street ward.
 1322–(Died) 1341

BROAD John (see John BROADE).

BROAD John, *goldsmith*; parish of St Michael's, Wood street. 1584–(Will proved) 1628

BROADBENT —, *jeweller*; Warwick lane. 1714–1718

BROADE [or BRODE] John, *goldsmith*; parish of St Giles's, Cripplegate.
 (Married) 1580–(Will proved) 1621

BROADLY James, *jeweller*; No. 24 Wood street. 1770–1772

BROADNEX Ann, *goldsmith*; Tucke court, parish of St Andrew's, Holborn. 1692

BROAKE John, *plate-worker*; Gutter lane. 1699–1704

BROCKLESBURY (or BROCKLESBY) Robert, *goldsmith*; London. 1615

BROCKUS John, *haft-maker*; Shoe lane. 1773

BRODAU —, *silversmith*; Norris street, St James's. 1731

 [1] Mayor of London, 1326–7.

BRODE John (see BROADE).
BRODIER Matthew, *plate-worker*; Newport alley. 1751
BRODLEY Samuel, *goldsmith*; London. 1636–(Will proved) 1648
BRODNECK —, *plate-worker*; Staples Inn. 1678
BROGDEN James, *goldsmith & watch-maker*; Dial, Aldersgate street. 1765–1794
BROGDEN John, *goldsmith*; Staining lane. 1797
BROKAT —, *goldsmith*; London. 1509
BROKENHEAD —, *goldsmith*; No. 33, Foster lane. 1796
BROKESBY Abel, *plate-worker*; St Anne's lane. 1727–1730
BROMAGE William, *plate-worker*; Drurelain (? Drury lane), by the New Church, Strand. 1770
BROME George, *plate-worker*; Fetter lane. 1726
BROMLEY John, *plate-worker*; Foster lane. 1720
 St Michael's alley, Cornhill. 1732
BROMSALL William, *goldsmith*; Snow fields, Southwark. 1766
BROOK John, *goldsmith*; parish of St Helen's, Bishopsgate. 1607
BROOK Richard, *goldsmith & jeweller*; No. 1 Poultry. c. 1790
BROOK Richard & SON, *clock-makers*; Poultry. 1795–1802
BROOKE Edmond, *goldsmith*; parish of St Mary Woolnoth. 1594
BROOKE Edward, *goldsmith*; parish of St Mary Woolnoth. 1594–1597
BROOKE John, *goldsmith*; Southampton Buildings, Holborn. (Insolvent) 1769
BROOKE Richard, *goldsmith*; parish of St Mary Woolnoth. (Married) 1581–(Buried) 1608
BROOKE Robert, *goldsmith*; parish of St Mary Woolnoth. 1595–1599
BROOKE Simon, *goldsmith*; London. 1560–1580
BROOKER James, *plate-worker*; Golden Snail, Fleet street. 1734
BROOKER Robert, *goldsmith*; Fleet street. (Insolvent) 1725
BROOKS — (see PERCHARD & BROOKS).
BROTHERTON John, *watch-case maker*; Islington. 1768
BROUGH Thomas, *goldsmith*; New street, Cloth Fair. 1797
 Aldersgate street. 1798
BROUGHTON J., *plate-worker*; Little Britain. 1779
BROUGHTON John, *silversmith*; St John's square, Clerkenwell. 1767–1773
 Bartholomew close. 1776
BROWN —, *pawnbroker*; Golden Ball, Marylebone street, near Golden square. 1759–1764
BROWN & CO., *goldsmiths*; Lombard street. 1744
BROWN Benjamin, *goldsmith*; No. 7 Foster lane. 1790–1793
BROWN C. & J., *jewellers*; No. 56 Rupert street. 1790–1793
BROWN Henry, *pawnbroker*; Bow street. 1726
BROWN J., *jeweller & watch-maker*; No. 149 Fleet street. c. 1780
BROWN James, *jeweller*; Eagle & Pearl, Church street, Soho. 1752
BROWN John, *goldsmith*; St Michael's, Shadwell. (Insolvent) 1723
BROWN John, *jeweller*; Crown & Pearl, Ludgate street, near St Paul's. (Sold off stock) 1748
BROWN John, *jeweller & goldsmith*; No. 76 St Paul's Churchyard. 1768–1796
BROWN John, *plate-worker*; Bartholomew close. 1774
BROWN John, *jeweller & watch-maker*; No. 146 Fleet street. 1790–1793
 No. 149 Fleet street. 1796
BROWN John & SONS, *jewellers & goldsmiths*; St Paul's Churchyard. 1765

BROWN Moses, *plate-worker*; Russell street, Covent Garden. 1697–1701

BROWN Mrs, *pawnbroker*; Three Balls, Wheeler street, Spitalfields. 1753

BROWN Peter, *jeweller*; Golden Ball, King street, Soho. 1747

BROWN Peter Thomas, *silversmith*; Wood street 1761

BROWN Robert, *plate-worker*; Piccadilly. 1736–1743

BROWN Roger, Sir, *goldsmith*; London. 1451

BROWN Thomas, *goldsmith*; London. 1567

BROWN William, *goldsmith*; parish of St Mary Woolnoth. 1623

BROWN William, *goldsmith*; London. 1739–1751

BROWN William (successor to Briscoe & Morrison), *jeweller & goldsmith*; Golden Ball, [No. 14] Cheapside, opposite Foster lane. 1768–1784

BROWN William, *goldsmith & jeweller*; No. 40 Piccadilly. 1796

BROWN William Thornborough (cf. William BROWN), *goldsmith & jeweller*; No. 14 Cheapside. 1790–1814

BROWNE —, *pawnbroker*; Three Blue Balls, Snow hill. 1753

BROWNE Aaron, *goldsmith*; Maiden lane. 1769

BROWNE Adam,[1] *goldsmith*; London. 1397

BROWNE John, *goldsmith*; London. (Died) 1620

BROWNE John, *working jeweller & silversmith*; No 9 Fish street hill, near y[e] Monument. c. 1770

BROWNE Mary & MAURICE Margaret, ? *goldsmiths*; late of Three Angels, Royal Exchange, Three Angels, against George yard, Lombard street. 1723

BROWNE Owen, *goldsmith*; London. 1606

BROWNE Richard, *goldsmith*; Three Angels, against George yard, Lombard street. 1731

BROWNE Thomas, *goldsmith*; London. 1553

BROWNE William, *goldsmith*; parish of St Vedast, Foster lane. (Buried) 1710

BROWOOD Benjamin, *goldsmith*; Bunhill row. 1778

BRUGUIER Philip, *plate-worker*; St Martin's lane, Leicester fields. 1738
Martin street. 1739

BRUGUIER Philip, Junr., *goldsmith*; Star, Bedford street. 1752–1773

BRUMHALL John, *plate-worker*; Upper Moorfields. 1713–1721

BRUNET Peter, *jeweller*; Palm Tree, Northumberland court, Strand, near Charing Cross. 1729
Northumberland street, Strand. 1735

BRUSE John, *goldsmith*; Fenchurch street. 1677

BRUSH Phillip, *plate-worker*; Lombard street. 1707
London. 1714–1723 (?)

BRUSHA (?) John, *silversmith*; parish of St Saviour's, Southwark. 1665

BRYAN Henry, *goldsmith*; at Mr Carpus's, Strand. 1750–1768

BRYAN John, *goldsmith*; Cheapside. (Will proved) 1620

BRYAN John, *plate-worker*; Panyer alley, Newgate street. 1735
Bunhill row. 1739

BRYCE Hugh, Sir,[2] *goldsmith*; Lombard street. 1475–(Died) 1496

BRYDON George, *plate-worker*; Maiden lane. 1720

BRYDON Thomas, *plate-worker*; St Martin's-le-Grand. 1697–1702

BRYON Simon, *goldsmith*; Snail & Ring, Tower street. (Deceased) 1743

BUCHAN John, *pawnbroker*; Three Blue Balls, Charles court, Strand, near Hungerford market.
(Giving up business) 1720

[1] Mayor of London, 1397. [2] Mayor of London, 1485–6.

Plate IX

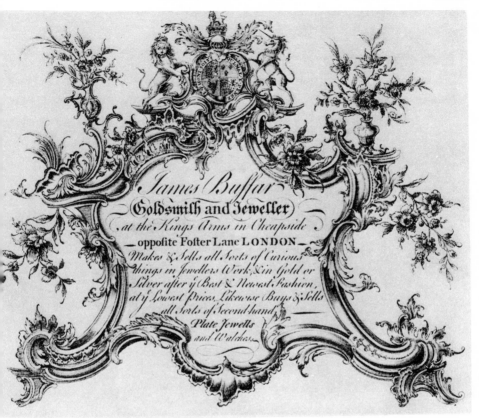

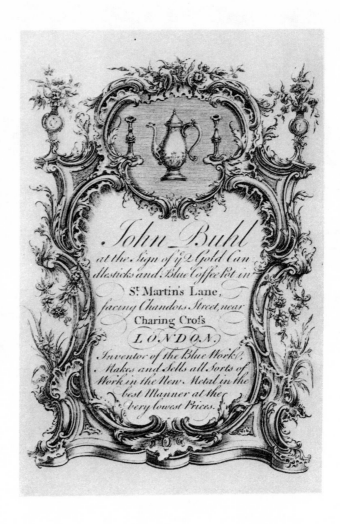

JOHN BUHL 1768–1774

BUCHING JOHN, *goldsmith*; London. 1441

BUCK JOHN, *goldsmith*; London. 1675–1684
 Black Boy, on London Bridge. 1712–1714

BUCK JOHN, JUNIOR (son of above), *goldsmith*; parish of St Olave, Southwark. (Died) 1726

BUCKETT JOHN, *plate-worker*; St James's street. 1770 (?)

BUCKLE J., *goldsmith*; London. 1638

BUDDRICK CHARLES, *jeweller*; No. 15 London Wall. 1790–1793

BUFFAR [or BUSSAR] JAMES, *goldsmith & jeweller*; King's Arms, Cheapside, opposite Foster
 lane. 1748
 King's Arms, Fleet street, between the Temple gates. (Leaving off trade) 1755

BUFFAR [or BUSSAR] JAMES & DOXEY THOMAS (cf. THOMAS DOXSEY), *goldsmiths*;
 King's Arms, Fleet street, between the Temple gates. 1752

BUHET PETER, *goldsmith*; London. 1737

BUHL JOHN, *silversmith & buckle-maker*; Two Gold Candlesticks & Blue Coffee Pot, St
 Martin's lane, facing Chandos street, near Charing Cross. 1768–1774

BULCK ANDREW, *jeweller*; Windmill street. 1762

BULL — (see LYNAM & BULL).

BULL ANTHONY, *goldsmith*; parish of St Gregory. 1600–(His daughter married) 1619

BULL JAMES, *goldsmith & jeweller*; No. 124 Leadenhall street. 1796

BULL JOHN, *goldsmith*; parish of St Michael's, Cornhill. 1557–(Buried) 1589

BULL NICHOLAS, *goldsmith*; London. 1540–1553

BULL THOMAS, *goldsmith & jeweller*; No. 15 Leicester square. 1790–(Bankrupt) 1792

BULL WILLIAM, *plate-worker*; Haymarket. 1698

BULLEN GEORGE, *goldsmith*; London. 1649–1657

BULLENS JOHN, *goldsmith*; parish of St Mary Woolnoth. 1672

BULLMER THOMAS, *goldsmith*; Smithfield Bars. 1716

BULLOCK HENRY, *goldsmith*; parish of St Vedast, Foster lane. (Buried) 1698

BULLOCK ROBERT, *goldsmith*; Horse-shoe, Cheapside. 1695–1703

BULT — (see GODBEHERE, WIGAN & BULT).

BULT JAMES & SUTTON JAMES (see SUTTON & BULT), *goldsmiths*; [No. 86] Cheapside.
 1782–1793

BUMFRIS THOMAS & JACKSON ORLANDO, *plate-workers*; Little Trinity lane. 1766

BUMFRISS THOMAS, *plate-worker*; Little Trinity lane. 1768–1773

BUNN JOHN, *goldsmith*; Hoxton. 1782

BURCH THOMAS, *goldsmith*; Moorfields. 1770

BURCHELL B., *goldsmith*; No. 79 Long Acre. 1788–1792

BURCHELL JOHN & MATTHEW, *goldsmiths & jewellers*; Anodyne Necklace, No. 78 Long
 Acre, next Drury lane. 1774–1779

BURCHMORE —, *pawnbroker*; Golden Ball, Saffron hill. 1753

BURDETT —, *silversmith*; Crown & Pearl, Little Old Bailey. 1732

BURDEYN JOHN, *goldsmith*; London. 1341

BURGESS —, *pawnbroker*; Moving Head, Borough, Southwark. 1754

BURGESS SPENCER, *plate-worker*; Ratcliff Cross. 1773

BURGESS THOMAS & LOFTHOUSE SETH (see also SETH LOFTHOUSE), *goldsmiths*; White
 Horse, Fleet street. 1719

BURKITT —, *silversmith*; Two White Friars, Fleet street. 1716

BURKITT —, *goldsmith*; Grove street, Soho. (Died) 1742

BURLEY Humphrey, *goldsmith*; parish of St Peter Westcheap. 1600
BURLINGHAM Samuel & Co., *goldsmiths*; Angel court, Lombard street. 1677
BURMAN Samuel, *jeweller*; No. 57 Leman street (Goodmans fields). 1790–1793
BURNE James, *plate-worker*; Bedfordbury. 1724
BURNET Edward, *goldsmith*; Hen & Chickens, Tooley street, near London Bridge. 1718
BURNETT Edward, *goldsmith*; Lombard street. (Bankrupt) 1740
BURNETT George, *buckle-maker*; James street. 1784
BURNEYE William, *goldsmith*; London. 1569
BURNINGHAM John, *goldsmith*; Black Raven, Newgate street. 1694
BURR Martin, *jeweller*; London. 1685
BURRIDGE J., *plate-worker*; Foster lane. 1706–1720
BURRIDGE Thomas, *plate-worker*; London. 1706–1717
 Foster lane. 1720
BURROW John, *goldsmith*; Bush lane. 1677
BURROW John, *goldsmith*; London. 1773
BURROWS Alice & George, *plate-workers*; Red Lion street, Clerkenwell. 1802
BURROWS E., *goldsmith & silversmith*; No. 232 Shadwell High street. 1790–1793
BURROWS George, *working goldsmith, buckle & spoon-maker*; No. 10 Clerkenwell close. 1781–1796
 No. 2 Percival street. 1827
BURROWS & Son, *working silversmiths*; No. 14 Red Lion street, Clerkenwell. 1800–1817
BURSON Gabriel, *goldsmith*; Blackfriars. 1568
BURT J., *goldsmith*; London. 1668
BURTON John, *watchcase-maker*; Staining lane. 1765
BURTON Robert, *plate-worker*; Noble street. 1758
BURTON William, *watchcase-maker*; Bridgewater square. 1767
BURWASH William, *watchcase-maker*; No 45 Red Lion street, Clerkenwell. 1782–1804
BUSCOMB —, *goldsmith & silversmith*; Jack, Wood street, Cheapside. 1734
BUSH John, *pawnbroker*; Bell, Charterhouse lane. (Left off trade) 1693
BUSHE —, *goldsmith*; Cripplegate ward. 1568
BUSHNEL [or BUSHNELLS] Thomas, *goldsmith*; Dial, East Smithfield. 1692
BUSSAR [or BUFFAR] James (cf. BUFFAR & DOXEY), *goldsmith*; King's Arms, Cheapside,
 opposite Foster lane. 1748
 King's Arms, Fleet street. 1752
BUSSEY E., *goldsmith*; London. 1516
BUTCHER William, *plate-worker*; Boshagate (*sic* ? Bishopsgate) street. 1755
BUTEUX Abraham, *plate-worker*; Green street, Leicester fields. 1721–1731
BUTEUX D., *goldsmith*; London. 1685
BUTEUX Elizabeth, *plate-worker*; Norris street, St James's. 1731–1734
BUTLER —, *silversmith*; Anchor, Cheapside. 1673
BUTLER John, *goldsmith*; Golden Cup, Lombard street. 1680–1689
BUTLER Thomas, *goldsmith*; parish of St Botolph, Bishopsgate. (Married) 1657
BUTLER & TURER (?), *silversmiths*; No. 18 High Holborn. 1790
BUTTALL Sarah, *plate-worker*; Minories. 1754
 London. 1772
BUTTY Francis (see HERNE & BUTTY), *goldsmith*. 1757–1762
 (See BUTTY & DUMEE.) 1759–1776

BUTTY Francis & DUMÉE Nicholas, *goldsmiths*; Clerkenwell close. 1757–1776

BYE Samuel, *goldsmith*; King's Head court, Gutter lane. (Buried) 1679

BYFIELD Thomas, *pawnbroker*; Golden Key, Eagle court, Strand, against Somerset House.
(Left off business) 1709

BYRLYNEY John, the elder (cf. John BYRLYNG), *goldsmith*; London. 1465

BYRLYNG John, *goldsmith*; parish of St Mary-at-hill (Billingsgate). 1483–1488

BYSSAM John, *goldsmith*; St Vedast's, Farringdon Within. 1568

CACHART Elias, *goldsmith*; Long Acre. 1742–1752

CADDY —, *pawnbroker*; Three Bowls & Rose, lower end of St Martin's lane. 1744

CADE John & GEARING John, *goldsmiths*; Leadenhall street.
(Dissolution of partnership, John CADE continues) 1797

CADYWOULD Edward, *goldsmith*; Redcross street. 1788

CAEPELL James, *goldsmith*; Beehive, Watling street. 1677

CAER Robert, *goldsmith*; London. 1523

CAFE [? CASE] John, *goldsmith*; Foster lane. 1740–1760

CAFE [? CASE] William, *plate-worker*; Gutter lane. 1757–(Bankrupt) 1772

CAILLON Pierre, *goldsmith*; Blackfriars. 1564

CALAME James Anthony, *goldsmith*; Exeter Change. 1764–1778

CALCOTT Daniel, *pawnbroker*; London. 1740

CALDECOTT Thomas (cf. Giles SOUTHAM), *working goldsmith*; Cabinet, south side of
St Paul's churchyard. c. 1760
"Removed to the late Mr Southam's, opposite Bartholomew close in Little
Britain." —

CALDECOTT William, *plate-worker*; Silver street. 1756–1766

CALDWELL —, *goldsmith and seal engraver*; London. 1542

CALLAGHAN Charles, *working silversmith & jeweller*; Silver Lion, Foster lane. 1782–1792
Silver Lion, No. 463 Strand. 1792

CALLARD Gabriel, *jeweller*; Tottenham Court road. 1778

CALLARD Isaac, *plate-worker*; King street, St Giles. 1726

CALLARD Isaac, Junior, *goldsmith*; Crown, Tottenham Court road. 1739

CALLARD Paul, *plate-worker*; King street, Soho. 1751–1755

CALTON Henry, Warden of Goldsmiths' Company. 1518

CALTON Thomas, *goldsmith*; Purse, in Chepe [Cheapside]. 1526–1530
London. 1553

CALTON W., *goldsmith*; London. 1568–1569

CAMPAR —, *silversmith*; Crown, Noble street. 1752

CAMPAR George, *plate-worker*; Cripplegate. 1749

CAMPBELL Archibald & CROCKETT James, *pawnbrokers*; Three Balls, Shoe lane. 1742

CAMPBELL George, *goldsmith*; Strand. 1775

CAMPBELL George & COUTTS James (see also MIDDLETON & CAMPBELL), *goldsmiths
& bankers*; Three Crowns, near Durham yard, Strand. 1754–1761

CAMPBELL George & MIDDLETON George, *goldsmiths & bankers*; Three Crowns, Strand,
near St Martin's lane. 1711–1748

CAMPBELL John, *goldsmith*; Three Crowns, near Hungerford market, Strand. 1691–(Died) 1712

CAMPBELL Joseph, *jeweller*; Crown & Pearl, King street, St Ann's, Soho. c. 1770

(119)

CAMPBELL & PARTNERS, *goldsmiths & bankers*; Three Crowns, Strand. 1709

CANE J., *goldsmith*; Leopard & Lamb (or Lamb & Leopard), over against St Dunstan's Church in Fleet street. 1702–1707

CANN (or CAM) JOHN, *plate-worker*; Bridgewater gardens (Cripplegate). 1740

CANNER CHRISTOPHER, *plate-worker*; Gutter lane. 1697–(Buried) 1708

CANNER CHRISTOPHER, *plate-worker*; Maiden lane. 1716
Foster lane. 1720

CANTILON DAVID (cf. CANTLAND), *goldsmith*; St James's street. 1718

CANTLAND — (cf. CANTILON), *goldsmith*; Two doors below White's chocolate house in St James's street. 1715

CAPE WILLIAM, *goldsmith*; Gutter lane. 1766

CAPILL JAMES (see KILBORNE & CAPILL), *goldsmith & banker*; King's Head, Lombard street. 1677–1682

CAPPER EDWARD, *silversmith*; Round court, St Martin's-le-Grand. 1761–1777 (?)
No. 23 Shoe lane. 1795

CARCO WILLIAM, *goldsmith*; London. 1598

CARELESS — (see JOHN STEVENSON).

CARES DANIEL, *goldsmith*; London. 1599

CARES WILLIAM, *goldsmith*; parish of St Mary Woolnoth. 1594–1599

CAREW (or CARY) NICHOLAS (see COOK & CAREW).

CAREW PAUL (see also CARY), *goldsmith*; Three Black Lyons, Russell street. 1699–1706

CAREY NICHOLAS (cf. NICHOLAS CAREW), *goldsmith*; parish of St Mary Woolnoth. 1675–1680

CARLTON THOMAS, *plate-worker*; Old Bailey. 1744–1748

CARMALT —, *pawnbroker*; Five Blue Bowls, Chandos street. 1742
Three Bowls, corner of Russell court, Covent Garden. 1745

CARMAN JOHN, *plate-worker*; New street [= Chancery lane]. 1728

CARMAN JOHN, *plate-worker*; Holborn. 1748–1752
Hatton garden, Holborn. 1755

CARMAN JOHN, *working goldsmith & sword cutler*; New street. 1752
Hatton garden. 1755
Ewer & Swords, near Bartlett's buildings, Holborn. c. 1760

CAROL (or CARO) GEORGE, *goldsmith*; parish of St Mary Woolnoth. 1600–1608

CARON —, *jeweller*; Little Newport street. 1726

CARON PETER, *jeweller*; Aldermanbury. 1768
No. 3 Old Fish street. 1793

CARPENDER [or CARPENTER] JOHN, *goldsmith*; next door to the Green Dragon ale-house on Snow hill. 1744–1748

CARPENTER —, *goldsmith*; Whitechapel. 1711

CARPENTER JOSEPH, *watch-case maker*; Blue Anchor alley. 1772

CARRICK JOHN, *goldsmith*; Exeter street. (Insolvent) 1729

CARROLL GEORGE, *jeweller*; Old Bailey. 1762

CARROLL JOHN, *jeweller*; New street, Shoe lane. 1762

CARSWELL JOHN, *goldsmith*; London. 1528, 1529

CARTELAGE THOMAS, *goldsmith*; Cheapside. 1465

CARTER — (see HAMMOND & CARTER).

CARTER ANTHONY, *goldsmith*; Three Golden Lyons, Gutter lane. 1706

Plate XI

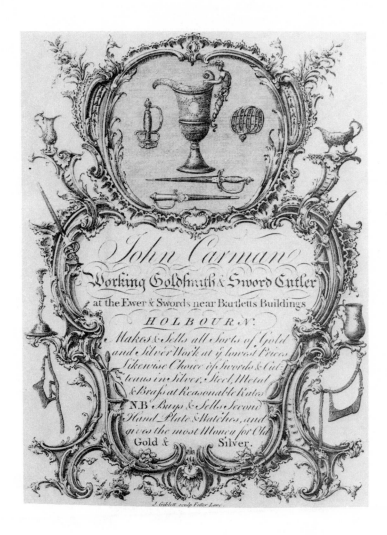

JOHN CARMAN 1748–*circa* 1760

K

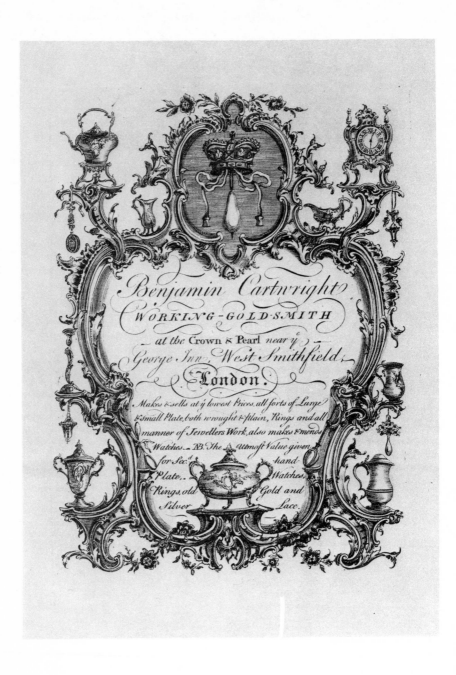

Benjamin Cartwright

WORKING-GOLD-SMITH

at the Crown & Pearl near ye

George Inn, West Smithfield,

London.

Makes & sells at ye lowest Prices, all sorts of Large
& small Plate, both wrought & plain, Rings and all
manner of Jewellers Work, also makes & mends
Watches. NB. The utmost Value given
for Sec.d hand
Plate, Watches,
Rings, old Gold and
Silver Lace.

BENJAMIN CARTWRIGHT 1739–1754

CARTER Edward, *goldsmith*; Unicorn, Russell street, Covent Garden. 1743, 1744
CARTER Edward (see MAKEPEACE & CARTER), *plate-worker*; Bartholomew close. 1777
CARTER Henry, *goldsmith*; parish of St Dunstan's-in-the-East. (Will proved) 1629
CARTER John, *goldsmith*; London. 1768–1789
 Westmoreland buildings, Aldersgate street. 1770
 No. 14 Bartholomew close. 1773–1777
CARTER Mrs, *silversmith*; Russell street, Covent Garden. 1762
CARTER Peter, *goldsmith*; Fleet street. 1775
 Foster lane. 1787
CARTER Richard, *goldsmith*; parish of St Vedast, Foster lane. 1629–(Buried) 1647
CARTER Richard (see MAKEPEACE & CARTER), *goldsmith*; Serle street, Lincoln's Inn. 1772–1778
CARTER Richd., SMITH Danl. & SHARP Robt., *plate-workers*; Westmoreland buildings, Aldersgate street. 1778
CARTER Thomas, *goldsmith*; Westmoreland buildings, Aldersgate street. 1766
CARTER William, *goldsmith*; London. 1560– c. 1570
CARTER William (succeeded by Robert BARRETT), *pawnbroker*; Three Balls, Holles street, Clare market. (Gave up trade) 1752
CARTIER Isaac, *watch-maker*; Angel court. 1768
CARTWRIGHT —, *silversmith*; Three Horse Shoes, Cow Cross. 1732
CARTWRIGHT Benjamin,[1] *working goldsmith & toy-maker*; Crown & Pearl, Bartholomew close, or Crown & Pearl, near ye George Inn, West Smithfield. 1739–1754
 No. 18 West Smithfield. 1768–1774
CARTWRIGHT Benjamin, *plate-worker & toy-maker*; King's Arms & Snuffers, Strand. 1749–1756
CARTWRIGHT Newman, *goldsmith*; Lombard street. 1751–1753
CARWOOD (or KIRWOOD) Thomas (see HILL & CARWOOD, also HIND & CARWOOD).
CARY (or CAREY) George, *goldsmith*; parish of St Mary Woolnoth. 1600–1610
CARY Nicholas (see CAREW).
CARY Paul (see also CAREW), *goldsmith*; over against the Rose Tavern, Covent Garden. 1701–1706
CARY William, *goldsmith*; parish of St Peter's, Cheapside. 1641
 Fleet street. 1661
CASE John [see CAFE (?) John].
CASE William [see CAFE (?) William].
CASSEN John, *silversmith to King Charles II*; London. 1664–1679
CASSON John, *goldsmith*; St Margaret, Lothbury. (Insolvent) 1724
CASTELFRANC Peter [see CASTLEFRANC], *jeweller*; Golden Head, [No. 40] Pall Mall. 1753–(Died) 1789
CASTELL John, *goldsmith*; London. 1570–1572
CASTELL John, *goldsmith*; Birchin lane. 1759
CASTLE Peter (see GWILLIM & CASTLE).
CASTLEFRANC Peter, *jeweller*; No. 40 Pall Mall. 1790–1793
CASWALL [or CARSWELL, see BRASSEY & CASWELL also TURNER & CASWALL]
 George, Sir, *goldsmith*; Acorn [or Golden Acorn], Lombard street. 1700–1709
CASWALL John & MOUNT John, *goldsmiths & bankers*; east side of Birchin lane. 1715–1742
CASWELL Mrs Ann, *pawnbroker*; Old Pye street, Westminster. 1744

[1] All three addresses refer to the same house.

CATER William, *goldsmith*; London. 1560–1570

CATES —, *goldsmith*; The Cup, East Smithfield. 1712

CATES —, *pawnbroker*; Five Blue Balls, Chandos street, Covent Garden. 1753
 Three Balls, Chandos street, Covent Garden. 1765

CATES Thomas, *pawnbroker*; Golden Ball, Cursitor alley, Chancery lane. 1703

CATON George, *gold & silver button maker*; Golden Lion & Crown, the corner of May's
 buildings, St Martin's lane. c. 1760

CATT John, *watch case maker*; Bridgewater Gardens. 1772

CATTERALL Thomas, *goldsmith*; Black Boy, Russell street, Covent Garden. 1697–1718

CAUSTON Thomas, *pawnbroker*; Foster lane. 1731

CAVE — (see ROBINSON & CAVE).

CAWDELL William, *goldsmith*; Foster lane. (Will proved) 1625

CAWTHORN Samuel, *jeweller*; Goldsmiths' Hall. 1766

CAYNE Andrew, *goldsmith*; parish of St Giles's, Cripplegate. 1641
 Bishopsgate Without. 1696

CHABBERT John, *goldsmith & jeweller*; Crown, in Holborn, over against Brownlow street.
 1731–1744

CHABOT James, *jeweller*; No. 21 Gutter lane. 1796

CHADD Richard & RAGSDALE John, *jewellers & goldsmiths*; New Bond street. 1765–1768

CHADD & RAGSDALE, *jewellers*; Golden Vause, New Bond street, almost opposite Conduit
 street. 1749–1768

CHADWELL Edward, *goldsmith*; parish of St Vedast, Foster lane. (Buried) 1710

CHADWELL John, *goldsmith*; Castle alley, Birchin lane. 1702–1722
 London. 1724

CHADWELL Jno., *working goldsmith*; Cornhill ward. 1691/2, 1692/3

CHADWICK —, *goldsmith and jeweller*; No. 36 Cornhill. 1781

CHADWICK James, *plate-worker*; Maiden lane. 1690–1703

CHADWICK John & HELLIER [or HILLER] Joseph, *jewellers*; Birchin lane. 1789
 No. 36 Cornhill. 1790–1793

CHALMERS George¹ (see also CHALMERS & ROBINSON), *goldsmith*; Sidney's alley,
 Leicester fields. 1773
 No. 1 Prince's street, Leicester square. 1783–1793

CHALMERS James, *silversmith*; Buckingham street. 1790–1793

CHALMERS & ROBINSON (see also George CHALMERS), *jewellers & goldsmiths*; Ring
 & Cup, Walker's court, Berwick street, Soho. c. 1760
 Golden Spectacles, Sidney's alley, Leicester fields. 1773

CHAMBERLAIN John, *goldsmith*; St Edmondsbury. 1704–1712

CHAMBERLEN John, *plate-worker*; Maiden lane. 1704

CHAMBERS Abraham, *goldsmith*; Three Squirrels, over against St Dunstan's Church, Fleet
 street. 1683–1693
 Golden Eagle (or Golden Falcon), over against St Dunstan's Church, Fleet
 street. (Killed by highwaymen) 1693

CHAMBERS Abraham, Junr., *goldsmith*; Falcon, Fleet street. 1733–1756

CHAMBERS Abraham & USBORNE Thomas, *goldsmiths & bankers*; Three Squirrels, Fleet
 street. 1733–1749

CHAMBERS James, *goldsmith*; Three Squirrels, over against St Dunstan's Church, Fleet street.
 c. 1680–1714

¹ These two addresses are probably alternatives for the same corner house.

CHAMBERS JOHN, *gold & silver buckle maker*; Three Squirrels, Fleet street. 1693
CHAMBERS WILLIAM, *goldsmith*; London. 1540–1553
CHAMBERS WILLIAM, *pawnbroker*; Three Bowls, Drury lane. 1709–1712
CHAMBRIER B. A., *goldsmith*; Church street, Soho. 1773
CHAMNIS JAMES, *goldsmith*; parish of St Giles', Cripplegate. 1697
CHAMPION DANIEL, *goldsmith*; Savoy. 1706
CHAMPION WILLIAM, *goldsmith*; No. 100 Shoreditch. 1790–1793
 Paul's court. 1791
CHANDLER ROBERT, *silversmith & jeweller*; Martin's court, St Martin's lane. 1790–1793
 No. 8 Leicester square. 1790–1796
CHANNIEN JOHN, *goldsmith*; Shoreditch. 1788
CHANTRELL EDMOND, *pawnbroker*; Old Bell, Deadman's place, Southwark. 1711–1720
CHAPMAN DANIEL, *plate-worker*; Bunhill row. 1729–1734
CHAPMAN FRANCIS, *goldsmith*; parish of St Mary Woolnoth. 1614–(Died) 1636
CHAPMAN GEORGE, *goldsmith*; parish of St Peter's, Broad street ward. 1692
CHAPMAN JASPER, *goldsmith*; Basinghall street. 1677
CHAPMAN JOHN, *plate-worker*; Noble street. 1730–1738
CHAPMAN RICHARD, *goldsmith*; parish of St Mary Woolnoth. 1696–1697
CHAPMAN WILLIAM, *goldsmith*; Rose, Tower street. 1681
CHARDIN JOHN, SIR,[1] *jeweller to Charles II*; Holland House, Kensington and Turnham
 Green 1681–(Died) 1712
CHARMAN —, *jeweller*; No. 26 St James's street. [N.D.]
 No. 3 George street, Adelphi. 1790–1793
CHARNELHOUSE WILLIAM, *plate-worker*; Gutter lane. 1703–(Buried) 1712
CHARPENTIER GIDEON ERNEST, *jeweller*; No. 4 Great St Andrew's street, Seven Dials.
 (Married) 1758–(Died) 1797
CHARPENTIER & WILHELM, *jewellers*; No. 4 Great St Andrew's street, Seven Dials. 1779
CHARTIER DANIEL, *plate-worker*; Heming's row [St Martin's lane]. 1740
CHARTIER FRANCIS, *jeweller*; No. 1 Angel court, Throgmorton street. 1779
CHARTIER JOHN, SENIOR, *plate-worker*; Heming's row [St Martin's lane]. 1697–1715
CHARTIER JOHN, JUNIOR, *goldsmith*; Heming's row [St Martin's lane]. 1723
CHASIGNETT JOHN, *goldsmith*; Farringdon Without. 1583
CHAUNDELER JOHN, *goldsmith*; London. 1540–1553
CHAUVEL PETER, *goldsmith*; next door to the Church in Broad street, near the Royal
 Exchange. 1734
CHAVANON PIERRE, *goldsmith*; Wardour street. 1706–1709
CHAVEAU JOHN, *goldsmith*; Hoxton. 1785
CHAWNER HENRY, *goldsmith*; Ave Mary lane. 1787
 Amen corner, Ave Mary lane. 1790–1793
 No. 34 Paternoster row. 1792–1796
CHAWNER HENRY & EMES JOHN,[2] *plate-workers*; Amen corner. 1796–1808
CHAWNER THOMAS, *plate-worker*; No. 60 Paternoster row. 1759–1799
 Red Lion street, Clerkenwell. 1767
 Amen corner. 1784
 Ave Mary lane. 1784, 1785

[1] Traveller and author (see *D.N.B.*).
[2] The present successors of this firm are Edward Barnard & Sons, 54 Hatton Garden.

LONDON GOLDSMITHS

CHAWNER WILLIAM (see also HEMING & CHAWNER), *goldsmith*; No. 60 Paternoster row.
 1759–1768
 New Bond street. 1773
CHAWNER WILLIAM & THOMAS, *silversmiths*; No. 60 Paternoster row. 1759–1768
CHEANEY RICHARD (see RICHARD CHENEY).
CHEARY —, *goldsmith*; Bull, Bird Cage alley, near St George's Church, Southwark. 1745
CHEESBROUGH WARNER, *gold & silver caster & jeweller*; 21 Beer lane, Thomas street. 1790–1793
 4 Racquet court, Fleet street. 1796
CHEFFIN —, *goldsmith*; Covent Garden. 1695
 Strand. 1699
CHENEVIX PAUL DANIEL,[1] *toyman & jeweller*; Golden Door, against Suffolk street, near Charing Cross. 1731–(Died) 1742
CHENEY (or CHEANEY) RICHARD, *goldsmith*; parish of St Mary Woolnoth. 1590–(Died) 1625
CHEPARDE NOYE, *goldsmith*; Barbican. 1600
CHESHIRE [or CHESHEIRE] HENRY, *goldsmith*; parish of St Mary Woolnoth. 1605–1609
CHESSON THOMAS, *jeweller*; Unicorn & Pearl, near Queen street, Cheapside. 1732
 Golden Salmon & Pearl, [No. 32] Ludgate hill. 1753–1760
 (Succeeded by Henry Hurt.)
CHEST JOHN, *goldsmith*; Cheapside. 1429
CHESTER ROBERT, *goldsmith*; Crown & Sceptre, Lombard street. 1704, 1705
CHESTER WILLIAM, *silversmith*; 116 High street, Borough. 1790–1793
CHESTERMAN ANN, *silversmith*; Fleet market. 1777
CHESTERMAN CHARLES, *goldsmith & pawnbroker*; Clare market. 1741
 Carey lane. 1752
 62 Fleet market. 1766–1793
CHETWIND JOHN, *goldsmith*; Golden Key, Strand. 1687–1692
CHIBNALL GEORGE, *goldsmith*; Lombard street. (Buried) 1592
CHICHELEY WILLIAM, *goldsmith*; London. 1409
CHILD —, *pawnbroker*; Three Balls, corner of Lumber court, Seven Dials. 1765
CHILD FRANCIS, SIR,[2] *goldsmith & banker*; Marygold, within Temple Bar. 1664–(Died) 1713
CHILD FRANCIS, SIR (JUNIOR),[3] *goldsmith & banker*. Marygold, within Temple Bar. 1721–(Died) 1740
CHILD FRANCIS, *goldsmith*; Lincoln's Inn fields. 1727
CHILD FRANCIS & BLANCHARD ROBERT, *goldsmiths & bankers*; Marygold, within Temple Bar. c. 1671–1681
CHILD FRANCIS & ROGERS JOHN, *goldsmiths & bankers*; Marygold, within Temple Bar. 1681
CHILD ROBERT, SIR, *goldsmith*; Marygold, Fleet street. 1713–(Died) 1721
CHILD STEPHEN, *goldsmith*; Lombard street. 1705–1713
CHILD STEPHEN & TUDMAN BENJAMIN, *goldsmiths*; Crown, Lombard street. c. 1700–1712
CHILDE JOHN, *goldsmith*; parish of St Peter, Westcheap. 1600
CHIRAC DENIS, *jeweller*; London. 1712
 Golden Head, Villiers street, York buildings. 1721–1731
CHITHAM CHARLES, *goldsmith*; parish of St Martin's-in-the-fields. (Married) 1668
CHITWOOD JOHN, *goldsmith*; parish of St Vedast, Foster lane. (Will proved) 1621

[1] Mrs Chenevix, the toy-woman, of Suffolk Street, leased the house (Strawberry Hill) at Twickenham which Horace Walpole took over from her in 1747. (*D.N.B.*)
[2] Lord Mayor, 1698–9.
[3] Lord Mayor, 1731–2.

(124)

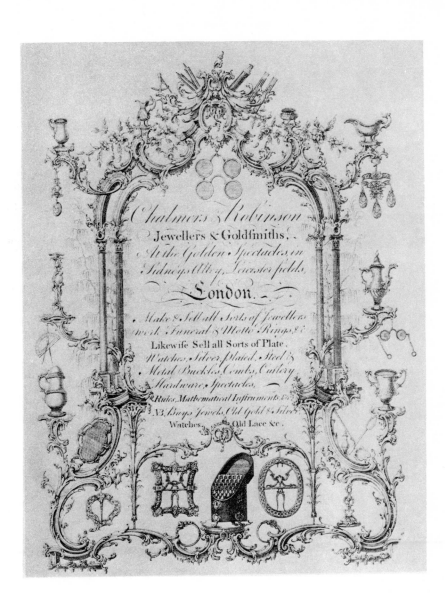

Chalmers & Robinson
Jewellers & Goldsmiths,
At the Golden Spectacles in
Sidneys Alley, Leicester fields,

London.

Make & Sell all Sorts of Jewellers
work, Funeral & Motto Rings, &c
Likewise Sell all Sorts of Plate,
Watches, Silver-plated, Steel &
Metal Buckles, Combs, Cutlery
Hardware, Spectacles,
Rules, Mathematical Instruments, &c
N.B. Buys Jewels, Old Gold & Silver,
Watches, Old Lace &c.

CHALMERS & ROBINSON

1733

Plate XII

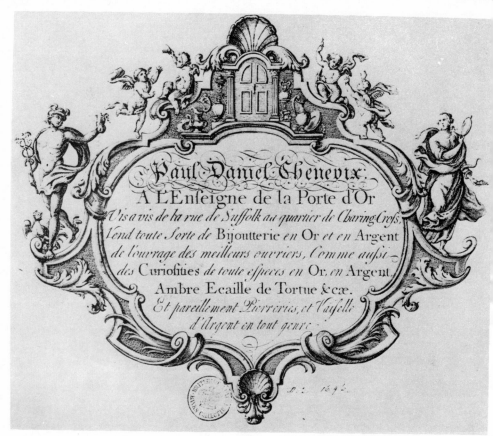

PAUL DANIEL CHENEVIX

CHIVEN Mrs, *goldsmith*; Crown & Pearl, Strand. 1709
CHRISTIAN Hans, *goldsmith*; London. 1457
CHRISTIAN John, *jeweller & goldsmith*; Gracechurch street. 1763–1765
 Leadenhall street. 1766
CHURCH John, *pawnbroker*; Two Vizards Masks & Golden Ball, Hewit's court, near St
 Martin's Church in the Strand. 1710–(Died) 1715
CHURCHILL Thomas (see WHITE & CHURCHILL), *goldsmith*; Strand. 1676, 1677
CLAPP Robert, *silversmith*; Westminster. (Bankrupt) 1734
CLARE Joseph, *plate-worker*; Wood street, by Love lane. 1713–1720
 Blackamoor's Head, Lombard street. 1721–(Deceased) 1728
CLARE Joseph, *goldsmith*; London. 1758
CLARE William, *goldsmith*; Fenchurch street. 1689
CLARIS Christian, *plate-worker*; James street, Covent Garden. 1727
CLARK — (cf. Francis CLARK), *goldsmith*; Hind, Fleet street. 1694
CLARK —, *goldsmith*; Strand. 1697–1699
CLARK — (or CLARKE), *pawnbroker*; King & Key (or Two Kings & Key), next door but
 one to the White Horse inn, Fleet street. 1749–1752
CLARK Charles, *plate-worker*; Bunhill row. 1739
CLARK Ebenezer, *silversmith*; removed from Fenchurch street to near St Dunstan's Church,
 Fleet street. 1790–1817
CLARK Francis (see — CLARK), *goldsmith*; Golden Hart (or Golden Buck), near St Dunstan's,
 Fleet street. 1693–1702
CLARK George, *goldsmith*; Golden lane. 1797
CLARK Simon, *goldsmith*; Love lane, Aldermanbury. 1677
CLARK Thomas, *plate-worker*; Ball alley. 1725
CLARK Thomas, *jeweller & toyman*; Golden Head, Strand, near Arundel street. c. 1750
CLARK William (see William HOW & William CLARK), *goldsmith*; Spital square. 1777
CLARKE —, *goldsmith*; Angel, Cheapside. 1553
CLARKE — (see FIELD & CLARKE), *silversmith*; No. 233 High Holborn. 1784–1793
CLARKE Catherine, *goldsmith*; London. 1773, 1774
CLARKE Edward, *goldsmith*; Swithin's lane. 1766
 Cornhill. 1766
CLARKE Edward, *jeweller & goldsmith*; No. 9 Holborn Bars. 1768
CLARKE Francis, *goldsmith*; parish of St Gregory's. (Will proved) 1638
CLARKE Francis, *goldsmith*; Golden Buck, Fleet street. 1693–1702
CLARKE Henry, *plate-worker*; Foster lane. 1709–1720
 St Anne's lane. 1720–1722
 Gutter lane. (Insolvent) 1737
CLARKE Henry, *goldsmith*; Wood street. 1734–(Dead) 1777
CLARKE Jasper, *pawnbroker*; Colchester street, Whitechapel. 1730
CLARKE John, *goldsmith*; London. 1551–1566
CLARKE John, *goldsmith*; parish of St Mary Woolnoth. 1568
CLARKE John, *goldsmith*; parish of St Vedast's, Foster lane. (Buried) 1576
CLARKE John, *goldsmith*; Cheapside. 1623
CLARKE John, *plate-worker*; Foster lane. 1722
 Gutter lane. 1724–1727

LONDON GOLDSMITHS

CLARKE LETITIA, *jeweller & goldsmith*; Eagle & Pearl, opposite Brook street, (No. 9) Holborn
 Bars. 1790–1802

CLARKE M., *goldsmith & jeweller*; Eagle & Pearl, opposite Brook street, (No. 9) Holborn. 1790–1793

CLARKE PETER, *jeweller*; Aldersgate ward. 1618

CLARKE RICHARD, *plate-worker*; Minories. 1708

CLARKE RICHARD, *goldsmith*; No. 9 Holborn Bars. 1770–1774

CLARKE RICHARD, *jeweller & toyman*; Eagle & Crown, No. 102 Cheapside, opposite Bow lane. [N.D.]

CLARKE RICHARD, *goldsmith*; No. 62 Cheapside. 1795, 1796

CLARKE SARAH, *goldsmith*; Borough of Southwark. 1777

CLARKE THOMAS, *goldsmith*; parish of St Vedast, Foster lane. (Buried) 1592

CLAUS FRANCIS, *jeweller*; St Martin's-in-the-fields. 1705

CLAUSEN NICHOLAS, *plate-worker*; Orange street, Leicester fields. 1709–1723

CLAY —, *jeweller*; Fenchurch street. 1760

CLAY RICHARD, *goldsmith*; Cheapside. 1623–1638

CLAY WILLIAM, *silversmith*; between Aldgate and the corner of the Minories. 1751

CLAYTON —, *jeweller*; Butcher Hall lane. 1719

CLAYTON ANTHONY, *teacher of shorthand—formerly goldsmith*; Montague court, Little Britain 1725

CLAYTON DAVID, *jeweller*; Golden Unicorn, Cheapside. 1703–1711
 Golden Unicorn, Butcher Hall lane, Newgate street. 1714

CLAYTON JOHN, *goldsmith*; London. (Bankrupt) 1737

CLAYTON JOHN & ANTHONY, *goldsmiths*; Flower-de-luce, Cheapside 1704–1706

CLEARE EDWARD, *silver buckle maker*; opposite the sign of the George in Long lane, Southwark. 1752

CLEAVE (or CLEEVE) EDWARD (see COX & CLEAVE).

CLEMENCE JOHN, *jeweller*; Dean's court, St Martin's-le-Grand. 1702

CLEMENS —, *pawnbroker*; Baptist's Head, facing the Great Old Bailey. 1752, 1753
 Crown, on Holborn hill. 1753

CLEMENTS ROBERT, *goldsmith*; George, Newgate street. 1695–1706

CLEMENTS ROBERT, *goldsmith & watch-case maker*; Aldermanbury. 1765, 1766

CLENT WILLIAM, *goldsmith*; parish of St Mary, Staining lane. (Married) 1632
 Bachelor's alley. 1646

CLERKE THOMAS, *goldsmith*; London. 1569

CLIFFE ROBERT (?) (see SURMAN, DINELEY & CLIFFE), *goldsmith*; Lombard street. 1753–1757

CLIFTON JOHN, *plate-worker*; Foster lane. 1708

CLIFTON JONAH, *plate-worker*; Tower street. 1703–1728

CLIFTON JONAS, *goldsmith*; Crown, Strand. 1718
 Crown, Henrietta street, Covent Garden. "Remov'd from a little beyond
 Hungerford in ye Strand." c. 1730

CLIFTON JOSIAH, *goldsmith*; London. 1720

CLINTON & COLES, *jewellers*; No. 16 Salisbury street, Strand. 1790–1793

CLOBURY NICHOLAS, *goldsmith*; Dagger, Lombard street. (Buried) 1665

CLOETT JASPER, *jeweller*; parish of St Benet Fink. 1679

CLOUDSLEY RICHARD, *jeweller*; Silver street. (Insolvent) 1769

CLOUGH EDWARD, *goldsmith*; London. 1454

COATES (or COATS) ALEXANDER & FRENCH EDWARD, *goldsmiths*; Bennet's court, Exeter
 Change. 1734

COATES THOMAS, *pawnbroker*; Globe, Shoe lane. 1693

COBY JAMES, *goldsmith*; Gutter lane. 1768

(126)

LONDON GOLDSMITHS

COCK ABRAHAM, *jeweller*; No. 10 Maiden lane, Wood street. 1790–1793
 No. 23 Arundel street, Strand. 1796

COCKE ABRAHAM, *goldsmith*; Golden Cup, Albemarle street, near St John's square [Clerkenwell].
 1747

COCKETT MATTHEW, *goldsmith*; Castle, Fleet street. (Married) 1700

COCKINE (or COCKYN) CHARLES, *goldsmith*; parish of St Andrew's, Holborn. 1641
 Near Staples Inn, Holborn. 1664, 1665

COCKNEDGE (or COCKNIDGE) WILLIAM, *goldsmith*; parish of St Mary Woolnoth. 1576–1578

CODLICOTT MRS, *pawnbroker*; Green Dragon, Addle hill. 1754

COGAN HENRY, *Comptroller of the Mint*; Tower of London. 1641, 1642

COGGS JOHN, *goldsmith & banker*; King's Head, over against St Clement's Church, Strand.
 1664–(Buried) 1710

COGGS JOHN (JUNIOR) (son of JOHN COGGS), *goldsmith*; London. 1724–(Died) 1751

COGGS JOHN & DANN JOHN, *goldsmiths & bankers*; King's Head, over against St Clement's
 Church, Strand. 1696–(Insolvent) 1709

COGUES — (see COOQŪS).

COHEN LEVI, *jeweller*; No. 72 Lower East Smithfield. 1790–1793

COKER — (see JOHN COOQŪS)

COKER EBENEZER, *plate-worker*; Golden Cup & Rising Sun, Clerkenwell close (or Green). 1738
 Clerkenwell close and No. 13 Goldsmith street, Wood street.
 1770–(Bankrupt) 1781

COKER EBENEZER & HAMMOND THOMAS, *goldsmiths*; Clerkenwell close.
 (Dissolved partnership) 1760

COKES HUGH, *goldsmith*; parish of St Mary Woolnoth. 1562

COLDECOTT WILLIAM, *goldsmith*; London. 1745

COLDS LAWRENCE (cf. LAWRENCE COLE also LAWRENCE COLES), *plate-worker*; Foster lane.
 1697–1714

COLE —, *silversmith*; Lamb & Woolpack, Cow Cross. 1731

COLE EMANUEL, *goldsmith*; parish of St Mary Woolnoth. 1576–1582

COLE H., *jeweller*; Eagle court, Strand. 1743

COLE HENRY, *goldsmith*; London. 1483

COLE HUMPHREY, *goldsmith*; the Mint in the Tower. 1572

COLE JOHN, *plate-worker*; Silver street. 1697–1705

COLE LAWRENCE (cf. LAWRENCE COLDS also LAWRENCE COLES), *goldsmith*; parish of St John
 Zachary. 1692, 1693

COLE ROBERT, *goldsmith*; Golden Anchor, opposite the Castle Tavern (or over against St
 Dunstan's Church), Fleet street. 1694, 1695

COLE SAMUEL, *goldsmith*; London. 1576

COLE THOMAS, *pawnbroker*; Golden Ball, Mutton lane. 1717

COLE THOMAS (see also NEWTON & COLE), *goldsmith*; Lombard street. 1760–1765

COLE & NEWTON (cf. NEWTON & COLE), ? *goldsmiths*; Lombard street. 1753–1755

COLEBROOK JAMES (see JACKSON & COLEBROOK), *goldsmith & banker*; near the Royal
 Exchange. 1706–1720

COLEMAN —, *goldsmith*; St Catherine's. 1695

COLEMAN —, *pawnbroker*; George, Minories. 1759

COLEMAN ANDREA, *goldsmith*; London. 1693

COLEMAN JOHN, *goldsmith*; No. 115 Newgate street. 1779–1784
 No. 118 Fleet street. [N.D.]

COLEMAN Stephen, *plate-worker*; Little Britain. 1697–1702
COLEMAN Tobias, *goldsmith*; parish of St Leonard's, Foster lane. 1642–1653
COLES Henry, *jeweller*; Eagle & Pearl, Tavistock street, Covent Garden. 1753–1755
COLES (or COLE) John Benjamin, *goldsmith*; No. 54 Barbican. 1790–1796
 No. 7 Panton street. 1796
COLES Lawrence (cf. Lawrence COLDS also Lawrence COLE), *goldsmith*; London. 1669–1697
COLES Walter, *goldsmith*; Foster lane. 1776
COLES William, *silversmith*; Silver street, St Olave's. 1744
COLES William, *silversmith*; Barbican. 1790–1793
COLEY & SON, *working silversmith*; No. 35 Fetter lane. 1790–1793
COLFE —, *goldsmith*; London. 1666
COLIBERT — (see WIRGMAN, SON & COLIBERT).
COLLARD Leonard, *goldsmith*; Lombard street. 1652–1661
COLLE (or COLNEY) Stephen, *goldsmith*; London. Temp. Henry VI
COLLETT Nicholas, *goldsmith*; parish of St Mary Woolnoth. 1637–1656
COLLEY Henry, *goldsmith*; London. 1583
COLLEY Thomas, *goldsmith & watch-maker*; Fleet street. 1770
COLLIER —, *silversmith*; Gutter lane. 1747
COLLIER Ann, *pawnbroker*; Black Hart, Bishopsgate street. 1702–(Deceased) 1707
COLLIER John, *goldsmith*; London. 1670–1672
COLLIER John, *jeweller*; No. 57 Wood street, Cheapside. 1790
COLLIER Thomas, *goldsmith*; parish of St Mary Woolnoth. 1635–1660
COLLIER Thomas, *plate-worker*; Foster lane. 1754
COLLIN Cuthbert, *goldsmith*; parish of St Mary Cree. (Will proved) 1645
COLLINS —, *goldsmith*; Russell street. 1680
COLLINS Edward, *pawnbroker*; White Hart, Ludgate street. 1715
COLLINS Francis, *goldsmith*; over against the Post Office, Lombard street. 1730–(Died) 1743
COLLINS Henry, *plate-worker*; parish of All Hallows, Lombard street. 1692–1693
 Maiden lane. 1698
 London. 1714
COLLINS J., *plate-worker*; Hind court, Fleet street. 1754–1774
COLLINS John, *goldsmith*; parish of St Mary Woolnoth. 1580–1584
COLLINS William, *goldsmith*; parish of St Mary Woolnoth. 1672–1675
COLLYER Thomas, *goldsmith*; parish of St Mary Woolnoth. 1634–1644
COLNEY Stephen (see Stephen COLLE).
COLTE John, *goldsmith*; parish of St Mary Woolnoth. 1602–(Buried) 1615
COLVILL John,[1] *goldsmith & banker*; Lombard street. 1655–1666
 [2]Lime street. 1666–(Buried) 1670
COLVILLE Henry, *goldsmith*; London. 1531–1553
COMBE Benjamin, *goldsmith*; parish of St Mary Woolnoth. 1675–1680
COMBETTE Antoine, *jeweller*; parish of St Martin's-in-the-fields. 1776
COMBYS Mrs, *pawnbroker*; Golden Ball, Gravel street, near Brook's market, Holborn. 1718
COMINS Ralph, *goldsmith*; London. 1350
COMPIEGNE —, *goldsmith*; Six Bells, Long Acre. 1738
COMPTON —, *goldsmith*; Clark (? Clare) market. 1715

[1] Pepys's *Diary*, 24 May 1665, 19 June 1665. [2] Pepys's *Diary*, 15 Oct. 1666, 12 Oct. 1668.

Plate XV

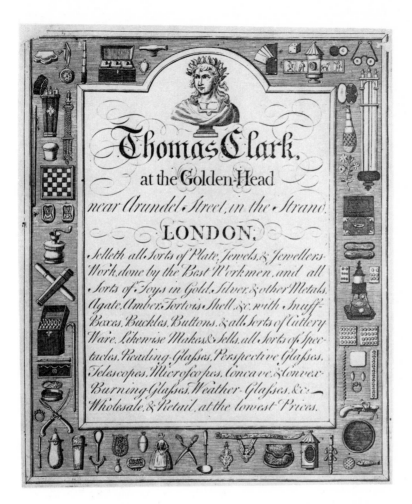

THOMAS CLARK

circa 1750

Plate XVI

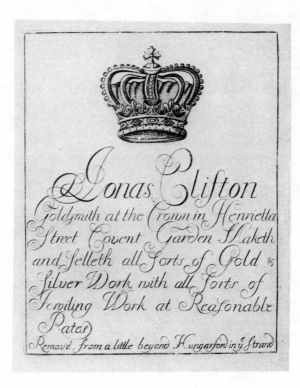

JONAS CLIFTON *circa* 1730

COMPTON WALTER, *goldsmith*; King's Arms, Vere street. 1680–1692
 Duke street, over against the lower end of Great Wild street. 1695–1712
 Strand. (Insolvent) 1719
COMYNS WILLIAM, *goldsmith*; London. 1645
CONELL THOMAS, *goldsmith*; London. 1567–1569
CONEN EDWARD, *plate-worker*; Carey lane. 1724
CONEN RICHARD, *goldsmith*; Philip lane. 1769
CONGREVE THOMAS, *plate-worker*; Borough. 1756–1760
CONIERS RALPH, *goldsmith*; parish of St Mary Woolnoth. 1593–(Buried) 1610
CONINE JOHN, *goldsmith*; Salisbury court [Fleet street]. 1677
CONRAD, *goldsmith*; London. 1269
CONSTABLE WILLIAM (see also GRAY & CONSTABLE), *goldsmith*; Sackville street, Piccadilly. 1800
CONSTABLE & TOOKEY, *jewellers & toymen*; 45 New Bond street. 1790
CONYERE (or CONYERS) RICHARD, *goldsmith*; parish of St Mary Woolnoth. 1695, 1696
COOK —, *jeweller*; Dog & Bear, Southwark. 1731
COOK ABRAHAM, *goldsmith*; No. 10 Noble street, Foster lane. 1790–1793
COOK JOHN, *goldsmith*; No. 22 Cheapside. 1762–1768
COOK JOSHUA, *silversmith*; Blue Anchor alley, Bunhill row. 1781–1793
COOK THOMAS, SIR, *goldsmith*; London. 1670–(Died) 1709
COOK THOMAS, SIR & CAREW (or CARY) NICHOLAS, *goldsmiths & bankers*; Griffin, Exchange alley, Lombard street. 1675–1684
COOK & VENABLES (see COOKE & VENABLES).
COOKE DANIEL, *goldsmith*; parish of St Helen's, Bishopsgate. 1613–1625
COOKE EDWARD, *jeweller*; Green Dragon court in Old Change. 1728
COOKE EDWARD, *goldsmith & jeweller*; No. 210 Borough, in the Haymarket, Southwark. 1760–1777
COOKE FRANCIS, *goldsmith*; parish of St John Zachary. (Married) 1671
COOKE JOHN, *goldsmith*; parish of St Vedast's, Foster lane. (Married) 1584–(Buried) 1601
COOKE JOHN, *jeweller*, London. 1684
COOKE JOHN, *goldsmith*; Porter, near Gracechurch street. 1690–1706
COOKE JOHN, *plate-worker*; Strand. 1699
COOKE JOHN, *goldsmith*; Great Wood street. (Deceased) 1706
COOKE JOHN, *goldsmith*; Golden Ball & Crown, Cheapside. 1751–1753
COOKE JOHN, *clock-maker*; No. 22 Wood street, Cheapside. 1765–1777
COOKE RICHARD, *goldsmith*; parish of All Hallows, Staining. 1630–(Will proved) 1652
COOKE RICHARD, *plate-worker*; Carey street. 1799
COOKE SAMUEL & VENABLES STEPHEN, *goldsmiths*; Sun, Lombard street. 1718–(Bankrupt) 1721
COOKE SAMUEL (see COOKE & VENABLES), *goldsmith*; Sun, Lombard street. 1718–(Deceased) 1731
COOKE (or COOK) THOMAS (see COOKE & GURNEY), *goldsmith*. 1721–(Died) 1761
COOKE (or COOK) THOMAS & GURNEY RICHARD, *goldsmiths*; Golden Cup, Foster lane. 1721–1773
COOKER JOHN (see JOHN COOQŪS).
COOLING WILLIAM, *pawnbroker*; Rose, Stanhope street. (Left off trade) 1719
COOMBES LAZARUS, *pawnbroker*; Three Bowls, Holles street, Clare market. 1703–(Left off trade) 1708
COOPER —, *goldsmith*; near the Maypole, Strand. 1705

COOPER Benjamin, *goldsmith*; Wheelbarrow, Crooked lane. 1725
COOPER Benjamin, *goldsmith*; No. 7 Brownlow street, Holborn. 1774–1779
COOPER Edmond, *goldsmith*; Crow & Braslet (Bracelet), Old Change. 1704
COOPER Edward, *gold chain-maker*; Gold Chain, Old Change. c. 1700
COOPER George, *goldsmith*; London. 1772
COOPER Gissingham (cf. Robert COOPER), *goldsmith & banker*; corner of Arundel street,
Strand. 1716–1768
COOPER Isaac (see SUTTON & COOPER).
COOPER Jane, *goldsmith*; No. 14 Strand. 1790–1793
COOPER John, *goldsmith*; parish of St Leonard's, Aldersgate Within. 1691–1693
COOPER John (cf. John COWPER), *goldsmith*; Golden Ball, over against the Maypole,
Strand. 1712
Against New Church, Strand. 1724–1727
COOPER John, *jeweller*; George street, Foster lane. 1751
St Martin's-le-Grand. 1752–1762
COOPER John & Hiram (see Isaac FOSTER & John & Hiram COOPER).
COOPER Matthew, *plate-worker*; Foster lane. 1699–(Insolvent) 1738
COOPER Matthew, *plate-worker*; Minories. 1725
COOPER Nathaniel, *goldsmith*; parish of St Giles', Cripplegate. (Married) 1657
COOPER Robert, *goldsmith*; Golden Lion, corner of Arundel street, Strand. 1694–1714
COOPER Robert & CO., *goldsmiths*; corner of Arundel street, Strand. 1717
COOPER Thomas, *goldsmith*; parish of St Anne and St Agnes. 1691–1692
COOPER William, *silversmith*; Blackfriars. c. 1690
Cheapside. 1691
COOPER & FOSTER, *goldsmiths*; Bartlett's court, Holborn. 1790–(Partnership dissolved) 1796
COOPER & GILES, *silversmiths*; Curtain, Hollywell-mount. 1773
COOQŪS, COQUES, COGUES or COKER, etc.,[1] John, *goldsmith*; on the north side of
Pall Mall. 1664–(Buried) 1697
COOTE (or COTE) Henry, *goldsmith*; parish of St Vedast. 1478–(Died) 1513
COOTE Richard, *goldsmith*; London. 1799
COPE John, *plate-worker*; Oate lane. 1701–1703
COPESTAKE Henry, *jeweller*; Crane court, Fleet street. 1790–1793
No. 8 New Bridge street, Blackfriars. 1790–1793
No. 9 Bell's buildings, Salisbury square. 1796
COPP George, *goldsmith*; near St Dunstan's. 1677
COPPER Henry, *maker of assays in gold and silver*; Carey lane. c. 1760
COPPING John, *goldsmith*; Billingsgate. 1708
COPPLEMAN Phillip, *goldsmith*; parish of St Anne's, Blackfriars. (Married) 1619
COQUES John (see John COOQŪS).
CORBET Thomas, *goldsmith*; St Martin's lane. 1699–(Bankrupt) 1706
CORDELL —, *goldsmith*; Rose & Crown, Cheapside. 1687
CORDELL Robert, *goldsmith*; Lombard street. 1642–(Buried) 1661
CORDES John, *jeweller*; Cecil court, near Pond's Coffee-house, St Martin's lane. 1702–1716
CORNAC Edward (see CORNOCK).
CORNASSEAU Isaac, *silversmith*; Acorn, Drury lane. 1722
CORNE Mary, *pawnbroker*; Tea Kettle, Fair street, Horsley down. 1757
CORNECK James & SON, *goldsmiths*; No. 8 Cheapside. 1784

[1] See page 8.

CORNELIUS Francis, *goldspinner*; Cripplegate Without. 1618
CORNELIUS Hans, *goldsmith*; London. 1630
CORNELIUS John, *goldsmith*; parish of St Bartholomew the Less. (Dead) 1592
CORNER —, *jeweller*; Bury street, St James's. 1731
CORNFORD Harry, *goldsmith*; London. 1586
CORNOCK (or CORNAC) Edward, *plate-worker*; Carey lane. 1707–1723
 Gutter lane. 1723–1731
CORNWALL Edmund, *goldsmith*; London. 1568
CORNYSHE Rasel, *goldsmith*; London. 1553
CORONEL Moses, *pawnbroker*; Three Balls, Winford street, corner of Bell lane, Spitalfields. 1763
COROSEY John, *plate-worker*; Foster lane. 1701–1720
COROUCH Moses, *pawnbroker*; Three Blue Balls, Boswell court, St Clement's (Strand). 1754
CORPORON John, *plate-worker*; Princes street. 1716
CORREGES James & Joseph, *jewellers*; St Martin's-le-Grand. (Insolvent) 1755
CORREGES James & FISHER Robert, *jewellers*; St Martin's-le-Grand.
 (Partnership dissolved) 1744
CORRY Henry (see CORY).
CORTAULD Samuel (see COURTAULD).
CORTENHALL Edward, *goldsmith*; parish of St Mary Woolnoth. 1558
CORY Henry, *plate-worker*; Aldersgate street. 1754
CORY John, *plate-worker*; Golden Cup, Fleet street. 1697–1722
CORY Mary, *goldsmith*; Aldersgate street. 1768
CORY Thomas, *goldsmith*; Golden Cup, Fleet bridge. 1687–1689
COSSON Edward, *goldsmith*; London. 1668
COSTE Henry, *goldsmith*; parish of St Vedast, Foster lane. (Buried) 1509
COTE Henry (see Henry COOTE).
COTTEN George, *jeweller*; Maiden lane, Covent Garden. 1790–1793
COTTERELL Thomas, *pawnbroker*; Shoe lane. 1795
COTTERELL Widow, *silversmith*; near Covent Garden. 1730
COTTON Humphrey, *goldsmith*; parish of St Giles', Cripplegate. 1593
COTTON Richard, *goldsmith*; Barking. 1620–(Will proved) 1623
COTTON Thomas, *goldsmith*; London. ? c. 1720
COUGNON (or COUGNION) Moyse, *goldsmith*; Newport alley. 1714–1720
 Near Golden square. 1722–1727
 Carnaby street. 1730–1737
COURCHY Thomas (? Thomas CHURCHILL of WHITE & CHURCHILL *q.v.*), *jeweller*;
 Plough, Lombard street. 1679
COURTAULD Augustine (or Augustus),[1] *goldsmith*; Church street, St Martin's lane. 1708–1729
 Chandos street. 1729–(Died) 1751
COURTAULD La. Pa. (Louisa Perina, widow of Samuel Courtauld), *goldsmith & jeweller*;
 Crown, Cornhill, No. 21, opposite the Royal Exchange. 1765–1768 (Died 1807)
COURTAULD Louisa & COWLES George (cf. George COWLES & Mrs COURTAULD),
 goldsmiths; [No. 21] Cornhill. 1769–1778
COURTAULD Louisa & Samuel, *plate-workers*; Cornhill (succeeded by John Henderson). 1777–1780
COURTAULD Peter, *goldsmith*; St Anne's, Westminster. (Married) 1709–(Buried) 1729
COURTAULD P. & COWLES, *goldsmiths*; No. 21 Cornhill. 1768–1777

 [1] See page 8.

L

COURTAULD Samuel (succeeded his father, Augustine Courtauld), *plate-worker*; Rising Sun, Chandos street. 1746–1751
 Crown, opposite Royal Exchange, [No. 21] Cornhill. 1751–(Died) 1765

COURTAULD Samuel, Junior (son of Samuel & Louisa COURTAULD) (see Louisa & Samuel COURTAULD, also COURTAULD & SON), *goldsmith*, Cornhill. 1777–1780 (Died in America) 1821

COURTAULD & SON, *goldsmiths*; No. 21 Cornhill. 1779

COURTHOPE Edward, *plate-worker*; Bishopsgate. 1697

COURTHOPE (or COURTHOPP) George, *goldsmith*; parish of St Clement Danes. 1641–(Widow re-married) 1661

COURTNALL Nicholas, *goldsmith*; Lombard street. 1559–1569

COURTNEY Adrian (see ATTWELL & COURTNEY), *goldsmith*; parish of St Mary Woolnoth. 1687–(Buried) 1705

COURTOP Hugh, *goldsmith*; parish of St Vedast's, Foster lane. (Buried) 1649

COUSTOS Paul, *jeweller*; London. (Deceased) 1762

COUTTS James (see also CAMPBELL & COUTTS), *goldsmith & banker*; Three Crowns, Strand. 1692

COUTTS James & Thomas, *bankers*; Three Crowns, Strand. 1761–1778

COVILL —, *goldsmith*; London. (Buried) 1670

COWARD & CO., *goldsmiths & jewellers*; No. 27 Royal Exchange, Cornhill. 1790

COWARD & SON, *goldsmiths*; No. 27 Cornhill. 1796

COWARD & JEFFERYS, *jewellers*; No. 149 Fleet street. 1784

COWDEROY George, *gold-worker*; No. 1 Buckingham street, Strand. 1790–1793

COWELL John, *watch-maker & goldsmith*; Dial, opposite Pope's Head alley, Cornhill; or, No. 97 Royal Exchange, Cornhill. 1763–1800

COWEN H., *goldsmith & jeweller*; No. 3 Sidney's alley, Leicester square. 1796

COWLES George (late partner with Mrs Courtauld), *goldsmith*; Swithin's lane. 1766
 No. 26 Cornhill. 1770–1793
 No. 30 Cornhill. 1780–1790
 Winchester street. 1790–1797

COWLES George & COURTAULD Mrs (cf. Louisa COURTAULD & George COWLES), *goldsmiths*; No. 21 Cornhill. 1768–1777

COWPER —, *goldsmith*; Surrey street. 1713

COWPER —, *goldsmith*; corner of Arundel street, Strand. 1724

COWPER Anthony, *goldsmith*; parish of St Vedast, Foster lane. 1623–(Will proved) 1633

COWPER Henry, *plate-worker*; Whitehall. 1782–1789

COWPER John (cf. John COOPER), *goldsmith*; Golden Ball, Strand. 1719–(Died) 1720

COWPER Robert, *goldsmith*; London. 1525–1529

COWSE Simon, *goldsmith*; parish of St Bartholomew the Great. (Will proved) 1630

COX George, *plate-worker*; Carey lane. 1698

COX James, *goldsmith*; Golden Urn, Racquet court, Fleet street. 1751

COX James, *goldsmith & jeweller*; No. 103 Shoe lane, Fleet street. 1757–1777

COX James & SON, *jewellers*; No. 103 Shoe lane, Fleet street. 1784–1795

COX John & CLEAVE Edward, *goldsmiths & bankers*; Peacock & Feathers, Cornhill. 1715–(Bankrupt) 1721

COX Mrs, *pawnbroker*; Blue Flower Pot, Queen street, near Seven Dials. 1702

COX Robert, *goldsmith*; London. 1749–1756

Plate XVII

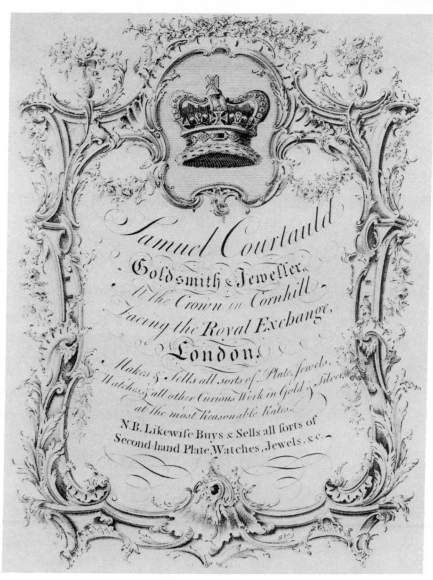

SAMUEL COURTAULD

1751–1765

Plate XVIII

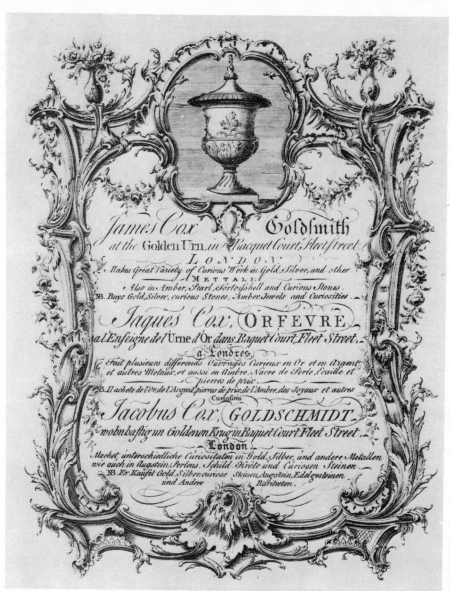

James Cox Goldsmith
at the Golden Urn, in Racquet Court, Fleet Street
 LONDON
Makes Great Variety of Curious Work in Gold, Silver, and other
 METALS.
Also in Amber, Pearl, Tortoisshell and Curious Stones.
N.B. Buys Gold, Silver, curious Stones, Amber, Jewels and Curiosities

Jaques Cox, ORFEVRE
à l'Enseigne de l'Urne d'Or dans Raquet Court Fleet Street.
 à Londres
Fait plusieurs differends Ouvrages Curieux en Or et en Argent,
et autres Metaux, et aussi en Ambre, Nacre de Perle, Ecaille et
 pierres de prix.
N.B. Il achete de l'Or, de l'Argent, pierres de prix, de l'Ambre, des Joyaux et autres
 Curiosites

Jacobus Cox, GOLDSCHMIDT,
wohnhaftig un Goldenen Krug in Raquet Court Fleet Street.
 London
Machet, unterschiedliche Curiositaten in Gold, Silber, und andere Metallen
wie auch in Augstein, Perlens, Schild Kröte und Curiosen Steinen.
N.B. Er Kaufet Gold, Silber, curiose Steinen, Augstein, Edelgesteinen
 und Andere Rariteten.

COX ROBERT ALBIN, *plate-worker*; Fetter lane. 1752–1773
 Little Britain. 1769
COX ROBERT ALBION, *goldsmith*; parish of St Anne's, Foster lane. 1794–(Died) 1826
COX WILLIAM, *goldsmith & jeweller*; No. 70 Cox's court, Little Britain. 1768–1772
COX WILLIAM, *goldsmith*; No. 61 St Paul's churchyard. 1773, 1774
COX WILLIAM, *buckle-maker*; Greenhills Rents. 1773
COX WILLIAM (see COX & WATSON), *goldsmith & jeweller*; No. 23 Aldersgate street. 1774–1784
 No. 11 Aldersgate street. 1784
COX WILLIAM & WATSON THOMAS, *goldsmiths & jewellers*; No. 23 Aldersgate street.
 1777–(Partnership dissolved) 1784
COXGROVE —, *goldsmith*; London. 1698
COYTE GEORGE, *goldsmith*; Catherine street, Strand. 1773
CRACKPLACE (or CRACKFORD) CUTHBERT, *goldsmith*; parish of St Mary Woolnoth. 1568–1578
CRADOCK — (see PARKER & CRADOCK).
CRADOCK GEORGE (see WANLEY & CRADOCK).
CRAG —, *goldsmith*; Orange street, St James's market. 1712
CRAGGS — (or CRAIG'S ?), *goldsmith*; Norris street, Haymarket. 1727
CRAIG ANN & NEVILLE JOHN (see also NEVILLE & CRAIG), *plate-workers*; Norris street,
 St James's. 1738–1746
CRAIG JOHN (cf. CRAIG & NEVILLE, also see CRAIG & WICKES), *goldsmith*; corner of
 Norris street, Haymarket. 1714–1735
CRAIG JOHN, *goldsmith*; corner of Norris street in the Haymarket. c. 1730–(Died) 1735
CRAIG JOHN & WICKES GEORGE (see CRAIG & NEVILLE, see also WICKES &
 NETHERTON), *goldsmiths & jewellers*; corner of Norris
 street [Haymarket]. c. 1730–(Partnership dissolved) 1735
CRAMB JOHN, *goldsmith*; London. 1380
CRAMMILLION PETER, *watchcase-maker*; St James's, Clerkenwell green. 1767–1769
CRANINGE —, *goldsmith*; Fleet street. 1725
CRANKS JOHN, *goldsmith*; London. 1579
CRANMER (or CRANMORE) SAMUEL, *goldsmith*; Crown, near Serjeant's Inn, Fleet street.
 1722–(Died) 1752
CRANWELL JOHN, *pawnbroker*; Key, Golden lane, near Cripplegate. 1704
CRASTE EDMOND, *goldsmith*; parish of St John Zachary. 1568
CRAWFORD —, *silversmith*; East Smithfield. 1747
CRAWLEY WILLIAM, *goldsmith*; parish of St Ann & St Agnes [Aldersgate]. (Married) 1636–1641
CREAGH GEORGE, *goldsmith*; Coventry street. 1713
CREAK JAMES, *goldsmith*; Monkwell street. 1784
CREAKE EDWARD, *goldsmith*; London. 1569
CREBIT JOHN, *goldsmith*; London. 1451
CRESPEL JAMES, *silversmith*; Panton street, Haymarket. 1779
CRESPEL SEBASTIAN & JAMES, *working silversmiths*; Whitcomb street, Leicester fields. 1762–1773
CRESPIN PAUL, *silversmith*; Golden Ball, Compton street, Soho. 1720–1757
CRESPIN PAUL, JUNIOR, *goldsmith*; London. 1740
CRESSWELL HENRY, *goldsmith*; parish of St Botolph, Aldersgate. 1637
 Parish of St John Zachary. 1641
CRESSWELL JOSEPH, *goldsmith*; corner of Adelphi, Strand. 1770–1775
CRESSWELL JOSEPH (from Mr Chenevix), *toyman*; Unicorn in Suffolk street. c. 1760

(133)

CRESWELL WILLIAM, *goldsmith*; parish of St Vedast, Foster lane. 1641–(Buried) 1662
CREUZE FRANCIS, *jeweller*; Old Broad street. 1752–1760
CREUZE FRANCIS & JOHN, *jewellers*; No. 39 (or 59) Broad street. 1768–1779
CREUZE FRANCIS & SON, *jewellers*; Old Broad street. 1755–1765
 Will's Coffee-house, Cornhill. 1790
CRICHTON — (see PATERSON & CRICHTON).
CRIPPS —, *silversmith*; Golden Ball, St James's street. 1762
CRIPPS JOHN, *jeweller*; parish of St Thomas Apostle. 1760–1765
 No. 43 Friday street. 1768–1781
CRIPPS MARK, *silversmith*; Golden Ball, St James's street. 1767–1773
CRIPPS WILLIAM, *silversmith*; Crown & Golden Ball, Compton street. 1743–1753
 Golden Ball, St James's street. 1752
CRIPPS WILLIAM, JUNR., *goldsmith*; London. 1767
CRIPPS & FRANCILLON, *jewellers*; No. 43 Friday street. 1784
 No. 24 Norfolk street. 1790–1796
CRISP (or CRIPS) NICHOLAS, *jeweller*; Bow churchyard. 1744–1763
CRISPEN —, *silversmith*; London. 1724
CRISPS & CO., *jewellers & goldsmiths*; next door to Johnson's Coffee-house. 1762
CRITCH JOHN, *goldsmith*; Temple Bar. 1678, 1679
CROFT — (see BACKWELL, DAREL, HART & CROFT).
CROFT & BACKWELL, *bankers*; Grasshopper, Pall Mall. 1774
CROFT RICHARD, *goldsmith*; Bear, Foster lane, right against Goldsmiths' Hall.
 1675–(Bankrupt) 1701
CROFT WILLIAM, *goldsmith*; parish of St Helen's, Bishopsgate. (Married) 1599–(Buried) 1607
CROKER JOHN, *jeweller & medallist*; London. 1691–(Died) 1741
CROOKE CUTBERD, *goldsmith*; Cheapside (?). 1623
CROOKE HUGH, *goldsmith*; parish of St Mary Woolnoth. 1558–(Buried) 1566
CROOKE HUGH [JUNR.], *goldsmith*; London. 1579
CROSFIELD THOMAS, *pawnbroker*; Three Bowls, Robin Hood court, Shoe lane. 1720
CROSHAW RICHARD (cf. RICHARD CROWTHAW), *goldsmith*; parish of St Mary Woolnoth.
 1594–(Died) 1621
CROSS JAMES, *goldsmith*; parish of St Mary Woolnoth. 1548–1550
CROSS (or CLARKE ?) JOHN, *goldsmith*; London. 1564
CROSS WILLIAM, *pawnbroker*; Golden Ball, Grub street. . 1715
CROSSLEY RICHARD, *goldsmith*; Foster lane. 1782–1786
 No. 14 Giltspur street. 1790–1798
CROSSLEY RICHARD (see SUMNER & CROSSLEY).
CROUCH JOHN, *pawnbroker*; Three Bowls, Plumtree street [St Giles's]. 1702–(Died) 1710
CROUCH JOHN, *goldsmith*; Giltspur street. 1774–1784
CROUCH JOHN & HANNAM THOMAS (see also HANNAM & CROUCH), *plate-workers*;
 No. 23 Giltspur street. 1766–1793
 No. 37 Monkwell street. 1790
CROW AARON, *goldsmith*; parish of St Peter Westcheap. (Buried) 1623
CROW EPHRAIM, *jeweller*; London. 1686
 London-house yard [Aldersgate street]. 1708
CROWDER RALPH, *goldsmith*; London. 1706
CROWDER WILLIAM, *goldsmith & jeweller*; No. 1 Bunhill row. 1795, 1796

CROWE John, *goldsmith*; London. 1451
CROWTHAW Richard (cf. Richard CROSHAW), *goldsmith*; London. 1631
CROWTHER Ralph, *goldsmith*; parish of St Mary Woolnoth. (Married) 1662
CRUICKSHANKS Robert, *goldsmith*; No. 17 Old Jewry. 1766–1774
 London. 1782
CRUMP (or CRUMPE) Francis (see also HEATH & CRUMPE), *plate-worker*; Newcastle
 street. 1741–1750
 Gutter lane. 1753–1773
CRUMPTON (or CROUNTON) John, *goldsmith*; parish of St Mary Woolnoth.
 (Married) 1639–(Died) 1658
CRUTCH —, *goldsmith*; Palgrave's Head, without Temple Bar. 1679
CRUTCHER John, *plate-worker*; East Smithfield. 1706, 1707
CRUTCHFIELD Jonathan, *plate-worker*; Garlick hill. 1697–1703
CUGNY (or CUNY) Louis, *plate-worker*; Three Crowns, corner of Panton street and Hedge
 lane, near Leicester fields. 1703–1727
 London. 1733
CULLEFORD (or CULLIFORD) Matthew, *plate-worker*; parish of St Mary Woolnoth. 1630–1634
CULVER Peter, *jeweller*; Fenchurch street. 1760
CUMBERLEDGE John, *refiner & goldsmith*; London. 1708–(Bankrupt) 1709
CUMMINS —, *gold chain-maker*; Old Change. 1732
CUNNINGHAM Daniel, *plate-worker*; Long Acre. 1716–1720
 London. 1727, 1728
CUNST Jasper, *goldsmith*; Salisbury court. 1773
CUNY Louis (see CUGNY).
CURGHEY John, *goldsmith*; Ship, corner of Crane court, near Fetter lane, Fleet street. 1734–1749
 Opposite St Dunstan's Church, Fleet street. 1752
CURTIS Elizabeth, *pawnbroker*; next door to the Surgeon's Arms, King street, Golden square,
 by the Green Dragon. 1726
CURTIS Thomas, *goldsmith*; Red Lion court, Fleet street. (Insolvent) 1723
CUTBERT — (or CUTHBERT), *goldsmith & banker*; Cheapside. 1677
CUTHBART Matthew, *goldsmith*; Aldersgate ward Without. 1694
 Cross Keys, Little Britain. 1701–1724
CUTHBERT —, *goldsmith*; London. 1660–1677
CUTHBERT John, *jeweller*, London. 1686 (?)
CUTHBERT Robert, *goldsmith*; Blackamoor's Head, Cheapside. 1675–1703
CUTHBERT William, *goldsmith*; Bull Head court, Cripplegate ward. 1692, 1693
CUTT William, *goldsmith*; Lombard street. (Will proved) 1636
CYBER Samuel, *jeweller*; Orange street, near Leicester fields. 1717

DABBS Arthur, *goldsmith*; London. 1735
DAILLEY Samuel, *jeweller*; Hand, Ring & Pearl, upper end of Earl's court, Bow street. 1730
DAINTREY Marmaduke, *plate-worker*; Noble street. 1739–1747
 Crown, Old street. 1747
DALBY —, *silversmith*; Plough, Cheapside. 1708
DALBY John, *jeweller & goldsmith*; No. 105 New Bond street. 1784–1796
DALE Hugh, *goldsmith*; parish of St Christopher-le-Stocks. (Married) 1594

DALE John, *goldsmith*; Chapter House, St Paul's. 1553
DALEMAN Thomas, *pawnbroker*; Brown Bear, Bow street, Covent Garden. 1753
DALTON Andrew (see Andrew DOLTON), *plate-worker*; Ball alley, Lombard street. 1708–1715
DALTON George, *goldsmith*; parish of All Hallows, Bread street. 1562–1577
DALTON Isaac, *plate-worker*; St Martin's-le-Grand. 1711–1713
DALTON Isaac, *watch pendant-maker*; Red Lion street. 1766
DALTON James, *watch-maker*; Islington. 1767
 Red Lion street. 1790
DAMPIERY Henry, *silversmith*; Strand. (Insolvent) 1723
DANBIE Robert, *goldsmith*; London. 1541–1568
DANBROOKE Daniel, *goldsmith*; parish of St Mary Woolnoth. 1620
DANDESAND Martin, *goldsmith*; London. 1569
DANIEL Jabez, *plate-worker*; Carey lane. 1749–1768
DANIEL (or DANIELL) Jabez & Thomas, *goldsmiths*; Carey lane. 1771–1773
DANIEL (or DANYELL) John, *goldsmith*; London. 1550–1553
DANIEL Josiah, *plate-worker*; Wood street. 1714
 London. 1725
DANIELL Thomas (see DANIELL & WALL, also DANIEL & JACKSON), *plate-worker*;
 Carey lane. 1773, 1774
 Silver Lion, No. 20 Foster lane. 1782–1793
DANIELL Thomas & JACKSON Randle, *goldsmiths*; Carey lane. (Partnership dissolved) 1778
DANIELL Thomas & WALL John, *silversmiths & jewellers*; No. 20 Foster lane, opposite
 Goldsmiths' Hall. 1781–(Partnership dissolved) 1782
DANIELL William, *goldsmith*; London. 1634–(Died) 1652
DANN John (see COGGS & DANN), *goldsmith*; King's Head, over against St Clement's
 Church, Strand. 1696–1709
DANOIS Daniel, *goldsmith*; Savoy. 1710
DANWAY Gyllam, *locket-maker*; St Sepulchre's, Farringdon Without. 1571
DARBYSHIRE George, *jeweller*; No. 8 Bridge street, Blackfriars. 1790–1793
DARDENNE Peter, *jeweller*; Pearl, Bow street, Covent Garden. 1702–1721
DARE Francis, *jeweller*; Queen street, Golden square. 1748
DARE John, *goldsmith*; No. 103 Minories. 1773
DARE (or DOVE) Matthew (see BLAND & DARE).
DARE & PEACOCK, *watch-makers*; No. 103 Minories. 1770–1774
DAREL — (see BACKWELL, DAREL, HART & CROFT).
DARGUITT James (cf. James DARQUITT), *silver turner & goldsmith*; Gutter lane. 1766–1769
 Noble street. 1772
 Foster lane. 1789
 Wood street. 1800
DARKERATT William, *plate-worker*; Acorn, Foster lane. 1718–1724
 Rose, over against St Martin's lane, in the Strand. 1725–1732
DARKERATT William, Junior, *plate-worker*; Acorn, Foster lane. 1724
 Rose, St Martin's lane, Strand. 1731–1733
DARLING Robert, Sir, *goldsmith & clock-maker*; Fenchurch street. 1748–1766
DARQUITT James (cf. James DARGUITT), *silver turner*; Noble street. 1722
DARTNALL David, *goldsmith*; No. 131 Oxford street. 1790–1793
DARVILL Edward, *plate-worker*; Golden Ball, No. 64 Watling street, near Bow lane.
 1757–(Insolvent) 1793

Plate XIX

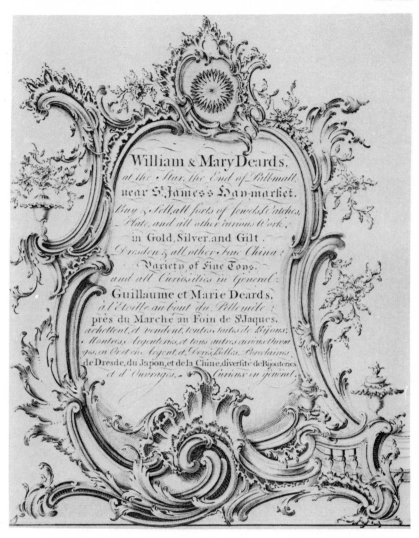

WILLIAM & MARY DEARD (or DEARDS) *circa* 1765

Plate XX

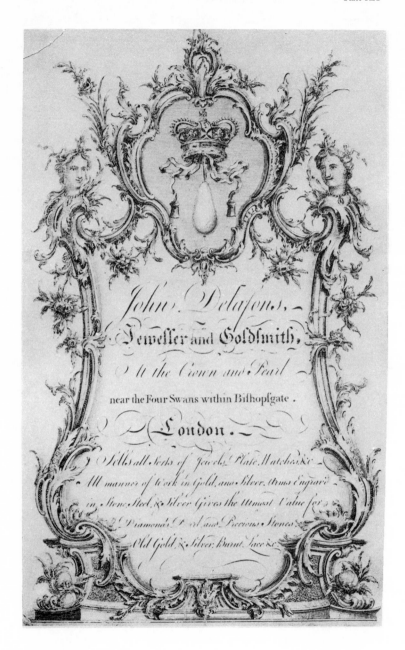

JOHN DELAFONS 1749–1768

DARWALL JOHN, *plate-worker*; Red Lion street. 1768
DAUNCE JOHN, *goldsmith*; London. 1510
DAVENPORT BURRAGE, *plate-worker*; Foster lane. 1773–1776
DAVENPORT ISAAC, *goldsmith*; Blackmoor's Head, Gutter lane. 1695–1703
DAVENPORT ISAAC, *goldsmith*; Queen's Head, over against St Clement's Church, Strand. 1731
DAVENPORT SAMUEL, *plate-worker*; No. 15 Lime street. 1786–1793
DAVID FLEURANT (see also DAVID FLEURANT), *plate-worker*; Green street, Leicester fields. 1724
DAVIDSON —, *pawnbroker*; Blue Ball, London Wall. 1757
DAVIDSON THOMAS, *case & silver lock-maker*; George yard, Tower hill. 1770–1772
DAVIDSON — & ESSEX H., *silversmiths & jewellers*; Nos. 223 and 224 Strand. 1790
DAVIE OLIVER (cf. OLIVER DAVY), *goldsmith*; parish of St George, Botolph lane. 1479
DAVIES — (cf. JOHN DAVIS), *goldsmith, jeweller & toyman*; No. 153 Leadenhall street, near Cornhill. 1790–1793
DAVIES RICHARD (succeeded his father Timothy Davies), *jeweller & goldsmith*; No. 15 New Bond street. 1794
DAVIES ROBERT, *goldsmith*; parish of St Edmund, Lombard street. 1619
DAVIES ROBERT, *goldsmith & jeweller*; No. 21 Bishopsgate Without. 1779
No. 85 Gracechurch street. 1790–1796
DAVIES SAMUEL, *goldsmith*; Golden Lion, Holborn bridge. 1747–(Deceased) 1749
DAVIES T. & H., *goldsmiths*; No. 39 Brewer street, Golden square. 1796
DAVIES THOMAS, *jeweller*; No. 39 Brewer street, Golden square. 1790–1793
No. 15 New Bond street. 1790–1793
DAVIES TIMOTHY, *jeweller, goldsmith, cutler & toyman*; No. 15 New Bond street, corner of Clifford street. 1782–1794
DAVIS ISAAC, *pawnbroker*; Three Bowls, Market lane, St James's. 1720
DAVIS JOHN (cf. — DAVIES), *toyman & jeweller*; No. 153 Leadenhall street. 1790–1793
DAVIS ROBERT, *goldsmith*; No. 81 Bishopsgate Without. 1784
DAVIS T., *necklace-maker & jeweller*; Middle Moorfields. 1790–1793
DAVIS THEOPHILUS, *plate-worker*; Hand & Pen, King street, Seven Dials. 1758
DAVIS THOMAS, *goldsmith*; parish of St Dunstan's-in-the-East. 1670
DAVIS THOMPSON, *plate-worker*; Holborn. 1757–1764
DAVOY —, *goldsmith*; Rider's court [Newport street]. 1705
DAVY OLIVER (cf. OLIVER DAVIE), *goldsmith*; London. 1443–1474
DAWES NICHOLAS, *goldsmith*; London. 1668
DAWSON J., *silversmith*; No. 114 Oxford street. 1790–1793
DAWSON JOHN, *goldsmith*; Noble street. 1790
DAWSON RICHARD, *goldsmith*; No. 3 Staining lane. 1793
Bell's Buildings (Salisbury square). 1793
George street. 1800
DAY GEORGE, *goldsmith*; London. 1637
Lombard street. 1641–1644
DAY SAMUEL, *goldsmith*; Gutter lane. 1678–(Buried) 1705
DAY THOMAS, *goldsmith*; Queen's Head, over against St Margaret's Church, Southwark. 1687
DAY WILLIAM, *goldsmith*; Red Lion court, Grub street. 1759
DAYBANKE JAMES, *goldsmith*; parish of St Saviour's, Southwark. 1613
DEACON JOHN, *goldsmith*; Addle street. 1771
Love lane, Wood street. 1773–1775
Greenhills Rents. 1773–1779

DEALTRY Thomas, *goldsmith & haft-maker*; Royal Exchange. 1765
 Sweating's alley. 1773
 No. 85 Cornhill. 1783–1799
DE AMBRESBURE Geoffrey, *goldsmith*; parish of St Michael, Wood street. (Died) c. 1272
DEAN —, *goldsmith*; Lombard street. 1664
DEAN Deodatus, *silversmith*; No. 80 Minories. 1784–1793
DEAN Francis, *goldsmith*; parish of St Vedast, Foster lane. (Buried) 1649
DEAN Thomas, *goldsmith & jeweller*; No. 80 Minories. 1796
DEANE W. & J., *plate-workers*; Ironmonger road. 1762
DEANS William, *goldsmith*; Buck lane, Old street. (Insolvent) 1769
DEARD John, *toyman & goldsmith* (?), Fleet street. (Died) 1731
DEARD John, *jeweller*; Davis (*sic*) [? Dover] street, Piccadilly. (Died) 1794
DEARD (or DEARDS) William, *goldsmith & toyman*; opposite St Dunstan's Church, Fleet
 street. 1740
 Opposite St Dunstan's Church, Strand. 1744–(Died) 1761
DEARD (or DEARDS) William, *toyman & goldsmith*; Strand. 1765
DEARD (or DEARDS) William, *toyman*; corner of Dover street, Piccadilly. 1777
DEARD (or DEARDS) William & Mary,[1] *goldsmiths & toymen*; Star, end of Pall Mall, near
 St James's, Haymarket. After 1765
DEARMER John, *watch-case maker*; Grub street. 1776
DE ASSHINGDONE William, *goldsmith*; parish of St Leonard, Foster lane. c. 1307
DEATH Thomas, *goldsmith*; parish of St Vedast, Foster lane. (Married) 1624–1644
DEBARY Peter, *jeweller*; Newport street. 1719
DE BASYNGSTOKE Richard, *goldsmith*; Wood street. 1346–(Died) 1349
DE BASYNGSTOKE Thomas, *goldsmith*; parish of St Michael, Wood street. (Buried) 1349
DEBAUFRE Peter, *jeweller & watch-maker*; Church street, Soho. 1689
 Drury lane, the second house from Russell court. 1706
DEBAUFRE Richard (see also NEVILLE & DEBAUFRE), *goldsmith*; Norris street, St
 James's. 1747–(Deceased) 1760
DE BENETLEGH John, *goldsmith*; parish of St Michael, Wood street. c. 1279
DE BENETLEY Adam, *goldsmith*; London. 1243
DE BENETLEYE Alan, *goldsmith*; parish of St Matthew, Friday street. c. 1289
DE BENTELE Andrew, *goldsmith*; parish of St Michael, Wood street. 1292
DE BERKELE Thomas, *goldsmith*; London. 1334
DE BERKING Simon, *goldsmith*; parish of St Peter, Wood street. 1334–1349
DE BERKINGE Thomas, *goldsmith*; parish of St Michael, Wood street. (Will dated) 1329
DE BERKINGE William, *goldsmith*; London. 1307
DE BETOYNE (or BRITAINE) Richard, Sir,[2] *goldsmith*; Bread street ward. 1322–(Died) 1341
DE BILLINGESGATE Gilbert, *goldsmith*; London. c. 1280
DE BRA Jaques, *goldsmith*; Blackfriars. 1562
DE BRANDONE Hugh, *goldsmith*; London. 1348
DE BRAUNCESTRE John, *goldsmith*; Friday street. 1348
DE BURGH Simon, *goldsmith*; parish of St Botolph, without Aldersgate. c. 1315

[1] "Farewell to Deard's and all her toys which glitter in her shop
 Deluding traps to girls and boys, the warehouse of the fop."
 (Lady Wortley Montagu's "Farewell to Bath", 1736.)

[2] Mayor of London, 1326–7.

DE CASTRE Bartholomew, *goldsmith*; London. 1397

DE CHICHESTER John, Sir,[1] *goldsmith*; corner of Friday street in the Chepe.
1357–1377 (Will enrolled 1381)

DE CORNHILL Henry, *goldsmith*; London. 1191–1193

DE CREZ John, *jeweller & toyman*; Harlequin, Princes street, near Coventry street, Leicester fields. 1775

DE CUNCY —, *silversmith*; Spur street, near Leicester fields. (Died) 1733

DECURY, *goldsmith*; Panton street, near Leicester fields. 1715

DE FARNDON Nicholas,[2] *goldsmith*; London. 1293–(Will dated) 1334

DE FARNDON Nicholas II, *goldsmith*; le Ship on the Hoop, Westchepe.
1339–(Will dated) 1361

DE FARNDON Thomas, *goldsmith*; Wood street, Cheapside. (Will proved) 1343

DE FARNDON William (cf. FARYNGDON also FARNDONE), *goldsmith*; London.
1278–(Died) 1293

DE FINCHINGFIELD Walter, *goldsmith*; London. 1291–(Died) 1307

DE FINCHINGFIELD William, *goldsmith*; London. 1357

DE FONTAINE James, *goldsmith*; parish of St Paul, Covent Garden. (Fined) 1721

DE FOUNTAIN —, *goldsmith & watch-maker*; near Temple Bar in the Strand. 1718

DE FRANCE Louis, *goldsmith*; Castle yard, Holborn. (Bankrupt) 1785

DE FRIES S., *jeweller*; No. 6 New Basinghall street. 1790–1793

DE FROWICK Thomas, Sir, *goldsmith*; London. 1270–1279

DE GLASSE Nicasius, *goldsmith*; Tower ward. 1583

DE GLOUCESTER Henry, *goldsmith*; London. 1300–(Died) 1332

DE GLOUCESTER John, *goldsmith*; Bread street ward. 1337

DE GLOUCESTER Robert, *goldsmith*; London. 1308

DE GLOUCESTER William, *the King's goldsmith*; London. 1255–1258

DE GLOUCESTER William, *Master of the Mint*; London. 1298

DE GODESON John, *goldsmith*; Bread street ward. 1337

DE GRUCHY John, *goldsmith*; Oxford street. 1773

DE HALGEFORD John, *goldsmith*; parish of Holy Trinity the Less. 1308

DE HAREWE William, *goldsmith*; parish of St Sepulchre within Newgate. (Died) 1308

DE HONILANE Ralph (see Ralph HONILANE).

DE HYNGESTON John, *goldsmith*; Wood street. 1349

DE HYNGGESTON John, *goldsmith*; parish of St Margaret, Lothbury. 1335

DE HYNGSTONE John (cf. John DE KINGESTON), *goldsmith*; London. 1333–(Died) 1336

DE KELESEYE John, *goldsmith*; London. (Will) 1348

DE KEMESYNGG John, *goldsmith*; London. (Will) 1341

DE KINGESTON John (cf. John DE HYNGSTONE).

DE LA BROSSE, *goldsmith*; St Martin's-in-the-fields. 1699–1711

DELACOURT J., *jeweller*; Queen street, Soho. 1790–1793

DELAFONS James, *jeweller*; St Martin's, Ludgate. 1765

DELAFONS John, *jeweller*; Ring & Crown, West street, near Seven Dials. 1738

DELAFONS John, *goldsmith & jeweller*; Crown & Pearl, near the Four Swans, within Bishopsgate. 1749–(Deceased) 1768

DELAFONS Philip, *enameller*; Tottenham Court road. 1768

[1] Mayor of London, 1369–70.
[2] Mayor of London several times, 1308–1323.

DELAFONS & SON, *jewellers*; No. 12 Broadway, Blackfriars. 1790–1793
DE LA FONTAINE Peter, *plate-worker*; Golden Cup, Litchfield street, Soho. c. 1740
DELAFORCE John, *pawnbroker*; Golden Ball, Bishopsgate street. 1756
DE LAGEMERE John, *goldsmith*; Tower ward. 1583
DE LAKE Jerome, *goldsmith*; Stepney. (Married) 1591
DELAMAINE —, *goldsmith*; Gerrard street, St Ann's [Soho]. 1742
DE LAMERIE Paul, *plate-worker*; Golden Ball, Windmill street, near the Haymarket. 1712–1737
 No. 45 Gerrard street. 1738
 No. 40 Gerrard street. 1739
 No. 55 Gerrard street. 1742
 No. 42 Gerrard street. 1743–(Died) 1751
DELAMY Samuel, *goldsmith*; London. 1762
DE LAYES Davy, *goldsmith*; Westminster. 1568
DE LETING —, *jeweller*; Crown court, in the Old Change, Cheapside, against Distaff lane. 1744
DELIGNY —, *working jeweller*; No. 24 Aylesbury street, Clerkenwell. ? c. 1790
DE LINCOLN John, *goldsmith*; London. 1350–1402
DE LINCOLN Thomas, *goldsmith*; London. 1323
DE LINCOLN Walter, *goldsmith*; next to the Goldsmiths' Hall. 1323
DE LISLE Louis, *jeweller*; Angel court. 1773
DE LISLE Thomas, *goldsmith*; St Martin's-le-Grand. 1562
DELL Humphrey, *goldsmith & jeweller*; Crown & Pearl, Wood street. 1706–1714
 Crown & Dolphin, Moor street. 1722
DELL Samuel, *plate-worker*; London. (?) 1688
 Watling street. 1697–1703
DELLAMY Samuel, *plate-worker*; New street square. 1762
DELMESTRE John, *plate-worker*; Whitechapel. 1755–1760
DE LOREN John, *goldsmith*; London. 1511
DE LOUTHE John, Queen's *goldsmith*; London. 1307
DELVES Edward, *goldsmith*; Mermaid, Lombard street. 1570–(Buried) 1638
DE LYNDOWE John, *goldsmith*; London. 1369
DE MAKENHEAD John (cf. John MAKENHEVED), *goldsmith*; London. 1334
DE MALLYNGG John, *goldsmith*; Gutter lane. (Died) 1341
DE MARE Lewis, *goldsmith*; Blackfriars. 1568
DE MARKEBY John, *goldsmith*; Mugwell (= Monkwell) street. 1339
DE MARKYNFELD John, *goldsmith*; Cheapside. c. 1349
DE MUNDEN Stephen, *goldsmith*; Cordwainer street. 1295
DENHAM Robert, *goldsmith*; parish of St Olave, Hart street. 1565
DENHAM Thomas, *goldsmith*; ward of Farringdon Within. 1569–1571
DENN Basil, *goldsmith*; Aldgate. (Insolvent) 1729
DENN Basil, Junior, *goldsmith & jeweller*; Gold Ring, London Bridge, near Southwark. 1743–1754
 Tooley street, Southwark. 1771
DENNE William (see SNOW & DENNE).
DENNET — (see SMART & DENNET).
DENNEY Daniel, *plate-worker*; St Martin's-le-Grand. 1786
DENNEY (or DENNY) William, *silversmith*; Golden Ball, St Swithin's lane. 1697
DENNIS Jacob, *goldsmith*; No. 6 Cockspur street. 1796
DENNISON Anderson, *goldsmith*; Cecil court. 1777

Plate XXI

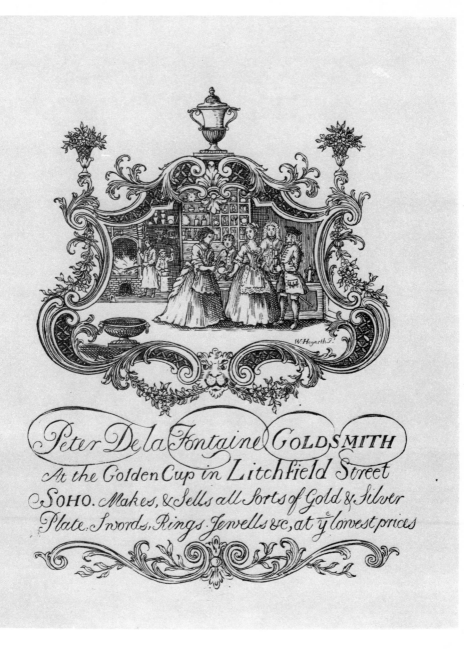

Plate XXII

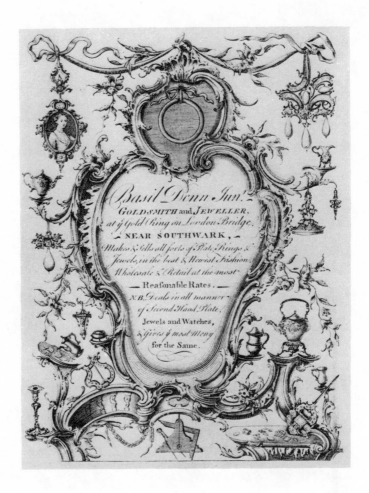

BASIL DENN, Junr. 1743–1754

DENNY WILLIAM, *goldsmith*; parish of St Mary Woolnoth. 1681–(Buried) 1707

DENNY WILLIAM, *goldsmith*; parish of St Mary Woolnoth. 1695–1733

DENNY WILLIAM & BACKE JOHN, *plate-workers*; Dove court, Lombard street. 1697–1720

DE NORWYCH WILLIAM, *goldsmith*; next to the Cardinal's Hat tavern in West Chepe. 1348

DENYS RICHARD, *goldsmith*; Gutter lane. 1340

DENZILOE JOHN, *goldsmith*; No. 3 Westmoreland buildings [Aldersgate street]. 1774–1793

DE OLIVEYRA ABRAHAM, *plate-worker*; St Helen's, Bishopsgate. 1725–1727

DE OLIVEYRA ABRAHAM LOPES, *plate-worker & engraver*; Houndsditch. 1739

DE PARYS ROGER, *goldsmith*; London. 1341

DEPESTOR (or DEPSTER) WILLIAM, *goldsmith*; Surgeons' Arms, Broad street. 1677

DE PIPHURST ROBERT, *goldsmith*; Gutter lane. (Died) 1312

DE PORKLEE THOMAS, *goldsmith*; Wood street. (Will) 1348

DEPPDALL GUY, *goldsmith*; Blackfriars. 1583

DE REYGATE JOHN, *goldsmith*; parish of St Peter-le-Poor (Broad street). 1291

DE REYGATE RICHARD, *goldsmith*; London. 1302

DE ROKESLEY GREGORY,[1] *goldsmith*; Old Exchange. 1271–(Died) 1291

DE ROKESLEY THOMAS, *goldsmith*; London. 1337

DEROUSIERE CHARLES, *jeweller*; No. 12 Villiers street, Strand. 1790–1793

DERRICK ANTHONY, *goldsmith*; Queen's Arms, Cheapside. 1550–1580

DERSK MICHAEL, *goldsmith*; London. 1500

DERYNG NICHOLAS, *goldsmith*; parish of St George, Southwark. [N.D.]

DE ST ALBAN NICHOLAS, *goldsmith*; London. c. 1259

DESAYNE ANDREW, *goldsmith*; ward of Bishopsgate Within. 1691, 1692

DE SECHEFORD HENRY, *goldsmith*; parish of St Agnes. 1320–(Died) 1337

DESERGNES PETER, *goldsmith*; London. 1773

DE SERRÉ JEAN, *goldsmith*; Rider's court [Newport street]. 1706

DES GRANGER SAMPSON, *goldsmith*; ward of Farringdon Without. 1618

DE SHORDYCH WILLIAM, *goldsmith*; London. 1349

DESMORTIERS JOSHUA, *goldsmith*; London. 1730–1735

DE SOLA SILVERA MOSES, *jeweller*; London. 1757

D'ESPAGNE WILLIAM, *goldsmith*; London. 1339

DES RUMEAUX JACQUES, *goldsmith*; London. 1714

DESSEBUES LEWIS, *goldsmith*; Golden Cup, Chandos street. 1720

DE STANES RICHARD, *goldsmith*; parish of St Giles, Cripplegate. (Will) 1306

DE STANES THOMAS, *goldsmith*; London. 1243

DE STEYNDROP GILBERT, *goldsmith*; parish of St Mary, Staining. 1351–(Buried) 1355

DESVIGNES PETER, *goldsmith*; Belton street, Long Acre. 1773

DE TOPPESFIELD JOHN, *goldsmith*; London. 1349

DE TOTENHALE NICHOLAS, *goldsmith*; parish of St John Zachary. 1348

DETRESARD JOSEPH, *gold & silversmith*; Bond street. 1796

DEVEER FREDERICK, *goldsmith*; No. 7 Angel court, Throgmorton street. 1753–1781

DEVESE PETER, *goldsmith*; Queen street, Golden square. 1773

DEVIS JOHN, *silversmith*; Lamb's Conduit street. 1784

DEVIS WILLIAM, *watch-maker & goldsmith*; Dial, opposite St Dunstan's Church, Fleet street. 1750–1765

[1] Eight times Mayor of London, 1274–1281 and 1284–5.

(141)

M

LONDON GOLDSMITHS

DEVONSHIRE ISRAEL, *spoon-maker*; Aldersgate street. 1773

DEVONSHIRE JOHN, *spoon-maker*; Paternoster row. 1762–1768

DEVONSHIRE THOMAS (see WATKINS & DEVONSHIRE), *spoon-maker*; Paternoster row.

DE WALPOLE ADAM, *goldsmith*; London. 1756–1773

DE WALPOLE JOHN, *goldsmith*; parish of All Hallows, Bread street. 1348–1350

(Buried) 1349

DE WALPOLE THOMAS, *goldsmith*; London. 1331

DE WALTON WILLIAM, *goldsmith*; London. 1347

DE WALYNGWICK NICHOLAS, *goldsmith*; London. 1339

DEWEY THOMAS, *goldsmith*; London. 1554

DE WYHALL RICHARD, *goldsmith*; London. 1323

DICANSON JOHN (see EVANS & DICANSON).

DICHER JOHN, *goldsmith*; parish of St Peter Westcheap. 1594

DICK CHARLES, *jeweller & goldsmith*; Coventry street, opposite the Haymarket. c. 1765

DICKEN ARTHUR, *silversmith*; Angel, Strand. 1720–1724

DICKENS BAYNHAM, *goldsmith*; London. 1443–1447

DICKENSON B., *silversmith*; Sir Isaac Newton's Head, Cornhill. 1728

DICKER WILLIAM, *goldsmith*; near Lombard street. 1725–(Bankrupt) 1728

DICKINES ROBERT, *goldsmith*; St Bride's. (Married) 1618

DICKINSON JOSEPH, *goldsmith*; St Edmondsbury. (Deceased) 1743

DICKINSON R., *silversmith*; next door to the Three Pigeons, Cornhill. 1727

DICKS ROBERT, *jeweller*; London. 1722

DIGGLE JOHN, *goldsmith*; Cardinal's Cap or Red Hat, in the Strand, near Charing Cross. 1694–1701

DIGHTON ISAAC, *plate-worker*; Gutter lane. 1697–(Buried) 1707

DINELEY THOMAS (see SURMAN, DINELEY & CLIFFE), *goldsmith*; Lombard street. 1753–1755

DINGLEY ROBERT, *goldsmith & jeweller*; at St Helen's Gate, Bishopsgate street. 1702–(Deceased) 1747

DINGLINGER SIGISMUND GODHELP, *jeweller*; Diamond Cross, St Martin's-le-Grand. 1749

DINGWALL —, *jeweller*; Suffolk street, Charing Cross. 1752–1755

DINGWALL JOHN, *jeweller*; No. 9 St James's street. 1784

DINGWALL & PRATHERNON, *jewellers*; No. 9 St James's street. 1790–1796

DIPPLE RICHARD, *ring-maker*; Silver street. 1778
Maiden lane. 1779

DISTON ROBERT, *goldsmith*; "St Forster's" (St Vedast's, Foster lane). 1584

DIVIENE —, *goldsmith*; parish of St Sepulchre's. (Deceased, widow re-married 1604)

DIXON CHARLES, *goldsmith*; parish of St Helen's, Bishopsgate. 1673–1675

DIXON GEORGE, *goldsmith*; parish of St Mary Woolnoth. 1666–1672

DOBREE (?) —, *pawnbroker*; Three Golden Balls, Carnaby street, Golden square. 1757

DOBSE GEORGE & JOSEPH, *goldsmiths & jewellers*; No. 68 Oxford street. 1790

DOBSON EDWARD, *jeweller & working goldsmith*; Crown, Ring & Pearl, Fleet street near Shoe lane. 1755–1773

DOBSON EDWARD, *goldsmith*; Old street. 1770–1778

DOBSON PRIOR & WILLIAMS, *plate-worker*; Paternoster row. 1755

DODD JAMES, *goldsmith*; parish of St Gabriel, Fenchurch street. 1692, 1693
Unicorn, Fenchurch street. 1705–1710

DODDS JOSEPH (see also TROUTBECK & DODDS), *goldsmith & jeweller*; No. 12 Aldersgate street. 1790–1796

(142)

DODSON JOHN, *goldsmith*; parish of St Saviour's, Southwark. 1667, 1668

DODSON ROBERT, *goldsmith*; Lombard street. 1620

DODSON THOMAS, *goldsmith*; Holborn. 1632–(Will proved) 1656

DOE CHARLES, SIR, *goldsmith*; Black Spread Eagle, Cheapside. 1641–(Died) 1671

DOE I., *goldsmith*; London. 1597

DOER JOHN, *goldsmith*; parish of St Andrew's Undershaft. (Will proved) 1654

DOLBIN JOHN, *goldsmith*; parish of St Vedast, Foster lane. (Buried) 1693

DOLBY JOHN, *silversmith*; No. 105 New Bond street. 1789–1793

DOLBY JOHN & SAVAGE THOMAS (see THOMAS SAVAGE), *goldsmiths*; No. 105 New Bond street. (Partnership dissolved) 1789

DOLTON ANDREW (see ANDREW DALTON), *goldsmith*; Ball alley, Lombard street. 1708
Unicorn & Ring, Lombard street. 1717
Unicorn & Gold Ring, Lombard street. 1718

DOODYNERE ANTHONY, *goldsmith*; Farringdon Without. 1583

DORRELL —, *silversmith*; Bell, Grub street. 1735

DORRELL JANE (see MAY & DORRELL).

DORRELL W., *plate-worker*; Smithfield Bars. 1763

DORRING WILLIAM, *jeweller*; No. 5 Hart street, Bloomsbury. 1790–1793

DOUBLE ABRAHAM, *jeweller*; Heathcock court, near Durham yard, Strand. 1709

DOUGHTY MARGARET (see MARGARET YORK).

DOUGLAS WILLIAM, *goldsmith*; Berkeley street, Clerkenwell. 1776

DOVE —, *goldsmith*; London. 1630

DOVE MATTHEW (see MATTHEW DARE).

DOVE PETER, *goldsmith*; Angel & Crown, Newport street, near Leicester fields. 1696–1712

DOVE T., *goldsmith*; London. 1630

DOVEY RICHARD, *goldsmith & jeweller*; No. 6 Craven buildings, Drury lane. 1770–1774

DOWDALL (or DOWEALL) EDWARD, *plate-worker*; Clerkenwell. 1748–1756

DOWNES JOHN, *plate-worker*; Wood street. 1697–1703

DOWNES JOHN, *jeweller*; next door to the Cock, in St James's street. 1731

DOWNING WILLIAM, *jeweller*; Falcon square. 1795

DOWSON JOHN, *goldsmith*; No. 77 Holborn, Holborn bridge; and Field court, Gray's Inn. 1766–1793

DOXSEY THOMAS (cf. BUFFAR & DOXEY), *goldsmith*; Castle alley, Royal Exchange. 1751
(?) Two Candlesticks & Key, Great St Helen's, within Bishopsgate. 1756–1773

DOYLE [or DOYLEY] LAUD, *goldsmith*; Drury lane. 1686
Plough, Lombard street. 1694–(Died) 1696

DRAKE —, *jeweller*; over against the Crown tavern, near Earl's court, Drury lane. 1711

DRAKE —, *silversmith*; Cannon, St John street. 1731

DRAKE JOHN (or JOSEPH ?), *goldsmith*; Greenhills Rents, near West Smithfield. (Insolvent) 1748

DRAKE WESCOMBE, *silversmith*; Golden Ball, Norton Folgate. 1724

DRALL REGINALD, *goldsmith*; parish of Holy Trinity the Less. 1582–1618

DRANFEILD WIDOW, *goldsmith*; parish of St Gabriel, Fenchurch street. 1692, 1693

DRAPER ROBERT, *goldsmith*; London. 1531–1553

DRAX JAMES, SIR, *goldsmith*; London. 1663

DREW AUGUSTUS, *goldsmith*; parish of St Mary Woolnoth. (Will proved) 1625

DREW CORNELIUS, *pawnbroker*; Sun, Silver street, near Cripplegate. 1707–1718

(143)

DRINKWATER Sandylands, *silversmith*; Hand & Coral, Gutter lane. 1731–1772
DROST Adrian, *jeweller*; No. 7 Palgrave place, Strand. 1790–1793
DRUMMOND —, *goldsmith*; Mitre, York buildings, Strand. 1716
DRUMMOND Andrew, *goldsmith & banker*; Golden Eagle, Charing Cross. 1712–1754
DRURY Dan, *goldsmith & knife-haft-maker*; Wood street. 1742–1766
DRURY Drew, *goldsmith*; Wood street. 1724–1727
DRURY Dru, *goldsmith*; parish of St Albans, Wood street. 1770
DRURY Drury (successor to Nathaniel JEFFERYS), *goldsmith*; [No. 32] Strand, corner of
 Villier's street. 1770–(Bankrupt) 1786
DRURY Drury & SON (successors to Nathaniel JEFFERYS), *goldsmiths*; No. 32 Strand.
 1781–1793
DRURY William, *goldsmith & jeweller*; No. 32 Strand. 1796
DRY Benjamin, *goldsmith*; London. (Bankrupt) 1714
DRYDEN Henry, *goldsmith*; parish of St Clement Danes. (Married) 1666–1675
DRYSDALE —, *pawnbroker*; Red Lion, Hop garden, Bedfordbury. [N.D.]
DRYSDALE John, *goldsmith*; Wood street. 1773–1785
DU BARRIS Pierre, *goldsmith*; London. 1692
DUBOIS —, *small plate-worker*; Golden Star, Eagle court, Strand. c. 1750
DUBOIS Isaac, *goldsmith*; Savoy. 1703
DUBOIS Joseph, *jeweller*; Newcastle court, Butchers' row, near Temple Bar. 1731
DUBOIS Joseph, *jeweller*; St Martin's-in-the-fields. 1738
DU BURREY —, *jeweller*; King street, Soho, near St Ann's Church. 1724
DU CANE Andrew, *goldsmith*; Cat, without Bishopsgate. 1685–1697
DUCEMETIERE —, *jeweller*; Ring & Pearl, Queen street [Seven Dials]. 1751
DUCK John, *goldsmith*; Angel, Foster lane. (Married) 1678–(Died) 1745
DUCKET Laurence, *goldsmith*; London. (Murdered) 1284
DUCKETT Abraham, *goldsmith*; parish of St Michael-le-Querne. c. 1579
DUCKETT Henry, *goldsmith*; parish of St Vedast, Foster lane. 1597–(Buried) 1603
DUCKSINGER Christopher, *goldsmith*; Aldersgate ward. 1618
DUCOMMIEU (DUCORNIEU or DUCOMMON) Louis (see BARRIER & DUCOMMIEU),
 spoon-maker; Rathbone Place. 1773–1778
DUCOMMON — (see BARRIER & DUCOMMIEU).
DUCORNIEU Louis (see BARRIER & DUCOMMIEU).
DUCYE Robert, Sir,[1] *goldsmith*; London. 1620–(Died) 1634
DUDLEY Augustus, *goldsmith*; London. 1668
DUGDALE Richard, *jeweller*; No. 12 Broad street, Golden square. 1790–1796
DUGOOD —, *jeweller*; at the saddler's shop, upper end of Haymarket. 1727, 1728
DUHAMEL —, *goldsmith*; Porter street [near Newport market]. 1698
DUHAMEL —, *jeweller*; Gerrard street, Soho. 1775
DUHAMEL Jacob, *jeweller*; Crown & Ring, Duke street, York buildings. 1715–1720
 Acorn (?) & Ring, Duke street, York buildings. 1720
 Crown & Ring, Henrietta street, Covent Garden. 1730–1737
DUKE Isaac, *plate-worker*; Wych street, Drury lane. 1743
DUMÉE Nicholas (see also HOLMES & DUMÉE, also BUTTY & DUMÉE), *plate-worker*;
 Clerkenwell. 1757–1789
DUMONT Lewis, *goldsmith*; Seven Dials. 1773

 [1] Mayor of London, 1630–1.

Plate XXIII

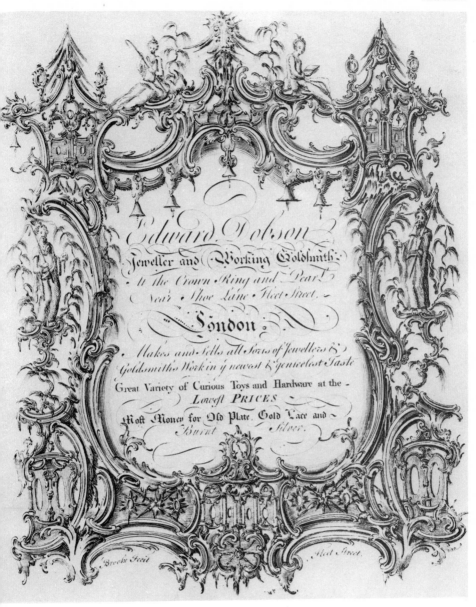

DWARD DOBSON

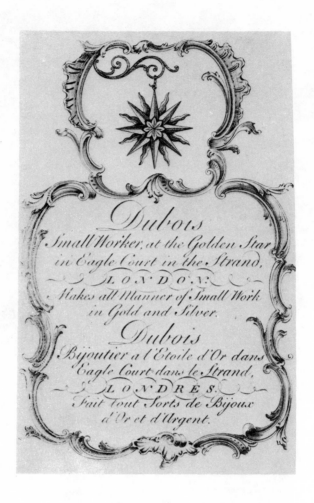

DUBOIS *circa* 1750

DUNCKERLEY Charles, *goldsmith*; Wood street. Before 1761
 Nixon's square, Cripplegate. 1761

DUNCOMBE Charles, Sir,[1] *goldsmith & banker*; Grasshopper, Lombard street.
 1672–(Retired) 1695. (Died) 1711

DUNCOMBE Valentine, *goldsmith*; Grasshopper, Lombard street. 1682–1688

DUNCOMBE, Charles & Valentine, *goldsmiths & bankers*; Grasshopper, Lombard street.
 1682–1688

DUNCOMBE Charles & KENT Richard, *goldsmiths & bankers*; Grasshopper, Lombard street.
 1672–1684

DUNN John, *pawnbroker*; Three Bowls, Holborn bridge. (Left off trade) 1716

DUNTNALL (or DURTNALL) —, *goldsmith & jeweller*; No. 131 Oxford street. 1790–1793

DUPONT Louis, *goldsmith*; London. 1722–1727

DUPONT Louis, *silversmith*; Wardour street. 1736
 Compton street. 1739–(Bankrupt) 1747

DUPONT Matthias, *jeweller*; Sherborn lane. 1753

DU PORTAIL (or DU PORTAL) Jaques, *goldsmith*; Little St Martin's lane. 1717–1721

DUPPA James, *goldsmith*; No. 15 Aldgate Within. 1777

DUPPA Mary, *goldsmith*; No. 15 Aldgate Within. 1777–1779

DURDEN Martin, *jeweller*; over against the Cock, Bow street. 1672

DURNFORD Robert, *gold-beater*; Drury lane. 1765

DUROLL David, *goldsmith*; Farringdon Without. 1583

DUROUSSEAU Matthew, *goldsmith*; King's Head, Gerrard street, Soho. 1704–1710

DUROUSSEAU R., *goldsmith*; Ryder court, near Leicester fields. 1699

DURRANT R., *goldsmith*; London. 1557–1569

DURRANT Robert, *goldsmith*; parish of St Vedast, Foster lane. (Buried) 1591

DURRANT Stephen, *goldsmith*; St Peter Westcheap. 1560–(Buried) 1590

DURTNALL (see DUNTNALL).

DUTENS John, *silversmith*; London. 1687

DUTENS Peter, *jeweller*; Golden Cup, Chandos street, St Martin's lane. 1730, 1731
 Leicester square. 1744–1765

DUTTON Charles, *goldsmith*; parish of St Gregory's. 1662

DUTTON Henry, *plate-worker*; Green street, Leicester fields. 1754–1773

DUTTON Humphrey, *goldsmith*; parish of St Botolph, Aldgate. 1583–1586

DUVAL John & Peter, *jewellers*; No. 5 Warnford court, Throgmorton street. 1765–1768

DUVAL John & SONS, *jewellers*; No. 5 Warnford court, Throgmorton street. 1777–1781

DUVAL John, SONS & CO., *jewellers*; No. 5 Warnford court, Throgmorton street. 1784–1796

DUVAL Peter, *jeweller*; No. 32 New Broad street buildings. 1770

DYCKESON (or DYXSON) William, *goldsmith*; London. 1561–(Died) 1562

DYER John, *goldsmith*; Crown & Pearl, Lombard street. 1744

DYER Joseph, *goldsmith*; Pearl & Crown, Lombard street. 1756–1762

DYER & NEWMAN (cf. John NEWMAN), *goldsmiths*; No. 49 Lombard street. 1768–1774

DYMOCK, Thomas, *goldsmith*; London. (Died) 1619

DYMOKE Thomas, *goldsmith*; parish of St Vedast, Foster lane. (Buried) 1704

DYMOND Edward, *plate-worker*; St Mary at Hill [Billingsgate]. 1722

DYXSON William (see William DYCKESON).

 [1] Lord Mayor of London, 1708–9.

EADES — (see GREEN & EADES).

EADY WILLIAM, *goldsmith*; West street, Smithfield. 1800

EALES BERNARD, *goldsmith*; Lombard street. 1678–(Died) 1694

EALES JAMES, *goldsmith*; King street, Westminster. 1690–1710
 Flying Horse, King street, Westminster. 1714–1721

EALESTON JOHN, *goldsmith*; London. 1559

EAMES JOHN (see JOHN EMES & CO.).

EARLE FRANCIS, *goldsmith*; parish of St Michael, Cornhill. (Married) 1657

EAST EDWARD, *goldsmith*; London. 1656–1668

EAST JOHN, *goldsmith*; Maiden lane. 1641

EAST JOHN, *goldsmith & banker*; Sun, without Temple Bar. 1663–1688

EAST JOHN, *plate-worker*; Foster lane. 1697–1703

EAST JOHN, *plate-worker*; London. 1704–1728
 St Ann's lane, Aldersgate. 1727–1734

EAST THOMAS, *goldsmith*; Marygold, Temple Bar. 1660

EAST WILLIAM, *goldsmith*; Sun, without Temple Bar. 1687

EASTON ROGER, *goldsmith*; parish of St Mary Woolnoth. 1580

EASTROM STEPHEN, *plate-worker*; Burleigh street. 1773

EASTWICK ADRIAN, *goldsmith*; Cross Key court. 1771
 Little Britain. 1774
 No. 102 Aldersgate street. 1784

EASTWICK HENRIETTA, *goldsmith*; No. 102 Aldersgate street. 1789–1793

EASTWICK THOMAS, *gold-beater*; Warwick lane. 1768

EATON JOHN, *plate-worker*; Gutter lane. 1760

EATON SAMUEL, *plate-worker*; Huggin court [Huggin lane]. 1759

EATON THOMAS, *spoon-maker*; Wood street. 1765

EATON WILLIAM, *goldsmith*; London. 1625

ECCLESTON GILBERT, *goldsmith*; London. 1510

ECCLESTON JOHN, *goldsmith*; Boar's Head, Westchepe, near Honey lane. (Died) 1552

ECKFORD JOHN, *plate-worker*; Drury lane. 1698–1720
 Red Cross street. 1739
 London. 1748

ECKFORD JOHN, JUNIOR, *plate-worker*; Three Tun court. 1725–1734

ECKMONDS JOHN, *goldsmith*; London. 1739

ECLES —, *silversmith*; Hand & Spur, Wood street. 1735

EDEN MOSES, *silversmith*; Foster lane. (Insolvent) 1725

EDGAR JAMES, *plate-worker*; Gutter lane. 1697

EDGE —, *jeweller*; Golden Artichoke, Strand, facing Cecil street. 1744

EDGER PETER, *goldsmith*; London. 1725

EDLIN SAMUEL, *goldsmith*; corner of St Mary Axe, Leadenhall street. 1712–1714
 Wood street. 1724–1727
 Old Bailey. 1734

EDMONDS (? EDWARDS) GRIFFITH, *goldsmith*; London. 1739

EDMONDS JOHN, *goldsmith*; Philpot lane. 1677

EDMONDS SIMON, *goldsmith*; London. 1597–1600

EDMONDS STEPHEN, *plate-worker*; Pall Mall. 1700

EDMONDS Thomas, *goldsmith*; London. 1739

EDMUND John, *engraver to the Mint*; London. 1380–1390

EDMUNDS Edward, *goldsmith*; London. 1643

EDSALL Jane, *pawnbroker*; Bird in Hand, lower end of Nightingale lane. 1720

EDWARDS — (see MOON & EDWARDS, also MOORE & EDWARDS).

EDWARDS Andrew, *goldsmith*; St Ann's lane. 1639–1641

EDWARDS (? EDMONDS) Griffith, *plate-worker*; Hemlock court [Little Sheer lane, Lincoln's Inn fields]. 1729–1739

EDWARDS James, *watch-maker, goldsmith & jeweller*; No. 149 Holborn Bars. 1767

EDWARDS John, *plate-worker*; Gutter lane. 1697

EDWARDS John, *silversmith*; Hemlock court [Little Sheer lane], Little Lincoln's Inn fields. 1712

EDWARDS John, *plate-worker*; St Swithin's lane. 1723–1753

EDWARDS John, *plate-worker*; Jewin street. 1788–1790

EDWARDS John & PITCHES George, *plate-workers*; St Swithin's lane. 1723

EDWARDS Nathaniel, *goldsmith*; parish of St Anne's, Blackfriars. (Married) 1596

EDWARDS Nicholas, *goldsmith*; Butcher row. 1800

EDWARDS Richard, *plate-worker*; Gutter lane. 1716–1723

EDWARDS William, *goldsmith, watch-maker & hardwareman*; (from Fetter lane), Staples Inn gate, near Holborn Bars. 1775–1783

EDWARDS William, *goldsmith & jeweller*; No. 121 Newgate street. 1790–1793

EDWARDS William John, *goldsmith & jeweller*; No. 36 Coleman street. 1781–1784
 No. 26 Coleman street. 1790–1796

EGLESTON John, *goldsmith*; London. 1568

EGLETON Christopher, *goldsmith*; parish of St Bartholomew the Great. (Married, aged 30) 1668

ELEY William, *buckle-maker*; Aylesbury street [Clerkenwell]. 1782
 No. 14 Clerkenwell green. 1786–1799

ELEY William & FEARN William, *plate-workers*; Clerkenwell green. 1797–1799

ELEY William & PIERREPOINT George, Bartholomew close. 1778

ELGER Peter, *goldsmith*; London. 1735

ELIOT Christopher, *goldsmith*; parish of St John Zachary. 1500–(Buried) 1505

ELKIN Henry, *goldsmith*; parish of St Helen's, Bishopsgate. 1671–(Buried) 1693

ELKINGTON John, *goldsmith*; parish of St Vedast, Foster lane. (Buried) 1604

ELLARD George, *goldsmith*; London. 1543
 Outside New Temple Bar. 1583

ELLINES Anthony, *jeweller, etc.*; Crown, Sun & Seven Stars, under St Dunstan's Church, facing Corbett's State Lottery Office. c. 1750

ELLINGHAM Anthony, *goldsmith*; London. (Will proved) 1655

ELLIOTT James, *goldsmith*; No. 84 Oxford street. 1784
 No. 119 Oxford street. 1800–1809

ELLIOTT Robert, *buckle-maker & small plate-worker*; Gutter lane. 1723, 1724

ELLIOTT William, *goldsmith*; Cannon street (? row), near London stone. 1716–(Killed) 1748

ELLIOTT William, *goldsmith*; Warwick lane. 1799

ELLIOTT & SON, *goldsmiths*; No. 119 Oxford street. 1805

ELLIOTT & MILLER, *goldsmiths*; Oxford street. 1797

ELLIS —, *goldsmith*; Gold Ring, Fleet street. 1702
 Ring, Wine Office court, Fleet street. 1721

ELLIS —, *goldsmith*; Queen's Head, Fleet street. 1702
 Seven Stars, near Globe tavern at Fleet ditch, Fleet street. 1710–1712
ELLIS —, *silversmith*; Golden Cup, Carey lane. 1735
ELLIS GEORGE, *jeweller*; Fleet street. 1714
ELLIS RICHARD, *jeweller*; Bell court. 1774
ELLIS THOMAS, *plate-worker*; Cow Cross (Smithfield). 1773–1780
 London. 1796
ELLIS & SONS, *jewellers*; No. 9 Worship street, Moorfields. 1796
ELLYSMER ROBERT, *goldsmith*; London. Temp. Henry VI
ELMES (or ELMS) EDWARD, *goldsmith*; Three Kings, Newgate street. 1699–1717
 London. 1724
ELSWORTH THOMAS, *jeweller*; Crown & Pearl, in the New Rents, St Martin's-le-Grand. c. 1750
 Near the Lion in the Wood, Salisbury court, Fleet street. c. 1760
ELTON EDWARD, *goldsmith*; Cheapside. 1634–1641
ELY ROGER OF, *goldsmith*; London. 1323
ELYOT CHRISTOPHER, *common Assayer*; London. 1478
EMAN TIMOTHY, *goldsmith*; Tottenham. (Will proved) 1638
EMES —, *goldsmith*; parish of All Hallows, Lombard street. 1779
EMES JOHN (see CHAWNER & EMES), *plate-worker*; Amen Corner. 1796–1808
EMES (or EMMS) JOHN, *goldsmith*; parish of All Hallows, Lombard street. 1692, 1693
 Lombard street. 1727
EMES (or EAMES) JOHN & CO., *goldsmiths*; Anchor & Crown, Lombard street. 1702–1721
EMES THOMAS, *goldsmith*; Lombard street. (Buried) 1729
ENGLAND JAMES, *planisher*; Sun street (Bishopsgate). 1795
ENGLAND THOMAS, *plate-worker*; Long Acre. 1725
 Fleet ditch. 1739
ENGLAND WILLIAM, *goldsmith*; parish of St Anne's, Westminster. (Insolvent) 1748
ENGLAND WILLIAM & VAEN JOHN, *plate-workers*; Bow lane, Cheapside. 1714
ERLEY JOHN, *goldsmith*; Crutched Fryars. 1568
ERNEST JOHN, *goldsmith*; London. 1483–1488
ERWIN —, *pawnbroker*; Tea Table, Chiswell street, Moorfields. 1752
ESSEX H. (see DAVIDSON & ESSEX), *silversmith*; No. 224 Strand. 1790
ESSORY (or ESWY) RALPH,[1] *goldsmith*; London. 1234–(Died) 1247
ESTIENNE JOHN FRANCIS, *jeweller*; Star & Pearl, Duke court, St Martin's lane, Charing Cross.
 1752–1755
ESTWICK —, *jeweller, or goldsmith* (?); Golden Falcon, Old Fish street. 1713
ESWY RALPH (see RALPH ESSORY).
ETZELL ANDREW, *goldsmith* (?); parish of St Martin's-in-the-fields. 1721
EVANCE STEPHEN, SIR (cf. PERCEFULL & EVANS), *goldsmith & jeweller*; Black Boy,
 Lombard street. 1684–(Bankrupt) 1712
EVANCE STEPHEN, SIR & HALES WILLIAM (see SIR STEPHEN EVANS), *goldsmiths*; Lombard
 street. 1702–(Bankrupt) 1712
EVANS —, *goldsmith, jeweller & toyman*; next door to Saville House, Leicester square. c. 1790
EVANS — (see THOMAS & EVANS).

 [1] Mayor of London, 1242–3.

Plate XXV

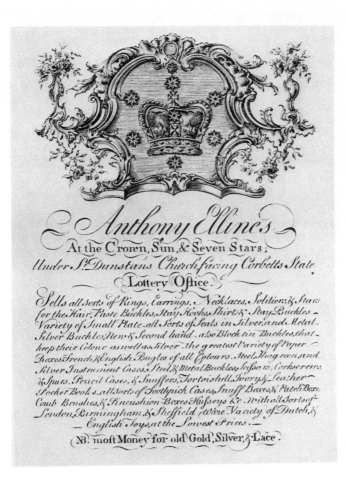

ANTHONY ELLINES *circa* 1750

Plate XXVI

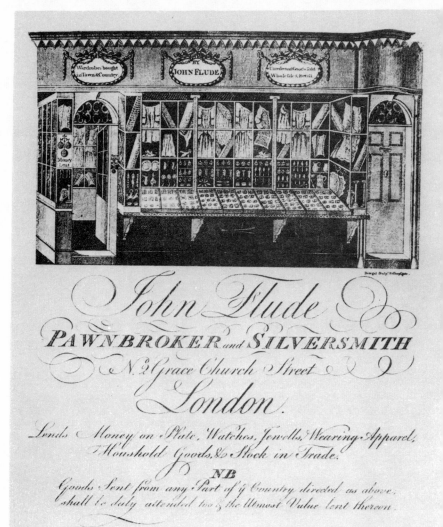

JOHN FLUDE

circa 1780

EVANS EDWARD, *pawnbroker*; Golden Ball, against Rose street, in Long Acre.
1719–(Left off trade) 1720
EVANS JAMES MORLEY, *goldsmith*; Greek street, Soho. 1768–1773
EVANS STEPHEN, SIR (see EVANCE), *goldsmith*; Three Flower-de-Luces, Lombard street. c. 1680
EVANS THOMAS, *plate-worker*; Aldersgate street. 1766
EVANS THOMAS, *silversmith & spoon-maker*; East Harding street. 1766
 Wood street. 1767–1769
 Barbican. 1774–1782
EVANS THOMAS, *silversmith*; No. 20 Featherstone street. 1790–1793
EVANS WILLIAM, *jeweller*; King street, Cheapside. 1755
 Removed to Clerkenwell. 1755
EVANS WILLIAM, *goldsmith, jeweller & hardware-man*; No. 23 Aldgate High street. 1774
EVANS WILLIAM & DICANSON JOHN, *jeweller*; King street, Cheapside. (Partnership dissolved) 1755
EVENCE STEPHEN, SIR (see EVANCE also EVANS).
EVERARD —, *goldsmith*; London. 1223–1225
EVERARD CHARLES, *goldsmith & banker*; Unicorn, Lombard street. 1652–1662
 Star, near Exchange alley, Lombard street. 1662–(Died) 1665
EVERARD CHARLES (JUNIOR), *goldsmith*; Palsgrave's Head, Exchange alley. 1658–1700
EVERSLY WILLIAM, *goldsmith*; parish of St Mary Woolnoth. (Married) 1621–(Buried) 1637
EVESDON (or EWESDIN) THOMAS, *plate-worker*; St Martin's-le-Grand. 1713
 London. 1716–1721
EWENS STEPHEN & FRANCIS, *pawnbrokers*; Three Black Lions, Strand, corner of Old Round
 court. 1721
EWER JOHN, *goldsmith*; Pall Mall. 1734–1748
EWESDIN THOMAS (see EVESDON).
EWING JOHN & NORRINGTON BENJAMIN, *bankers & goldsmiths*; Angel & Crown, Lombard
 street. 1677
EXELBY GEORGE, *working jeweller*; No. 6 Red Lion street, Clerkenwell. 1793
EXMEW THOMAS, SIR,[1] *goldsmith*; parish of St Mary Magdalen, Milk street. 1508–(Buried) 1528
EXMO THOMAS, *goldsmith*; Foster lane. 1485
EXNYNG HARRY, *goldsmith*; London. Temp. Henry VI
EXTON JOHN, *pawnbroker*; Gilded Heart, without Bishopsgate. (Left off trade) 1699
EYMAKER —, *jeweller*; Bow street, Covent Garden. 1747
EYRE JOHN, *goldsmith*; Holborn. (Will proved) 1630
EYTON JAMES, *goldsmith*; Fish street hill. 1677

FAINELL JOSEPH, *goldsmith*; London. 1710–1720
FAIR THOMAS, *haft-maker*; Golden lane. 1773
FAIRFAX WILLIAM, *goldsmith*; London. 1620
FALKENHAM THOMAS, *goldsmith*; London. 1700
FALKINGHAM —, *goldsmith*; over against the Sun, in Threadneedle street, corner of
 Bartholomew lane. 1726
FALKNER —, *goldsmith*; Angel, Charing Cross. 1681
FAR RALPH, *goldsmith*; Mile End green. 1677
FARINGDON (or FARNDONE) NICHOLAS, SIR,[2] *goldsmith*; London. 1308–(Died) 1361

[1] Mayor of London, 1517-8. [2] Mayor of London, 1308, 1313, 1320 and 1323.

FARMER JOHN, *goldsmith*; Holborn bridge. 1692–(Left off trade) 1709

FARMER JOHN & CO., *silversmiths*; No. 127 Oxford street. 1796

FARMER NOYE (NOAH), *goldsmith*; parish of St Mary Woolnoth. 1590–(Buried) 1600

FARNDONE NICHOLAS, SIR (see FARINGDON).

FARNELL JOHN, *plate-worker*; St Anne's lane. 1714–1720
 Golden Ball, corner of Plum-tree court, Holborn bridge. 1729

FARNELL THOMAS, *pawnbroker*; next door to the Naked Boy, Grub street. 1703

FARQUHARSON GEORGE, *jeweller*; No. 421 Strand. 1784

FARRAN (or FERRAN) —, *goldsmith*; Blue Perriwig, Russell street, Covent Garden. 1710–1712

FARRAN JOHN, *goldsmith*; Upper Moorfields. 1773

FARRAN ROB., *watch-chain, gilt & silver button-maker*; No. 9 Middle Moorfields. 1768–1774

FARRAND BANKS (see SAVORY, FARRAND & CO.), *goldsmith*; No. 48 Cheapside. 1790–1827

FARRAR (or FARRER) THOMAS (see THOMAS FARREN).

FARREN ANN, *plate-worker*; Swithin's lane. 1743

FARREN THOMAS, *plate-worker*; Unicorn, Swithin's lane, near the Post Office. 1703–1741

FARYNGDON WILLIAM, SIR (see also SIR NICHOLAS FARINGDON), *goldsmith*; London.
 1279–(Died) 1293

FASSET WILLIAM, *goldsmith*; Dutch walk, Exchange. 1677

FATURA JOHN, *goldsmith*; Dorset street. 1790

FAULKERINGHAM THOMAS, *goldsmith*; Golden Ball, corner of Bearbinder lane. 1701

FAULKNER T., *goldsmith*; Crown & Pearl, New street, by St Martin's lane. 1733

FAUX JOHN, *silversmith*; Worship street, Moorfields. 1777–1784

FAUX THOMAS, *buckle-maker*; Worship street, Moorfields. 1784

FAUX & LOVE, *silversmiths*; Worship street, Moorfields. 1774

FAVRE ISAAC, *jeweller*; Golden Head, Fountain court, Strand. 1734

FAWCON ISAAC, *goldsmith*; "The Bullwarke", parish of St Olave's, Hart street. (Buried) 1600

FAWDERY HESTER, *plate-worker*; Goldsmith street. 1727

FAWDERY JOHN, *plate-worker*; Foster lane. 1690

FAWDERY JOHN, *plate-worker*; Hemenes (*sic*) row [? Heming's row, St Martin's lane]. 1728–1730

FAWDERY THOMAS, *plate-worker*; London. 1700

FAWDERY WILLIAM, *plate-worker*; Goldsmith street. 1690
 Gold (*sic*) street [? Goldsmith street]. 1720
 London. 1720

FAWLER THOMAS, *plate-worker*; Bull and Mouth street, St Martin's-le-Grand. 1700

FAWSON WILLIAM, *jeweller*; Gutter lane. 1700

FAYLE GEORGE, *plate-worker*; Wilderness lane [Salisbury court]. 1767–1777
 Dogwell street, White Friars. 1777

FAYLE JOHN, *haft-maker*; Wilderness lane, Salisbury court. 1772, 1777

FAYREMAN ROBERT (see ROBERT FERMAN).

FAZAKERLEY THOMAS, *watch-maker & goldsmith*; Dial & Crown, St John's street, near Hick's
 Hall. 1765–c. 1780

FEAKE HENRY, *goldsmith*; parish of St Mary Woolnoth. 1611

FEAKE JAMES, *goldsmith*; London. 1588

FEAKE JOHN, *goldsmith*; Lombard street. 1600–1640

FEAKE JOHN, JUNIOR, *goldsmith*; London. 1650

FEAKE WILLIAM, *goldsmith*; London. (Will proved) 1620

FEAKE WILLIAM, *goldsmith*; London. 1632–(Will proved) 1666
FEARN ROBERT, *goldbeater*; Cow lane. 1768
FEARN WILLIAM, *spoon-maker*; No. 75 Wood street. 1773, 1774
FEARN WILLIAM, *spoon-maker*; Castle street. 1783
FEARN WILLIAM (see ELEY & FEARN), *goldsmith*; Clerkenwell green. 1799
FEARN WILLIAM (see GEORGE SMITH & WILLIAM FEARN).
FEKEMAN ABEL, *goldsmith*; London. (Married) 1592
FELCE MRS, *pawnbroker*; next door to the Image yard[1] in the low ground, Piccadilly. 1744
FÉLINE EDWARD, *goldsmith*; corner of Rose street, Covent Garden. 1720–1739
King street, Covent Garden. 1739–1755
FÉLINE EDWARD, *goldsmith*; King street, Covent Garden. 1770–1786
FÉLINE MAGDALEN (widow of Edward Féline), *plate-worker*; Covent Garden. 1753–1762
FELLS —, *pawnbroker*; Three Blue Balls, corner of Half Moon street, Strand. 1754
Three Balls, Denmark street, over against St Giles's Church. 1754
FELLS JOHN, *goldsmith*; Cornhill. (Married) 1568
FELLS JOSEPH, *goldsmith*; Bunch of Grapes, near New Exchange, Strand. 1679–1702
FENN HENRY, *goldsmith*; parish of St Bartholomew's the Great. (Will proved) 1620
FENNELL EDITH, *goldsmith*; London. 1780
FENNELL EDWARD, *plate-worker*; Foster lane. 1780–1791
FENNELL WILLIAM, *plate-worker*; Foster lane. 1775
FENROTHER (or FENRHUTHER) ROBERT, *goldsmith*; Aldersgate ward. 1493–(Died) 1524
FERMAN (or FAYREMAN) ROBERT, *goldsmith*; parish of St Mary Woolnoth. 1542–(Buried) 1566
FERNELL EDWARD (see also GRUNDY & FERNELL), *silversmith*; Fetter lane. 1796
FERRAN — (see FARRAN).
FERRIS EDWARD, *goldsmith*; Whitecross street. 1786
FERRIS MATTHEW, *plate-worker*; Lillypot lane. 1754
FERRON —, *silversmith*; Golden Fan, Andrew's street, St Giles. 1733
FERRY —, *jeweller*; Brick lane, near Old street. 1751
FFREEK WILLIAM, *goldsmith*; London. 1586
FFRICE ROBERT, *goldsmith*; London. 1550
FFRIER ROBERT (see ROBERT FRIER).
FFULKE CHRISTOPHER, *goldsmith*; London. 1558–1569
FICKETT JOHN, *goldsmith*; parish of St John Zachary. 1668
FICKETTS ANTHONY, *goldsmith*; parish of St John Zachary. 1641–1685
FIELD —, *goldsmith*; Sun, Lombard street. 1728
FIELD ALEXANDER, *working silversmith*; No. 2 Bowling Green walk, Haberdashers row, Hoxton. 1790
FIELD JOHN, *goldsmith*; No. 232 High Holborn. 1790–1793
No. 322 High Holborn. 1790–1793
FIELD JOSHUA, *plate-worker*; Maiden lane. 1702
FIELD & CLARKE, *silversmiths*; No. 233 High Holborn. 1784–1793
FILKIN THOMAS (see WOOD & FILKIN).
FINALL WILLIAM, *goldsmith*; Queen's Head, over against St Clement's, Strand. 1708–1712
London. 1724–1727
FINCH CHARLES, *silver button-maker*; Queen's Head, Great Russell street, Covent Garden. c. 1760

[1] The yards of many statuaries occupied ground west of Berkeley street.

FINEN TEDGE, *goldsmith*; London. (Married) 1610

FINER THOMAS, *watch-maker & jeweller*; No. 5 Hatton garden. 1796

FINES KENDALL (see KENDALL FYNES).

FINTHAM ROBERT, *goldsmith*; London. 1668

FISH —, *goldsmith*; Lamb, over against Half Moon tavern, Cheapside. 1709, 1710

FISHER F., *working jeweller in general*; No. 41 Duke street, West Smithfield. c. 1800

FISHER (or FYSHER) JASPER, *goldsmith*; parish of St Mary Woolnoth.
(Married) 1549–(Deceased) 1553

FISHER (or FYSHER) JASPER, *goldsmith*; London. 1566–1582 (?)

FISHER JOSEPH, *goldsmith*; No. 1 Leicester fields. 1770–1772
No. 2 north side of Leicester square. 1784–1796

FISHER RICHARD, *jeweller*; Primrose hill, Salisbury square. 1790–1793

FISHER ROBERT (see CORREGES & FISHER).

FISHER WILLIAM, *plate-worker*; No. 73 Little Britain. 1766–1773

FISHER WILLIAM PARK, *goldsmith & jeweller*; Eagle & Pearl, Tavistock street, Covent Garden. c. 1760

FISHER WILLIAM & JOHN, *goldsmiths*; London. 1793

FISHER & SONS, *jewellers*; No. 9 Worship street, Moorfields. 1796

FITZHUGH WILLIAM, *goldsmith*; parish of St Mary Woolnoth. 1400–(Buried) 1434

FLAEL RALPH, *goldsmith*; London. 1180

FLAKE JOHN, *goldsmith*; London. 1640–1653

FLANNAGAN HENRY, *pawnbroker*; Hampshire Hog, St Giles'. 1764

FLAVIL JOHN, *plate-worker*; Maidenhead, Maiden lane. 1726

FLAVILL THOMAS, *jeweller*; Carey lane, near Goldsmiths' Hall. 1753

FLEMING —, *goldsmith*; Maiden lane, near Goldsmiths' Hall. 1714

FLEMING BENJAMIN (cf. B. FLEMMING), *goldsmith*; Golden Key, next the Inner Temple
Gate. 1709, 1710

FLEMING JOSEPH, *silversmith*; No. 34 High Holborn. 1790

FLEMING WILLIAM, *plate-worker*; Blackwell Hall court, Cripplegate Without. 1692–1697

FLEMING WILLIAM, *goldsmith*; London. 1708–1724
Gutter lane, near Cheapside. 1712
Maiden lane. 1727

FLEMMING BENJAMIN (cf. BENJAMIN FLEMING), *goldsmith*; against St Dunstan's Church
[Fleet street]. 1709, 1710

FLETCHER BERNARD, *plate-worker*; Staining lane. 1723–1727

FLETCHER EDITH, *plate-worker*; Foster lane. 1727–1729

FLETCHER GEORGE, *goldsmith*; St Martin's-in-the-fields. (Deceased) 1592

FLETCHER JAMES, *pawnbroker*; Three Blue Bowls & Golden Ball, Stanhope street, near
Clare market. 1729

FLETCHER JOHN, *plate-worker*; Silver street. 1700–1705

FLEURANT DAVID (see also FLEURANT DAVID), *plate-worker*; Green street, Leicester fields. 1724

FLEURIAN CHARLES, *jeweller*; St Martin's-in-the-fields. (Insolvent) 1769

FLEURIAN (or FLEURIAU) FRANCIS, *jeweller*; St Martin's-in-the-fields. 1727
Eagle & Pearl, in Duke street, York buildings [Strand]. 1730

FLEURIAU CHARLES, *jeweller*; Eagle & Pearl, Craven street. 1755

FLIEGER —, *jeweller*; London. 1685

FLIGHT — (see PEWTRESS, FLIGHT & HALLIDAY).

FLIGHT JOHN, *plate-worker*; Foster lane. 1710

(152)

Plate XXVII

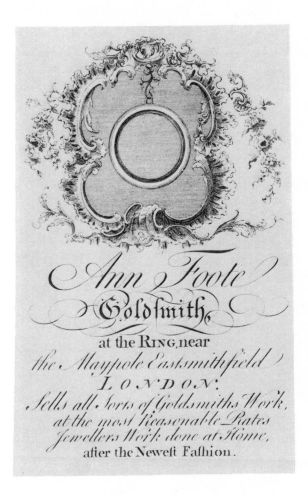

Plate XXVIII

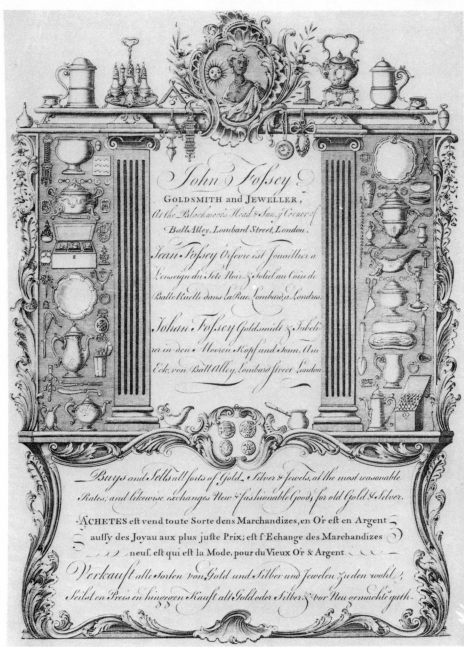

JOHN FOSSEY

FLINT Robert, *goldsmith*; Westminster. (Married) 1576
FLINT Thomas, *goldsmith*; (Married) 1552
 Parish of St Margaret, Lothbury. c. 1597
FLINTS William, *haft-maker*; Dogwell street, White Friars. 1773
FLOWER Edward, *jeweller & toy-man*; Rolls buildings, Fetter lane. 1770–1772
 Chichester Rents, Chancery lane. 1774–1796
FLOWER Francis, *goldsmith*; London. 1772
FLOWER William, *goldsmith*; London. 1462
FLOWERDEW Thomas, *goldsmith*; Poultry. 1677
FLOYER Peter, *goldsmith*; Staining lane. 1679
 Love lane [Eastcheap]. 1695–(Died) 1702
FLOYER Peter, *goldsmith*; London. 1772, 1773
FLUDE John, *pawnbroker & silversmith*; No. 2 Grace Church street. c. 1780
FLYNTE Roger, *goldsmith*; parish of St John Zachary. 1568
FODEN John, *goldsmith*; Golden Falcon, at the Fetter lane end in Holborn; or, near Furnival's
 Inn in Holborn. 1691–1694
FOGELBERG Andrew, *plate-worker*; Church street, Soho. 1773–1800
FOGELBERG Andrew & GILBERT Stephen, *plate-workers*; No. 30 Church street, Soho. 1780–1793
FOISSEAU Abraham, Senior, *silversmith*; St Giles-in-the-fields. 1745
 Tower street. (Deceased) 1756
FOLKINGHAM Thomas, *plate-worker*; Golden Ball, Swithin's lane, near Stocks market. 1706–1720
 Golden Ball, over against Sun Tavern behind Royal Exchange. 1724
FONTAINE Thomas, *goldsmith*; London. 1561–1564
FOOTE Ann, *goldsmith*; Ring, near the Maypole, East Smithfield. 1752
FORBYTHE James, *jeweller*; Fetter lane. 1769
FORDHAM William, *goldsmith & jeweller*; Golden Buck, Lombard street. 1701–1729 (?)
FORMAN Francis, *goldsmith*; parish of St Matthew's, Friday street. (Will proved) 1635
FORREST George, *silversmith*; St Giles', Cripplegate. 1729
FORRESTE Robert, *goldsmith*; London. 1589
FORSE Hallett, *jeweller*; No. 27 Camden street, Islington. 1795
FORSHALL & BLONDELL, *pawnbrokers*; Two Golden Balls & Crown, bottom of St Martin's
 lane. 1758
FORSTER —, *jeweller*; Wood street, Cheapside. 1751
FORSTER John, *goldsmith*; le Walschrente, West Chepe. 1406
FORSTER & JOHNSON, *jewellers & goldsmiths*; Pearl, Wood street, Cheapside. c. 1760
FORSYTH A., *working goldsmith*; No. 2 Tavistock street. 1790–1793
FOSBROOKE Thomas, *goldsmith*; parish of St Sepulchre's. (Married) 1617
FOSSEY John, *plate-worker*; Hand & Seal, Gutter lane. 1724–1733
FOSSEY John, *goldsmith*; Lombard street. (Died) 1746
FOSSEY John, *goldsmith*; Golden Ring, corner of Ball alley, Lombard street. 1746–1748
FOSSEY John, *goldsmith & jeweller*; Blackmoor's Head & Sun, corner of Ball alley in Lombard
 street. 1748
FOSSEY Jonathan, *plate-worker*; Wood street. 1733
FOSTER —, *goldsmith*; Lombard street. 1649
FOSTER —, *silversmith*; Southwark. (Died) 1751
FOSTER Felix, *jeweller*; St Laurence lane. (Bankrupt) 1724
FOSTER George, *goldsmith*; Purple (?) lane, Holborn. (Bankrupt) 1769
FOSTER Isaac, *goldsmith*; No. 1 Bartlett's buildings passage, Fetter lane, Holborn. 1787–1799

FOSTER Jacob, *silversmith*; Pearl & Crown, Southwark. 1726–1728

FOSTER John, *silversmith*; Mint street, Southwark. (Insolvent) 1769

FOSTER Thomas, *haft-maker*; King's Head court, Fetter lane. 1769–1773

FOSTER William, *spoon-maker*; Bishopsgate Without. 1773

FOSTER W. L., *plate-worker*; Blue Anchor alley. 1775–1780

FOSTER Isaac & COOPER John & Hiram, *goldsmiths*; No. 1 Bartlett's buildings, Holborn.
1790–(Partnership dissolved) 1796

FOSTOCK Nathaniel, *goldsmith*; Pall Mall. 1723–(Deceased) 1731

FOUBERT Thomas, *goldsmith & jeweller*; Crown & Pearl, Frith street, Soho. 1735–1738

FOULQUIER John, *goldsmith*; St Martin's-le-Grand. 1749
Blue Hare court, Coleman street. (Insolvent) 1755

FOUNTAIN John, *plate-worker*; Aldersgate street. 1762 (?–1792)

FOUNTAIN William, *plate-worker*; Charterhouse lane. 1787
Red Lion street, Clerkenwell. 1794–1800

FOUNTAIN John & BEADNALL John, *goldsmiths*; London. 1793

FOUNTAIN William & PONTIFEX Daniel (see also PONTIFEX & FOUNTAIN),
plate-workers; No. 13 Hosier lane. 1791

FOWLER —, *silversmith*; Fox & Crown, Aldersgate street. 1720

FOWLER Abraham, *goldsmith*; Temple Bar. 1696
Three Squirrels, opposite St Dunstan's Church, Fleet street. 1723

FOWLER Abraham (see FOWLER & ROCHE, also NICHOLLS & FOWLER), *goldsmith*;
Fleet street. 1720–(Deceased) 1738

FOWLER Abraham & ROCHE James, *goldsmiths*; Three Squirrels, near Temple Bar. 1723–1729

FOWLES (or FOWLE) Robert, *goldsmith & jeweller*; Queen's Head, Fleet bridge. 1675
Black Lion, Fleet street. 1693–1705

FOWLES Thomas, Sir, *goldsmith & banker*; Black Lion, Fleet street. 1666–(Died) 1692

FOWLES (or FOWLE) & WOOTTON (see also WOOTTON & FOWLE), *goldsmiths*;
Black Lion, within Temple Bar, Fleet street. 1694

FOX (or FOXE) John, *goldsmith*; Gilt Fox, Chepe. 1569–(Died) 1597

FOX John, *pawnbroker*; Hand & Ear, next St Sepulchre's Church. 1707

FOX Mordecai (see also ALLEN & FOX), *plate-worker*; Swithin's lane. 1739–1755

FOX Richard, *goldsmith*; parish of St Vedast, Foster lane. (Buried) 1596

FOXE William, *goldsmith*; London. 1557–1569

FRAILLON Blanche, *plate-worker*; Lanchester (*sic*) [? Lancaster] court, Strand. 1727

FRAILLON James, *plate-worker*; Maiden lane, Covent Garden. 1702–1710
Lanchester street (*sic*) [? Lancaster court], Strand. 1723

FRANCIA —, *jeweller*; No. 4 Roll's buildings, Fetter lane. 1790

FRANCILLON — (see CRIPPS & FRANCILLON).

FRANCES John, Sir (see Sir John FRAUNCEYS).

FRANCIS —, *goldsmith*; parish of St Mary Woolnoth. 1587

FRANCIS —, *pawnbroker*; Two Golden Balls, Grub street. (Giving up trade) 1744

FRANCIS Benjamin, *goldsmith*; Steyning lane. 1614–(Killed at battle of Newbury) 1643

FRANCIS Mrs, *goldsmith*; Black Lion, St Martin's lane. 1720

FRANCIS Thomas, *goldsmith*; parish of St Saviour's, Southwark. 1644

FRANCIS Thomas, *goldsmith*; Aldersgate. (Died) 1648

FRANCIS William, *goldsmith*; London. 1607
Parish of SS. Anne & Agnes. 1641

FRANCIS WILLIAM, *goldsmith*; Black Lion, St Martin's lane, near Charing Cross. 1692–1712
 Shoreditch. 1724–1727
FRANCIS WILLIAM, *goldsmith*; parish of St Mary Woolnoth. 1695
FRANCKE WILLIAM, *goldsmith*; parish of St Mary Woolnoth. 1589–1591
FRANCKNELL THOMAS, *goldsmith*; parish of St Mary Woolnoth. (Married) 1583–(Buried) 1597
FRANK —, *goldsmith*; near Charing Cross end of St Martin's lane. 1720
FRANK WILLIAM, *goldsmith*; parish of St Mary Woolnoth. 1570–(Buried) 1598
FRANKLYN THOMAS, *goldsmith*; London. 1600
FRANKLYN WILLIAM, *goldsmith*; parish of St Mary Woolnoth. (Buried) 1558
FRASER —, *working goldsmith & jeweller*; No. 5 Little St Martin's lane. [N.D.]
FRASER JOHN, *goldsmith*; Ship & Pine Apple, opposite Castle court in the Strand. [N.D.]
FRAUNCEYS (or FRANCES) JOHN, SIR,[1] *goldsmith*; parish of St John Zachary. 1383–(Died) 1405
FRAY JOHN, *plate-worker*; No. 3 Crown court. 1744–1748
 Field lane. 1756
FRAY JOHN (see DENNIS WILKS & JOHN FRAY, also see WHITE & FRAY).
FREAME JOHN, *goldsmith*; Three Anchors, Lombard street. 1694–1702
FREAME [JOSEPH] & BARCLAY [JAMES], *goldsmiths & bankers*; Black Spread Eagle, Lombard
 street. 1736–1759
FREAME JOHN & GOULD THOMAS, *goldsmiths & bankers*; Three Anchors, Lombard street 1694–1708
FREAME JOSEPH & GOULD THOMAS, *goldsmiths & bankers*; Black Spread Eagle, Lombard
 street. 1728–1736
FREAR ROBERT, *goldsmith*; parish of St Mary Woolnoth. 1550
FREDERICK GEORGE, *jeweller*; No. 2 Cook's court, Carey street. 1790–1793
FREDRICK SACRE, *goldsmith*; Cripplegate Without. 1618
FREEAR ROBERT (see ROBERT FRIER).
FREEMAN EDWARD, *goldsmith*; parish of St Mary Woolnoth. 1698
FREEMAN HENRY, *goldsmith*; Maiden lane. 1769
FREEMAN JAMES, *goldsmith*; Beech lane. 1780
FREEMAN (or FREMAN) JOHN, *goldsmith*; London. 1534–1555
FREEMAN PHILIP, *plate-worker*; Whitechapel. 1773
 Bartholomew close. 1774
FREEMAN THOMAS, *plate-worker*; Westmoreland buildings. 1773
FREEMAN THOMAS & MARSHALL J., *plate-workers*; Bartholomew close. 1764
FREETH THOMAS, *silversmith*; Clerkenwell close. 1790–1793
FRENCH —, *goldsmith*; Ring & Pearl, Old Round court, near Chandos street. c. 1760
FRENCH EDWARD (see also FRENCH & COATS), *plate-worker*; Bennet's court, Exeter
 Change. 1734
FRENCH JAMES (see also FRENCH & SON), *goldsmith & jeweller*; No. 21 Tavistock street,
 Covent Garden. 1799
FRENCH JOHN, *goldsmith*; London. 1453
FRENCH JOHN, *goldsmith & jeweller*; Paul's alley, Red Cross street. 1773
 No. 2 Tavistock street, Covent Garden (see also FRENCH & MARKLAND).
 1779–1784
 No. 21 Tavistock street, Covent Garden. 1790–1793
FRENCH JOHN & SON [JAMES], *goldsmiths & jewellers*; No. 21 Tavistock street, Covent
 Garden. 1790–1798
FRENCH EDWARD & COATS ALEXANDER, *plate-workers*; Bennet's court, Exeter Change. 1734
 1 Mayor of London, 1400–1.

FRENCH John & MARKLAND Brian, *goldsmiths*; No. 2 Tavistock street, Covent Garden.
(Partnership dissolved) 1781
FRENDE John, *goldsmith*; London. 1500–(Died) 1505
FRENDE John, *goldsmith*; London. 1535–1553
FRENSHAM (or FRENSHAW) Joshua, *plate-worker*; Shoe lane. 1697–1707
FRENSSHE John, *goldsmith*; London. 1382
FREW Robert, *goldsmith*; parish of St Mary Woolnoth. 1546–1550
FRIER (or FREEAR) Robert, *goldsmith*; parish of St Mary Woolnoth. 1550–1559
FRISBEE William (see also FRISBEE & STORR), *plate-worker*; Cock lane, Snow hill. 1792
Cow lane, Snow hill. 1795
FRISBEE William & STORR Paul, *plate-workers*; Cock lane, Snow hill. 1792
FRISBY Samuel, *goldsmith*; London. (Will proved) 1655
FRISQUET Peter Nicholas, *jeweller*; No. 30 Lothbury. 1763–1781
FRITH Ralph, *silversmith*; Golden Cup, Shoreditch. 1728
FROST John, *goldsmith & jeweller*; Golden Cup, opposite St Peter's Church, Cornhill. 1757
FROWICK Thomas De, Sir (see DE FROWICK).
FRUSHARD John, *jeweller*; No. 6 Birchin lane. 1790–1793
FRY Charles, *pawnbroker*; Cannon, Barbican. 1717
FRY John, *goldsmith*; Bull & Mouth street. 1770–1773
FRY William, *goldsmith*; parish of St Andrew's, Holborn. c. 1637
FRYAR Robert, *plate-worker*; Gutter lane. 1773
FRYE Robert, *goldsmith*; London. 1569–1588
FUETER Daniel Christian, *silversmith*; Man in the Moon, King's road, Chelsea.
1753–(Emigrated to America) c. 1760
FULKYNE Dennys, *goldsmith*; St Laurence Pountney. 1568
FULLER Henry, *goldsmith*; London. 1660
FULLER John, *jeweller*; No. 65 Snow hill. 1790–1793
FUMOLEAU Jaques, *goldsmith*; Phoenix street. 1714–1717
FURNELL Edward, *goldsmith*; Fetter lane. 1779–1786
FURSER (or FURZER) Walter, *goldsmith*; parish of St Mary Woolnoth. 1625–(Buried) 1632
FURY Louis, *jeweller*; Ring & Pearl, Tavistock street, Covent Garden. 1715
FUTTER Henry, *goldsmith*; parish of St Mary Woolnoth. 1634–1650
FYNES Henry, *jeweller*; Lawrence lane. 1728
FYNES Kendall, *jeweller*; York buildings. (Insolvent) 1723
Ring, Villiers street. 1728
FYNSTWAYTE William, *goldsmith*; London. 1568, 1569
FYSHER Jasper (see Jasper FISHER).

GADVANDERHULL John, *goldsmith*; against King's Bench. 1699
Pied Bull alley. 1700
GAHEGAN John, *plate-worker*; Three Dove court, St Martin's-le-Grand. 1734
GAINSFORD (or GAYNFFORD) Henry, *goldsmith*; parish of St Mary Woolnoth. 1563–1570
GALE —, *goldsmith & jeweller*; Strand, near Essex street. 1756

Plate XXIX

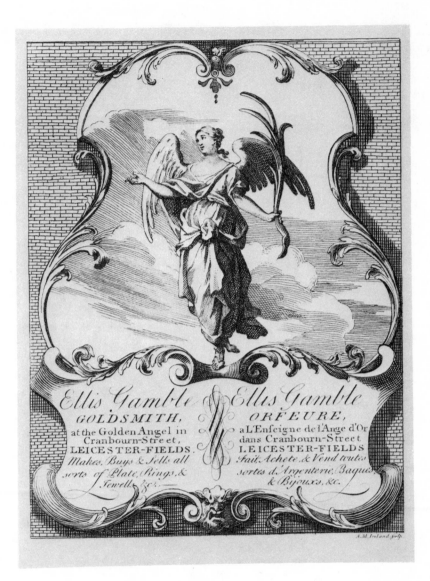

Ellis Gamble

GOLDSMITH,
at the Golden Angel in
Cranbourn-Street,
LEICESTER-FIELDS.
Makes, Buys & Sells all
sorts of Plate, Rings, &
Jewells &c.

Ellis Gamble

ORFEURE,
a L'Enseigne de l'Ange d'Or
dans Cranbourn-Street
LEICESTER-FIELDS
Fait, Achete, & Vend toutes
sortes d'Argenterie, Bagues,
& Bijoux, &c.

A.M.Ireland.sculp

ELLIS GAMBLE 1712–1733

Plate XXX

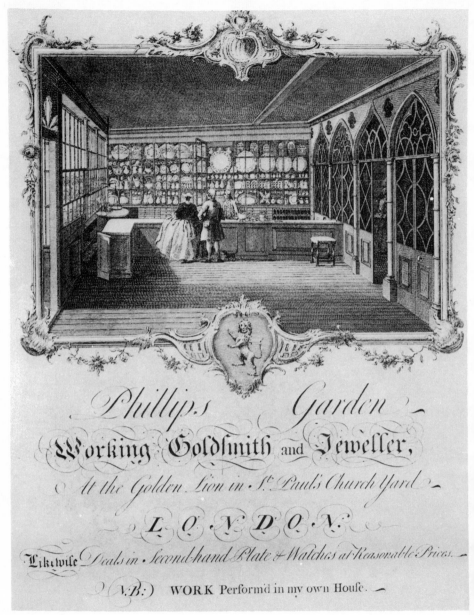

PHILLIPS GARDEN

[*Original size* 10¾ in. × 8½ in.]

1739–1762

GALL JOHN DANIEL, *silversmith & jeweller*; No. 2 New street, Covent Garden. 1790–1793

GALLANT WILLIAM, *goldsmith*; parish of St Michael, Wood street. (Will proved) 1647

GALLIS JOHN, *goldsmith*; parish of St Dunstan's-in-the-East. (Will proved) 1624

GALLWITH MRS, *pawnbroker*; Rising Sun, near Hog lane, Norton Folgate. 1730

GAMBEL WILLIAM, *goldsmith*; Red Lion street, Clerkenwell. 1727

GAMBLE ELLIS (succeeded WILLIAM GAMBLE), *goldsmith*; Golden Angel, Cranbourn street (or alley), Leicester fields. (Hogarth apprenticed to Gamble in) 1712–(Bankrupt) 1733

GAMBLE WILLIAM (succeeded by his son ELLIS GAMBLE), *goldsmith*; Foster lane. 1692 (?)–1703

GAMMON HANNIBAL, *goldsmith*; parish of St Dunstan's-in-the-West. (Buried) 1607

GAMON DINAH, *plate-worker*; Staining lane. 1740

GAMON JOHN, *plate-worker*; Gutter lane. 1726–1728
 Staining lane. 1739

GAMON JOHN, JUNIOR, *goldsmith*; Carey lane. 1767

GAMON MICHAEL, *ring-maker & goldsmith*; Paul's court, Huggin lane. 1767–1773
 Bull and Mouth street. 1780
 No. 6 Noble street, Foster lane. 1783–1793

GAMON MICHAEL & SAMUEL, *ring-makers*; No. 6 Noble street, Foster lane. 1790–1793

GARBETT JOHN, *goldsmith*; Anchor & Crown, Lombard street. (Deceased) 1747

GARBETT & PELL, *silversmiths*; Half Moon & Star, Foster lane. 1726

GARDEN HENRY, *goldsmith*; St Paul's churchyard. 1762

GARDEN PHILLIPS, *working goldsmith & jeweller*; Gutter lane. 1739
 Golden Lion, North side of St Paul's churchyard. 1739–(Bankrupt) 1762
 Succeeded by John Townsend. 1762

GARDEN PHILLIPS, *goldsmith*; Marylebone. 1773

GARDENER — (or GARDINER), *silversmith*; Red Cross, Chepe. 1560–1569

GARDENER ANTHONY, *goldsmith*; Farringdon Without. 1583

GARDENER JOHN (see JOHN GARDYNER).

GARDINER HENRY, *jeweller*; Rolls' buildings, Fetter lane. 1760

GARDINER PHILIP, *goldsmith*; parish of St Dunstan-in-the-West. c. 1624

GARDNER —, *pawnbroker*; White Horse, Little Tower hill. 1754

GARDNER ABRAHAM, *jeweller*; Eagle & Crown, opposite Bow lane, Cheapside. 1762

GARDNER DANIEL, *spoon-maker*; Old Brentford. 1794

GARDNER RICHARD, *plate-worker*; Archer street, Haymarket. 1773
 Silver street. 1782–1787

GARDNER THOMAS, *goldsmith*; parish of St Vedast, Foster lane. (Buried) 1576

GARDNER THOMAS, *goldsmith & watch-maker*; Dial, Minories near Aldgate. 1740–1752

GARDYNER JOHN, *goldsmith*; parish of St Mary Woolnoth. 1539–(Buried) 1540

GARNAULT —, *jeweller*; Threadneedle street. 1774

GARNAULT MICHAEL, *jeweller*; Broad street, near Royal Exchange. 1713

GARNIER DANIEL, *plate-worker*; Pall Mall. 1687–1697

GARNONS THOMAS, *goldsmith*; parish of St Dunstan's-in-the-West. 1607–1613

GARRARD JOHN, *goldsmith*; parish of St Mary Woolnoth. (Buried) 1520

GARRARD ROBERT (see also WAKELIN & GARRARD), *plate-worker*; Panton street. 1792–1802

GARRARD ROBERT, JUNIOR, *plate-worker*; No. 31 Panton street, Haymarket. 1802–1821

GARRARD WILLIAM, *plate-worker*; Staining lane. 1735
 Removed to Noble street. 1739–1773
 Short's Buildings. 1749–1755
GARRARD R. & BROTHERS (ROBERT, JAMES & SEBASTIAN) (late WAKELIN & GARRARD),
 plate-workers; No. 31 Panton street. 1818
GARRET JAMES, *silversmith*; London. 1729
GARRETT FRANCIS, *goldsmith*; parish of St Dunstan's-in-the-West. 1603–(Buried) 1617
GARRETT (or GARRETTYE) JOHN, *goldsmith*; parish of St Mary Woolnoth. (Buried) 1659
GARRETT MARTIN, *goldsmith*; parish of St Dunstan's-in-the-West. (Buried) 1597
GARRETT THOMAS, *goldsmith*; parish of St Dunstan's-in-the-West. 1599–1617
 Parish of St Mary Woolnoth. 1614–(Died) 1626
GARTHORNE GEORGE, *plate-worker*; Keyre (= Carey) lane. 1674–1697
 Monkwell street. 1724–1727
GARTHORNE FRANCIS, *plate-worker*; Sun, Swithin's lane. 1677(?)–1726
GASTON (GOSTON or GORTON) JOHN, *goldsmith*; Queen's Head, near Bedford House
 [Strand]. 1668
GATCHET GEORGE, *goldsmith*; London. 1560–1569
GATCLIFF SAMUEL, *jeweller*; next door to "Pontack's" in Abchurch lane. 1712–1714
GATESFIELD RICHARD (succeeded by Widow Gatesfield), *silver cock-spur maker*; Crown,
 Exeter street. 1751
GATLIFFE WILLIAM, *goldsmith*; parish of St Olave's, Silver street. (Insolvent) 1725
GATWARD JOSEPH, *goldsmith*; St Sepulchre's. 1789
GAUBERT STEPHEN, *goldsmith*; Lichfield street, Soho. 1796–1800
GAY ELIZABETH, *goldsmith*; parish of St Vedast, Foster lane. (Buried) 1703
GAY WILLIAM, *goldsmith*; parish of St Vedast, Foster lane. 1660–(Buried) 1687
GAYNES (or GINES) RICHARD (see GINES), *goldsmith*; Lombard street. 1717
GAYNSFORD (or GAYNFFORD) HENRY (see HENRY GAINSFORD).
GAYWOOD JOHN & JOSEPH, *goldsmiths*; Golden Cross, near Exeter Change, Strand. 1693–1697
GAYWOOD (or GEYWOOD) JOSEPH, *goldsmith*; Golden Cross, near Exeter Change; or,
 near the Savoy, in the Strand. 1693–1706
 Dial, near Savoy gate, Strand. 1712–(Deceased) 1713
GAZE ROBERT, *plate-worker*; Shoe lane. 1795–1798
GEARING — (see MOORE & GEARING).
GEARING HARRY (see PORTAL & GEARING).
GEARING JOHN (see CADE & GEARING), *goldsmith*; Leadenhall street. 1797
GEAY JACQUES, *goldsmith*; Fort street, Artillery ground. 1702
GEDDES CHARLES (successor to JOHNSTON & GEDDES), *jeweller*; Golden Ball, Panton
 street, near Leicester square. c. 1760
GEDDES CHARLES (cf. JOHNSTON & GEDDES, also CHRISTOPHER JOHNSON), *jeweller*;
 Crown & Pearl, in Strand, near Durham yard. c. 1765
GELY PIERRE, *goldsmith*; London. 1689–1692
GEORGE LEWIS (see GEORGE LEWIS).
GERMAINE FRANCIS THOMAS, *goldsmith*; Pimlico. (Bankrupt) 1770
GERRARD CHRISTOPHER, *plate-worker*; Portugal street. 1719, 1720
GERRARD JOHN, *goldsmith*; Cheapside. 1634–1641
GERRARD RALPH (see GERRARD & HERLE), *goldsmith*; Bearbinder lane. 1686
 Three Lions, Lombard street. 1699–c. 1703
 Fox, Lombard street. c. 1703–1709

GERRARD ROBERT, *goldsmith*; No. 14 Coventry street, Haymarket. 1790

GERRARD RALPH & HERLE CHARLES (cf. GERRARD & NEWELL), *goldsmiths*; Three Lions,
Lombard street. (Bankrupt) 1709

GERRARD & NEWELL (cf. GERRARD & HERLE), *goldsmiths*; Three Lions, Lombard street. 1701– c. 1703

Fox, Lombard street. c. 1703–1706

GEYWOOD JOSEPH (see JOSEPH GAYWOOD).

GIBBES —, *goldsmith*; Aldersgate ward. 1640

GIBBON (or GIBBONS) EDWARD, *plate-worker*; Aldersgate street. 1719
Lad lane. 1723–1727

GIBBON SIMON, *goldsmith*; Cheapside. 1632–(Will proved) 1645

GIBBONS CHARLES, *plate-worker*; St Martin's-le-Grand. 1732–1734

GIBBONS JOHN, *plate-worker*; Foster lane. 1700
Red Lion street. 1723–1726

GIBBONS JOHN, *goldsmith*; Orange Street, near Red Lion square. 1712–1717

GIBBONS SYMON, *goldsmith*; parish of St Peter Westcheap. 1598

GIBBONS (or GIBBON) WILLIAM (see THOMAS SMITH & WILLIAM GIBBONS), Cheapside. 1642

GIBBS RICHARD, *goldsmith*; Foster lane. 1641–1703

GIBBS WILLIAM, *goldsmith*; Foster lane. 1634–(Died) 1689

GIBSON —, JUNIOR, *pawnbroker*; Three Golden Balls, Little Turnstile. 1756

GIBSON EDWARD, *plate-worker*; near Half Moon alley, Bishopsgate Without. 1691–1713
Bishopsgate street. 1697–1721

GIBSON JOHN, *jeweller*; Bow street, Covent Garden. 1714–1724

GIBSON MRS, *silversmith*; Bishopsgate street. 1755

GIBSON WILLIAM, *plate-worker*; Carey lane. 1697

GIBSON WILLIAM, *goldsmith*; St Anne's, Westminster. 1705

GIDDINGS JAMES, *silversmith*; at Mr Muns, Gold street. 1761

GIFFE NOY, *goldsmith*; Cripplegate. 1583

GIGNAC BENJAMIN, *plate-worker*; Dean's court, St Martin's-le-Grand. 1741–1748

GILBERT — (see JEFFERYS, JONES & GILBERT).

GILBERT (or GILBERD) EDWARD, *goldsmith*; Ship, Cheapside. 1562–1569

GILBERT (or GILBERD) HENRY, *goldsmith*; Rose, Cheapside. 1569–1580

GILBERT JOHN, *goldsmith*; London. 1668

GILBERT STEPHEN, *goldsmith*; Panton street. 1776–1771
Church street, Soho. 1784–1794

GILCHRIST —, *jeweller*; Ring & Pearl, near Beaufort buildings [Strand]. 1755

GILCHRIST ARCHIBALD, *goldsmith & jeweller*; Unicorn & Ring, Lombard street.
1731–(Deceased) 1742

GILCHRIST STERLING, *goldsmith*; Lombard street. 1755–1760

GILES — (see COOPER & GILES).

GILES GEORGE, *goldsmith*; London. 1783

GILL JOHN, *goldsmith*; Wheatsheaf & Anchor, No. 37 Gracechurch street. 1755–1768

GILLARD HENRY, *goldsmith*; London. 1558

GILLINGHAM —, *silversmith*; Black Lion, Strand. 1703

GILLINGHAM GEORGE, *plate-worker*; Guilford (? Giltspur) street. 1718
Giltspur street. 1721–1728

GILLOIS PETER, *plate-worker*; Wardour street, Soho. 1754–1773

(159)

GILLOIS Peter, Junr., *goldsmith*; Queen street, Seven Dials.　　　　1782–1785
GILPIN John, *goldsmith*; Golden Anchor, Cheapside.　　　　1692–1700
　　　　London.　　　　1724
GILPIN Thomas, *goldsmith*; Acorn, Strand.　　　　1730
　　　　(Succeeded Gilbert Langley at) Lincoln's Inn Back Gate, Serle street, next door
　　　　to Will's Coffee-house.　　　　1731–1773
GIMBER William, *plate-worker*; Ratcliff highway.　　　　1697
GINES George, *goldsmith*; Ship & Crown, Gracechurch street.　　　　1721–1744
GINES Richard (see Richard GAYNES), *goldsmith*; Rose & Crown, corner of Nag's Head
　　　　court (or corner of Ball alley), Lombard street.　　　　1698–(Died) 1742
GINES Emm. & CO.,[1] *goldsmith*; Lombard street.　　　　1748–(Will proved) 1756
GINES George & William, *bankers &* (?) *goldsmiths*; Rose & Crown, No. 50 Lombard street.
　　　　　　　　1751–1768
　　　　(Succeeded by GINES & ATKINSON.)　　　　1770–1781
GINES & PEWTRESS, *goldsmiths*; Gracechurch street.　　　　1748
GIORAUD Peter, *silversmith*; Spitalfields.　　　　1737
GIRARD Noah, *jeweller*; Lothbury court, Throgmorton street.　　　　1706
　　　　French court, Broad street.　　　　1708
GIRLING Peter, *goldsmith*; parish of St Nicholas Olave.　　　　1605–(Buried) 1623
GLADSTANES Thomas, *jeweller*; Coventry street.　　　　1784
GLADWIN (or GLADIN) Edward, *goldsmith*; parish of St Mary Woolnoth.　　　　1673–1689
GLADWIN Thomas, *silversmith*; Spotted Dog, Lombard street.　　　　1719
GLADWIN Thomas, *plate-worker*; Marylebone street.　　　　1737
GLADWIN Thomas, *plate-worker*; Houndsditch.　　　　1773
GLADWIN William, *goldsmith*; parish of St Mary Woolnoth.　　　　1679–(Died) 1696
GLAGG Thomas, *goldsmith*; London.　　　　1729
GLANFIELD (or GLANVILL) Francis, *goldsmith*; parish of St Mary Woolnoth.　　　　1597–1599
GLASS Alexander, *silversmith*; No. 237 High Holborn.　　　　1779
　　　　No. 306 High Holborn.　　　　1784
GLASSE Thomas, *goldsmith*; parish of St Vedast, Foster lane.　　　　1591–(Buried) 1592
GLEGG Thomas & VERE Samuel [succeeded by VERE & ASGILL], *goldsmiths & bankers*;
　　　　White Horse, facing Lloyd's Coffee-house, Lombard street.　　　　c. 1730–1734
GLENTON Thomas, *goldsmith*; parish of St Mary Woolnoth.　　　　1541–1545
GLOSTER John, *goldsmith*; parish of St Saviour's, Southwark.　　　　1610–1613
GLOVER John, *goldsmith*; parish of St Vedast, Foster lane.　　　　(Buried) 1598
GLOVER Samuel, *ring-maker*; Mutton court [Maiden lane].　　　　1777
　　　　Staining lane.　　　　1786
　　　　No. 4 Noble street, Foster lane.　　　　1790
GLYN Henry, *goldsmith*; London.　　　　1559
GOARE Samuel, *goldsmith*; parish of St Saviour's, Southwark.　　　　1639
GODBEHERE (or GODBERE) Samuel (late James STAMP), *goldsmith & jeweller*; No. 86
　　　　Cheapside, next Mercers' Chapel.　　　　1784
GODBEHERE Samuel & WIGAN Edward, *plate-workers*; Cheapside.　　　　1786
GODBEHERE, WIGAN & BULT, *plate-workers*; Cheapside.　　　　1800
GODBEHERE (or GOODBEHERE), WIGAN & CO. (late Mr Stamp's), *working goldsmiths*;
　　　　No. 86 Cheapside, next Mercers' Chapel.　　　　1787–1796
GODDARD —, *goldsmith*; near the Stone-cutters' alley, in the Pall Mall.　　　　1694

[1] Probably widow of Richard Gines in partnership with her two sons George and William.

Plate XXXI

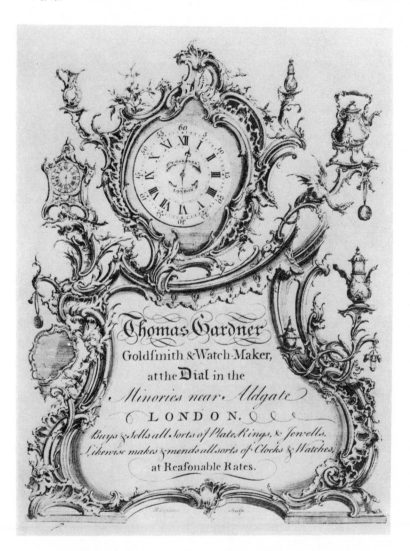

THOMAS GARDNER 1740–1752

Plate XXXII

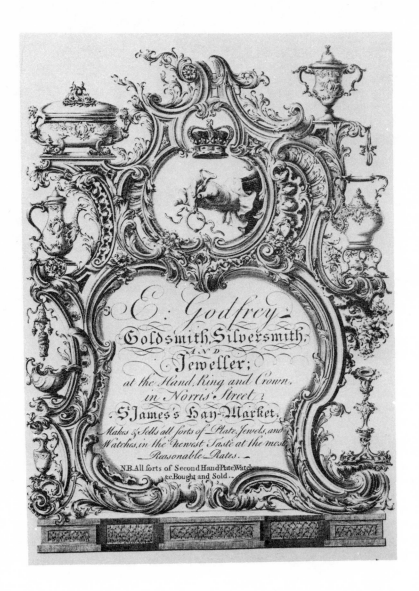

ELIZABETH GODFREY 1741-1758

GODDARD Edward, *goldsmith*; Pall Mall. 1702, 1703
GODDARD F., *jeweller*; No. 8 Rathbone place. 1796
GODDARD John, *pawnbroker*; back door of the Vine tavern, Eagle street, Holborn. 1726
GODDARD Jonathan, *pawnbroker*; Golden Ball, Burleigh street, near Exeter street, Strand. 1744
GODDARD Philip, *plate-worker*; Fountain court, Cheapside. 1723
GODDARD Philip, *goldsmith*; London. 1773
GODDE Phillipe, *goldsmith*; New street, Covent Garden. 1698
GODDEN Richard, *goldsmith & jeweller*; No. 85 Cornhill. 1790–1793
GODDERDYKE (or GODDERYKE) —, *goldsmith*; Unicorn, Cheapside. 1561
GODFREY —, *goldsmith*; Wood street. 1380
GODFREY Benjamin, *goldsmith & silversmith*; Hand, Ring & Crown, Norris street, Haymarket. 1732–1739
GODFREY Elizabeth, *goldsmith, silversmith & jeweller*; Hand, Ring & Crown, Norris street, St James's, Haymarket. 1741–1758
GODLY Benjamin, *gold and silver flatter*; Newgate street. 1767
GODMAN John, *goldsmith*; parish of St Vedast, Foster lane. (Died) 1405
GODWARD William, *goldsmith*; Castle street, Southwark. 1798
GODWIN Benjamin, *plate-worker*; Gutter lane. 1730–1732
GODWIN John, *goldsmith*; No. 161 Strand. 1796
GODWIN Meshach, *plate-worker*; Foster lane. 1722–1726
GOLD John, *goldsmith*; Priest court [Foster lane]. 1796
GOLD Thomas, *goldsmith*; Lombard street. 1693
GOLDEN Wilfred, the elder, *goldsmith*; parish of St Olave's, Silver street. 1648
GOLDEVILLE Henry, *goldsmith*; London. 1553
GOLDNEY Thomas (late James NEILD), *jeweller & goldsmith*; No. 4 St James's street, near the Royal Palace. 1791–1827
GOLDSTON —, *goldsmith*; Lombard street. 1664
GOLDWELL Thomas, *goldsmith*; Great Knightrider street. (Insolvent) 1725
GOLDWIRE Richard, *plate-worker*; Oxford street. 1753
GOLL John Daniel, *silversmith*; No. 12 New street, Covent Garden. 1790–1796
GOOD John, *goldsmith*; No. 305 High Holborn. 1784–1793
GOODALE Joseph, *pawnbroker*; Flying Horse, Fore street, near Cripplegate. 1702
GOODBEHERE, WIGAN & CO. (see GODBEHERE).
GOODE Henry, *goldsmith*; parish of St Margaret's, Lothbury. (Will proved) 1651
GOODE John, *plate-worker*; Heming's row [St Martin's lane]. 1702
GOODERE Edmund & MATTHEWS Thomas, *goldsmiths*; next the Fountain tavern, Strand. 1691
GOODFELLOW —, *silversmith*; Bell yard, Temple Bar. 1752
GOODMAN Mrs, *pawnbroker*; Golden Key, Widegate street, without Bishopsgate. 1745
GOODRICH John, *goldsmith*; London. 1569
GOODWIN Benjamin, *goldsmith*; London. 1730
GOODWIN Elizabeth, *plate-worker*; Noble street. 1729
GOODWIN James, *plate-worker*; Foster lane. 1710
Noble street. 1721–1729
GOODWIN John, *goldsmith*; Lombard street. (Buried 1639)
GOODWIN William, *goldsmith*; Newgate street. 1700–1704
GORDNER Thomas (see Thomas GARDNER).

LONDON GOLDSMITHS

GOREHAM John, *plate-worker*; Blackmoor's Head, Gutter lane. 1728–(Died) 1761
GORSUCH John, *plate-worker*; Little East Cheap. 1726
GORTON John (see John GASTON).
GOSLING —, *plate-worker*; Fox & Crown, Philip lane, Addle street. 1732
GOSLING Francis, Sir, *goldsmith*; Three Squirrels, Fleet street. 1742–(Died) 1768
GOSLING Joseph, *goldsmith & clock-maker*; No. 55 Cornhill. 1775–1790
GOSLING Richard, *plate-worker*; Barbican. 1730–1743
 Cornhill. 1743–1754
GOSLING Richard & Joseph, *spoon-makers*; Fox & Crown, Cornhill. 1773
GOSLING Richard & SONS, *goldsmiths*; No. 55 Cornhill. 1760–1775
GOSLING Robert, *goldsmith & jeweller*; No. 160 Fenchurch street. 1770–1784
GOSLING Thomas, *jeweller*; Snow hill. 1775
GOSLING William, Sir, *goldsmith & banker*; London. 1670–1686
GOSLING & BENNET (cf. WARD & GOSLING), *bankers*; Three Squirrels, Fleet street. 1743–1752
GOSLING & CO., *bankers & goldsmiths*; Three Squirrels, over against St Dunstan's Church,
 Fleet street. 1747
GOSSART John, *goldsmith*; in Orange court, near the Mews [Leicester square]. 1725
GOSSON Richard, *goldsmith*; parish of St Vedast, Foster lane. (Married) 1584–(Buried) 1623
GOSSON Richard, *goldsmith*; London. 1630
GOSSON William, *goldsmith*; Foster lane. 1700
GOSTON John (see John GASTON).
GOSTWICK Thomas, *goldsmith*; parish of St Vedast, Foster lane. (Buried) 1637
GOTTLIEB John, *jeweller*; St Martin's-le-Grand. 1753
GOUGH Thomas, *goldsmith*; parish of St Vedast, Foster lane. (Buried) 1575
GOUILLET —, *jeweller*; Potter street, Newport market. 1762
GOUILLET Charles, *jeweller*; Leicester fields. 1774–1779
GOUILLET (or GOULET) Peter, *jeweller*; (from Bath; sets up business at) Crown & Pearl,
 Leicester fields. 1744
GOULD —, *goldsmith*; London. 1699–1700
GOULD James, *plate-worker*; Golden Lion, or Three Golden Lions, Gutter lane. 1722–1737
GOULD James, *plate-worker*; Candlestick, Gutter lane. 1739–1743
GOULD James, *plate-worker*; Golden Bottle, Ave Mary lane. 1741–1744
GOULD James, *candlestick maker*; Ave Mary lane. 1773
GOULD John, *goldsmith*; London. 1722–1747
GOULD Thomas (see FREAME & GOULD).
GOULD William, *silversmith*; Wheatsheaf, Gutter lane. 1732
 Candlestick, Foster lane. 1733–1748
 Old street. 1753–1757
GOUYNIN —, *jeweller*; Turk's Head, Bennet street, St James's. 1752
GOYON Andrew, *silversmith*; St Giles-in-the-fields. 1723
GRAINGER Thomas, *pawnbroker*; Rose, Salisbury court, Fleet street. 1711–1720
GRANIER Charles, *gold laceman*; Monmouth street, St Giles'. 1717
GRANT —, *goldsmith*; Southwark. 1698
GRANT Dorothy, Mrs, *goldsmith*; Southwark. 1697–1712
GRANT Jacob, *goldsmith*; against Three Crown court, in the Borough, Southwark. 1709–1717
GRANT John, *jeweller & goldsmith*; No. 3 Cockspur street, Haymarket. 1784–1793

(162)

GRANT Richard, *silversmith*; Compton street. 1766

GRANT Samuel (see BERG & GRANT).

GRANTHAM William, *goldsmith*; parish of St Vedast. 1397–1403

GRAVETT John, *goldsmith*; parish of St Martin's, Ludgate. (Will proved) 1641

GRAY —, *silversmith*; without the Bars, Whitechapel. 1731

GRAY George, *jeweller*; No. 24 Dean street, Fetter lane. 1777
 No. 4 Billiter square. 1779–1781

GRAY John, *goldsmith*; parish of St Peter Westcheap. 1599

GRAY John, *goldsmith*; London. 1739

GRAY John, *jeweller & goldsmith*; Billiter square. 1782–1799

GRAY J. & G., *jewellers*; No. 4 Billiter square. 1796

GRAY Robert, *goldsmith & jeweller*; No. 13 New Bond street. 1777–1792

GRAY Robert & William, *goldsmiths & jewellers*; No. 13 New Bond street. 1792

GRAY Thomas, *jeweller & goldsmith*; No. 25 Strand. 1784–1796

GRAY Thomas, *jeweller*; No. 42 Sackville street. 1787–1793
 No. 41 Sackville street. 1802–1814

GRAY W., *goldsmith*; No. 9 Robinson's row, Kingsland. 1795

GRAY William, *goldsmith & jeweller*; No. 13 New Bond street. 1792–1825

GRAY Thomas & CONSTABLE William, *goldsmiths*; Sackville street. (Partnership dissolved) 1799

GRAYGOOSE Samuel, *pawnbroker*; Three Blue Balls, Holliwell street, Strand. 1758

GREEN — (see WILLERTON & GREEN, also WILLERTON, SKULL & GREEN).

GREEN —, *goldsmith*; Blue Anchor, Little Tower hill. 1699

GREEN —, *goldsmith*; Minories. 1709–(Died) 1737

GREEN (or GREENE) David, *plate-worker*; Foster lane. 1701–1720

GREEN Edward, ? *goldsmith*; parish of St John Zachary. (Will proved) 1620

GREEN (or GREENE) Henry, *plate-worker*; Gold street. 1700–1720
 Noble street. 1724–1734

GREEN Henry, *silversmith*; Carey lane, near Foster lane, Cheapside. 1710–1718

GREEN Henry, *goldsmith*; St John Zachary. 1727

GREEN Henry (see ALDRIDGE & GREEN), *goldsmith*; Aldersgate street. 1773–1795

GREEN (or GREENE) Henry, *silversmith*; No. 62 St Martin's-le-Grand. 1786–1796

GREEN John (succeeded by William Man), *goldsmith*; Three Flower-de-Luces & Crown,
 Henrietta street. 1687–1695

GREEN Joseph, *goldsmith & pawnbroker*; Ring & Ball, Little Tower hill. 1723–1734

GREEN (or GREENE) Nathaniel, *goldsmith*; Black Lion, Leicester fields. 1694–1697
 St Martin's lane. 1698–1704

GREEN Nathaniel, *jeweller to His Majesty*; Dover street. (Died) 1728

GREEN (or GREENE) Richard, *plate-worker*; Foster lane. 1703–1734

GREEN (or GREENE) Richard, *goldsmith & jeweller*; Strand, opposite the New Exchange. c. 1750

GREEN Samuel, *plate-worker*; Ball alley, Lombard street. 1721
 Three Half Moons, Lombard street. (Bankrupt) 1726

GREEN T., *goldsmith*; London. 1516

GREEN (or GREENE) Thomas,[1] *goldsmith*; London. 1560–(Hanged) 1584

GREEN Thomas, *goldsmith*; Lombard street. 1724–1727

GREEN Thomas (see ROWE & GREEN).

[1] "Convicted of diminishing her Majesties coign." Hanged, beheaded and quartered at Tyburn.

GREEN Thomas Abbott (cf. GREEN & WARD), *goldsmith*; Ludgate hill. 1795
GREEN William, *goldsmith*; London. 1700
GREEN Richard & AMBER Norton, *goldsmiths & bankers*; near Durham yard, Strand.
 1745–(Bankrupts) 1755
GREEN & EADES, *goldsmiths*; Crown, Lombard street. 1719
GREEN & WARD, *goldsmiths*; No. 1 Ludgate street. 1790–1796
GREENE Edward, *goldsmith*; parish of St Mary Woolnoth. 1586, 1587
GREENE Edward, *goldsmith*; Aldersgate ward. 1640
 Foster lane. 1641
GREENE Edward, *goldsmith*; London. 1663
GREENE Richard, *goldsmith*; London. 1722–1731
GREENE Thomas, *goldsmith*; London. 1511
GREENE Thomas, *goldsmith*; parish of St Peter's, Cheapside. 1641–1677
GREENEBANCKE George, *goldsmith*; parish of St Alban's, Wood street. (Deceased) 1605
GREENHILL George, *goldsmith*; parish of St Dionis Backchurch. (Banns published) 1654
GREENOUGH —, *goldsmith*; Cup & Ring, Minories. 1721
GREENSILL Edward, *jeweller*; No. 34 Strand. 1784–1796
GREENSILL Joseph, *jeweller*; No. 36 Strand. 1779
GREENSILL Joseph, *goldsmith & jeweller*; No. 35 Strand, between Buckingham and Villiers
 streets. No connection with the shop next door of the same name. 1784–1796
GREENSILL Joseph, *jeweller*; No. 38 Strand. 1790–1793
GREENSILL & SON, *jewellers & goldsmiths*; No. 35 Strand. 1796
GREENWAY Henry, *goldsmith*; London. 1653
GREENWAY Henry, *plate-worker*; Giltspur street. 1775–1778
 London. 1790
GREGG —, *pawnbroker*; Barnaby street, Southwark. 1755
GREGORY Barnaby, *goldsmith*; parish of St Mary Woolnoth. 1603–1633
GREGORY Jeremy, *goldsmith*; London. 1668
GREGORY Roger, *goldsmith*; parish of St Saviour's, Southwark. 1664
GRESHAM Richard, Sir,[1] *merchant & goldsmith*; (?) Milk street. 1539–1549
 Lombard street. 1549–(Died) 1556
GRESHAM Thomas, Sir,[2] *goldsmith*; Grasshopper, Lombard street. 1549–(Died) 1579
GRETE Edmond, *goldsmith*; parish of St Mary Woolnoth. 1581–1587
GREVILL Francis, *goldsmith*; Strand and Lombard street. 1698
GREVILL & SMYTH, *goldsmiths*; Lombard street. 1707
GRIBELIN Isaac, *goldsmith*; Savoy. 1706
GRIFFIN —, *silversmith*; Carpenters' Arms, Clerkenwell. 1730
GRIFFIN Benjamin, *plate-worker*; Bond street. 1742–1748
GRIFFIN John, *goldsmith*; parish of St Dionis Backchurch. 1692, 1693
GRIFFIN Robert, *goldsmith*; Holborn. (Bankrupt) 1739
GRIFFIN & ADAMS, *goldsmiths, jewellers & cutlers*; No. 7 Ludgate street. c. 1795
 No. 76 Strand. 1802–1827
GRIFFITH —, *goldsmith*; Tooley street, Southwark. 1709
GRIFFITH Jeffrey (see also LAUNDRY & GRIFFITH), *plate-worker*; over against the New
 Bagnio, St James's street. 1700
 Staining lane. 1731–1740

[1] Mayor of London, 1537–8. M.P. 1545. [2] Founded Royal Exchange 1566.

Plate XXXIII

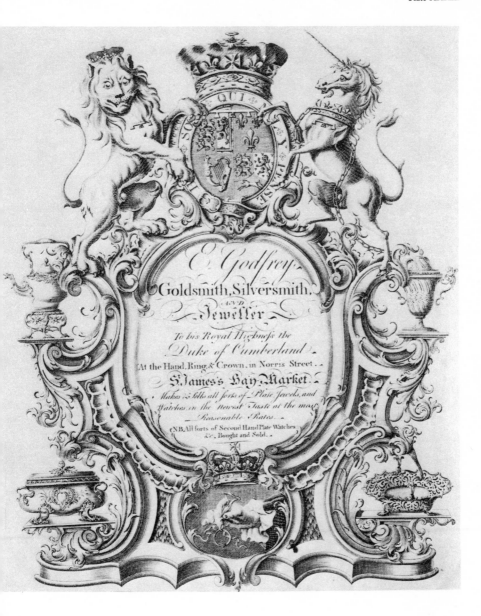

ELIZABETH GODFREY

[Original size 9½ in. × 8 in.]

1741–1758

Plate XXXIV

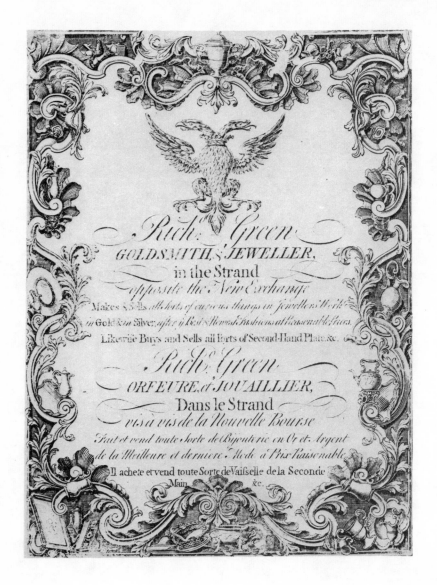

RICHARD GREEN *circa* 1750

GRIGG —, *goldsmith*; Strand. 1681

GRIGG ANTHONY, *goldsmith*; parish of St Vedast, Foster lane. (Will proved) 1621

GRIGGE —, *goldsmith*; Black Boy, over against St Dunstan's Church, Fleet street. 1660

GRIGNION REYNOLDS, *goldsmith*; Queen street, Seven Dials. 1773

GRIMES JOHN, *goldsmith*; parish of St Mary Woolnoth. (Died) 1677

GRIMES ROBERT, *pawnbroker*; Five Roses, Saffron hill. 1687

GRIMSTEAD THOMAS, *jeweller & goldsmith*; St Paul's churchyard. 1753–1765

GRIMSTON —, *goldsmith*; Golden Lion, Fleet street, over against Fetter lane end. 1679

GRIMSTONE —, *goldsmith*; Palsgrave's Head, near Temple Bar. 1679

GROOM HENRY, *goldsmith*; Foster lane. 1679

GROOME ROBERT, *silver turner*; St Martin's-le-Grand. 1767

GROON JOHN, *watch-case maker*; Warwick lane. 1765

GROSVENOR JOHN, *goldsmith*; London. 1673

GROSVENOR WILLIAM, *goldsmith*; parish of St Mary Woolnoth. (Married) 1658

GROVES THOMAS (see KENSTEBER & GROVES).

GRUNDY WILLIAM, *plate-worker*; Fetter lane. 1743–1779

GRUNDY WILLIAM, *goldsmith*; Golden Cup, Pemberton row, near Gough square, Fleet street. 1751

GRUNDY WILLIAM & FERNELL EDWARD (see also EDWARD FERNELL), *plate-workers*; Fetter lane. 1779

GUBBIN HENRY, *goldsmith*; Dean street. 1766

GUERRE (GUERRIER or GUERRIE) JOHN, *plate-worker*; Mitre, Strand. 1717

GUICHARD LOUIS, *plate-worker*; King street. 1748–1751

GUICHARDIÈRE JEAN, *goldsmith*; Rider's court [Newport street]. 1706–1715

GUICHERY JEAN, *goldsmith*; Newport street. 1706

GUIRAUT JACOB, *goldsmith*; Little Earl street, St Giles'. 1709–(Died) 1730

GULLIVER NATHANIEL, *plate-worker*; Gutter lane. 1722

GUNTER THOMAS, *goldsmith*; St Olave's street, Southwark. 1718

GURDEN (or GURDON) BENJAMIN, *jeweller & goldsmith*; Noble street. 1740–1773
No. 114 Wood street. 1777–(Deceased) 1804

GURDEN BENJAMIN & SON, *jewellers*; No. 114 Wood street. 1777

GURNEY RICHARD, *goldsmith*; Foster lane. 1721–1727

GURNEY RICHARD & CO., *plate-workers*; Foster lane. 1734–1750

GURNEY T. & R., *silversmiths*; Golden Cup, Foster lane. 1721

GURNEY WILLIAM, *goldsmith*; Foster lane. 1744

GURNEY RICHARD & COOK THOMAS (see also COOKE & GURNEY), *goldsmiths*; Golden
Cup, Foster lane. 1721–1773

GWILLIM WILLIAM, *plate-worker*; Carey lane. 1740–1744

GWILLIM WILLIAM & CASTLE PETER, *plate-workers*; Carey lane. 1744

GWILT RICHARD, *goldsmith*; No. 219 Borough. 1768–1774

GWYN BACON, *pawnbroker*; next the Star inn, Blackman street, Southwark. 1706

GYBLETT THOMAS, *gold beater*; New Compton street. 1789

GYBLETT WILLIAM, *gold beater*; Vere street. 1765
St Clement Dane's. 1767

GYLBARD (or GYLBART) —, *goldsmith*; Black Boy, Cheapside. (Killed) 1562

GYLFORD —, *goldsmith*; corner of Beaufort buildings, Strand. 1712

(165)

HACKER —, *goldsmith*; Mermaid, Lombard street. 1664
HACKETT SIMON, *goldsmith*; London. (Will proved) 1620
HADDON FRANCIS, *goldsmith*; parish of St Mary Woolnoth. 1602–1615
HADUCK (or HADOCK) ALBERT, *goldsmith*; parish of St Vedast, Foster lane. (Buried) 1592
HAGUE (or HAGNE) JOHN, *plate-worker*; Noble street. 1758
HAINES WILLIAM, *goldsmith*; parish of All Hallows, Lombard street. (Will proved) 1632
HALES PETER, *goldsmith*; King street, St Ann's, Soho. 1749
HALES WILLIAM (see EVANCE & HALES), *goldsmith*; Lombard street. 1704
 Duke street, Westminster. 1724–1727
HALEY GEORGE, *silversmith*; Golden Ball, Goodacres court, St Martin's lane. (Married) 1699
HALIFAX JOHN, *goldsmith*; London. 1768–1776
HALL —, *goldsmith*; Black Swan, Newgate street. 1690
HALL BENJAMIN, *pawnbroker*; Bell, Deadman's place, Southwark. 1715
HALL EDWARD, *goldsmith*; Maiden lane. 1720
HALL FRANCIS, *goldsmith*; Cheapside. 1634–1649
HALL GEORGE, *working goldsmith*; No. 482 Strand. 1790
HALL JOHN, *goldsmith*; parish of St Clement Danes. c. 1626
HALL JOHN, *goldsmith*; Leadenhall street. 1681
HALL MATTHEW, *goldsmith*; London. 1451
HALL ROBERT, *goldsmith*; London. 1442
HALL ROBERT, *pawnbroker*; Three Balls, New Belton street, Long Acre. 1764
HALL THOMAS, *goldsmith;* London. 1403
HALL THOMAS, *goldsmith*; Goldsmiths' row. 1678–(Buried ?) 1718
HALL THOMAS, *goldsmith*; Denmark street, Strand. 1773
HALL WILLIAM,[1] *goldsmith*; parish of St Vedast, Foster lane. 1656–(Buried) 1660
HALL WILLIAM, *plate-worker*; Finsbury street. 1795–1800
HALLAM MRS, *pawnbroker*; near the Maypole, East Smithfield. 1722
HALLE MATHEW, *goldsmith*; parish of St Vedast. (Died) c. 1463
HALLE ROBERT, *goldsmith*; London. 1416
HALLÉE ABRAHAM, *jeweller*; St Anne's, Westminster. 1724
HALLER —, *goldsmith*; corner of Buckingham street in York buildings, Strand. 1683
HALLETT GEORGE, *goldsmith*; corner of Buckingham street in the Strand. 1683–1686
HALLETT JAMES, SIR, *goldsmith*; Angel (or Golden Angel), Cheapside. 1690–(Died) 1734
 Bloomsbury square. 1727
HALLETT JAMES, JUNR., *goldsmith*; Angel, Cheapside. 1706–(Died) 1723
HALLIDAY — (see PEWTRESS, FLIGHT & HALLIDAY).
HALLIFAX THOMAS, SIR, *goldsmith & banker*; Birchin lane. 1753–(Died) 1789
HALLOWES (or HALLOWS) THOMAS, *goldsmith*; Southampton street, Strand. 1773
 Strand. (Insolvent) 1774
HALLSWORTH HENRY, *plate-worker*; Bull and Mouth street. 1773
 Angel street. 1774–1781
HALLYWELL JOHN, *goldsmith*; London. (Died) 1563
HALSTED (or HALSTEEDE) JOHN, *goldsmith*; parish of St Dunstan's-in-the-West. (Married) 1587
HALSTED ROBERT, *goldsmith*; Crown & Dial (or Golden Crown), Fleet street, between Water
 lane and Salisbury court. 1662–1703

 [1] Francis Child, the banker, was apprenticed to William Hall in 1656.

LONDON GOLDSMITHS

HALSTED WILLIAM, *goldsmith*; Black Spread Eagle, Fenchurch street. 1694
HALSTONE ROBERT, *goldsmith*; London. c. 1510
HAMBLY PATIENCE, MRS, *silversmith*; Tooley street, Southwark. 1743
HAMLET THOMAS (see also LAMBERT & HAMLET), *goldsmith*; No. 2 St Martin's court,
Leicester square. 1793
Corner of Sydney alley, Coventry street; or, No. 1 Princes street, Leicester
square. c. 1800–(Bankrupt) 1842. (Died) c. 1849
HAMMERSLEY HUGH, *goldsmith*; Three Cups, near Somerset House, Strand. 1677–1690
HAMMERSLEY RICHARD, *goldsmith*; Sun & Marygold, against Katherine street, near the
Savoy, Strand. 1694–1696
HAMMOND —, *pawnbroker*; Bell, Maiden lane, Covent Garden. 1706
HAMMOND THOMAS (see COKER & HAMMOND).
HAMMOND WILLIAM (see also ATTWELL & HAMMOND), *goldsmith*; Exchange alley.
1722–(Deceased) 1744
HAMMOND & CARTER, *goldsmith*; No. 45 St Martin-le-Grand. 1768
Westmoreland buildings [Aldersgate street]. 1770
HAMON LEWIS, *plate-worker*; Great Newport street. 1716–1735
Church street, Soho. 1738, 1739
HAMOND WILLIAM, *goldsmith*; parish of St Michael Bassishaw. 1695
HAMONDE THOMAS, *goldsmith*; parish of St Mary Woolnoth. 1575
HAMPTON THOMAS, *goldsmith*; London. 1567–1569
HAMS JOHN, *goldsmith*; Monkwell street. 1789
HANBERRIE RICHARD, *goldsmith*; London. 1560–1569
HANCOCK JONATHAN, *goldsmith*; London. 1658
HANCOCK W., *goldsmith*; London. 1770
HAND WILLIAM, *goldsmith & banker*; Russell street, Covent Garden. 1710
HANDCOCK THOMAS, *goldsmith*; parish of St Mary Woolnoth. 1693–1699
HANET JOHN & GEORGE, *gold-workers*; Porter street, near Leicester fields. 1763–1772
HANET PAUL, *plate-worker*; Savoy. 1705–1708
Next to the Golden Boy, Castle street, St Martin's court. 1710–1728
Great St Andrew's street. 1715–1728
Rider's court, Soho. 1733
HANFAN, JOHN, *goldsmith*; London. 1620
HANKEY HENRY, SIR, *goldsmith*; Ball & Ring (or Ring & Ball), Fenchurch street. 1690–1704
Golden Ball, Fenchurch street. 1701–1723
HANKEY SAMUEL, *goldsmith & banker*; Ring & Ball, under St Dionis Backchurch, Fenchurch
street. 1685–1690
HANKEY JOSEPH, SIR & THOMAS, SIR, *bankers*; Three Golden Balls, Fenchurch street. 1765–1768
HANKEY MESSRS, *goldsmiths*; Golden Ball, Fenchurch street. 1721
HANKIN RICHARD, *goldsmith*; Worship street. 1789
HANKINS THOMAS, *goldsmith & jeweller*; St Margaret's hill, Southwark. 1769
HANKS JOB, *plate-worker*; Gutter lane. 1699
HANMER CHARLES, *goldsmith*; Westminster. (Married) 1581
HANN WILLIAM, *goldsmith*; over against Round court in the Strand. 1699
HANNAM JOHN, *goldsmith*; Golden Cup, the north side of St Paul's churchyard, beyond the
narrow passage towards Cheapside. 1698
HANNAM THOMAS & CROUCH JOHN (see also CROUCH & HANNAM), *goldsmiths*;
No. 23 Giltspur street. 1766–1793
No. 37 Monkwell street. 1790

(167)

HANNAM Thomas (?) & MILLS Richard (cf. Richard MILLS), *goldsmiths*; London. 1765
HANNE —, *goldsmith*; Bunch of Grapes, near York buildings, in the Strand. 1705
HANNUM Samuel, *goldsmith*; parish of St Saviour's, Southwark. 1660
HANSLOP Charles, Whitechapel. (Married) 1700
HANSON Edward, *goldsmith*; Green Dragon, Cheapside. 1665
HANSON Thomas, *goldsmith*; parish of St Gregory's. (Will proved) 1636
HARACHE (see HARRACHE).
HARDEL Philip, *jeweller*; Golden Head, Villiers street, York buildings. 1755
HARDEY — (or HARDY), *goldsmith*; Parrot, Great Minories, near Aldgate. 1727
HARDEY (or HARDY) Mrs, *goldsmith*; Parrot, Minories. 1743–1747
HARDING Agas, Mrs, *goldsmith*; London. 1513
HARDING Edward, *goldsmith*; parish of St Mary Woolnoth. 1583–1586
HARDING Robert, *goldsmith*; parish of Bow Church, Cheapside. 1478–(Will proved) c. 1504
HARDING Thomas (see also Thomas HARDING & CO.), *working goldsmith & jeweller*;
Crown & Spur, No. 43 Minories. 1751–1781
HARDING Thomas, *goldsmith*; Paul's court. 1782
HARDING Thomas, *goldsmith*; Harp lane. 1795
HARDING Thomas & CO. (see also Thomas HARDING), *goldsmiths*; No. 43 Minories. 1760–1802
HARDING W., *goldsmith*; No. 113 Minories. 1790–1793
HARDING William, *goldsmith*; Black Bull, Mint street. 1712
HARDRETT Abraham & Martin, *jewellers*; Farringdon Within. 1583
HARDWELL William, *goldsmith*; parish of St Vedast, Foster lane. 1649–(Buried) 1660
HARDWICK William, *goldsmith*; Addle street, Aldermanbury. (Insolvent) 1761
HARDY — AND Mrs (see HARDEY).
HARDY Joseph, *plate-worker*; No. 26 Clement's lane, Lombard street. 1799–1800
HARDY Joseph (see PRATT, SMITH & HARDY).
HARDY Thomas, *goldsmith*; Cheapside. 1642
Parish of St Vedast, Foster lane. (Will proved) 1642
HARDY William, *goldsmith & jeweller*; Ratcliffe highway near Sun Tavern fields. c. 1720
HARDY Jos. & LOWNDES Thomas (see Thomas LOWNDES, also LOWNDES &
LYCETT), *plate-workers*; London. 1798
HARE —, *silversmith*; Hand & Spur, Clerkenwell close. 1738
HARELING John (see John HARLING).
HARENDEN William, *goldsmith*; parish of St Vedast, Foster lane. (Will proved) 1622
HARGRAVE Henry, *goldsmith*; Lombard street. 1587–(Buried) 1597
HARGRAVE Humphrey, *goldsmith*; parish of St Matthew, Friday street. (Married) 1622
HARGRAVES Henry, *goldsmith*; Southwark. 1594
HARLEY Isaac, *goldsmith*; Silver street. 1765
Foster lane. 1781–1786
HARLING (or HARELING) John, *goldsmith*; Heart & Crown & White Horse, Lombard street.
(Prior to) 1660–(Died) 1691
HARMAN James, *goldsmith*; parish of St Michael Bassishaw. (Will proved) 1620
HARMAR James, *silversmith*; Ship yard, Temple Bar. 1747
HARNICK Michael, *jeweller*; Warwick lane. 1753
HARPER Thomas, *working goldsmith & jeweller*; No. 207 Fleet street. 1784–1796
HARPER William, *goldsmith*; King street, Soho. 1790–1793

Plate XXXV

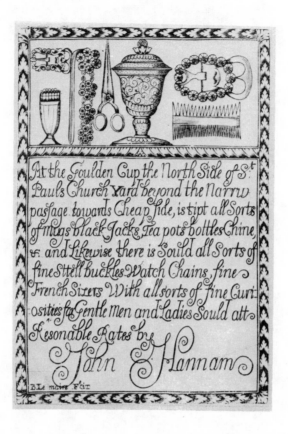

At the Goulden Cup the North Side of Sʳ Pauls Church Yard beyond the Narrw pasſage. towards Cheap ſide, is tipt all Sorts of mugs black Jacks, Tea pots bottles Chine, &c. and Likewise there is Sould all Sorts of fine Stſell buckles Watch Chains, fine French Sizers With all sorts of fine Curiosities for Gentle Men and Ladies Sould att Resonable Rates by John Hannam

B Le main Fecit

JOHN HANNAM 1698

Plate XXXVI

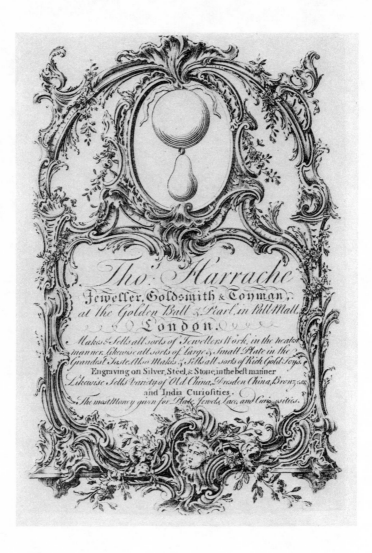

THOMAS HARRACHE 1751–1773

HARRACHE ABRAHAM, *goldsmith*; Rider's court, Compton street. 1704–1706
HARRACHE MRS, *silversmith*; corner of Great Suffolk street. 1699
HARRACHE (or HARACHE) FRANCIS, *silversmith & toy-man*; Blackmoor's Head, Great St Andrew street, St Giles's. 1732–1758
HARRACHE JEAN, *goldsmith*; Rider's court, Soho. 1722–1726
HARRACHE (or HARACHE) PETER [succeeded by his son Peter], *plate-worker*; Suffolk street, Charing Cross. 1675–(Died) 1700
HARRACHE (or HARACHE) PETER, JUNIOR, *plate-worker*; Compton street, near St Anne's Church. 1698–1705
HARRACHE PETER, JUNIOR, *goldsmith*; Grafton street. 1714–1717
HARRACHE (or HARACHE) THOMAS, *jeweller, goldsmith & toy-man*; parish of St Martin's-in-the-fields. 1744–1750
Removed from corner of St Martin's lane, Long Acre. 1751
Golden Ball & Pearl, Pall Mall. 1751–1773
HARRENDEN WILLIAM, London. 1633
HARRIS BENJAMIN, *plate-worker*; Temple Bar. 1697–1708
HARRIS FRANCIS, *goldsmith*; parish of St Leonard's, Foster lane. (Married) 1645
HARRIS GEORGE, *silversmith*; Hatton Wall, Hatton street. 1790–1793
HARRIS GEORGE, *goldsmith*; Bunhill row. 1800
HARRIS JACOB, *goldsmith & jeweller*; Clement's Inn, leading to Clare market. 1752
HARRIS JAMES, *goldsmith*; Gutter lane. 1768–1781
HARRIS JOHN, *goldsmith*; Holborn bridge. 1691–1695
HARRIS JOHN, *plate-worker*; Foster lane. 1716–1734
HARRIS JOHN, *silversmith*; Monkwell street. 1786–1793
HARRIS NATHANIEL, *goldsmith*; St Thomas, Southwark. 1790
HARRIS RICHARD (see SWEETAPLE, HODGKINS & HARRIS).
HARRIS RICHARD, *silversmith*; St Dunstan's-in-the-West. (Bankrupt) 1728
HARRIS WILLIAM, *goldsmith*; parish of St Botolph's, Aldgate. (Married) 1623
HARRIS GEORGE & MAY DANIEL, *goldsmiths*; Bunhill row. (Partnership dissolved) 1800
HARRISON —, *goldsmith*; Three Flower-de-Luces, Strand. 1692–1698
HARRISON —, *jeweller*; King's street, Westminster. 1730
HARRISON —, *pawnbroker*; Golden Ball, Whitecross street, Southwark. 1744
HARRISON —, *pawnbroker*; Three Balls, Denmark street, St Giles' Church. 1753
HARRISON ABRAHAM, *goldsmith*; parish of St Paul's, Covent Garden. (Married) 1661
HARRISON CUTHBERT, *goldsmith*; parish of St Peter's, Cheapside. 1608
HARRISON EDWARD, *goldsmith*; Hen & Chickens, Cheapside, opposite Bow Church. 1686–(Died) 1716
HARRISON EDWARD, *goldsmith*; parish of St Peter's, Broad street ward. 1692
HARRISON EDWARD, *pawnbroker*; Petticoat lane, Whitechapel. 1747
HARRISON JOHN, *goldsmith*; London. 1534–1547
HARRISON ROBERT, *goldsmith*; London. 1550
HARRISON RICHARD, *goldsmith*; parish of St Mary Woolnoth. 1577
HARRISON THOMAS, *goldsmith & banker*; Wood street, Cheapside. 1452
HARRISON THOMAS, *goldsmith*; London. 1569, 1570
HARRISON THOMAS, *pawnbroker*; Three Blue Balls, Fair street, Horsely down. (Gave up trade) 1742
HARRISON THOMAS, *silver small-worker*; Moorfields. 1774

HARRISON William, *goldsmith*; Little Britain. 1723, 1724
HARRISON William, *goldsmith*; Monkwell street. 1769
HARRY Joseph, *goldsmith*; No. 3 Rosoman street. 1793
HARRYSON John, *goldsmith*; London. 1562-1574
HARRYSON Robert, *goldsmith*; parish of St Vedast, Foster lane. (Buried) 1568
HART —, *spoon-maker*; Upper Holloway. 1747
HART — (see BACKWELL, DAREL, HART & CROFT).
HART Aaron, (?) *goldsmith & jeweller*; Crown & Pearl, Bennet street, near Great Queen street,
 by Storey's gate, Westminster. c. 1760
HART Barnard, *silversmith*; Poor Jewry lane. (Insolvent) 1769
HART Clement, *pawnbroker*; Three Blue Balls, corner of Hanover court, Grub street. 1758
HART Jacob, *jeweller*; No. 377 Strand. 1796
HART John, *goldsmith*; parish of St Mary Woolnoth. 1540-1544
HART Naphtali (see URQUHART & HART).
HART William, *goldsmith*; London. 1718
HART William, *goldsmith & banker*; Grasshopper, Fleet street. 1738-1747
HART & CO., *gold & silversmiths*; Coventry street, Haymarket. 1796
HARTE John, *goldsmith*; parish of St Mary Woolnoth. 1540
HARTLEBURY John, *jeweller*; Friday street. (Bankrupt) 1719
HARTLEY Elizabeth, *plate-worker*; May's buildings [St Martin's lane]. 1748
HARTOPP Robert, *goldsmith*; London. c. 1535
HARTOPP Thomas, *goldsmith*; London. 1542-1582
 Parish of St Vedast, Foster lane. 1582
HARTY Guy, *goldsmith*; Aldersgate. 1576
HARVEY Mrs, *pawnbroker*; Houndsditch. 1747
HARVEY Dorothy, Mrs (see also Thomas HARVEY), *pawnbroker*; Parrot, Shoe lane, near
 Fleet street. 1705
HARVEY John, *goldsmith*; London. 1540
HARVEY John, *plate-worker*; Queen's Head, Gutter lane. 1739-1750
HARVEY John, *goldsmith*; Great Kirby street, Holborn. (Insolvent) 1761
HARVEY John, *goldsmith*; London. 1773, 1774
HARVEY Thomas (see also Mrs Dorothy HARVEY), *pawnbroker*; Parrot, Shoe lane, near
 Fleet street. 1707
HARWOOD Henry, *pawnbroker*; Three Bowls, Eagle street, near Red Lion square, Holborn.
 1705-1711
HARWOOD John, *plate-worker*; Basing lane. 1734
 Bunhill row. 1739
HASKIN Benjamin, *ring-maker*; Wandsworth. 1790
HASLEWOOD Roger, *jeweller*; No. 58 Dorset street, Salisbury court, Fleet street. 1768-1770
 No. 53 Salisbury court, Fleet street. 1779-1784
HASTINGS —, *goldsmith*; Charing Cross. 1743-1755
HATCH Jane, *jeweller*; No. 84 St James's street. 1790-1793
HATCOMBE —, *goldsmith*; London. 1568
HATCOMBE Edmond, *goldsmith*; London. 1553
HATFIELD Charles (see also Susannah HATFIELD), *plate-worker*; Golden Ball, St Martin's
 lane. 1727-1739
HATFIELD Susannah, *plate-worker*; St Martin's lane. 1740

HATTER ELIZABETH, *pawnbroker*; Three Hats, Horsely Down, Southwark.	1710
HATTON —, *pawnbroker*; Three Green Balls, Berwick street.	1745
HATWOODE —, *goldsmith*; London.	1540–1553
HAUCHER L., *goldsmith*; Little Cranbourn alley.	1773
HAUGHTON S., *goldsmith*; London.	1724
HAVERS GEORGE, *plate-worker*; Lily Pot lane.	1697–1705
HAVERS THOMAS, *goldsmith*; parish of St Vedast, Foster lane.	1617–(Will proved) 1621
HAWERBEKE GARROD [or HAVERBEK GERARD], *goldsmith*; London.	1458–1465
HAWES JOHN, *goldsmith*; parish of St Vedast, Foster lane.	1639–1642
HAWFIELD RICHARD, *goldsmith*; parish of St Olave's, Hart street.	(Buried) 1629
HAWFIELD THOMAS, *goldsmith*; parish of St Peter's, Westcheap.	(Died before) 1596
HAWKES SAMUEL, *plate-worker*; Bishopsgate street.	1697–1702
HAWKINS BENJAMIN, *goldsmith*; Frying Pan alley, Wood street.	1773
HAWKINS JOHN, *jeweller*; No. 12 Cheapside.	1795, 1796
HAWKINS ROBERT, *goldsmith*; London.	1569
HAWKINS STEPHEN, *goldsmith*; Lombard street.	1543
HAWSON GEORGE, *goldsmith*; parish of St John Zachary.	1692, 1693
HAY THOMAS ATTE, *goldsmith*; London.	1397–(Died) 1405
HAYES CORNELIUS (cf. CORNELIUS HUGHES), *goldsmith*; London.	1553
HAYFIELD THOMAS, *goldsmith*; parish of St Peter's, Westcheap.	(Deceased) 1598
HAYFORD DANIEL, *goldsmith*; Bartlemy close.	1739
HAYFORD HUMPHREY, SIR,[1] *goldsmith*; parish of St Edmond, Lombard street	1451–(Buried) 1478
HAYNES GEORGE, *goldsmith*; London.	1572, 1573
HAYNES HENRY, *goldsmith*; London.	1749
Little Windmill street.	1773
HAYNES WILLIAM, *goldsmith*; Lombard street.	(Married) 1590
HAYNES & KENTISH (see also KENTISH & HAYNES), *goldsmiths*; No. 18 Cornhill.	1790–1796
HAYS THOMAS, *goldsmith*; London.	1553
HAYTER THOMAS (see GEORGE SMITH & THOMAS HAYTER).	
HAYTON AMOS, *pawnbroker*; Three Bowls, Cecil court, near St Martin's lane.	1710
Removed from above to Three Bowls, Heming's row, near St Martin's lane.	1715
HAYWOOD THOMAS, *jeweller & goldsmith*; Burleigh street, Strand.	1774–1777
HAZARD GEORGE, *goldsmith*; Long lane, Southwark.	1783
HEADINGTON THOMAS, *goldsmith*; London.	(Mentioned) 1619
HEALY JOSHUA, *plate-worker*; Foster lane.	1725
HEARD THOMAS, *goldsmith*; London.	1561–1570
HEARNDEN NICHOLAS, *spoon-maker*; Pickaxe street [= Aldersgate street].	1773–1779
HEARNE LEWIS, *goldsmith*; Clerkenwell.	(Absconded) 1765
HEATH GABRIEL (cf. GABRIEL SLEATH), *plate-worker*; Gutter lane.	1706–1739
HEATH GABRIEL & CRUMPE FRANCIS (cf. SLEATH & CRUMPE), *plate-workers*; Gutter lane.	1753
HEATHE GARRET, *goldsmith*; Foster lane.	1568
HEBERT (or HERBERT) HENRY, *silversmith*; Three Crowns, Panton street by Leicester fields.	1734–1739
Golden Heart, Dean street, Soho.	1747

[1] Mayor of London, 1477–8.

HEDE WILLIAM, *goldsmith*; London. 1456

HEDGES JOHN, *goldsmith*; Devereux court, Temple Bar. 1790–1793

HEDGES JOHN, *jeweller*; Red Lion street, Clerkenwell. 1790–1793

HEDGES STEPHEN, *goldsmith*; Salisbury court, Fleet street. 1773

HEESER (or HEESOR) MAURICE, *goldsmith*; Red Lion street, Clerkenwell. 1773

HEGER JOSEPH, *working jeweller*; Holles street, Clare market. c. 1790

HELLIER (or HILLER) JOSEPH (see CHADWICK & HELLIER).

HELY JOHN, *plate-worker*; St Martin's lane. 1699

HEMAN GRAVES, *goldsmith*; London. 1613

HEMING GEORGE (see GEORGE HEMMING), *goldsmith & jeweller*; Hand & Hammer, opposite
the Black Bear Inn, Piccadilly. c. 1760–1773
No. 151 New Bond street. 1784–1793

HEMING RICHARD, *goldsmith*; No. 151 New Bond street. 1790

HEMING THOMAS,[1] *goldsmith*; Piccadilly. 1745–1765
King's Arms in Bond street, facing Clifford street. 1765–1773

HEMING GEORGE & CHAWNER WILLIAM (see also WILLIAM CHAWNER), *plate-workers*;
King's Arms, New Bond street, facing Clifford street. 1773–1781

HEMMING GEORGE (see GEORGE HEMING), *goldsmith*; Piccadilly. 1773

HEMPSTEED —, *goldsmith*; Fleet Street. 1710

HENAULT FRANCIS, *jeweller*; No. 4 George street, Adelphi. 1790–1793

HENDERSON JOHN, *jeweller & goldsmith*; No. 21 Cornhill (succeeded Mrs Courtauld). 1780–1790

HENDRICKS AARON, *jeweller*; Vine street, Minories. 1763–1767
No. 2 Devonshire court, Devonshire square. 1768–1770

HENESSY & TAYLOR, *jewellers*; No. 13 Nicholas square, Aldersgate street. 1790

HENLY THOMAS, *pawnbroker*; Vizard Mask, Hewet's court, near St Martin's Church, Strand.
1704, 1705

HENNELL DANIEL, *goldsmith*; No. 16 Foster lane. 1791

HENNELL DAVID, *working goldsmith*; Flower-de-Lis & Star, in Gutter lane, corner of Carey
lane, near Cheapside. 1736–1758

HENNELL ROBERT (cf. HOBART HONNEL), *working goldsmith*; No. 16 Foster lane. 1769–1791

HENNELL DAVID & ROBERT, *plate-workers*; Foster lane. 1763–1797

HENNELL R. & S., *plate-workers*; Foster lane. 1802

HENRICK EDMUND, *goldsmith*; London. 1538

HENRIQUES CHRISTIAN, *silversmith*; Orange court, Leicester fields. 1762

HENRY —, *goldsmith*; Unicorn, Tothill street. 1745–1757

HENRY PIERRE, *goldsmith*; St Anne's, Westminster. 1711

HERBERT CORNELIUS, *watch-maker & goldsmith* (?); London bridge. 1699–(Died) 1755

HERBERT HENRY (see HENRY HEBERT).

HERBERT SAMUEL, *plate-worker*; Aldersgate street. 1747–1749

HERBERT SAMUEL & CO., *plate-workers*; Foster lane. 1750–1761

HEREFORD JOHN, *goldsmith*; parish of St Matthew, Friday street. 1641–(Will proved) 1642

HERFORD WILLIAM, *goldsmith*; Lombard street. (Deceased) 1760

HERICKE WILLIAM, SIR (see HERRICK).

HERIOT ALEXANDER, *jeweller* to King Charles I. c. 1646

HERIOT GEORGE,[2] *goldsmith & jeweller*; near the New Exchange, Strand.
1603. (Born) 1563–(Died) 1624

[1] Existing successors are Messrs Hemming & Co. Ltd, 28 Conduit street.
[2] Founder of Heriot's Hospital, Edinburgh.

Plate XXXVII

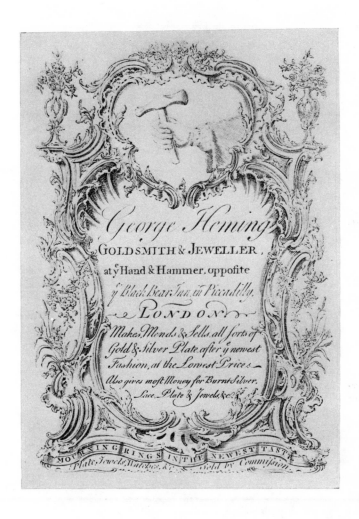

GEORGE HEMING *circa* 1760–1773

Plate XXXVII

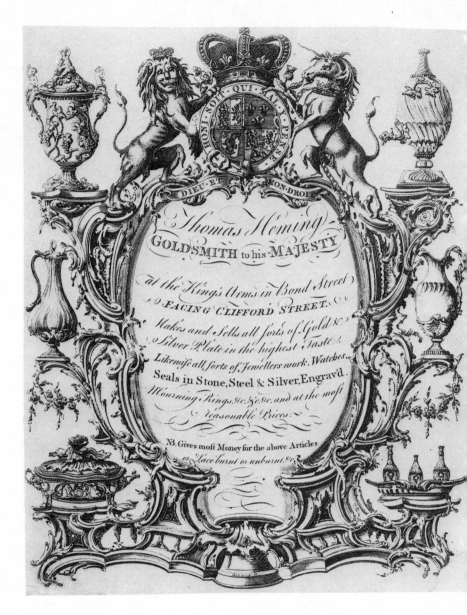

THOMAS HEMING

[Original size 9½ in. × 7⅝ in.]

1765–1773

HERIOT (or HERRIOT) Harboard, *goldsmith*; Naked Boy, Fleet street. 1711–1717

HERIOT (or HERRIOT) James, *goldsmith & banker*; Naked Boy, near Fleet bridge, Fleet street.
1664–1717

HERIOT Joseph, *plate-worker*; Great St Andrew's street, Seven Dials. 1750–1778

HERKINS Margery, *goldsmith*; Lombard street. 1540–c. 1550

HERLE Charles (cf. GERRARD & HERLE), *goldsmith*; London. (Bankrupt) 1709

HERNE Lewis, *goldsmith*; Clerkenwell. (Absconded) 1765
 Aldersgate street. (Bankrupt) 1768

HERNE Lewis & BUTTY Francis, *plate-workers*; Clerkenwell close. 1757–1762

HERRICK (or HEYRICK) Nicholas,[1] *goldsmith*; parish of St Vedast, Foster lane.
(Married) 1582–(Died) 1592

HERRICK Nicholas, *goldsmith*; Islington. 1641

HERRICK (or HERICKE) William, Sir,[2] *goldsmith & jeweller*; Wood street.
c. 1590–(Died) 1653

HERRING Anthony, *goldsmith*; ? parish of St Clement Danes. 1600–(Died before) 1621

HERRING Michael, *goldsmith*; London. 1646

HERRIOT (see HERIOT).

HERSEY William, *goldsmith*; London. 1366

HESSEY Thomas, *goldsmith*; London. 1366

HETHE Symken, *goldsmith*; London. Temp. Henry VI

HETHERINGTON Humphrey, *goldsmith*; London. 1722

HETON Francis, *goldsmith*; parish of St Vedast, Foster lane. 1561–(Buried) 1585

HETTIER Toussaint, *brooch-maker*; Shoe lane. 1564

HEURTELEN Isaac, *silversmith*; London. 1687

HEWETT Edmund, *pawnbroker*; Three Golden Balls, Aldersgate street. 1753

HEWETT Martin, *goldsmith*; parish of St Vedast, Foster lane. (Will proved) 1623

HEWETT Richard, *pawnbroker*; Three Bowls, Holborn. 1698

HEWLETT John, *goldsmith*; parish of St Vedast, Foster lane. 1685–(Buried) 1688

HEWLETT Mary, Mrs, *pawnbroker*; Three Bowls, Little Russell street, Bloomsbury. 1728

HEYDON —, *goldsmith*; London. 1579

HEYFORD Humphrey, *goldsmith*; London. 1722

HEYRICK Nicholas (see Nicholas HERRICK).

HIBBINS Peter, *goldsmith*; London. 1573

HICCOX —, *goldsmith*; Holborn. 1731

HICHENS —, *goldsmith*; London. 1707

HICKENS T. (or HICKIN Thomas), *goldsmith*; over against Gray's Inn Gate, Holborn. 1694
 Unicorn, Holborn. 1695–1701

HICKFORD —, *goldsmith*; Angel, Cheapside. 1653

HICKMAN Edmund, *plate-worker*; Foster lane. 1719

HICKMAN Joseph, *watch-maker & jeweller*; No. 54 Basinghall street. 1777
 No. 20 Bridgewater square. 1797

HICKMAN William, *silversmith & cutler*; No. 91 Borough, Southwark. 1790–1793

HIDE Samuel, *goldsmith*; parish of St Katherine Cree. (Deceased before) 1613

HIDE Samuel, *goldsmith*; parish of St Matthew, Friday street. 1641

HIGGENS Samuel, *goldsmith*; Golden Ball, near Turn Stile, Holborn. 1682–1699

HIGGINBOTHAM John, *plate-worker*; Rosemary lane. 1745

[1] Father of Robert Herrick, the poet. [2] Uncle of Robert Herrick, the poet.

(173)

P

HIGGS Edward & James, *silver button makers*; No. 21 Peerpool lane [Gray's Inn lane]. 1793

HIGNETT Margaret, *pawnbroker*; Crown, Holborn. 1725

HILDER William, *goldsmith*; Fenchurch street. 1751–1753

HILDYARD Mrs, *pawnbroker*; next door to Elephant & Castle, High Holborn. 1720

HILL —, *goldsmith*; Southampton court, Covent Garden. 1712–1729

HILL — (see SAMUEL & HILL).

HILL Ann, *plate-worker*; Albemarle street. 1734–1737

HILL Caleb, *plate-worker*; Clerkenwell. 1728–1735

HILL Charles, *silversmith*; London. 1781

No. 3 Charing Cross. 1790–1796

HILL Edmund, *goldsmith*; Foster lane. 1641–(Will proved) 1665

HILL George, *goldsmith*; Black Lion, corner of Salisbury street, near Savoy. 1679–1694

HILL James, *goldsmith*; Arms of France, Ball alley, Lombard street. 1788–1793

No. 49 Lombard street. 1796

HILL John, *goldsmith*; parish of St Vedast, Foster lane. (Deceased) 1430

HILL John, *goldsmith*; Lombard street. 1624–(Buried) 1646

HILL John, *goldsmith*; London. 1717

HILL Peter, *goldsmith*; corner of Salisbury street, Strand. 1703

HILL Robert, *goldsmith*; London. 1469

HILL Robert, *goldsmith*; Lombard street. 1686–(Buried) 1695

HILL Robert, *plate-worker*; St Swithin's lane. 1716–1742

HILL Sampson, *working jeweller*; No. 5 Ball alley, Lombard street. 1790–1796

HILL Thomas, *jeweller & watch-maker*; Fleet street. 1766 (?)

Aldersgate street. 1772

HILL (?) John & CARWOOD Thomas (see also HIND & CARWOOD), *goldsmiths*; London 1672

HILLAN Charles (?), *silversmith*; Crown & Golden Ball, Compton street, Soho. 1741

HILLAN Christian, *plate-worker*; Earl street. 1730

Crown & Golden Ball, Compton street, Soho. c. 1740

HILLBACK Matthew, *goldsmith*; Primrose street. 1775

Redcross square. 1788

HILLER Joseph (see CHADWICK & HELLIER).

HILLIARD Nicholas, *goldsmith*; Foster lane. 1568–1572

HILLYARD John, *goldsmith*; London. 1560

HILLYARD Nicholas, *goldsmith*; London. 1570–1619

HILTOFT John (see HYLTOFT).

HINCHAM —, *goldsmith*; London. (Died before) 1590

HIND Abraham, *goldsmith*; Golden Ball, Fenchurch street. 1675–1690

HIND (or HINDE) John (see HIND & CARWOOD), *goldsmith*; Golden Ball, Fenchurch

street. 1663–1690

HIND Paris, *working jeweller*; No. 26 Spa row [? Clerkenwell]. 1790–1790

HIND John & CARWOOD (or KIRWOOD) Thomas (see also HILL & CARWOOD),

goldsmiths & bankers; over against the Exchange, Cornhill. 1670–1675

HINDMARSH George, *plate-worker*; St Martin's-le-Grand. 173

HINDMARSH George, *plate-worker*; Blackfriars. 173

HINDMARSH George, *plate-worker*; Glasshouse street. 173

HINDMARSH George, *goldsmith*; Blackamoor's Head, Strand. 174

HINDMARSH George, *goldsmith*; Crown, Tooley street, Southwark. 1751

HINDMARSH George, *jeweller & goldsmith*; Crown, opposite Durham yard, Strand. c. 1750
 King's Arms & Birdcage, opposite Durham yard, Strand. c. 1750

HINTON Benjamin,[1] *goldsmith & banker*; Flower-de-Luce, Lombard street. 1663–(Deceased) 1702

HINTON Edmund,[2] *goldsmith*; parish of St George's, Southwark. 1665–(Buried) 1680

HINTON Thomas, *goldsmith* (?) *& banker*; London. 1717

HINTON William, *plate-worker*; Red cross street. 1704–1711

HISLOP Richard, *goldsmith*; Rosoman street. 1790
 Corporation lane. 1792

HITCH Henry, *goldsmith*; parish of St Giles', Cripplegate. (Married) 1659

HITCHCOCK Samuel, *plate-worker*; Gutter lane. 1712–1731

HITCHES William, *goldsmith*; London. 1451

HITCHIN John, *silversmith*; Addle Street. 1761

HOARE Benjamin, *goldsmith & banker*; Golden Bottle, Fleet street. 1724–1728

HOARE Charles, *goldsmith*; Golden Bottle, Fleet street. 1697

HOARE Henry (succeeded his father Sir Richard Hoare), *goldsmith & banker*; Golden Bottle,
 Fleet street. 1718–(Died) 1724

HOARE Henry, *goldsmith*; London. 1772

HOARE (or HORE) James, *goldsmith & banker*; Golden Bottle, Cheapside. 1664–1690
 Golden Bottle, Fleet street. c. 1690

HOARE James & Richard, *goldsmiths & bankers*; Golden Bottle, Cheapside. c. 1674–1690
 Golden Bottle, Fleet street. c. 1690

HOARE John, *goldsmith*; parish of St John Zachary. (Married) 1581–1600

HOARE Richard, Sir,[3] *goldsmith & banker*; in, or near, Lombard street. c. 1672
 Golden Bottle, Goldsmiths' row, Cheapside. (Before) 1674–1690
 Golden Bottle, Fleet street. c. 1690–(Died) 1719

HOARE Richard, Sir,[4] *goldsmith*; Fleet street. 1734–(Died) 1754

HOBART John, *goldsmith* (?); Blue Flower Pot, Clare court, Drury lane. 1702

HOBDELL Henry, *goldsmith*; Aldermanbury. 1767
 Silver street. 1773

HOBDELL John, *goldsmith & jeweller*; No. 28 Addle street. 1790–1793

HOBDELL Richard, *goldsmith*; No. 22 Silver street, Wood street. 1790
 Addle street. 1798

HOBSON John, *goldsmith*; London. 1679–1713

HOBSON Richard, *goldsmith*; Lombard street. 1664–1677

HODGE Thomas, *silversmith*; Redcross street. 1768

HODGE William, *silversmith*; Snow hill. 1779
 Old street. 1786

HODGES — (see Joseph HODGES); *jeweller, goldsmith & engraver*; Golden Eagle, Maiden lane,
 Covent Garden. [N.D.]

HODGES Mrs (see also George HODGES), *pawnbroker*; Golden Ball, Charles street, near St
 James's square. 1704

HODGES George (see also Mrs HODGES), *plate-worker*; Charles street, St James's. 1728

HODGES John, *goldsmith*; parish of St Mary Bothaw. 1609

HODGES Joseph (see HODGES —), *goldsmith*; Maiden lane. (Bankrupt) 1771

[1] Possibly the Mr Hinton referred to in Pepys' *Diary*, 18 Dec. 1665. Cf. Edmund Hinton, see p. 15 *supra*.
[2] ? Referred to in Pepys' *Diary*, 18 Dec. 1665. Wheatley's note, vol. v, p. 165, see p. 15 *supra*.
[3] Lord Mayor of London, 1712–13. [4] Lord Mayor of London, 1745–6.

LONDON GOLDSMITHS

HODGES Thomas, *goldsmith*; Lombard street. 1641–1647

HODGKINS Benjamin (see SWEETAPLE, HODGKINS & HARRIS).

HODGKINS William (see MINCE & HODGKINS), *goldsmith*; Bell square [St Martin's-le-Grand]. 1783

HODGKIS —, *plate-worker*; Dove court, St Martin's. 1719

HODGSON George, *goldsmith*; parish of St Agnes and St Anne's [Aldersgate]. (Will proved) 1640

HODSELL Edward (see EDWARD HODSOLL).

HODSOLL Edward (see also HODSOLL & MICHELL), *banker*; near Catherine street, Strand. 1763–1776

HODSOLL William, *goldsmith & banker*; Sun & Marygold, near Somerset House, opposite Catherine street. 1712

 Sun, without Temple Bar. 1714

 Sun, corner of Dutchy lane, Strand. 1717

 Sun, opposite Catherine street, Strand. 1744–1755

 Strand.[1] 1763

HODSOLL & MICHELL, *bankers*; Strand, near Catherine street. 1776–1795

HODSOLL & STIRLING (Sir Walter),[2] *bankers*; No. 345 Strand. 1795

HODSON Edward, *goldsmith*; parish of St Anne's, Aldersgate. (Will proved) 1651

HODSON John, *plate-worker*; Wapping. 1695–1697

HOFMAN Arnold, *goldsmith*; London. Temp. Henry VI

HOGG Andrew, *goldsmith*; Northumberland court, Strand. 1773

HOGGES Thomas, *goldsmith*; London. 1642

HOHLFIELD Godfrey, *jeweller*; Pearl, Bridge street, Covent Garden. 1728

HOLADAY Edward, *plate-worker*; Golden Cup, Grafton street, near Newport market. 1709, 1710

 Golden Cup, end of Gerrard street, near Newport market. 1712–(Died) 1719

HOLADAY Sarah, *plate-worker*; Grafton street. 1719–1740

HOLBORNE William, *goldsmith*; London. 1569–1594 (?)

HOLBROOK J., *jeweller*; Ring & Pearl, Buckingham street, York buildings. 1762

HOLBROOK Joseph, *jeweller*; Fleet street. 1751

HOLDER Richard, *goldsmith*; York buildings [Strand]. 1732

HOLDS Charles, *silver dial plate maker*; No. 51 Bartholomew close. 1793

HOLE Edward, *goldsmith*; parish of St Mary Woolnoth. 162

HOLLAND John, *plate-worker*; Queen's Head, Foster lane. 1711, 1712

 Bishopsgate street. 1711–1739

HOLLAND John, *jeweller, goldsmith & clockmaker*; No. 5 Bishopsgate Without. 1765–1779

HOLLAND Joshua, *plate-worker*; Foster lane. 1711–1729

HOLLAND Thomas, *plate-worker*; Fleet street. 1707–1718

HOLLAND Thomas, *plate-worker*; Temple Bar. 1798

HOLLIER John, *jeweller*; Arundel street, Strand. c. 1760

 Rolls buildings, Fetter lane. c. 1765

HOLLOWAY —, *pawnbroker*; Three Crowns, near the Watch House, High Holborn. 1721

HOLLOWAY Charles, *goldsmith*; King's Head, Strand, by Temple Bar. 1692–1699

HOLLOWAY John, *working goldsmith*; No. 28 Wych street. 1775–1793

HOLLOWAY Makepeace, *goldsmith*; Cup, Leadenhall street. 1694

HOLMER William, *plate-worker*; Foster lane. 1750–1753

[1] All these five addresses refer to the same house.

[2] Subsequently the business was taken over by Snow's Bank, afterwards styled Strahan's, and finally merged in the Westminster Bank.

(176)

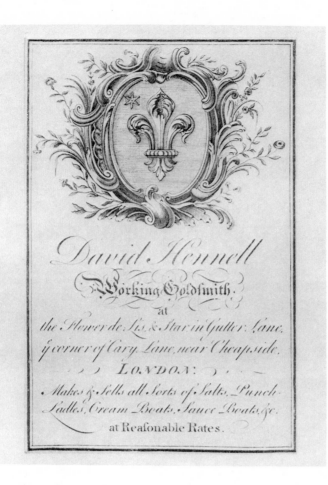

DAVID HENNELL 1736–1758

Plate XL

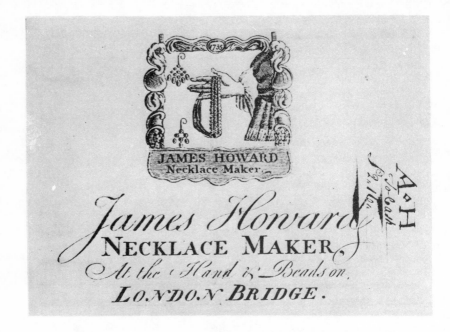

JAMES HOWARD 1735

HOLMES Edward, *goldsmith*; Foster lane. 1773
HOLMES Edward & SON, *jewellers*; No. 9 Foster lane. 1777–1793
HOLMES John, *goldsmith*; London. 1670
HOLMES William (cf. WHYTE & HOLMES), *working silversmith*; No. 12 Clerkenwell green.
 1768–1796
HOLMES William & DUMÉE Nicholas, *plate-workers*; No. 12 Clerkenwell green. 1773–1779
HOLT Alexander, *goldsmith*; parish of St Mary Woolnoth. 1640–(Died) 1657
HOLTON Wade, *goldsmith*; London. 1772
HOLY Daniel, WILKINSON & CO. (see WILKINSON, HOLY & CO.), *silver plate manu-
 factory*; No. 6 Crane court, Fleet street. 1793
 No. 8 New Bridge street, Blackfriars. 1796
HOMFRE Robert, *goldsmith*; St Martin's-le-Grand. 1562–1564
HONILANE (or DE HONILANE) Ralph, *goldsmith*; London. 1298–1307 (Will enrolled 1315)
HONNEL Hobart (cf. Robert HENNELL), *goldsmith*; Foster lane. 1772
HOOD Samuel, *plate-worker*; Maiden lane. 1694–1702
 Shoreditch. 1724–1727
HOOKE Robert, *goldsmith*; parish of St Matthew, Friday street. (Married) 1605–1641
HOOKER (? or HOOPER) Nicholas, *goldsmith*; parish of St Matthew, Friday street. 1613–1630
HOOKER Richard, *goldsmith*; parish of St Matthew, Friday street. (Married) 1599
HOOKER William, *goldsmith*; parish of St Peter's, West Cheap. (Married) 1589
HOOKHAM John, *jeweller*; Aldersgate street. 1774
HOOPER Henry, *jeweller & toy-man*; No. 39 Cheapside. 1790–1796
HOOPER J., *goldsmith*; No. 33 Cheapside. 1796
HOOPER Nicholas (cf. Nicholas HOOKER), *goldsmith*; London. 16—
HOPE Edward, *silversmith & jeweller*; No. 97 Oxford street. 1784
HOPKINS John, *plate-worker*; Rose & Crown, St Bride's lane. 1720–1726
HOPKINS John, *goldsmith*; Goldsmiths' Arms & Ring, Bride lane. 1730
 "Removed to the same sign in Fleet street" (corner of Bride lane). 1732–1736
 (See John HOPKINS at the Golden Cup & Cover, Fleet street.)
HOPKINS John, *goldsmith*; Golden Cup & Cover, near Fleet bridge in Fleet street. 1736–1763
 (Cf. John HOPKINS at Goldsmiths' Arms & Ring, Bride lane.)
HOPKINS William, *plate-worker*; Hatton Garden. 1739
HOPKINS William, *ring-maker*; No. 17 Maiden lane, Wood street. 1781–1796
HORBBIN John, *pawnbroker*; Golden Ball, Oxford road. 1747
HORE James (see James HOARE).
HORNBY, HORNEBY or HORNBOY —, *goldsmith & banker*; Star, Lombard street. 1677–1688
HORNBY (HORNEBY or HORNBOY) Joseph, *goldsmith & banker*; Star, Lombard street.
 1666–1677
 Unicorn, Lombard street. 1666
HORNBY (HORNEBY or HORNBOY) Joseph & Nathaniel, *goldsmiths & bankers*; Star,
 Lombard street. 1670–1700
HORNBY (HORNEBY or HORNBOY) Nathaniel, *goldsmith & banker*; Star, Lombard
 street. 1677–1696
HORNE (or HORN) George, *goldsmith*; Angel & Crown, opposite New Exchange, Strand.
 1716–1728
HORNE Lewis, *goldsmith*; Aldersgate street. (Bankrupt) 1768
HORNE William, *goldsmith*; London. c. 1500

HORNE George & KILMAINE David (see also David KILMAINE), *goldsmiths*; Angel & Crown, over against New Exchange, near Durham yard [Strand]. 1716

HORNE (or HORN) & TEMPLE (see George HORN and also TEMPLE), *goldsmiths*;
 opposite New Exchange, Strand. 1730
 Angel & Crown, near Durham yard, Strand. 1740

HORSLEY John, *candle-stick maker*; Hoxton. 1773

HORTON Joseph, *goldsmith*; Lombard street. (Before) 1700
 Corner of Coventry street, Haymarket. 1693–1700

HORTON Regin(ald), *goldsmith*; London. 1538–1540

HORTON Rogier, *goldsmith*; London. 1553

HORTON Thomas, *goldsmith*; East Smithfield. 1599

HORTOPP Robert, *goldsmith*; Chapter house (St Paul's). 1553

HORWOOD Nathaniel, *plate-worker*; Dean street, Soho. 1773

HOSIER James, *jeweller*; Greek street, Soho. 1790–1793

HOSKINS Thomas, *goldsmith*; Bunch of Grapes, Cheapside. 1687–1703

HOTOFT —, *goldsmith*; parish of St Botolph, Aldersgate. (Deceased—widow re-married) 1603

HOUGH William, *goldsmith*; Lombard street. 1641–1655 (?)

HOUGHAM Charles, *working goldsmith*; No. 138 Aldersgate street. 1769–1784

HOUGHAM Charles & Solomon, *goldsmiths*; No. 138 Aldersgate street. 1790–1796

HOUGHAM, Henry, *goldsmith*; Islington. 1800

HOUGHAM Solomon, *goldsmith*; No. 138 Aldersgate street. 1786–1795

HOUSE (or HOWSE) John, *goldsmith*; Abchurch lane. 1716–1727

HOUSTON —, *goldsmith*; Fleet street. (Died) 1733

HOUSTON Charles, *goldsmith*; Three Bells, Fleet Street, near Fleet bridge. 1731

HOUSTON George, *goldsmith*; Golden Cup, corner of Mitre Tavern passage, Fleet street; or, near St Dunstan's Church, Fleet street. 1742–1773

HOW — (see IRONSIDE, BELCHIER & HOW).

HOW George, *silversmith*; White Hart court, Gracechurch street. 1730

HOW John, *pawnbroker*; Black Spread Eagle, Phoenix street, near Bloomsbury. 1704

HOW Thomas, *goldsmith*; Half Moon, over against Foster lane, Cheapside. 1698, 1699

HOW William (cf. William HOWSE), *goldsmith & jeweller*; No. 13 Fleet street. 1770–1774

HOW William & CLARK William, *plate-workers*; Spital square. 1777

HOW & MASTERMAN (see also MASTERMAN & HOW), *goldsmiths*; No. 1 White Hart court, Gracechurch street. 1753–1763

HOW, MASTERMAN & ARCHER (see MASTERMAN & ARCHER), *goldsmiths*; No. 1 White Hart court, Gracechurch street. 1765

HOWARD —, *goldsmith*; Great Newport street. 1733

HOWARD James (see also John HOWARD), *necklace-maker*; Hand & Beads, on London bridge. 1735–1760

HOWARD John, *pawnbroker*; King's Arms, Hatton wall, near Hatton Garden.
 (Gave up trade) 1707

HOWARD John (see also James HOWARD), *necklace-maker & jeweller*; Hand & Beads, on London bridge. 1760
 Hand & Beads, next Monument yard, [No. 40] Fish Street hill. 1763–1781

HOWARD William, *goldsmith*; Gutter lane. 1721

HOWARD William, *plate-worker*; Clerkenwell. 1760

HOWE Richard, *goldsmith*; London. 1569

HOWE Robert, *goldsmith*; London (?). 1620

HOWEL MRS, *silversmith*; St Bride's court, Fleet street. 1752

HOWELL BENJAMIN, *goldsmith*; Peacock (Peacock's Feathers, or, Peacock & Feathers), Cornhill, near Royal Exchange. 1704-(Died) 1715

HOWES JOHN (see JOHN HOUSE).

HOWES (or HOWSE) WILLIAM (cf. WILLIAM HOW), *goldsmith & clock-maker*; between the two Temple Gates, Fleet street, or, Temple Bar. 1730–1774

HOWLAND SAMUEL, *plate-worker*; Long lane [Aldersgate street]. 1760–1772

HOWLETT JOHN, *small-worker*; Little Compton street, Soho. 1790–1793

HUBBARD JOSEPH, *jeweller*; St John's square. 1790–1793

HUBERT the goldsmith; London. 1269

HUDELL RENÉ, *plate-worker*; Green street. 1718

HUDSON ALEXANDER, *plate-worker*; Bull and Mouth street. 1701–1705

HUDSON EDWARD, *goldsmith*; parish of St Peter Westcheap. 1591

HUDSON JAMES, *goldsmith*; Ratcliffe highway. 1773

HUDSON JOHN, *goldsmith*; Royal Exchange & Grasshopper, Lombard street. 1702–(Buried) 1705

HUDSON JOHN (see also PARSONS & HUDSON), *goldsmith*; St Martin's Churchyard. 1784

HUDSON JOHN, *goldsmith*; No. 35 St John's square. 1786–1793

HUDSON JOHN & ROGER, *goldsmiths*; Lombard street. 1695

HUDSON ROGER, SIR, *goldsmith*; Royal Exchange & Grasshopper, Lombard street. 1682–1705
Bishopsgate street. 1727–1734

HUDSON ROGER, *goldsmith*; New court, Swithin's lane, near the Post Office. 1713

HUDSON WILLIAM, *goldsmith*; parish of St Gregory by St Paul's. 1678

HUGES — (? HUGHES), *jeweller*; Ring & Pearl, over against the Five Bells tavern in the Strand. 1722

HUGHES —, *silver button maker*; Blue Anchor, near the Talbot Inn, in the Strand. c. 1760

HUGHES (or HAYES) CORNELIUS, *goldsmith*; London. 1530–1553

HUGHES GARRARD, *goldsmith*; London. c. 1520

HUGHES RICHARD, *plate-worker*; London. 1773

HULBART JOHN, *goldsmith*; Cup, Sydney street, by Leicester fields. 1714

HULIN WILLIAM, *goldsmith*; London. 1666

HULSON JOHN, *goldsmith*; London. 1555

HUMBLE WILLIAM, *goldsmith*; parish of St Mary Woolnoth. c. 1520–1553

HUMFREY WILLIAM, *goldsmith*; parish of St Katherine's Cree. c. 1605

HUMPHREY JOHN, *plate-worker*; St Martin's-le-Grand. 1710

HUMPHREYS —, *jeweller*; Angel court, Throgmorton street. 1714

HUMPHREYS —, *pawnbroker*; Three Bowls, West street, near Seven Dials. 1758

HUMPHREYS ARTHUR (see BOULTON & HUMPHREYS).

HUMPHREYS ARTHUR (see PRATT & HUMPHREYS).

HUMPHREYS JOHN, *goldsmith*; St Dunstan's-in-the-West. 1717, 1718

HUMPHREYS WIDOW, *pawnbroker*; Red Lamp, King street, St James's. 1745

HUMY ROBERT, *goldsmith*; parish of St Botolph, Bishopsgate. (Married) 1618

HUNT JAMES, *gold-worker*; King street, Cheapside. 1760–1773
No. 9 King street, Cheapside. 1768–1777

HUNT JAMES, *goldsmith*; Ironmonger lane. (Deceased) 1782

HUNT SAMUEL, *goldsmith*; Montague court, Aldersgate ward. 1692, 1693

HUNT William, *goldsmith*; King street, Cheapside. 1753

HUNT William & SON, *gold-workers*; Golden Lion, King street, Cheapside. 1755–1763

HUNTER Andrew, *gold-worker*; Great Russell street. 1760–(Died) 1764

HUNTER Catherine, *toy-man & jeweller*; White Bear, King street, Cheapside, near Guild Hall. [N.D.]

HUNTER George, *plate-worker*; Noble street. 1748
 Little Britain. 1755–(Insolvent) 1761
 Shoe lane. 1765–1772

HUNTER William, *plate-worker*; King street, Soho. 1739

HUNTER William (succeeded by his nephew William Hunter), *goldsmith & jeweller*; Anchor
 & Ring, (No. 51) Lombard street. 1732–(Died) 1762
 Three Golden Lions, Anchor & Ring, Lombard street. 1752

HUNTER William (nephew of William HUNTER, *supra*); *jeweller & goldsmith*; Anchor
 & Ring, (No. 51) Lombard street. 1762–1796

HUNTINGDON William, *goldsmith*; parish of St Vedast, Foster lane. (Buried) 1595

HUNTINGFORD Richard, *goldsmith*; parish of St Vedast, Foster lane. (Buried) 1697

HUNTLEY John, *goldsmith*; near the Bank. (Insolvent) 1773

HUNTLEY William, *silversmith*; Old street. 1769

HURDMAN Richard, *goldsmith*; London. c. 1535

HURT Henry (succeeded by THEAD & PICKETT before 1759), *goldsmith & toy-man*;
 (removed from St Paul's churchyard to) Golden Salmon, (No. 32) north side
 of Ludgate hill (succeeded Thomas Chesson). 1745–1755

HUTCHINS John, *goldsmith*; Lamb, Cheapside. 1721–1725

HUTCHINS Robert, *goldsmith*; parish of St Mary Woolnoth. (Deceased before) 1597

HUTCHINSON Robert, *goldsmith*; London. 1579

HUTSON John, *plate-worker*; St John's square, Clerkenwell. 1784–1800

HUTTEN Henry, *goldsmith*; parish of St Peter, Paul's Wharf. 1614–1616

HUTTON Patrick, *goldsmith & clock-maker*; Cannon street. 1774

HUTTON Richard, *goldsmith*; Flying Horse, King street, Westminster. 1677

HUTTON Samuel, *plate-worker*; Crown, Noble street. 1724
 Hat & Feather, Goswell street. 1734–1740

HUTTON Sarah, *plate-worker*; [Hat & Feather], Goswell street. 1740

HUXSER George, *goldsmith*; London. c. 1520

HYAT Roger, *goldsmith*; London. 1560–1570

HYATT John, *plate-worker*; Little Britain. 1741

HYATT John, *goldsmith*; Little Britain. (Entered) 1748–1765

HYATT John & SEMORE Charles, *goldsmiths*; Little Britain. 1750–1765

HYDE Edward, *goldsmith*; parish of St Mary Woolnoth. 1597

HYDE James & Thomas, *goldsmiths*; (No. ? 33 or 38) Gutter lane, Cheapside. 1784–1796

HYDE John, ? *jeweller*; Cornhill. 1755–1760

HYDE & LEEDS, *jewellers & hardwaremen*; Anchor & Case of Knives, near Royal Exchange,
 Cornhill. 1763–1768

HYLTOFT John, *goldsmith*; Chepe. 1360–1369

IBBOTT George, *plate-worker*; Plough court. 1753–1763

ILGER —, *goldsmith*; London. 1221–1223

IMMINES Thomas, *pawnbroker*; Crown, Fetter lane. 1727–1731

Plate XLI

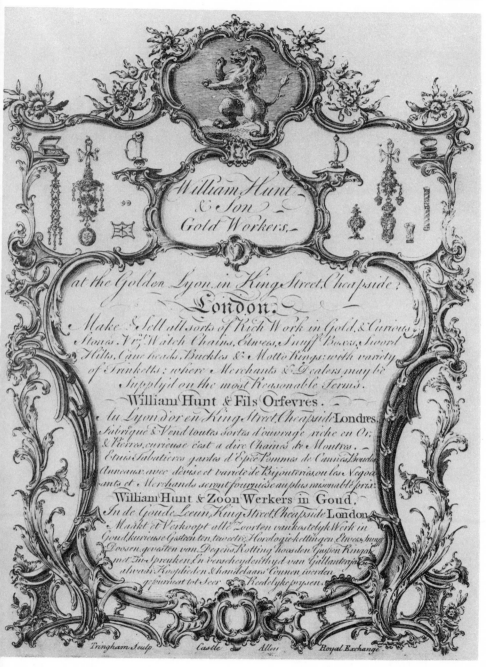

Plate XLII

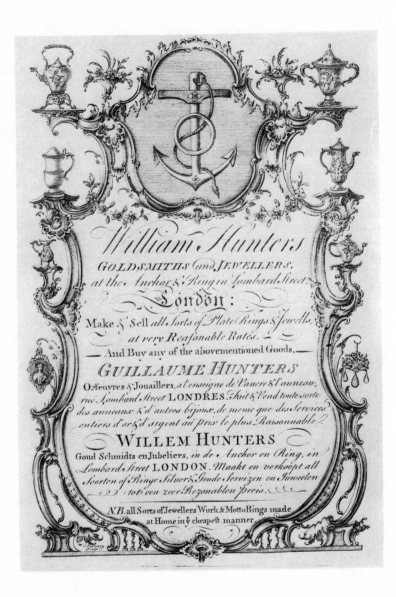

William Hunters

GOLDSMITHS (and) JEWELLERS,
at the Anchor & Ring in Lombard Street,

London:

Make & Sell all Sorts of Plate Rings & Jewells,
at very Reasonable Rates.
— And Buy any of the abovementioned Goods. —

GUILLAUME HUNTERS

Orfeuvres & Jouaillers, a l'enseigne de l'ancre & l'anneau,
rue Lombard Street LONDRES. Fait & Vend toute sorte
des anneaux & d'autres bijoux, de même que des Services
entiers d'or & d'argent au prix le plus Raisonnable.

WILLEM HUNTERS

Goud Schmidts en Jubeliers, in de Anchor en Ring, in
Lombard Street LONDON. Maakt en verkoopt all
Soorten of Ringe Silver & Goude Servizen en Juweelen
tots een zeer Rezonablen preis.

N.B. all Sorts of Jewellers Work & Motto Rings made
at Home in y cheapest manner.

WILLIAM HUNTER (or HUNTERS) 1732–1762

IMPEY DIKE, *plate-worker*; Staining lane. 1727
 Gutter lane. (Insolvent) 1729
 Noble street. 1736
INALL JOHN, *jeweller*; Hatfield street, Goswell street. 1748
INGRAM WILLIAM, *goldsmith*; parish of All Hallows, Lombard street. (Buried) 1656
INMAN EUODIAS,[1] *goldsmith*; parish of St Leonard, Foster lane. 1641
 In Smithfield Rounds [= ? Smithfield Penns]. c. 1670
INNES JOHN (see JOHN INNS).
INNES ROBERT, *plate-worker*; May's buildings [St Martin's lane]. 1742–1758
INNOCENT JOHN, *goldsmith & spoon-maker*; No. 17 Little Newport street. 1764 (?)–1793
INNS (or INNES) JOHN, *goldsmith*; parish of St Mary Woolnoth. (Married) 1664–1679
INWOOD JOHN, *goldsmith*; London. (Will proved) 1655
IRELAND JOHN, "*gold drawer*"; St Martin's-le-Grand. (Married) 1596
IRELAND WILLIAM, *goldsmith*; parish of St Mary Woolnoth. 1616–1618
IRONSIDE EDMUND, *goldsmith*; London. (Died) 1754
IRONSIDE EDWARD, *plate-worker*; Lombard street. 1697–1736
IRONSIDE EDWARD,[2] *goldsmith*; London. 1745–(Died) 1753
IRONSIDE & BELCHIER, *goldsmiths, bankers & clock-makers*; Black Lion, Lombard street. 1729–1744
IRONSIDE, BELCHIER & HOW, *goldsmiths*; Lombard street. 1753–1755
IRTON —, *pawnbroker*; Three Bowls, corner of Crown court, facing Compton street, Soho. 1742
IRVINE JOHN, *spoon-maker*; Minories. 1773
ISAAC JACOB, *goldsmith*; London. 1641
ISAACS LEVI, *jeweller*; No. 56 Mansel street, Goodman's fields. 1772–1784
ISLES BERNARD, *goldsmith*; Lombard street. 1686
ISRAEL JOHN, *goldsmith & jeweller*; No. 110 Whitechapel. 1784
 No. 27 Bury street. 1790–1793
ISRAEL LEVI, *goldsmith*; No. 10 Charing Cross. 1796
ISSOD JOYCE, *plate-worker*; Fleet street. 1697
ISSOD THOMAS, *plate-worker*; White Horse, Fleet bridge. 1690–1697
 Fleet street. 1697

JACKSON — (see KNIGHT & JACKSON).
JACKSON —, *gold chain maker*; Grub street. 1732
JACKSON MRS, *goldsmith*; Angel, Fleet street. 1719
JACKSON ABRAHAM, *goldsmith*; parish of St Vedast, Foster lane. (Buried) 1700
JACKSON ALEXANDER, *goldsmith*; London. 1643–1649
JACKSON ALEXANDER, *goldsmith*; London. (Died) 1703
JACKSON CHARLES, *plate-worker*; Cannon street. 1714–1727
 Tower street. 1734
 Golden Cup, St Swithin's lane. 1739
JACKSON ELIZABETH (later ELIZABETH OLDFIELD), *plate-worker*; Paternoster row. 1748
JACKSON FRANCIS, *goldsmith*; parish of St Vedast, Foster lane. 1562–(Buried) 1574
JACKSON JOHN, *plate-worker*; Angel, or, Angel & Crown, Fleet street. 1684–1714
JACKSON JOHN, *jeweller*; Crown & Pearl, George street by Goldsmiths' Hall, Foster lane. 1734

 [1] Issued a token (Williamson's [London] No. 2862). See page 44.
 [2] Lord Mayor of London, 1753.

JACKSON JOHN, *goldsmith*; New street, Fetter lane. 1762
JACKSON JOHN, *spoon-maker*; Little Britain. 1773
JACKSON ORLANDO (see YOUNG & JACKSON), *plate-worker*; Wild street [? Drury lane]. 1759
 Haymarket. 1773
 Aldersgate street. 1774
JACKSON RANDAL (see also JACKSON & WHITE), *jeweller*; No. 46 Paternoster row. 1779–1781
JACKSON RICHARD, *watch case maker*; Bridgewater square. 1772
JACKSON ROGER, *goldsmith*; Golden Falcon, Essex buildings, Strand. 1691
 Golden Lion, Fleet street. 1692
JACKSON THOMAS, *plate-worker*; Noble street. 1736
 Paternoster row. 1739
 Mutton lane [? Clerkenwell]. 1769
JACKSON WILLIAM, *goldsmith*; London. 1632–(Died) 1644
JACKSON & CO., *goldsmiths*; No. 110 Wood street, Cheapside. 1796
JACKSON NATHANIEL & COLEBROOK — (see also COLEBROOK), *goldsmiths & bankers* (?);
 London. 1706–1708
JACKSON NATHANIEL & COMPANY, *goldsmiths & bankers*; Threadneedle street, behind
 Royal Exchange. 1708
JACKSON & WHITE (see also RANDAL JACKSON), *jewellers*; No. 46 Paternoster row. 1790–1793
JACOB DENNIS, *goldsmith*; opposite Sun Tavern, Charing Cross. 1762
 Charing Cross. 1773
 Cockspur street, Charing Cross. 1784–1796
JACOB ISAAC, *goldsmith*; parish of St Mary, Whitechapel. (Married) 1641
JACOB (or JACOBS) JOHN,¹ *plate-worker*; Heming's row, St Martin's lane. 1731–1757
JACOB JOHN, *goldsmith*; Acorn, Panton street, near Leicester fields. 1768
 Spur street, Leicester fields. 1773
JACOBS — (see MAYERS & JACOBS).
JACOBSON JOEL, *silversmith*; No. 37 Charles street, Covent Garden. 1790–1796
JAMES —, *goldsmith*; Giltspur street, near Newgate. 1738
JAMES JOHN, *jeweller*; New Rents, St Martin's-le-Grand. 1790–1793
JAMES THOMAS, *goldsmith & jeweller*; No. 53 Tooley street. 1790–1793
 No. 6 St Ann's lane, Aldersgate street. 1796
JAMESON THOMAS, *goldsmith*; London. 1679
JANAWAY — (see WETHERELL & JANAWAY).
JANAWAY JOHN, *goldsmith*; St Paul's Churchyard. 1777
JANVIER —, *silversmith*; Angel & Crown, Cecil court, St Martin's lane. 1710
JAPARD NOÉ, *goldsmith*; St Vedast's, Farringdon Within. 1568
JARMAN SAMUEL, *spoon-maker*; Foster lane. 1767
 Great Newport street. 1773
JARVIS THOMAS, *watch-maker & goldsmith*; Dial, Wapping Old Stairs. c. 1750
JASON —, *pawnbroker*; Three Golden Balls, Bird street, Grosvenor square. 1758
JAY EDWARD, *plate-worker*; Strand. 1757
 Salisbury court [Fleet street]. 1773–1793
JAY HENRY, *plate-worker*; Ball alley, Lombard street. 1716–1727
 Newington. 1734
JAY HENRY, *goldsmith*; London. 1770
JAYNES SALOMON, *goldsmith*; Castle street, St Martin's-in-the-fields. 1669

¹ John Jacob married Anne Courtauld, d. of Augustine Courtauld in 1738.

JEANES Thomas, *goldsmith*; Lombard street. 1750–(Deceased) 1752

JEBB John, *goldsmith*; St Peter's hill [Doctors' Commons]. 1781

JEFFERIES William, *goldsmith*; parish of St John Zachary. (Deceased—widow re-married) 1610

JEFFERSON John, *goldsmith*; No. 28 Fetter lane. 1795–1799

JEFFERYS George, *goldsmith & jeweller*; No. 76 Strand. 1790–1796

JEFFERYS, Henry & CO., *goldsmiths, jewellers & cutlers*; No. 96 Fleet street. 1790–1793
 Great Knife Case, No. 91 Fleet street. 1796

JEFFERYS Nathaniel (succeeded by DRURY Drury & SON), *goldsmith*; [No. 32] Strand
 [corner of Villiers street]. 1768–1773

JEFFERYS Nathaniel, Junr., *goldsmith & jeweller*; No. 70 Piccadilly, corner of Dover street.
 1784–1793
 No. 71 Piccadilly. 1796
 No. 34 Pall Mall. 1802

JEFFERYS Samuel, *plate-worker*; Wapping Old Stairs. 1697–1731

JEFFERYS Thomas, *pawnbroker*; Blackmoor's Head, Saffron hill. 1716

JEFFERYS Thomas (see also JEFFREYS & JONES), *goldsmith & jeweller*; Cockspur street,
 Charing Cross. 1765–1777

JEFFERYS & JONES (see Thomas JEFFERYS), *goldsmiths & jewellers*; Cockspur street, near
 Charing Cross. 1779–1793

JEFFERYS, JONES & GILBERT, *goldsmiths & jewellers*; Cockspur street, Charing Cross. 1796

JEFFREYS George, *jeweller*; St Paul's churchyard. 1765

JENEWEYS George, *goldsmith*; London. c. 1500

JENKES Robert (see KIRWOOD & JENKES), *goldsmith*; Goldsmiths' Hall. 1724–1734

JENKINS Elias, *jeweller*; St Martin's-in-the-fields. 1744

JENKINS James, *plate-worker*; Gutter lane. 1731
 Aldersgate. 1738

JENKINS John, *goldsmith*; Unicorn, Cheapside. 1695, 1696
 Essex street, Strand. 1697

JENKINS John, *goldsmith*; Lombard street. 1709–1724

JENKINS John & James, *goldsmiths*; Lombard street. (Bankrupt) 1730

JENKINS Thomas, *goldsmith*; Cornish Daw, Essex street. 1688–1708

JENKINS John & KING William, *goldsmiths*; King's Head, Lombard street. 1699–1715

JENKYNSON Thomas, *goldsmith*; Lombard street. 1577

JENNER Robert, *goldsmith*; London. 1640–(Died) 1648

JENNINGS —, *goldsmith*; Roe Buck, against Salisbury house [Strand]. 1688

JENNINGS —, *goldsmith*; Silver Cup, Maiden Lane. 1718

JENNINGS D., *goldsmith & jeweller*; No. 132 Fenchurch street. 1796

JENNINGS Edward, *plate-worker*; Tower street, Seven Dials. 1709–1712 (?)
 Little Britain. 1720–1727

JENNINGS Henry, *goldsmith*; Golden Key, over against Exeter Change, Strand. 1686–1688

JENNINGS John, *goldsmith*; parish of St Andrew's Undershaft. (Married) 1624

JENNINGS Thomas, *pawnbroker*; Crown, Fetter lane. 1719–1725
 Ludgate hill. 1727

JENNINGS William, *goldsmith*; Pall Mall. 1686

JENSON Robert, *goldsmith*; parish of St Vedast's, Foster lane. (Buried) 1593

JERNEGAN — (cf. Henry JERNEGAN), *goldsmith*; Covent Garden. 1717–1720

JERNEGAN Edward, *jeweller*; Featherstone buildings, Holborn. 1753–1760

JERNEGAN Henry (cf. Henry JERNINGHAM), *goldsmith*; Sun, Russell street, Covent
Garden. 1723
St Paul's churchyard. (Bankrupt) 1720
Great Russell street, Covent Garden. 1736

JERNINGHAM Henry (cf. Henry JERNEGAN), *goldsmith*; Russell street. 1735–(Died) 1761

JESSE Thomas, *goldsmith*; parish of St Mary Abchurch. (Married) 1698

JOCE — (see JOSEE).

JOHN Edmond, *goldsmith*; London. 1753

JOHNSON —, *goldsmith*; Cheapside. 1700

JOHNSON —, *goldsmith*; removed from Cup & Ring, Wood street, to Cup & Ring, over
· against Cripplegate Conduit, without Cripplegate. 1721–1723

JOHNSON —, *pawnbroker*; King street, Little Tower hill. 1744

JOHNSON — (see FORSTER & JOHNSON).

JOHNSON Charles, *plate-worker*; Gunpowder alley. 1743

JOHNSON Christopher (cf. Charles GEDDES, also JOHNSTON & GEDDES), *jeweller*;
Crown & Pearl, Salisbury court, Fleet street. c. 1760

JOHNSON Glover, Junior, *plate-worker*; Maiden lane. 1712–1720

JOHNSON Gregory, *goldsmith*; Cheapside. 1548

JOHNSON Henry, *goldsmith*; Three Flower-de-Luces, Cheapside. 1690–1703
Lombard street. 1706

JOHNSON James, *goldsmith & banker*; Three Flower-de-Luces, Cheapside. 1677–1689

JOHNSON James, *jeweller*; Carey lane. 1766

JOHNSON Jeremiah, *goldsmith*; Lombard street. 1641–(Buried) 1676

JOHNSON John, Sir,[1] *goldsmith*; Three Flower-de-Luces, Cheapside. 1672–(Died) 1698

JOHNSON John, *silversmith*; Ring & Cup, next door to the Bull & Mouth inn, near Aldersgate.
1714

JOHNSON John, *goldsmith*; Maiden lane. 1773–1779

JOHNSON Joseph, *pawnbroker*; Three Bowls, corner of Maypole alley, Wych street.
(Deceased) 1742

JOHNSON Lawrence, *working goldsmith*; Katherine street, corner of Exeter street, near the
Strand. 1751–1763

JOHNSON Lawrence, *silversmith*; Covent Garden. (Deceased) 1755

JOHNSON Mary, *plate-worker*; Noble street. 1727

JOHNSON Nicholas, *goldsmith*; London. 1538–(Died) 1581

JOHNSON Nicholas, *goldsmith*; parish of St Vedast, Foster lane. (Buried) 1700

JOHNSON Robert, *goldsmith*; London. 1506–(Died) 1507

JOHNSON Robert, *goldsmith*; London. 1525

JOHNSON Robert, *goldsmith*; parish of St Catherine Cree. (Will proved) 1656

JOHNSON Robert, *goldsmith*; Fleet street. 1730

JOHNSON Robert, *goldsmith*; Heath Cock alley, Strand, against Durham yard. [N.D.]

JOHNSON Roland, *goldsmith*; London. 1580

JOHNSON Thomas, *goldsmith*; parish of St Mary-le-Strand. c. 1625

JOHNSON Thomas, *pawnbroker*; Bell, at the backside of St Clement's. (Deceased) 1708

JOHNSON Whyte, *goldsmith*; London. 1464

JOHNSON William, *goldsmith*; London. 1585

JOHNSON William, *goldsmith*; parish of St Sepulchre's. 1639–1660

[1] Founded the Free Writing School in Priest Court, Foster Lane.

LONDON GOLDSMITHS

JOHNSON William, *pawnbroker*; Three Balls, corner of Russell street, Brydges street,
 Covent Garden. 1753
JOHNSTON Alexander (see also JOHNSTON & GEDDES), *plate-worker*; Panton street. 1747
JOHNSTON Alexander, *plate-worker*; Old Jewry. 1773
JOHNSTON James, *goldsmith*; Carey lane. 1773
JOHNSTON [Alexander] & GEDDES [Charles] (see also Charles GEDDES), *jewellers*;
 Golden Ball, Panton street, near Leicester square. c. 1760
JOLLAND Anthony, *plate-worker*; Staining lane. 1721
JONAS & DAVIS, *necklace-makers & jewellers*; No. 107 Gravel lane, Houndsditch. 1779
JONES — (see JEFFERYS & JONES).
JONES —, *jeweller*; Cock & Pearl, Newport street. 1718–1722
JONES —, *jeweller*; Long Acre. 1727
JONES —, *jeweller*; Nevill's alley, Fetter lane. 1728
JONES —, *jeweller*; Two Green Posts, George street, York buildings, Strand. 1721–1729
JONES —, *goldsmith*; Blue Ball, Foster lane. 1743
JONES —, *jeweller*; Peacock, New Round court, Strand. 1762
JONES —, *silversmith*; Holiday yard, Creed lane. 1764
JONES Cave, *goldsmith*; Golden Ball, corner of St Michael's alley, Cornhill. 1732
JONES Charles, *jeweller*; Golden Snail, Carey lane. 1747
JONES Daniel, *silversmith*; Old Bailey. 1744
JONES Dyall (see MOLIERE & JONES).
JONES Edward, *goldsmith*; London. 1673–1716
JONES Edward, *plate-worker*; Lombard street. 1694
 Foster lane. 1697
JONES Elizabeth, Mrs, *pawnbroker*; Golden Dove, Old Artillery ground, near Spitalfields. 1716
JONES Elizabeth (see also Robert JONES), *silversmith*; No. 49 Bartholomew close. 1790–1793
JONES Francis, *goldsmith*; parish of St Mary Woolnoth. 1652–1696
JONES George Greenhill, *plate-worker*; Foster lane. 1724–1744
JONES James, *plate-worker*; Noble street. 1755–1763
JONES Jenkin, *jeweller & goldsmith*; No. 61 St James's street. 1784–1790
JONES Job, *pawnbroker*; Old Gravel lane. 1764
JONES John, *goldsmith*; parish of St Alban's, Wood street. 1692
JONES John, *plate-worker*; Foster lane. 1719
 Maiden lane. 1723
JONES John, *plate-worker*; Rotherhithe. 1729
JONES John, *silversmith*; Rose & Crown, St Martin's-le-Grand. 1733–1737
JONES J. & W., *silver buckle makers*; Great St Andrew street, Seven Dials. 1793
JONES Lawrence, *goldsmith*; parish of St Mary Abchurch. (Married) 1595
JONES Lawrence, *plate-worker*; Old Bailey. 1696–1720(?)
 London. 1724
 Cripplegate. 1734
JONES Mary, *pawnbroker*; Golden Ball & Bunch of Grapes, —(?). 1722
JONES Richard (see BENTLEY & JONES).
JONES Robert (see Elizabeth JONES, also JONES & SCHOFIELD), *plate-worker*; Bar-
 tholomew close. 1776–1796
 No. 49 Little Bartholomew close. 1800
JONES Samuel, *jeweller & goldsmith*; London. 1769

HGS (185)

Q

JONES THOMAS, *pawnbroker & goldsmith*; No. 145 Fleet street. 1796
JONES WILLIAM, *goldsmith*; parish of St Mary Woolnoth. 1561–1569
JONES WILLIAM, *working goldsmith*; Foster lane. 1761
 St Martin's lane Within. 1767
JONES RICHARD & MORRIS WILLIAM GEORGE (see LOWNDES & BATHURST).
JONES ROBERT & SCHOFIELD JOHN, *plate-workers*; Bartholomew close. 1776–1778
JONQUAIRE PIERRE, *goldsmith*; London. 1707
JORDANS —, *pawnbroker*; Three Blue Balls, facing Hungerford market, Strand. 1760
JORNSIDE —, *goldsmith*; corner of Birchin lane, Lombard street. 1728
JOSEE (or JOCE) —, *goldsmith*; London. 1258–1276
JOUBERT PIERRE, *goldsmith*; St Anne's, Westminster. 1699
JOUET PETER, *goldsmith*; St Giles's Without [Cripplegate]. 1718 (?)
JOUET SIMON, *goldsmith*; Maiden lane. 1723
 White Hart, Foster lane. 1739–1747
 Aldersgate. 1752
JOYCE JOSEPH, *goldsmith*; Greek street, Soho. 1753
JOYCE JOSEPH, SENIOR & JUNIOR, *goldsmiths*; Greek street, Soho. (Partnership dissolved) 1753
JOYCE STEPHEN, *goldsmith*; Moor street, Soho. 1770
 King street, Soho. 1773–1778
JUDD VALENTINE, *goldsmith*; parish of St Mary Woolnoth. 1600–(Buried) 1612
JUDD WILLIAM & SIMPSON THOMAS, *goldsmiths & jewellers*; Oxford street.
 (Partnership dissolved) 1796
JUDKINS MATTHEW, *goldsmith*; Gutter lane. 1705
JUKEL JOHN, *goldsmith*; parish of St Michael, Candlewick street [= Crooked lane, Cannon street]. c. 1284
JUNOD JAMES, *goldsmith & engraver*; Frith street, Soho. (Bankrupt) 1782
JURY WILLIAM (see ABDY & JURY).
JUSON WILLIAM, *plate-worker*; Foster lane. 1704–1714
JUSTIS, JUSTISE or JUSTUS WILLIAM, *plate-worker*; Golden Ball, Staining lane, near Haber-
 dashers' Hall. 1731–1755
JUSTIS & CO., *goldsmith*; Well yard, St Bartholomew's Hospital. 1765–1772
JUX EDWARD, *goldsmith*; St Mary Woolchurch Haw. 1580–1586

KANDLER CHARLES (see also KANDLER & MURRAY), *plate-worker*; St Martin's lane. 1727
KANDLER CHARLES, *plate-worker*; Jermyn street, St James's. 1778–1793
KANDLER FREDERICK, *plate-worker*; Jermyn street, against St James's Church. 1735–1773
KANDLER CHARLES & MURRAY JAMES, *plate-workers*; St Martin's lane. 1727
KAY —, *pawnbroker*; Two Golden Balls, Chick lane, West Smithfield. 1753–1756
 Two Golden Balls, Fetter lane, Holborn. 1762
KAYLE HUGH & MARTIN RICHARD, SIR (see also SIR RICHARD MARTIN), *goldsmiths*; Lom-
 bard street. 1586–1599
KEALE (or KAYLE) HUGH (see also KAYLE & MARTIN), *goldsmith*; parish of St Mary
 Woolnoth. 1562–(Buried) 1604
KEALE JOHN, *goldsmith*; parish of St Mary Woolnoth. 1539–(Died) 1574
KEALE WILLIAM, *goldsmith*; parish of St Mary Woolnoth. 1607–1609
KEANE RICHARD, *goldsmith*; Bishopsgate (?). 1600
KEATE LANCELOT (see also JOHN PEARSON & LANCELOT KEATE), *goldsmith*; Unicorn, near
 Hungerford market, Strand. 1698–1716

Plate XLIII

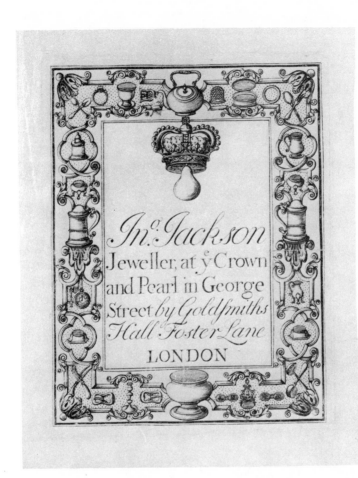

1734

Plate XLIV

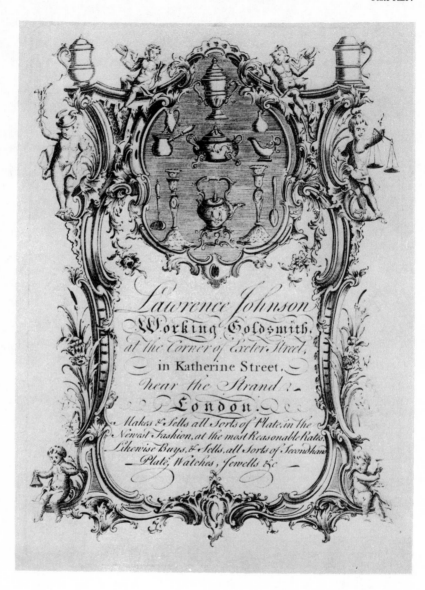

LAWRENCE JOHNSON

1751–1763

KEATE Lancelot & PEARSON Thomas (see also John PEARSON & Lancelot KEATE),
goldsmiths; Unicorn, Strand. 1699–1728
KEATE (or KEATT) William, goldsmith; Foster lane. 1693–1697
 St Martin's-in-the-fields. 1706–(Bankrupt) 1710
 Golden Cup, East Smithfield. 1697–1714
 London. 1724
KEATES William, working goldsmith; No. 135 Fleet street. 1790–1796
KEATT William (see William KEATE).
KEAYS William, goldsmith; London. 1773
KEBLE Robert, plate-worker; Foster lane. 1710
KEBLE William, goldsmith; City of London. (Married) 1615
KEECH John, goldsmith; parish of St Martin's-in-the-fields. c. 1673
KEELE Henry, goldsmith; London. 1586
KEELING Thomas (cf. Thomas KELINGE), goldsmith; London. 1546–1583
KEIGWIN —, goldsmith; Sun, against Southampton street, Strand. 1710–1712
KEIGWIN John, plate-worker; Snow hill. 1715–1719
KEITH William, goldsmith; near Hungerford market [Strand]. 1707
KELINGE Thomas (cf. Thomas KEELING), goldsmith; parish of St Mary Woolnoth. 1546–1561
 London. 1583–1586
KELK John, goldsmith; London. Temp. Henry VI
KELKE Stephen, goldsmith; London. 1483–(Died) 1511
KELWAY William, goldsmith; London. 1549–1553
KEMP — (cf. Francis RUFFIN), London. (Before) 1760
KEMPE Joseph, goldsmith; London. 1731
KEMPTON Robert, plate-worker; Foster lane. 1697–1718
KENDALL Luke, goldsmith & jeweller; No. 26 Wood street, Cheapside. 1768–1782
KENDALL Roger, goldsmith; London. Temp. Henry VI
KENDRICK —, jeweller; Hog lane, St Giles-in-the-fields. (Died) 1764
KENDRICK William, goldsmith; Queen street, Seven Dials. 1768–1773
 No. 36 Lombard street. 1772
KENEBEL John, engraver & jeweller; No. 13 Frith street, Soho. 1790
KENNET John, silversmith; No. 11 Foster lane. 1790
KENSTEBER (or KENTENBER) John & GROVES Thomas, plate-workers; Red Lion street,
 Clerkenwell. 1757–1773
KENT Richard (see DUNCOMBE & KENT).
KENTISH John (see KENTISH & TURNER, also KENTISH & HAYNES), jeweller, gold-
 smith & toy-man; Johnson's court, Fleet street. 1748
 Star, No. 18 Cornhill, corner of Pope's Head alley, opposite Royal
 Exchange. 1758–1793
KENTISH John & HAYNES (see also HAYNES & KENTISH), jewellers & watch-makers;
 No. 18 Cornhill. 1784–1793
KENTISH & TURNER, jewellers & goldsmiths; No. 18 Cornhill. 1777–1779
KENTON Banks, goldsmith; Leadenhall street. 1676
KENTON Francis, goldsmith & banker; King's Arms, Fleet street. 1668–1677
 Angel, Lombard street. 1682–1687
KENTON M., goldsmith; King's Arms, Fleet street. 1677
KER (or KERR) Robert, goldsmith; Golden Cup, Cheapside. 1712–(Bankrupt) 1732
KERBY Michael (see Michael KIRBY).

LONDON GOLDSMITHS

KERSILL Ann, *plate-worker*; Foster lane. 1747
KERSILL Richard, *plate-worker*; Foster lane. 1744–1763
KERSILL Robert, *goldsmith*; Cheapside. (Bankrupt) 1732
KERSILL William, *plate-worker*; Gutter lane. 1749
 No. 21 Aldersgate street. 1772–1777
KETCH —, *goldsmith & banker*; Black Horse, Strand, near Charing Cross. 1677
KETTLEWELL — (see TURMEAU & KETTLEWELL).
KETTLEWOOD Henry, *goldsmith*; parish of St Mary Woolnoth. 1579–1584
KETTLEWOOD John, *goldsmith*; parish of St Mary Woolnoth. 1549–1583
KEWE John, *goldsmith*; London. 1512
KEY Samuel, *goldsmith*; Gutter lane. 1745
 Fountain court. 1769
KEY Thomas, *goldsmith*; London.
 (Died at sea in service of the Commonwealth—will proved) 1656
KEY William, *goldsmith*; No. 64 Barbican. 1790–1793
KEYLWAY William (see William KELWAY).
KIDD (? KIDDER) John, *goldsmith*; London. 1773–1783
KIDDER James, *goldsmith*; parish of St James's, Westminster. 1765
KIDDER John, *plate-worker*; Heddon street. 1773
 Piccadilly. 1780–1786
KIDNEY William, *plate-worker*; Foster lane. 1739
KILBORNE Thomas & CAPILL James, *goldsmiths & bankers*; King's Head, Lombard street.
 1677–1682
KILLICK Andrew, *plate-worker*; Lily Pot lane [Noble street]. 1749
KILMAINE David (see also HORNE & KILMAINE), *plate-worker*; Snow hill. 1715
 Angel & Crown, Strand. 1716–(Died) 1728
KINEARD John, *plate-worker*; Orange street. 1743–1766
KING — (cf. Jeremiah KING), *goldsmith*; Swan, Foster lane. 1736
KING — (see SHELLEY & KING).
KING Edward, *silversmith*; Duke street, St Martin's lane. 1790–1793
KING James, *goldsmith*; Kensington grove (?). 1773
KING Jeremiah, *plate-worker*; Carey lane. 1723
 Foster lane. 1736–1742
 Foster lane (?). 1743–1769
KING John, *plate-worker*; No. 73 Little Britain. 1770–1777
KING John, *plate-worker*; Fore street. 1785
 Moor lane. 1789–1800
KING Matthew, *goldsmith*; parish of St Vedast, Foster lane. 1618–(Will proved) 1623
KING Peter, *goldsmith*; London. 1586
KING Richard, *goldsmith & jeweller*; No. 22 Oxford street. 1784–1793
KING Robert, *goldsmith*; parish of St Mary Woolnoth. 1674–1677
KING Thomas, *goldsmith*; parish of St Mary Staining. (Married) 1662
KING William, *goldsmith*; London. 1611
KING William (see JENKINS & KING), *goldsmith*; King's Head, Lombard street. 1699–1715
 Clapham. 1724–1727
KING William, *plate-worker*; Cross street, Hatton Garden. 1761–1764
KINGMAN James, *goldsmith*; No. 104 Leadenhall street. 1771–1783

(188)

KINMAN WILLIAM, *goldsmith*; East Harding street.	1773
KIPP WILLIAM, *goldsmith*; Candlewick street [= Cannon street].	1618
KIRBY JOHN, *goldsmith*; parish of St Faith under St Paul's.	(Married) 1584
KIRBY (or KERBY) MICHAEL, *goldsmith*; parish of St Saviour's, Southwark.	1652–1668
KIRK JOHN, *goldsmith*; Goldsmiths' Hall, Noble street.	1724–1730
Foster lane.	1734
KIRK JOHN, *jeweller & toy-man*; at the end of Northumberland House, Charing Cross.	1752
Removed to the corner of St James's place, St James's street	1752, 1753
KIRK (or KIRKE) JONAH, *goldsmith*; Cannon street.	1697
Cannon street (?).	1704
KIRK (or KIRKE) JONATHAN, *goldsmith*; parish of St Lawrence Pountney.	1692
Golden Cup, Lombard street.	1703–1705
KIRK & SAVAGE, *silver buckle makers*; No. 52 St Paul's churchyard.	1793
KIRKE — (see SNOW, BRIGHT & KIRKE).	
KIRKEBY JOHN, *goldsmith*; London.	(Will dated) 1483
KIRKHAM THOMAS, *silver buckle maker*; Monkwell street.	1793
KIRKHAM WILLIAM, *goldsmith*; St Sepulchre's.	(Insolvent) 1723
KIRKWOOD THOMAS, *goldsmith*; London (cf. THOMAS KIRWOOD).	1670
KIRWOOD MATTHEW, SIR (see KIRWOOD & JENKES, also WOOLFREY & KIRWOOD),	
goldsmith & banker; Golden Fleece, Lombard street.	1700–1718
KIRWOOD THOMAS, *goldsmith*; Cornhill (cf. THOMAS KIRWOOD).	1672–1688
KIRWOOD MATTHEW, SIR & JENKES ROBERT, *goldsmiths*; London.	(Bankrupt) 1718
KLUPFELL FREDERICK, *jeweller*; parish of St Martin's-le-Grand.	1735
KNAPPE GEORGE, *goldsmith*; New street, Shoe lane.	1678
KNEVITT THOMAS, *goldsmith*; Langbourne ward.	1640
KNIGHT CHARLES, *goldsmith & clock-maker*; Flower-de-Luce, Great Russell street.	1685–1697
KNIGHT JAMES, *working jeweller*; No. 26 King street, Borough.	1790–1793
KNIGHT JOHN, *jeweller*; No. 6 Carpenters buildings, London Wall.	1768
KNIGHT JOSEPH, *goldsmith*; Flower-de-Luce, Great Russell street, Covent Garden.	
	1696–(Bankrupt) 1712
KNIGHT MATTHEW, *goldsmith*; parish of St Vedast, Foster lane.	(Buried) 1684
KNIGHT SYMON, *goldsmith*; Rose & Crown, Foster lane.	1699, 1700
KNIGHT VALENTINE, *jeweller*; Noble street.	1776
KNIGHT WILLIAM, *goldsmith*; parish of St Vedast, Foster lane.	1641–(Buried) 1683
KNIGHT WILLIAM, *goldsmith*; parish of St Saviour's, Southwark.	1661
KNIGHT & JACKSON, *goldsmiths & bankers*; Unicorn, Lombard street.	1727–1729
KNOPFELL FREDERICK, *plate-worker*; Windmill street.	1752
KNOTT —, *goldsmith*; Three Cocks, Cheapside.	1695
KYMER FRANCIS LANGLEY, *jeweller*; Old street.	1761
LA BROSSE —, *goldsmith*; parish of St Anne's, Soho.	(Deceased) 1721
LACAM ISAAC, *jeweller*; Villiers street, York buildings [Strand].	1726
Pearl, Buckingham street.	1733
Pall Mall.	1744
LACAM JOHN, *jeweller & goldsmith*; Ring & Crown, corner of Fountain court, Strand.	1744–1747
Pall Mall.	1751–1753
LA CLEAR-NEAL, *goldsmith*; No. 41 Berwick street.	1796

LA COSTE Peter, *jeweller*; Crown & Pearl, George street, Foster lane. 1744, 1745

LACY Charles, *goldsmith*; No. 12 Ludgate street. 1784–1793

LADBROKE Robert, Sir,[1] RAWLINSON & CO., *goldsmiths & bankers*; Phoenix, No. 10
 Lombard street, corner of Sherborne lane. 1736–(Died) 1773

LADDE (or LADDS) William, *goldsmith*; Three Kings, Cheapside. 1695–1699

L'ADVOCAT Isaac (cf. PETIT), *jeweller*; Two Blue Posts, Grafton street, Soho. 1733–1744

LADYMAN John, *plate-worker*; Sherborne lane. 1692–1713
 London. 1724

LAFOSSE William, *jeweller*; Broad street, opposite to Austin Fryars Gate. 1726

LA FOSSE William, *jeweller*; No. 52 Old Broad street. 1744–1793

LAGARENNE Michael Cabaret, *goldsmith*; St Martin's-in-the-fields. 1709–1711

LAIGHT George, *working goldsmith*; No. 5 Clerkenwell green. 1790–1793

LAKE Francis, *goldsmith*; parish of St Saviour's, Southwark. 1611

LAMB —, *goldsmith*; Blackmoor's Head, within Aldgate. (Died) 1743

LAMB Edward, *plate-worker*; Castle street. 1740

LAMB Henry, *goldsmith & banker*; Grapes, Lombard street. 1677–1703

LAMB Walter, *goldsmith*; London. 1519

LAMB & BOWMAN, *goldsmiths*; Lombard street. 1709

LAMBE George, *plate-worker*; Heming's row [St Martin's lane]. 1713–1717

LAMBE George (Widow of), *plate-worker*; ?Heming's row. 1721

LAMBE Henry, *goldsmith*; parish of St Mary Woolnoth. 1679

LAMBE Henry, *goldsmith*; Unicorn, Lombard street. 1683–1709

LAMBE Jane, *plate-worker*; Chandos street. 1719–1732

LAMBE John, *spoon-maker & watch-maker*; No. 29 Fetter lane. 1783–1796

LAMBE Jonathan, *plate-worker*; London bridge. 1697

LAMBERMAN Baltasir, *jeweller*; Dowgate ward. 1618

LAMBERT Edmund, *goldsmith*; parish of St Peter's, West Cheap. (Married) 1604

LAMBERT Edward, *goldsmith*; Fleece, Lombard street. 1692–(Died) 1699

LAMBERT Francis, *goldsmith*; No. 2 St Martin's court, Leicester square. c. 1800
 No. 12 Coventry street, corner of Panton square. [N.D.]
 Nos. 11 and 12 Coventry street. 1803–(Died) 1841

LAMBERT Humphrey, *goldsmith*; London. 1609

LAMBERT John, *jeweller*; next door to the Cock & Lion, Abchurch lane, Lombard street. 1722

LAMBERT Walter, *goldsmith*; London. 1538–1553

LAMBERT Francis & HAMLET Thomas (see also Thomas HAMLET), *goldsmiths*; No. 2
 St Martin's court, Leicester square. c. 1800

LAMBERT & RAWLINGS, *goldsmiths & jewellers*; No. 12 Coventry Street. [N.D.]

LAMBORN Thomas, *goldsmith*; Cold Bath fields. [N.D.]
 Fleet street. (Insolvent) 1772

LAMERIE Paul (see Paul DE LAMERIE).

LAMIER Jeames, Senr. & Junr., *goldsmiths*; Cheape ward. 1583

LAMMAS Jeremiah, *goldsmith*; parish of St Mary Staining. 1692/3–1724

LAMPFERT (or LAMFERT), *plate-worker*; Windmill street. 1748
 ? Windmill street. 1769

LAMY Daniel, *jeweller*; New court, Throgmorton street. 1730–1738

 [1] Lord Mayor of London, 1747–8.

LANCE Benjamin, *goldsmith*; London. 1781–1784

LANDIFIELD —, *goldsmith, jeweller & watch-maker*; Fenchurch street. (Retired) 1777

LANE Benjamin, *goldsmith*; Rose [Exchange alley], Lombard street. 1694–(Died) 1717

LANE Thomas, *goldsmith*; London. 1724

LANGCASTLE Richard, *goldsmith*; parish of St Peter's, West Cheap. (Married) 1608

LANGCASTLE Stephen, *goldsmith*; Cheapside. 1642

LANGDALE George, *goldsmith*; parish of All Hallows, Honey lane. 1590, 1591

LANGFORD Thomas, *plate-worker*; Lombard street. 1715–1720

LANGFORD John & SEBILLE John, *plate-workers*; St Martin's-le-Grand. 1759–1773

LANGLEY —, *goldsmith*; next door but one to Will's Coffee-house at Lincoln's Inn Little Gate. 1717

LANGLEY Gilbert (son and successor of Haldanby Langley), *goldsmith*; Searle street, Lincoln's Inn back gate, next door to Will's Coffee-house. 1730–(Bankrupt) 1738

LANGLEY Haldanby, *goldsmith*; Bible, Searle street, over against Lincoln's Inn Back Gate. 1690–1718

LANGLEY John, Sir,[1] *goldsmith*; London. 1566–(Died) 1578

LANGLOIS James, *plate-worker*; St Andrew's street. 1738

LANGTON Dennis, *goldsmith*; Wheatsheaf & Crown, Lombard street. 1709–1718

LANGTON John, *goldsmith*; Holborn. (Will proved) 1624

LANGTON John, *goldsmith*; Whitecross street. 1790

LANGTON Richard, *goldsmith*; over against the Post Office, Lombard street. 1730
Crown & Anchor, or Anchor & Crown, Lombard street. 1741–1746
Crown & Anchor, Fenchurch street, near opposite to Rood lane. 1746–(Died) 1753

LANNYSON, LAVYSON or LOVYSON John, *goldsmith*; Lombard street. 1569–(Died) 1583

LANSDEL John, *goldsmith*; London. 1724–1734

LAPLANTE Peter, *jeweller*; St Martin's-in-the-fields. 1737

LAPLEY James, *goldsmith & banker*; Three Cocks, upper end of Cheapside. 1659–(Died) 1694

LAPLEY James, Junior, *goldsmith*; Cheapside. (Buried) 1695

L'ARCHEVEQUE John, *jeweller*; Gold street, Cheapside. 1753

LARDENOIS Elcana, *goldsmith*; Blackfriars. 1617

LARDENOYES Nicholas, *goldsmith*; Blackfriars. 1568

LARDENOYS Christopher, *goldsmith*; Blackfriars. 1617

LARDIE Launcelot, *goldsmith*; Blackfriars. c. 1565–1571

LAROCHE Louis, *plate-worker*; Lumber court, corner of Seven Dials. 1725–1739

LASHER James, *goldsmith*; parish of All Hallows, Bread street. 1608

LASSELS John, *goldsmith*; Charing Cross. 1693–1696

LASSELS Richard, *goldsmith*; Unicorn, Strand. 1680–1694
? Unicorn, Strand. 1723

LATCH Samuel, *goldsmith*; Lombard street. 1645

LATHAM John, *plate-worker*; Colman street. 1791

LATHAM (or LATHOM) Ralph, *goldsmith*; London. 1509–(Died) 1556

LAUBIE Louis, *goldsmith*; London. 1750

LAUGHTON Charles, *plate-worker*; Bedfordbury. 1741

LAUGHTON John, *plate-worker*; Maiden lane. 1694–1699

LAUGHTON Mrs, *pawnbroker*; Five Bells & Candlestick, —?. 1717

[1] Lord Mayor of London, 1576–7.

LONDON GOLDSMITHS

LAULEYE Thomas, *goldsmith*; London. 1372
LAUNDRY —, *silversmith*; Cross Keys, Threadneedle street. 1727
LAUNDRY Samuel, *plate-worker*; Gutter lane. 1727
LAUNDRY Samuel & GRIFFITH Jeffrey, *plate-workers*; Staining lane. 1731
LAURENCE Thomas (see Thomas LAWRENCE).
LAUTIER John, *goldsmith*; No. 20 Fleet street. 1773–1777
LAVER Benjamin, *goldsmith*; New Bond street. 1769–1779
 St George's, Hanover square. 1774
 No. 4 Bruton street, Berkeley square. 1783–1800
LAVINTON John, *goldsmith*; Bunch of Grapes, Cheapside. (Died) 1707
LAVIS John, *plate-worker*; Bride lane. 1749
LAVYSON John (see John LANNYSON).
LAW John, *candlestick-maker*; Moorfields. 1768
LAWERD Robert, *goldsmith*; London. 1540–1553
LAWLEY Francis, *haft-maker*; Green Arbour court. 1773
LAWRENCE Thomas, *goldsmith*; parish of St Mary Woolnoth. 1582–(Died) 1624
LAWRENCE Thomas, *plate-worker*; Golden lane. 1742
LAWSON Robert, *pawnbroker*; Golden Ball, Great Hart street, Covent Garden. 1744
LAWT Balthazar, *goldsmith*; London. 1599
LAYFIELD Samuel, *goldsmith*; King's Head, by Royal Exchange, Cornhill. 1685
 White Horse, Lombard street. 1694–1697
LAYTON Bartholomew, *goldsmith*; parish of St Mary Woolnoth. 1639–1640
LAYTON Thomas, *silversmith & jeweller*; Fore street. 1788
 No. 82 Wardour street, Soho. 1790–1793
LAYTON William, *goldsmith*; Lombard street. 1568–1573
LAZANES Aaron, *jeweller*; St Mary Axe. 1747
LEA Joseph, *working goldsmith*; Noble street. 1781
 No. 2 Silver street, Wood street. 1790–1793
 No. 20 Silver street, Wood street. 1796
LEA Samuel, *plate-worker*; Heming's row [St Martin's lane]. 1711–1724
LEACH John, *plate-worker*; Distaff lane. 1697
 ? Distaff lane. 1698–1710
LEACH Thomas, *goldsmith & jeweller*; removed from Addle street. 1747
 Anchor & Crown, Lombard street. 1747–(Died) 1762
LEADBETTER Charles, *goldsmith & jeweller*; Carey lane. 1768
 Oat lane [Noble street]. 1773
LEADHAM Thomas, *goldsmith*; parish of St Michael's, Wood street.
 (Married) 1580. (Will proved) 1631
LEAKE Joseph, *goldsmith*; Gutter lane. (In debtors' prison) 1749
LEAKE Ralph (see Ralph LEEKE or LEET).
LEASER —, *silversmith*; Maiden lane, near Covent Garden. 1717
LE BAS William, *goldsmith*; Red Lion street. 1773
 Goldsmiths' Hall. 1786
LE BLANC —, *jeweller to Their Majesties*; London. 1728
LE BLOUNT (or BLUND) Ralph, *goldsmith*; London. 1267–(Died) 1296
LE BLUND Hugh, *goldsmith*; London. 1243
LE BRET Richard, *goldsmith*; West Cheap. c. 1310
LE BRET Robert, *goldsmith*; parish of St Matthew, Friday street. 1331–(Will enrolled) 1336

(192)

⌐E BROSSE, *working silversmith*; London.	1721
⌐E BRUN Nicholas, *goldsmith*; (?) Fleet street.	c. 1309
⌐ECERFFE (or LE SERFFE) John, *goldsmith*; St Martin's-le-Grand.	1538–1585
⌐E CHEAUBE Pierre, *plate-worker*; Pall Mall.	1707
Glasshouse street.	1726
⌐E COINTE John Robert, *jeweller*; Dean street, Soho.	1765–1781
China walk, Chelsea.	1784
⌐E COMPT Jones, *silversmith*; Drury lane.	(Insolvent) 1723
⌐E COUR David, *goldsmith*; Dorset street, Spitalfields hamlet.	1700
⌐E COURT David, *jeweller*; over against Drapers' Hall in Throgmorton street.	1718–1726
⌐EDIE John, *jeweller*; Glasshouse yard, Water lane.	1790–1793
⌐EDIE Lewis, Junior, *jeweller*; Newcastle street, Butcher row.	(Insolvent) 1769
⌐EE —, *gold chain maker*; Dyott street, St Giles's.	1733
⌐EE —, *goldsmith*; Hand & Buckle, Fore street.	1752
⌐EE Edmund, *goldsmith*; London.	1538–1553
⌐EE Edward, *goldsmith*; London.	1517
⌐EE George (in partnership with John TASSELL), *goldsmith*; parish of St Mary Woolnoth.	1692, 1693
⌐EE George (cf. Nathaniel BRASSEY & LEE), *goldsmith*; Lombard street.	1740
⌐EE Henry, *silversmith*; No. 10 Shoreditch.	1790–1796
⌐EE Jeremy, *plate-worker*; Watling street.	1739–1742
? Watling street.	1761
⌐EE John, *goldsmith & jeweller*; Bunhill row.	1782
No. 53 Rosoman street.	1790
⌐EE Matthew, *goldsmith*; Cripplegate.	1752
LEE Roger, *goldsmith*; London.	1659
LEE Roger, *goldsmith*; London.	1734
LEE Samuel, *plate-worker*; Newgate street.	1701–1720
Bishopsgate Without.	(Bankrupt) 1723
LEE Timothy, *goldsmith*; parish of St Gabriel, Fenchurch street.	1692, 1693
London.	1700
LEEDS — (see HYDE & LEEDS).	
LEEK Samuel, *goldsmith*; Lamb, Cheapside conduit.	1680
LEEKE Ralph (see also Ralph LEET), *plate-worker*; [London].	1679
Bridge street, Covent Garden.	1686
Angel, Catherine street, Strand.	1692
Covent Garden.	1697–1702
LEET Ralph (? cf. Ralph LEEKE), *goldsmith*; [London].	1657
LE FARENDON (see FARINGDON, also FARYNGDON).	
LE FORT Cæsar, *jeweller*; London (?).	1762
LE FRANCOIS Abraham, *plate-worker*; Porter street, Soho.	1740
West street, Seven Dials.	1746–1750
LE FREYNSSHE Peter, *goldsmith*; Cornhill.	(Executed) 1326
L'ÉGARÉ Francis, *jeweller*; London.	1682
LEGER (see LIGER).	
LEGET Thomas, *goldsmith*; London.	1431–1451
LE GOLDSMYTH Andrew, *goldsmith*; Bread street.	1324
LE GOLDSMYTH Robert, *goldsmith*; London.	1325–1338

LE GRAND Henry, *silver snuff-box maker*; parish of St Martin's-in-the-fields.　1726

LEGRIX John, *French plate-worker*; Chandelier, next door to the Golden Leg, opposite Langley
　　street, Long Acre.　c. 1760

LE HONGRE Guillaume, *goldsmith*; The Fleet.　1562–1584

LEIGH John, *goldsmith*; parish of St John Zachary.　1623
　　Foster lane.　1641

LEIGH William, *goldsmith*; No. 71 Oxford street.　1790–1793

LEIGHTON William, *goldsmith*; London.　1573

LE JEUNE Joshua, *goldsmith*; Lichfield street.　1773
　　? Lichfield street.　1782

LE LONGE Richard, *goldsmith*; London.　1349

LE MAISTRE, *goldsmith*; Blackfriars.　1562–1564
　　Parish of St Helen's.　1571

LE MARECHAL, *goldsmith*; London.　1340

LE MASERER Simon, *goldsmith*; London.　1369

LE MAY —, *goldsmith*; Grafton street.　1715–1717

LE MAZERER John, *goldsmith*; London.　1303

LEMERE John, *goldsmith*; Blackfriars.　1583

LENEY Bonaventure, *goldsmith*; St Martin's-le-Grand.　1564–1585

LENT Hugh & John, *goldsmiths*; St Dunstan's hill.　1677

LENYDE Thomas,[1] *goldsmith*; London.　1403

LEOFSTANE —,[2] *goldsmith*; London.　c. 1100–1135

LEOFSTANE FitzHenry Alwin Fitz[3] (cf. FitzHenry ALWYN), *goldsmith*; London.　1189–1213

LE PLASTRIER John, *jeweller*; Austin Friars.　1708–1710

LE PLUTRIER Abraham, *jeweller*; near Somerset House.　(Insolvent) 1721

LE ROUX Alexander, *watch case maker*; Dowgate hill.　1722

LE ROUX Peter, *goldsmith*; parish of St Martin's-in-the-fields.　(Married) 1678

LE SAGE Augustus, *goldsmith & clock-maker*; corner of Suffolk street, Charing Cross.　1752–1773
　　Cockspur street.　1755–1784
　　St James's, Haymarket.　1790

LE SAGE John Hugh, *plate-worker*; St Martin's lane, Long Acre.　1718
　　Old street.　1722
　　Great Suffolk street, Charing Cross.　1739–1743

LE SAGE Simon, *plate-worker*; Golden Cup, the corner of Great Suffolk street, near the
　　Haymarket.　1739–(Left off business) 1761

LE SHOREDITCH Robert, *goldsmith*; London.　1339–1350

LETSHAM William, *goldsmith*; St Giles without Cripplegate.　(Will proved) 1626

LETURGEON David, *silver turner*; next door to King Charles' Head, Church lane [Strand].
　　1702–1704

LEVER Benjamin, *goldsmith & jeweller*; No. 3 Bruton street, Golden square.　1790–1793

LEVY — (see NEWTON & LEVY).

LEVY Aaron, *silversmith*; Broad street, Ratcliffe Highway.　1790–1793

LEVY Abraham the Younger, *jeweller & diamond cutter*; Tower hill.　(Bankrupt) 1733

LEVY Alexander, *jeweller*; London.　(Bankrupt) 1708–1711

LEVY Andrew, *jeweller*; London.　(Bankrupt) 1729

　　[1] Probably identical with Thomas SENYCLE.　　　　[2] Provost of London.
　　[3] Mayor of London and Provost of the City, 1189–1213.

Plate XLV

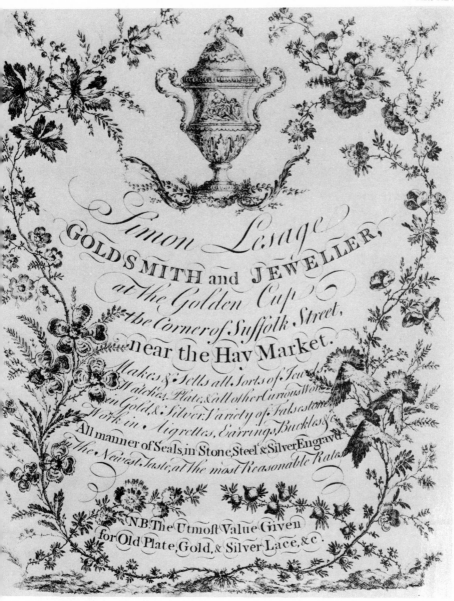

Simon Lesage
GOLDSMITH and JEWELLER,
at the Golden Cup
the Corner of Suffolk Street,
near the Hay Market.
Makes & Sells all Sorts of Jewels,
Watches, Plate, & all other Curious Work
in Gold & Silver. Variety of False stones.
Work in Aigrettes, Earrings, Buckles &c
All manner of Seals in Stone, Steel & Silver Engrav'd
in the Newest Taste, at the most Reasonable Rates.

N.B. The Utmost Value Given
for Old Plate, Gold, & Silver Lace, &c.

Plate XLVI

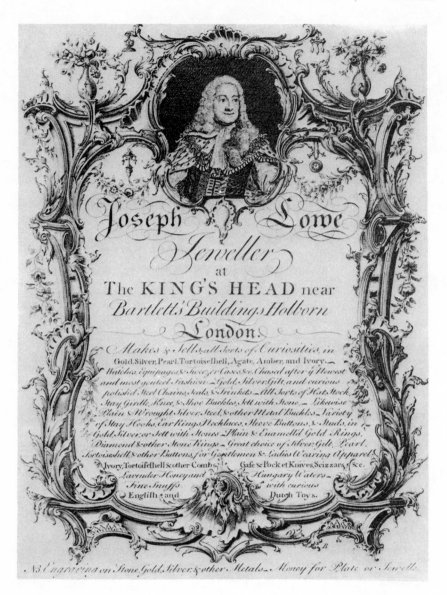

Joseph Lowe

Jeweller

at

The KING'S HEAD near

Bartlett's Buildings Holborn

London

Makes & Sells all sorts of Curiosities, in
Gold, Silver, Pearl, Tortoiseshell, Agate, Amber, and Ivory
Watches, Equipages & Tweezer Cases &c. Chased after y Newest
and most genteel Fashion — Gold, Silver, Gilt, and curious
polished Steel Chains, Seals, & Trinkets — All Sorts of Hat Stock
Stay Girdle, Knee, & Shoe Buckles, Sett with Stone — Likewise
Plain & Wrought Silver, Steel, & other Metal Buckles, Variety
of Stay Hooks, Ear Rings Necklaces, Sleeve Buttons, & Studs, in
Gold, Silver, or Sett with Stones — Plain & Enamell'd Gold Rings.
Diamond & other Stone Rings — Great choice of Silver, Gilt, Pearl,
Tortoiseshell & other Buttons, for Gentlemen & Ladies Wearing Apparel
Ivory, Tortoiseshell & other Combs Case & Pocket Knives, Scizzars &c.
Lavender Honey and Hungary Waters
Fine Snuffs, with curious
English, and Dutch Toys.

N.B. Engraving on Stone, Gold, Silver, & other Metals — Money for Plate or Jewells.

JOSEPH LOWE 1748

LEVY HYAM, *goldsmith*; No. 121 Whitechapel High street.	1790
LEVY ISRAEL, *goldsmith & jeweller*; No. 11 Cockspur street.	1790–1796
LEVY JOSEPH, *jeweller & goldsmith*; No. 11 New Round court, Strand.	1777–1793
LEVY JOSEPH, *silversmith*; No. 49 Tooley street.	1790–1793
LEVY L., *silversmith*; No. 41 Ratcliffe highway.	1790–1793
LEVY LYON, *jeweller*; No. 47 St Mary Axe.	1784–1793
LEVY MOSES, *goldsmith*; Red Lion street, Whitechapel.	1768
LEVY SAMUEL ANDREW, *jeweller*; No. 27 Bury street, St Mary Axe.	1777
LEWES JOHN, *goldsmith*; London.	1538–1553
LEWES ROBERT, *goldsmith*; parish of St Leonard's, Foster lane.	(Deceased) 1591
LEWES THOMAS, *goldsmith*; parish of St Bride's, Fleet street.	(Married) 1592
LE WHYMPIER JOHN, *goldsmith*; London.	1307
LEWIS — (cf. GEORGE LEWIS), *goldsmith*; Angel, over against New Exchange in the Strand.	1707–1712
LEWIS EDWARD, *goldsmith & watch-maker*; Naked Boy & Coral, St Margaret's hill, Southwark.	1766
LEWIS GEORGE, *plate-worker*; Angel (or Angel & Crown or Golden Angel & Crown), over against New Exchange, Strand.	1697–1714
LEWIS HENRY, *goldsmith*; parish of St John Zachary.	(Married) 1596
LEWIS HENRY, *goldsmith*; Lombard street.	(Buried) 1701
LEWIS HUGH, *goldsmith*; parish of St Leonard, Foster lane.	1641
Parish of St Botolph, Aldersgate street.	1643–1657
LEWIS HUGH,[1] *goldsmith*; Little Britain.	(Hanged) 1653
LEWIS JOSEPH, *buckle-maker & goldsmith*; No. 38 Foster lane.	1769–1784
No. 8 Cheapside.	1790–1796
LEWYS HENRY (see HENRY LEWIS).	
LEWYS THOMAS, *goldsmith*; parish of St Alphage [London Wall].	(Married) 1589
LEY PETLEY, *plate-worker*; near the pump at Aldgate.	1710
Within Aldgate.	1715
? Within Aldgate.	1721
LEY TIMOTHY, *plate-worker*; Fenchurch street.	1697
? Fenchurch street.	1729
LEYTON BARTHOLOMEW, *goldsmith*; London.	1666–1668
L'HEMMEDIEU PETER, *goldsmith*; Ring & Acorn, Shug lane, Golden square.	1752
L'HOMMEDIEU OZÉE, *goldsmith*; White Lion street.	1715–1739
LIAS THOMAS, *goldsmith*; London.	1799–1840
LIDDIARD THOMAS, *goldsmith & watch-maker*; No. 54 St Paul's churchyard.	1773–1795
LIDDIARD THOMAS & SON, *jewellers*; No. 54 St Paul's churchyard.	1796
LIÈGE JEAN, *goldsmith & jeweller*; Old Soho.	1717
LIGER ISAAC, *plate-worker*; Heming's row [St Martin's lane].	1704–(Died) 1730
LIGER JOHN (son of ISAAC LIGER), *plate-worker*; Pearl, Heming's row [St Martin's lane].	1730–1732
LIKE GEORGE, *silversmith*; No. 39 Butcher row, Strand.	1790–1796
LILL ANN (late WIDOW POWELL), *pawnbroker*; Black Hart (formerly Black Hart & Rose), Skinners street end, without Bishopsgate (cf. JOHN POWELL).	1720
LILLEY JOB, *goldsmith*; near Smithfield Bars.	1743–1755
St John street.	1745

[1] "April 26, 1653. Hugh Lewis, goldsmith in Little Britain, hanged at Tyborn for receiving and concealing stolen plate" ["Obituary of Richard Smith," p. 35.]

LILLY William, *goldsmith*; St John's street, Smithfield. 1768–1770
 Smithfield Bars. 1777
LIMPANY Robert (see Robert ZIMPANY).
LINDSAY (or LYNDSAY) John (see also LINDSAY & REEVE), *banker & goldsmith*; Angel,
 Lombard street. 1663–(Bankrupt) 1679
 Broad street. 1666–1669
LINDSAY John & REEVE Peirce, *bankers & goldsmiths*; Angel, Lombard street. (Bankrupt) 1679
LINGARD John, *plate-worker*; Fish street. 1718
 Maiden lane. 1719, 1720
LIPMAN Abraham Wolf, *jeweller*; Duke's place [Aldgate]. (Insolvent) 1769
LISTER John, *goldsmith & jeweller*; Well street, Cripplegate. 1790
LITTLELER Joseph, *goldsmith & jeweller*; No. 179 Strand. 1796
LITTLEWOOD Samuel, *goldsmith*; No. 9 Lombard street. 1773
LLOYD —, *goldsmith*; Hatton Garden. 1701
LLOYD Evan, *goldsmith*; Fleet street. (Will proved) 1624
LLOYD & CO., *goldsmith*; Bishopsgate street. 1762
LOCK Joseph, *silversmith*; No. 7 Francis court, Berkeley street, Clerkenwell. 1778–1779
LOCK Nathaniel, *plate-worker*; Blackwell Hall court, Cripplegate. 1692–1698
 ? Blackwell Hall court, Cripplegate. 1702–1715
LOCK Nicholas, *goldsmith*; Bartholomew close. 1677
LOCKEY Roland, *goldsmith*; Fleet street. (Will proved) 1616
LOFTHOUSE Mary, *plate-worker*; Maiden lane. 1731
LOFTHOUSE Matthew, *plate-worker*; Temple Bar. 1705–1721
 ? Temple Bar. 1733
LOFTHOUSE Seth (see also BURGESS & LOFTHOUSE), *plate-worker*; Bishopsgate. 1697
 White Horse, Fleet street, near Fleet bridge. 1712–1722
LOLE (or LOWE) William, *goldsmith*; parish of St Mary, Aldermanbury. (Will proved) 1653
LONERYE (or LOVERYE) Richard, *goldsmith*; London. 1334–1337
LONG Charles, *working goldsmith*; Star court, Cheapside. (Insolvent) 1743
LONG John, *goldsmith & banker*; Blackamoor's Head, Lombard street. 1718–1725
LONG & BLAND, *goldsmiths*; Black Moor's Head, Lombard street. 1718–1720
LONGEDALE George, *goldsmith*; London. 1557–1569
LONGWORTH Francis, *goldsmith*; parish of St Mary Woolnoth. 1590–(Died) 1598
LONYSON (or LOVYSON) John, *goldsmith*; Lombard street. 1569–(Buried) 1583
LOOKER William, *plate-worker*; Carey lane. 1713
 St Anne's lane. 1720
LORD Job, *jeweller*; London. 1685
LORD Obadiah, *goldsmith*; Brabant court, Fenchurch street. 1711
LORY Richard, *goldsmith*; parish of St Mary Woolnoth. 1580
LOUIS John, *goldsmith*; London. 1682
LOUNDE Richard, *goldsmith*; London. 1548
LOUNDE Widow, *goldsmith*; London. 1560
LOVE Anthony, *goldsmith*; London. 1513
LOVE James, *goldsmith & jeweller*; No. 23 Aldgate High street. 1784–1796
LOVEJOY John, *goldsmith*; parish of St Mary Woolnoth. (Married) 1591–(Died) 1612
LOVELACE William, *goldsmith*; Charles square, Hoxton. 1792
LOVELL Robert, *plate-worker*; Maiden lane. 1702–1708
 Next the Pye tavern, without Bishopsgate. 1707–1715

LOVERYE Richard (see Richard LONERYE).
LOVETT Drew, *goldsmith*; London. 1610–1617
LOVETT Drew, *goldsmith*; parish of St Andrew's, Holborn. 1629–1642
LOVETT Joseph, *goldsmith*; London. 1610–1617
LOVETT Nicholas, *goldsmith*; Southwark. Temp. Henry VI
LOVETT Richard, *goldsmith*; parish of St Mary le Savoy. (Will proved) 1641
LOVYSON John (see John LONYSON, LANNYSON or LAVYSON).
LOW Caleb, *silversmith*; No. 20 Great Bill alley. 1790
LOWDEN John, *goldsmith*; London. 1720
LOWDERS —, *goldsmith*; Jewel & Crown, near Durham yard, Strand. 1693, 1694
LOWE —, *jeweller*; Noble street, near Goldsmiths' Hall. 1764
LOWE Jonathan, *jeweller*; No. 126 St Martin's lane. 1790–1793
LOWE Joseph, *jeweller*; King's Head, near Bartlett's buildings, Holborn. 1748
LOWE William (see William LOLE).
LOWNDES Thomas (see HARDY & LOWNDES, also LOWNDES & LYCETT), *silver*
buckle maker & goldsmith*; Round court. 1784
St Martin's-le-Grand. 1786
LOWNDES Charles & BATHURST Thomas (successors to Richard JONES & William
George MORRIS), *silver button makers*; Crown, Russell street, corner
of Bow street, Covent Garden. c. 1760
LOWNDES Thomas & LYCETT Edmund (see EDMUND LYCETT), *goldsmiths*; No. 25
Noble street, Foster lane. 1789–1793
LOWTH William, *goldsmith*; London. 1510–1517
LUCAS Charles, *goldsmith*; St Olave's, Silver street. (Bankrupt) 1734
LUCAS Richard, *goldsmith*; London. 1668
LUCAS Robert, *goldsmith*; London. 1377–(Died) 1382
LUCAS Robert, *plate-worker*; Lombard street. 1726
Bow lane. 1739
LUCY —, *goldsmith*; Golden Cup, Russell street, Covent Garden. 1687
LUDLOW John, *plate-worker*; without Aldgate. 1713
Ball alley, Lombard street. 1720
LUFF John, *plate-worker*; Pemberton street, Gough square. 1739
Fleet street. 1743
LUKIN C. (see MORRISET & LUKIN).
LUKIN William, *silversmith*; Golden Cup, Gutter lane. 1699
Blackamoor's Head, corner of York buildings, Strand. 1712–1734
Golden Cup, Strand. 1718
Parish of St George's, Hanover square. (Bankrupt) 1751
LULLS Arnold, London. Temp. James I
LUMPANY Robert (see Robert ZIMPANY).
LUND John, *goldsmith*; Three Golden Lions, near Temple Bar. 1695–(Bankrupt) 1712
Fleet street. 1727–1734
LUPART Peter, *goldsmith*; Golden Lion, Lombard street. 1693–1696
LUPSETT Thomas, *goldsmith*; London. 1509, 1510
LURIER Guillaume, *goldsmith*; St Martin's-le-Grand. 1564
LUSH John, *goldsmith*; Rolls buildings [Fetter lane]. 1768

(197)

R

LONDON GOLDSMITHS

LUTWYCHE William (see VERE & LUTWYCHE), *working goldsmith & jeweller*; Anchor
 & Dove, No. 42 Lombard street. 1766–1772
 Anchor & Dove, No. 15 Fenchurch street, near Gracechurch street. 1771–1777
 No. 149 Fenchurch street. 1777–(Deceased) 1783
LYAS German, *goldsmith*; London. 1450–1452
LYCETT Edmund (see also LOWNDES & LYCETT), *working goldsmith*; No. 25 Noble street,
 Foster lane. 1790–1793
LYDE Henry, *goldsmith*; London. (Deceased) 1760
LYMPANY Robert (see Robert ZIMPANY).
LYMSON William, *goldsmith*; London. 1549–1553
LYNAM Henry, *goldsmith*; No. 76 Strand. 1788
LYNAM Henry & Warwick (see also LYNAM & BOX), *goldsmiths*; No. 76 Strand. 1790–1793
LYNAM Henry & BOX John, *goldsmiths*; Strand. (Partnership dissolved) 1768
LYNAM & BULL, *goldsmiths*; No. 26 New Bond street. 1790
 Golden Salmon, No. 36 New Bond street. 1793
LYNCHE German, *goldsmith*; London. 1460–1483
LYNDSAY (or LINDSAY) John (see also LINDSAY & REEVE), *goldsmith & banker*; Angel,
 Lombard street. 1663–(Bankrupt) 1679
LYNGARD Edward, *goldsmith*; parish of St Vedast's, Foster lane. (Buried) 1574
LYNNE James, *goldsmith*; parish of St Mary Woolnoth. 1553–(Buried) 1559
LYON —, *goldsmith*; Lincoln's Inn fields. 1701
LYONS Henry, *goldsmith*; parish of St Anne's, Blackfriars. (Married) 1586

MAAS Peter, *goldsmith*; London. 1567–1569
MABBE John, *goldsmith*; London. 1532–1576
MABBE John, Junr., *goldsmith*; London. 1575–(Died) 1617
 Tabard, Southwark. 1578
MABBE Stephen, *goldsmith*; London. 1585
MAC DUFF Lawrence, *plate-worker*; Old Bailey. 1773
MAC FARLANE Jessie, *plate-worker*; Cloth Fair. 1739
MACKARNES John, *goldsmith*; Minories. 1641–1643
MACKENZIE Charles, *gold snuff-box maker*; Craven buildings. (Deceased) 1749
MACKENZIE William, *plate-worker*; Great Windmill street, Haymarket. 1748–1752
MACKETT Wilmer, *goldsmith*; corner of Friday street, Cheapside. 1714–1725
MACKFARLANE Jacob, *silversmith*; No. 19 Old street. 1790–1793
MACKFARLEN J., *plate-worker*; Golden Ball & Canister, Cloth Fair. 1739
MACKMURDIE John, *plate-worker*; Bear alley, Fleet market. 1772
 Gunpowder alley. 1776
MACYE Robert, *goldsmith*; parish of St Vedast [Foster lane]. (Married) 1608
MADDEN John (cf. — MADDING), *goldsmith*; Cheapside. 1721
MADDEN Jonathan, *plate-worker*; Lombard street. 1702–1706
 (?) Lombard street. 1723, 1724
MADDEN Matthew, *plate-worker*; parish of All Hallows, Lombard street. 1692, 1693
 Lombard street. 1697
 Lombard street (?). 1695–1701
MADDING (or MADDEN) —, *goldsmith*; Golden Bottle, upper end of Cheapside.
 1716–(Died) 1730

LONDON GOLDSMITHS

MADDOCKES Thomas, *goldsmith*; parish of St Vedast, Foster lane. (Will proved) 1621
MADDOX William, *goldsmith*; parish of St Saviour's, Southwark. 1612–1642
MADDUX Edward, *goldsmith*; King's Head, St John's street. 1658–1687
MADOX (or MADDOXE) John, *goldsmith*; parish of St Saviour's, Southwark. 1638–(Died) 1660
MADOX Thomas, *goldsmith*; parish of St Matthew's, Friday street. (Will proved) 1655
MAGGOT —, *silversmith*; Golden Ball, near Bow Church, Cheapside. 1718
MAGNIAC Charles, *goldsmith*; Old Change. 1767
MAGNIAC Francis, *jeweller*; St John's square [Clerkenwell]. 1790–1793
MAGNIAC William, *jeweller*; St John's square, Clerkenwell. 1790–1793
MAIDMAN Ralph, *plate-worker*; Noble street. 1731–(Insolvent) 1737
MAIDSON John, *goldsmith*; London. 1668
MAILTON Samuel, *goldsmith*; No. 210 High street, Borough. 1790–1793
MAIN Andrew, *jeweller & toy-man*; No. 102 New Bond street. 1796
MAINWARING William, *goldsmith*; parish of St Mary Woolnoth. 1637–(Buried) 1659
MAISONNEUVE Benjamin, *jeweller*; Craven street, Strand. (Deceased) 1762
MAISONNEUVE Benjamin, *jeweller*; Craven street, Strand. 1768–1770
MAITLAND James, *silversmith*; Grasshopper, corner of Suffolk street. 1728–1730
MAKEMEID Christopher, *plate-worker*; Shoe lane. 1773
MAKEMEID Mary, *goldsmith*; Shoe lane. 1773
MAKEMEID William, *goldsmith*; Mortimer street. 1780
MAKENHEVED John (cf. John DE MAKENHEAD), *goldsmith*; parish of St Peter's, Wood
street. (Died) 1349
MAKEPEACE Robert, *goldsmith*; Serle street, Lincoln's Inn. 1767–1775
MAKEPEACE Robert II, *goldsmith*; No. 6 Serle street, Lincoln's Inn. 1794
MAKEPEACE Robert & SONS, *goldsmiths*; No. 6 Serle street, Lincoln's Inn. 1784
MAKEPEACE Robert & Thomas, *goldsmiths*; No. 6 Serle street, Lincoln's Inn. 1790–1796
MAKEPEACE Robert & CARTER Edward, *plate-workers*; Bartholomew close. 1777
MAKEPEACE Robert & CARTER Richard, *goldsmiths*; No. 6 Serle street, Lincoln's Inn. 1772–1777
MALBERRY (or MARBURY) Francis, *goldsmith*; parish of St Mary Woolnoth.
1621–(Buried) 1639
MALCOTT William, *goldsmith*; London. (Will proved) 1621
MALDIN Richard, *goldsmith*; Craven street, City road. 1794
MALETAYLE John (cf. John MALTAWIE), *goldsmith*; St Nicholas Acon. 1544
MALLARD Francois, *goldsmith*; Cranbourn alley. 1706
MALLESON Thomas, *goldsmith & jeweller*; Golden Cup, [No. 62] north side of Cornhill,
second house from Bishopsgate. 1765–1793
MALLESON & SON, *goldsmiths & jewellers*; No. 62 Cornhill. 1779–1781
MALLUSON Edward, *plate-worker*; Shoe lane. 1743
MALPAS Joseph, *goldsmith & jeweller*; Blowbladder street. 1748
No. 9 Wood street. 1755–1779
MALTAWIE John (cf. John MALETAYLE), *goldsmith*; London. 1557
MALTON John, *goldsmith*; Wheatsheaf & Star, Cheapside. 1716–1724
MALVAYNE Herre, *goldsmith*; London. 1380
MALYN Isaac, *plate-worker*; Gutter lane. 1710
MAMMAL [T. (?)], *goldsmith*; London. 1683
MAN Richard, *goldsmith*; parish of St Mary Woolnoth. 1604–1615

(199)

MAN WILLIAM (succeeded John Green), *goldsmith*; Three Flower-de-Luces & Crown, Henrietta street, Covent Garden. 1701

MANBY JOHN, *spoon-maker*; Little Britain. 1782

MANEY JOHN, *goldsmith*; parish of St Saviour's, Southwark. 1664

MANINGE — (cf. FRANCIS MANYNGE), *goldsmith*; London. (Before) 1666–1667

MANJOY GEORGE (cf. GEORGE MARJOY).

MANLY JAMES, *goldsmith & jeweller*; No. 119 Cheapside, opposite Bread street. 1784
 (And) No. 1 Suffolk street, Charing Cross. —

MANLY JAMES, *gold-worker & jeweller*; No. 28 Noble street, Foster lane. 1796

MANN THOMAS, *pawnbroker*; Catherine Wheel, Blackman street, Southwark. 1708–1710

MANN THOMAS, *plate-worker*; Foster lane. 1713
 Clerkenwell. 1736
 Albemarle street, Clerkenwell. 1739
 (?) Albemarle street, Clerkenwell. 1750

MANN THOMAS, *goldsmith*; Bishopsgate street. 1743

MANNERS JAMES, *silversmith*; Rose, Strand. 1734–1739

MANNERS JAMES, JUNIOR, *plate-worker*; Villiers street [Strand]. 1745

MANNING —, *goldsmith*; (?) London. 1620

MANNING —, *goldsmith & jeweller*; Dean street, Fetter lane. (Died) 1771

MANNING WILLIAM, *goldsmith*; Golden Key & Crown, Lombard street, opposite the General Post Office. 1747–1755

MANSELL SAMUEL, *silversmith*; Strand. 1773

MANTLE OLIVER, *goldsmith*; parish of St Michael's, Queenhithe. (Married) 1611

MANTLE WILLIAM, *goldsmith*; Lombard street. 1630–(Buried) 1665

MANWARRING CAVENDISH, *silversmith*; Philip lane. 1787

MANYNGE FRANCIS (cf. — MANINGE), *goldsmith*; Cheapside. 1642

MARBURY FRANCIS (see MALBERRY).

MARC JEAN LOUIS, *silversmith*; Savoy. 1700–1704

MARCH JACOB, *goldsmith*; Cornhill. 1763

MARCHAND PETER, *jeweller*; Hungerford market. 1694
 Porter street, Newport market. 1699

MARCHANT EUSEBIUS, *goldsmith*; Farringdon Without. 1583

MARCHANT GARRET, *goldsmith*; Blackfriars. 1576

MARCHANT PETER, *jeweller*; Billiter square, Fenchurch street. 1711
 Great St Helen's, Bishopsgate street. 1720

MARCHANT WILLIAM, *goldsmith & jeweller*; St Paul's Head court. 1775
 No. 255 High Holborn. 1784–1793

MARCHEGAY ALEXANDER, *jeweller*; parish of St Giles's. 1746

MARECHAL JEAN PIERRE, *jeweller*; Savoy. 1726

MARESCHAL THOMAS, *goldsmith*; London. (Died) 1340

MARGAN (or MARYAN) RICHARD & SHERBORNE THOMAS (see also SHERBORNE & MARYAN), *goldsmiths*; No. 6 Strand. (Partnership dissolved) 1790

MARGAS JACOB, *plate-worker*; St Martin's lane. 1706–1720
 St Martin's-in-the-fields. (Bankrupt) 1725

MARGAS SAMUEL (son of Jacob Margas), *plate-worker*; St Martin's lane. 1714
 King street, Covent Garden. 1720
 (?) King street, Covent Garden. 1730

MARIETTE MICHAEL, *jeweller*; Pearl street, Spitalfields. 1770

LONDON GOLDSMITHS

MARINEER Peter, *goldsmith*; Aldgate. 1618
MARJOY (MARGOY or MANJOY) George, *goldsmith*; Dog row, Whitechapel. 1720
MARKE Adrian, *goldsmith*; Blackfriars. 1568
MARKHAM William, *goldsmith*; parish of St Vedast, Foster lane. 1635–(Buried) 1647
MARKLAND Brian (see FRENCH & MARKLAND).
MARKS Mark, *jeweller*; Great Alie street, Goodman's fields. 1790–1793
MARLOW Jeremiah, *goldsmith & engraver*; Spread Eagle, Lombard street. c. 1677–(Retired) 1709
MARLOW Jeremiah, Junior, *goldsmith*; Blackmore's Head, within Aldgate. 1718–(Died) 1734
 London. 1724
 Abchurch lane. 1728
MARLOW John, *goldsmith*; Spotted Dog, Lombard street. 1686–1697
MARLOWE John, *goldsmith*; parish of St Matthew, Friday street. 1641
MARMEER Peter, *goldsmith*; Bassishaw ward. 1618
MARMION James, *goldsmith*; parish of St Dunstan's-in-the-West. c. 1673
 Golden Lion, Fleet street. 1694, 1695
MARMUR Peter, *goldsmith*; London. 1600
MARREL James (see MARTEL).
MARRIOTT Gabriel, *goldsmith*; London. 1645–1655
MARRIOTT (or MARRYOTT) John (see also RAWSON & MARRIOTT), *goldsmith*; London. 1666
MARRIOTT John, *goldsmith*; Cheapside. 1774
 Carey lane. 1788
MARSH Jacob, *plate-worker*; Swithin's lane. 1744–1748
 No. 78 Lombard street. 1753–1772
MARSH Richard, *goldsmith*; parish of St Denis Backchurch. 1641–1643
MARSH Thomas, *pawnbroker*; Golden Ball, Cursitor street. 1764
MARSHALL Henry, Sir,[1] *goldsmith*(?); London. 1737–(Died) 1754
MARSHALL J. (see FREEMAN & MARSHALL).
MARSHALL Jac., *goldsmith*; No. 8 Lombard street. 1774
MARSHALL Thomas, *goldsmith*; parish of St Mary Woolnoth. 1539–(Buried) 1578
MARSTON William, *goldsmith*; London. 1674
MARTEL Gabriel, *goldsmith*; Blackfriars. 1562–1564
MARTEL (or MARREL) James, *jeweller*; Golden Ball, Chandos street. (Deceased) 1728
MARTEN George, *goldsmith*; parish of St Vedast, Foster lane. 1575
MARTEN Richard, *goldsmith*; parish of St Peter's, West Cheap. (Married) 1584
MARTEN Thomas, *goldsmith*; parish of St Swithin's. (Married) 1604
MARTEN William, *goldsmith*; London. 1569
MARTIN —, *goldsmith*; Golden Ball, Chandos street. 1725
MARTIN Charles, *plate-worker*; Rose & Crown, Field lane. 1729
 London. 1740
MARTIN George, *goldsmith*; London. 1562
MARTIN George, *goldsmith*; parish of St Antholin [Budge row]. c. 1623
MARTIN James, *goldsmith & banker*; Grasshopper, Lombard street. 1717–1728
MARTIN James & Thomas, *goldsmiths*; Grasshopper, Lombard street. 1714–1725
MARTIN John, *jeweller*; No. 16 Brownlow street, Bedford row. 1763–1772
MARTIN John Joseph, *goldsmith*; Princes street, Westminster [Wardour street]. —
 Hedge lane. (Insolvent) 1774

[1] Lord Mayor of London, 1744–5.

MARTIN Luc, *goldsmith*; Savoy. 1710
MARTIN Nathaniel, *goldsmith*; London. 1620
MARTIN Richard, Sir[1] (see also KAYLE & MARTIN), *goldsmith & banker*; Harp, Goldsmith's
 row, Cheapside. 1558–(Died) 1617
MARTIN Richard, Junior,[2] *goldsmith & banker*; Grasshopper, Lombard street. c. 1584–(Died) 1618
MARTIN Thomas, *goldsmith*; parish of St Swithin. 1604
MARTIN Thomas (cf. STONE & MARTIN), *goldsmith & banker*; Grasshopper, Lombard
 street. 1702–1718
 Clapham. 1727
MARTIN (or MARTYN) Thomas, *cutler & silversmith*; Castle street, Leicester square. 1790–1793
MARTIN Thomas & James, *goldsmiths & bankers*; Grasshopper, Lombard street. 1715–1725
MARTIN & HOWELL (cf. MERTTINS & MITFORD), *goldsmiths*; Peacock, Cornhill. 1703
MARTINDALE —, *goldsmith*; No. 47 Gutter lane, Cheapside. 1796
MARTINEAU —, *jeweller*; Porter's street [near Newport market]. 1755
MARTINGO Moses, *silversmith*; New Bond street. 1777
MARVAUD Elias, *goldsmith*; London. 1728–1737
MARY Jean, *goldsmith*; Earls court [Drury lane]. 1722
 Duke street. 1728–1730
MARYAN Richard (see also MARGAN & SHERBORNE); White Hart court, Lombard
 street. 1795
MASGRET David, *jeweller*; Suffolk street. 1696
MASHAM Willoughby, *plate-worker*; Newgate street. 1701–1705
MASON —, *goldsmith*; London. 1666
MASON Asahel, *jeweller*; Lombard street. (Bankrupt) 1726
MASON Hudson, *goldsmith*; opposite St Martin's Church, Strand. 1770–1776
MASON Matthew, *goldsmith*; Foster lane. 1641–(Died) 1703
MASON Thomas, *goldsmith*; Golden Key, Lombard street. 1706
MASON Thomas, *plate-worker*; Sherborn lane. 1716–1720
 (?) Sherborn lane. 1733
MASON Thomas, *plate-worker*; Fish Street hill. 1739
MASON Thomas, *goldsmith*; London. 1744
MASON William, *goldsmith*; Tucke court, parish of St Andrew's, Holborn. 1692
MASON William, *watch-maker & goldsmith*; near East lane, Rotherhithe Wall. 1765–1779
MASOUN John, *goldsmith*; parish of St Peter Westcheap. 1608
MASQUERIER Lewis, *goldsmith & watch-maker*; Ring & Pearl, No. 12 Coventry street, near the
 Haymarket. 1753–1785
MASQUERIER & PERIGAL (cf. PERIGAL & MASQUERIER), *goldsmiths, jewellers &*
 toy-men; Ring & Pearl, No. 11 Coventry street, St James's. c. 1770
MASQUERIER Lewis & PERIGAL John (cf. PERIGAL & MASQUERIER), *goldsmiths &*
 watch-makers; No. 27 Coventry street. 1774–(Bankrupt) 1778
MASSE James, *jeweller*; Throgmorton street. 1727
MASSE James, *jeweller*; Old Broad street. 1753–1760
MASSÉ Theophilus, *goldsmith*; Rider's court [Newport street]. 1706
 London. (Mentioned) 1715
MASSEY Henry, *goldsmith*; London. 1469
MASSEY Samuel, *goldsmith*; No. 8 Foster lane. 1773–1788 (?)

 [1] Lord Mayor of London, 1589 and 1594, see *D.N.B.* [2] See *D.N.B.*

Plate XLVII

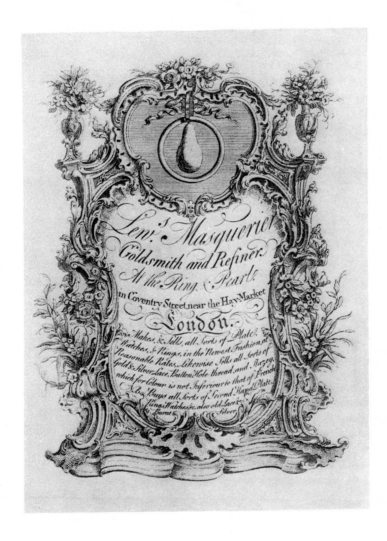

LEWIS MASQUERIER 1753–1785

Plate XLVIII

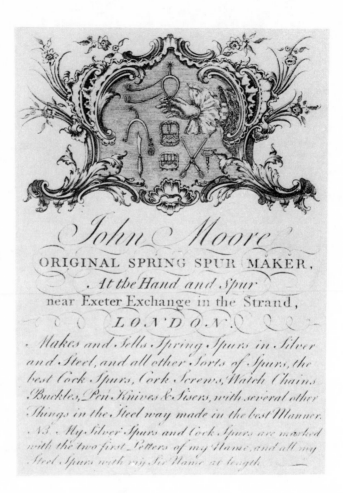

JOHN MOORE *circa* 1750

MASTER —, *pawnbroker*; Three Balls, Cow Cross. 1760

MASTERMAN JOHN (see also HOW & MASTERMAN), *goldsmith & watch-maker*; No. 1
White Hart court, Gracechurch street. 1753–1784

MASTERMAN & ARCHER, *goldsmiths*; No. 1 White Hart court, Gracechurch street. 1768

MASTERMAN & HOW, *goldsmiths*; White Hart court, Gracechurch street. 1753

MASTERMAN THOMAS, HOW & SPRINGHALL NATHANIEL, *goldsmiths*; No. 1 White Hart
court, Gracechurch street. (Partnership dissolved) 1800

MASTERMAN & SPRINGHALL, *goldsmiths & watch-makers*; No. 1 White Hart court, Grace-
church street. 1790–1796

MASTERS JOHN, *goldsmith*; Fleet bridge. (Died) 1641

MASTERS JOHN, *goldsmith & jeweller*; No. 52 Strand. 1796

MASTERS THOMAS, *goldsmith*; Milk street. (Died) 1636

MASTERS WILLIAM, *silversmith*; No. 243 High Holborn. 1790

MATHEW MARY (cf. MARY MATTHEW), *plate-worker*; George alley [Lombard street (?)]. 1707

MATHEW PHILIP, SIR (see SIR MATTHEW PHILIP).

MATHEW WILLIAM, *plate-worker*; Minories. 1711–1720

MATTHEW (or MATTHEWE) JOHN, *goldsmith*; parish of St Mary Woolnoth. 1562–1566
Parish of St Christopher's, Cornhill. 1571

MATTHEW JOHN, *plate-worker*; Ball alley [Lombard street (?)]. 1710

MATTHEW MARY (cf. MARY MATHEW also WILLIAM MATTHEW), *goldsmith*; London. 1700–1709

MATTHEW RICHARD, *goldsmith*; London. 1583–1589

MATTHEW WILLIAM, *plate-worker*; Foster lane. 1697
(?) Foster lane. 1711

MATTHEW WILLIAM (cf. MARY MATHEW), *plate-worker*; George alley, Lombard street. 1700

MATTHEWS —, *pawnbroker*; Crown, Cecil court, St Martin's lane. (Deceased) 1745

MATTHEWS JAMES, *silver turner*; No. 32 Gutter lane. 1790–1793

MATTHEWS JOHN (see NATHANIEL PEARCE & JOHN MATTHEWS).

MATTHEWS THOMAS (see GOODERE & MATTHEWS).

MATTHEWS WILLIAM, *plate-worker*; Clerkenwell. 1728–1733

MATTHEWS WILLIAM, *pawnbroker*; Crown, Peter street, the Mint, Southwark.
(Leaving off business) 1744

MAUDE BENJAMIN, *goldsmith & watch-maker*; St Martin's-le-Grand. 1771–1794

MAULTON —, *goldsmith*; Star & Wheatsheaf, Cheapside. 1716

MAUNDAY (or MAUNDY) THOMAS, *goldsmith*; Grasshopper, Foster lane. 1650
(?) Grasshopper, Foster lane. 1641–1665

MAUNDAY W., *goldsmith*; London. 1630–1634

MAURAN (or MORANT) GABRIEL, *goldsmith*; Greek street, St Anne's, Soho. 1706–1710

MAURICE JOHN, *goldsmith*; parish of St Mary Woolnoth. 1683

MAURICE MARGARET (see MARY BROWNE & MARGARET MAURICE).

MAWSON JOHN & CO., *goldsmiths & bankers*; Golden Hind, Fleet street. 1668–1680
Golden Buck, over against St Dunstan's Church, Fleet street. 1675–c. 1683

MAY DANIEL (see HARRIS & MAY).

MAY RICHARD, *goldsmith*; St John street. 1769
Quakers' buildings [= (?) Quakers' Meeting House, White Hart yard,
Lombard street]. 1771–1773

MAY RICHARD & DORRELL JANE, *plate-workers*; Quakers' buildings. 1771
(?) Quakers' buildings. 1781

(203)

MAYASTRE (MAYAFFREE or MAYOFFE) ANDREW, *jeweller*; Golden Head, Tavistock
street, Covent Garden. 1722–1745

MAYE RICHARD, *goldsmith*; parish of All Hallows, Honey lane. (Will proved) 1622

MAYE THOMAS, *goldsmith*; London. 1560–1569
Parish of All Hallows, Bread street. 1581

MAYERS & JACOBS, *warehousemen & jewellers*; Little Duke's place, Aldgate. 1772
No. 46 St Mary Axe. 1774

MAYHEW JOHN, *goldsmith*; London. 1390–1399

MAYHEW JOHN,[1] *goldsmith*; near the Hermitage bridge, Wapping. 1666

MAYNARD CHARLES, *jeweller & watch-maker*; St Martin's-le-Grand. 1752–1774

MAYNARD R., *goldsmith*; London. 1545

MAYNE ROBERT, *goldsmith*; London. 1512

MAYNWARING ARTHUR, *goldsmith*; parish of St John Zachary. (Married) 1642
London. 1692

MAYO JOSEPH, *jeweller*; Craven street, Strand. 1770–1777

MAYOFFE (or MAYASTRE) ANDREW, *jeweller*; Golden Head, Tavistock street. 1722–1745

MAYS NATHANIEL, *goldsmith*; St James's. 1744

MEACH RICHARD, *working goldsmith*; No. 156 Upper Thames street. 1790–1793

MEAD AMBROSE, *goldsmith*; Bird in Hand, Fleet street. 1665

MEAD JOHN, *goldsmith & banker*; Goat, next door to the Fountain tavern, Strand. 1683–1702
Black Lion, Temple Bar. 1705–1713

MEAD WILLIAM,[2] *goldsmith & banker*; Goat, Strand. [N.D.]
Black Lion, Temple Bar. 1715–(Bankrupt) 1723. (Deceased) 1724

MEAD & BRIGHTHALL, *goldsmiths & bankers*; Black Lion, Temple Bar. 1715

MEADE RICHARD, *goldsmith*; London. 1773

MEADHURST WILLIAM, *goldsmith*; London. 1773

MEADOW CHARLES, *goldsmith*; Aldersgate ward. 1618

MEADOWES CHARLES, *goldsmith*; parish of St Mary Staining. 1641

MEARS WILLIAM, *pawnbroker*; Golden Ball, Crown court, Long walk, near Christ Church
Hospital. 1717

MEARS WILLIAM, *goldsmith*; St Martin's-le-Grand. 1768–1773

MEDE EDWARD, *goldsmith*; parish of St Vedast, Foster lane. 1575

MEDLEY ROBERT, *goldsmith*; London. 1560–1564
Parish of St Vedast, Foster lane. (Buried) 1594

MEDLYCOTT EDMUND, *plate-worker*; Golden Ball, Foster lane. 1748–1755

MEELE —, *pawnbroker*; White Bear, Little Newport street. 1720

MEGAULT —, *jeweller*; Castle street, near Leicester fields. 1721

MEGRET DAVID (see MESGRET).

MELL CHARLES, *goldsmith*; parish of St Mary Abchurch. 1674

MELTHAM ROBERT, *goldsmith*; Wood street. 1511

MELTON —, *goldsmith*; London. 1516

MENIER GUILLAUME, *goldsmith*; St Andrew's street. 1706, 1707

MENNELL (see MEYNELL).

MENNET FRANCIS LEWIS, *jeweller*; Tottenham Court road. (Insolvent) 1769

MERCER THOMAS, *plate-worker*; West street, Soho. 1740

[1] Issued a token (Williamson's [London] No. 1347). See page 44.
[2] The business was taken over by Child's the bankers.

MERILL James, *goldsmith*; parish of St Vedast, Foster lane. (Married) 1606-(Will proved) 1625
MERITON (or MERRITON) Samuel, *plate-worker*; Anchor, Huggin alley, Wood street. 1746
MERITON Samuel, *goldsmith*; No. 18 Foster lane, Cheapside. 1784-1796
MERITON Thomas, *goldsmith*; Foster lane. 1800
MERRELL Walter, *goldsmith*; parish of St Vedast, Foster lane. 1634-(Buried) 1636
MERRITT —, *pawnbroker*; Three Blue Balls, Rose street, Covent Garden. 1764
MERRY John, *jeweller*; Smithfield Bars. 1747
MERRY John, *silversmith*; No. 76 Fleet street. 1790
MERRY Thomas, *silversmith*; Maidenhead, Maiden lane (Married) 1699
MERRY Thomas, *plate-worker*; London. 1724
 Smithfield Bars. 1727-1745
 St John street. 1731
 St Sepulchre's. 1734
MERRY Thomas, *goldsmith*; London. 1773
MERTIN —, *jeweller*; Threadneedle street. 1747
MERTTINS (or MERTTIN) George, Sir,[1] *goldsmith & watch-maker*; Peacock, near Royal
 Exchange, Cornhill. 1688-(Died) 1727
MERTTINS Henry, *jeweller*; Throgmorton street. 1725
MERTTINS John, *jeweller*; Peacock, near Royal Exchange, Cornhill. 1685-1703
MERTTINS Michael (see MITFORD & MERTTINS).
MERTTINS & HOWELL (cf. MARTIN & HOWELL).
MERTTINS George, Sir & MITFORD John, *goldsmiths*; Peacock, Cornhill. 1712-1716
MERZ Lauret, *goldsmith*; Plough court, Carey street. 1773
MESGRET (or MEGRET) David, *jeweller*; Red Balcony, Suffolk street. 1695, 1696
MESYNGRE Richard, *goldsmith*; London. 1465
METCALFE —, *goldsmith*; Crown & Sceptre in Holborn, near Fetter lane. 1707
METCALFE Heselrige, *jeweller*; Wood street. (Died) 1748
METCALFE James, *goldsmith*; Dean street [Fetter lane]. 1692
METCALFE Mary, *goldsmith*; Crown & Sceptre, Fetter lane end in Holborn. 1714-(Died) 1718
METCALFE Thomas, *goldsmith*; London. 1550-1566
METHAM Robert, *plate-worker*; Butcher Hall lane. 1773
METHAM Robert, *jeweller*; No. 146 Cheapside. 1784-1793
 No. 149 Cheapside. 1796
METHUEN George, *plate-worker*; Heming's row [St Martin's lane]. 1743-1761
METTAYER Lewis, *plate-worker*; Acorn, Pall Mall. 1700-1725
 At the end of Suffolk street. 1712-1716
 London. 1735
MEURE Peter (see ARCHAMBO & MEURE).
MEVER James, *goldsmith*; St Laurence Pountney. 1568
MEWBURN (or NEWBURN) John, *goldsmith*; Hare court. 1793-1796
MEYNELL Francis,[2] *goldsmith & banker*; Lombard street. (Before) 1650-1666
 Removed to Broad street at the Great Fire. (Died) Oct. 1666
MEYNELL Francis, *goldsmith*; London. 1773-1782
MEYNELL Isaac, *goldsmith*; Lombard street. 1665-(Died) 1675

[1] Lord Mayor of London, 1724-5.
[2] Mentioned in Pepys' *Diary*, 18 Sep. 1662, 19 Jan. 1663, 1 Feb. 1664, 8 June 1665, 5 Oct. 1665 & 8 Oct. 1666.

MICHAEL James, *goldsmith*; next door to the Bull & Gate inn, Holborn. 1721

MICHAEL John, *pawnbroker*; next door to the Bull & Gate, Holborn. (Deceased) 1720

MICHAELL —, *goldsmith*; High Holborn. 1701

MICHELL — (see HODSOLL & MICHELL).

MICHELL Edmund, *goldsmith*; London. 1660–1674

MICHELL Edward, *goldsmith*; London. 1640–1652

MICHON Pierre, *goldsmith*; London. 1688
Pearl & Crown, Grafton street, Soho. 1705–1710

MICKIN —, *goldsmith*; over against Gray's Inn. 1694

MIDDLETON George (see also MIDDLETON & CAMPBELL), *goldsmith & banker*; Three
Crowns, Strand, near St Martin's lane. 1692–(Died) c. 1745

MIDDLETON Hugh, Sir (see Sir Hugh MYDDELTON).

MIDDLETON James, *pawnbroker*; Gun-bank, St George's East. 1793

MIDDLETON John, *goldsmith*; parish of St Mary Woolnoth. (Buried) 1618

MIDDLETON John, *pawnbroker*; Three Bowls & Anchor (or Three Blue Balls & Anchor),
St Clement's lane, Clare market. 1745

MIDDLETON Simon, *goldsmith*; London. 1644–1668

MIDDLETON William, *goldsmith*; London. 1620

MIDDLETON William, *plate-worker*; Leadenhall street. 1697–1705

MIDDLETON George & CAMPBELL John, *goldsmiths & bankers*; Three Crowns, Strand,
near St Martin's lane. 1692–c. 1712

MIDDLETON George & CAMPBELL George (succeeded by George CAMPBELL &
David BRUCE, and later CAMPBELL & COUTTS), *goldsmiths & bankers*;
Three Crowns,Strand, near St Martin's lane (or near Durham yard). 1692–c. 1745

MIEG Charles, *plate-worker*; Porter street [Newport market]. 1767

MIERS John, *jeweller*; No. 111 Strand, eleven doors west of Waterloo bridge. 1796

MIGAULT —, *jeweller*; Ring & Pearl, Porter street [near Newport market]. 1724

MIGAULT Oliver, *jeweller*; Castle street, over against Green street, near Leicester fields. 1717

MILLER — (see ELLIOTT & MILLER), *goldsmith*; Oxford street. 1797

MILLER Andrew, *goldsmith*; parish of St Leonard's, Foster lane. (Married) 1653

MILLER Anne, *goldsmith*; London. 1773

MILLER Charles, *pawnbroker*; Seven Stars, Petticoat lane. 1726

MILLER Henry, *plate-worker*; Bow lane. 1712–1714
Noble street. 1720
Parish of St Sepulchre's. (Insolvent) 1729
London. 1739–1755

MILLER Isaac, Junior, *pawnbroker*; Golden Anchor, Whitecross street. 1708

MILLER William, *jeweller*; Queen street, Bartholomew close. 1784
No. 14 St Ann's lane, Aldersgate. 1790–1793
No. 15 Wine Office court, Fleet street. 1796

MILLINGTON John, *plate-worker*; Butcher Hall lane. 1718–1720
Bishopsgate. 1728

MILLINGTON Thomas, *jeweller & engraver*; No. 31 Gutter lane, Cheapside. 1763–1774

MILLS Charles, *pawnbroker*; Catherine Wheel, Houndsditch. (Deceased) 1725

MILLS Dorothy (cf. MILLS & SARBIT, also Dorothy SARBIT), *plate-worker*; Saffron hill.
1752–1754
(?) London. 1754–1767

Plate XLIX

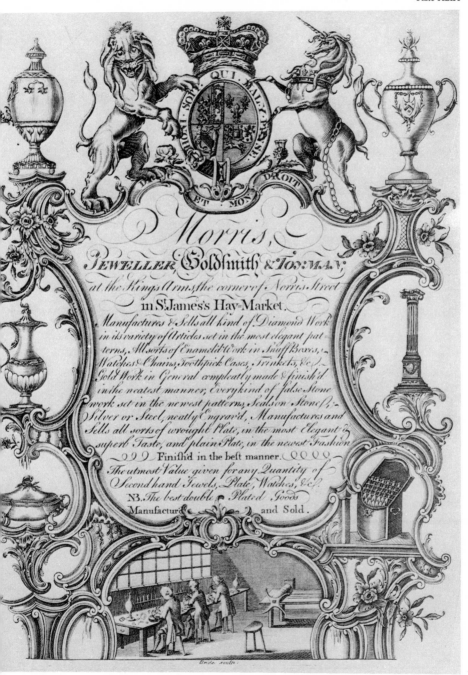

Plate L

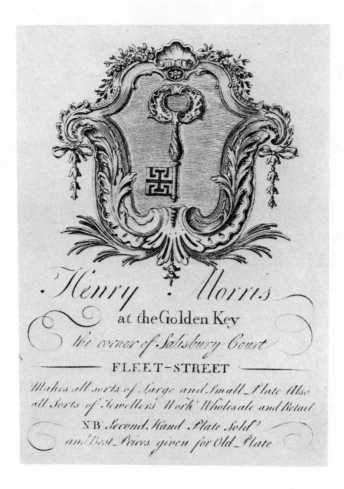

HENRY MORRIS *1733–circa 1760*

MILLS Hugh, *plate-worker*; Saffron hill. 1745–1749

MILLS John, *goldsmith*; Leopard, against St Clement's, Strand. 1687

MILLS Richard (see also HANNAM & MILLS), *plate-worker*; London. 1729–1742
 White Horse alley. 1755

MILLS Dorothy & SARBIT Thomas (cf. Dorothy SARBIT), *goldsmiths*; Saffron hill. 1746, 1747

MILWARD William, *goldsmith*; Foster lane. 1687

MINCE James, *goldsmith*; Bell square [Foster lane]. 1783–1789

MINCE James & HODGKINS William (see also William HODGKINS), *plate-workers*; Bell
 square, Foster lane. 1780

MINORS Thomas, *goldsmith & banker*; Broad street. 1734
 Vine, Lombard street. 1738

MINORS & BOLDERO, *goldsmiths & bankers*; Vine, Lombard street. 1742–1760

MINSHULL —, *goldsmith*; Golden Falcon, against Hungerford market, Strand. 1711–1712

MINSHULL Spicer, *goldsmith*; London. 1725

MINSHULL (or MINSHALL) Thomas, *goldsmith*; Golden Falcon (or Falcon), Fleet street.
 1679–1699

MISPLACE Richard, *silversmith*; Serle street, Lincoln's Inn. 1784

MITCHELL James, *goldsmith*; No. 84 Little Tower hill. 1784–1793

MITCHELL Richard, *goldsmith*; parish of St Agnes, Aldersgate. (Married) 1583

MITCHELL Thomas (see also VIET & MITCHELL), *jeweller*; Dial & King's Arms, Cornhill.
 1742–1744
 Cornhill, near the Royal Exchange. 1746–1751

MITCHELL Viet (see also VIET & MITCHELL), *jeweller & goldsmith*; No. 6 Cornhill. 1768–1793

MITCHELL Robert & VIET (see also VIET & MITCHELL), *clock-makers*; No. 6 Cornhill. 1768

MITCHELSON James, *jeweller*; Crown & Pearl, Throgmorton street, near the Royal
 Exchange. [N.D.]

MITFORD John & MERTTINS Michael (see also George MERTTINS & John MITFORD),
 goldsmiths; Peacock, Cornhill. (Bankrupt) 1720

MOATE Henry, *silversmith*; next door to the Mug in Long Acre. 1718
 Bow street, Covent Garden. (Bankrupt) 1723

MOLCOTT William, *goldsmith*; parish of St Mary Woolchurch Haw. (Buried) 1621

MOLDE Nicholas, *goldsmith*; London. 1553

MOLIERE John & JONES Dyall, *plate-workers*; Clerkenwell green. 1773

MOMPESSON Edward, *goldsmith*; Black Lion, Birchin lane. 1693–1701

MONDAY (or MUNDAY) Robert, *goldsmith*; Horsley down, Southwark. 1698–1707

MONDET A., *jeweller*; Old Feathers, near Argyle buildings, Oxford road. [N.D.]

MONGER Peter, *goldsmith*; parish of St Anne and St Agnes. 1691–1693
 Parish of St Mary Woolnoth. 1694–1696

MONGSON —, *jeweller*; Porter street, Soho [near Newport market]. 1751

MONK —, *pawnbroker*; Three Blue Balls, Little Russell street, Covent Garden. 1765

MONK Edward, *goldsmith & jeweller*; No. 171 Fleet street. 1790–1793

MONKS —, *pawnbroker*; Three Balls, Russell street, Covent Garden. 1764

MONTAGUE Benjamin, *goldsmith*; No. 10 Clerkenwell green. 1779–1793

MONTAGUE Benjamin & J. J., *goldsmiths*; Clerkenwell green. 1788

MONTAGUE Benjamin & PINGSTON Robert (see Robert PINGSTON), *goldsmiths*;
 Clerkenwell green. (Partnership dissolved) 1788

MONTGOMERY A., *plate-worker*; London. 1697
 Cambridge street. 1729–1750

LONDON GOLDSMITHS

MONTGOMERY JOHN, *plate-worker*; Angel, corner of Cambridge street, Golden square. 1729–1749
 Angel, Silver street, Golden square. 1742–1749
 London. 1750

MONTJOY GEORGE, *goldsmith*; Suffolk street. 1709

MOODY WILLIAM, *plate-worker*; Berwick street. 1756–1760

MOON & EDWARDS (cf. MOORE & EDWARDS), *gold and silversmiths*; No. 4 Holborn
 hill. 1790

MOOR & PAYNE (see also PAYNE & MOOR), *goldsmiths*; King's Arms, Lombard street.
 1687–1704

MOORE A., *goldsmith*; London. 1650

MOORE AARON, *pawnbroker*; Three Bowles, Salisbury court. 1725

MOORE ANDREW, *plate-worker*; Bridewell. 1697

MOORE DAVID, *goldsmith*; Cheapside. 1792

MOORE EDWARD, *goldsmith*; Gracechurch street. 1773

MOORE ESTHER, *silversmith*; No. 37 Gracechurch street. 1790–1793

MOORE JOHN, *goldsmith*; London. 1597

MOORE JOHN, *silver spur-maker*; Hand & Spur, near Exeter Exchange in the Strand. c. 1750

MOORE JOHN, *working goldsmith*; No. 118 Fleet street. 1758–1774
 Silver street. 1778
 London. 1793

MOORE JOSEPH, *goldsmith*; parish of St Mary Woolnoth. 1688–1701

MOORE NICHOLAS, *goldsmith*; parish of St Peter's, West Cheap. 1598

MOORE RICHARD, *goldsmith*; Star court. (Buried) 1707

MOORE ROBERT, *goldsmith*; at Mr Webb's in Fleet street. 1642
 Charing Cross. (Will proved) 1651

MOORE ROBERT, *goldsmith*; parish of St Mary Woolnoth. 1692, 1693

MOORE ROBERT, *gold-beater*; Long lane. 1769

MOORE SAMUEL, *goldsmith*; Lombard street. 1632–(Died) 1678

MOORE THOMAS, *goldsmith*; Swan alley. (Insolvent) 1748
 London wall. 1750–1752

MOORE WILLIAM (see also MOORE & GEARING), *goldsmith & watch-maker*; No. 55
 Paternoster row. 1774–1788
 No. 5 Ludgate street. 1790–1796

MOORE & EDWARDS (cf. MOON & EDWARDS), *goldsmiths & jewellers*; No. 4 Holborn.
 1790–1793

MOORE & GEARING (see also WILLIAM MOORE), *goldsmiths & watch-makers*; No. 55
 Paternoster row. 1784

MOORE & SON, *goldsmiths & jewellers*; No. 20 New street, Covent Garden. 1790–1796

MOORE ROBERT & THOMAS JEREMIAH (see also JEREMIAH THOMAS), *goldsmiths*; Artichoke,
 Exchange alley. 1684–1692

MOORIS JOHN, *goldsmith*; parish of St Vedast, Foster lane. (Buried) 1583

MOOTHE JOHN (cf. JOHN MOTHE), *goldsmith*; London. 1580

MORANT GABRIEL (see GABRIEL MAURAN).

MORDEN GEORGE, *goldsmith*; parish of St Bride's, Fleet street.
 (Married) 1619–(Will proved) 1624

MORDEN SAMPSON, *goldsmith*; St Martin's-le-Grand. 1568–1582

MORE EDWARD, *goldsmith*; Cripplegate. (Deceased) 1594

MORGAN —, *pawnbroker*; Three Balls & Gold Ball, Bow street. 1764

MORGAN Richard, *plate-worker*; Aldersgate street. 1766
MORGAN William, *goldsmith*; parish of St Vedast, Foster lane. 1641
 Parish of St Alban's, Wood street. (Will proved) 1653–1656
MORGAN William, *goldsmith*; Sun, Jermyn street. 1706
MORGASS Samuel, *silversmith*; Sugar Loaf, on the Paved Stones in St Martin's lane. 1715
MORISON James (see James MORRISON).
MORLEY E., *goldsmith*; London. 1799
MORLEY John, *goldsmith*; London. 1588–1594
MORLEY T. (see BASKERVILLE & MORLEY).
MORLEY Thomas, *goldsmith*; parish of St Catherine Clee. 1610
MORLEY Thomas, *goldsmith*; No. 7 Westmoreland buildings [Aldersgate street]. 1790–1793
MOROCOCK John, *watch-case maker*; Rope-makers alley. 1771
MORRELL Richard, *goldsmith*; Foster lane. 1641–(Died) 1703
MORREST —, *goldsmith*; without Temple Bar. 1705
MORREYS John (cf. John MORRIS), *goldsmith*; parish of St Mary Woolnoth. 1586
MORRICE —, *goldsmith*; near Hospital Gate, Smithfield. 1728
MORRILL —, *pawnbroker*; Three Bowls, Rose street, Covent Garden. 1759
MORRIS —, *jeweller, goldsmith & toyman*; King's Arms, corner of Norris street, St James's,
 Haymarket. c. 1760
MORRIS George, *goldsmith & enameller*; Well Close square. 1750
 White Swan, Foster lane. 1751–1752
MORRIS Henry, *jeweller, goldsmith & toyman*; Golden Key, corner of Salisbury court, [No. 82]
 Fleet street. 1733–1777
MORRIS Henry, *plate-worker*; Smithfield. 1739
MORRIS Henry & SON, *goldsmiths*; Golden Key, near Salisbury court, Fleet street. 1751, 1752
MORRIS John, *goldsmith*; London. (Died) 1583
MORRIS John (cf. John MORREYS), *goldsmith*; London. 1585–1589
MORRIS John, *goldsmith*; Almary churchyard [St Mary Aldermary]. 1677
MORRIS William (see JONES & MORRIS).
MORRISET James, *goldsmith*; Denmark street, Soho. 1773–1778
MORRISET James & WIRGMAN Gabriel, *goldsmiths*; Denmark street, Soho.
 (Partnership dissolved) 1778
MORRISET R. & LUKIN C., *goldsmiths & jewellers*; No. 22 Denmark street, Soho. 1784–1796
MORRISON (or MORISON) James, *goldsmith*; Bartholomew close. 1740–1752
 Giltspur street. 1776–1780
MORRISON Richard (see BRISCOE & MORRISON), *jeweller & goldsmith*; St Paul's
 churchyard. 1768
 Three Kings & Golden Ball, No. 15 Cheapside, opposite Foster lane. 1769–1783
 [Succeeded Stafford BRISCOE.]
MORRITT John, *goldsmith & jeweller*; No. 93 High Holborn. 1790
MORSE —, *jeweller*; Orange street. 1731
MORSE Thomas, *goldsmith*; Spotted Dog, Lombard street. 1718–1724
MORSON James, *plate-worker*; Foster lane. 1716–1722
MORSON Richard, *goldsmith & banker*; Anchor & Three Crowns (or Three Crowns & Anchor),
 Lombard street. 1700–1736
MORSON Richard (see also MORSON & STEPHENSON), *goldsmith & jeweller*; No. 98
 Fleet street. 1774
 No. 12 Ludgate street. 1775
 No. 129 Ludgate hill. 1777

S

MORSON Richard & STEPHENSON Benjamin (see also Benjamin STEPHENSON),
goldsmiths; Golden Cup, [No. 5] Ludgate hill. 1760–1774
Corner of Bride lane, No. 98 Fleet street. 1760–1772
(Partnership dissolved) 1774
MORY Robert, goldsmith; Golden Cock, Strand. 1693
Naked Boy & Bunch of Grapes, near Hungerford market, Strand. 1693–1699
MORY Robert, goldsmith; London. 1724
MOSER George Michael,[1] gold-chaser; Greyhound court, Strand. 1736
London. c. 1725–(Died) 1783
MOSER John, filigree-worker in gold and silver; New Round court, Strand. 1763
MOSTIAN — (see Thomas MUSCHAMP).
MOTHE John (cf. John MOOTHE), goldsmith; parish of St Vedast, Foster lane. (Buried) 1617
MOTHERBY John, plate-worker; Bull and Mouth street [St Martin's-le-Grand]. 1718
MOULDEN Thomas, goldsmith; Three Crowns, lower end of Cheapside. 1733–1739
MOULTON Samuel, buckle-maker; Southwark. 1777
No. 210 High street, Borough. 1784–1796
MOUNTENAY Edward, goldsmith; parish of St Vedast, Foster lane. 1740
MOUNTFORD Hezekiah, plate-worker; Red Lion court. 1711
MOUNTFORT H., jeweller & toyman; next yᵉ Temple gate, Fleet street. c. 1760
MOWDEN David, plate-worker; Crown & Seal, Noble street. 1738
MUIRE Peter, goldsmith; Coventry street. 1773
MUNDAY Robert (see Robert MONDAY).
MUNDY John, Sir,[2] goldsmith; parish of St Peter in Cheap. 1510–(Buried) 1537
MUNDY Roger, Sir, goldsmith; London. 1518–(Died) 1537
MUNDYE Rogier, goldsmith; London. 1553
MUNDYE Vincent, goldsmith; London. 1533–1553
MUNNS John, plate-worker; Gutter lane. 1753
London. 1776, 1777
MUNSON —(?) (cf. John MAWSON), goldsmith; Golden Hind, over against St Dunstan's
Church, Fleet street. 1672
MURE George, pawnbroker; Golden Ball, Little Queen street, Oxford road. 1756
MURRALL Thomas, goldsmith; Gwin's buildings, Islington. 1780
MURRAY Francis, goldsmith; Windmill street. 1799
MURRAY G. K. goldsmith; Golden Heart, St James's street. 1755
MURRAY James (see KANDLER & MURRAY).
MURTON Richard, goldsmith; parish of St Michael Bassishaw. (Buried) 1595
MUSCHAMP Thomas, goldsmith; London. 1463
MUSCHAMPE Thomas, goldsmith; Ring & Ruby, Lombard street. 1560–(Buried) 1578
MUSSARE —, jeweller; York buildings [Strand]. 1705
MYDDELTON Hugh, Sir,[3] goldsmith; Basinghall street. 1600
Golden Inn, Cheapside. 1609–1615. (Born) 1555–(Died) 1631
MYLIUS Charles, gold and silver button-maker; Hanover street, Long Acre. (Bankrupt) 1766
MYLLES —, goldsmith; parish of St Vedast, Foster lane. 1587 (?)

NAIZON Francis, jeweller & goldsmith; No. 42 Poultry. 1781–1784

[1] First Keeper of Royal Academy 1768, see D.N.B.
[2] Mayor of London, 1522–3. [3] Founder of New River Company, see D.N.B.

Plate LI

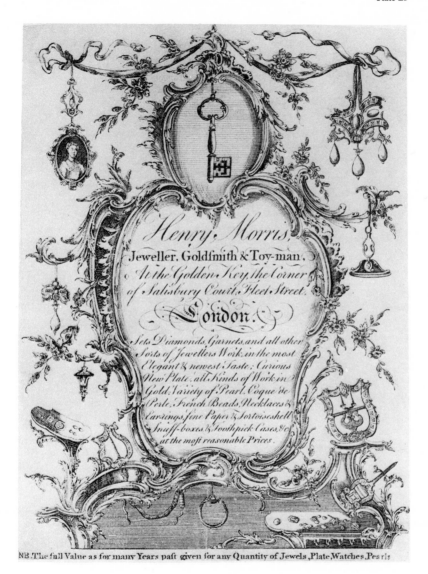

NB.The full Value as for many Years past given for any Quantity of Jewels ,Plate,Watches,Pearls

HENRY MORRIS *circa* 1760–1777

Plate LII

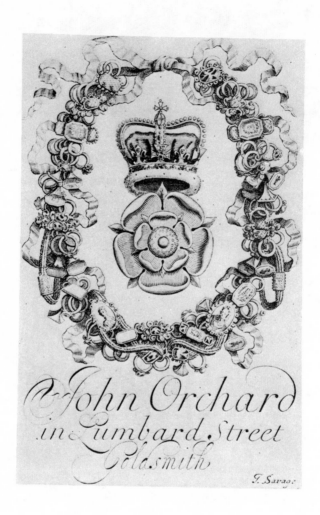

JOHN ORCHARD 1695-1697

NANFAN JOHN, *goldsmith*; parish of St Bride's, Fleet street. (Married) 1620
NASH BOWLES, *plate-worker*; St Martin's-le-Grand. 1720–1724
NASH GAWAN, *plate-worker*; Wood street. 1726
Carey lane. 1739
NASH JACOB, *silversmith*; Lombard street. 1755
NASH ROBERT, *goldsmith*; No. 20 Hanover street. 1790–1793
NASH WILLIAM, *jeweller*; Princes street, near Stocks market. 1701
London. 1724
NASH & WILSON (cf. NORTH & WILSON), *goldsmiths*; No. 27 Holywell street, Strand. 1790
NATHAN ABRAHAM, *jeweller*; London. 1723
NATTER GEORGE SIGISMUND, *plate-worker*; Fleet street. 1773–1778
NAYER WILLIAM, *goldsmith*; parish of St Vedast, Foster lane. (Married) 1656
NAYLOR —, *jeweller*; King street, Covent Garden. 1748
NAYLOR JOHN, *spoon-maker*; Bridgewater street. 1773
NEALE ANTHONY, *goldsmith*; London. 1553
NEALE CHARLES, *silver-turner*; Wenlock street [City road]. 1782
NEALE RICHARD, *goldsmith*; London. 1655
NEALSON RICHARD, *pawnbroker*; Five Roses, Saffron hill, near Holborn. 1704–1708
NEAVE FRANCIS, *goldsmith*; Hart, Lombard street. 1649
NEDOM THOMAS, *goldsmith*; parish of St Vedast, Foster lane. (Buried) 1581
NEEDHAM ROBERT, *silversmith & jeweller*; No. 56 Piccadilly. 1790–1796
NEILD JAMES[1] (succeeded by GOLDNEY), *jeweller, goldsmith & sword cutler*; No. 4 St James's
street, near the Royal Palace. 1770–1794. (Died) 1814
NEILD & GOLDNEY (see also GOLDNEY), *goldsmiths & jewellers*; No. 4 St James's street. 1796
NEILL THOMAS, *silversmith*; No. 26 Surrey street, Strand. 1790–1793
NELE —, *goldsmith*; London. 1516
NELME —, *goldsmith*; Golden Hart, Bishopsgate street. 1693
NELME ANTHONY, *goldsmith*; Golden Bottle, Amen corner, Ave Mary lane. 1685–(Died) 1722
Foster lane. 1691
NELME FRANCIS, *goldsmith*; Gold Bottle, Ave Mary lane. 1721
St Martin's, Ludgate. 1736
NELME FRANCIS, *goldsmith*; Ave Mary lane. 1722–1727
London. 1739–1759
NELME ANTHONY & FRANCIS, *goldsmiths*; Gold Bottle, Ave Mary lane. 1721
NELTHORPE GEORGE, *jeweller & goldsmith*; Rose & Crown, over against the Blue-Coat
Hospital gate, in Newgate street. c. 1710
NELTHORPE HENRY, *goldsmith & banker*; Rose, Lombard street. 1675–1677
NELTHORPE RICHARD, *goldsmith*; Exchange alley. 1694–1713
London. 1724
NENE THOMAS (see THOMAS NEVE).
NERVELL GEORGE, *goldsmith*; London. 1729
NETHERTON SAMUEL (see WICKES & NETHERTON).
NEVE THOMAS, *goldsmith*; parish of St Mary Woolnoth. 1629
NEVETT THOMAS, *goldsmith*; parish of St Mary Woolnoth. 1623
Green Dragon, Lombard street. 1637–(Died) 1655
NEVILLE JOHN, *plate-worker*; Hand & Ring, Norris street, Haymarket. 1743–1752
London. 1770 (?)

[1] See page 7.

NEVILLE JOHN & CO., *goldsmiths*; Haymarket. 1740

NEVILLE & CRAIG (see also CRAIG & NEVILLE), *goldsmiths*; Haymarket. 1744

NEVILLE & DEBAUFRE (see also RICHARD DEBAUFRE), *goldsmiths*; Hand & Ring, Norris
Street, St James's. 1747

NEWBERIE WILLIAM, *goldsmith*; parish of St Giles, Cripplegate. (Married) 1670

NEWBOLD (or NEWBOLE) GEORGE, *goldsmith*; parish of St Mary Woolnoth. 1580–1593

NEWBURN JOHN (see MEWBURN).

NEWCOMBE JOSEPH, *jeweller*; No. 8 New street, Shoe lane. 1790–1793

NEWELL GEORGE (see GERRARD & NEWELL), *goldsmith*; Three Lions, Lombard street.
1701–c. 1703

Fox, Lombard street. c. 1703–1728

Cannon street. 1727

NEWELL JOSEPH & GEORGE, *goldsmiths*; London. (Bankrupt) 1708

NEWENHAM RICHARD, *pawnbroker*; Bell, Charterhouse lane. 1702

NEWHALL HENRY, *goldsmith*; London. 1550

NEWMAN ALLAN, *goldsmith*; London. 1483–1488

NEWMAN CAIUS, *goldsmith*; London. (Died) 1613

NEWMAN GABRIEL, *goldsmith*; London. 1560–1569

NEWMAN JOHN (cf. DYER & NEWMAN), *goldsmith & jeweller*; No. 49 Lombard street.
1774–1784

NEWMAN JOHN, *goldsmith & jeweller*; No. 27 Piccadilly. 1796–1809

No. 25 Piccadilly. 1814–1817

No. 17 Piccadilly. 1825

NEWMAN RICHARD, *goldsmith*; parish of St Mary Woolnoth. 1692, 1693

NEWMAN ROBERT, *gold chain-maker*; Cock lane, near Snow hill conduit. c. 1760

NEWMAN SAMUEL, *working goldsmith*; Cornhill ward. 1691/2, 1692/3

NEWTON — (see also JONATHAN NEWTON & THOMAS COLE), *goldsmith & jeweller*;
Crown & Acorn, Lombard street. 1711

Acorn & Crown, Lombard street. 1738

NEWTON — (see PEARCE & NEWTON).

NEWTON CHARLES, *silversmith*; Little Old Bailey. (Insolvent) 1725

NEWTON JOHN, *plate-worker*; Lombard street. 1720

Maiden lane. 1739–1742

NEWTON JOHN, *goldsmith*; Blackamoor's Head, within Aldgate. 1748–1753

NEWTON JOHN, *jeweller*; No. 76 Lamb's Conduit street. 1790–1793

NEWTON JONATHAN (cf. NEWTON & COLE), *plate-worker*; Lad lane. 1711

Anchor & Crown, Lombard street. 1718–1740

NEWTON RICHARD, *goldsmith*; Holborn. (Bankrupt) 1777

NEWTON RICHARD JENKINSON, *goldsmith*; James street, Covent Garden. 1794

NEWTON T., *goldsmith*; London. 1586–1596

NEWTON THOMAS, *goldsmith*; Fenchurch street. 1752–1763

NEWTON JONATHAN & COLE THOMAS (cf. COLE & NEWTON), *goldsmiths & jewellers*;
Crown & Acorn, Lombard street. 1744, 1745

NEWTON & LEVY, *jewellers*; No. 41 Haydon square, Minories. 1790–1793

NICHOLL JOHN, *goldsmith*; London. 1518–1521

NICHOLL MICHAEL, *plate-worker*; Staining lane. 1723

NICHOLL SAMUEL (cf. NICHOLL & ABDY), *goldsmith*; within Aldgate. 1742–1744

NICHOLL & ABDY (cf. SAMUEL NICHOLL), *goldsmiths*; within Aldgate. 1753

NICHOLLS —, *goldsmith*; Three Squirrels, Fleet street. 1721

NICHOLLS RICHARD & FOWLER ABRAHAM (see ABRAHAM FOWLER & JAMES ROCHE),
 goldsmiths & bankers; Golden Key, without Temple Bar. 1720

NICHOLS JOHN, *goldsmith*; parish of St Olave's, Old Jewry. (Married) 1587

NICHOLS RICHARD, *goldsmith*; Golden Key, without Temple Bar. 1705–1720

NIGHTINGALE RICHARD, *plate-worker*; Shoe lane. 1697–1701

NOAKE JOHN, *silversmith*; late of St Bride's. (Insolvent) 1729

NOBLE RICHARD, *goldsmith*; Lombard street. 1768
 Charing Cross. 1784

NOBLE THOMAS, *silversmith & brazier*; Charing Cross. 1770

NOBLE THOMAS & ROBINSON, *silversmiths*; Charing Cross. 1774–1777

NOBLEMAN GARRET, *goldsmith*; St Martin's-le-Grand. 1585

NODES JOHN, *goldsmith & toyman*; late of Temple Bar. 1743

NODES JOHN, *goldsmith*; Strand. 1770–1777

NODES WILLIAM (successor to MR ROBINSON), *goldsmith, jeweller & sword cutler*; New
 Bond street, near Grosvenor square. 1769–1776
 No. 126 New Bond street. 1783–1794

NODES & SYDENHAM (succeeded by H. & J. SYDENHAM, 1802), *jewellers*; No. 126 New
 Bond street. 1796

NOELL JOHN, *goldsmith*; parish of St Sepulchre, Newgate. (Will proved) 1634

NOELL THOMAS, *goldsmith*; Noble street. 1641
 London. 1649–1652

NOKE WILLIAM, *goldsmith*; parish of St Peter's, West Cheap. 1580–(Deceased) 1592

NONEED BARTHOLOMEW, *watch-case maker*; Cross street, Clerkenwell. 1787–1799

NORCOTT DANIEL & JOSEPH, *goldsmiths*; Blackamoor's Head, corner of Buckingham street,
 Strand. 1713–(Bankrupt) 1721

NORCOTT J., *goldsmith*; Blackamoor's Head, corner of York buildings, Strand. 1703–1710

NORMAN GEOFFREY, *goldsmith*; parish of St Mary Abchurch (?). c. 1308

NORMAN PHILIP, *plate-worker*; St Martin's lane. 1773

NORMAN RICHARD, *silversmith*; Jerusalem court [Gracechurch street]. 1766
 Sutton street. 1776

NORMAN WILLIAM, *goldsmith*; parish of St Vedast, Foster lane. (Married) 1666

NORMAN WILLIAM, *goldsmith*; London. 1771

NORRINGTON BENJAMIN (see EWING & NORRINGTON).

NORRIS —, *goldsmith*; parish of St Helen's, Bishopsgate. 1591

NORRIS — (see SHEPHERD & NORRIS).

NORRIS, JUNIOR, *gold and silversmith & jeweller*; No. 26 Cheapside. [N.D.]

NORRIS Cs., *working jeweller*; Anchor & Crown, Lombard street. c. 1770

NORRIS CHARLES, JUNIOR, *jeweller*; No. 22 Cheapside. 1784–1790
 No. 18 Gracechurch street. 1790–1796

NORRIS ELIZABETH (widow of PHILIP NORRIS), *pawnbroker*; Black Peruke, Panton street. 1716

NORRIS PHILIP, *pawnbroker*; Black Peruke, Panton street, Leicester fields. c. 1710

NORTH — (see WHIPHAM & NORTH).

NORTH HUGH, *goldsmith*; White Lion, against Bull Inn court, Strand. 1698–1703

NORTH RICHARD, *goldsmith & jeweller*; No. 47 Lombard street. 1768–1777
 No. 44 Lombard street. 1784–1796

NORTH & WILSON (cf. NASH & WILSON), *goldsmiths*; Holywell street, Strand. 1790–1793

NORTHCOTE HANNAH, *goldsmith*; London. 1798
NORTHCOTE THOMAS, *plate-worker*; Berkeley street, Clerkenwell. 1781–1790
 Shoemaker row. 1776–1789
 London. 1793
NORTHCOTE THOMAS & BOURNE GEORGE, *plate-workers*; Berkeley street, Clerkenwell.
 1794–(Partnership dissolved) 1796
NORTON & THORNHILL, *hardwaremen & jewellers*; Nos. 22 and 23 Fish Street hill. 1781–1796
NORWOOD RICHARD, *goldsmith*; Three Flower-de-Luces, Lombard street. 1701–c. 1722
NOTTE WILLIAM, *goldsmith*; London. 1567–(Died) 1568
NUNESAN (or NUNSSAN) JOHN, *goldsmith*; at the Insur[ance] Office [Birchin lane (?)]. 1677
NUTHEAD JAMES, *goldsmith*; parish of St Vedast, Foster lane. (Buried) 1592
NUTSHAWE JAMES, *goldsmith*; London. 1564
NUTSHAWE THOMAS, *goldsmith*; parish of St Mary Woolnoth. 1564
NUTTING HENRY, *plate-worker*; Noble street. 1796–1804

OAKE JOHN, *goldsmith*; Grubb street. 1767
OCALL RICHARD (see RICHARD OCKOLD).
OCKLEY — (see TRELEGON & OCKLEY).
OCKOLD (or OCALL) RICHARD, *goldsmith*; parish of St Mary Woolnoth. 1618–(Buried) 1634
OLDFIELD ELIZABETH (cf. ELIZABETH JACKSON), *plate-worker*; Paternoster row. 1748
OLIVER PETER, *goldsmith*; Fleet lane. 1571
OLIVER THOMAS, *goldsmith & jeweller*; No. 17 Fleet street. 1784–1796
OPENSHAWE WILLIAM, *goldsmith*; parish of St Botolph's, Aldgate. (Married) 1615
ORCHARD JOHN, *goldsmith*; Rose & Crown, Lombard street. 1695–1697
ORFORD ROBERT, *goldsmith & jeweller*; No. 71 Oxford street. 1796
ORME CARDINAL, *goldsmith*; parish of St Peter's, Cheapside. 1641–1646
ORME JOHN, *silversmith*; Hand & Spur, Denmark court, Strand. 1743
 Hand & Spur, Exeter street, Strand. 1744
ORPWOOD ROBERT, *goldsmith*; London. (Died) 1609
ORWELL JOHN, *engraver to the Mint*; London. 1432–(Died) 1472
OSBORN STEPHEN, *goldsmith*; Borough, Southwark. 1703
OSBORNE EDWARD, *jeweller*; Coleman street. 1727
OSBORNE GEORGE, *goldsmith*; Stratford-le-Bow. (Buried) 1634
OSBORNE JOHN, *silversmith*; Wood street. 1780–1785
OSBORNE JONAS, *goldsmith*; Little Britain. 1773–(Bankrupt) 1774
OSBURNE GEORGE, *goldsmith*; London. (Died) 1581
OTHO —, *the King's goldsmith*; London. 1124–1126
OTHO FITZ EDWARD, *engraver to the Mint*; London. 13th century
OTHO FITZ HUGH, *engraver to the Mint*; London. 1280–1290
OTHO FITZ THOMAS, *engraver to the Mint*; London. 1265–1290
OTTO FITZ WILLIAM, *engraver to the Mint*; London. c. 1130
OTHO FITZ WILLIAM, *engraver to the Mint*; London. 1204
OTHO FITZ WILLIAM, *the King's goldsmith*; London. 1243
OTHO FITZ WILLIAM, *goldsmith*; London. 1290–1294
OTTO THE ELDER, *engraver to the Mint*; London. 1090–1100

Plate LIII

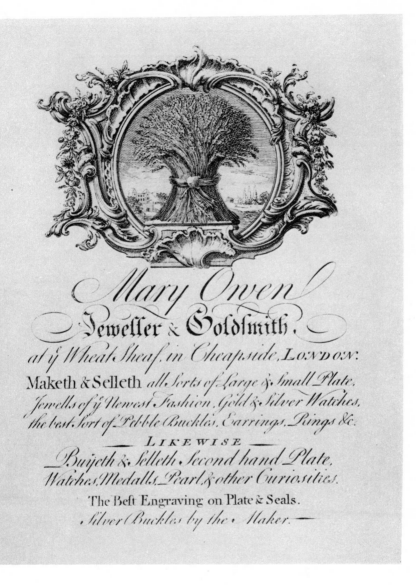

Mary Owen

Jeweller & Goldsmith,

at ÿ Wheat Sheaf, in Cheapside, LONDON:

Maketh & Selleth all Sorts of Large & Small Plate,
Jewells of ÿ Newest Fashion, Gold & Silver Watches,
the best Sort of Pebble Buckles, Earrings, Rings &c.

———— LIKEWISE ————

Buijeth & Selleth Second hand Plate,
Watches, Medalls, Pearl, & other Curiosities.

The Best Engraving on Plate & Seals.
Silver Buckles by the Maker. ——

MARY OWEN 1745

Plate LIV

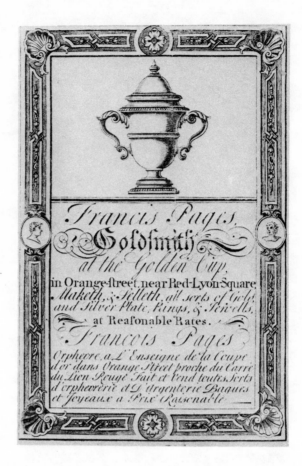

FRANCIS PAGES 1731

OTTO THE YOUNGER, *engraver to the Mint*; London. c. 1120

OUVRY (or OURRY) LOUIS, *plate-worker*; Golden Crown, New street, Covent Garden. 1740–1742

OVERING CHARLES, *plate-worker*; Carey lane. 1697–1706

OVITT SAMUEL, *goldsmith*; Brewer's yard, Shoe lane. (In prison for debt) 1720

OWEN MARY, MRS, *goldsmith*; Wheatsheaf, upper end of Cheapside. 1745

OWEN SYMON, *goldsmith*; parish of St Mary, Staining lane. 1629–(Will proved) 1634

OWEN WILLIAM, *goldsmith*; Wheatsheaf, Cheapside. 1720–1733
 Cheapside. 1737–1740

OWEN MARY, MRS & WILLIAM, *goldsmiths*; Cheapside. 1756

OWING JOHN, *plate-worker*; Noble street. 1724, 1725
 London. (?) 1741

OXENDLY ROBERT, *goldsmith*; London. 1518

OXENEYE (or OXNEY) SALOMAN, *goldsmith*; London. 1403–1419

OXENSHAWE WILLIAM, *goldsmith*; parish of St Botolph's, Aldgate. (Married) 1589

OYLE PHILIP, *plate-worker*; Cheapside. 1699

PACE THOMAS, *silversmith & watch-maker*; No. 128 Whitechapel. 1790–1793

PADDESLEY (or PATTISLEY) JOHN, SIR,[1] *goldsmith*; London. 1421–1451

PADMORE GEORGE, *goldsmith*; No. 29 Frith street, Soho. 1774

PADMORE JOHN, *jeweller & goldsmith*; No. 448 Strand. 1784

PAGAN DANIEL (see DANIEL PAYAN).

PAGE BENJAMIN, *goldsmith*; Half Moon alley, Little Moorfields. 1688–1696

PAGE JOHN, *jeweller*; No. 8 Hind court, Fleet street. 1790–1793

PAGES FRANCIS, *plate-worker*; Golden Cup, Orange street, near Red Lion square. 1729–1739

PAGITTER MRS, *goldsmith*; against St Dunstan's Church, Fleet street. 1702

PAGLER JOHN, *silversmith*; Queen's street. 1781
 Aldersgate street. 1787

PAILLET MARK, *plate-worker*; London. 1687
 Heming's row [St Martin's lane]. 1698
 London. 1700–1714

PAIN — (see EDMOND PAYNE), *goldsmith*; Raven, over against Exeter Exchange [Strand]. 1702

PAINE EDMOND (see also PAYNE), *goldsmith*; Cat, in the Strand, near Cecil street. 1712

PAINE ROBERT (see also PAYNE), *goldsmith*; London. 1640

PAINE & PEARCE (see also PAYNE & CO.), *goldsmiths*; Lombard street. 1707

PALATINE HIGHMAN, *silversmith*; Red Lion street, Whitechapel. (Bankrupt) 1769

PALMER ANDREW, *goldsmith*; North side of Cheapside. (Before) 1580–1583

PALMER JOHN, *silversmith*; London. 1751

PALMER JOHN, *goldsmith*; Fetter lane. 1800

PALMER RICHARD, *watch-case maker*; No. 2 Red Lion street, Clerkenwell. 1793

PALMER SYMON, *goldsmith*; London. 1538–1553

PALMER THOMAS, *goldsmith*; London. 1630

PALMER THOMAS, *goldsmith*; No. 132 Lower Holborn. 1784–1793
 No. 132 Holborn hill. 1796

PALMER WILLIAM, *goldsmith*; London. 1478

PALTERTON JOHN, *goldsmith*; London. 1550

[1] Mayor of London, 1440–1.

LONDON GOLDSMITHS

PALTOCK JOHN (see also SNOW & PALTOCK), *goldsmith & banker*; Fleet street. 1712–172⁊

PALTRO JAMES, *plate-worker*; Golden Head, — ?. 173⁊

PANIE (or PAVIE) THOMAS, *goldsmith*; parish of St Mary Woolnoth. 169⁊

PANTHER (or PANTER) ARTHUR, *goldsmith*; parish of St Michael Bassishaw. (Will proved) 163⁊

PANTIN ESAIE [ISAIAH], *goldsmith*; St James's, Westminster. 170⁊

PANTIN LEWIS (I) (successor to SIMON PANTIN (II)), *plate-worker*; Peacock, Castle street,
　　　　　　　　　　　　　　　　　　Leicester fields. 1733–1744

PANTIN LEWIS (II), *goldsmith, jeweller & toyman*; Crown & Sceptres, [No. 45] Fleet street,
　　　corner of Mitre court. 1770–178⁊
　　　No. 36 Southampton street. 1784
　　　No. 62 St Martin's-le-Grand. 180c

PANTIN MARY (widow of SIMON PANTIN (II)), *plate-worker*; Green street, Leicester fields.
　　　　　　　　　　　　　　　　　　　1733–173⁊

PANTIN SAMUEL, *plate-worker*; St Martin's lane. 1701–172⁊

PANTIN SIMON (I), *plate-worker*; Peacock, St Martin's lane. 1699–1701
　　　St Martin's-in-the-fields. 1709–1711
　　　Removed to Peacock, Castle street, Leicester fields. 1717–(Died) 1728

PANTIN SIMON (II) (succeeded SIMON PANTIN (I)), *plate-worker*; Peacock, Castle street,
　　　　　　　　　　　　　　　　　　Leicester fields. 172⁊
　　　Removed to Green street, Leicester fields. 1731–(Died) 173⁊

PANTON THOMAS, *goldsmith*; parish of St Alphage. (Married) 1664

PAPAVOINE —, *jeweller*; Pall Mall. 173⁊

PAPEATTE JOHN, *goldsmith*; parish of All Hallows, Bread street. (Married) 1681–(Died) 169c

PARADISE WILLIAM, *plate-worker*; Lad lane. 1718–172c
　　　London. 1724–1751

PARDO THOMAS, *goldsmith & banker*; Golden Anchor, Lombard street. 167⁊

PARDOE —, *pawnbroker*; Three Balls, West street, near Seven Dials. 175⁊

PARGETER JOHN, *goldsmith*; without Aldgate. 1743–174⁊

PARGETER RICHARD, *plate-worker*; Fetter Lane. 1727–1730
　　　New street, Shoe lane. 173⁊
　　　Without Aldgate. 1744

PARGETIER RICHARD, *goldsmith*; London. 177⁊

PARGITER JOHN,[1] *goldsmith*; Golden Hind, or Golden Buck, Fleet street. 165⁊
　　　Fleet street, next door but one to Serjeant's Inn gate. 1636–(Died) 1668

PARGITER JOHN, JUNIOR (son of JOHN PARGITER of Fleet street), *goldsmith*; near North-
　　　umberland House, Charing Cross. 1685, 168⁊
　　　Parish of St Clement's. (Buried) 1688

PARGITER JOSEPH, *goldsmith*; parish of St Botolph's, Aldgate. (Bankrupt) 1744

PARIS (or PARRYS) MATTHEW, *goldsmith*; parish of St Mary Woolnoth. 1629–1631
　　　Parish of St Michael's Bassishaw. 1641

PARKE —, *goldsmith*; Blue Ball, Holborn, near Little Queen street. 1744

PARKER —, *goldsmith*; Orange street, Red Lion square. 1752

PARKER DANIEL, *pawnbroker*; Seven Stars, Lamb's Conduit passage, near Red Lion square.
　　　　　　　　　　　　　　　　　(Left off trade) 1709

PARKER H., *jeweller*; Wilderness road, Goswell street. 1790

PARKER HANNAH & SON, *jewellers*; No. 56 St Paul's churchyard. 1790–1793

PARKER JAMES, *silversmith*; No. 8 Addle street, Wood street. 1790–1796

[1] Described in Pepys' *Diary*, 21 Oct. 1661.

(216)

LONDON GOLDSMITHS

PARKER JOHN, *jeweller & goldsmith*; No. 55 St Paul's churchyard. 1770–1781
 No. 56 St Paul's churchyard. 1784–1796
PARKER JOHN, *silversmith & jeweller*; No. 2 Rathbone place. 1796
PARKER THOMAS, *goldsmith*; No. 174 Fleet street. 1790–1797
PARKER THOMAS, *jeweller*; No. 17 Wilderness road, Goswell street. 1796
PARKER T. & WILLIAM, *gold and silversmiths*; No. 16 Prince's street, Soho. 1790–1793
PARKER WILLIAM, *goldsmith*; Angel, Fleet street, near Temple Bar. 1692–1697
PARKER WILLIAM, *silversmith & jeweller*; No. 20 Prince's street, Leicester square. 1796
PARKER WILLIAM, *gold and silversmith*; No. 233 High Holborn. 1796
PARKER & CRADOCK, *goldsmiths*; Golden Buck, Fleet street. 1712
PARKER JOHN & WAKELIN EDWARD (successors to WICKES & NETHERTON; see also
 EDWARD WAKELIN), *goldsmiths & jewellers*; [King's Arms], Panton
 street, near St James's, Haymarket. 1759–1777
 (Succeeded by WAKELIN & TAYLOR and later by WAKELIN &
 GARRARD.)
PARNUM MRS, *goldsmith*; Black Swan, East Smithfield. 1689
PARQUOT PETER, *jeweller & goldsmith*; Eagle & Pearl, King street, St Ann's [Soho], facing
 Nassau street. 1744
PARR ROBERT, *jeweller & goldsmith*; Diamond Cross, Fleet street, near Salisbury court. c. 1760
 Diamond Cross, facing yᵉ pump, St Paul's churchyard. 1767
PARR SARAH, *plate-worker*; Cheapside. 1720, 1721
 London. 1732
PARR THOMAS, *plate-worker*; Wood street. 1697
PARR THOMAS, *plate-worker*; No. 27 Cheapside. 1717–1775
PARRY BENJAMIN, *goldsmith*; London. (Buried) 1703
PARS ALBERTUS, *goldsmith*; Furnival's Inn court. 1773
PARS EVERT, *silversmith*; Wych street. 1751
PARSONS JOHN [cf. JOHN PEARSON], *goldsmith*; Three Black Lions, Charing Cross. 1689–1694
PARSONS & HUDSON (see also JOHN HUDSON), *goldsmiths*; St Martin's churchyard. 1774–1779
PARTRICK FRANCIS, *pawnbroker*; Three Balls, Drury lane, corner of Bennett's court. 1756
PARTRIDGE AFFABEL, *Queen's goldsmith*; London. 1550–1568
PARTRIDGE JOHN, *goldsmith*; Wheatsheaf, upper end of Cheapside. 1691–1706
PARTRIDGE JOSEPH, *jeweller*; Bartholomew close. 1763–1768
PARTRIDGE SETH, *goldsmith*; Cheapside. 1716–1748
PARTRIDGE THOMAS, *goldsmith*; Prince's Head, Poultry. 1727
PASHLEY [or PAISHLEY] JOHN, *pawnbroker*; Three Bowls, Market lane, near St James's
 market. 1707–1710
PASSAVANT SUSANNA (succeeded THOMAS WILLDEY), *jeweller & toyman*; Plume of
 Feathers, Ludgate hill, opposite the Old Bailey. 1755
PASSAVANT WILLIAM, *goldsmith*; No. 14 Red Lion passage. 1790–1793
PASSEL [or PASSIL] JOHN, *goldsmith*; King's Arms, Cheapside. 1689–(Gave up business) 1697
PATERSON —, *jeweller*; New Exchange court, Strand. 1762
PATERSON THOMAS, *goldsmith*; at the foot of the Hay Market. 1714
PATERSON & CRICHTON, *jewellers*; Crown & Pearl, Green street, Leicester square. c. 1765
PATRICK FITZ JOHN, *goldsmith*; London. 1269
PATRICKSON ROBERT, *goldsmith*; parish of St Alban's, Wood street. 1624–(Will proved) 1641

HGS (217) 28

PATTERSON JOHN, *goldsmith*; London. 1531–1553
PATTISLEY JOHN, SIR (see SIR JOHN PADDESLEY).
PATTON CHARLES, *goldsmith*; St James's street. 1753
PAUMIER GABRIEL, *silversmith*; Cock lane, near the church, Shoreditch. 1753–1755
PAUMIER GABRIEL & SON, *silversmiths*; Nicholas street, Shoreditch. 1760
PAUMIER PETER, *silversmith*; Nicholas street, Shoreditch. 1763–1770
PAVIE THOMAS (see THOMAS PANIE).
PAWLETT GEORGE, *goldsmith*; parish of St Vedast, Foster lane. (Buried) 1687
PAYAN DANIEL, *jeweller*; No. 44 St Martin's lane, Charing Cross. 1790–1793
PAYLE THOMAS, *goldsmith*; parish of St Saviour's, Southwark. 1666
PAYN — (cf. PAYNE & MOOR), *goldsmith*; King's Arms, Lombard street. 1687
PAYNE —, *goldsmith*; against Exeter Exchange [Strand]. 1702
PAYNE —, *pawnbroker*; Three Blue Balls, Golden lane. 1753, 1754
 Three Balls & Acorn, Golden lane. 1763
PAYNE EDMOND (see also PAINE), *goldsmith*; Cat, near Exeter Change, Strand. 1700–1715
 Raven, Strand. 1702
 Goat, Strand. 1705, 1706
PAYNE HANCE, *goldsmith*; parish of St Vedast, Foster lane. (Buried) 1575
PAYNE HUMPHREY, *plate-worker*; London. 1697–1699
 Golden Cup, Gutter lane. 1701–1720
 Hen & Chickens, Cheapside. 1720–1740
 London. 1750
PAYNE HUMPHREY & JOHN, *goldsmiths & jewellers*; Hen & Chickens, Cheapside. 1753–1755
PAYNE JOHN (son of HUMPHREY PAYNE), *goldsmith*; No. 44 Cheapside. 1751–1779
PAYNE ROBERT (see also PAIN), *goldsmith*; Tower Precincts. (Widow's will proved) 1647
PAYNE THOMAS, *goldsmith*; Langbourne ward. 1692, 1693
 Parish of St Mary Woolnoth. (Died) 1711
PAYNE THOMAS & RICHARD, *jewellers & goldsmiths*; No. 42 Cheapside, and No. 10 Cockspur
 street. 1777–1783
PAYNE & CO. (or PAINE & PEARCE), *goldsmiths*; Queen's Arms, Lombard street. 1709–1721
PAYNE & MOOR (cf. MOOR & PAYNE), *goldsmiths*; King's Arms, Lombard street. 1687–1704
PEACOCK EDWARD (see STOCKER & PEACOCK), *plate-worker*; Strand. 1710–(Died) 1729
PEACOCK JAMES, *goldsmith*; No. 103 Minories. 1773
PEACOCK JOHN, *goldsmith*; parish of St Mary Woolnoth. 1618–1628
PEACOCK ROBERT, *goldsmith*; Whitecross street. 1706
PEACOCK ROBERT, ? *goldsmith*; Gold Lion, Strand. (Opened a shop at Bath 1765)
PEACOCK SAMUEL, *jeweller*; No. 30 Old Exchange [Cheapside]. 1790–1793
PEACOCK WILLIAM, *goldsmith*; parish of St Mary Woolnoth. 1616
PEAKE HUGH, *goldsmith*; parish of St Mary Woolnoth. 1590
PEAKE ROBERT, *goldsmith*; parish of St Sepulchre. 1641
PEAKE ROBERT, *plate-worker*; Noble street. 1697–1704
PEAKE VAUGHAN, *goldsmith*; Foster lane. (Insolvent) 1720
PEAKE WILLIAM, *goldsmith*; parish of St Peter's, Cheap. (Buried) 1551
PEARCE CAPT., *goldsmith*; Three Golden Cocks [or Three Cocks], upper end of Cheapside. 1700–1703
PEARCE EDMUND, *plate-worker*; New Exchange, Strand. 1704–1722
PEARCE EDWARD (cf. EDMUND PEARCE), *goldsmith*; London. 1720, 1721

Plate LV

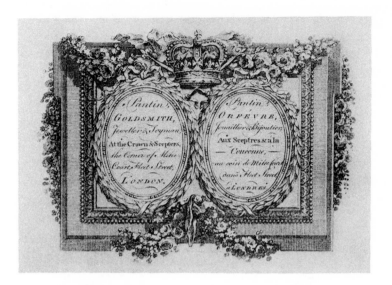

LEWIS PANTIN (Junior) 1770–1781

Plate LVI

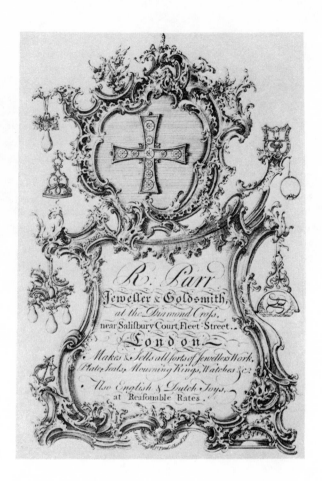

ROBERT PARR *circa* 1760

PEARCE JAMES, *plate-worker*; London. 1698
PEARCE JOHN, *goldsmith*; Golden Bellows, Newgate street. 1742–1760
PEARCE NATHANIEL & MATTHEWS JOHN, *goldsmiths & bankers*; Lombard street.
(Bankrupt) 1718–1723
PEARCE & NEWTON, *goldsmiths*; Newgate street. 1763
PEARCY —, *pawnbroker*; Rose & Three Balls, East Smithfield. 1758
PEARNE WILLIAM, *jeweller*; No. 11 Leicester square. 1790–1793
PEARSE JOHN, *pawnbroker*; Three Balls, Blackman street, Southwark. 1745
PEARSON —, *goldsmith*; Smithfield Bars. 1721
PEARSON —, *goldsmith*; Golden Ball, St Martin's-le-Grand. 1753
PEARSON EDWARD, *goldsmith*; Fleet street. 1723, 1724
PEARSON JOHN [cf. JOHN PARSONS], *goldsmith*; Three Black Lions, near Charing Cross. 1694
Unicorn, near Hungerford market, Strand. 1694–1698
PEARSON MARY, *jeweller & toyshop*; No. 31 Fleet street. 1770–1772
PEARSON RICHARD (cf. RICHARD PERSON).
PEARSON (or PEIRSON) RICHARD, *goldsmith*; opposite St Dunstan's Church [Fleet street]. 1713
PEARSON RICHARD, *goldsmith*; London. 1747
PEARSON THOMAS (see LANCELOT KEATE & THOMAS PEARSON).
PEARSON WILLIAM, *plate-worker*; Ball alley. 1710–1720
PEARSON WILLIAM, *silver-plater*; No. 75 Long Acre. 1796
PEARSON JOHN & KEATE LANCELOT, *goldsmiths*; Unicorn, Strand. 1698
PEART THOMAS, *goldsmith*; parish of St Mary Woolnoth. 1659–1663
PEASTON R., *goldsmith*; St Martin's-le-Grand (?). 1762–1766
PEASTON WILLIAM, *working goldsmith*; St Martin's-le-Grand. 1745–1760
Jewin street. 1778
PEASTON W. & R., *plate-workers*; St Martin's-le-Grand. 1756–1763
PEATE HENRY, *goldsmith*; Red Cross street. 1692, 1693
PEBWORTH WILLIAM, *goldsmith*; Foster lane. 1781
Clerkenwell. 1786
PEDLEY HESTER, *pawnbroker*; Black Swan, Charterhouse lane. 1707
PEEKE THOMAS, *goldsmith*; parish of All Hallows, Honey lane. 1578–1583
PEELE LOWTHER, *plate-worker*; Holborn. 1775–1785
PEELE THOMAS, *plate-worker*; Jewin street. 1704
PEIRCE — (see PAINE & PEIRCE).
PEIRCE JOHN, *goldsmith*; Bull Head court, Cripplegate ward. 1692, 1693
PEIRCE JOHN, *goldsmith*; Flower-de-Luce, Newgate street, near the Gate. 1710
St Sepulchre's. 1736
PEIRSON (see also PIERSON).
PEIRSON WILLIAM, *goldsmith*; parish of St Olave's, Silver street. (Dead before) 1621
PEIRSON WILLIAM, *goldsmith*; London. 1668
PEKE JOHN, *goldsmith*; Wood street. 1441
PEKENYNGE JOHN (see JOHN PIKENYNGE).
PEKERINGE JOHN, parish of St Mary Woolnoth. 1557
PELL — (see GARBETT & PELL).
PELS —, *goldsmith*; near New Exchange, Strand. 1687
PELTERE NICHOLAS, *jeweller*; Aldersgate ward. 1618
PEMBER RICHARD, *goldsmith*; parish of St Peter, Paul's wharf. (Married) 1616

(219)

T

PEMBERTON George, *goldsmith*; London. 1654
PEMBERTON James, Sir,[1] *goldsmith*; parish of St Vedast, Foster lane. (Married) 1599
 Parish of St John Zachary. (Died) 1613
PEMBERTON John, *goldsmith*; parish of St Peter, Westcheap. (Married) 1619
PEMMERTON James (see James PEMBERTON).
PENDEREL William, *goldsmith*; London. 1687
PENFOLD E. [see Edward PINFOLD].
PENFOLD John, *goldsmith*; Foster lane. 1696, 1697
PENFOLD Miles, *goldsmith*; No. 115 Newgate street. 1770–1777
PENISTON Anthony, *goldsmith*; parish of St Mary Woolnoth. 1620–1640
PENISTON William, *goldsmith*; Old Bailey. 1711
PENNE Elizabeth, Mrs, *pawnbroker*; Three Bowls, Long Acre. 1724
PENNY William, *goldsmith*; Cross lane, Long Acre. 1775
PENNYFEATHER Henry, *silversmith*; New rents, St Martin's-le-Grand. 1790–1793
PENS Jean, *goldsmith*; Savoy. 1705
PENSTONE Henry, *plate-worker*; London. 1691–1705
 Gracechurch street. 1697
PENSTONE William, *plate-worker*; Foster lane. 1697–1717
PENSTONE William, *haft-maker & spoon-maker*; Monkwell street. —
 Noble street. 1773–(Bankrupt) 1778
PEPPER Thomas, *goldworker & enameller*; No. 5 George street, Foster lane. 1790–1796
PEPYS John, *goldsmith*; Golden Falcon, West Smithfield. 1688
 Old Bailey. 1689–1700
PEPYS John, *watch-maker & jeweller*; Crown & Sceptre, Fleet street. 1715–1749
PEPYS William, *goldsmith*; Lombard street. 1728–(Died) 1742
PERCEFULL Peter & EVANS Stephen (see PERCIVAL & EVANS, also PURCEVAL),
 goldsmiths & bankers; Black Boy, Lombard street. 1677–1688
PERCHARD Daniel, *goldsmith*; Strand. 1743
PERCHARD Matthew, *goldsmith*; Golden Cup, Cannon street, near Abchurch lane. 1744–1768
 No. 15 Abchurch lane. 1755–1768
PERCHARD Peter,[2] *goldsmith*; No. 15 Abchurch lane. 1777–(Died) 1806
PERCHARD Peter & Peter, *goldsmiths*; No. 15 Abchurch lane. 1763–1777
PERCHARD & BROOKS, *goldsmiths & jewellers*; No. 12 Charles street, Hatton Garden. c. 1800
 No. 14 Clerkenwell green. 1808–1817
PERCIVAL Peter & EVANS Stephen (see PERCEFULL & EVANS, also PURCEVAL),
 goldsmiths & bankers; Black Boy, Lombard street. 1677–1688
PERE Denis, *jeweller & silversmith*; Hayes court. 1705
 Ring & Pearl, Heming's row [St Martin's lane]. 1742
PERIER Charles, *plate-worker*; Macclesfield street [Soho]. 1727
 King's street, Covent Garden. 1731–(Bankrupt) 1734
PERIGAL Gideon, *goldsmith & silver-turner*; London. 1703
 St Martin's-in-the-fields. 1715
PERIGAL John (cf. MASQUERIER & PERIGAL), *goldsmith, jeweller & watch-maker*; No. 12
 Coventry street, Haymarket. 1784–1793
 No. 11 Coventry street, Haymarket. 1796
PERIGAL & MASQUERIER (cf. MASQUERIER & PERIGAL), *goldsmiths & jewellers*; Ring &
 Pearl, No. 11 Coventry street, St James's. 1774

[1] Lord Mayor of London, 1611–12. [2] Lord Mayor of London, 1804–5.

PERKINS JONATHAN, *working goldsmith*; Mugwell [Monkwell] street. 1772
 No. 16 Hosier lane, Smithfield. 1781–1796
PERKINS JONATHAN, SENIOR & JUNIOR, *plate-workers*; No. 16 Hosier lane, Smithfield. 1795
PERKINS VINEYARD or WINNIATT [? WYNYARD], *jeweller*; No. 53 Dorset street, Salisbury
 square. 1790–1793
 No. 53 Salisbury court, Fleet street. 1796
PERO ISABEL, *plate-worker*; Orange court [? Leicester square]. 1741
PERO JOHN, *plate-worker*; Strand. 1717
 Suffolk street. 1732
 Orange street [? court]. 1739
PERRIN JOHN (see JOHN PERRYN).
PERRY CLEMENT, *goldsmith*; parish of St Mary Woolnoth. (Churchwarden) 1658
PERRY JAMES, *haft-maker*; No. 131 Chancery lane. 1773
PERRY JOHN, *plate-worker*; Paul's court. 1757
PERRY JOHN, *silversmith*; Clerkenwell close. 1772
 Holborn. 1779
PERRYN —, *goldsmith*; Golden Bottle, Cheapside. 1653
PERRYN JOHN, *goldsmith*; London. 1637–(Died) 1657
 Cheapside. 1641
PERSON (? PEARSON) RICHARD, *goldsmith*; opposite St Dunstan's Church [? Fleet street]. 1713
PERTH ROBERT (cf. ROBERT PERTT), *goldsmith*; London. 1738–1755
PERTT ROBERT, *plate-worker*; Newgate street. 1738–1744
PESTELL THOMAS, *jeweller*; Coleman street. 1714–1728
PETER — (cf. SIMON PETERS), *goldsmith*; West Smithfield. 1704
PETER SIMON, *pawnbroker*; Golden Ball & Cross Keys, Horton street, Clare market. 1724–1744
PETERS JOHN, *goldsmith*; Grub street. 1780
PETERS RICHARD, *goldsmith*; Gold Ring, St Margaret's hill, Southwark. 1724–(Died) 1747
PETERS SIMON, *goldsmith*; Hospital gate, Smithfield. 1694–1720
PETERSON ABRAHAM, *plate-worker*; No. 23 Salisbury court, Fleet street. 1790–1793
PETERSON ABRAHAM & PODIE PETER (cf. PODIE & PETERSON), Salisbury court. 1783–1790
PETIT — (successor to Mr Is. L'ADVOCAT), *jeweller*; No. 5 Macclesfield street, Soho. c. 1790
PETLER WILLIAM, *goldsmith*; Horse Shoe alley. 1699
PETLEY WILLIAM, *plate-worker*; Blowbladder street. 1699–1717
 London. 1717–1731
PETRIJ JEAN, *plate-worker*; Pall Mall. 1701–1707
PETTIT JACOB, *jeweller*; Wardour street, Soho. 1769
PETTIT JOHN COOK, *working goldsmith*; No. 2 Dogwell court, Lombard street, Whitefriars.
 1790–1793
PEWTRESS THOMAS (cf. GINES & PEWTRESS), *goldsmith & banker*; Ship & Crown, Grace-
 church street, corner of Nag's Head court. 1748–1754
 Tower hill. 1769–(Died) 1814
PEWTRESS, FLIGHT & HALLIDAY, *bankers*; No. 34 Lombard street. 1769
PEWTRESS THOMAS & ROBARTS JOSIAH, *goldsmiths & bankers*; Ship & Crown, Gracechurch
 street. 1753
 Three Kings, Lombard street. 1768
PHELCE RICHARD, *goldsmith*; parish of St Michael's, Wood street. (Married) 1616
PHELIP MATTHEW (cf. MATTHEW PHILIP), *goldsmith*; London. 1448

PHELIPEAU PIERRE, *goldsmith*; Church street, St Anne's. 1705
 Newport alley. 1705-1710
 Greek street. 1714-1735
PHELPS JOHN, *goldsmith & pawnbroker*; Crown & Pearl, over against Exeter Exchange, Strand.
 1684-1697
 Crown, Strand. 1699
PHELPS WILLIAM, *goldsmith*; Paternoster row. (Insolvent) 1743
PHILIP MATTHEW, SIR,[1] *goldsmith*; Aldersgate ward. 1450-(Died) 1476
PHILLIP PHYLLIS (or PHILLIS PHILIP), *plate-worker*; Cannon street. 1720
 Finch lane. 1727
 Friday street. 1734
PHILLIPS HUMPHREY, *working silversmith*; Charles street, Strand. 1744
PHILLIPS JOHN, *plate-worker*; Foster lane. 1717
PHILLIPS JOHN, *goldsmith*; Cold Bath square [Clerkenwell]. 1773-1795
PHILLIPS RICHARD, *goldsmith*; parish of St Vedast, Foster lane. (Buried) 1574
PHILLIPS RICHARD, *goldsmith*; parish of St Mary Woolnoth. 1601-1607
PHILLIS PHILIP (see PHYLLIS PHILLIP).
PHINIMORE JOSEPH, *goldsmith*; parish of St Mary Woolnoth. (Will proved) 1625
PHIPPS JAMES, *goldsmith*; No. 40 Gutter lane. 1769-1783
PHIPPS JOHN, *goldsmith*; London. 1765
PHIPPS SAMUEL, *silver turner*; Staining lane. 1765-1767
PHIPPS THOMAS, *goldsmith*; Gutter lane. 1788
PHIPPS JAMES & THOMAS, *goldsmiths*; Gutter lane. (Partnership dissolved) 1783
PHIPPS THOMAS & ROBINSON EDWARD (see ROBINSON & PHIPPS), *goldsmiths*; No. 40
 Gutter lane. 1784-1796
PHITHIAN JOHN, *pawnbroker*; Three Bowls, Adam & Eve court, Oxford road. 1747
PICASSE STEPHEN, *goldsmith*; Denmark street. 1773
PICKARDE WILLIAM, *goldsmith*; Fleet street. 1571
PICKAYES AGMONDISHAM, *King's goldsmith*; Cheapside. 1641-(Died) 1673
PICKERING GEORGE, *goldsmith*; parish of St Vedast's. 1641
 Bull, Charterhouse lane. 1653
PICKERING JOHN, *gold and metal worker*; No. 86 Long Acre. 1790-1793
PICKERING MATTHEW, *plate-worker*; Mugwell [Monkwell] street. 1703-1706
PICKETT WILLIAM[2] (see THEAD & PICKETT, also PICKETT & RUNDELL), *goldsmith &
 jeweller*; Golden Salmon, [No. 32] Ludgate hill. 1758-(Died) 1796
PICKETT & RUNDELL (succeeded WILLIAM PICKETT), *goldsmiths & jewellers*; Golden
 Salmon, No. 32 Ludgate hill. 1777-1785
 (Succeeded by RUNDELL & BRIDGE.)
PIERCE THOMAS, *goldsmith*; Prince's street, Leicester fields. 1711
PIERCY ROBERT, *plate-worker*; London. 1759-1777
 Foster lane. 1773-1775
PIERREPONT —, *jeweller*; Silver street, Wood street. 1753
PIERREPONT GEORGE, *silversmith*; Angel street. 1786
PIERS DANIEL, *plate-worker*; Spur street [Leicester fields]. 1746-1749
 Bottom of Leicester fields. 1752-1754
PIERS MARY, *goldsmith*; Leicester fields. 1758
 London. 1758-1762

[1] Mayor of London, 1463-4. [2] Lord Mayor of London, 1789-90.

Plate LVII

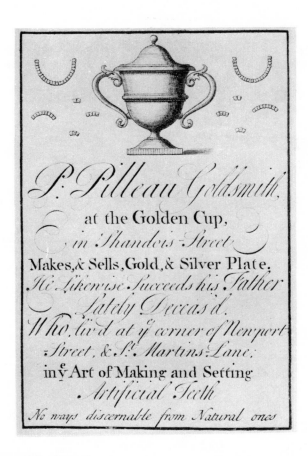

P. Pilleau Goldsmith,
at the Golden Cup,
in Shandois Street,
Makes, & Sells, Gold, & Silver Plate,
He Likewise Succeeds his Father
Lately Deceas'd.
Who, liv'd at y͘ corner of Newport
Street, & S͘t͘ Martins-Lane,
in y͘e Art of Making and Setting
Artificial Teeth
No ways discernable from Natural ones

PEZÉ PILLEAU (Junior) 1719–1755

Plate LVIII

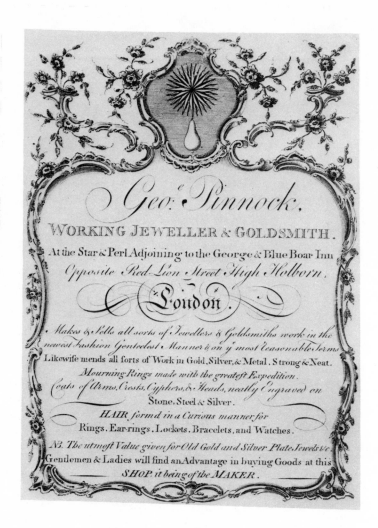

GEORGE PINNOCK *circa* 1760

PIERSE Math., Capt., *goldsmith*; Newgate street. 1721

PIERSON (see also PEIRSON).

PIERSON — (cf. Richard PIERSON), *goldsmith*; over against St Dunstan's Church, Fleet
street. 1702

PIERSON Edward (succeeded Richard PIERSON), *goldsmith*; Acorn, St Dunstan's-in-the-
West [Fleet street]. 1718–1731

PIERSON Richard, *goldsmith*; Acorn, over against the Temple, next door to the Queen's
Head tavern [Fleet street]. 1672–1712

PIERSON William, *goldsmith*; London. 1689

PIGGETT —, *goldsmith*; the Piazza, Covent Garden. 1704

PIGOTT —, *goldsmith*; Gutter lane. (Wife buried) 1556

PIKE —, *pawnbroker*; Three Bowls, against Hosier lane, Snow hill. 1744

PIKENYNGE John, *goldsmith*; London. 1563–1566

PILE John, *goldsmith*; St Martin's-in-the-fields. 1637–1641

PILKINGTON Robert, *plate-worker*; Savoy. 1739

PILLEAU —, "*French goldsmith*"; King's Arms, St Martin's lane. 1697

PILLEAU Alexis,[1] *goldsmith & maker of artificial teeth*; St Martin's lane. 1697

PILLEAU Joseph, *goldsmith*; London. 1687

PILLEAU Pezé, Senior, *goldsmith & artificial teeth maker*; upper end of St Martin's lane. (Before) 1703
Cecil court [St Martin's lane]. 1703–1705
At the Two Black Posts tavern, St Martin's lane. 1705
Golden Anchor, over against Slaughter's Coffee-house, St Martin's lane. 1709

PILLEAU Pezé, Junior,[1] *goldsmith & maker of artificial teeth*; Golden Cup, over against Slaughter's
Coffee-house, at the upper end of St Martin's lane. 1719
Removed over the way to corner of Newport street, St Martin's lane. 1719
Golden Cup on the Paved Stones in Chandos street. 1719–1755

PINARD Paul, *goldsmith & laceman*; Hog lane. 1751
Crown, [No. 2] New street, Covent Garden. c. 1760–1784

PINCHLEY William, *goldsmith*; London. 1663

PINCKING Israel, *plate-worker*; St James's street. 1697
London. 1710

PINCKNEY Henry[2] [cf. GOSLING & CO.], *goldsmith*; parish of St Dunstan's-in-the-West. 1641
Three Squirrels, Fleet street, over against St Dunstan's Church. 1650–1660
Golden Dragon, Fleet street. 1660–1666

PINCKNEY Philip, *goldsmith*; Golden Dragon, Fleet street. 1680
Sun, without Temple Bar. 1697–(Bankrupt) 1708

PINCKNEY William, *goldsmith*; Golden [or Green] Dragon, near Inner Temple gate, next
door to the Three Squirrels. 1660–1675

PINDER Thomas, *goldsmith*; parish of St Mary Magdalen, Milk street. (Will proved) 1620

PINDER William, *goldsmith*; No. 67 Aldersgate street. 1779
Noble street, Foster lane. 1784

PINE Philip, *watch-maker & jeweller*; No. 20 Aldgate. 1779–1782

PINE Samuel, *goldsmith*; parish of St Saviour's, Southwark. 1668

PINEDA Peter, *silversmith*; Grafton street, Westminster. (Insolvent) 1723

PINFOLD Edward, *goldsmith*; Black Lion, Lombard street. 1686–1712

PINFOLD John, *goldsmith*; London. 1569

[1] Pilleau family, see p. 9.
[2] Issued a farthing token, see p. 44. Probably the "Mr Pinckney" mentioned in Pepys' *Diary*
1 Dec. 1660 whose house was destroyed in Great Fire 1666.

PINGO Thomas, *jeweller*; Golden Head, on the Paved Stones, Gray's Inn lane c. 1750(?)

PINGSTON Robert (see MONTAGUE & PINGSTON), *working silversmith*; No. 23
 Bartholomew close. 1790–1793

PINKNEY W. (see William PINCKNEY).

PINNOCK George, *working jeweller & goldsmith*; Star & Pearl, adjoining the George & Blue
 Boar inn, opposite Red Lion street, High Holborn. c. 1760

PINSOLD Edward (see Edward PINFOLD).

PITCHES George (see EDWARDS & PITCHES).

PITMAN Ursula, Mrs, *goldsmith*; King's Head, over against the Bull inn, Holborn. 1684–1690

PITT — (cf. Captain PITTS), *goldsmith*; Holborn. 1695

PITTS —, *goldsmith & jeweller*; Piccadilly, near Half Moon street. c. 1790

PITTS Captain (cf. PITT), *goldsmith*; next door to the Cross Keys tavern, Holborn. 1695

PITTS Thomas, *working silversmith & chaser*; Golden Cup, No. 20 Air street, Piccadilly. 1767–1793

PITTS William, *plate-worker*; St Martin's street. 1781–1785
 Litchfield street. 1786–1791
 Little Wild street. 1799, 1800

PITTS William & PREEDY Joseph, *plate-workers*; Litchfield street. 1791
 Newport street. 1795–1800

PLANCK Anthony, *jeweller*; London. 1699
 Parish of St Leonard's, Foster lane. 1706
 Ring & Pearl, Bread street, near Cheapside. 1727

PLANCK (or PLANK) Anthony, *jeweller*; Bread street, Cheapside. 1749–1751
 Serjeant's Inn, Fleet street. 1760–1779
 No. 63 Great Queen street. 1777

PLANCK Peter, *refiner*; Long Acre. 1768

PLANCKNEY Robert, *goldsmith*; parish of St Mary Woolnoth. 1577–(Buried) 1581

PLASTRIER John, *jeweller*; London. 1690

PLATEL Philip, *plate-worker*; Blackmoor's Head, corner of York buildings [Strand]. 1737

PLATEL Pierre,[1] *plate-worker*; over against the Duke of Schomberg's, in Pall Mall. 1699–1707
 The Lower End of Pall Mall at the Iron Rails. 1716
 London. (Died) c. 1720

PLATTIER Simon, *goldsmith*; Vintry ward. 1583

PLAYER —, *goldsmith*; Tower street. (Died) 1665

PLAYER Gabriel, *plate-worker*; Ratcliffe. 1700–1704
 Near Wapping dock. 1710
 Malling, Kent. 1727

PLAYER Simon, *goldsmith*; parish of All Hallows, Lombard street. (Married) 1632
 London. 1659

PLAYFAIR William & WILSON William, *plate-workers*; Portland road. 1782

PLAYFAIR, WILSON & CO., *working silversmiths*; near Rathbone place. 1784

PLOCKET Claudyn, *goldsmith*; Farringdon Without. 1583

PLUMLEY C. & J., *goldsmiths, jewellers & watch-makers*; Crown & Pearl, No. 43 Ludgate hill. [N.D.]

PLUMLEY William (nephew and successor to John BRISCOE, *q.v.*), *watch-maker, goldsmith
 & jeweller*; Crown & Pearl, No. 43 Ludgate hill. 1768

PLUMLEY William, Junior, *watch-maker & goldsmith*; No. 43 Ludgate hill. 1780–1831

PLUMMER Michael, *plate-worker*; Gutter lane. 1791–1795

[1] Paul de Lamerie was apprenticed to Pierre Platel in 1703.

PLUMMER William, *plate-worker*; Foster lane. 1755–1763
PLUMMER William, *plate-maker*; Gutter lane. 1773–1789
 No. 47 Gutter lane. 1784
 No. 40 (or No. 43) Gutter lane. 1790–1793
PLUTRIER Abraham, *jeweller*; Savoy. (Insolvent) 1721
PLYMLEY Francis, *goldsmith*; Nicholas lane. 1715
 Finch lane. (Insolvent) 1723
POCOCK Edward, *plate-worker*; Foster lane. 1728–1734
PODIE & PETERSON (cf. PETERSON & PODIE), No. 23 Salisbury square. 1790
POINLOU Stephen, *jeweller*; Westminster. (Bankrupt) 1710
POINTS —, *silversmith*; London. 1723
POIRET Robert, *goldsmith*; Foster lane. 1771
POLACK David Moses, *jeweller*; St Mary Axe. (Deceased) 1735
POLE (or POLLE) Thomas, *goldsmith*; parish of St Matthew, Friday street. 1395–(Died) 1413
POLLE Thomas, *goldsmith*; parish of St Matthew, Friday street. 1369–(Buried) 1395
POLLIN John, *silversmith*; Soho. (Insolvent) 1723
POLLOCK John, *plate-worker*; Long Acre. 1734–1739
 Old Belton street, near Long Acre. 1748
 London. 1752, 1753
POMER Andrew, *goldsmith*; London. 1554
POND Charles Chapman, *jeweller & goldsmith*; removed from London to the Butter market
 in St Edmund's Bury [Bury St Edmund's]. [N.D.]
POND George, *jeweller*; Bartholomew close. 1777
PONT John, *plate-maker*; Staining lane. 1739
PONT John, *haft-maker*; Maiden lane. 1773
PONTER —, *silversmith*; Castle street. 1723
PONTIFEX Daniel, *plate-worker*; No. 13 Hosier lane. 1794
PONTIFEX & FOUNTAIN (see FOUNTAIN & PONTIFEX), *silversmiths*; No. 13 Hosier
 lane. 1796
POOL Nathaniel, *goldsmith*; parish of St Mary Woolnoth. (Buried) 1690
POOLE George, *jeweller*; No. 43 Fetter lane. 1768
 No. 88 Bartholomew close. 1772–1784
POOLE James, *goldsmith*; London. 1580
POOLE & BICKERTON (cf. George Poole), *jewellers*; No. 88 Bartholomew close. 1770–1774
POPE —, *goldsmith*; Ball court in Salisbury court, Fleet street. 1716
POPE Thomas, *goldsmith*; London. 1567–1569
 Parish of St Vedast, Foster lane. 1584
POPE Thomas, *jeweller*; Wharton's court, Holborn. 1790–1793
POPPELMAN John Frederick, *jeweller*; Covent Garden. 1719
PORT Thomas, *plate-worker*; Queen street. 1713
 Prince of Wales's Head, over against the Bank, in the Poultry. 1717–1730
PORT William, *goldsmith*; London. Temp. Henry VI
PORTAL Abraham,[1] *goldsmith, jeweller & dramatist*; Rose street, Soho. 1749
 Salmon & Pearl, No. 34 Ludgate hill (see PORTAL & GEARING). 1763–1778
 Castle street, Holborn. 1795–(Died) 1809
PORTAL William, *haft-maker*; Orange street. 1768–1773

[1] See page 10. For list of his plays see *D.N.B.*

PORTAL ABRAHAM & GEARING HARRY, *goldsmiths, jewellers & toymen*; Salmon & Pearl,
 No. 34 Ludgate hill. 1774–(Bankrupt) 1778
PORTER, JOHN, *plate-worker*; Strand. 1698
 Clare court, Drury lane. 1705
 London. 1712
PORTER JOHN, *goldsmith*; Barbican. 1790
PORTER WILLIAM, *goldsmith*; London. 1443–1457
PORTMAN GEORGE, *goldsmith*; parish of St Mary Woolnoth. (Died) 1672
PORTMAN JOHN, *goldsmith & banker*; parish of St Mary Woolnoth. 1641
 Unicorn, Lombard street. 1644–1663
 London. 1670–(Died) 1683
POST WILLIAM, *watch-maker & goldsmith*; Dial, London bridge. 1731–1738
 No. 42 Fish Street hill. 1772–1781
POSTON JOSEPH, *jeweller*; Cheapside. (Married) 1699
POTHERCARY CHRISTOPHER, *watch-case maker*; Bridgewater square. 1768
POTTER JOHN, *silversmith*; Strand. (Bankrupt) 1770
POTTER NATHANIEL, *goldsmith*; Bunch of Grapes, Cheapside. 1659
POTTER THOMAS, *goldsmith*; parish of St Botolph, Billingsgate. 1641–1668
POTTER W. (see NICHOLAS SMITH & W. POTTER).
POTTER WILLIAM, *goldsmith*; parish of St Mary Staining. 1692, 1693
POTTER WILLIAM, *plate-worker*; Wild street. 1777, 1778
POTTINGER JOHN, *jeweller*; No. 6 Bell's buildings, Salisbury square. 1790–1796
POTTS THOMAS, *goldsmith*; Bolt court, Fleet street. 1728
POUNTIN —, *goldsmith*; Long Acre. 1699–1701
 Acron, upper end of Drury lane. 1715
POUNTING ESSIAH, *goldsmith*; parish of St Giles', Cripplegate. (Married) 1658
POUPARD PETER, *goldsmith*; Smock alley, Spitalfields. 1765–1772
POWELL —, *pawnbroker*; Three Golden Balls, Oxford street. 1765
POWELL HANNAH, *silversmith*; No. 56 St Paul's Churchyard. 1790–1793
POWELL JOHN, *pawnbroker*; Black Hart, Bishopsgate street (cf. ANN LILL). 1714, 1715
POWELL THOMAS, *plate-worker*; St Martin's-le-Grand. 1756
 Bolt court [Fleet street]. 1758
 Craig's court, Charing Cross. 1773–1789
POWELL THOMAS, *jeweller*; Peacock, Gutter lane, Cheapside. c. 1760
POWELL WILLIAM, *pawnbroker*; Blue Ball, Hoxton market. 1731, 1732
POWELL WILLIAM, *silver turner*; Little Britain. 1771
 No. 39 Monkwell street. 1793
POWNALL (PETER ?), *goldsmith*; Golden Ball & Pearl, Cheapside. 1712–1721
PRANCE (or PRAUNCE) MILES,[1] *goldsmith*; Princess street, Covent Garden. 1679–1689
PRATHERNON — (see DINGWALL & PRATHERNON).
PRATT THOMAS BOULTON, *goldsmith*; Gutter lane. 1774–1790
PRATT T. B. & HUMPHREYS ARTHUR, *plate-workers*; No. 44 Poultry. 1780
PRATT THOMAS BOULTON, SMITH WILLIAM EDWARD, & HARDY JOSEPH, *goldsmiths &*
 jewellers; No. 82 Cheapside. 1790–(Dissolved partnership) 1796
PREDIE EDMUND, *goldsmith*; parish of St Botolph, Bishopsgate. (Widow re-married) 1588
PREEDY JOSEPH, *plate-worker*; Westmoreland buildings, Aldersgate street. 1777

 [1] The perjurer (see *D.N.B.*). Cf. page 6 *supra*.

Plate LIX

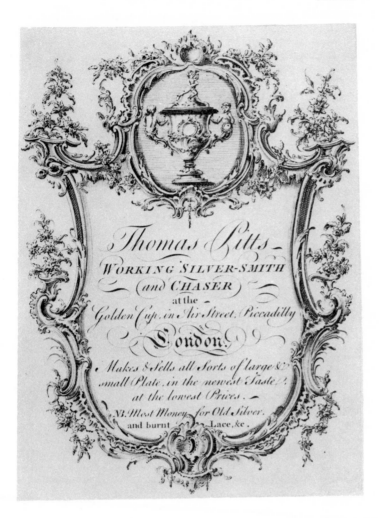

THOMAS PITTS 1767–1793

Plate L

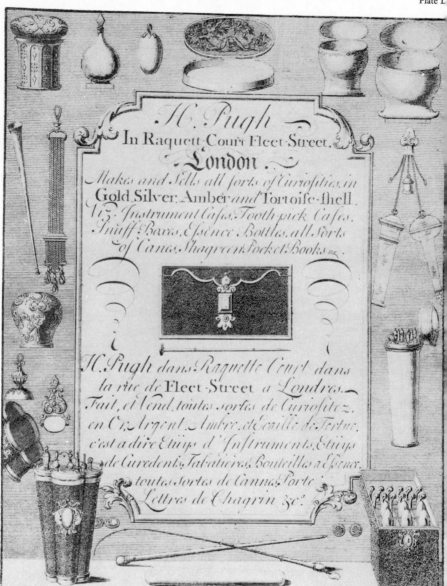

H. PUGH

circa 1740

REEDY Joseph (see also PITTS & PREEDY), *goldsmith*; Lichfield street, Soho. 1791
 Newport street, Soho. 1800

REIST (or PRIEST) James, *goldsmith*; Whitecross street. 1767–1771
 Watling street. 1783

REIST (or PRIEST) John, *plate-worker*; Salisbury court. 1748–1751

REIST Moses, *goldsmith*; Little Britain. 1797

REIST Peter, *goldsmith*; late of London. (Bankrupt) 1726

REIST William, *goldsmith*; corner of Lad lane, Wood street. 1763

REIST William (see SHAW & PREIST).

REIST William, *goldsmith*; Hackney. 1782

REIST (or PRIEST) William & James, *goldsmiths*; No. 30 Whitecross street. 1764–1773

RESBURY Charles, *silversmith & jeweller*; Queen's Head, No. 9 New street, Covent Garden.
 1790–1793

RESENT William, *silversmith*; Goswell street. 1787

RESSON William, *goldsmith*; parish of St Sepulchre. 1673

RESTON John, *goldsmith*; parish of St Clement Danes. (Married) 1661–1665

RESTON Richard, *goldsmith*; London. 1469

RESTON William, *common assayer & goldsmith*; London. 1495–1516

RETTY Richard, *pawnbroker*; Three Bowls, Little Newport street. c. 1715
 Three Bowls, Vere street, by Clare market. 1719

RETTY Thomas, *pawnbroker*; Three Balls, New Belton street [St Giles's]. 1755

RETTY William, *goldsmith*; Great St Bartholomew's. (Insolvent) 1772
 No. 16 Cross Keys court, Little Britain. 1795

RICE —, *pawnbroker*; Three Bowls, corner of Hosier lane, Snow hill. 1742
 Three Bowls, opposite Hosier lane, Snow hill. 1753

RICE —, *pawnbroker*; Three Blue Balls, Holles street, Clare market. 1760

RICE Charles, *pawnbroker*; Golden Ball, Heming's row [St Martin's lane]. 1711

RICE Decimus, *silversmith*; Goswell street. (Insolvent) 1720

RICE Edmund (or Edward), *goldsmith*; Maiden lane, Wood street. 1773

RICE Edward, *jeweller*; London. 1685

RICE George, *goldsmith & jeweller*; No. 89 Oxford street. 1790–1796

RICE Harvey, *plate-worker*; Wine street (? court). (Before) 1726
 Flower-de-Luce court. 1726
 London. 1737

RICE Heneage, *goldsmith*; Golden Lion, without Temple Bar. 1681–(Died) 1709

RICE Samuel (see Thomas & Samuel PRICE).

RICE Thomas, *goldsmith*; parish of St Mary Bothaw. 1672

RICE Thomas, *goldsmith & banker*; Goat, Lombard street. 1675–1686

RICE Thomas, *silversmith*; No. 170 High Holborn. 1784

RICE Thomas & Samuel, *goldsmiths*; Lombard street. (Bankrupt) 1685

RICHARD Edmond, *goldsmith & watch-maker*; Redcross (?) square. 1768

RICHARD (or PRITCHARD) Thomas, *plate-worker*; against the Red Bull in Drury lane.
 1709–1711

RIEST (see also PREIST).

RINCE —, *goldsmith*; Russell street, Covent Garden. 1698

RINCE James, *goldsmith*; parish of St Andrew's, Holborn. 1610

RINCE James, *goldsmith*; parish of St Clement Danes. 1642–(Will proved) 1649

RAEBURN John, *haft-maker & goldsmith*; New street, Fetter lane. 1773
RAGDALE —, *goldsmith*; King's Head, over against Mercer's Chapel, Cheapside. 1694
RAGDALE (or RAGSDALE) Nathaniel [succeeded Richard HOARE], *goldsmith*; Golden Bottle, near the Conduit, Cheapside. 1695–1706
RAGSDALE George (successor to CHADD & RAGSDALE), *jeweller, goldsmith & toyman*; Golden Vause, [No. 25] New Bond street, near Conduit street. 1769–1783
RAGSDALE John (see CHADD & RAGSDALE).
RAINAUD Philip, *plate-worker*; Suffolk street. 1707–(Bankrupt) 1728
RAINBOW W., *goldsmith*; London. 1631
RAINE Richard, *plate-worker*; Fleet street. 1712
RAKELEY (or ROCKLEY) William, *goldsmith*; London. 1443–1445
RAM Anthony, *goldsmith*; parish of St Matthew, Friday street. (Married) 1610
RAM Benjamin, *goldsmith*; parish of St Mary Aldermanbury. (Will proved) 1625
RAM Stephen, *goldsmith*; Angel, Lombard street. 1700–1719
Hackney. 1727–1734
RAMSAY (or RAMSEY) Mary, Dame, *goldsmith*; London. 1600
RAMSEY —, *pawnbroker*; Dove & Two Balls, Baldwin's gardens [Gray's Inn lane]. 1755
RANALES John, *goldsmith*; Chiswell street. 1755–1758
RANCOCK John, *pawnbroker*; Blue Ball, New Gravel lane, Shadwell. 1723
RAND — (see SMITH & RAND).
RAND John, *plate-worker*; Black Dog, Lombard street. 1703–1713
RANDLES John, *goldsmith*; Upper Moorfields. 1773
RANDOLFE Peter, *goldsmith*; London. 1376
RANDS Henry, *goldsmith*; parish of St Matthew, Friday street. 1673
RANIOLDE R., *pawnbroker*; Golden Rose, Frith street, Soho. 1745
RANKLYN Edward, *goldsmith*; London. 1560–1579
RANSON William, *goldsmith*; parish of St Mary Woolnoth. 1650–1653
RAPILLIARD Jean, *goldsmith*; Westminster. 1693
RAPILLIART Paul, *goldsmith*; London. 1692
RASH Bendish, *pawnbroker*; Three Neats' Tongues, near St Margaret's Church, Westminster. 1719
RASINGE Ralph, *goldsmith*; Fleet street. 1641, 1642
RAVEN Andrew, *plate-worker*; St Martin's-le-Grand. 1697
London. 1706–1728
RAVENSCROFT John, *goldsmith*; Old Bailey. 1773
RAWDON Edward, *goldsmith & banker*; London. c. 1458
RAWLE William, *haft-maker*; Castle street, Strand. 1773
RAWLINGS — (see LAMBERT & RAWLINGS).
RAWLINS Eleanor (? Widow of William RAWLINS), *goldsmith*; Scalding alley. 1648
RAWLINS Richard, *goldsmith*; Grafton street, Soho. 1773
RAWLINS (or RAWLINGS) William, *goldsmith*; parish of St Mary Woolnoth. 1607–(Died) 1637
RAWLINSON Randall, *goldsmith*; London. 1600–1612
RAWLINSON Thomas, Sir[1] (cf. LADBROKE, RAWLINSON & CO.), *goldsmith & banker*; Phoenix, Lombard street. 1707–1755
RAWLINSON William, *goldsmith*; parish of St Mary Woolnoth. 1582–1589
RAWSON (RASON or REASON) William, *goldsmith*; Lombard street. 1641
London. 1656–1666

[1] Lord Mayor of London, 1754.

RAWSON WILLIAM & MARRIOTT JOHN, *goldsmiths*; London. 1666

RAY (? JACOB or JOSEPH), *goldsmith*; St Giles', Cripplegate. (Insolvent) 1725

RAY THOMAS, *watch-case maker*; Water street. 1768

RAY WILLIAM, *watch-case maker*; Bridewell, Fleet ditch. 1776

RAYMOND JOHN, *goldsmith*; Boy & Coral, Gutter lane. c. 1755

RAYNAMS MRS, *pawnbroker*; Golden Ball, St Andrew street, St Giles-in-the-fields. 1705

RAYNE JOHN, *goldsmith*; parish of St Leonard's, Foster lane. (Married) 1627
 London. 1636

RAYNER THOMAS, *goldsmith*; Angel, Cranborn street, Leicester fields. (Retired) 1722

RAYNER THOMAS, *silversmith*; London. 1733

RAYNES JOHN, *goldsmith*; Gutter lane. (Married) 1725
 Sign of Pallas, Foster lane. (Insolvent) 1743

RAYNHAM (REYNHAM or REYNOLD) THOMAS, *goldsmith*; parish of St John Zachary (?).
 1360–(Died) 1388

REA JOHN, *goldsmith*; Fleet street. (Will proved) 1622

READ (or REED) GEORGE; *goldsmith & banker*; parish of St Mary Woolnoth. 1700–1705

READ SAMUEL, *silversmith*; Little Bartholomew close. 1790–1793

READE (or REDE) BARTHOLOMEW, SIR,[1] *goldsmith*; parish of St John Zachary. 1481–(Died) 1505

READE JOHN, *plate-worker*; Lawrence Pountney lane. 1701–1704
 London. 1705–1712

READE RICHARD, *goldsmith*; parish of St John Zachary. 1593

READE TIMOTHY, *goldsmith*; parish of St Vedast, Foster lane. (Buried) 1617

READE JOHN & SLEAMAKER DANIEL (see D. SLEAMAKER), *plate-workers*; Lawrence
 Pountney lane. 1701–1704

READING JOHN, *goldsmith*; Clerkenwell. 1766

READING WILLIAM, *goldsmith*; Delahay street, Westminster. (Insolvent) 1743

READSHAW JOSHUA, *plate-worker*; Golden Ball, St Ann's lane. 1697
 Wood street. (Bankrupt) 1728

REASON WILLIAM (see WILLIAM RAWSON).

REBOUL MICHAEL, *jeweller*; parish of St Clement Danes. 1729

REDBORNE HUMPHREY, *goldsmith*; parish of St Sepulchre's. (Will proved) 1651

REDE BARTHOLOMEW, SIR (see SIR BARTHOLOMEW READE).

REDE (or REEDE) THOMAS, *goldsmith*; London. 1553

REDMONDE —, *goldsmith*; London. 1437

REED GEORGE,[2] *goldsmith & banker*; parish of St Mary Woolnoth. 1700–1705

REEDE (or REDE) BARTHOLOMEW, SIR (see SIR BARTHOLOMEW READE).

REEDE THOMAS, *goldsmith*; London. 1516–1518

REEVE JAMES, *goldsmith*; Redcross street, St Giles'. (Will proved) 1654

REEVE PEIRCE (see also LINDSAY & REEVE), *goldsmith*; Angel, Lombard street. 1679

REEVE WILLIAM, *plate-worker*; Blackmoor's Head, Minories. 1731
 Lombard street. 1735–1753

REINAUD —, *silversmith*; lower end of Suffolk street. 1726

RELFE JOHN, *jeweller*; London. 1694

REMO MRS, *pawnbroker*; Golden Ball, St Andrew street, St Giles'. 1712

REMY JOHN BAPTIST, *jeweller*; York buildings [Strand]. (Deceased before) 1751

[1] Mayor of London, 1502–3. [2] See page 3.

Plate LXI

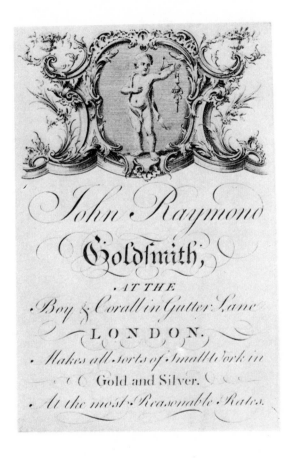

JOHN RAYMOND *circa* 1755

Plate LXII

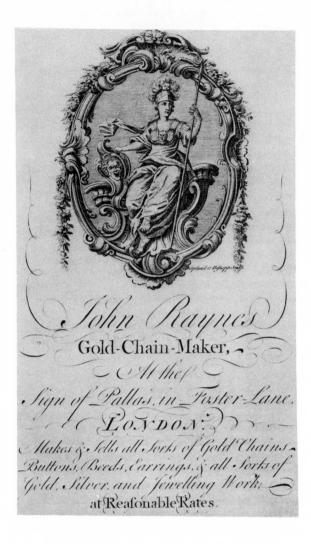

JOHN RAYNES 1725–1743

RENOU ABRAHAM, *goldsmith*; near The Stag, Rider's court, Cranbourn street. 1702
 Newport market. 1704
RENOU PHILIP, SENR., *goldsmith*; over against The George, Earl's street. 1703
 Castle street, Seven Dials. 1705
 St Paul's, Covent Garden. 1720
 St Martin's-in-the-fields. 1721
RENOU THOMAS, *plate-worker*; St John street. 1792
RENOU TIMOTHY, *goldsmith*; London. 1800–1804
REVE JOHN, *goldsmith*; parish of St Michael's Bassishaw. (Deceased before) 1602
REW ROBERT, *plate-worker*; Greenhill's [? Greenwood's] rents [Bishopsgate street]. 1754–1773
REYNES ROBERT, *goldsmith*; London. 1530–1553
REYNHAM (or REYNOLD) THOMAS (see THOMAS RAYNHAM).
REYNOLDS —, *goldsmith*; Fleet street. 1699–1701
REYNOLDS —, *goldsmith*; Cup & Star, Fleet street, near Bride lane. 1718
REYNOLDS — (cf. THOMAS REYNOLDS), *goldsmith*; Minories, near Tower hill. 1762
 No. 92 Minories. 1796
REYNOLDS CHRISTOPHER, *pawnbroker?*; Hart street, Covent Garden. 1732
REYNOLDS JANE, *goldsmith*; Minories. 1770
REYNOLDS JOHN, *goldsmith*; Lombard street. 1542–(Deceased) 1553
REYNOLDS JOHN, *goldsmith*; London. 1609–1629
REYNOLDS JOHN, *haft-maker*; New street, Fetter lane. 1773
REYNOLDS THOMAS, *goldsmith*; No. 1 Sparrow court, Minories. 1784–1793
 No. 92 Minories. 1796
REYNOLDS THOMAS & SON, *goldsmiths*; No. 1 Sparrow court, Minories. 1783–1794
REYNOLDS WILLIAM, *plate-worker*; Swallow street. 1773
 London. 1778–1787
REYNOLDSON WILLIAM, *plate-worker*; St James's market. 1757
 London. 1773
RIBOULEAU ISAAC, SENR., *plate-worker*; London. 1687
 St Martin's lane. 1714–1723, 1730 (?)
RIBOULEAU ISAAC, JUNR., *goldsmith*; London. 1724
 Lombard street. (Insolvent) 1729
RICCARD WILLIAM, *goldsmith & jeweller*; Castle street, Leicester square, near the King's mews.
 1774–1793
RICE STEPHEN, *goldsmith & jeweller*; removed from Bruton street to Pall Mall. 1788
 No. 20 Pall Mall. 1790–1793
RICE THOMAS, *goldsmith*; parish of St Mary Woolnoth. 1685
RICHARDS JAMES, *watch-case maker*; Bridgewater square. 1767–1769
RICHARDS JO., *gold & silversmith*; No. 26 Southampton street, Strand. 1796
RICHARDS THOMAS, *jeweller*; No. 114 Strand. 1772–1774
RICHARDS WILLIAM, *goldsmith*; London. 1730
RICHARDSON ISAAC, *goldsmith & spoon-maker*; Paul's court. 1779
 Maiden lane. 1791
RICHARDSON JOHN, *plate-worker*; Gutter lane. 1723
 Smithfield. 1752
 London. 1768
RICKABY RICHARD, *pawnbroker*; Three Blue Balls, Grosvenor square. 1757
RICOULT JOHN, *goldsmith*; Aldersgate ward. 1618

(231)

RICRAFT —, *goldsmith*; Catherine street, Covent Garden. 1716

RIDOUT GEORGE, *plate-worker*; Lombard street. 1743

RIGAL ANTOINE, *goldsmith*; St Martin's-in-the-fields. 1709–1711

RIGBY CHARLES, *goldsmith*; Heming's row, St Martin's lane. (Insolvent) 1748

RIGFORTH BENJAMIN, *goldsmith*; Nicholas lane. 1677

RILEY CHRISTOPHER, *plate-worker*; Strand. 1697
 London. 1686(?)–1709

RISBY ANTHONY, *goldsmith*; London. 1619

RITHERDON GEORGE, *goldsmith*; Aldgate. 1753–1783

RITHERDON ROBERT, *goldsmith*; No. 3 Aldgate Without. 1790–1796

RIVERS (or RIVORS) ISAAC (see ISAAC RIVIERE).

RIVIERE (RIVERS or RIVORS) ISAAC, *silversmith*; Tottenham Court road. 1765–1773
 St Giles-in-the-fields. 1769

RIVIERE SAMUEL NEWTON (cf. RIVIERE & SON), *goldsmith & jeweller*; No. 68 New Bond
 street. 1782–1808

RIVIERE & SON[1] (cf. S. N. RIVIERE), *jewellers*; No. 68 New Bond street. 1809

ROAKER PHILIP (see PHILIP ROKER).

ROBARTS ESTHER, *pawnbroker*; Seven Stars, Stonecutter street, Shoe lane. 1721

ROBARTS JOHN CHAPMAN, *silversmith*; No. 202 Strand. 1790–1793

ROBARTS JOSIAH (see PEWTRESS & ROBARTS).

ROBARTSON ANDREW, *jeweller*; Salisbury court [Fleet street]. 1780

ROBERT ISAIAH (see ROBERTS).

ROBERT WALTER, *silversmith*; No. 98 Bishopsgate Without. 1787–1793

ROBERTES THOMAS, *goldsmith*; Foster lane. 1568

ROBERTS — (see WILLERTON & ROBERTS).

ROBERTS —, *goldsmith*; Green Dragon, Strand. 1695–1700

ROBERTS —, *goldsmith*; near York buildings, Strand. 1697

ROBERTS — (cf. HUGH ROBERTS), *goldsmith*; Golden Ball, Newgate street. 1691–1701

ROBERTS FRANCIS, *goldsmith*; London. 1726

ROBERTS HUGH, *plate-worker*; Newgate street. 1697
 London. 1697–1714

ROBERTS (or ROBERT) ISAIAH, *working goldsmith*; No. 88 Bishopsgate Within. 1795, 1796

ROBERTS JOSIAH, *goldsmith*; No. 88 Bishopsgate street. 1790–1793

ROBERTS PHILIP, *goldsmith*; Bell dock, Wapping. 1751
 Near the Hermitage. 1753

ROBERTS WILLIAM, *goldsmith*(?); Three Black Lions, without Temple Bar, near Palgrave
 Head court. 1707

ROBERTSON GEORGE, *jeweller*; Leicester fields. 1755
 Crown & Pearl, near corner of the Hay Market, facing Piccadilly. c. 1760

ROBERTSON GEORGE, *diamond merchant & jeweller*; Frith street, Soho. 1774–1777

ROBERTSON WILLIAM, *plate-worker*; Porter street. 1753
 Newport street. 1773

ROBINS JOHN, *plate-worker*; St John's street [? Clerkenwell]. 1774–1800
 Clerkenwell green. 1795

ROBINS JOHN, *goldsmith*; No. 67 Aldersgate street. 1784–1796

1 Also of Bath and Cheltenham.

ROBINS (or ROBYNS) Richard, *goldsmith*; London. 1552
 Parish of St Mary Woolnoth. 1568–(Buried) 1577
ROBINS Thomas, *goldsmith*; Stationers' [Hall] court [Ludgate hill]. 1800
ROBINS William, *goldsmith & jeweller*; No. 13 Fleet street. 1784–1796
ROBINSON — (see NOBLE & ROBINSON).
ROBINSON Anthony, *goldsmith*; No. 232 Strand. 1784
ROBINSON David, *goldsmith*; Holborn. 1785
ROBINSON Edward, *goldsmith*; Warwick lane, near Newgate. 1716
ROBINSON Edward (see PHIPPS & ROBINSON, also ROBINSON & PHIPPS), *goldsmith*;
 Gutter lane. 1783
ROBINSON Henry, *goldsmith*; parish of St Mary Woolnoth. 1692–1695
ROBINSON John, *goldsmith*; parish of St Mary Woolnoth. (Buried) 1591
ROBINSON John, *plate-worker*; Porter street, Soho. 1738
 Leicester fields. 1739–1742
ROBINSON John, *goldsmith & jeweller*; Star & Ring, New Bond street, St George's, Hanover
 square. 1759–1769
ROBINSON John, *plate-worker*; New Bond street. 1773
ROBINSON Jonathan, *plate-worker*; Golden Crown, Orange street. 1723
ROBINSON Philip, *goldsmith*; Golden Parrot, Cheapside. 1714, 1715
 Golden Ball, corner of Salisbury court, Fleet street. 1713–1728
 Fleet street. 1734–(Deceased) 1744
ROBINSON Ralph, *goldsmith*; London. 1640
ROBINSON Richard, *goldsmith*; parish of St Vedast, Foster lane. (Buried) 1563
ROBINSON Richard,[1] *goldsmith*; London. (Hanged) 1577
ROBINSON Samuel, *jeweller*; No. 2 Warwick court, Warwick lane. 1752–1774
ROBINSON Thomas, *goldsmith*; London. 1586
 Parish of St Leonard's, Foster lane. 1609
ROBINSON William, *goldsmith*; St Bride's. (Bankrupt) 1729
ROBINSON Benjamin & ARCH William, *goldsmiths & bankers*; Globe, Lombard street. 1703–1708
ROBINSON & CAVE (cf. Anthony ROBINSON), *goldsmiths*; No.232 Strand,near Temple Bar. —
ROBINSON & PHIPPS (see Edward ROBINSON, also PHIPPS & ROBINSON), *goldsmiths*;
 No. 40 Gutter lane. 1790–1793
ROBOTHAM Walter, *toyman & jeweller*; Red M. and Dagger, Pope's Head alley, Cornhill. 1731
ROBY James, *goldsmith, jeweller & cutler*; No. 2 Princes street, facing Coventry street, Leicester
 square. 1793–1796
ROBY Samuel, *plate-worker*; Bell court, Foster lane. 1740
ROBYNS Richard (see Richard ROBINS).
ROBYNSON Henry, *goldsmith*; parish of St Mary Woolnoth. 1685–1698
ROBYNSON Roger, *goldsmith*; St Benet G[racechurch]. (Deceased before) 1592
ROCHE — (see FOWLER & ROCHE).
ROCHFORT —, *pawnbroker*; Three Balls, Russell court, Brydges street, Covent Garden. 1754
ROCKLEY William (see William RAKELEY).
ROCKLIFF Thomas, *goldsmith*; parish of Christ Church (? Newgate street). 1604
RODENBOSTEL G., *plate-worker*; Piccadilly. 1778
ROE Ebenezer, *plate-worker*; Maiden lane. 1709
ROE Nathaniel, *goldsmith*; Foster lane [removed to Norwich[2]]. 1710–1717

[1] "Drawn from the Tower to Tyborne & there hanged for clipping of gold coins" (Holinshed).
[2] He was a sheriff of the City of Norwich in 1737.

ROFFE John, *goldsmith*; parish of St Saviour's, Southwark. (Died) 1656

ROGER (? or ROGERS) William, *goldsmith*; London. 1630

ROGERS —, *goldsmith*; London. (Died in Newgate) 1639

ROGERS Henry, *goldsmith*; at Temple Bar. 1683–1716
 London. 1724–1727

ROGERS John (see CHILD & ROGERS), *goldsmith & banker*; Marygold, Temple Bar. 1681

ROGERS Richard, *goldsmith*; parish of St Peter's, Westcheap. (Married) 1557–1566

ROGERS Richard, *goldsmith*; parish of St Mary Woolnoth. (Married) 1580–1584

ROGERS Richard, *goldsmith*; parish of St Edmond's, Lombard street. 1602

ROGERS Richard, *goldsmith*; Fleet street. (Will proved) 1656

ROGERS Richard, *goldsmith*; parish of St Andrew's, Holborn. (Re-married) 1670

ROGERS Robert, *goldsmith*; Lombard street. 1769–1773

ROGERS William, *goldsmith*; Southwark. (Will proved) 1626

ROGIERS Theodore, *goldsmith*. Temp. Charles I

ROKER Elizabeth, *plate-worker*; Bishopsgate street. 1776

ROKER John, *working goldsmith*; Golden Cup, without Bishopsgate. 1740–1745

ROKER Matthew, *plate-worker*; Greenwich. 1755–1773

ROKER (or ROAKER) Philip, *silversmith*; parish of St Mary Woolnoth. 1683–1701

ROKER Philip, *plate-worker*; Sherborne lane. 1697
 Long Acre. 1720
 King street, Westminster. 1739

ROKER Philip, *goldsmith*; Bishopsgate street. 1768–1776

ROKER John & Philip, *goldsmiths*; Golden Cup, Bishopsgate Without. 1743–1773

ROLFE Edmund, *goldsmith*; Fetter lane. 1605
 Parish of St Olave, Hart street. (Will proved) 1632

ROLFE William, *goldsmith*; Lombard street. (Married) 1602–(Died) 1648

ROLLES Philip, *plate-worker*; London. 1675
 Strand. 1697

ROLLES Philip (compare Philip ROLLOS), *goldsmith*; London. 1701–1720
 Near York buildings, Strand. 1727

ROLLOS (or ROLLES) Philip, *goldsmith*; London. 1701–1722

ROLPH — (see BENNET & ROLPH).

ROLPH William, *goldsmith*; London. 1600–(Died) 1647

ROMAN Ann, *plate-worker*; Water lane. 1697

ROMER Emick, *goldsmith*; London. 1722

ROMER Emick, *plate-worker*; No. 123 High Holborn. 1770(?)–1773

ROMER John, *plate-worker*; Compton street, Soho. 1773

ROMER Stephen, *goldsmith & jeweller*; No. 33, Bridge street, Covent Garden. 1790–1796

ROMILLY —, *jeweller*; Nassau street, Soho. 1747

ROMILLY Peter, *jeweller*; King street, Soho. 1773
 No. 17 Frith street, Soho. 1768–1794

ROMILLY Peter & SON, *jewellers*; No. 43 Frith street, Soho. 1779
 No. 17 Frith street, Soho. 1784–1790

ROMNEY Simon, *goldsmith*; Little Wood street, Cornhill. 1686–1692

RONDELET Jos., *jeweller*; Crown court, Broad street. 1722

RONGENT —, *jeweller*; Heming's row, St Martin's lane. 1748

RONGENT Etienne, *plate-worker*; Golden Cup, St Anne's, Soho. 1731
 London. 1755

ROOD JAMES, *plate-worker*; Angel Precinct.	1718
Bow lane.	1710
ROOD (or ROODE) MARY, *plate-worker*; Maiden lane.	1720, 1721
ROODE ALEXANDER, *plate-worker*; parish of St Martin Orgar.	1692
Ship, Cannon street.	1694–1706
ROODE GUNDRY, *plate-worker*; Staining lane.	1709–1721
Golden lane.	1737
ROOKE WIDOW, *pawnbroker*; Three Tobacco Rolls, Blackamoor street.	1703
ROOKSBY BENJAMIN, *goldsmith*; Basing lane [Bow lane].	1773
ROOME —, *goldsmith*; London.	1710
ROPER WILLIAM, *plater & jeweller*; St Martin's lane.	1774–1777
No. 2 Great Queen street, Lincoln's Inn fields.	1779
ROSE —, *jeweller*; next door to the Duke's Head, Henrietta street.	1674
ROSE JOSEPH, *goldsmith*; Foster lane.	1767–1782
ROSS ROBERT, *plate-worker*; New street, Covent Garden.	1774–1776
ROSS WILLIAM, *silversmith*; parish of St Botolph, Aldersgate.	1725
ROSSE MICHAEL, *jeweller*; Cecil street.	(Stock sold) 1735
ROTHERDON GEORGE (see GEORGE RITHERDON).	
ROTHLEY WILLIAM, *goldsmith*; London.	Temp. Henry VI
ROUND CHARLES, *goldsmith & watch-maker*; Carthusian street.	1765
ROUS WILLIAM (see WILLIAM RUSSE).	
ROUSE HENRY, *goldsmith*; Gutter lane.	1662
Parish of St Vedast, Foster lane.	1668–1676
ROUSE JANE, *goldsmith*; parish of St Vedast, Foster lane.	(Buried) 1704
ROUSSEL ISAAC, *goldsmith*; Savoy.	1701–1706
ROUSSEL LOUIS, *goldsmith*; Charing Cross.	1706
ROUSSEL NICASIUS, *goldsmith*; Blackfriars.	1617
ROUSSEL PETER (see PETER RUSSEL).	
ROUSSON ANTHONY, *silversmith*; parish of St Giles's.	(Insolvent) 1723
ROWE JOHN, *plate-worker*; London.	1724
Gutter lane.	1749–1773
Monkwell street.	1778
ROWE THOMAS, *goldsmith & banker*; George, Lombard street.	1670–1690
ROWE THOMAS, *plate-worker*; Cannon street.	1753
ROWE THOMAS & GREEN THOMAS, *goldsmiths & bankers*; George, Lombard street.	1672–1677
ROWLAND JOHN, *goldsmith & banker*; Winchester street.	1677
Lombard street.	1682–(Died) 1704
ROWLETT RAFE, *goldsmith*; London.	1551–1553
ROWLEY EDWARD, *working goldsmith*; Cornhill ward.	1692, 1693
ROWLEY EDWARD, *goldsmith*; Half Moon, Spital gate, Bishopsgate street.	1708
ROWLINGS SAMUEL, *pawnbroker*; Three Pigeons & Crown, Drury lane.	1709
ROWND CHARLES, *goldsmith*; parish of St Mary Staining.	(Married) 1655
ROYCRAFT —, *goldsmith*; corner of Exeter street, in Catherine street, Strand.	1713
ROYCROFT RICHARD, *goldsmith*; Angel, Brydges street, Covent Garden.	1714
ROZA JOHN BAPTISTA, *gold spinner*; Cripplegate Without.	1618
RUDD THOMAS, *goldsmith*; parish of St Michael's, Queenhithe.	1641
Parish of St Catherine Cree.	(Will proved) 1655

RUDGE Thomas, *pawnbroker*; Three Golden Balls,[1] Houndsditch. 1731

RUDYERD Thomas, *goldsmith*; parish of St Dunstan's-in-the-West. 1612

RUFFIN Francis (from Mr KEMP), *gold chain maker & small-worker*; Crown & Chains,
 Carey lane. c. 1760
 Cripplegate. 1773

RUGG Richard, *plate-worker*; Saffron hill. 1754
 St John's square, Clerkenwell. 1766–1775

RUGG & THAINE, *goldsmiths*; No. 15 Cheapside. 1784–1793

RUGGLES Thomas, *ring-maker*; Aldersgate street. 1791

RUMBOLD Thomas, *pawnbroker*; Black Spread Eagle, near the watch house, Holborn. 1705

RUNDELL (see PICKETT & RUNDELL).

RUNDELL Philip & BRIDGE John (succeeded PICKETT & RUNDELL), *goldsmiths &*
 jewellers; Golden Salmon, No. 32 Ludgate hill. c. 1780–1802

RUNDELL, BRIDGE & RUNDELL,[2] *goldsmiths, jewellers, watch-makers &c. to Their Majesties*;
 32 Ludgate hill. 1805–1839

RUNDLE Edward, *goldsmith*; Foster lane. 1641, 1642

RUNDLE (or RUNDALL) John, *goldsmith*; London. c. 1600
 Foster lane. 1641

RUSH Mrs, *jeweller*; Ludgate hill. 1762

RUSH Samuel, *jeweller & clock-maker*; No. 16 Ludgate hill and Porter street, near Newport
 market. 1744–1790

RUSH Thomas, *plate-worker*; Acorn, or Acron, Fetter lane. 1724
 London. 1734–1744
 Acorn, Aldersgate street. 1739–1773

RUSHFORTH Fendall, *goldsmith & assayer to the Goldsmiths' company*; Goldsmiths' Hall. 1770–1777
 Carey lane. 1781

RUSLEN (or RUSLIN) John, *goldsmith*; Golden Cup, St Swithin's lane. 1690–1715

RUSSE (or ROUS) William, *goldsmith*; London. 1429–(Will enrolled) 1437

RUSSEL (or ROUSSEL) Peter, *toyman*; at Chenevix's Toy Shop facing Suffolk street,
 Charing Cross. 1759

RUSSELL —, *goldsmith*; Upper Shadwell, against New Gravel lane. 1715–1719

RUSSELL Abraham, *plate-worker*; St Anne's lane. 1702, 1703
 London. 1710, 1711

RUSSELL Elias, *goldsmith*; Suffolk street. 1755–1773

RUSSELL John, *goldsmith*; Northumberland street. 1773

RUSSELL William, *goldsmith*; Foster lane. 1787

RUSTON John, *goldsmith*; parish of St Mary Woolnoth. 1693

RUTLAND Jonathan, *silversmith*; No. 110 Oxford street. 1790–1793
 No. 114 Oxford street. 1796

RUTTER John, *jeweller*; James's walk, Clerkenwell. 1790–1793

RUTTKYN Robert, *goldsmith*; Cornhill. (Married) 1580

RUTTY Daniel, *goldsmith*; London. 1666 (?)

RYCLE Lawrence, *goldsmith*; parish of St Mary Woolnoth. (Buried) 1560

RYLAND Richard, *pawnbroker*; London. 1731

RYLAND William, *goldsmith*; parish of St Leonard's, Eastcheap. 1692

[1] Hilton-Price in his "Signs of London Pawnbrokers" (*Archaeological Journal*, June 1902) says that this is the earliest instance he has met with of a pawnbroker using this sign. Compare Richard Adney (1731), p. 94.

[2] This business was bought by F. Lambert and transferred to Coventry street.

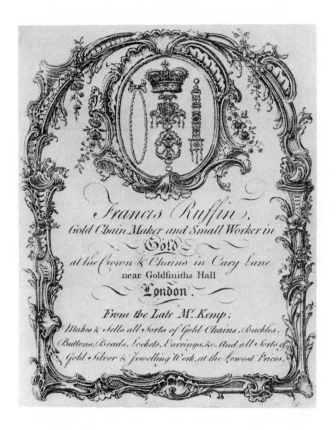

FRANCIS RUFFIN *circa* 1760

Plate LXIV

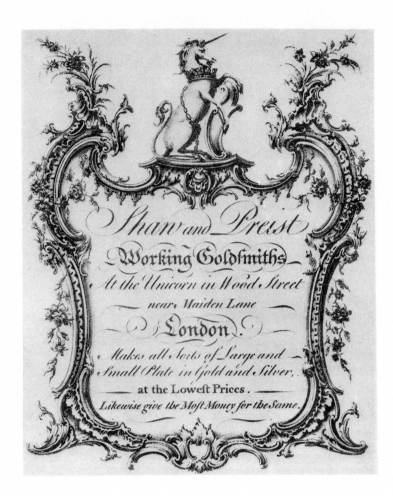

SHAW & PREIST 1749-1758

RYLANDS Mrs, *pawnbroker*; Blue Ball, Little New street, near Shoe lane. 1726
RYLE —, *pawnbroker*; Golden Key, Chamber's street, Goodman's fields. (Left off trade) 1744
RYMORE William, *goldsmith*; London. 1449
RYSWKE Diryke, *goldsmith*; London. 1465
RYVES Robert, *goldsmith & banker*; London. 1670–1672

SACHEVERELL John, *goldsmith*; Bagnio court, Christ Church [Newgate street]. (Insolvent) 1755
SADLER Arthur, *pawnbroker*; Rose, near St Bride's Church, Fleet street. (Left off business) 1739
SADLER Arthur, *goldsmith*; London. 1772
SADLER Thomas, *plate-worker*; Foster lane. 1701–1720
SAFFORY John, *goldsmith & jeweller*; No. 13 Tokenhouse yard, Lothbury, or No. 13 Lothbury.
1760–1777
SAGE Peter, *goldsmith*; Blackfriars. 1576
SAGNIER John & CO., *goldsmiths & jewellers*; Diamond Cross, next door to Mr Drummond's,
Charing Cross. 1769
SAINT John James (see St JOHN).
SAINT (or SAINCT) Phillipe, *goldsmith*; Newport street. 1714–1730
St JOHN James, *goldsmith*; Black Horse, Cheapside. 1677
White Horse, Lombard street. 1687–1695
London. 1724
SALESBURIE William, *goldsmith*; London. 1379
SALISBURY Tremer, *goldsmith*; Westminster. (Insolvent) 1723
SALLAM Robert, *plate-worker*; Watling street. 1773
SALLISBURY Thomas, *goldsmith*; parish of St John Zachary. (Will proved) 1654
SALMON Robert, *goldsmith*; Barbican. 1766
St Martin's Churchyard. 1773
No. 49 Strand. 1784–(Bankrupt) 1788
SALMONS Henry & CO., *jewellers & goldsmiths*; Coventry court, Piccadilly. 1772
SALOMEAU Jean, *goldsmith*; Little St Andrew street. 1709–1735
SALTER Edward, *goldsmith*; No. 20 Cannon street. 1784–1793
SAMPEL William, *plate-worker*; Baldwin's gardens. 1755
London. 1763
SAMPSON John, *jeweller*; No. 24 Bartholomew close. 1790
SAMPSON Stephen, *goldsmith*; Aldersgate ward. 1618
SAMUEL Humphrey, *goldsmith*; Strand. 1784
SAMUEL & HILL, *silversmiths*; No. 3 Charing Cross. 1790–1793
SANBERRY William, *goldsmith*; London. 1668–1679 (?)
SANCHEY William, *goldsmith*; Ropemaker's alley, Little Moorfields. (Died) 1673
SANCKEY William, *goldsmith*; parish of St Mary Woolnoth. (Married) 1627–1649
Lombard street. 1641
SANDBY William, *goldsmith*; London. 1626
SANDEN William, *goldsmith*; St Martin's-le-Grand. 1755
London. 1785
SANDERS Benjamin, *plate-worker*; Staining lane. 1737–1744
SANDERS Hugh (see Hugh SAUNDERS).
SANDERS John, *plate-worker*; Oring (*sic*) street. 1717
London. 1720–1748
SANDERS John, *silversmith*; White Horse court. 1782

(237)

SANDERS Joseph, *plate-worker*; Carey lane. 1730
 London. 1732–1742
SANDERSON — (see SAUNDERSON).
SANDFORD Edward, *goldsmith*; Unicorn, Russell street, Covent Garden. 1689–1705
SANDS Thomas, *watch-case maker*; Lillypot lane. 1769
SANKEY William (see William SANCKEY).
SANKEY William, *goldsmith*; London. 1647–1659
SANKEY & TRIST, *goldsmiths*; Rose & Crown, Lombard street. Early 18th-century
SARAZIN David, *goldsmith*; Threadneedle street. 1699
SARAZIN Jaques, *goldsmith*; Threadneedle street. 1700
SARBIT Dorothy (cf. Dorothy MILLS, also MILLS & SARBIT), *plate-worker*; Saffron hill. 1753
SARBITT John, *goldsmith*; Martin's court, Leicester square. 1790–1796
SARDET Henry, *plate-worker*; High Holborn. 1773–1777
SARFE John, *goldsmith*; St Martin's-le-Grand. 1568
 Aldgate ward. 1582
SARGANT —, *goldsmith*; near the Globe tavern, Fleet street. 1753
SARGANT —, *silversmith*; Hen & Chickens, Fleet street. 1762
SARGENT Benjamin, *goldsmith*; Fleet street. 1743
SARNEY John, *plate-worker*; Gutter lane. 1768–1773
SARSON Thomas, *goldsmith*; Wood street. (Fugitive for debt) 1745
SATCHWELL Thomas, *goldsmith & jeweller*; Paternoster row. 1767–1773
 London. 1780
SAUL Henry, *goldsmith*; removed from Newcastle court, near Temple Bar; to Crown & Ring,
 Brydges street, Covent Garden. 1755
SAUNDERS Alexander, *plate-worker*; Noble street. 1757
 Foster lane. 1766
 St Martin's churchyard. 1773
SAUNDERS Elizabeth, *pawnbroker*; over against the Dial, Fleet lane. (Left off trade) 1716
SAUNDERS Hugh, *plate-worker*; St Bride's lane. 1718–1726
SAUNDERS John, *goldsmith*; parish of St Peter, Paul's wharf. (Married) 1614
SAUNDERS John, *goldsmith*; London. 1674
SAUNDERSON George, *goldsmith*; Golden Bell, near Northumberland house, Strand. 1693–1696
SAVADGE Thomas, *goldsmith*; London. 1628–(Will proved) 1637
SAVAGE — (see KIRK & SAVAGE).
SAVAGE James, *plate-worker*; Fetter lane. 1728–1733
SAVAGE Thomas, *goldsmith*; London. (Died) 1611
SAVAGE Thomas (cf. DOLBY & SAVAGE), *goldsmith & jeweller*; No. 105 New Bond street. 1789
 No. 36 New Bond street. 1790–1793
SAVORY Joseph (see BARNARD & SAVORY), *working goldsmith, cutler & jeweller*; Strand. 1777
 Golden Fleece, No. 48, near Bow Church, Cheapside. 1782–1788
 (Succeeded by SAVORY, FARRAND & CO.)
SAVORY, FARRAND & CO. (see Banks FARRAND), *goldsmiths & jewellers*; No. 48 Cheap-
 side. 1790–1796
SAVORY, FARRAND & SHELDRAKE, *goldsmiths & jewellers*; No. 48 Cheapside. 1793–1809
SAVORY & PRYOR, *cutlers & silversmiths*; No. 10 Poultry. 1793–1796
SAVYDGE Thomas, *goldsmith*; Addle street. 1584
SAYLES Robert, *goldsmith*; London. 1511

(238)

SCALES EDWARD, *goldsmith*; No. 33 Strand. 1773–1780

SCALES WILLIAM, *goldsmith*; London. 1449

SCAMMELL JOSEPH, *silversmith*; No. 38 Noble street. 1788–1793

SCARBOROUGH WILLIAM, *goldsmith*; Cheapside. 1642
 Black Lion, over against Mercers' Chapel, Cheapside. 1663

SCARLET WILLIAM, *goldsmith*; Cradle court, Cripplegate ward. 1692, 1693

SCARLETT RICHARD, *plate-worker*; Foster lane. 1719–1730

SCARLETT WILLIAM, *plate-worker*; Foster lane. 1697–1725

SCHOFIELD JOHN (see ROBERT JONES & JOHN SCHOFIELD), *plate-worker*; Bartholomew
 close. 1776
 No. 29 Bell yard, Temple Bar. 1778–1796

SCHOFIELD ROBERT & JOHN, *goldsmiths*; London. 1772–1776.

SCHRIMPSHAW (or SCRIMSHIRE) MICHAEL, *goldsmith & banker*; Golden Lion, Fleet street.
 1675–1697. (Deceased) 1699

SCHUPPE JOHN, *plate-worker*; Dean's court, St Martin's-le-Grand. 1753–1773

SCHURMAN ALBERT, *plate-worker*; Red Lion street, Holborn. 1756–1762

SCOTT HUMPHREY, *goldsmith*; parish of St John Zachary. 1593

SCRIMSHIRE MICHAEL (see MICHAEL SCHRIMPSHAW).

SCRIVEN —, *pawnbroker*; Three Balls, corner of Beale street, Golden square. 1753

SCRIVEN —, *pawnbroker*; Three Blue Balls, corner of Beach street, Barbican. 1755

SCRIVEN —, *pawnbroker*; Three Blue Balls, corner of St Martin's lane, Strand. 1760

SEABROOK JAMES, *plate-worker*; Wood street. 1714–1720
 Maiden lane. 1718
 Parish of St John Zachary. 1723
 Parish of St Giles, Cripplegate. (Insolvent) 1748

SEALE (or SEARLE) JOHN (see TEMPLE & SEALE).

SEALY JOHN, *goldsmith*; London. 1665
 Parish of St Mary Woolnoth. (Died) 1682

SEAMER (or SEAMOUR) JAMES (cf. JAMES SEYMOUR), *goldsmith*; Flower-de-Luce, near
 Serjeant's Inn, Fleet street. 1695–1709
 Three Flower-de-Luces, Fleet street. 1701–(Deceased) 1739

SEAMOUR THOMAS, *goldsmith*; parish of St Mary Woolnoth, Langbourne ward. 1692, 1693

SEATON GEORGE, *goldsmith & jeweller*; No. 29 Gutter lane. 1768–1784

SEBILLE JOHN (see LANGFORD & SEBILLE).

SEDGWICK FRANCIS, *goldsmith*; Cross Keys & Cushion, next Nando's Coffee-house, between
 the Temple gates, Fleet street. 1685
 Cross Keys, below Fleet conduit, Fleet street. 1685–1690
 Fleet street. 1692

SEDGWICK SIMON, *goldsmith*; parish of St Mary Woolnoth. 1588–(Died) 1619

SELBY ROBERT, *goldsmith*; parish of St Sepulchre, Farringdon ward. 1693–1724

SELLON — (see WRIGHT & SELLON).

SELLOWES JOHN, *goldsmith*; parish of St Matthew, Friday street. (Married) 1598

SELYS —, *goldsmith*; London. 1480

SEMAN BARTHOLOMEW, *goldsmith*; London. 1422–(Died) 1430

SEMAN (or SEMERN) BARTHOLOMEW, *goldsmith*; London. 1468

SEMORE CHARLES (see HYATT & SEMORE).

SEMPEL WILLIAM (see BASKERVILLE & SEMPEL).

SENYCLE Thomas,[1] *goldsmith*; London. 1403

SENYSON John, *goldsmith*; London. 1573

SERGANT Henry, *jeweller*; No. 68 Salisbury court, Fleet street. 1774

SERJEANT Benjamin, *goldsmith*; Fleet street, over against Salisbury court. 1743–1765
 No. 133 Fleet street. 1768–1796

SERLE Edward, *goldsmith*; St Martin's-in-the-fields. (Insolvent) 1729

SETH Thomas, *pawnbroker*; Sugar Loaf, Fore street, by Moor lane. (Left off trade) 1709

SEVERN Richard, *jeweller & toyman*; Crown & Pearl, corner of Pauls Grave [Palsgrave] Head
 court, near Temple Bar. c. 1760

SEWELL Thomas, *goldsmith*; Goswell place, Old street. 1800

SEYLEY —, *goldsmith*; London. 1516

SEYMOUR James (cf. SEAMER, also SEAMOUR), *goldsmith*; Flower-de-Luce, corner of Mitre
 court, Fleet street. 1693–1734

SEYMOUR Thomas, *goldsmith*; Seven Stars, Lombard street. 1660–(Died) 1698

SHAA (or SHAW) Edmund, Sir,[2] *goldsmith*; Foster lane. 1462–(Died) 1488

SHAA (or SHAW) John, Sir,[3] *goldsmith*; Wood street. 1483–(Died) 1504

SHACKMAN John, *goldsmith*; Charing Cross. 1713

SHAKLETON William, *goldsmith*; parish of St Mary Woolchurch Haw. 1578

SHALES Mrs, *goldsmith*; Unicorn, near Serjeant's Inn, Fleet street. 1692

SHALES Charles (cf. SHALES & SMITHIN, also SHALES & BOWDLER), *goldsmith*; Vine,
 Lombard street. 1693–(Died) 1734

SHALES (or SHALER) John, *goldsmith*; Unicorn, near Serjeant's Inn, Fleet street. 1674–1699

SHALES & BOWDLER, *goldsmiths*; Vine, Lombard street. 1715

SHALES & SMITHIN (cf. Samuel SMITHIN), *goldsmiths*; Unicorn, Lombard street. c. 1695–1702

SHARDEN —, *jeweller*; Fountain court, Strand. 1726

SHARP (or SHARPE) Richard, *goldsmith*; St Mary Woolchurch Haw. 1557–(Buried) 1575

SHARP Robert, *goldsmith*; London. 1567–1569

SHARP Robert (see Daniel SMITH & Robert SHARP), *goldsmith*; Alderbury [Alderman-
 bury]. 1770
 Westmoreland buildings [Aldersgate street]. 1789

SHARP & WILLIAMS (cf. Robert WILLIAMS), *watch-makers, jewellers & goldsmiths*; No. 6
 Strand. 1771–(Partnership dissolved) 1781
 (Succeeded by Robert WILLIAMS.)

SHARPE Edward, *goldsmith*; parish of St Clement Danes. 1641–(Will proved) 1652

SHARPE Robert, *goldsmith*; Bartholomew close. 1791

SHARPE Thomas, *goldsmith*; Flying Horse, Lombard street. 1676

SHARPE William, *silver buckle maker*; No. 75 Holborn bridge. 1784–1796
 No. 3 Princes street, Barbican. 1790

SHARPNELL James, *goldsmith & jeweller*; No. 36 Ludgate street. 1770–1774

SHAVEL Peter, *jeweller*; over against South Sea House, Broad street. 1723

SHAW Christopher, *goldsmith*; parish of St John Zachary. 1641
 London. 1656

SHAW Daniel, *plate-worker*; Great Arthur (*sic*) street. 1748

SHAW Edmund, Sir (see Sir Edmund SHAA).

 [1] Probably identical with Thomas LENYDE.
 [2] Mayor of London, 1482–3.
 [3] Knighted at battle of Bosworth. Mayor of London, 1501–2.

SHAW John, Sir (see Sir John SHAA).
SHAW Mary, *pawnbroker*; Greyhound & Hare, Houndsditch. 1717
SHAW Philip, *silversmith*; late of Bishopsgate. (Prisoner for debt) 1720
SHAW William, *goldsmith*; corner of Maxfield's (*sic*) street [? Macclesfield street], facing
 Gerrard street. 1725
 Gerrard street, Soho. 1727
 Golden Ball, Gerrard street, Soho. 1743–1745
SHAW William, *plate-worker*; Maiden lane. 1749
SHAW William, *goldsmith*; No. 22 Wood street, Cheapside. 1763–1772
SHAW William, *plate-worker*; Bishopsgate street. 1769–1773
SHAW William & PREIST William, *working goldsmiths*; Unicorn, Wood street, near Maiden
 lane. 1749–1758
SHAWE John, *goldsmith*; Barking. 1620–(Will proved) 1640
SHAWE Richard, *goldsmith*; parish of St Sepulchre's. (Will proved) 1651
SHAWELL Peter, *jeweller*; Broad street. 1723
SHAYLER William, *goldsmith*; No. 44 Lombard street. 1752–1775
SHEARER —, *pawnbroker*; Three Bowles, Great Wild street. 1744
SHEEN William, *plate-worker*; Old Belton street [Drury lane]. 1755
 St Anne's lane. 1773
 Cow Cross. 1775
SHEENE Alice, *plate-worker*; Lombard street. 1700
 London. 1700–1715
SHEENE Joseph, *plate-worker*; parish of All Hallows, Lombard street. 1692, 1693
 London. 1697–1710
 Lombard street. 1710
SHEER (SHEERS, or SHERE) W., *goldsmith*; Cup & Crown, Lombard street. 1753
SHELDON (or SHELDEN) Richard, *goldsmith*; Red Cross, Lombard street. 1680
SHELDON Richard, *goldsmith*; Lillypot lane. 1794
SHELDRICK C., *goldsmith*; Cheapside. 1795
SHELLEY Charles, *goldsmith*; Panton street, Hay Market. 1664–(Died) 1717
SHELLEY Philip, *goldsmith*; parish of St John Zachary. (Buried) 1603
SHELLEY Samuel, *goldsmith*; Bartholomew close. 1773
 No. 149 Strand. 1784–1793
SHELLEY & CO., *goldsmiths & jewellers*; No. 61 St Paul's churchyard. 1774–1777
SHELLEY & KING, *jewellers*; Strand. 1770–1772
 Removed from Star & Garter, near Norfolk street [Strand] to No. 146 Strand. 1772
 No. 110 Oxford street. 1779–1781
SHELMERDINE Daniel, *silversmith*; Noble street by Foster lane. (Insolvent) 1729
SHEPHERD Henry, *goldsmith*; No. 4 Pope's Head alley, Cornhill. 1760–1768
 Removed to No. 29 Cornhill. 1768
 No. 19 Cornhill. 1770
 No. 24 Cornhill. 1772
 No. 85 Cornhill. 1777–1779
SHEPHERD John, *plate-worker*; Gutter lane. 1685 (?)–1697
SHEPHERD Thomas, *working silversmith*; Bull and Mouth street. 1771
 Glasshouse yard, Aldersgate street. 1785–1789
SHEPHERD & NORRIS, *goldsmiths*; Crown & Pearl, Pope's Head alley, Cornhill. 1761
SHEPPARD John, *goldsmith*; Angel, Lombard street. 1690–1702
SHEPPARD William, *goldsmith*; Angel, Lombard street. 1690–(Bankrupt) 1702
 Suffolk street, Southwark. 1727

SHEPPARD WILLIAM & BRAGG JOSEPH, *goldsmiths*; Angel, Lombard street. 1696–(Bankrupt) 1702

SHERBORNE THOMAS, *goldsmith & jeweller*; No. 6 Strand. 1790–1800

SHERBORNE THOMAS & MARYAN (or MARGAN) RICHARD, *goldsmiths*; No. 6 Strand.
(Partnership dissolved) 1790

SHERE HENRY, *goldsmith*; Cup & Crown, Lombard street. 1751–1755

SHERE HENRY & ARNOLD HENRY (see also HENRY ARNOLD), *goldsmiths*; Cup & Crown,
No. 46 Lombard street. 1760–1772

SHERE W. (see SHEER).

SHERGOLD JUDITH, MRS, *pawnbroker*; next door to the Green Man & Still, Whitecross
street, Southwark. (Left off trade) 1722

SHERMER THOMAS, *plate-worker*; Foster lane. 1717–1720

SHEWELL EDWARD, *goldsmith*; Lombard street. 1761

SHEWTE ROBERT, *goldsmith*; London. (Died) 1581

SHIELDS (or SHIELS), *jeweller*; Spring gardens. 1751
Star, Charing Cross. 1751–1762

SHIPLEY WILLIAM, *silversmith*; No. 40 Piccadilly. 1790–1793

SHIPMAN JOHN, *goldsmith*; parish of St Vedast, Foster lane. (Married) 1621–(Buried) 1653

SHIRLEY JAMES, *goldsmith*; Clapham. 1641

SHIRLEY ROBERT, *goldsmith*; London. 1612
Parish of St Edmund's, Lombard street. 1641

SHORDEN (or SHORDEER) WILLIAM, *goldsmith*; parish of St Mary Woolnoth. 1612

SHORE MATTHEW, *goldsmith*; Grasshopper, Lombard street. c. 1461–1480

SHORE WILLIAM,[1] *goldsmith*; (? Three Crowns) Lombard street. 1466–1480

SHORT —, *jeweller & goldsmith*; Fleet street. 1747

SHORTER JOHN, SIR,[2] *goldsmith*; Bankside, Southwark. 1668–(Died) 1688

SHORTER ROBERT, *pawnbroker*; Crown & Cushion, Bridgewater square. 1744

SHOVELL PETER, *jeweller*; by the South Sea House, Broad street. 1723

SHRAPNELL JAMES, *goldsmith & jeweller*; No. 60 Charing Cross. 1777–1793

SHRAPNELL & SON, *goldsmiths & jewellers*; No. 60 Charing Cross. 1796

SHRIMPTON (see ALEXANDER & SHRIMPTON).

SHRUDER JAMES, *goldsmith*; Wardour street. 1737
Golden Ewer, Greek street, Soho. 1739
Golden Ewer, corner of Hedge lane, Leicester square. 1744–(Bankrupt) 1749
London. 1753

SHULDHAM —, *goldsmith*; Cheapside. 1762

SHUTE FRANCIS, *goldsmith*; parish of St Mary Woolnoth. 1584–(Buried) 1608

SHUTE WALTER, *goldsmith*; parish of St Mary Woolnoth. 1624–1634

SICKLEMORE (or SYKAMORE) MOSES, *goldsmith*; Star, St Margaret's hill, Southwark. 1692–1694

SIDAWAY JOHN, *silversmith*; No. 10 Little Britain. 1790–1793

SIEBER ERNEST, *plate-worker*; Crown street. 1746

SIERVENT SAMUEL, *plate-worker*; St Martin's lane. 1755

SIGNELL ROBERT, *goldsmith*; London. 1569–1583

SILVER DANIEL, *jeweller*; Monmouth court, Hedge lane, near Charing Cross. 1699–1711

[1] William Shore was the husband of Jane Shore the mistress of Edward IV. Chaffers and others have confused this man with Matthew Shore.

[2] Lord Mayor of London, 1687–8.

Plate LXV

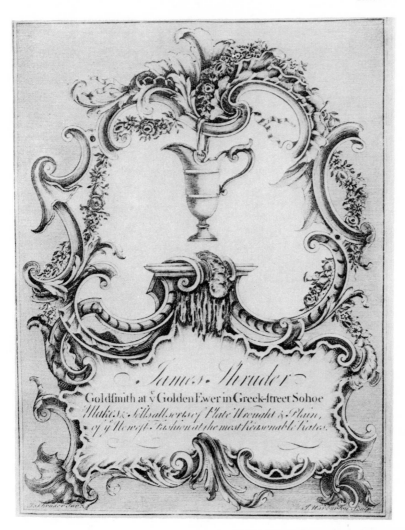

JAMES SHRUDER

Plate LXVI

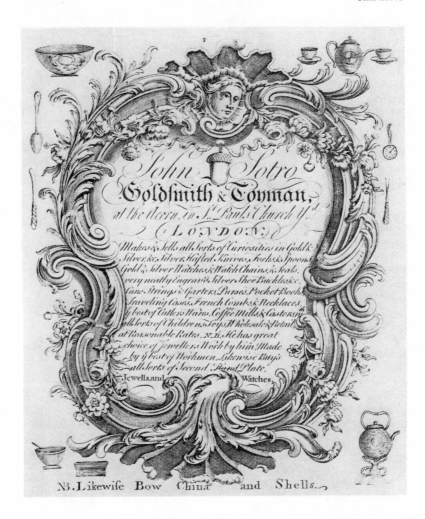

John Sotro
Goldsmith & Toyman,
at the Acorn in S.t Pauls Church Y.d
LONDON.
Makes & Sells all Sorts of Curiosities in Gold &
Silver, &c; Silver Hafted Knives, Forks & Spoons,
Gold & Silver Watches & Watch Chains, & Seals,
very neatly Engrav'd, Silver Shoe Buckles &c.
Cane Strings & Garters, Purses, Pocket Books,
Traveling Cases, French Combs & Necklaces,
y.e best of Cutlers Wares, Coffee Mills & Casters, &.c
all Sorts of Childrens Toys, Wholesale & Retail
at Reasonable Rates. N.B. He has great
choice of Jewellers Work by him Made
by y.e best of Workmen, Likewise Buys
all Sorts of Second Hand Plate,
Jewells and Watches,

N.B. Likewise Bow China and Shells.

JOHN SOTRO 1750

SILVER Joseph, *jeweller & goldsmith*; Eagle & Pearl, No. 113 Fetter lane. 1780–1784
 No. 28 Hatton Garden. 1790–1832
 No. 51 Hatton Garden. 1838 and 1839
SIMKINSON Roger, *goldsmith*; No. 41 Fleet street. 1760–1772
SIMKISS Richard, *goldsmith*; Maiden lane, Wood street. 1773
SIMMONS John, *goldsmith*; Golden Ball, corner of Racquet court, in Fleet street. 1753–1756
SIMMONS Samuel, *jeweller & goldsmith*; Shug lane, Piccadilly. 1743
SIMMS William, *jeweller*; Christopher's alley, Moorfields. 1795
SIMON Peter, *plate-worker*; Earl street. 1725
SIMONS William, *goldsmith*; parish of St Vedast, Foster lane. 1649–(Buried) 1658
SIMONS William, *spoon-maker*; No. 6 Barbican. 1771–1773
 London. 1786
SIMONS William, *plate-worker*; Lambeth. 1776
SIMPSON John & Francis, *jewellers in Ordinary to Charles II*; London. 1660
SIMPSON Launcelot, *goldsmith*; Moorfields. 1780
SIMPSON Thomas, *goldsmith*; parish of St Mary Woolnoth. 1615–1620
SIMPSON Thomas, *goldsmith*; Ludgate street. 1776
 St Paul's churchyard. 1782
SIMPSON Thomas (see JUDD & SIMPSON).
SIMS John, *jeweller*; Union court, Broad street. 1790–1793
SIMS Robert, *jeweller*; Old street square, King street [Old street]. 1753
SIMSON —, *goldsmith*; Golden Lion, over against Short's gardens in Drury lane. 1710
SINGLETON Francis, *plate-worker*; London. 1677–1702
 Foster lane. 1697
SKEEN William, *goldsmith*; St Ann's lane. 1767, 1768
 Greenhill's (*sic*) rents [? Greenwood's rents]. 1775
 Well street, Falcon street. 1783
SKEGGS Sarah, *goldsmith*; No. 355 Rotherhithe street. 1790–1796
SKETCHER John, *goldsmith*; parish of St Mary Woolnoth. 1656–1658
SKINNER —, *goldsmith*; London. 1449
SKOTT —, *goldsmith*; Barking (?). 1584
SKULL — (see WILLERTON, SKULL & GREEN).
SLADE Richard, *pawnbroker*; Aldersgate street. 1709
SLADE William, *necklace-maker*; No. 12 Broadway, Blackfriars. 1770–1778
SLATER James, *plate-worker*; Great Trinity lane. 1732
SLATER Samuel, *pawnbroker*; Shoe lane. 1767
SLEAMAKER Daniel (see READE & SLEAMAKER), *plate-worker*; Swithin's lane. 1704
 London. 1707–1732
SLEATH Gabriel (cf. Gabriel HEATH), *plate-worker*; Gutter lane. 1669 (?), 1704–(Died) 1756
SLEATH Gabriel & CRUMPE Francis (cf. HEATH & CRUMPE), *plate-workers*; Gutter
 lane. 1753–1755
SMALLMAN John, *pawnbroker*; Golden Wheatsheaf, Houndsditch. (Left off trade) 1736
SMALLWOOD Thomas, *pawnbroker*; Bennet's yard, near Masham street, Westminster. 1747
SMART John, *pawnbroker*; Lock & Key, Petticoat lane. (Left off business) 1744
SMART & DENNET, *goldsmiths & enamellers*; No. 35 Frith street, Soho. 1790–1796
SMETHEN William, *goldsmith*; parish of St Peter's, West Cheap. (Buried) 1551
SMITH —, *goldsmith*; Exchange alley. 1688
SMITH — (cf. Thomas SMITH, Cheapside), *goldsmith*; Gold Ring, Cheapside. 1719

SMITH —, *silversmith*; Bishopsgate street. 1762

SMITH ABRAHAM, *goldsmith*; parish of St Mary Woolnoth. 1641–(Died) 1656

SMITH ANDREW, *jeweller*; Coventry street, Haymarket. 1796

SMITH ANN, MRS, *goldsmith*; Cock alley, without Cripplegate. 1692–1698

SMITH CHARLES, *pawnbroker*; Three Bowls, Market street, near St James's market. (Deceased) 1731

SMITH CHARLES, *jeweller*; No. 4 Oat lane, Wood street. 1790–1793

SMITH DAVID, *goldsmith*; Smithfield Bars. 1713

SMITH EDWARD (cf. PAUL WRIGHT), *jeweller*; Foster lane. 1766

SMITH FRANCIS, *goldsmith*; parish of St Mary Woolnoth. 1591

SMITH GEORGE, *plate-worker*; Gutter lane. 1732–1739
London. 1742

SMITH GEORGE, *buckle and haft-maker*; No. 110 Wood street. 1765–1782

SMITH GEORGE (see also SMITH & HAYTER), *goldsmith & buckle-maker*; No. 4 Huggin lane,
Wood street. 1769–1793

SMITH GEORGE, *plate-worker*; Bartholomew close. 1774
Wood street. 1782

SMITH GEORGE, *spoon-maker*; No. 60 Paternoster row. 1783, 1784

SMITH GEORGE, JUNR., *goldsmith*; London. 1796–1815

SMITH G. & S., *plate-workers*; Foster lane. 1751

SMITH HANNAH, MRS, *pawnbroker*; Old Golden Ball, Charles street, St James's market. 1723–1725

SMITH HARMAN, *goldsmith*; Noble street. 1767–1769

SMITH JAMES, *goldsmith*; Lombard street. 1710

SMITH JAMES, *goldsmith*; London. (Bankrupt) 1713

SMITH JAMES, *plate-worker*; Foster lane. 1718–1734

SMITH JAMES, *goldsmith*; London. 1720–1728

SMITH JAMES, *goldsmith*; Hen & Chickens, Tooley street. 1731

SMITH JAMES, *plate-worker*; Monkwell street. 1744

SMITH JAMES, *plate-worker*; Old Bailey. 1746

SMITH JAMES, *silversmith*; Angel, Fleet street. 1750, 1751
Corner of Racquet court, Fleet street. 1751–1762
No. 115 Fleet street [identical with above]. 1760–1780

SMITH JAMES, *working goldsmith*; Angel, Great Old Bailey, near Newgate. c. 1760

SMITH JAMES, *goldsmith*; parish of St John Zachary. (Died) 1771

SMITH JOHN, *goldsmith*; parish of St Vedast, Foster lane. 1641

SMITH JOHN, *goldsmith*; parish of St Giles, Cripplegate. 1641
Over against Cripplegate Church. 1681

SMITH JOHN, *goldsmith*; White's alley [Holborn]. 1692

SMITH JOHN, *goldsmith*; Golden Cock, Strand, near Norfolk street. 1694–1697

SMITH JOHN or JONATHAN, *goldsmith*; Holborn. 1697–(Will dated 1703)–1710

SMITH JOHN or JONATHAN, *plate-worker*; Little Britain. 1720

SMITH JOSEPH, *plate-worker*; Foster lane. 1707

SMITH JOSEPH, *plate-worker*; Clerkenwell. 1728–1733

SMITH JOSEPH, *goldsmith*; No. 49 Lombard street. 1783–(Bankrupt) 1792

SMITH LUKE, *goldsmith*; parish of St Mary Woolchurch Haw. 1587–(Buried) 1604

SMITH NICHOLAS (see NICHOLAS SMITH & W. POTTER), *goldsmith*; Phoenix, Lombard
street. 1680–1684

SMITH PHILIP, *watch-case maker*; Mugwell [Monkwell] street. 1768

SMITH R., *goldsmith*; over against Cripplegate Church. 1715
SMITH RICHARD, *goldsmith*; Langbourne ward. 1692, 1693
 Parish of St Mary Woolnoth. 1695–1699
SMITH RICHARD, *pawnbroker*; Sash, Earl street, St Giles. 1707
SMITH RICHARD, *jeweller*; No. 12 Cloak lane, Dowgate hill. 1784–1793
SMITH ROBERT, *goldsmith*; parish of St Vedast, Foster lane. (Will proved) 1624
SMITH ROBERT, *goldsmith*; Paul's alley, Red Cross street, Cripplegate ward. 1692, 1693
SMITH ROBERT, *silversmith*; No. 15 Bartholomew close. 1790–1793
SMITH SAMUEL, *plate-worker*; Swithin's lane. 1700–1704
SMITH SAMUEL, *plate-worker*; Gutter lane. 1719
SMITH SAMUEL, *plate-worker*; Foster lane. 1754
SMITH SAMUEL, *goldsmith & banker*; No. 12 Aldermanbury. 1773–1800
SMITH THOMAS, *goldsmith*; parish of St Sepulchre. 1640, 1641
SMITH THOMAS (see THOMAS SMITH & WILLIAM GIBBONS), *goldsmith*; Cheapside. 1641
 Blackmoor's Head, Cheapside. 1656–1659
SMITH THOMAS, *goldsmith*; Friday street. 1658
SMITH THOMAS, *goldsmith*; Dove court, Gutter lane. 1705
SMITH THOMAS (cf. — SMITH, Gold Ring, Cheapside), *goldsmith*; Cheapside. 1721
SMITH THOMAS, *plate-worker*; Wood street. 1750
 London. 1774
SMITH THOMAS, *goldsmith*; Hare, Lombard street. 1755
SMITH WALTER, *goldsmith & jeweller*; Acorn & Star, [No. 98] Bishopsgate street. 1760–1762
SMITH WILLIAM (cf. THOMAS SMITH); *jeweller & working goldsmith*; Blackmoor's Head,
 opposite Gutter lane, [No. 32] Cheapside. 1760–1779
 No. 30 Milk street. 1769–1779
SMITH WILLIAM EDWARD (see PRATT, SMITH & HARDY).
SMITH W. & R., *jewelry warehouse*; King street, Cheapside. 1796
SMITH GEORGE & FEARN WILLIAM, *goldsmiths*; Lovell's court, Paternoster row. 1786–1796
SMITH THOMAS & GIBBONS WILLIAM (cf. WILLIAM SMITH), *goldsmiths*; Blackmoor's
 Head, Cheapside. 1659
SMITH GEORGE & HAYTER THOMAS, *goldsmiths*; Huggin lane, Wood street. 1792–1796
SMITH NICHOLAS & POTTER W. (see also NICHOLAS SMITH), *goldsmiths*; Phoenix,
 Lombard street, corner of Sherborne lane. 1681–1683
SMITH & RAND, *jewellers*; Dorset street, Salisbury square. 1790–1793
SMITH DANIEL & SHARP ROBERT, *plate-workers*; London. 1763–1789
 No. 50 Aldermanbury. 1763–1777
 Westmoreland buildings [Aldersgate street]. 1780
 No. 14 Bartholomew close. 1779–1796
SMITHES GEORGE (see GEORGE SMYTHES).
SMITHIE THOMAS, *goldsmith*; London. 1649
SMITHIER WILLIAM, *goldsmith*; parish of St Mary Woolnoth. 1657
SMITHIES (or SMITHES) GEORGE, *goldsmith*; Friday street. (Married) 1588
 Parish of St Mary Staining. (Buried) 1615
SMITHIES JOHN, *goldsmith*; London. 1666
SMITHIN SAMUEL (cf. SHALES & SMITHIN), *goldsmith*; Unicorn, Lombard street. c. 1695–1702
 Vine, Lombard street. 1702
SMITHSEND JOHN, *plate-worker*; Minories. 1697
SMITHSON MRS, *pawnbroker*; Blackamoor's Head, Castle street, Long Acre. 1718

(245)

SMITHSON William, *goldsmith*; parish of St Dunstan's-in-the-East. (Will proved) 1624
SMYTH — (see GREVILL & SMYTH).
SMYTHES George, *goldsmith*; London. 1611–(Died) 1615
SNAGG Richard, *goldsmith*; Unicorn, Lombard street. 1682
 Exchange, Lombard street. 1683
 Flying Horse, Lombard street. 1691
 Lombard street. 1708–(Buried) 1715
SNELL —, *goldsmith*; London. 1724
SNELL George, *goldsmith & banker*; Fox, Lombard street. 1640–1677
 Acorn, Lombard street. 1666
SNELL John, *goldsmith & banker*; Fox, Lombard street. 1668–1685
 Cock, Lombard street. 1680
SNELL Nathaniel, *goldsmith*; London. (Will proved) 1647
SNELL William, *goldsmith & banker*; Seven Stars (afterwards Acorn), Lombard street. 1665, 1666
SNELL William, *goldsmith*; London. 1724
SNELLING John, *plate-worker*; Holborn. 1697–1704
SNELLING Mrs, *goldsmith*; Lock & Key in Holborn, over against Hatton garden. 1716
SNOW Jeremiah, Sir, Bart., *goldsmith & banker*; Golden Anchor, Strand. c. 1660
 Lombard street. 1660–(Died) 1702
SNOW Richard, *goldsmith*; London. 1625
 Parish of St John Zachary. 1641
SNOW Robert, *goldsmith*; parish of St Michael's, Wood street. (Will proved) 1638
SNOW Thomas, *goldsmith & banker*; Golden Anchor, Strand. 1700–1720
SNOW Thomas & CO., *goldsmiths & bankers*; without Temple Bar. 1744–1768
SNOW, BRIGHT & KIRKE, *jewellers*; No. 9 Foster lane. 1796
SNOW Thomas & DENNE William, *goldsmiths & bankers*; without Temple Bar. 1754–c. 1768
SNOW Thomas & PALTOCK John (see also John PALTOCK), *goldsmiths & bankers*; ? Fleet street and Strand. 1728
SNOW & WALTON, *goldsmiths & bankers*; Golden Anchor, without Temple Bar. 1660
SOAME (or SOANE) —, *goldsmith*; London. 1704
SOAME William, *plate-worker*; Friday street. 1723–1739
SOAME William, *plate-worker*; Cheapside. 1732–1739 (Died 1772, "having retired many years")
SOANE Bartholomew, *goldsmith*; London. 1668
SOLOMON Lazarus, *jeweller*; Heming's court, Haymarket. 1790–1793
SOLOMON William, *plate-worker*; Church street, Soho. 1747
SOLOMONS Henry & CO., *jewellers & goldsmiths*; Coventry court, Piccadilly. 1770
SOMERFORD Francis, *goldsmith*; Princes street. 1776
SOMMERS —, *goldsmith*; Golden Buck (or Golden Hind), Fleet street. 1686
SOMMERS Richard, *goldsmith*; parish of St Mary Woolnoth. (Will proved) 1625
SONE —, *goldsmith*; parish of St Mary Woolchurch Haw. 1604–1607
SONE Thomas, *goldsmith*; Exchange alley. 1715
SONES Thomas, *watch-case maker*; Lillypot lane. 1766
SOREL Thomas, *goldsmith*; "described as of Westminster Abbey". 12—
SOTRO John, *goldsmith & toyman*; Acorn (or Golden Acorn), north side of St Paul's church-yard. 1750
SOUTH Edward, *goldsmith*; parish of St Mary Steyning. 1641–1655 (?)
SOUTH Robert, *goldsmith*; London. 1667

SOUTHAM Giles (cf. Thomas CALDECOTT), *goldsmith & jeweller*; Little Britain.
1745–(Died) 1747
SOUTHWOOD William, *goldsmith*; London. 1530–(Died) 1557
SOUX Daniel (cf. SUKS —), *goldsmith*; Goulston square, near Whitechapel Bars. 1701
SOWTHOWSE William, *goldsmith*; parish of St Benetfink. (Married) 1593
SPACKMAN John, *plate-worker*; Spread Eagle, Strand. 1694–1696
 Charing Cross. 1697
SPACKMAN John, *plate-worker*; London. 1724
 Foster lane. 1741
SPACKMAN Thomas, *plate-worker*; Foster lane. 1700–(Bankrupt) 1719
SPACKMAN William, *plate-worker*; Lillypot lane. 1714–1726
SPAEN Carlos, *goldsmith*; London. 1445–1447
SPALES George, *goldsmith*; Lombard street. 1697
SPARAWE John, *goldsmith*; parish of St Peter's, West Cheap. 1603
SPARROW Richard, *goldsmith*; Cheapside. 1603
SPEARINGE Nicholas, *goldsmith*; parish of St Andrew's Undershaft. (Married) 1583
SPEARN William, *spoon-maker*; St Martin's-le-Grand. 1771
SPEILMAN (or SPILMAN) John, Sir, *the Queen's goldsmith*; London. 1583–1597
SPENCER —, *goldsmith*; Grasshopper, Lombard street. 1693
SPENCER Justyne, *goldsmith*; parish of St Mary Woolnoth. 1586, 1587
SPENDELEY Robert, *goldsmith*; London. 1540–1553
SPERON William, *goldsmith*; London. 1336
SPICER John, *jeweller*; parish of St Dunstan's-in-the-West. (Married) 1733
SPILMAN John (see John SPEILMAN).
SPILSBURY Francis, *plate-worker*; Black Spread Eagle, Foster lane. 1729–1739
SPILSBURY Francis, Junr., *plate-worker*; No. 24 Gutter lane. 1767–1773
SPINDELLAW John, *silver button maker*; Great New street. 1772
SPINK —, *goldsmith*; Grasshopper, Lombard street. 1696
SPINK Elmes (?), *goldsmith*; parish of St Nicholas Acon, Langbourne ward. 1692, 1693
SPIRES —, *pawnbroker*; Three Golden Balls, Clare street, Clare market. 1760
SPITTIMBER James, *goldsmith*; Unicorn & Bible, Cheapside. 1745
SPOONER Thomas, *goldsmith*; London. 1553
SPRAGE Charles, *plate-worker*; Chapel court. 1734
SPRATNELL Samuel, *silversmith*; Cockspur street, Charing Cross. 1790–1793
SPRIMONT Nicholas,[1] *plate-worker*; Compton street, Soho. 1742–(Died) 1770
SPRING Hugh, *plate-worker*; Foster lane. 1721–(Insolvent) 1729
SPRING William, *plate-worker*; Golden Cup, near Hungerford market, Strand. 1701–1727
 Strand. 1734
SPRINGHALL Nathaniel (see MASTERMAN & SPRINGHALL, also HOW & SPRINGHALL).
SPYCER Robert, *goldsmith*; parish of St Mary Woolnoth. 1538
SPYER Joseph & Solomon, *jewellers*; No. 26 Prescott street, Goodman's fields. 1796
SPYER Solomon, *jeweller*; No. 26 Great Prescott street. 1790–1793
SQUIRE George, *plate-worker*; London. 1697–1699
 Golden Angel, Fleet street. 1720
 London. 1723–1729

[1] See p. 7.

STACKHOUSE Thomas, *silversmith*; Candlestick & Snuffers, Gutter lane. 1724
 Blue Ball court, Salisbury court, Fleet street. [N.D.]
STALEY John, *goldsmith*; parish of St Martin's-in-the-fields. 1641
STALEY (or STAYLER) John, *goldsmith*; over against the Cross Keys tavern in Henrietta
 street, Covent Garden. c. 1655–(Deceased) 1683
STALEY (or STAYLEY) Richard, *goldsmith & banker*; Covent Garden. 1673–1685
STALEY William (see William STAYLEY).
STALLARD Philip, *jeweller*; No. 13 New square, Shoe lane. 1790–1793
STALLWORTHY Daniel, *goldsmith*; parish of St Mary Staining. (Will proved) 1640
STAMP Francis, *plate-worker*; No. 86 Cheapside. 1780
STAMP James, *working goldsmith & jeweller*; Ludgate street. 1766
 No. 86 Cheapside. 1772–1779
STAMP James & Francis, *goldsmiths*; No. 86 Cheapside. (Succeeded by James SUTTON.) 1780
STAMP Richard, *goldsmith*; Cheapside. 1772
STAMP James & BARKER John, *working goldsmiths & jewellers*; No. 32 Ludgate street. 1768
 (Partnership dissolved) 1770
STAMPER John (see ALDRIDGE & STAMPER), *goldsmith & jeweller*; London. 1743
 Star, corner of Hind court, opposite Water lane, in Fleet street. 1762–1766
 No. 148 Fleet street. 1772
STANDLEY John, *goldsmith*; parish of All Hallows, Bread street. 1615–(Buried) 1664
STANDOLF (or STANDELF) John, *goldsmith*; ward of Farringdon Within. c. 1420
STANDULPH John, *goldsmith*; parish of St Vedast, Foster lane. (Buried) 1369
STANFORD John, *goldsmith*; parish of St Peter's, West Cheap. (Married) 1605
STANGER Anne, *pawnbroker*; Crown, next door to Fleece tavern, Piccadilly. 1704
STANLEY —, *jeweller*; Crown court, Fleet street. 1747
STANLEY Edmund, *goldsmith*; parish of St John Zachary. (Died before) 1586
STANNARD William, *goldsmith*; parish of St Nicholas Acon, Langbourne ward. 1692, 1693
STAPLES Charles, *jeweller*; St Bride's [Fleet street]. 1766
 Dean street, Fetter lane. 1779–1793
STAPLES Edward (alias SMITH), *goldsmith*; Aldgate. (Absconded) 1721
STAPLES Edward, *goldsmith*; parish of St Mary, Whitechapel. (Insolvent) 1729
STARKEY Henry, *goldsmith*; parish of St Mary Woolnoth. 1631–1636
 Parish of St Michael's, Wood street. 1641
STAUNTON Rowland, *goldsmith*; parish of St Mary Woolnoth. 1540–1542
STAYLER John (see John STALEY).
STAYLEY Richard (see Richard STALEY).
STAYLEY (or STALEY) William,[1] *goldsmith*; Covent garden. (Executed) 1678
STEAD Ann, *pawnbroker*; next the Three Tuns, Long Acre. 1712
STEDMAN Henry Adam, *goldsmith*; Golden lane. c. 1762
 Brick lane. (Bankrupt) 1769
STEDMAN & VARDON, *goldsmiths & jewellers*; No. 36 New Bond street. 1796
STEERES John, *goldsmith*; Blue Lion, Old Round court, Chandos street. 1771
 No. 9 Pall Mall. 1786
STEEVENS Jacob (see Jacob STEPHENS).
STEMMING —, *goldsmith*; Piccadilly. 1752
STEPHENS (or STEVENS) —,[2] *silversmith*; London. 1660–1664

[1] Tried and sentenced to death for being guilty of High Treason, 21 Nov. 1678 (*D.N.B.*).
[2] See Pepy's *Diary*, 2nd Nov. 1660, 23rd Jan. 1661, 12th Aug. 1664 and 19th Oct. 1664.

Plate LXVII

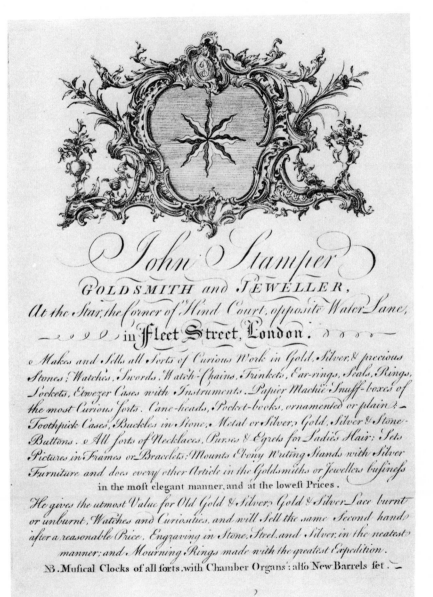

John Stamper

GOLDSMITH and JEWELLER,

At the Star, the Corner of Hind Court, opposite Water Lane, in Fleet Street, London.

Makes and Sells all Sorts of Curious Work in Gold, Silver, & precious Stones: Watches, Swords, Watch-Chains, Trinkets, Ear-rings, Seals, Rings, Lockets, Etwezer Cases with Instruments. Papier Maché Snuff-boxes of the most Curious Sorts. Cane-heads, Pocket-books, ornamented or plain: Toothpick Cases, Buckles in Stone, Metal or Silver: Gold, Silver & Stone-Buttons. All Sorts of Necklaces, Purses & Egrets for Ladies Hair: Sets Pictures in Frames or Bracelets: Mounts Ebony Writing Stands with Silver Furniture and does every other Article in the Goldsmiths or Jewellers business in the most elegant manner, and at the lowest Prices.

He gives the utmost Value for Old Gold & Silver, Gold & Silver Lace burnt or unburnt, Watches and Curiosities, and will Sell the same Second hand after a reasonable Price, Engraving in Stone, Steel, and Silver, in the neatest manner: and Mourning Rings made with the greatest Expedition.

N.B. Musical Clocks of all sorts, with Chamber Organs: also New Barrels set.

Plate LXVIII

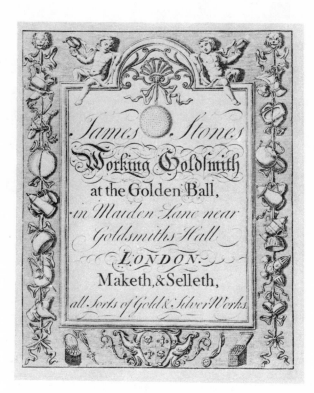

James Stones

Working Goldsmith
at the Golden Ball,
in Maiden Lane near
Goldsmiths Hall
LONDON
Maketh, & Selleth,
all Sorts of Gold & Silver Works.

JAMES STONES *circa* 1760

STEPHENS —, *goldsmith*; No. 32 Aldgate High street. 1784–1793

STEPHENS David, *pawnbroker*; Black Spread Eagle, Phoenix street, Bloomsbury. 1716

STEPHENS (or STEEVENS) Jacob, *goldsmith*; parish of St Saviour's, Southwark. 1643–1651

STEPHENS John, *goldsmith*; Panton street, near Leicester fields. 1706

STEPHENS Joseph, *silversmith*; Whitechapel. 1721–1752

STEPHENS Roger, *goldsmith*; parish of St John Zachary. 1641–1673

STEPHENS (or STEVYNS) Thomas, *goldsmith*; London. 1549–(Died) 1578

STEPHENSON — (see MORSON & STEPHENSON).

STEPHENSON (or STEVENSON) Ambrose, *plate-worker*; Barbican. 1706–1720

STEPHENSON Benjamin, *plate-worker*; No. 5 Ludgate hill. 1774–1779

STEPHENSON Jacob, *goldsmith*; parish of St Saviour's, Southwark. 1646

STEPHENSON William, *silversmith*; No. 27 Lombard street. 1786–1796

STEVENS — (see — STEPHENS).

STEVENS Humphrey, *goldsmith*; Lombard street. 1551–(Buried) 1579

STEVENS Jos., *goldsmith*; No. 32 Aldgate Without. 1772–1774

STEVENS Thomas, *goldsmith*; parish of St Mary Woolnoth. 1543–(Buried) 1549

STEVENSON — (cf. STEVENSON & ACTON), *goldsmith*; Birchin lane. 1707

STEVENSON (or STEPHENSON) Ambrose, *plate-worker*; Barbican. 1706–1720

STEVENSON John (successor to Wm CARELESS), *gilt & silver button maker*; Golden Lion, opposite St Clement's Church, Strand. 1766–1774

STEVENSON Widow, *pawnbroker*; Golden Cup, Golden lane, St Luke's. 1745

STEVENSON & ACTON (cf. — STEVENSON), *goldsmiths*; Birchin lane. 1711

STEVYNS Thomas (see Thomas STEPHENS).

STEWARD John, *plate-worker*; Grub street. 1755

STEWARD John, *goldsmith*; No. 99 Wood street, Cheapside. 1789–1796
Bunhill row. 1799

STEWARD Joseph, *plate-worker*; Maiden lane. 1719–1739

STEWARD Joseph, *small-worker*; Gutter lane. 1765, 1766

STEWARD Joseph, *goldsmith*; ? 89 or 98 Wood street, Cheapside. 1770–1793

STEWART (?) John, *goldsmith*; London. 1742

STEWART William, *jeweller*; Gerard street, Soho. 1762
Crown & Pearl, Strand, facing Hungerford market. [N.D.]

STIBBS Christopher, *goldsmith, jeweller & cutler*; No. 17 Poultry. 1784

STILES —, *pawnbroker*; Three Blue Balls, Castle street, Leicester fields. 1758

STIRLING John, *goldsmith & jeweller*; No. 4 Queen's square, Bartholomew close. 1773–1784

STIRLING Walter, Sir (see HODSOLL & STIRLING).

STOAKES Samuel (see Samuel STOKES).

STOCKBRIDGE John, *goldsmith*; Cripplegate. 1582

STOCKDALE —, *pawnbroker*; Three Golden Balls, Gt Pulteney street, Golden square. 1754

STOCKDALE Edward, *jeweller*; parish of St Clement Danes. 1679

STOCKE James, *goldsmith*; Cheapside (?). 1566–(Buried) 1578

STOCKER (or STOCKAR) John Martin, *plate-worker*; Mitre, near York buildings, Strand. 1705–1712

STOCKER John Martin & PEACOCK Edward (see Edward PEACOCK), *goldsmiths*; Strand. 1705–1710

STOCKS (see STOKES).

STOCKTON Manasses, *goldsmith*; London. 1528

STOCKTON Manasses, *goldsmith*; Cheapside (?). 1569–(Buried) 1590

STOCKWELL Henry, *jeweller*; Bell's building, Salisbury square. 1790–1793

STOCKWELL Richard, *pawnbroker*; Three Bowls, Bride lane, Fleet street. 1715–1719

STOKES (or STOCKS) Humphrey,[1] *goldsmith & banker*; Paternoster row. 1660–1666
 Removed to Black Horse, Lombard street. 1677

STOKES Joseph, *plate-worker*; Southwark. 1697

STOKES (or STOCKS) Joseph, *goldsmith*; White Hart court, Lombard street. 1704–1709

STOKES Robert (successor to Humphrey STOKES), *goldsmith*; Black Horse, Lombard street.
 1700–1705 (?)

STOKES Samuel, *goldsmith*; parish of All Hallows, Lombard street. (Buried) 1669

STONE Andrew, *goldsmith*; Grasshopper, Lombard street. 1699–1711

STONE Nathaniel, *goldsmith*; Lombard street. 1691

STONE Thomas, *pawnbroker*; Rose & Three Balls, Princes street, Clare market. 1758

STONE & MARTIN (cf. Thomas MARTIN), *goldsmiths & bankers*; Grasshopper, Lombard
 street. 1701–1711

STONER (or STONOR) Clement, *goldsmith*; parish of St Mary le Bow. (Married) 1633–1689 (?)

STONES James, *working goldsmith*; Golden Ball, Maiden lane, near Goldsmiths' Hall. c. 1760–1790

STONYWELL William, *goldsmith*; parish of St Leonard's, Foster lane. (Married) 1593

STOREY Charles, *goldsmith & jeweller*; No. 1 Poultry. 1743, 1790–1796

STOREY Charles, *jeweller & toyman*; Sun, Sidney's alley, Leicester fields. 1751–1773

STORKE James, *goldsmith*; London. 1560–1569

STORNAC Sebastian, *goldsmith*; Colman street [Colman Hedge lane]. 1706–1710
 Southampton court near Covent Garden. 1714–1717

STORR Marmaduke, *goldsmith & watch-maker*; Lombard street. 1772

STORR Paul (cf. FRISBEE & STORR) *plate-worker*; Cock lane, Snow hill. 1792
 Church street, Soho. 1792
 Moved to Air street, Piccadilly. 1796
 Dean street, Soho. 1807–1839
 (Succeeded by STORR & MORTIMER, and later HUNT & ROSKELL).

STOWERS Adam, *pawnbroker*; Ship & Shears, High Holborn. 1754

STRANGE William, *silversmith*; New street, St Bride's. (Insolvent) 1743

STRAUGHAN (? STRAHAN) —, *jeweller*; York buildings [Strand]. 1695

STREET William, *plate-worker*; Staining lane. 1717–1720

STREETE John, *goldsmith*; London. 1449–1451

STREETIN Thomas, *plate-worker*; No. 1 Plough court. 1791, 1792
 Great Sutton street, Clerkenwell. 1796
 Clerkenwell green. 1799

STRELLEY Philip, *goldsmith*; parish of St Mary Colechurch. 1603. (Mentioned) 1620

STRELLEY Philip, *goldsmith*; London. 1653–1655

STRICKLAND E., *silversmith*; No. 9 Fish street hill. 1795, 1796

STRICKLAND Samuel, *goldsmith*; Katherine street, Strand. 1695–1699
 Lombard street. 1706
 Shoreditch. 1727–1734

STRINGER George, *pawnbroker*; Three Bowls, corner of Bennett's court, Drury lane. 1745

STRINGER William, *pawnbroker*; Three Blue Balls, Bennett's court, Drury lane. 1752

STROCKE John, *goldsmith*; parish of St Botolph, Aldgate. (Married) 1582

STRONG John, Junior, *silver buckle maker*; Goswell street. 1778

[1] Pepys' "my little goldsmith in Paternoster row". See several references in the *Diary*, 1666–1667.

STROUD WILLIAM, *goldsmith*; Maiden lane, Wood street. 1761

STROWD WILLIAM, *goldsmith*; Burleigh street, Strand. 1792–1804

STRUDDLE STEPHEN, *goldsmith*; parish of St Bride's, Fleet street. (Married) 1596

STRUDER —, *goldsmith*; Golden Cup, Panton street. 1751

STUBBS JOHN, *goldsmith*; No. 241 Holborn. 1790–1793

STUBBS JOSEPH, *goldsmith*; No. 241 Holborn. 1796

STUDLEY NATHANIEL & WALLIS WILLIAM (see WALLIS & STUDLEY), *goldsmiths*;
London. 1698–1701

STURGIS THOMAS, *goldsmith*; London. 1668

STURT THOMAS,[1] *goldsmith & pawnbroker*; Castle yard, near Holborn Bars. 1701–1707

STYLES ANTHONY, *goldsmith*; parish of St Clement Danes. (Will proved) 1646

SUDBURY —, *goldsmith*; Swan, over against St Clement's Church [Strand]. 1664

SUDELL WILLIAM, *goldsmith*; Butler's alley. 1770
Pelican court [Little Britain]. 1776–1785

SUKS — (cf. DANIEL SOUX), *goldsmith*; George yard, Holborn. 1712

SULLE NICHOLAS, *goldsmith*; London. 1665

SUMMERVILLE ROBERT, *silversmith*; St John's street [Clerkenwell]. 1783

SUMNER WILLIAM, *goldsmith*; No. 1 Clerkenwell close. 1773–1796
Albion buildings, Bartholomew close. 1790

SUMNER WILLIAM & CROSSLEY RICHARD, *plate-worker*; Clerkenwell. 1775–1780

SURMAN ROBERT, *goldsmith & banker*; Grasshopper, Lombard street. 1731–1748

SURMAN, DINELEY & CLIFFE, *goldsmiths*; Lombard street. 1753–1755

SURMOUNT CHARLES, *jeweller*; No. 38 Villiers street, Strand. 1790–1793

SUTHERLAND —, *ring-maker*; No. 6 Orange street, Leicester square. c. 1790

SUTHERLAND JOHN, *jeweller*; Little street, Leicester square. 1753

SUTHERLAND THOMAS, *goldsmith*; No. 2 Vigo lane, Piccadilly. 1790–1796

SUTHES WILLIAM, *goldsmith*; Lambeth. (Will proved) 1625

SUTTON HENRY, *goldsmith*; parish of St Vedast, Foster lane. 1569–(Buried) 1592

SUTTON ISAAC, *goldsmith*; parish of St Andrew Undershaft. 1574–(Buried) 1589

SUTTON JAMES, *working goldsmith & jeweller*; No. 86 Cheapside, next door to Mercers'
Chapel. (Successor to JAMES & FRANCIS STAMP.) 1780–1782

SUTTON JOHN,[2] *goldsmith*; London. 1440–(Died) 1450

SUTTON JOHN, *plate-worker*; parish of St Mary Woolnoth. 1674–1707

SUTTON JOSEPH, *working goldsmith*; Acorn, [No. 12] New street, Covent Garden. 1754–1784

SUTTON NICHOLAS, *goldsmith*; London. 1562

SUTTON SAMUEL, *silver lock maker*; Shoe lane. 1776

SUTTON THOMAS, *plate-worker*; Mugwell street [Monkwell street]. 1711

SUTTON JAMES & BULT JAMES (see BULT & SUTTON), *plate-workers*; No. 86 Cheapside.
1782–1793

SUTTON WILLIAM & CO. (successors to JAMES STAMP), *goldsmiths*; No. 85 Cheapside. 1784–1796

SUTTON WILLIAM & COOPER ISAAC, *goldsmiths*; Cheapside. 1786

SWANN WILLIAM, *goldsmith*; Fleet street. 1777
Covent Garden. 1791

SWANN WILLIAM & CO., *goldsmiths*; Seven Stars, Friday street. 1702–1744

SWANSON ROBERT, *plate-worker*; Blackman street. 1743

[1] See p. 3. [2] Killed on London Bridge in defence of London against Jack Cade's rebels.

SWARTBRIGHT WILLIAM, *goldsmith*; parish of St Mary Woolchurch Haw. (Buried) 1577
SWEET EDWARD, *goldsmith*; St Martin's-in-the-fields. (Insolvent) 1723
SWEETAPLE JOHN, SIR, *goldsmith & banker*; Black Moor's Head, Lombard street. 1677–1701
SWEETAPLE JOHN, HODGKINS BENJAMIN & HARRIS RICHARD, *goldsmiths*; Lombard street.
(Bankrupt) 1701
SWIFT —, *silversmith*; Wood street. 1753
SWIFT JOHN, *plate-worker*; Noble street, near Goldsmiths' Hall. 1728–1773
SWIFT THOMAS, *haft-maker*; Old Bailey. 1773–1777
SWINDELLS EDWARD, *watchcase-maker*; Featherstone street. 1767
SYDENHAM — (see NODES & SYDENHAM), *goldsmith, jeweller and sword-cutler*; No. 126
New Bond street. 1797–1817
SYKAMORE MOSES (see MOSES SICKLEMORE).
SYMMER GEORGE, *jeweller*; St Martin's-in-the-fields. (Insolvent) 1725
SYMMES ISAAC, *goldsmith*; parish of St Botolph, Aldgate. (Married) 1604
SYMONDS C., *goldsmith*; No. 20 Fleet street. 1796
SYMONDS JOHN, *goldsmith*; Highgate. (Married) 1619
SYMONDS THOMAS, *goldsmith*; No. 27 Cheapside. 1772
No. 20 Fleet street. 1774–1793
SYMONDS WILLIAM, *goldsmith*; London. 1540–(Died) 1543
SYMONDS WILLIAM, *goldsmith*; Gutter lane. 1641
London. 1652
SYMONS JOHN, *goldsmith*; Poppins alley [Fleet street]. 1768
SYMPSON FABIAN, *goldsmith*; parish of St Mary Woolnoth. 1601–1608
Parish of St Dunstan's-in-the-East. 1641
SYMPSON GILES, *goldsmith*; parish of St Mary Woolnoth. 1590–1608
SYMPSON JAMES, *goldsmith*; parish of St Vedast, Foster lane. (Married) 1616
SYMPSON RICHARD, *goldsmith*; London. 1570
SYMPSON THOMAS, *goldsmith*; parish of St Mary Woolnoth. 1568–1580
SYMPSON WILLIAM, *goldsmith*; London. 1529–1531
SYNGIN RICHARD, *plate-worker*; Carey lane. 1697
London. 1701–1709

TABOIS PETER, *goldsmith*; Red Lion street. 1773
TACONET JOSEPH, *goldsmith*; Phoenix street, Soho. 1799
TAILBUSHE ROBERT, *goldsmith*; parish of St Mary Woolnoth. 1560
TAILLEFER PAUL, *goldsmith*; London. 1722–1730
TALBOYS (or TAYLEBOIS) ROBERT, parish of St Mary Woolnoth. 1549–(Died) 1580
TALLSWORTH WILLIAM, *goldsmith*; London. 1500
TANNER WILLIAM, *plate-worker*; Spotted Dog, Cheapside, over against Foster lane. 1707–1713
TANQUERAY ANN, *plate-worker*; Pall Mall. 1713–1731
TANQUERAY DAVID, *plate-worker*; Green street. 1713
Pall Mall. 1720–1725
TANT WILLIAM, JUNIOR, *spoon-maker*; Grub street. 1773–1784
TAPP FRANCIS, *goldsmith, cutler & jeweller*; No. 85 Strand. 1770–1784
TASKER ROGER, *goldsmith*; parish of St Mary Woolnoth. 1574–1582
TASKER ROGER, *goldsmith*; London. 1739
TASSELL JOHN (cf. GEORGE LEE), *goldsmith*; Bunch of Grapes, Lombard street. 1670–1695
TATE (? YATE) BENJAMIN, *goldsmith*; London. 1615–1635

Plate LXIX

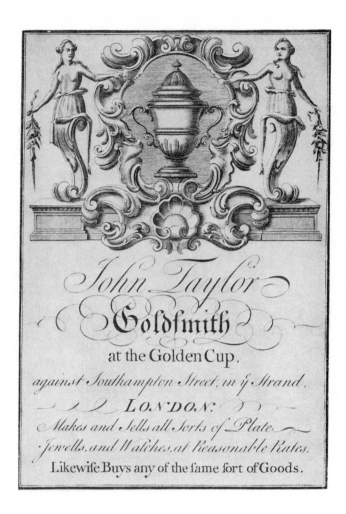

Plate LXX

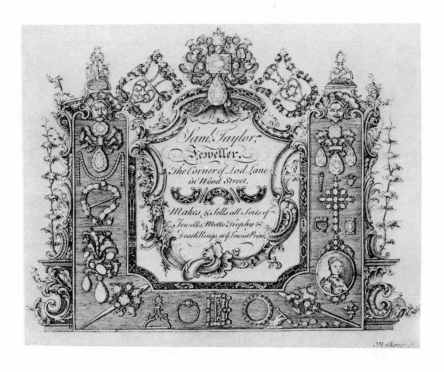

SAMUEL TAYLOR 1744-1757

TAULMAN EDMUND, *goldsmith*; St Martin's-le-Grand. (Bankrupt) 1758

TAYLEBOIS ROBERT (see ROBERT TALBOYS).

TAYLER GEORGE, *silversmith & bucklesmith*; No. 32 Blue Anchor alley, Bunhill row. —

TAYLER (or TAYLOR) JAMES, *goldsmith*; Black Spread Eagle, Lombard street. 1676

TAYLER JOHN, *plate-worker*; Gutter lane. 1728–1734

TAYLEUR JOHN, *plate-worker*; Newgate street. 1775–1784

TAYLOR — (see HENESSY & TAYLOR).

TAYLOR JAMES, *cutler & silversmith*; No. 121 Cheapside. 1796

TAYLOR JASPER, *silversmith & watch-maker*; next Barnard's Inn, Holborn. 1747

TAYLOR JOHN (see also PETER & JOHN TAYLOR), *goldsmith*; Golden Cup, against South-
ampton street, Strand. 1728–1734

TAYLOR JOHN, *goldsmith & cutler*; No. 12 St Martin's-le-Grand. 1790–1793

TAYLOR PETER, *plate-worker*; Golden Cup, against Southampton street, or, corner of Cecil
street, Strand. 1740–1753

TAYLOR PETER & JOHN, *goldsmiths*; Golden Cup, Strand. 1740

TAYLOR ROBERT, *goldsmith*; Bishopsgate street. 1771

TAYLOR SAMUEL, *jeweller*; corner of Lad lane, Wood street. 1744–1757

TAYLOR SAMUEL, *jeweller*; Bartholomew close. 1762

TAYLOR SAMUEL, *jeweller & clock-maker*; Maiden lane, Wood street. 1773
No. 10 Ball alley, Lombard street. 1807–1810

TAYLOR THOMAS, *goldsmith*; London. 1586

TAYLOR THOMAS, *goldsmith*; Golden Lion, Fleet street. 1711

TAYLOR TIMOTHY, *jeweller*; Chandos street. (Insolvent) 1769

TAYLOR WILLIAM (see WAKELIN & TAYLOR).

TAYLOR WILLIAM, *silver buckle maker*; Huggin alley, Gutter lane, Cheapside. c. 1780

TAYLOUR ROGIER, *goldsmith*; London. 1553

TEARLE THOMAS, *plate-worker*; Foster lane. 1719–1725

TEARLE (or TURLE) THOMAS, *plate-worker*; Russell street. 1739–1742

TEBOE — (cf. THOMAS THIBAULT), *jeweller*; Blewitt's buildings, Fetter lane. 1747

TEMPEST CHARLES, *goldsmith*; Three Crowns, Drury lane. 1702–1710
Over against the Castle, Drury lane. 1712

TEMPEST ROBERT, *goldsmith*; Golden Bottle, Cheapside. 1664–(Buried) 1673

TEMPEST ROBERT, *goldsmith*; Three Crowns, Lombard street. 1723

TEMPLE — (see HORNE & TEMPLE).

TEMPLE FRANCIS, *goldsmith*; London. 1674

TEMPLE JOHN[1] (cf. JOHN TEMPLE & JOHN SEALE), *goldsmith*; Three Tuns, Lombard street.
1670–1684

TEMPLE JOHN & THOMAS, *goldsmiths*; Three Tuns, Lombard street. 1678–1684

TEMPLE THOMAS (see WELSTEAD & TEMPLE), Three Tuns, Lombard street. 1672
Precinct of Birchin lane. 1692, 1693

TEMPLE JOHN & SEALE (or SERLE) JOHN, *goldsmiths & bankers*; Three Tuns, Lombard street.
1677–1684

TERRITT JOSEPH, *goldsmith*; Thistle & Crown, Cheapside. 1752

TERRY CHRISTOPHER, *goldsmith*; London. 1515

TERRY F., *goldsmith*; London. 1606

[1] "Mr Temple, the fat blade, Sir Robert Viner's chief man" (Pepys' *Diary*, 30 Sept. 1665).

TERRY GARNET, *engraver & jeweller*; No. 54 Paternoster row. 1777–1796
 No. 20 City road. 1798
TERRY JOHN, *goldsmith*; parish of St Botolph, Aldersgate. (Will proved) 1637
TERRY JOHN, *goldsmith*; Aldersgate street. 1641–(Will proved) 1656
TERRY WILLIAM, *goldsmith*; Lombard street. 1600–(Buried) 1629
TEULINGS CONSTANTINE, *plate-worker*; Dean street. 1755
 Dukes court, St Martin's lane. 1762–1773
 No. 15 Charing Cross. 1784–1793
THAINE JOHN (see RUGG & THAINE), *silversmith*; No. 15 Cheapside. 1788
THAME JAMES, *goldsmith*; parish of All Hallows, Bread street. 1349
THATCHER EDWARD, *goldsmith*; at Mrs Allen's, Fleet bridge. 1642
 Fleet street. 1643
THEAD & PICKETT (cf. WILLIAM PICKETT), *goldsmiths*; Golden Salmon, [No. 32] on the
 north side of Ludgate hill. 1758–1772
THEEUS LODOWICK, *goldsmith*; London. (Will proved) 1622
THIBAULT THOMAS, SENIOR, *goldsmith*; parish of St Anne's, Soho. 1699
THIBAULT THOMAS, JUNIOR, *goldsmith*; London. 1712
THIBAULT THOMAS (cf. — TEBOE), *goldsmith*; Fetter lane. 1734
THIBAUT —, *goldsmith*; Grafton street, Soho. 1695
THIBAUT —, *goldsmith*; New Brentford. 1716, 1717
THIBAUT PETER, *goldsmith*; London. 1735
THISTLETHWAITE ROBERT, *goldsmith*; parish of St Martin's, Ludgate. (Will proved) 1641
THOMAS EVAN, *goldsmith*; London. 1774
THOMAS JEREMIAH (see MOORE & THOMAS), *goldsmith*; Artichoke, Exchange alley. 1666–1684
THOMAS JOHN, *goldsmith & jeweller*; No. 55 St James's street. 1790–1796
THOMAS RICHARD, *plate-worker*; King's Arms yard. 1755–1764
THOMAS RICHARD, *jeweller*; No. 98 Strand. 1790–1796
THOMAS ROBERT, *goldsmith*; London. 1597
THOMAS & EVANS, *jewellers*; No. 16 Staining lane. 1790–1796
THOMASSON JAMES, *goldsmith*; parish of St Mary Woolnoth. 1706–1723
THOMASSON JAMES, *goldsmith & jeweller*; Golden Cup & Key, near Cullum street, in Fen-
 church street. 1745–1755
THOMASSON THOMAS, *goldsmith*; London. 1706
THOMASSON THOMAS, *goldsmith*; Fenchurch street. (Bankrupt) 1744
THOMEGAY MARK, *gold & silver manufacturer*; No. 12 Middle Moorfields. 1760–1793
THOMPSON EDWARD, *goldsmith*; parish of St Mary Staining. (Bankrupt) 1729
THOMPSON JAMES, *goldsmith*; Golden Key, Lombard street. 1709–1725
THOMPSON JOHN, *goldsmith*; London. 1442
THORNBURG FRANCIS, *goldsmith*; Streatham street, Bloomsbury. 1799
THORNE ROBERT, *goldsmith*; No. 12 Wood street, opposite Maiden lane. 1751–1772
THORNE SAMUEL, *plate-worker*; Cannon street. 1697–1700
THORNE T., *goldsmith*; near Cheapside. 1717
THORNE THOMAS, *goldsmith*; No. 23 Wood street, Cheapside. 1760–1772
THORNEY — (cf. STEPHEN THORNLEY), *goldsmith*; Lombard street. 1648
THORNHILL — (see NORTON & THORNHILL).
THORNLEY STEPHEN (cf. — THORNEY), *goldsmith*; parish of St Edmund's, Lombard street. 1641

THORNYCROFT Edward, *goldsmith*; Strand. 1714-(Bankrupt) 1719
THORNYCROFT Henry, *goldsmith*; Golden Bottle, Strand, near Charing Cross. 1697-1707
THORPE Thomas, *goldsmith*; Goat, near the Temple gate, Fleet street. 1684
THOVY Michael,[1] *goldsmith*; London. (Hanged) 1275
THRELKELD Mary, Mrs, *goldsmith*; Ring & Ball, Minories. 1752-1755
THRELKELD William, *goldsmith*; Ring & Ball, Minories. 1743
THRISCROSS —, *plate-worker*; Smithfield Bars. 1697
THURET —, *working silversmith*; London. 1721
THURGOOD Richard, *jeweller*; No. 175 Fenchurch street. 1784
THURKLE Francis, *haft-maker*; Fetter lane. 1773
 London. 1795
THURSBEY (or THURSEBY) Thomas, *goldsmith*; parish of St Vedast, Foster lane. (Buried) 1597
THURSBY John, *goldsmith*; Golden Ball, Lombard street. 1677-1700
THURSTON John, Sir, *goldsmith*; parish of St Vedast, Foster lane. 1515-(Died) 1519
THWAITES James, *goldsmith*; Ratcliff highway. 1770-1772
THYRMER Pierre, *goldsmith*; Blackfriars. 1562-1564
TICHBORNE John, *goldsmith*; parish of St Botolph, Aldgate. (Dead before) 1609
TIMIER Pierre, *goldsmith*; Blackfriars. 1562-1564
TIFFARD —, *jeweller*; Pearl, St Martin's lane. 1721
TIFFIN John, *plate-worker*; Watling street. 1701
TILBY J., *seal-maker & jeweller*; No. 3 Rosoman street, Clerkenwell. 1796
TILLETT John, *goldsmith*; Newington Butts. 1786-1795
 Cross street, Newington. 1798
TIMBERLAKE Joseph, *plate-worker*; Castle street. 1743
TIMBRELL Robert, *goldsmith*; Sherborne lane. 1690-1715
TIMBRELL Thomas, *goldsmith & banker*; Lombard street. (Bankrupt) 1740
TIMBRELL Robert & BENTLEY Benjamin, *goldsmiths*; London. 1714, 1715
TINSON Thomas, *silversmith*; No. 1 Charing Cross. 1790-1796
TIRIE —, *goldsmith*; London. 1620-1623
TISDALE — (cf. Joseph WRIGHT).
TITTERTON George, *plate-worker*; Temple Bar. 1697
 London. 1708, 1709
TOBIAS M., *watch-maker & silversmith*; No. 68 Bell dock, Wapping. 1796
TODD Silvester, *goldsmith*; London. 1540-1553
TOKETT Marmaduke, *goldsmith*; Wardour street. 1773
TOLSON Richard, *goldsmith*; London. 1687
TOMKINS —, *goldsmith*; London. 1442
TOMKINSON Humphrey, *jeweller & goldsmith*; Maiden lane, Covent Garden. 1768-1777
 No. 30 Southampton street, Covent Garden. 1779-1784
TOMKIS Richard, *silversmith*; Minories. 1775
TOMLINSON James, *goldsmith*; over against the Temple, Fleet street. (Absconded) 1660
TOMLINSON Richard, *silversmith*; No. 5 Covent Garden. 1790-1793
TOOKEY — (see CONSTABLE & TOOKEY).
TOOKEY Elizabeth, *spoon-maker*; Silver street. 1773-1775
TOOKEY James, *plate-worker*; Noble street. 1750

[1] See p. 5.

(255)

TOOKEY Thomas, *plate-worker*; Silver street. 1773
 Monkwell street. 1779

TOOKIE Samuel (see TURNER & TOOKIE).

TOONE William, *plate-worker*; Cripplegate. 1725

TOPHAM James, *jeweller & goldsmith*; No. 9 Basing lane. 1784–1796

TOPHAM John, *jeweller*; No. 9 Basing lane. 1795

TOPLADY John, *goldsmith*; Golden Ball, Fenchurch street. 1686

TORBET William, *plate-worker*; Dog & Pottage Pot, corner of Lisle street in Prince's street,
 St Ann's [Soho]. 1737

TOREL William, *goldsmith*; London. 1290

TORET Henry, *goldsmith*; London. Temp. Henry VI

TORIN James Lewis, *jeweller*; No. 30 Throgmorton street. 1740–1774

TOUCHERONDE Jean Fourreau, *goldsmith*; St Andrew street. 1717–1737

TOULMAN Edward, *small worker in gold & silver*; Crown, Great Dean's court, St Martin's-le-
 Grand, near St Paul's. (Bankrupt) 1758

TOWES Christopher, *engraver & jeweller*; No. 119 Cheapside. 1787–1795
 No. 6 St Ann's lane, Aldersgate street. [N.D.]

TOWMAN Thomas, *plate-worker*; Dolphin court. 1753–(?) 1772

TOWNLEY Thomas (see WARD & TOWNLEY), *goldsmith*; Ram, Lombard street. 1677

TOWNSEND Charles, *goldsmith*; Fleet street. 1794

TOWNSEND Edmund, *plate-worker*; Cripplegate. 1697

TOWNSEND Elizabeth & John, *working goldsmiths & jewellers*; [Golden Lion], No. 61
 St Paul's churchyard. 1768–1772

TOWNSEND John, *goldsmith*; Gold Ring, St Margaret's hill, Southwark. 1751

TOWNSEND John, *goldsmith*; Gray's Inn lane. 1755

TOWNSEND John (succeeded Phillips GARDEN in 1762), *working goldsmith & jeweller*;
 Golden Lion, [No. 61] north side of St Paul's churchyard. 1762–1765

TOWNSEND Thomas, *goldsmith*; parish of St Botolph, Bishopsgate. (Married) 1655

TOWNSEND Thomas, *plate-worker*; St Martin's lane. 1738

TOWNSEND William, *goldsmith & jeweller*; No. 74 Fleet street. 1790–1796

TOWNSHEND John, *goldsmith*; London. 1784

TRAHERNE Benjamin, *plate-worker*; St Martin's lane. 1697–1700

TRAHERNE Philip (see Philip TREHERNE).

TRAPPES Francis, *goldsmith*; parish of St Michael's Bassishaw. 1568–(Deceased) 1584

TRAPPIS Robert, *goldsmith*; parish of St Leonard, St Martin's-le-Grand. (Buried) 1526

TRAPPIS (or TRAPPES) Robert, *goldsmith*; London. 1531–1553
 Helmet, Cornhill. 1534–1549

TRAPPIS Thomas, *goldsmith*; London. 1530–1553

TRATT Francis, *jeweller*; Hand & Pearl, against St Mary Ax Church, in Leadenhall street. 1718

TREAT (or TRETT) Richard, *goldsmith*; parish of St Mary Woolnoth. (Married) 1626–1630
 Lombard street. 1641

TREAT Thomas, *goldsmith*; London. 1627

TREATE Robert, *goldsmith*; parish of St Botolph, Bishopsgate. (Married) 1622

TREENE Edward, *goldsmith*; London. 1626

TREHERNE Mrs, *goldsmith*; King street, Westminster. 1716

TREHERNE (or TRAHERNE) Philip, *goldsmith*; near Somerset house, Strand. 1669–1674

TRELEGON James, *goldsmith*; Strand. 1780

Plate LXXI

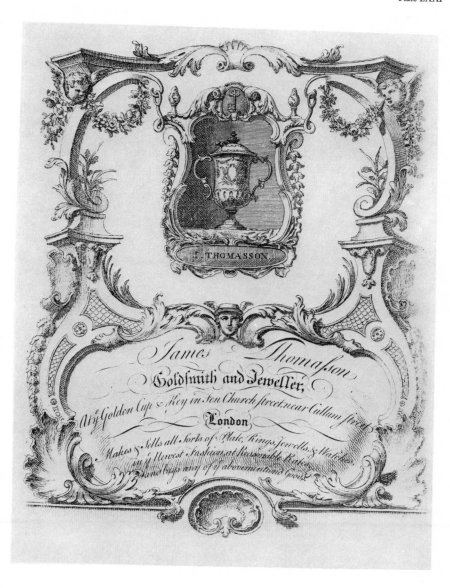

JAMES THOMASSON

1745–1755

Plate LXX

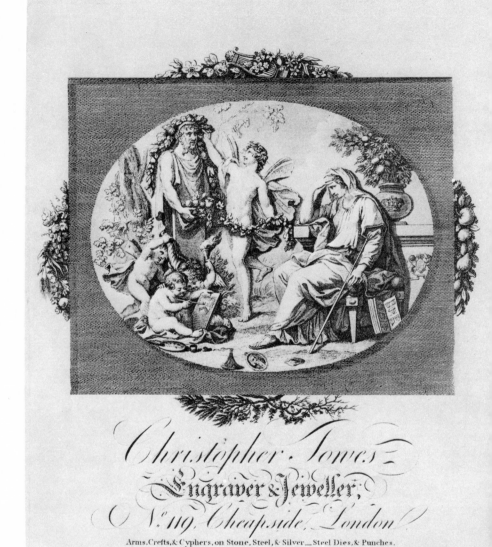

Christopher Towes
Engraver & Jeweller,
N.º 119, Cheapside, London

Arms, Crests, & Cyphers, on Stone, Steel, & Silver.—Steel Dies, & Punches.

A large choice of Gold Seals, Fancy-work & Motto Rings; with immediate dispatch.

Strong Likenesses in miniature, & elegantly mounted in Gold.—

English & Foreign Bills of Exchange, Bills of Parcels, Cards, Book-Plates &c. engraved;

And Copper, & Letter Press Printing, in general.

CHRISTOPHER TOWES

TRELEGON & OCKLEY, *goldsmiths & jewellers*; No. 54 New Bond street. 1790–1796

TRELEGON & TURNER, *jewellers*; No. 54 New Bond street. 1790

TRENDER ANN, *goldsmith*; Prince's street. 1792

TRENDER J., *goldsmith*; Barbican. 1795

TRENDER ROBERT, *goldsmith*; Aldersgate street. 1790

TRENHOLME JONATHAN, *haft-maker & small-worker*; Case of Knives & Forks & Goldsmiths' Arms, Wood street. c. 1760

TRESILIAN WILLIAM, JUNIOR, *jeweller*; Bedford street, Covent Garden. 1755

TREVETT ABRAHAM, *goldsmith*; Holborn. (Married) 1618

TREVILLIAN JOHN, *goldsmith*; parish of St Catherine Cree. 1641–(Will proved) 1651

TRIBLE, JOHN, *jeweller*; corner of Newport alley, near Newport market. 1723
 Litchfield street, Soho. 1726
 Golden Ball (? Litchfield street). 1729

TRICKETT — (see TRIQUET).

TRINGHAM JAMES, *goldsmith*; Noble street. 1793

TRINGHAM JOHN, *goldsmith*; Newgate street. 1780

TRIP REINARD, *goldsmith*; London. 1580

TRIPP JOB, *plate-worker*; Golden Ball, St Martin's lane, facing May's buildings. 1754
 Bridge street, Westminster. 1769–1778

TRIPPS ROBERT, *goldsmith*; London. 1589

TRIQUET (or TRICKETT) —, *silversmith*; over against the Mitre tavern in the Strand. 1747–(Died) 1758

TRIQUET JAMES, *jeweller & goldsmith*; Duke of Montagu's Head, [No. 35] Strand, near York buildings. 1762–1774

TRIST — (see SANKEY & TRIST).

TRISTRAM BENJAMIN, *watch-case maker*; Gutter lane. 1767
 Huggin lane. 1769

TROUGHTON BRYAN, *jeweller*; No. 29 Fenchurch street. 1768
 No. 35 Fenchurch street. 1772–1777
 No. 36 Fenchurch street. 1781

TROUGHTON BRYAN & NATHANIEL, *wholesale jewellers*; Fenchurch street. 1763–1765

TROUTBECK JOHN & DODDS JOSEPH, *goldsmiths*; Aldersgate street. (Partnership dissolved) 1793

TROVELL PETER, *goldsmith*; parish of St Augustine [Watling street]. (Married) 1595

TRUNKET HENRY, *jeweller*; Whalebone court, near Royal Exchange. 1712
 Coleman street. 1727

TRUSS WILLIAM, *plate-worker*; Foster lane. 1710–1721

TUDMAN BENJAMIN, *"goldsmith & banker in linen"*; Crown, Lombard street. 1697–(Buried) 1712

TUDMAN BENJAMIN, JUNIOR, *goldsmith & banker*; Crown, Lombard street. 1701

TUDMAN BENJAMIN & CHILD STEPHEN, *goldsmiths & bankers*; Lombard street. c. 1700–1712

TUFFLEY WILLIAM, *goldsmith*; No. 41 Great Queen street, Lincoln's Inn fields. 1774
 (Cf. address of WM. TUITE.)

TUFFLY WILLIAM, *goldsmith*; Cannon street. 1742–(Bankrupt) 1756

TUITE ELIZABETH, MRS, *plate-worker*; York buildings [Strand]. 1741
 London. (?) 1769

TUITE JOHN, *goldsmith*; Ireland's yard, Blackfriars. 1721
 Green Door, Litchfield street, near Newport market. 1721–1739
 George street, York buildings, Strand. 1745

TUITE JOHN, *goldsmith*; London. 1763

TUITE THOMAS, *goldsmith*; London. 1720

TUITE WILLIAM, *goldsmith*; King street, Golden square. 1756
 No. 41 Great Queen street, Lincoln's Inn fields. 1761–1775
 (Cf. address of W̄M. TUFFLEY.)

TURBITT WILLIAM, *goldsmith*; Foster lane. 1710–1713

TURBUTT BENJAMIN, *silversmith*; Holborn. (Sale of stock; deceased) 1751

TURLE THOMAS (see THOMAS TEARLE).

TURMEAU ALLAIN, *goldsmith*; Golden Key, Grafton street. 1748–1755
 Golden Key, Litchfield street, Soho. (Deceased) 1762

TURMEAU JANE (successor to ALLAIN TURMEAU), Golden Key, Litchfield street. 1762

TURMEAU & KETTLEWELL, *jewellers*; No. 23 Villiers street, Strand. 1790–1796

TURNEOR WILLIAM, *goldsmith & engraver*; Charing Cross. (Insolvent) 1737

TURNER — (see KENTISH & TURNER).

TURNER — (see TRELEGON & TURNER).

TURNER BERNARD (cf. TURNER & TOOKIE), *silversmith*; Golden Fleece, Lombard street.
 1668–1677

TURNER EDWARD, *plate-worker*; St Ann's lane [Foster lane]. 1720–1722

TURNER FRANCIS, *plate-worker*; St Ann's lane [Foster lane]. 1709–1720

TURNER JAMES, *silver-turner*; St Martin's lane. 1761

TURNER JAMES, *jeweller & goldsmith*; No. 28 St James's street. 1790–1796

TURNER JOHN, *jeweller*; No. 10 London Wall. 1790–1796

TURNER SAMUEL, *goldsmith*; London. (Bankrupt) 1710

TURNER WILLIAM, *plate-worker*; Addle street. 1754–1756

TURNER WILLIAM, *spoon-maker*; Wood street. 1767–1768

TURNER ELIAS & CASWALL (commonly called The Sword Blade Company); *goldsmiths*
 & bankers; Lombard street. 1713

TURNER BERNARD & TOOKIE SAMUEL, *goldsmiths & bankers*; Golden Fleece, Lombard street.
 (Before) 1666–1677

TURNER & WILLIAMS, *plate-workers*; Staining lane. 1753

TURPIN THOMAS, *goldsmith*; London. 1568–1570

TURQUAND —, *jeweller*; Northumberland court, Strand. 1747

TURTON WILLIAM, *small-worker in silver*; Little Britain. 1777–1779
 No. 43 Grub street, Cripplegate. 1792

TURTON & WALBANCKE, *jewellers*; No. 8 Fore street, Cripplegate. 1790–1793

TUSTIN FRANCIS, *jeweller*; Long lane, Smithfield. 1672

TWEEDIE JOHN, *plate-worker*; Holywell street. 1783

TWEEDIE WALTER, *plate-worker*; Holywell street. 1775–1786

TWELL WILLIAM, *plate-worker*; Gutter lane. (Married) 1702–1711

TWISLETON JOHN, *goldsmith*; parish of St Matthew's, Friday street. 1516–(Buried) 1525

TWYCROSS STEPHEN, *working jeweller*; No. 3 Pemberton row, Gough square. 1784–1793
 No. 9 Newcastle street, Strand. 1796–1809

TWYFORD FRANCIS, *jeweller*; Hatfield street. (Insolvent) 1769

TWYFORD NICHOLAS, SIR,[1] *goldsmith in ordinary to the King*; parish of St John Zachary.
 1377–(Buried) 1391

[1] Knighted by Richard II for his services in defending the City against the forces of Wat Tyler (1381).
Mayor of London, 1388–9 (see *D.N.B.*).

TYAN JAMES, *goldsmith*; parish of St Martin's-in-the-fields. (Deceased before) 1604

TYLER JEAMES, *jeweller*; Farringdon Within. 1583

TYLER JOHN, *goldsmith*; Lombard street. (Will proved) 1641

TYLER WILLIAM, *goldsmith*; parish of St John Zachary. 1641–(Will proved) 1650

TYLSWORTH WILLIAM, *goldsmith*; London. 1553

TYRILL CHRISTOPHER, *goldsmith*; London. 1516

TYRILL ROBERT (cf. BRADSHAW & TYRILL), *goldsmith*; Angel court, Strand. 1742–1757

TYSOE THOMAS, *goldsmith*; Ship, Gracechurch street. 1699–1706

UDALE ROBERT, *goldsmith*; London. 1511–1516

ULYATE THOMAS, *goldsmith*; Brydges street [Covent Garden]. 1778

UMFREY —, *goldsmith*; London. 1465

UNDERHILL HUGH, *goldsmith*; parish of St Vedast, Foster lane. 1624

UNDERWOOD —, *goldsmith*; Three Flower-de-Luces, Holborn. 1701, 1702

UNDERWOOD —, *jeweller*; facing the terrace in St James's street. 1750

UNDERWOOD A., *goldsmith*; London. 1771

UNDERWOOD FRANCIS, *pawnbroker*; Golden Ball, Grub street. 1716

UNDERWOOD JOHN, *jeweller*; No. 36 Noble street, near Goldsmiths' Hall. 1751–1777

UNDERWOOD THOMAS, *pawnbroker*; Golden Ball, High Holborn. 1707

URLIN SIMON, *goldsmith*; parish of St Vedast, Foster lane. 1641–(Buried) 1681

URQUHART DUNCAN & HART NAPHTALI, *goldsmiths*; London. 1791–1805

USBORNE THOMAS (see CHAMBERS & USBORNE).

USHER PETER, *goldsmith*; Jewin street. 1780

UTBER (or UTHER) JEFFERY, *goldsmith*; Golden Ring, Fenchurch street. 1719–(Bankrupt) 1721

VAILLANT FRÀNÇOIS, *goldsmith*; [No. 4] Exchange court. 1701

VALESCURE STEPHEN, *jeweller*; No. 2 Church alley, Basinghall street. 1779–1781

VALORE PETER, *jewel seller*; Cordwainer street. 1581

VAN BECK —, *jeweller*; Piccadilly. 1717

VAN BRANDENBERG GILBERT, *engraver to the Mint*; London. 1422

VANCE (VAUSE or VASE) RICHARD, *goldsmith*; parish of St Mary Woolnoth. (Married) 1637–(Buried) 1641

VANDELF JOHN, *goldsmith*; London. 1497

VAN DEN SANDE FREDERICK, *goldsmith*; Coleman street. (Will proved) 1628

VAN DORT CORNELIUS, *goldsmith*; London. 1579

VAN EMDEN EGRIJCK HYSSCKENS, *goldsmith*; Golden Cup, Cheapside. 1550

VANHAM LEONARD, *jeweller*; Addle street. 1740

VANHARBOUR PAUL, *jeweller*; Aldersgate ward. 1618

VAN HESSELL JOHN, *goldsmith*; Langbourne ward. 1618

VANNE JOHN, *banker*; parish of St Antholin. c. 1316

VAN SCHIPCROFT AUDREAN (or VAN SCHIPCROOT ADRIAN), *goldsmith*; Muddiford court [Mountford's court], Fenchurch street. 1677

VAN WINTERBECKE MICHAEL, *goldsmith*; parish of St Michael's, Bread street. (Married) 1632

VARDON — (see STEDMAN & VARDON).

VARDON SAMUEL & THOMAS, *goldsmiths*; No. 29 Frith street, Soho. 1779–1793

VARLEY J. B., *jeweller*; No. 132 Fleet street. 1796

VASE RICHARD (see RICHARD VANCE).

VAUGHAN —, *goldsmith*; Blackamoor's Head, Princes street, Leicester fields. 1731

VAUGHAN EDWARD, *goldsmith*; Cheapside. 1622–(Buried) 1654

VAUGHAN HUGH, *goldsmith*; parish of St Clement Danes. 1641
 Parish of St Giles's, Cripplegate. (Will proved) 1649

VAUGHAN RICHARD, *goldsmith*; St Michael-le-Querne. 1641–1647

VAUGHTON JOHN, *goldsmith*; parish of St Mary Woolchurch. 1641
 Parish of St Mildred's, Poultry. (Will proved) 1656

VAUSE LAUNCELOT, *goldsmith*; parish of St Katherine Cree. (Married) 1622

VAUSE RICHARD (see RICHARD VANCE).

VAUTIER NICOLAS, *jeweller*; Porter street, St Anne's, Westminster. 1706

VEDEAU AYMÉ (see AYMÉ VIDEAU).

VENABLES DAVID, *goldsmith*; parish of St Mary Woolnoth. (Buried) 1705

VENABLES STEPHEN, *goldsmith*; parish of St Peter's, Cheapside. 1635–1641

VENABLES STEPHEN, *goldsmith*; parish of St Mary Woolnoth. 1688–(Buried) 1689

VENABLES STEPHEN, *goldsmith*; Cornhill ward. 1691/2, 1692/3
 Parish of St Mary Woolnoth, Langbourne ward. 1692/3
 Parish of St Mary Woolnoth. 1695

VENABLES STEPHEN (see COOKE & VENABLES), *goldsmith*; Sun, Lombard street. (Bankrupt) 1721

VENOUR THOMAS, *goldsmith*; London (?). 1665

VERE —, *jeweller*; Maiden lane, Covent Garden. 1762

VERE JOHN HENRY (see also VERE & LUTWYCHE), *goldsmith & jeweller*; Anchor & Crown,
 [No. 48] Lombard street. 1766–1773
 Walbrook. (Insolvent) 1774

VERE SAMUEL (see GLEGG & VERE).

VERE JOSEPH & ASGILL CHARLES (succeeded GLEGG & VERE), *goldsmiths & bankers*; facing
 Lloyd's Coffee-house, Lombard street. 1740–1750

VERE JOHN HENRY & LUTWYCHE WILLIAM, *goldsmith*; Anchor & Dove, Lombard street.
 (Before) 1766

VERGREW PETER, *goldsmith*; New court, Throgmorton street. 1677

VERLANDER JOHN, *silversmith*; Artichoke court, Whitecross street. 1739–(Insolvent) 1743

VERLANDER PHILIP, *plate-worker*; Brick lane. 1773

VERTON —, *goldsmith*; London. 1516

VEUDE MATTHEW, *goldsmith*; Vintry ward. 1583

VEUGNY PAUL, *goldsmith*; Savoy. 1705

VIDEAU AYMÉ, *plate-worker*; Green street, Leicester fields. 1739–1773

VIET MARIE ANNE & MITCHELL THOMAS (cf. VIET MITCHELL, also THOMAS MITCHELL),
 jewellers & toymen; Dial & King's Arms,
 [No. 6] Cornhill, near Royal Exchange. 1742

VINCENT —, *silversmith*; Great Trinity lane. 1729

VINCENT EDMOND, *plate-worker*; St Ann's, Soho. 1768
 King's Arms court. 1773

VINCENT EDWARD, *goldsmith*; London. 1713
 Strand. 1716–(Bankrupt) 1722

VINCENT EDWARD, *goldsmith*; Dean street, Fetter lane. 1739–(Insolvent) 1743

VINCENT PHILIP, *plate-worker*; Earl street, Seven Dials. 1757–1764

VINCENT RICHARD, *goldsmith*; "late at the Cock in Old Bailey". (Insolvent) 1737
 "Late of Fleet lane." (Insolvent) 1749

Plate LXXIII

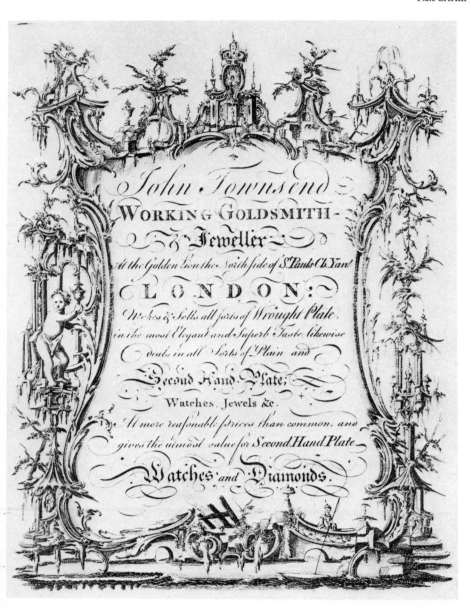

Plate LXXIV

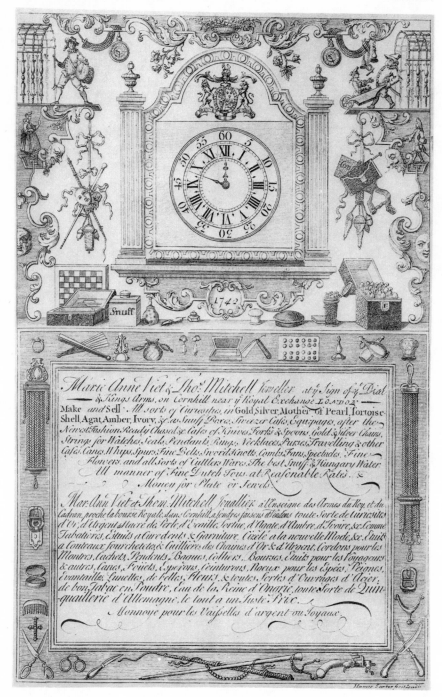

MARIE ANNE VIET & THOS. MITCHELL

[Original size 11½ in. × 7⅜ in.]

1742

VINCENT WALTER, *pawnbroker*; Blue Ball, Orange court, Leicester fields. 1724
VINCENT WILLIAM, *plate-worker*; No. 8 St Ann's lane, Wood street. 1766–1793
VINER (see also VYNER).
VINER JAMES, *goldsmith*; Lombard street. (Married) 1662–(Died) 1666
VINER ROBERT, *goldsmith*; parish of St Mary Woolnoth. (Died) 1690
VINER WILLIAM, *goldsmith*; Lombard street. (Died) 1657
VIOLET THOMAS,[1] *goldsmith & banker*; London. 1634–1665
 Little Britain. 1641
 (?) Parish of St Bride's, Fleet street. 1665
VOETT JACOB, *goldsmith*; London. 1679
VONHAM FREDERICK, *silversmith*; Eagle court, Strand. 1751
 George street. 1752
 York buildings [Strand]. 1773
VYNER GEORGE, SIR, *goldsmith & banker*; Lombard street. 1658–(Buried) 1673
VYNER ROBERT, SIR,[2] *goldsmith & banker*; Lombard street, next to St Mary Woolnoth Church. 1662
 Coleman street. 1680–(Buried) 1688
VYNER THOMAS, SIR,[3] *goldsmith & banker*; London. 1620
 Vine, Lombard street. 1623–(Buried) 1665
VYOLETT THOMAS (see THOMAS VIOLET).

WABERLY JOHN, *goldsmith*; London. 1540–c. 1553
WACE CHRISTOPHER (see CHRISTOPHER WAISTE and CHRISTOPHER WASE), *goldsmith*; parish
 of St Vedast, Foster lane. 1568–(Buried) 1605
WADE JOSEPH, *jeweller*; Bateman's buildings, Bartholomew close. 1790–1793
WADE PETER, *goldsmith*; Mermaid, Lombard street. 1677–1687
WADE RICHARD, *silver turner*; Little Britain. 1765–1767
WADE WILLIAM, *goldsmith*; parish of St Leonard's, Foster lane. 1641
 Dagger Ordinary, Foster lane. 1661–1665
WAGGET JAMES, *silversmith*; Bucklersbury. (Deceased) 1768
WAIGHT MARY (see JOHN WAYT), *pawnbroker*; Golden Ball, Maiden lane, Covent Garden. 1731
WAISTE CHRISTOPHER (see CHRISTOPHER WACE and CHRISTOPHER WASE).
WAIT — *silversmith & watch-maker*; Gun Dock, Wapping. 1749
WAKEFIELD GEORGE, *goldsmith*; London. (Died before) 1616
WAKEFIELD GEORGE, *goldsmith*; London. 1640–1647
WAKELIN EDWARD (see PARKER & WAKELIN), *goldsmith*; Panton street.
 1747–1766. (Died) 1784
WAKELIN JOHN & GARRARD ROBERT, *goldsmiths*; Panton street. 1792–1805
WAKELIN & PARKER (see PARKER & WAKELIN).
WAKELIN JOHN & TAYLOR WILLIAM (successors to PARKER & WAKELIN), *goldsmiths*;
 Panton street. 1776–1796
WAKYNGKNYGHT HENRY, *goldsmith*; London. Temp. Henry VI
WANDREVALE GIRARD, *brooch-maker*; St Martin's-le-Grand. 1564
WALBANK WILLIAM (see TURTON & WALBANCKE), *silversmith*; Cripplegate buildings.
 1790–1793

[1] Sentenced to imprisonment by Star Chamber for exporting gold and silver, 1634 (see *D.N.B.*).
[2] Lord Mayor of London, 1674–5. Mentioned on several occasions in Pepys' *Diary* (see *D.N.B.*).
[3] Lord Mayor of London, 1653–4. Funeral described in Pepys' *Diary*, 1 June, 1665 (see *D.N.B.*).

LONDON GOLDSMITHS

WALDEGRAVE EDWARD, *goldsmith*; Anchor, or Anchor & Crown, Russell street, Covent
Garden. 1690–1721

WALDO JANE, MRS, *jeweller*(?); Golden Artichoke, New Exchange (Strand). 1719

WALDRON MAURICE, *goldsmith*; London. 1630

WALKER BOWYER, *plate-worker*; near the two pumps, in St Thomas's, Southwark. 1735

WALKER GEORGE, *goldsmith*; High street, Marylebone. (Before 1778)
Salisbury street, Strand. (Bankrupt) 1778

WALKER JOSEPH, *pawnbroker*; Three Bowls, Aldersgate. 1722

WALKER JOSEPH & WALKER JOSEPH, JUNIOR, *pawnbrokers*; next door to the White Lion,
Aldersgate. 1723

WALKER RICHARD, *goldsmith*; parish of St Peter's, Westcheap. (Married) 1596

WALKER SAMUEL, *working jeweller & seal-maker*; No. 23 Finch lane, Cornhill. c. 1790

WALKER WILLIAM, *goldsmith*; London. 1557

WALKER WILLIAM, *goldsmith*; Daie's alley [Gutter lane]. 1598

WALKER WILLIAM, *goldsmith*; Black Lion, near Durham yard, Strand. 1683–1689

WALL DANIEL, *goldsmith*; corner of Three Nuns inn, Whitechapel. 1719

WALL HUGH, *goldsmith*; London. 1594

WALL JOHN, *silversmith*; No. 24 Wood street, Cheapside. 1783–1793

WALL JOHN (see DANIELL & WALL).

WALL THOMAS, *plate-worker*; Lombard street. 1708
London. 1739

WALL WILLIAM, *pawnbroker*; Hole in the Wall, Great Kirby street. 1726

WALLER ELIZABETH, *pawnbroker*; Tennis court, Middle row, Holborn. 1724

WALLER JOHN, *goldsmith*; parish of St Mary Woolnoth. (Will proved) 1632

WALLINGTON —,[1] *goldsmith*; London. 1667

WALLIS CHARLES, *goldsmith*; Minories. 1678–1706

WALLIS EDWARD, *goldsmith*; parish of St Matthew, Friday street. (Will proved) 1642

WALLIS JOHN, *goldsmith & banker*; Angel, Lombard street. 1677

WALLIS PETER, *jeweller*; Fleet street, corner of Shoe lane. 1728

WALLIS THOMAS, *plate-worker*; Little Britain. 1758

WALLIS THOMAS, *goldsmith*; Aldersgate street. 1765

WALLIS THOMAS, *plate-worker*; No. 37 Monkwell street. 1767–1784

WALLIS THOMAS, *working goldsmith & spoon-maker*; No. 54 Red Lion street, Clerkenwell. 1777–1814

WALLIS WILLIAM, *goldsmith*; London. 1724
Parish of St Andrew's, Holborn. (Insolvent) 1729

WALLIS WILLIAM & STUDLEY NATHANIEL (see STUDLEY & WALLIS), *goldsmiths*;
London. (Bankrupt) 1702

WALPOLE HENRY, *goldsmith*; London. 1773

WALSH JOHN, *goldsmith*; London. 1370–1409

WALSH JOHN, *goldsmith*; London. 1451

WALSH NICHOLAS, *goldsmith*; London. 1348

WALSH WALTER, *goldsmith*; London. 1698–1702

WALTER ANTHONY, *goldsmith*; London. 1644

WALTER HERMAN, *goldsmith*; Spafields, Clerkenwell. 1773

[1] Pepys' *Diary*, 15 Sept. 1667: "He is a little fellow, did sing with a most excellent bass, and yet a poor
fellow, a working goldsmith that goes without gloves".

(262)

WALTER JOSHUA, *goldsmith*; parish of St Mary Woolnoth, Lombard street. 1617

WALTON — (see SNOW & WALTON).

WALTON —, *pawnbroker*; Three Blue Balls, King street, Golden square. 1758

WALTON WILLIAM, *goldsmith*; parish of St Peter's, West Cheap. 1443–(Died) 1458

WANLEY GEORGE, *goldsmith & banker*; Three Squirrels, Fleet street. 1713–1727

WANLEY GEORGE & CRADOCK GEORGE, *goldsmiths & bankers*; Three Squirrels, Fleet street. 1713–1720

WAPELL GEORGE, *goldsmith*; London. 1674

WARD —, *silversmith*; Anchor, St Paul's churchyard. 1717

WARD — (see GREEN & WARD).

WARD BENJAMIN, *goldsmith*; next to the Monument on Fish street hill. 1698–(Deceased) 1715

WARD JAMES & JOSEPH, *goldsmiths*; London. (Bankrupt) 1709

WARD JOHN, *plate-worker*; Whitechapel. 1656–1661
 Wapping. 1689

WARD JOSEPH, *plate-worker*; Water lane. 1697
 Rose & Crown, Cornhill. 1706–1708
 St Paul's churchyard. 1717
 Foster lane. (Bankrupt) 1723
 Goldsmiths' Hall. 1727–1734

WARD MICHAEL, *plate-worker*; London. 1720
 Cloth Fair. 1750

WARD ROBERT (see WARD & TOWNLEY).

WARD WILLIAM, SIR, *goldsmith & jeweller to Queen Henrietta Maria*; Southwark. 1609–1630

WARD WILLIAM, *goldsmith*; parish of St Saviour's, Southwark. 1612–(Will proved) 1624

WARD WILLIAM, *goldsmith*; near Fetter lane, Holborn. 1641

WARD WILLIAM, *goldsmith*; White Conduit street, Pentonville. 1800

WARD & GOSLING, *bankers*; Three Squirrels, Fleet street. 1742

WARD ROBERT & TOWNLEY JOHN, *goldsmiths & bankers*; Ram, Lombard street. 1677

WARDLAW JOHN, *goldsmith*; London. 1610

WARDS EDWARD, *goldsmith*; Basinghall street. 1677

WARE —, *goldsmith*; London. 1663

WAREYN WILLIAM, *goldsmith*; London. Temp. Henry VI

WARHAM WILLIAM, *plate-worker*; Golden Cup, Shire lane. 1698–(Bankrupt) 1722

WARHAM WILLIAM, JUNIOR, *plate-worker*; Chancery lane. 1705–1727
 Star, over against the Black Spread Eagle in Chancery lane. 1708–1712
 Near King's Head tavern, Chancery lane. 1711
 By the pump, Chancery lane. 1715

WARING RICHARD, *goldsmith*; London. 1646

WARK —, *goldsmith*; George, Lombard street. 1551–1560

WARLEY HENRY, *goldsmith*; London. 1509

WARLEY NICHOLAS, *goldsmith*; parish of St Mary Woolnoth. 1509–(Buried) 1521

WARLEY R., *goldsmith*; London. 1516

WARNER —, *pawnbroker*; Three Golden Balls, near the Pound, St John's, Clerkenwell. 1760–1765

WARNER ELIZABETH, *pawnbroker*; Sun Dial, Corbet court, Spitalfields. 1716

WARNER JOHN, *goldsmith*; Strand. 1663
 Golden Anchor, without Temple Bar, Strand. 1682–(Died) 1722

WARNER THOMAS, *pawnbroker*; Three Balls, King street, Tower hill. (Deceased) 1774

WARRE —, *jeweller & goldsmith*; Golden Lion, fifth door from Devereux court, nearer Temple
 Bar. c. 1760
WARREN —, *silversmith*; Crown, Wych street. 1748
WARREN George, *goldsmith*; London. 1568–1586
WARREN Joshua, *goldsmith*; parish of St Leonard's, Aldersgate Within. 1691/2, 1692/3
WARREN Laurence, *Assay Master of the Mint*; London. 1545
WARREN Thomas, *silversmith*; parish of St Saviour's, Southwark. 1649
WARRENSON George, *goldsmith*; London. 1552
WARTER Richard, *silversmith*; Golden Lion, Holborn bridge. 1708–(Died) 1747
WARTOPS Richard, *goldsmith*; Lion, Lombard street. 1673
WARWICK Beauchamp, *goldsmith*; parish of St Bride's. (Insolvent) 1725
 Parish of St Bartholomew the Great. (Insolvent) 1743
WARWICK William, *gold seal maker & jeweller*; No. 2 Charterhouse square. —
 No. 88 London Wall. 1790–1793
WARYN John, *goldsmith*; London. 1451
WASE Christopher (see Christopher WACE and Christopher WAISTE).
WASSON John, *goldsmith*; Star, near Exchange alley, Lombard street. 1660–1662
WASTELL Samuel, *plate-worker*; Finch lane. 1701
 Mitre, Leadenhall street. 1705–1708
WASTELL Thomas, *goldsmith*; London. 1516–1553
WATERHOUSE —, *goldsmith*; London. 1668–1670
WATERHOUSE Thomas, *goldsmith*; Silver street. 1702
WATERS —, *goldsmith*; Holborn bridge. 1712
WATERS James, *goldsmith*; Foster lane. 1770–1773
WATERS Jonathan, *pawnbroker*; Sun, Charterhouse lane, West Smithfield. 1731
WATERS Thomas, *pawnbroker*; Sun, Charterhouse lane, West Smithfield. 1729
WATERSTONE John, *goldsmith*; London. 1549
WATKINS Francis, *jeweller*; Mitre court, Goldsmiths' row, Cheapside. 1704
WATKINS John, *goldsmith*; London. 1773
WATKINS William, *jeweller*; Cock & Pearl, King street, Covent Garden. 1706
WATKINS William, *plate-worker*; Paternoster row. 1756–1773 (?)
WATKINS William & DEVONSHIRE Thomas (see Thomas DEVONSHIRE), *plate-*
 workers; Paternoster row. 1756
WATSON —, *goldsmith*; London. 1568
WATSON —, *pawnbroker*; Three Balls, Coventry street, Haymarket. 1745–1760
WATSON James, *jeweller*; No. 24 Arundel street, Strand. 1790–1793
WATSON Thomas, *goldsmith*; Lombard street. 1642
 Parish of St Mary Woolnoth. (Buried) 1652
WATSON Thomas, *goldsmith*; London. 1752
WATSON Thomas (see COX & WATSON), *jeweller*; No. 23 Aldersgate street. 1784–1796
WATSON William, *goldsmith & jeweller*; No. 170 Strand. 1784
 No. 190 Strand. 1790–1793
 No. 149 Strand. 1796
WATTON Richard L., *goldsmith*; London. 1773
WATTS Benjamin, *plate-worker*; Carey lane. 1698
 Golden Snail, Fleet street. 1720–1721
 Fleet street. 1724–1727

Plate LXXV

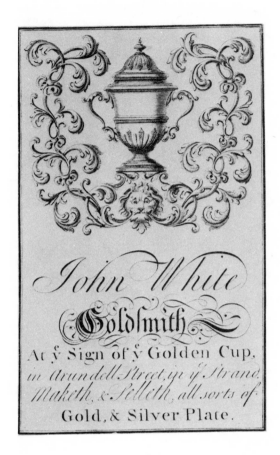

JOHN WHITE 1719–1724

Plate LXXVI

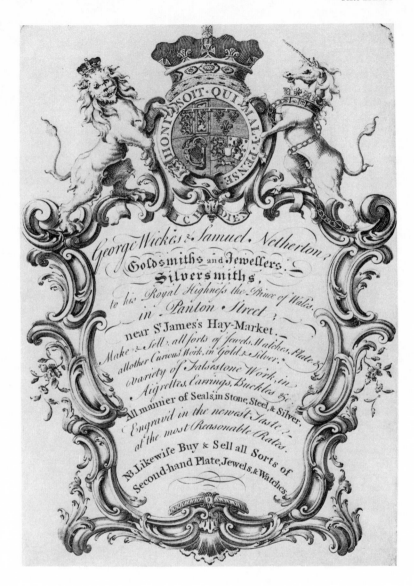

GEORGE WICKES & SAMUEL NETHERTON 1751–1759

WATTS Henry, *jeweller*; Crown court, Cheapside. 1715
WATTS Richard, *plate-worker*; Maiden lane. 1710
 Gutter lane. 1720–1723
WATTS William, *goldsmith*; No. 8 Cripplegate buildings. 1770–1774
 No. 8 Fore street, Cripplegate. 1777–1779
WAYNE William, *goldsmith*; parish of Creechurch. 1641
 London. 1649–1658
WAYSMITH Francis, *plate-worker*; King's Arms court. 1757
 London. 1773
WAYT John (cf. Mary WAIGHT), *pawnbroker*; Golden Ball, Maiden lane, Covent Garden. 1726
WEATHERELL George, *pawnbroker*; Nightingale lane, Wapping. 1743
WEATHERELL John (see John WETHERALL).
WEAVER John, *jeweller*; Coleman street. (Deceased) 1752
WEBB George, *goldsmith*; parish of St Mary Woolnoth. 1539–(Buried) 1551
WEBB Peter; *jeweller*; No. 28 Throgmorton street. 1724–1772
WEBB Richard, *goldsmith*; Golden Cup, Little Newport street. 1747
WEBB Robert, *goldsmith*; St Martin's-in-the-fields. 1690
WEBB William, *goldsmith*; parish of St Bride's, Fleet street. (Married) 1622
WEBSTER John, *goldsmith*; parish of St Peter's, West Cheap. 1598
WEDDELL Samuel, *jeweller*; Hyde street, Bloomsbury. 1777
WEEKES George (see George WICKES).
WEEKS —, *goldsmith*; Black Lion, near the Maypole, Strand. 1681
WEEKS Edward, *goldsmith & watch-maker*; Cornhill. 1772
WEIR George, *plate-worker*; Heming's row [St Martin's lane]. 1727
WELCHE Brian, *goldsmith*; parish of St Leonard's, Foster lane. (Married) 1587
WELD John; *goldsmith*; parish of St Mary Woolnoth. (Married) 1622–1630
WELD Richard, *goldsmith*; parish of St Mary Woolnoth. 1616–1626
WELDER Samuel, *plate-worker*; Oxford City, Gutter lane. 1714–1720
 Foster lane. 1729–1733
WELDER Thomas, *silversmith*; No. 40 Foster lane. 1784
WELDRING John, *plate-worker*; parish of St Clement's, Strand. 1773
 London. 1790
WELLES (or WELLS) John, *jeweller*; corner of Paternoster row, Cheapside. 1760–1765
 No. 4 Cheapside. 1768
WELLES Samuel, *plate-worker*; Staining lane. 1740
 London. 1750
WELLS —, *goldsmith*; Crown & Pearl, Cheapside. 1731
WELLS Daniel & Jane, *silversmiths*; next door to Rose & Crown, Salisbury court, Fleet street. 1725
WELLS Edmond, *goldsmith*; London. 1773
WELLS John, *goldsmith*; West Smithfield. (Insolvent) 1730
WELLS Matthew, *goldsmith & jeweller*, Russell court, Covent Garden. 1760–1765
WELLWOOD William, *pawnbroker*; Cock lane, next to the Golden Key, near Shoreditch. 1711
WELSHE Hugh, *goldsmith*; London. 1527
WELSTEAD Obadiah, *goldsmith*; Doves court, Leather lane, Holborn. (Insolvent) 1737
WELSTEAD Robert (cf. Robert WILSTEAD), *goldsmith*; Hare, Lombard street. 1657–1672
WELSTEAD Robert, *goldsmith*; London. 1695–1702
WELSTEAD Robert & TEMPLE Thomas, *bankers & goldsmiths*; (?) Three Tuns, Lombard
 street. 1672

WELSTONBY WILLIAM, *goldsmith*; London. 1449
WENDOVER JOHN, *goldsmith*; parish of St Vedast, Foster lane. (Buried) 1679
WENNINGTON WILLIAM, *jeweller*; No. 2 Thavies inn, Holborn. 1796
WENTLE GEORGE, *gold & silversmith*; No. 147 Aldersgate street. 1790–1793
WENTWORTH NICHOLAS, *goldsmith*; parish of St Dunstan's-in-the-West. 1719
WERLYNGWORTH NICHOLAS, *goldsmith*; ? Cheapside. (Buried) 1349
WERRITZER PETER, *plate-worker*; London. 1739
 Salisbury street. 1750–1752
WERTON WILLIAM, *goldsmith*; Islington. 1799
WEST BENJAMIN, *plate-worker*; Carey lane. 1737
 Foster lane. 1739–1746
WEST JAMES, *plate-worker*; Blackmoor's Head, Foster lane. 1734–1739
WEST MATTHEW, *plate-worker*; London. 1673
 Foster lane. 1697–1707
WEST MATTHEW, *goldsmith*; Seven Stars, Clare street, Clare market. 1697–1731
 Seven Stars, over against Sun tavern, Old Bailey. 1731–1735
WEST WILLIAM, *plate-worker*; Leicester fields. 1738
WESTBROOK WILLIAM, *goldsmith*; next to the Cross Keys tavern, Holborn. 1702–1719
 London. 1738
WESTERLEY RICHARD, *goldsmith*; London. (Married) 1587
WESTLEY HENRY, *goldsmith*; parish of St Vedast, Foster lane. 1574
WESTMAN JOHN, *goldsmith*; Lombard street. 1640–1642
WESTON SAMUEL, *goldsmith*; Crown & Pearl, Cornhill. 1725
WESTON WILLIAM, *jeweller*; Hide street, near Silver street, Bloomsbury. 1766
 Silver street. 1773
 Noble street. (Insolvent) 1774
WESTRAY JOHN, *goldsmith*; Little Britain. 1765
 No. 10 Little Britain. 1790
WESTWOOD HUMPHREY, *goldsmith*; Tottenham. (Will proved) 1622
WETHERALL (or WETHERHILL) JOHN, *goldsmith*; parish of St Mary Woolnoth.
 1561–(Buried) 1578
WETHERALL (WETHERELL or WETHERHILL) THOMAS, *goldsmith*; parish of St Mary
 Woolnoth. 1540–(Buried) 1554
WETHERED JAMES, *plate-worker*; Catherine street. 1709
WETHERELL JOHN, *goldsmith*; London. 1739–1752 (?)
WETHERELL & JANAWAY, *jewellers, goldsmiths & toymen to the Royal Family*; No. 114
 Cheapside. 1785–1796
WETHERHILL JOHN (see JOHN WETHERALL).
WETHYHALE RICHARD, *goldsmith*; parish of St Peter's, Cheapside. 1427
WHALEY MICHAEL, *goldsmith*; parish of St Mary Woolnoth. 1670–1678
WHARTON EDWARD, *goldsmith*; Black-a-moor's Head, Charing Cross. 1694–1699
 London. 1724
WHEAT SAMUEL, *goldsmith*; Maiden lane. 1756–1773
WHEATE JEREMIAH, *goldsmith*; Foster lane. 1767–1772
WHEATELEY RICHARD, *goldsmith*; parish of St Christopher-le-Stocks. (Widow re-marries) 1594
WHEATLEY JOSEPH, *goldsmith*; parish of St Vedast, Foster lane. (Buried) 1703
WHEATLEY SAMUEL, *goldsmith*; Aldersgate street. 1797

WHEELER CHARLES, *plate-worker*; Golden Tun, near Ivy bridge [Strand]. 1681

WHEELER JOHN, *goldsmith & banker*; Cheapside. 1559–(Died) 1575

WHEELER JOHN, JUNIOR (son of above), *goldsmith & banker*; Fleet street. 1570–(Died) 1609

WHEELER RICHARD, *goldsmith*; London. 1608

WHEELER RICHARD, *goldsmith*; Strand. 1684

WHEELER THOMAS, *silversmith*; No. 114 Oxford street. 1793

WHEELER WILLIAM, *goldsmith*; parish of St Peter's, West Cheap. 1598

WHEELER WILLIAM, *goldsmith*; parish of St Matthew's, Friday street. 1622–1641

WHEELER WILLIAM (son of JOHN WHEELER (II)), *goldsmith & banker*; Marygold, Fleet street. 1627–(Died) 1663

WHEELER WILLIAM, JUNIOR (son of above), *goldsmith & banker*; Marygold, Fleet street. 1666–c. 1675
 (Succeeded by ROBERT BLANCHARD & FRANCIS CHILD.)

WHEELER WILLIAM, *goldsmith*; London. 1699

WHERRIT ROBERT, *goldsmith*; London. 1773

WHICHDALE RICHARD, *goldsmith*; London. 1430

WHIP —, *goldsmith*; Newgate street. 1712

WHIP RICHARD, *goldsmith*; Golden Lion, Newgate street. 1723–1727

WHIPHAM THOMAS, *working silversmith*; Foster lane. 1737–1739
 Ave Mary lane. 1751–1756
 Grasshopper, (No. 61) Fleet street. 1760–1784

WHIPHAM & NORTH, *goldsmiths & jewellers*; No. 61 Fleet street. 1790–1802

WHIPHAM THOMAS & WILLIAMS WILLIAM, *plate-workers*; [Spread Eagle], Foster lane. 1740–1746

WHIPHAM THOMAS & WRIGHT CHARLES, *plate-workers*; No. 9 Ave Mary lane. 1757–1775

WHITAKER GEORGE, *buckle-maker*; Prince's street. 1790

WHITCHURCH —, *pawnbroker*; Striped Ball, next door to the King's Bagnio, Long Acre. (Left off business) 1716

WHITE — (see JACKSON & WHITE).

WHITE — (see BELDON & WHITE).

WHITE —, *goldsmith*; Buck & Cock, Lombard street. (Before) 1666–1670

WHITE —, *goldsmith*; Holborn. 1706–1708

WHITE DAVID (cf. DAVID WHYTE), *goldsmith*; London. 1773

WHITE FULLER [cf. FULLER WHITE & JOHN FRAY], *plate-worker*; Golden Ball & Pearl, Noble street. 1742–1773

WHITE JAMES, *goldsmith*; London. 1635

WHITE JAMES FEAKE, *goldsmith*; London. 1667

WHITE JOHN, *plate-worker*; Golden Cup, Arundel street, Strand. 1719–1724

WHITE JOHN, *goldsmith*; London. 1720–1733

WHITE JOHN, *plate-worker*; Green street. 1739

WHITE JOHN, *goldsmith*; London. 1772

WHITE NICHOLAS, *goldsmith*; Blackfriars. 1581

WHITE PETER, *goldsmith*; London. (Buried) 1635

WHITE PETER (see also WHITE & CHURCHILL), *goldsmith & banker*; Plough, Lombard street. 1673–1695

WHITE ROBERT, *goldsmith*; King's Head court, (?) Fetter lane. 1705

WHITE SAMUEL, *plate-worker*; Oat lane. 1773–1776

WHITE THOMAS, *goldsmith*; Blue Anchor, Lombard street. 1677–1695

WHITE PETER & CHURCHILL THOMAS, *goldsmiths & bankers*; Plough, Lombard street. 1677–1690

WHITE FULLER & FRAY JOHN (cf. FULLER WHITE), *plate-workers*; Golden Ball & Pearl,
 Noble street. 1750
WHITEHALL GILBERT, *goldsmith*; London. 1670–(Will proved) 1710
WHITEHALL GILBERT, *goldsmith*; parish of St Mary Woolnoth. 1695
WHITEHEAD JAMES, *goldsmith*; parish of St Mary Woolnoth. 1653–(Buried) 1675
WHITEWAY SAMUEL, *goldsmith*; Golden Ball & Pearl, Cheapside. 1725–1731
 London. 1760
WHITFORD SAMUEL, *goldsmith*; London. 1773–1790
WHITFORD WILLIAM, *silversmith*; near Foster lane. 1753
 London. 1773
WHITING JOHN, *goldsmith*; London. 1682
WHITLOCK RICHARD, *goldsmith*; parish of St Andrew's, Holborn. 1641–(Married) 1666
WHITMORE CHRISTOPHER, *pawnbroker*; Golden Ball, Middle Row, St Giles-in-the-fields. 1707
WHITMORE MRS SARAH, *pawnbroker*; Seven Stars, Ship yard, near Temple Bar. 1707
 Bolt court, Fleet street. 1710
WHITTINGHAM HENRY, *goldsmith*; parish of St Olave's, Silver street. 1641
 London. 1644–1656 (?)
WHOMAN JOHN, *pawnbroker*; Golden Ball, Plumtree street, Bloomsbury. 1731
WHORWOOD FIELD, *goldsmith*; London. 1655
WHYTE DAVID, *plate-worker*; Clerkenwell. 1766
 No. 19 Little Britain. 1766–1774
WHYTE & HOLMES, *working silversmiths*; No. 12 Clerkenwell green. 1770
WIBIRD JOHN, *working goldsmith*; Babbmays mews, Jermyn street, St James's. c. 1760
WIBURD JAMES, *plate-worker*; Tooley street, Southwark. 1766–1773
WICHALLER (or WICHEHALLER) —, *goldsmith*; Deptford. 1728
WICKENDEN JOHN, *goldsmith*; London. 1772
WICKES GEORGE (son of WILLIAM WICKES) (see CRAIG & WICKES, also WICKES &
 NETHERTON), *plate-worker*; Leadenhall street. (Before) 1721
 Threadneedle street. 1721
 Norris street, Haymarket. c. 1730–1735
 King's Arms, Panton street, two doors from Haymarket. 1735–1761
WICKES GEORGE & NETHERTON SAMUEL (see also CRAIG & WICKES), *goldsmiths &*
 jewellers; King's Arms, Panton street.
 1751–(Left off business) 1759
WICKES JOHN, *goldsmith*; London. 1550
WICKES WILLIAM, *goldsmith*; next Merchant Taylors' Hall, Threadneedle street. 1680–1726
WICKS JOHN, *goldsmith*; London. 1453
WICKSTEAD JOHN, *gold beater*; Chandos street, Covent Garden. 1686
WIDOWES (or WIDDOWERS) RICHARD, *goldsmith*; parish of St Peter's, West Cheap. 1625
WIGAN EDWARD (see GODBEHERE & WIGAN), *plate-worker*; Cheapside. 1800
WIGAN THOMAS, *goldsmith*; London. 1773
WIGGS ROBERT, *goldsmith*; parish of St Peter's, West Cheap. (Buried) 1570
WIGHT JAMES, *goldsmith*; London. 1773
WIGHT WILLIAM, *jeweller*; Crown, King street, Cheapside. c. 1760
 Devonshire street [? Queen square]. 1766
WILCOCK —, *goldsmith*; Dial, Minories. 1695–1699
WILCOX THOMAS, *goldsmith*; Crown, Strand, against York house. 1681
WILDBORE WILLIAM, *goldsmith*; London. (Deceased) 1749

Plate LXXVII

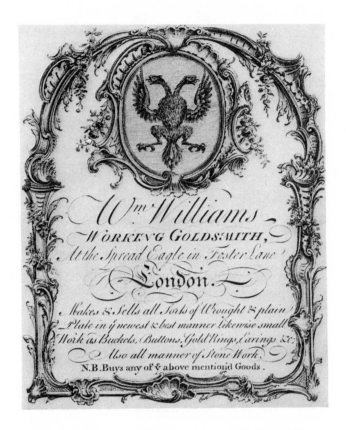

WILLIAM WILLIAMS 1742–1748

Plate LXXVIII

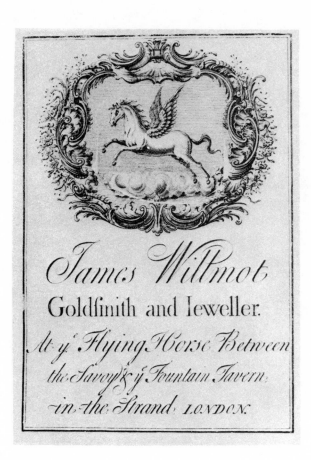

JAMES WILLMOT 1741

WILDE JOHN, *goldsmith*; London. 1622

WILDE SAMUEL, *goldsmith*; parish of St Vedast, Foster lane. (Buried) 1675

WILDEY —, ? *jeweller*; corner of St Paul's churchyard. (?) c. 1750

WILDING JOHN, *goldsmith*; parish of St Olave's, Southwark. 1641–(Will proved) 1649

WILDMAN —, *goldsmith*; Hat & Bible, Cheapside. 1725

WILDMAN —, *goldsmith*; Cheapside. 1728

WILDMAN CHRISTOPHER, *goldsmith*; No. 6 Great Newport street. 1784–1793

WILDMAN SAMUEL, *goldsmith & jeweller*; Sun, [No. 63] Cheapside, opposite Laurence lane. 1768–1796

WILDMAN THOMAS, *goldsmith*; Black-a-moor's Head, Cheapside. 1742–1762

WILDMAN WATKINSON, *goldsmith*; Sun, Cheapside, facing Laurence lane. 1730–1765

WILFORD STARLING *plateworker*; Gutter lane. 1717–1729
"Livin in Sene Pulkas Parshe" (*sic*) (? St Sepulchre's parish). 1729
London. 1730–1737

WILK (or WILKES) WILLIAM, *goldsmith*; lower end of School House lane, Ratcliffe. 1695–1710

WILKES (or WILKS) JAMES, *plate-worker*; Golden lane. 1722
St Mary Axe. 1728

WILKES (or WILKS) JAMES, *plate-worker*; Fell street [Wood street]. 1739

WILKIN HENRY, *goldsmith*; Ring, Fenchurch street. 1705–(Bankrupt) 1710

WILKINS JOHN, *goldsmith*; Lombard street. 1576–(Buried) 1600

WILKINS (or WILKINSON) THOMAS, *goldsmith*; No. 8 Cornhill. 1790–1793

WILKINSON GEORGE, *jeweller*; Sugar Loaf, Bucklersbury. 1709

WILKINSON THOMAS (see THOMAS WILKINS), London. 1773
No. 8 Cornhill. 1790–1793

WILKINSON, HOLY & CO. (cf. DANIEL HOLY, WILKINSON & CO.), *silver plate manu-factory*; No. 6 Crane court, Fleet street. 1793

WILKS DENNIS, *plate-worker*; London. 1728–1736
Old street. 1737–1739

WILKS JAMES, *goldsmith*; Golden Ball, Wood street, near Cripplegate. 1735

WILKS WIDOW, *pawnbroker*; Parkins' rents, near Old Pye street. 1743

WILKS DENNIS & FRAY JOHN, *plate-workers*; Fore street. 1753

WILL JAMES, *goldsmith*; corner of Monument yard [Fish street hill]. 1710

WILLATS MOSES, *goldsmith*; Elephant, Poultry. 1762
London. 1773

WILLAUME DAVID, SENIOR, *goldsmith & banker*; London. 1674–1712
Windsor Castle, Charing Cross. 1686–1690
Golden Ball, Pall Mall. 1697–1712

WILLAUME DAVID, JUNIOR, *goldsmith & banker*; London. (Apprenticed) 1706–1746
Golden Ball, on the terrace in St James's street. 1716–1720
St Martin's-in-the-fields. 1721

WILLDEY THOMAS, *goldsmith*; corner of Ludgate street, near St Paul's. (Deceased) 1748
(Succeeded by MRS SUSANNA PASSAVANT.)

WILLERTON & GREEN, *jewellers*; No. 21 New Bond street. 1784–1796

WILLERTON & ROBERTS, *jewellers & toymen*; New Bond street. 1773

WILLERTON, SKULL & GREEN, *jewellers & watch-makers*; No. 21 New Bond street. 1783–1794

WILLIAM FITZWILLIAM, *goldsmith*; London. 1212

WILLIAMS — (see TURNER & WILLIAMS).

WILLIAMS —, *silversmith*; Ratcliffe. 1747

(269)

AA

WILLIAMS MRS, *pawnbroker*; Blue Ball, Queen street, Seven Dials. 1718
WILLIAMS CHARLES, *plate-worker*; Lamb alley. 1697–1704
WILLIAMS DAVID (see DAVID WILLAUME).
WILLIAMS HENRY, *goldsmith*; parish of St Gregory. (Will proved) 1635
WILLIAMS HUMPHRY, *goldsmith*; parish of St Peter, Westcheap. (Buried) 1625
WILLIAMS ISELAND, *goldsmith*; parish of St Saviour's, Southwark. 1663
WILLIAMS JAMES, *plate-worker*; Paternoster row. 1755, 1756
WILLIAMS JOHN, SIR, *the King's goldsmith*; Elsing spital [Cripplegate]. 1541
WILLIAMS JOHN, *goldsmith*; parish of St Peter, Westcheap. 1601
 London. 1610
 Cheapside. (Died) 1636
WILLIAMS JOHN, *goldsmith & watch-maker*; Union court. 1770
WILLIAMS JOHN, *jeweller & goldsmith*; Albion buildings, Bartholomew close. 1773–1793
WILLIAMS NICHOLAS, *goldsmith*; parish of St Ethelburga. (Married) 1581
WILLIAMS RICHARD, *goldsmith*; parish of St Vedast, Foster lane. 1574–(Buried) 1590
WILLIAMS RICHARD, *plate-worker*; Gutter lane. 1712
WILLIAMS ROBERT, *plate-worker*; Golden Unicorn, King street, Westminster. 1726–(Buried) 1762
WILLIAMS ROBERT (see SHARP & WILLIAMS), *goldsmith & jeweller*; No. 6 Strand, near
 Northumberland street. 1781–1788
 London. 1797
WILLIAMS ROBERT, JUNR., *goldsmith*; London. 1796–(Died) 1847
WILLIAMS THOMAS, *goldsmith & banker*; Crown, Lombard street. 1669–(Deceased) 1697
WILLIAMS THOMAS, *goldsmith*; Brick lane. (Insolvent) 1772
WILLIAMS WILLIAM (cf. WHIPHAM & WILLIAMS), *working goldsmith*; Spread Eagle,
 Foster lane. 1742–1748
WILLIAMSON TIMOTHY, *jeweller*; No. 196 Fleet street. 1768
 No. 59 Fleet street. 1774–1777
WILLIE GEORGE, *goldsmith*; London. 1620
WILLIS ELIAB, *goldsmith*; Hand & Ring, Poultry. 1712
WILLIS JOHN, *goldsmith*; New Bond street. 1784
 St John's lane. 1786
WILLITT JAMES, *goldsmith*; Three Black Lions, near Palsgrave Head court, without Temple Bar. 1697
WILLMOT JAMES, *goldsmith & jeweller*; Flying Horse, between the Savoy and the Fountain
 tavern, Strand. 1741
WILLMOT JOHN, *goldsmith*; Ring & Pearl, Abchurch lane, opposite Pontac's [coffee-house]. 1748–1755
WILLMOT JOHN, *gold ring maker*; the corner of the Three Tuns tavern, [No. 86] St Margaret's
 hill, Southwark. 1762–1775
WILLMOT WILLIAM, *goldsmith*; No. 86 St Margaret's hill, Southwark. 1777–1781
WILLMOTT JOHN, *pawnbroker*; Clothworkers' Shears, Houndsditch. 1731
WILMORE DANIEL, *goldsmith*; parish of St Helen's, Bishopsgate. 1658
WILSON — (see NASH & WILSON, also NORTH & WILSON).
WILSON ALEXANDER, *silversmith*; Adam street, St Martin's-in-the-fields. (Bankrupt) 1755
WILSON HENRY, *goldsmith*; parish of St Mary Woolchurch Haw. 1697
 London. 1724
WILSON JOHN, *goldsmith*; London. 1580
WILSON JOHN (see BOLITHO & WILSON).
WILSON JOSEPH, *goldsmith*; Black Boy, against St Dunstan's Church, Fleet street. 1688–1704

WILSON Joseph, *goldsmith*; Plough (or Blue Plough), Lombard street. 1695–1720
WILSON Michael, *goldsmith*; Sun, Little Lombard street. 1695–(Buried) 1709
WILSON William, *goldsmith & banker*; over against St Clement's church, Strand.
1713–(Shot himself) 1725
WILSON William (see PLAYFAIR & WILSON).
WILSTEAD Robert (cf. Robert WELSTEAD), *goldsmith*; London. 1678
WILTSHIRE Thomas, *silversmith*; No. 46 Lombard street. 1796
WIMANS —, *plate-worker*; Foster lane. 1697–1705
WIMBISHE George, *goldsmith*; London. (Will proved) 1620
WIMBUSH —, *goldsmith*; London. 1662
WINBURGEN Roger, *goldsmith*; London. 1517
WINDAL —, *goldsmith*; St Martin's churchyard. 1712
WINGFIELD Thomas, *jeweller*; Angel street. 1769
WINKINS Nicholas, *plate-worker*; Red Lion street. 1751
WINN William, *goldsmith*; near Hermitage stairs, Wapping. 1712
Minories. 1724–1734
WINN William, *goldsmith*; near Aldgate. 1744
WINSMORE John, *goldsmith*; London. 1773
WINSTANLEY —, *goldsmith*; Unicorn & Crown, Lombard street. 1751–1755
WINTER John, *goldsmith*; London. 1773
WINTER Richard, *goldsmith*; parish of St Saviour's, Southwark. 1660
WINTER William, *goldsmith*; No. 21 Bunhill row, Moorfields. 1772–1779
WINTLE George, *silver spoon maker*; Angel street. 1787
No. 147 Aldersgate street. 1790–1793
WINTLE Samuel, *goldsmith*; London. 1783
WINTLE Thomas, *goldsmith & jeweller*; Ring & Pearl, No. 9 Poultry. 1760–1790
WIRGMAN Gabriel (see MORRISET & WIRGMAN), *goldsmith*; Red Lion street, Clerken-
well. 1773
Denmark street, Soho. 1778–1783
WIRGMAN John, *plate-worker*; Strand. 1745
Princes street. 1766–1772
WIRGMAN Peter,[1] *toyman, jeweller & enameller*; No. 11 Denmark street, Soho. 1790
No. 69 St James's street. 1784–1796
WIRGMAN, SON & COLIBERT, *jewellers, gold-workers & enamellers*; No. 11 Denmark street,
Soho. 1796
WISDOM John, *plate-worker*; Watling street. 1704–(Died) 1731
WITHERS Fabian (see FABIAN WYTHERS).
WITHERS Samuel, *goldsmith*; London. 1773
WODE Will., *goldsmith*; London. 1665
WODEWARD William, *engraver to the Mint*; London. 1455
WOLDING & BALCOMB, *goldsmiths*; Strand, near Arundel street. 1763
WOLDRING John, *goldsmith*; Strand. (Insolvent) 1769
WOLFE Isaac, *goldsmith*; parish of All Hallows, Honey lane. (Will proved) 1623
WOLFE Joseph, *jeweller*; Mitre court, near Aldgate. 1768–1770
WOLFF Morgan, *goldsmith*; London. 1520–1553
WOLFRYS Nathaniel (see Nathaniel WOOLFREY).

[1] Here Dr Johnson bought his silver shoe-buckles (Boswell). No. 69 is the original site of White's Chocolate House—later Arthur's Club.

WOLK John, *goldsmith*; London. 1480

WOLLASTON (or WOOLLESTON) John, Sir,[1] *goldsmith*; Foster lane. 1618–(Died) 1658

WOLLASTON Nicholas, *goldsmith*; parish of St John Zachary. 1641–1646

WOLSTONCRAFT Arthur, *goldsmith*; parish of St Andrew Undershaft. (Will proved) 1655

WONTNER John, *silversmith & watch-maker*; No. 125 Minories. 1770–1812

WOOD Edward, *plate-worker*; Puddle Dock [Upper Thames street]. 1722
 Carey lane. 1735–(Deceased) 1752

WOOD George, *goldsmith*; parish of All Hallows, Honey lane. 1595–1597

WOOD John, *silversmith*; Minories. 1770

WOOD John, *jeweller*; Noble street, Foster lane. 1772–1781

WOOD Nicholas Thomas, *goldsmith*; St James's, Clerkenwell. 1791

WOOD Richard, *goldsmith*; Black Swan, Holborn. 1675

WOOD Samuel, *plate-worker*; Gutter lane. 1733–1740

WOOD Samuel, *plate-worker*; Southgate [? St Paul's churchyard]. 1773

WOOD Thomas,[2] *goldsmith*; Goldsmiths' row, Cheapside. 1484–(Died) 1504

WOOD Thomas, *goldsmith*; parish of St Peter the Apostle in West Cheap. 1567

WOOD William, *goldsmith*; parish of St Mary Woolnoth. 1604–1625

WOOD Christopher & FILKIN Thomas, *spoon-makers*; Battersea. 1773

WOODCOCK Edward, *diamond cutter*; Bury street, near Aldgate. 1709

WOODCOCK Isaac, *goldsmith*; parish of St Edmund's, Lombard street. (Will proved) 1625

WOODHOUSE Thomas, *goldsmith*; London. 1773

WOODNORTH William, *goldsmith*; George street. 1771

WOODNOT Arthur, *goldsmith*; Foster lane. 1623

WOODS Christopher (cf. Christopher WOOD & Thos. FILKIN), *plate-worker*; King street,
 Soho. 1775

WOODS Thomas, *goldsmith*; Maidenhead, Great Wood street. 1694

WOODWARD Charles, *plate-worker*; Tooley street. 1741

WOODWARD Richard & Thomas, *goldsmiths & bankers*; Exchange alley. 1723–(Bankrupt) 1731

WOODWARD William, *plate-worker*; Fenchurch street. 1731–1743
 London. 1752

WOOLESTON John, Sir (see Sir John WOLLASTON).

WOOLFREY Nathaniel, *goldsmith*; Golden Fleece, Lombard street. 1696–1705
 Clapham. 1727
 St Bartholomew's Hospital. 1734

WOOLFREY Nathaniel & KIRWOOD Matthew, Sir, *goldsmiths*; Golden Fleece,
 Lombard street. 1705

WOOLLER William, *plate-workers*; Cloth fair. 1750
 London. 1767

WOOLLEY Thomas, *jeweller & goldsmith*; No. 41 Hatton street. 1790–1793

WOOLSTOW Benjamin, *goldsmith*; Cheapside. 1727

WOOTTON Thomas, *goldsmith*; Temple Bar. 1700
 Black Lion, Fleet street. 1703

WOOTTON & FOWLE (or FOWLES), *goldsmiths*; Black Lion, Fleet street. 1693

WORBOYS Arthur, *jeweller*; No. 4 Wine Office court, Fleet street. 1767–1775
 No. 94 Fleet street, near Bride lane. 1774–1781

WORBOYS John, *goldsmith*; No. 30 Ludgate hill. 1784–1793
 Fleet street. 1799

[1] Lord Mayor of London, 1643-4. [2] Built Goldsmiths' row in Cheapside, 1491.

Plate LXXIX

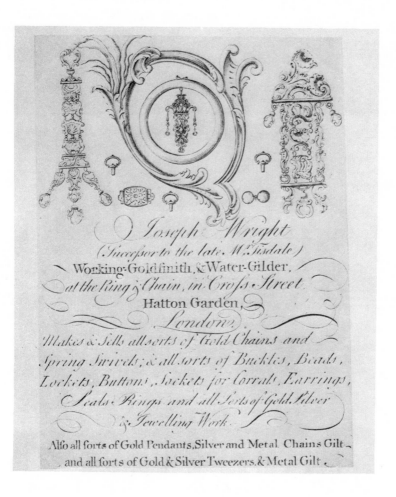

JOSEPH WRIGHT *circa* 1750

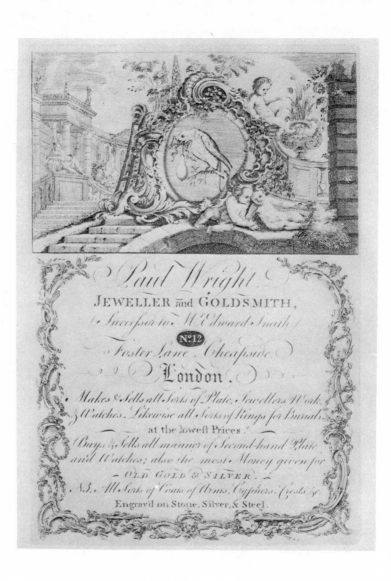

PAUL WRIGHT 1771–1773

WORBOYS Thomas, *jeweller*; Bell's buildings, Salisbury square. 1790–1793

WORMELAYTON Thomas, *goldsmith*; parish of St Thomas, Foster lane. 1641

WORMELEIGHTON Daniel, *goldsmith*; parish of St Agnes & St Anne's [Aldersgate].
1641–(Will proved) 1647

WORSLEY John, *jeweller*; Ring & Pearl & Case of Knives, opposite Mincing lane, Fenchurch
street. c. 1780

WORSLEY Thomas, *jeweller*; No. 22 Cheapside. 1784

WORTHINGTON William, *goldsmith & gilder*; No. 158 Fleet street. 1767–1773

WORTOPP Rowland, *goldsmith*; Lion, Lombard street. 1674

WOTTON Richard L., *goldsmith*; London. 1773

WRAGG Samuel, *goldsmith*; Golden Lion, Fleet street. 1700

WREN John, *plate-worker*; Worship street. 1776
No. 95 Bishopsgate Without. 1777–1785
London. 1795

WRIGHT —, *silversmith*; Holborn. 1735

WRIGHT — (see WRIGHT & SELLON), *working goldsmith & watch-maker*; Dial & Three
Crowns, Southwark. 1749–(Died) 1758

WRIGHT Adam, *goldsmith*; parish of St Clement Danes. (Married) 1594

WRIGHT Anthony, *goldsmith & banker*; Russell street, Covent Garden. 1727
Golden Cup, Great Russell street, Covent Garden. 1729–1754
Golden Cup, [No. 5] Henrietta street. 1759–1768

WRIGHT Anthony & SON, *bankers*; Golden Cup, Henrietta street. 1774

WRIGHT Arthur, *goldsmith*; parish of St Giles-in-the-fields. (Married) 1625

WRIGHT Charles, *jeweller*; Crown & Pearl, Wood street, near Cheapside. c. 1760

WRIGHT Charles[1] (see WHIPHAM & WRIGHT), *goldsmith*; No. 9 Ave Mary lane, Pater-
noster row. (Married) 1764–1780
No. 76 Strand. 1784–1788
No. 94 Watling street. 1790

WRIGHT Emery, *goldsmith*; parish of St Clement Danes. (Married) 1586

WRIGHT John, *goldsmith*; parish of St Michael's, Wood street. (Will proved) 1650

WRIGHT John, *goldsmith*; London. 1706–1708

WRIGHT John, *goldsmith*; London. 1773

WRIGHT Joseph (successor to the late Mr TISDALE), *working goldsmith & water gilder*;
Ring & Chain, Cross street, Hatton Garden. c. 1750

WRIGHT Paul (successor to Edward SMITH), *goldsmith*; [Parrot & Pearl], No. 12 Foster lane.
1771–1773

WRIGHT Richard, *goldsmith & banker*; Golden Cup, Great Russell street. 1697–1718

WRIGHT Robert, *goldsmith*; parish of St Vedast, Foster lane. 1569–1578

WRIGHT Sacheverel, *goldsmith*; London. 1771–1773

WRIGHT Thomas, *goldsmith*; late of Shoe lane. 1720
Maiden lane. 1721

WRIGHT Thomas, *goldsmith*; London. 1754–1772

WRIGHT Thomas, *goldsmith*; Golden Ball, Duke's court, St Martin's lane. 1765–1775

WRIGHT Thomas, *goldsmith*; Beach lane. 1769

WRIGHT William, *goldsmith & banker*; Golden Cup, Russell street, Covent Garden.
1699–(Died) 1724

[1] The present successors of this firm are Edward Barnard & Sons, 57 Hatton Garden.

WRIGHT WILLIAM, *working goldsmith*; No. 217 Tooley street. 1790–1796
WRIGHT & SELLON, *working goldsmiths & watch-makers*; Dial & Three Crowns, Borough,
 Southwark. 1749–1769
WYATT JOSEPH, *goldsmith*; Angel street. 1790
WYATT RICHARD, *goldsmith*; Blowbladder street. (Insolvent) 1748
WYBURN JAMES, *goldsmith*; Walworth. 1795
WYDDER FABIAN (see FABIAN WYTHERS).
WYGAT —, *silversmith*; Hemlock court [? Carey street]. 1710
WYGGE ROBERT, *goldsmith*; London. 1550–1566
WYKE FRANCIS, *goldsmith*; opposite Gray's Inn gate, Holborn. (Deceased) 1757
WYKEN ROBERT, *goldsmith*; Gutter lane. 1349
WYLERSBY GEORGE, *keeper of the Exchange*; London. 1468
WYNDESORE WILLIAM, *goldsmith*; London. 1340
WYNN W., *goldsmith*; Minories. 1725
WYTHERS FABIAN (or WYDDER), *goldsmith*; parish of St Mary Woolnoth. 1539–1553

YARD WARW[ICK ?], *goldsmith*; [Royal] African House [Leadenhall street]. 1677
YARMAN SAMUEL, *spoon-maker*; Great Newport street. 1771
YARNER, *goldsmith*; Newgate street. 1701
YATE (? TATE) BENJAMIN, *goldsmith*; London. 1615–1635
 St Michael-le-Querne. 1641
YATE ROBERT, *goldsmith*; London. 1701
YATES (or YEATES) FRANCIS, *goldsmith*; Golden Ring, Lombard street. 1678–1704
YATES NATHANIEL, *goldsmith*; parish of St Saviour's, Southwark. 1657–1664
YEATE (or YATES) JOHN, *goldsmith*; parish of St Peter, Cheapside. 1641
 Cheapside (?). (Mentioned) 1652
YEATES FRANCIS (see FRANCIS YATES).
YELVERTON WILLIAM, *goldsmith*; No. 115 Portland street. 1784–1793
YEMANS THOMAS, *goldsmith*; London. 1562
YEO —, *goldsmith*; Rising Sun, Tavistock street, Covent Garden. 1746
YEOMANS ROBERT, *goldsmith*; parish of St Dunstan's-in-the-East. (Will proved) 1625
YERBURY DANIEL, *plate-worker*; Bread street. 1715
YONGE AMBROSE, *goldsmith*; parish of St Vedast, Foster lane. (Buried) 1563
YORK (or YORKE) EDWARD, *plate-worker*; parish of St Mary Staining. 1692, 1693
 London. 1699–1705
 Holborn. 1705
 King street, Westminster. 1717–1732
YORK (ALIAS DOUGHTY) MARGARET, *pawnbroker*; removed from Plumb Tree court, Shoe
 lane, to next door to the Golden Cup, Noble street,
 Foster lane. 1725
YORK THOMAS, *goldsmith*; London. 1773
YOUNG —, *necklace-maker*; near St Luke's Church, Whitecross street, Old street. ? c. 1760
YOUNG EDWARD, *pawnbroker*; Exeter court, near Exeter Change, Strand. 1726
YOUNG GEORGE, *goldsmith*; Glasshouse street. 1722
 Broken wharf [Upper Thames street]. (Insolvent) 1723
YOUNG GEORGE, *plate-worker*; Moorfields. 1746–1749

YOUNG Henry, *goldsmith, jeweller & toyman*; No. 9 Fleet street. 1768–1777
 Star & Garter, No. 18 Ludgate street near St Paul's. 1779–1793
YOUNG James, *plate-worker*; No. 32 Aldersgate street. 1773–1790
YOUNG James & SON, *silversmiths*; No. 70 Little Britain. 1790–1793
YOUNG John, *goldsmith*; Fore street precinct. 1698
YOUNG William, *plate-worker*; St Andrew's street. 1735–1739
 High Holborn. 1744–1747
 Golden Cup, Holborn bridge. 1752–(Deceased) 1755
YOUNG William, *jeweller*; Christopher's court. 1767
YOUNG James & JACKSON Orlando (see Orlando JACKSON), *plate-workers*; Aldersgate
 street. 1774
YOUNGE Henry, *goldsmith*; parish of St Mary Abchurch. 1672–1674

ZIERBOHM —, *jeweller*; Fountain court, Strand. 1747
ZIMPANY (or LYMPANY) Robert, *goldsmith*; parish of St Dunstan's-in-the-West.
 (Will proved) 1627
ZIMPANY (LYMPANY or LUMPANY) Robert, *goldsmith*; parish of St Mary Woolnoth.
 1647–1650
ZOUCH Richard, *plate-worker*; Chequer court, near Charing Cross. 1735–1739

INDEX

NOTE. An Index inclusive of every goldsmith's name mentioned in this book is rendered unnecessary by reason of the alphabetical arrangement of the lists provided in Chapters IV and VII.

This Index, therefore, consists only of those names which recur in other parts of the book together with such general headings as seemed likely to require reference.

Neither does this Index include the goldsmiths' shop-signs as the list given in Chapter VI affords easy reference to them.

INDEX

INDEX